Adventures
in the
Human Spirit

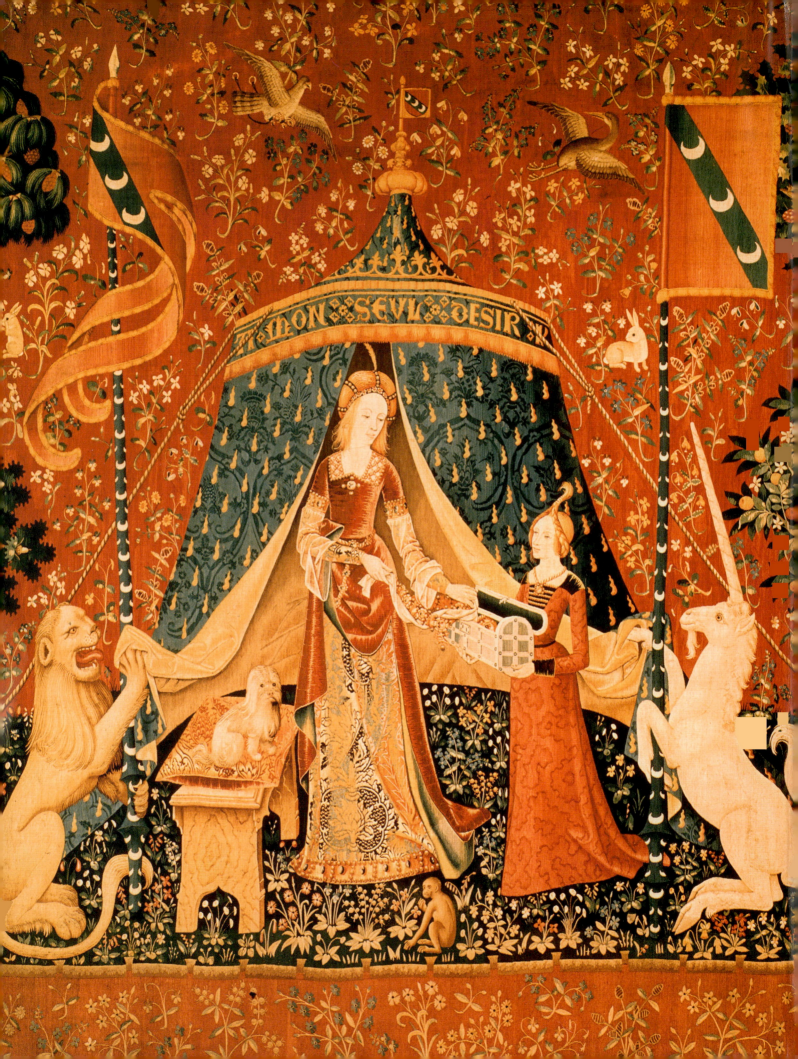

Fifth Edition

Adventures
in the
Human Spirit

Philip E. Bishop

Valencia Community College

Prentice Hall, Inc., Upper Saddle River, N. J. 07458

Library of Congress Cataloging-in-Publication Data

Bishop, Philip E.
 Adventures in the human spirit / Philip E. Bishop. -- 5th ed.
 p. cm
 Includes bibliographical references and index.
 ISBN 0-13-224459-4
 1. Cvilization, Western--History--Textbooks. 2. Humanities--History--Textbooks. I.
Title.

CB245.B57 2007
808'.09821--dc22

2006051559

Editor in Chief: Sarah Touborg
Senior Editor: Amber Mackey
Director of Marketing: Brandy Dawson
Executive Marketing Manager: Marissa Feliberty
Editorial Assistant: Carla Worner
Manufacturing Buyer: Sherry Lewis
Senior Managing Editor: Lisa Iarkowski

This book was designed and produced by
Laurence King Publishing Ltd, London
www.laurenceking.co.uk

Every effort has been made to contact the copyright holders, but should there be any errors or omissions, Laurence King Publishing Ltd
would be pleased to insert the appropriate acknowledgment in any subsequent printing of this publication.

Commissioning Editor: Melanie White
Copy Editor: Nicola Hodgson
Picture Researcher: Claire Gouldstone
Designer: Ian Hunt

Front cover: Gustav Klimt, *The Kiss* (detail), 1907–8. Oil and gold on canvas,
5 ft 10⁷/₈ x 5ft 10⁷/₈ ins (1.8 x 1.8 m). Österreichische Galerie Belvedere, Vienna.

Frontispiece: *The Lady and the Unicorn: "To my only desire"*, French school,
late 15th century. Wool and silk, 12 ft 5³/₅ ins x 15 ft 1²/₃ ins (3.8 x 4.64 m).
Musée National du Moyen Âge et des Thermes de Cluny, Paris.

10 9 8 7 6 5 4 3 2 1
ISBN–13: 978-0-13-224459-6
ISBN–10: 0-13-224459-4

Contents

5 The Spirit of Monotheism: Judaism, Christianity, Islam 97

6 The Early Middle Ages: The Feudal Spirit 130

7 The Late Middle Ages: The Gothic Awakening 158

Extracts

This book includes poems or short extracts from the following authors and works. Copyright information is given in the Notes on page 447–450.

Timecharts

Maps

Other Tables and Charts

Difficult and unfamiliar names and terms in the text are followed by their phonetic pronunciation in square brackets. A simple phonetic system is used which includes the symbols:

ah = raw	oh = boat	tch = righteous
ay = late	oo = boot	zh = Asia
g = get	ow = bow	(n), (r), etc = barely
igh, eye = bite	uh = plumb	voiced or nasal

Picture Credits

The author, publisher, and Laurence King Ltd. wish to thank the institutions and individuals who have kindly allowed works to be reproduced in this book. Museums and galleries are given in the captions; copyright notices and other sources of photographs are listed below.

1.1 Institut du Patrimoine Royale des Beaux-Arts, Brussels
1.2 The Kobal Collection, London
1.4, 1.5 Scala, Florence
1.6 © The Isamu Noguchi Foundation and Garden Museum/ARS, New York and DACS, London. (53.87a–i) Photo © 1995 The Metropolitan Museum of Art
1.9 William Gottlieb/Redferns, London
1.10 Linda Rich, Surrey

2.1 John Ross, Rome
2.3 Mick Sharp, Caernafon
2.5 (84–11004) © University of Pennsylvania Museum
2.7 © Naturhistorisches Museum, Vienna/photo Alice Schumacher
2.8 ZEFA/Maroon
2.9 Dr. E. Strouhal/Werner Forman Archive
2.10 Harvard University – Museum of Fine Arts Expedition, 99.22. Reproduced with permission. Photo © 2003 Museum of Fine Arts, Boston. All rights reserved.
2.11 Hirmer Fotoarchiv, Munich
2.12 Courtesy of Liverpool Museum, Merseyside/Bridgeman Art Library, London
2.13 Courtesy of National Museum, New Delhi/photo Bridgeman Art Library, London
2.14 Photo E. G. Schempf
2.15 South American Pictures © Chris Sharp

3.1 Sonia Halliday, Weston Turville (F. H. C. Birch)
3.3, 3.4, 3.5 © 2000 Craig and Marie Mauzy, Athens
3.6 Reproduced with permission. Photo © 2003 Museum of Fine Arts, Boston. All rights reserved.
3.7 Reunion des Musees Nationaux, Paris
3.8 © R. Sheridan/Ancient Art and Architecture Collection
3.9 (L.2006.10) Photograph © 1999 The Metropolitan Museum of Art, New York
3.10 (32.11.1) Photograph © 1997 The Metropolitan Museum of Art
3.11, 3.16 © 2000 Craig and Marie Mauzy, Athens
3.12 The Art Archive/Acropolis Museum Athens/Dagli Orti
3.13, 3.22, 3.24, 3.25, 3.27 Hirmer Fotoarchiv, Munich
3.14 National Archaeological Museum, Athens
3.15 Royal Ontario Museum, Toronto
3.20, 3.31 Alison Frantz, New Jersey
3.23 British Museum, London
3.26a & b Scala, Florence
3.28, 3.36 Monumenti Musei e Gallerie Pontificie
3.30 © 2006 Alinari/Topfoto
3.33 Fotografica Foglia, Naples

3.34 Bildarchiv Preussischer Kulturbesitz, Berlin
3.35 Alinari and Art Resource, New York

4.1a Fototeca Unione, Rome
4.1b, 4.20 © Dorling Kindersley
4.2 Museo della Civiltà, Rome
4.3 Bridgeman Art Library, London
4.7 Deutsches Archäologisches Institut, Rome
4.8 Fototeca Unione, Rome
4.11, 4.13 © Vincenzo Pirozzi
4.14 Photo © Paul M. R. Mayeaert, Mont de L'Enclus (Orroir), Belgium
4.17 Fototeca Unione, Rome
4.18 R. Lieberman
4.21, 4.22 Fotografica Foglia, Naples
4.23 Alinari and Art Resource, New York
4.24, 4.25 Scala, Florence
4.28 Fotmas Index, Kent
4.29a Freer Gallery of Art, Smithsonian Institution, Washington, D.C.

5.3 Barnaby's Picture Library, London
5.4 Alinari and Art Rserouces, New York
5.7, 5.11, 5.19, 5.20, 5.21. 5.22, 5.26 Scala, Florence
5.8 Pontifica Commissone dell'Arte Sacra, Rome
5.9 Alinari, Florence
5.10 Alinari and Art Resource, New York
5.15, 5.34, 5.36, Sonia Halliday, Weston Turville
5.18 Art Archive, London
5.25 © Cameraphoto, Venice
5.28 ZEFA/H. Gratwohl
5.30 British Library, London
5.32, 5.33 AKG, London/Jean Louis Nou

6.1, 6.8, 6.25 Paul M. R. Maeyaert, Mont de l'Enclus (Orroir), Belgium
6.2 Bridgeman Art Library, London /The Board of Trinity College, Dublin, Ireland
6.3 Domkapitel Aachen/photo Münchow
6.4 Scala, Florence
6.6 © V&A Images. All rights reserved.
6.9 British Library, London
6.11, 6.35 Bridgeman Art Library, London/Giraudon/Musée Condé, Chantilly, France
6.12, 6.13, 6.14, 6.18 Scala, Florence
6.15 British Museum, London
6.19 AKG, London/Stefan Drechsel
6.20 AC Cooper
6.21 Kenneth J. Conant, "Cluny: Les Églises et la Maison du Chef d'Ordre," The Medieval Academy of America, Cambridge, MA © 1968
6.25 Bulloz, Paris
6.26 A. F. Kersting, London
6.27 © British Library Manuscript Reproductions, London
6.28 British Library Manuscript Reproductions, London
6.29 British Library, London
6.32, 6.33 Rheinisches Bildarchiv, Cologne
6.34 Bürgerbibliothek, Bern

7.1 Bridgeman Art Library, London
7.3 Bibliothèque Nationale, Paris
7.4 The Walters Art Museum, Baltimore

7.10, 7.11 Sonia Halliday, Weston Turville
7.12 Sonia Halliday, Weston Turville (Laura Lushington)
7.13 James Austin, Cambridge, England
7.14 © Erich Lessing/Art Resource, New York
7.18 Comstock/George Gerster
7.19 Bridgeman Art Library, London/Giraudon/ Bibliothèque Nationale, Paris
7.20 Bridgeman Art Library, London/Laruos-Giraudon, Paris
7.21 Bildarchiv Preussischer Kulturbesitz, Berlin
7.22 Scala Florence
7.26 Art Archive, London
7.27, 7.28, 7.29, 7.30 Scala, Florence

8.1, 8.17, 8.24, 8.26 Studio Fotografico Quattrone, Florence
8.3 Osvaldo Böhm, Venice
8.4 Mansell Collection, London
8.5 Scala, Florence – courtesy of the Ministero Beni e Att. Culturali
8.6, 8.10, 8.11, 8.16, 8.19, 8.20, 8.22, 8.32, 8.40 Scala, Florence
8.7, 8.12, 8.14, 8.15, 8.25, 8.28, 8.38 Alinari/Art Resource, New York
8.8 (1943.4.92 (A-146)) © Board of Trustees, National Gallery of Art, Washington.
8.27 © David Coulson/Robert Estall Photolibrary, Sudbury, Suffolk
8.29 The Royal Collection. © 2000 Her Majesty Queen Elizabeth II
8.31 Bridgeman Art Library/Giraudon/Louvre, Paris
8.30 Réunion des Musées Nationaux, Paris
8.36 Stanza della Segnature, Vatican Palaces, Rome
8.37 Vatican Museums, Rome
8.41 Vatican Palaces, Rome
8.42 Nippon Television Network/Scala, Florence
8.43 Ralph Liebermann/Calmann & King
8.45 © James Morris, London

9.1, 9.32, 9.33, 9.36 Scala, Florence
9.4, 9.5, 9.28 Réunion des Musées Nationaux, Paris
9.6 National Gallery, London
9.7a Bridgeman Art Library, London/Giraudon
9.8 © Vanni Archive/CORBIS
9.10 Institut du Patrimoine Royale des Beaux-Arts, Brussels
9.9, 9.12, 9.17, 9.31 Bridgeman Art Library, London
9.13 Museo del Prado
9.15 Artothek/Städel Museum Frankfurt am Main
9.14 Musée d'Unterlinden, Colmar, Germany
9.18, 9.19 Fotmas Index, London
9.20 C. Walter Hodges, Shakespeare and the players, London 1948, pp. 62–3
9.21 Reproduced by permission of Viscount de l'Isle, from his private collection
9.22 Mary Evans Picture Library
9.23 Lebrecht Music and Arts Photo Library
9.27 Bridgeman Art Library/Jean-Loup Charmet, Paris
9.29 Bridgeman Art Library/ Merilyn Thorold

Preface

It is a pleasure to offer readers the fifth edition of *Adventures in the Human Spirit* as an invitation to a life-long conversation with the Western humanities. This accessible and engaging single-volume survey emphasizes the connections between ideas and cultural creation in a concise and focused history of the Western arts, religion, philosophy, and science.

In particular, the book's boxed features are key elements offering varied lenses for students to view the history of culture. **Key Concepts** define and illustrate essential ideas in historical context, usually with a link to contemporary problems. **Global Perspectives** point to crucial moments in non-Western civilizations that invite comparison with Western cultures. **Windows on Daily Life** use original documents to portray in vivid detail the lives of ordinary people at a particular moment in history. Each chapter begins with a list of **Key Topics**, and other boxes highlight provocative quotations from thinkers and artists of the age, or prompt the students' thinking by asking a **Critical Question** or posing **The Write Idea**.

New to the fifth edition. There has been significant expansion on many sections in the fifth edition, and these changes are based on the valuable input of our reviewers:

New or revised text: There are new **Global Perspective boxes** on the Zimbabwe realm and on Gandhi and colonial liberation, as well as new text on the ancient Americas, Hiberno-Saxon art, International Gothic, Purcell, and contemporary art. In addition I have revised the treatment of Plato and Aristotle, Augustine, the Scientific Revolution, and Hegel and Marx, and added new material on Plotinus and Christian Neoplatonism.

New illustrations: All have new text and commentary, and highlights include the Colosseum, Pantheon, the Doge's Palace, Borromini, and Sullivan's Wainwright Building (for architecture); the reliquary of St.-Foy, Book of Kells, the Renaissance *studiolo*, and *The Lady and the Unicorn* tapestry (for the decorative arts); and key works by Masaccio, Botticelli, Gainsborough, Carriera, Kahlo, Ringgold, and Xu Bing (for the pictorial arts).

Reorganized materials: The early Aegean world is now placed together with the rest of ancient Greece in Chapter 3. Medieval Muslim philosophy has been moved to the early Middle Ages (Chapter 6), which also now concludes with the Crusades. El Greco is incorporated into the discussion of mannerism in Chapter 9, and the baroque (Chapter 10) now appropriately opens at its well-spring, Italy and, in particular, Bernini. Discussions of the major revolutions in eighteenth-century and romantic music have also been consolidated in Chapters 11 and 12. World War II and the Holocaust now appropriately conclude the chapter on Modernism (Chapter 14).

Teaching and Learning Package. *Adventures* is accompanied by an extensive supplements package for students and instructors.

For Students, there are three very exciting features:
1) the Companion Website at www.prenhall.com/bishop gives open access to an extensive online study resource, with quizzes, weblinks, chapter objectives, and more.
2) a Music CD is included with each copy of the book. Providing a sampling of music throughout history, selections embrace such composers as Bach, Berlioz, and Bernstein (see full listing on page 464).
3) *Humanities Notes*, a notebook for students, is designed to help organize course notes for each chapter of the book around key illustrations, quotations, and short extracts. ISBN: 0132244640.

For Instructors, there are the Instructor's Manual with Test Item File, available for download from the instructor's support section at www.prenhall.com, and also TestGen (ISBN: 0132244616), an electronic test generator for Windows and Macintosh.

The humanities inspire a special passion in those who teach. I am grateful to many passionate colleagues, both near and far, for their advice: George Brooks, Aida Diaz, Elizabeth Eschbach, Anakira Gabriella, Florence Neubauer, Wendy Schwam, Karen Styles, Jennifer Taylor, Rachel Waite, and many others.

At Prentice Hall, my publisher Sarah Touborg and editor Amber Mackey have been constant in their encouragement. At Laurence King Publishing, Donald Dinwiddie managed this edition with gracious and erudite attention to every detail. Nicola Hodgson's editing smoothed many rough edges and Claire Gouldstone has enhanced this edition with beautiful new images. Designer Ian Hunt produced a book of great visual appeal.

I am indebted to these reviewers, whose suggestions I always considered and often followed

Julia diLiberti, College of DuPage
Beverly Carter, Grove City College
Kevin Morgan, St Petersburg College
Holly S. Hurlburt, Southern Illinois University, Carbondale
Maryanne C. Ward, Centre College

I continue to hope that Adventures in the Human Spirit will be the one volume on Western art and ideas that readers keep on the shelf for a lifetime.

Philip Bishop
Orlando, Florida, 2006

The Humanities:
An Introduction to
the Adventure

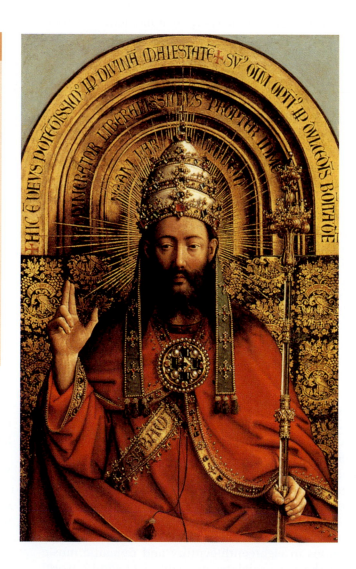

1.1 Hubert and Jan van Eyck, *God the Father*, detail of the *Ghent Altarpiece*, St. Bavo, Ghent, completed 1432. Tempera and oil on wood. The human capacity to create such splendid works of art arises from our search for meaning in the world and the need to give symbolic expression to our innermost beliefs and desires.

In 1800, a boy was discovered in Aveyron, southern France, who evidently had lived in the wilds much of his young life. The child could only growl and grunt, and, as one would expect, had frightful table manners. The so-called "wild boy of Aveyron" provoked a debate among scientists and philosophers over the definition of human nature. Yet the boy himself could not join the debate because he lacked the most basic faculties of human culture: the ability to think and the capacity to explain himself intelligibly to others. The "wild boy of Aveyron" could take no part in the adventure of the human spirit.

Finding a Voice

Human beings are distinguished from other creatures by the richness of their inner life, the constant flow of thoughts and feelings that constitutes human experience. Deprived of the means to express this experience, the boy of Aveyron suffered an impoverished inner life as well. By comparison, consider the famous dramatic character Hamlet, in the tragedy by William Shakespeare (Fig. **1.2**). With his university education, Hamlet jokes easily with his companions, stages an impromptu drama, and philosophizes about the human condition. Even as he contemplates suicide, Hamlet's keen mind grasps the complexity of the human soul and the potential for human achievement. In Hamlet's words:

> What a piece of work is a man! how noble in reason! how infinite in faculties! in form and moving, how express and admirable! in action, how like an angel! in apprehension, how like a god! the beauty of the world! the paragon of animals!

Most of all, through his capacity for artful speech and action, Hamlet makes his inner life intelligible to Shakespeare's audiences, enriching us through the character's own self-understanding. The boy of Aveyron could never overcome his isolation from human culture, while Hamlet's voice – anguished but eloquent – has spoken to countless generations.

Tradition: Nurturing the Creative Spirit

Humans, since their beginnings as nomads and cave-dwellers, have transformed the wisdom and beauty of human experience into works of art and thought. The process of nurturing and transmitting this creative spirit is called tradition – a process that sustains a civilization's essential values and impresses them on succeeding generations. Some human traditions may be transmitted informally, through family customs and children's play. However, a civilization's core traditions are passed on by organized intention, usually by training or schooling. A religious faith, for example, does not leave it to chance

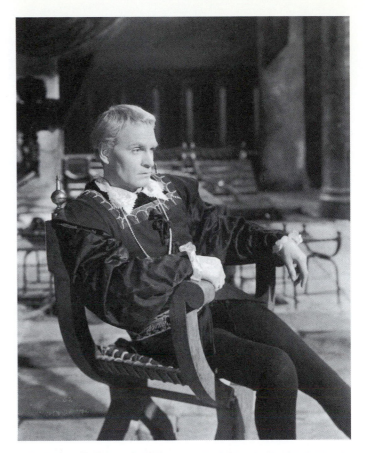

1.2 Laurence Olivier as Shakespeare's Hamlet, in the 1948 filmed version of *Hamlet*, also directed by Olivier.

that children learn the faith's essential beliefs and history: in the ritual of Passover, Jewish children repeat an ancient story of God's blessing; during Ramadan, the Islamic month of fasting, young Muslims observe annual rituals of purification; and at a first Holy Communion, a Christian child reenacts the faith's sacred meal and ritually joins the community of believers.

Yet tradition is not a one-way process of transmitting culture to individuals. Tradition shapes the experience of each generation and stimulates new creativity. Every creative spirit depends on the models of tradition, the accumulated expression and reflection of past generations. Through the traditions of the past, humans may discover a unique experience of the present.

Modes of Expression and Reflection

The **humanities** are the study of the creative process of tradition as it occurred in the past and continues in the present. Through the humanities, we learn how humans have expressed their most intense experiences and reflected on their most essential truths. The humanities encompass what may be called **modes of expression**, including the visual arts (painting, sculpture, architecture, photography, and film); the performing arts (music,

dance, and theater); and the literary arts (poetry and prose). The modes of expression also include such decorative arts as embroidery and metalworking, which are often employed in association with other arts.

Closely allied to these arts are what may be called **modes of reflection**, such as philosophy, religion, and history. In these modes, humans reflect on the most fundamental questions of their experience: "What is truth?", "What is the nature of the divine?", or "What is the meaning of the past?". In pursuing such questions, the modes of reflection may often borrow from artistic expression. The humanities understand these diverse modes – the arts, religion, philosophy – in their fruitful interaction and development.

This textbook is concerned chiefly with the historical development of arts and ideas in Western civilizations – the Mediterranean region, Europe, and the Americas – from about 3000 B.C. to the present day. Within several chapters, the reader will find a unit devoted to other civilizations – Chinese, African, Indian – that provides a global perspective on Western civilization. Also, the features entitled "Windows on Daily Life" provide brief portraits of everyday experience.

The purpose of this book is to introduce the humanities in such a way that the reader may take a more active part in the creative process of tradition. As we learn to command more fully the modes of expression and reflection, our experience is enriched and our powers of thought and creativity are enlarged. Study of the humanities is a part of this individual development. The humanities teach us to understand the languages of tradition, so that we may speak more effectively in the present.

The Arts

The following section offers a brief introduction to the arts and suggests critical questions to encourage active responses from the reader.

The Pictorial Arts

- In what medium is the picture created?
- What are the picture's important lines and shapes?
- How does the picture use color and light?
- Does the picture contain significant patterns?
- How are the parts of the picture combined into a meaningful whole?

One of humankind's most ancient skills is the ability to make **pictures**. The primal impulse to visualize the world is embodied in the pictorial arts of painting, printmaking, and photography. In today's culture, pictorial images surround us in astounding numbers and intensity, providing endless opportunities for questioning the pictorial arts.

In what medium is the picture created?
The **medium** (pl. **media**) is the physical or material means by which a picture is communicated. A painter might choose the medium of oil paint applied to wood (see Fig. 1.1) or canvas, or watercolor applied to paper. Each painting medium has its own technical requirements and pictorial qualities. The transparent wash of a watercolor contrasts sharply with the tangible density of oil paint. Likewise, the pictorial media of printmaking and photography have their own complex technical requirements and unique aesthetic effects.

What are the picture's important lines and shapes?
A **line** is an extended point, the most basic element of pictorial communication. Lines help to define the picture as a whole: horizontal and vertical lines tend to define space as stable and orderly, while diagonal lines create tension and motion. Lines can establish a direction for the eye to follow, even when the line is implied. A **shape** is the space bounded by a line, and may be curved or linear,

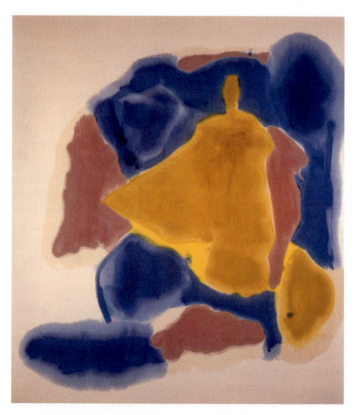

1.3 Helen Frankenthaler, *Formation*, 1963. Acrylic on canvas, 6 ft 4 ins x 5 ft 5 ins (1.93 x 1.65 m). Collection Alexis Gregory, New York.
Compare the mood created by Frankenthaler's acrylic blues, yellows, and pinks to the colors of the medieval stained-glass window *Notre-Dame-de-Belle-Verrière* (Fig. 7.1).

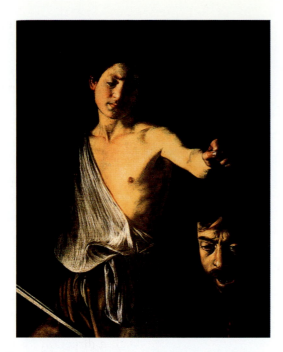

1.4 Caravaggio, *David with the Head of Goliath*, 1609–10. Oil on canvas, 4 ft 1½ ins × 3 ft 3⅜ ins (1.25 × 1 m). Borghese Gallery, Rome. The Italian painter Caravaggio achieves a gruesome effect with his lighting of Goliath's severed head, held by the biblical hero David. Note the direction of the light and the powerful contrast between foreground and background.

regular or irregular. Shapes also help to create a pictorial structure, and are used to evoke in the viewer a certain feeling. A viewer responds differently, for example, to the organic shape of a shell than to the shapes of machines and buildings.

How does the picture use color and light? Pictures act directly on the viewer by their color (Fig. **1.3**). Aside from their visual and emotional quality, colors also have symbolic importance within a culture. In the Middle Ages, for example, red and blue were traditionally associated with the Virgin Mary. Additionally, **light** creates a sense of depth when it falls across an object. Light also creates dramatic interest by emphasizing important elements or creating a play of light and shadow (Fig. **1.4**).

Does the picture contain significant patterns? A **pattern** is the repetition of a pictorial element according to a particular design. The pattern may consist of line, shape, color, or some other significant pictorial element. Patterns create a visual structure or rhythm that makes a picture's meaning more intelligible.

How are the parts of the picture combined into a meaningful whole? **Composition** is the combination of a picture's elements into one whole. Composition may involve the picture's division into major parts, such as

foreground and background. Johannes Vermeer's *The Allegory of Painting* (see Fig. 10.31) creates a clear division between the background figure of the model (well-lighted, costumed, and on display), and the foreground figure of the painter (in shadow, self-effacing, anonymous). With composition an artist can orchestrate the picture's elements into a complex pictorial statement.

Many pictorial works communicate a narrative or symbolic message. In such cases, the following questions are also useful in understanding the pictorial arts:

- Does the picture tell a story?
- Does it contain important symbols?
- Is there a dramatic action?

Sculpture: The Art of Shaping

- Is the sculpture full-round or in relief?
- From what materials is the sculpture shaped?
- What is the sculpture's texture?
- Does the sculpture imply movement?
- What is the sculpture's relation to site?

Sculpture is the shaping of material into a three-dimensional work of art. Like painting, it is one of the most ancient arts. Sculpture can take virtually any shape and can be crafted in virtually any material. This art form ranges from the exquisitely proportioned stone of ancient Greek statuary to the playfully modern combinations of Alexander Calder (see Fig. 15.11). Of such different sculptural works, the thoughtful student may ask the following questions:

Is the sculpture full-round or in relief? A **full-round** (also called "freestanding") sculpture is shaped so that the work stands freely and can be seen from all sides (see Fig. 8.24). Full-round statues of human figures may be on any scale, from small figurines to colossal statues. **Relief sculpture** is attached to a wall or panel and is commonly used to decorate a building, as in the reliefs on Lorenzo Ghiberti's panels for the east doors on the Florence Baptistery (Fig. **1.5**) and the sculptural decoration on the Gothic cathedral at Chartres, France (see Fig. 7.13).

From what materials is the sculpture shaped? Sculpture can be made from any material able to be carved, molded, assembled, or cast. As with painting, a sculptor may work in a variety of media or materials. Some materials, such as stone and wood, are shaped by chipping away the excess, a **subtractive** process (Fig. **1.6**). Plaster sculptures, on the other hand, are created by an **additive** process of building up layers of material. Metal can be beaten or bent into the desired shape, or it can be melted and then poured into a mold.

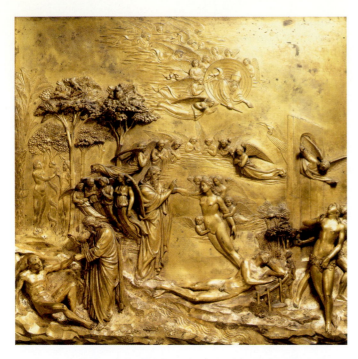

1.5 Lorenzo Ghiberti, *Creation of Adam and Eve*, panel from the *Gates of Paradise*, Cathedral Baptistery, Florence, 1425–52. Gilt bronze, 31¼ ins (79 cm) square.
Ghiberti's panels for the Florence Baptistery east doors varied the degree of relief, from high to low, to create the visual impression of a three-dimensional space.

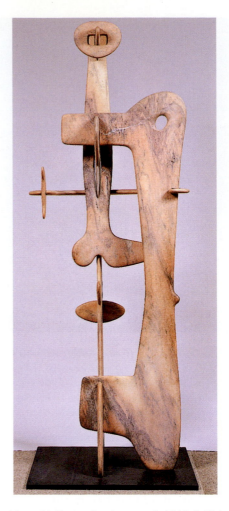

1.6 Isamu Noguchi, *Kouros* (in nine parts), 1944–5. Pink Georgia marble (slate base), height approx. 9 ft 9 ins (2.97 m). The Metropolitan Museum of Art, Fletcher Fund, 1953 (53.87a-i). Photograph ©1995 The Metropolitan Museum of Art
Noguchi chose a traditional material, stone, for this abstractly shaped sculpture. Compare this with the traditional Greek *kouros* (Fig. 3.10).

What is the sculpture's texture? Texture is the way an object feels to the sense of touch. A painting can only suggest textures, whereas a sculpture's textures may actually be touched and explored. Sculptural materials appeal to the touch in different ways. Marble, for example, can be finished to an extremely smooth texture that resembles glass or human flesh. Michelangelo's late-fifteenth-century sculpture the *Pietà* (see Fig. 8.25), for example, has a remarkably flawless texture that suggests the perfection of Christ's sacrifice.

Does the sculpture imply movement? Though most sculptures are immobile, some can appear to move through the space that they occupy. Bernini's fearsome *David* (see Fig. 10.2) has drawn his sling and is about to unleash the missile that will kill Goliath, while in Donatello's more static version (see Fig. 8.24), David rests his foot on Goliath's head. Twentieth-century artists freed sculpture so that some parts could actually move. The first "mobile" was invented in the early twentieth century, when the irreverent modernist Marcel Duchamp (see page 393) placed a bicycle wheel on a stool.

What is the sculpture's relation to site? Sculpture may have a specific relation to its site, that is, its location in a surrounding space. Naturally, a religious sculpture is vitally related to the church, temple, or other place of worship in which it is housed.

Architecture: The Art of Shelter

- What is the building's function?
- From which materials is the building constructed?
- What is the building's design?
- What is the relation between the exterior and interior of the building?
- How does the building employ the other arts?

The most ambitious of the arts is **architecture**, the art of enclosing a space to provide shelter. Compared with sculpture or painting, architecture requires considerably greater resources of wealth, materials, technical

knowledge, and labor. For this reason, significant works of architecture are often associated with wealth and power. Usually only the most powerful members of a society can afford to construct large buildings.

What is the building's function? Nearly all buildings serve a function in the community that constructs them. The earliest great buildings were temples built to honor the gods or palaces that housed the families of kings and pharaohs. Temples had a sacred function, because they were associated with the divine and holy, whereas a royal palace had a secular function, serving everyday needs. Because the temple and the palace involved the community as a whole, their function was public.

Houses and other structures used strictly by individuals are termed private or domestic architecture. Virtually all significant buildings have a function that combines sacred or secular, private or public use.

From which materials is the building constructed? Materials are as essential to architecture as to sculpture. The ancient Greeks (see Chapter 3) built their houses from wood and their temples from stone. Consequently, Greek private architecture has disappeared, while ancient Greek temples still inspire architects today. Often new architectural materials incorporate the old. The Romans developed the use of concrete – a material made of cement, sand, stone, and water – but decorated this unsightly material with an outer layer of stone, in order to make their buildings look like those of the ancient Greeks. Twentieth-century builders improved concrete by adding steel reinforcement.

What is the building's design? The most important and complex aspect of a building is its **design**, the way the building is assembled to create a sheltering space. Architectural design is akin to composition in painting, yet more essential. A poorly composed painting will merely languish in an attic; a poorly designed building may collapse. Architectural design is so closely tied to function and materials that these three elements of architecture – design, function, materials – form an interdependent triad. Eero Saarinen's Trans World Flight Center at the Kennedy International Airport, New York (Fig. **1.7**), can assume such a flowing, bird-like design because it is made of steel-reinforced concrete. The blocks of stone used in ancient Egyptian (see Fig. 2.9) and Greek buildings could not have achieved such flexibility of design. However, their carved columns and sculpture created a monumental presence appropriate to their religious function.

What is the relation between the exterior and interior of the building? A building presents itself to the world through its exterior, yet usually serves its function through the interior. A building's exterior and interior may reflect a common design, as with Frank Lloyd Wright's Guggenheim Museum in New York (see Fig. 15.16). Exterior and interior may exhibit different principles of design, creating a tension between outside and inside.

How does the building employ the other arts? Most commonly, a building employs the other arts, especially painting and sculpture, for decorative purposes. Temples and churches commonly use exterior relief sculpture to attract and educate the faithful. However, buildings can also employ performing arts such as music or theater, often creating a mutual influence among the arts. The sound of choirs singing in St. Mark's in Venice in the fifteenth century was so distinctive that the church's architecture helped shape the development of Renaissance music (see page 248).

Music: The Art of Sound

- What are the music's basic melody and rhythm?
- What instruments or voices perform the music?
- Where is the music performed, and for what purpose?
- What is the form of the musical composition?

Music is an art that depends upon performers – players or singers – to bring it to life. It is an abstract and ephemeral art, consisting only of sounds stretched across time. Music differs from ordinary sound – noise – in that it is organized in a way meaningful to the ear. The basic component of music is the **tone**. A musical tone has a certain pitch that sounds either high or low. A flute can play tones of a higher **pitch** than a cello, just as a soprano's voice is pitched higher than a tenor's. A musical tone also has **color**, which means simply how the tone sounds. Because they produce sound in different ways, the flute and violin have different colors, even when playing the same tone. Finally, musical tones have **dynamics**, depending on how loudly or softly the tones are played. When these elements of musical tone – pitch, color, dynamics – are combined, composers and musicians create the infinite variety of the world's music.

What are the music's basic melody and rhythm? A **melody** is a series of tones that make some sense to the ear, that create a tune that the ear can follow. Anything the listener can hum is a melody. Anything one can tap a foot to is a **rhythm**, a beat created by regularly accented tones. Rhythm is essential to one of music's most important functions, as an accompaniment to dance. In African musical cultures, rhythm dominates other elements of musical expression. The combination of drums and other percussion instruments of different colors creates a rich texture of rhythmic patterns.

The possibilities of melody and rhythm are infinite, yet most music follows particular rules for inventing

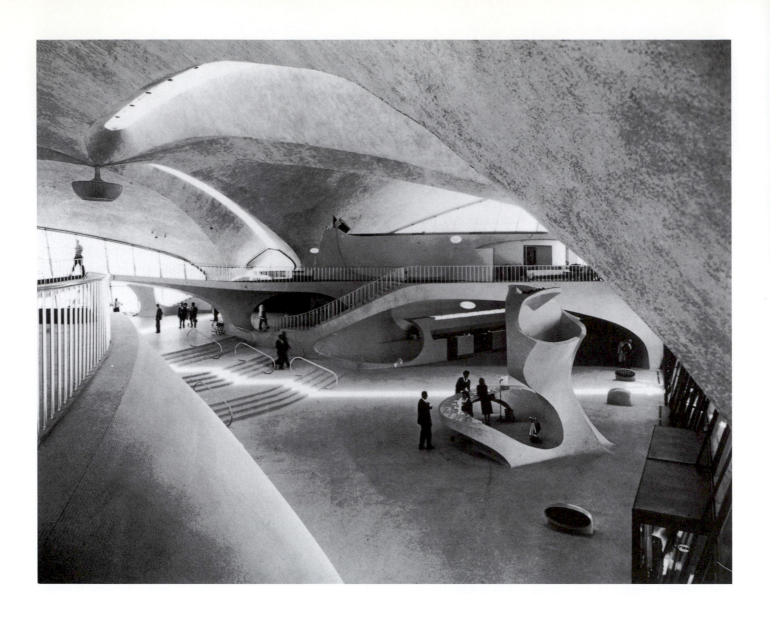

melodic and rhythmic arrangements. In Western music melodies are expressed in a **key** – a series of seven tones with set intervals between tones. Some twentieth-century musical innovators like Arnold Schoenberg discarded these melodic rules, creating a music that to some people may sound like noise but is, in fact, highly organized. Rhythm is usually determined by a basic **meter**, the set number of beats per musical unit. The form of dance music called the waltz is easily recognized by its triple meter, or three beats per measure.

What instruments or voices perform the music?
The color of a musical work depends on the combination of musical instruments or voices that perform it. In recent centuries, composers have written music calling for a specific combination of instrumental or choral voices. Mozart (see page 310) composed frequently for a string quartet, while Brahms' symphonic works require the orchestra to have a large brass section (Fig. **1.8**). Vocal

1.7 Eero Saarinen, Main lobby of the Trans World Flight Center, Kennedy International Airport, New York, 1962.
Modern architecture often leaves concrete undecorated, but reinforces it internally with steel rods, allowing the creation of the fluid lines of the Flight Center.

music is written for voices in a certain range: an opera role, for example, may require a tenor voice or a baritone. A composition for voice may call for a specified number of soloists (one singer per part) and a chorus (several singers singing the same part).

Where is the music performed, and for what purpose? The setting of a musical performance is usually closely related to its function. As with architecture, music can serve either sacred or secular functions, depending on whether it is performed during a religious service or in a concert hall. The setting and function also help determine the choice of instruments – a parade calls

for a marching band, while a wedding reception would more likely employ a string ensemble.

What is the form of the musical composition? As in the other arts, musical **form** means the arrangement of a composition's parts into a unified and meaningful whole. A musical form may be very simple and brief, like a nursery rhyme with a single verse, or it may be very large, with the performance lasting several hours and

1.9 Jazz pianist and composer Thelonius Monk.
Though often based on simple melodies, jazz music in performance achieves remarkable melodic and rhythmic complexity.

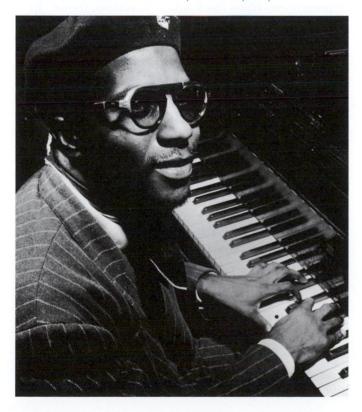

requiring a full orchestra and a large chorus. Popular songs, for example, usually take the form of A–B–A. An initial melody and rhythm (A) are stated and often repeated. Then a verse is sung to a different but closely related second melody (B). Finally, the opening melody (A) is repeated to create closure. In the Western musical tradition, even larger and more complex forms – such as the movements of a **symphony** – follow this pattern of statement, variation, and restatement. Understanding any musical composition can usually begin with identifying its parts and seeing their relation.

The number of musical forms can be overwhelming. During the last 300 years, composers have invented and practiced dozens of different musical forms (Fig. **1.9**). The origin of these musical forms is closely related to a composition's setting and function. For example, the **cantata** was a choral work that set a biblical story to music and was often performed in churches. The **blues** was a mournful song form that originated from the hollers of African-American slaves as they worked in the fields. Both forms are still performed today, the cantata in churches and the blues in nightclubs.

Dance: The Art of Movement

- What kind of dance is it?
- What is the relation between the dance and the music?
- Is the dance mimetic?
- How are the dancing movements combined into a meaningful whole?

Like music, the performing art of dance is difficult to capture. **Dance** is the rhythmic and patterned movement of the human body, usually to musical accompaniment. It is perhaps the most ancient art, and one that is still practiced in every known human culture. Dance can be as simple and spontaneous as the gyrations of a stadium

crowd cheering for their favorite team. Or it can be as formalized and complex as a classical ballet. Our historical knowledge of dance is limited since, like music, its performance leaves few historical traces.

What kind of dance is it? Dance is generally categorized according to three types: popular dance, ballet, and modern dance. **Popular dance** includes forms of dance passed on traditionally, such as folk dances, or dances practiced for social occasions, such as ballroom dancing. Popular dances can be highly complex and artistic, and may require considerable training. Popular dances are not always performed for an audience.

Ballet is a theatrical dance that combines highly formalized steps and poses with athletic leaps and turns. The five "positions" of classical ballet were prescribed in the seventeenth century and are still learned in ballet studios today (Fig. **1.10**). The term "ballet" also describes

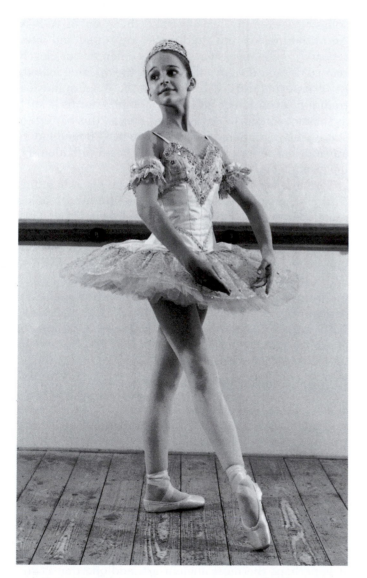

1.10 The formalized poses of classical ballet stem from the 17th century.

the combination of ballet dance, music, and staging in a theatrical work such as *Swan Lake* or *Sleeping Beauty*. In a ballet, the dancers' steps and movements are orchestrated by the **choreographer**, who must coordinate the music, story, and dance to form an intelligible whole. A dance choreographer is part composer, part theatrical director, and part dance master.

The last of the dance types is **modern dance**, which includes the forms of dance created in reaction to classical ballet. Modern dance seeks more freedom and expressiveness than ballet, but still involves choreography and theatrical performance. It is often more abstract and less oriented toward a story than traditional ballet, and it often incorporates modern music and art.

What is the relation between the dance and the music? Dance is so closely allied with music that musical styles are often named for the dance they accompany. From the waltz to hip-hop, dance and music have been melded with one another. The dance form of the minuet, which originated in France, was preserved in the eighteenth-century symphonies of Mozart (see page 312). In the 1970s, disco music fueled a popular dance revival among young people dissatisfied with rock-and-roll's informal dance styles. In the same way, the improvisational music of jazz (see page 411) has fostered the equally inventive form of jazz dance.

Is the dance mimetic? The term "mimetic" stems from the Greek word for "imitation." Mimetic dance imitates the gestures and actions of real life, and is especially important in ballet and other narrative forms. In a romantic ballet, for example, the dancers' calculated poses and movements may be choreographed to imitate the joy of a couple in love.

How are the dancing movements combined into a meaningful whole? A dance's form, much like the form of music or theater, is the artful combination of dancing gestures and movements. In a dance performance, the dancers' movements create a changing combination of line, motion, pattern, tension, and rhythm. More so than with any other art, the form of dance is perceptible only in performance. The three-dimensional energy and complexity of a dance performance cannot be fully captured by a system of notation or even by film, although filmed dance has been revived by the popularity of music videos.

The Art of Theater

• How is the play staged through set, lighting, and costume?
• How do the director and actors interpret the dramatic script?

Theater is the art of acting out dramatic literature in a live performance. Since most readers will have studied

dramatic works as literature, this introduction considers aspects of theatrical performance.

How is the play staged through set, lighting, and costume? The stage is the physical space in which a dramatic work is performed. Most Western theaters today use a conventional **proscenium** stage. The proscenium stage is enclosed within a rectangular frame, and the audience views the action through an invisible "fourth wall." A theater may instead have a **thrust** stage, in which a stage platform projects into the audience, or a stage **in-the-round**, which has a performance area completely surrounded by the audience.

The most complex elements of staging involve the theatrical **set**, which is made up of lighting and scenery. The set design creates the imaginary space in which the dramatic action is performed (Fig. **1.11**). Sets may incorporate elaborate scenery and stage machinery. Some medieval dramas known as morality plays managed to represent the Garden of Eden, a fiery hell, and the throne of heaven, all in one elaborate set. Twentieth-century expressionist theater used complicated revolving stages and sets to accommodate huge casts. With the advent of electrical lights, theatrical **lighting** became essential in shaping the theatrical performance. Lighting helps to underscore mood, character, and other elements of the dramatic action taking place on the stage.

1.11 Peter Wexler, scene design for *The Happy Time*, Broadway Theater, New York.

The **costumes** worn by actors are also part of the staging and set the tone of a theatrical performance. The choice of costumes is an especially important decision when performing a play from the past. For example, should a director costume Shakespearean characters in modern dress or in period costume? Like theatrical lighting, costume can emphasize an aspect of the character or imply changes in a character during the performance.

How do the director and actors interpret the dramatic script? **Acting** is probably the aspect of theatrical performance that audiences are most sensitive to and critical of. Under the director's guidance, actors are responsible for realizing the dramatic script in their words and actions on stage. An actor's performing skill and discrimination largely determine the impact a character will have on the audience.

The **director** of a play governs every aspect of the performance, including staging, acting, and changes in the script. Yet the director has no immediately visible role in the performance. The director's decisions can only be inferred from the performance itself. A critical audience should appreciate the director's choices in casting – the choice of particular actors for certain roles. The director also determines how they move together on stage, and how quickly or slowly the action proceeds. With such decisions, the director controls the essential character of the whole theatrical performance.

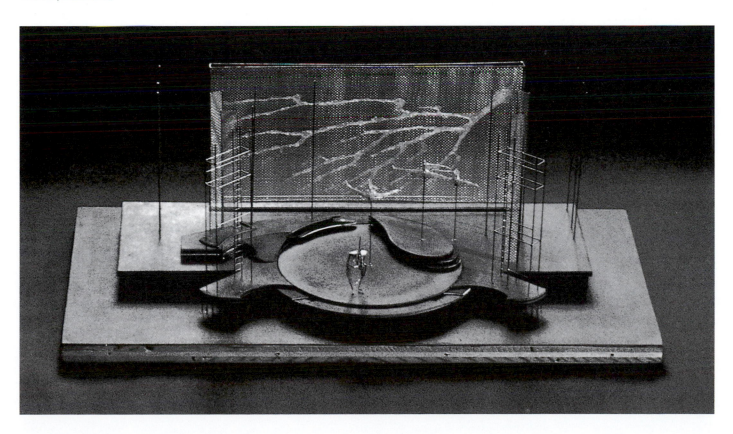

A Note about Opera

Opera can be defined simply as theater set to music. Yet such a simple definition cannot suggest opera's spectacular effects. Opera combines all the performing arts – music, dance, and theater – in an artistic experience that cannot be matched by any of these arts alone.

Unfortunately, opera suffers from an inaccessibility to audiences. The need for a precise match between the words of an opera and its music makes it difficult for operas to be translated. An opera written in Italian or French is usually performed in the original language, so an English-speaking audience must be satisfied with a program summary or translated dialogue titles projected over the stage. In addition, opera has historically been an art of the upper classes, and it is still associated with elite audiences.

Still, opera is a stunning art form that can, with a little cultivation, provide pleasure for any humanities student. From a student's point of view, opera is interesting if only because it can stimulate so many of the questions asked already in this brief introduction to the arts:

- How is the opera staged?
- What is the relation between the words and the music?
- How has a director interpreted the script?
- What instruments and voices are used?
- How has a singer interpreted the musical score and the dramatic script?
- How is dance incorporated into the operatic narrative?

The variety of questions suggests that opera, perhaps the least known of the performing arts, is the best-chosen introduction to those arts.

The Literary Arts

Literature divides generally into two kinds: **fiction**, composed from the author's imagination; and **non-fiction**, recounting the author's actual thoughts or real events. The largest body of literature is fictional and divides further into three main genres: drama, poetry, and narrative fiction.

Drama is literature to be acted out in theatrical performance, an art discussed as the art of theater, above. **Poetry** is a literature of rhythmic sound and concentrated imagery. Poetry usually employs a regular pattern of stresses (called a **meter**) and often contains highly condensed metaphor and symbol. Poetry may actually take the form of drama (Greek tragedy, for example) or narrative (the ancient epics). Poetry of the most personal and concentrated kind is called **lyric**, which can be written in particular forms (for example, the sonnet, elegy, or ode). About poetry, one may ask:

- What form does the poem take?
- What are its patterns of sound (meter, rhythm)?
- How does it employ metaphor or symbol?

Narrative fiction is literature that tells a story. The most common forms of narrative fiction are the novel and the short story, which usually describe events and characters in believable, true-to-life detail. However, narrative can also take the form of fantasy, recounting a dream or vision. The narrator or author often sees the action from a specific point of view, and may comment on the action or characters. In reading narrative fiction, it helps to observe:

- What form does the narrative take?
- What is the action (plot)?
- Who are the chief characters, and what are their significant speeches and actions?
- What is the author's point of view?

Fictional works often contain underlying ideas, or **themes**, that develop across the whole work. Identifying a literary work's themes often helps the reader to understand it as a whole and connect it to other works.

Non-fictional literature takes such forms as **biography**, the literary account of a person's life, and the **essay**, a brief exposition of the author's views on a particular subject.

An Invitation to the Adventure

In considering any work of art, it is always important to concentrate not only on the work itself, but also on one's own responses. We acquire a voice in the human conversation by asking ourselves:

- What is my response to the work of art?
- How is that response shaped by the work itself and by my own experience?

If, as some say, knowledge is power, knowledge is also pleasure. Knowledge of a human culture gives us power in that culture and pleasure in being a part of it. This is just as true for pop music's latest fad as it is for the classical symphonies of Mozart and Beethoven. A knowledge of both musical cultures broadens a person's potential to have power and find pleasure in his or her world.

The works of culture discussed in this survey offer a rich texture of meaning and experience. Understanding them is often hard work – one must grasp the basic

principles of music, for example, while also attending to the subtleties of a symphony or opera. The rewards are substantial. As we learn to command more fully the cultures around us, our own powers of thought and creativity are enlarged. This text aims to prepare readers for the challenges of the humanities and introduce them to their pleasures. It is an invitation to join, actively and intelligently, the adventure of the human spirit.

CHAPTER SUMMARY

A summary of questions to help the reader discover the pleasures of the humanities:

The Pictorial Arts
- In what medium is the picture created?
- What are the picture's important lines and shapes?
- How does the picture use color and light?
- Does the picture contain significant patterns?
- How are the parts of the picture combined into a meaningful whole?

Sculpture
- Is the sculpture full-round or in relief?
- From what materials is the sculpture shaped?
- What is the sculpture's texture?
- Does the sculpture imply movement?
- What is the sculpture's relation to site?

Architecture
- What is the building's function?
- From which materials is the building constructed?
- What is the building's design?
- What is the relation between the exterior and interior of the building?
- How does the building employ the other arts?

Music
- What are the music's basic melody and rhythm?
- What instruments or voices perform the music?
- Where is the music performed, and for what purpose?
- What is the form of the musical composition?

Dance
- What kind of dance is it (popular, ballet, modern)?
- What is the relation between the dance and the music?

- Is the dance mimetic?
- How are the dancing movements combined into a meaningful whole?

Theater
- How is the play staged through set, lighting, and costume?
- How do the director and actors interpret the dramatic script?

Opera
- How is the opera staged?
- What is the relation between the words and the music?
- How has a director interpreted the script?
- What instruments and voices are used?
- How has a singer interpreted the musical score and the dramatic script?
- How is dance incorporated into the operatic narrative?

Poetry
- What form does the poem take?
- What are its patterns of sound (meter, rhythm)?
- How does it employ metaphor or symbol?

Narrative Fiction
- What form does the narrative take?
- What is the action (plot)?
- Who are the chief characters, and what are their significant speeches and actions?
- What is the author's point of view?

Personal Response
- What is my response to the work of art?
- How is that response shaped by the work itself and by my own experience?

2 The Ancient World

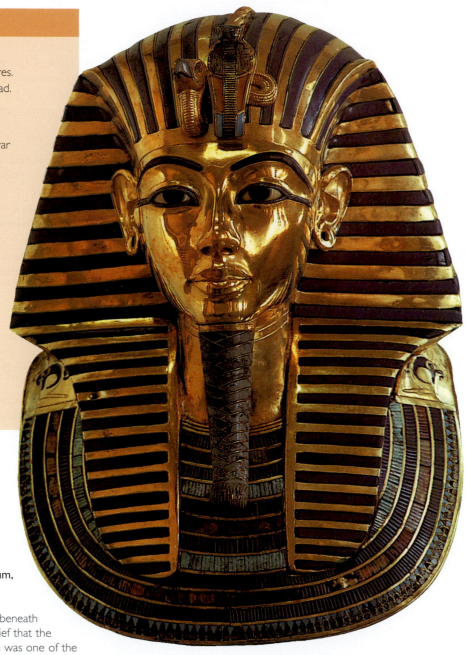

2.1 Funerary mask of King Tutankhamen, c. 1340 B.C. Gold inlaid with enamel and semiprecious stones, height 21 ins (54 cm). Egyptian Museum, Cairo.

The coffin of King Tutankhamen contained his mummified body beneath this splendid gold mask. The belief that the human soul lived on after death was one of the first and most important religious ideas of humans in the ancient world. Ancient tombs in Egypt, China, and the Aegean are essential sources for our knowledge of ancient civilizations.

In 1922 a British archaeologist and his Egyptian assistants were the first to look on King Tutankhamen (Fig. **2.1**) in nearly 3,500 years. In the 1970s, millions more would file through the exhibition of King Tutankhamen's tomb. What was the fascination of this god-king, dead at age nineteen, buried in such glittering splendor in Egypt's fertile valley? Perhaps, King Tutankhamen could reveal the secrets of the **ancient world**: its stories of creation and the gods, its rulers worshiped as gods, its monuments to divine power and the mystery of death. In the eyes of King Tutankhamen, so ancient yet so familiar, perhaps we see the elemental beginnings of human civilization; from his lips, perhaps we hear the tales of the first adventures of the human spirit.

The First Humans

Characterize the likely purpose or function of Stone Age art.

The first humans of our kind appeared some 100,000 years ago, spreading from Africa to Asia and Europe, sustaining themselves by hunting and food-gathering.

Their primitive culture bore the essential features of later human civilization. They honored the mysterious forces of the cosmos with painted and carved images. They built monumental structures – mystic circles of stone and swelling mounds of soil – to commune with the awesome heavens and the dark earth. They buried their dead with provisions to console their spirits in the next life. Around their fires, they must have chanted stories of cosmic battles and heroic deeds.

Living in the Paleolithic period, or Old Stone Age (see chart page 28), these first adventurers of the human spirit left only isolated traces of their achievement. In southwest Europe, **cave artists** painted Paleolithic beasts with uncanny realism, sometimes using humps in the rock to suggest the natural forms of animals. At Lascaux [LAH-skoh] in France, cave artists sketched immense "bulls" that seem to thunder across the cave wall (Fig. **2.2**).

2.2 Hall of Bulls, Lascaux, France, c. 15,000–13,000 B.C. Paint on limestone.
Paleolithic artists may have applied paint by chewing charcoal and animal fat, and spitting the mixture onto the cave walls. Note how the animal forms at center left are superimposed on one another, perhaps a representation of spatial depth.

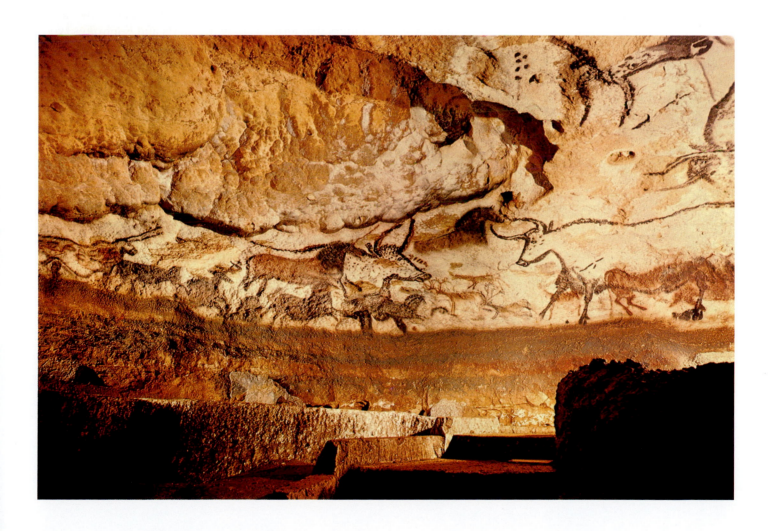

These barely accessible painted chambers must have been the site for ritual ceremonies, illuminated only by flickering lamps.

Paleolithic sculptors rendered the human image in a vivid and often naturalistic style. Carved figures were usually female, often pregnant or with exaggerated sexual features (see Fig. 2.7). These first sculptures were possibly used for adornment or as magical charms to induce fertility and ease childbirth.

By the Neolithic period, or New Stone Age (see chart), humans had begun to shape the physical environment itself, creating **megalithic** (large stone) structures. The most famous megalith stands at Stonehenge in England

2.3 Stonehenge, Salisbury Plain, England, c. 2100–2000 B.C.
The largest stones of this megalith, weighing 50 tons, were hauled from a site 150 miles away. The outer circle of standing stones, topped by lintels or beams, was oriented to mark the solstice.

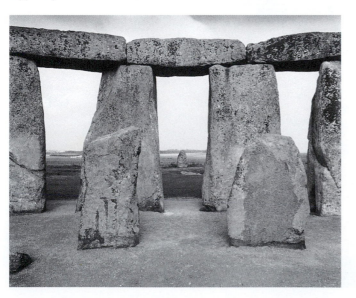

(Fig. **2.3**), where Stone-Age architects erected a circle of huge standing stones. Stonehenge's outer ring is a series of post-and-lintel forms, one of the earliest architectural structures. The stones are aligned with astronomical positions and the megalith may have served as an observatory as well as a center of religious worship.

The Bronze Age (see chart) emerged in the wake of perhaps the most important shift in human history, from food-gathering to food-growing economies. Human settlement stabilized around intensive agriculture in areas spread across the globe, from China to India to Andean South America. The largest cities – and the first centers of human civilization – arose in the **Near East** (present-day Turkey to Iran and Arabia), on the easily irrigated plains of Mesopotamia [mez-oh-po-TAY-mee-uh].

Mesopotamia

Identify similar religious themes and artistic features in ancient Near Eastern civilizations.

The region of **Mesopotamia** (literally "between the rivers," located in present-day Iraq) is justifiably called the cradle of human civilization (Fig. **2.4**). The urban centers that formed along the Tigris and Euphrates [yoo-FRAY-teez] rivers nurtured achievements in the arts, writing, and law. Mesopotamia's rich cities were also the prize for a succession of empires that dominated the Near East and northern Africa during ancient times.

The Sumerians

By 3500 B.C., Mesopotamia's fields and pastures supported a dozen cities inhabited by the **Sumerians** [soo-MER-ee-uns], the first people to use writing and construct monumental buildings. The Sumerians' writing (called **cuneiform**) consisted of pictographs pressed into clay tablets used to record contracts and to track wealth. Sumeria's riches supported a substantial ruling class and the leisure time necessary for fine arts. In a Sumerian tomb at Ur, archaeologists have found the soundbox of a spectacular lyre, decorated with a bull's head (Fig. **2.5**). The head itself is gold-covered wood, with a beard of lapis lazuli, a prized blue stone. The lyre was probably used in a funeral rite that included the ritual sacrifice of the musician who played it.

The Sumerian religion, as with most ancient faiths, is known through surviving fragments of myth (see Key Concept, p. 31). The Sumerian creation myth, called the *Enuma elish* [ay-NOO-mah AY-leesh], reflects the violence of the ancient world. The mother goddess Tiamat does battle with the rowdy seventh generation of gods, led by the fearsome Marduk. After Marduk slays Tiamat, he cleaves her body in half to create the mountains of

Mesopotamia. The rivers Tigris and Euphrates arise from the flow of Tiamat's blood. The creation of humanity is equally gruesome. Marduk shapes the first man from the blood of a sacrificed deity, to serve the gods as a slave.

In their sacred buildings, the peoples of ancient Mesopotamia honored the divine forces that controlled the rain and harvests. The first monumental religious structures were Sumerian stepped pyramids called **ziggurats**. Often made of mud-brick, the ziggurat was actually a gigantic altar. In mounting its steps, worshipers rose beyond the ordinary human world into the realm of the gods. The great ziggurat at Ur-Nammu (c. 2100 B.C.) was dedicated to the moon-god and was probably topped by a temple for sacrifices (Fig. **2.6**).

Empires of the Near East

The myths and art of the ancient Near East were repeatedly transformed as a succession of conquerors and empires gained political dominance. For example, the

c. 3500 B.C.	First Mesopotamian cities
2550–2400 B.C.	Soundbox from royal tomb at Ur, Sumeria (**2.5**)
1790–1750 B.C.	Law code of Hammurabi
612 B.C.	New Babylon kingdom rules Mesopotamia
c. 500 B.C.	Palace of Darius and Xerxes at Persepolis (**2.8**)

myth of a Sumerian hero-king seeking immortality was recast by the **Old Babylonians** as the *Epic of Gilgamesh* (c. 2000 B.C.). The myth of Gilgamesh included a version of the Great Flood story also told in the Hebrew Bible. Old Babylon's most significant king was Hammurabi [hah-moo-RAH-bee] (ruled 1792–1750 B.C.), who instituted a legal code dictating the orderly resolution of disputes and uniform punishments for crime. The Code of Hammurabi specified retributions for particular crimes, codifying the ancient legal principle of "an eye for an eye."

The Old Babylonian empire was followed by that of the Assyrians, skilled and ruthless warriors whose conquests extended to lower Egypt. One Assyrian ruler decorated his palace at Nimrud (in modern-day Iraq) with scenes of lion hunts and luxuriant gardens. When Babylonian rule

2.4 The Ancient World.
Large-scale urban civilization originated in Mesopotamia and spread westward across the Mediterranean and eastward into India and China.

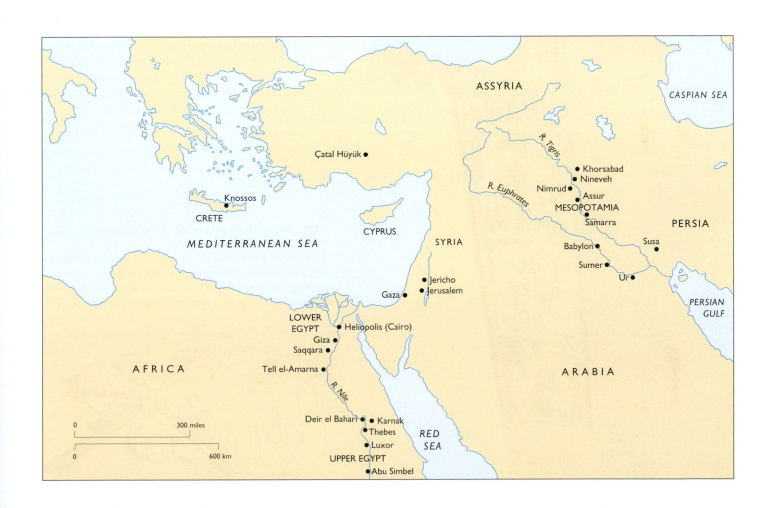

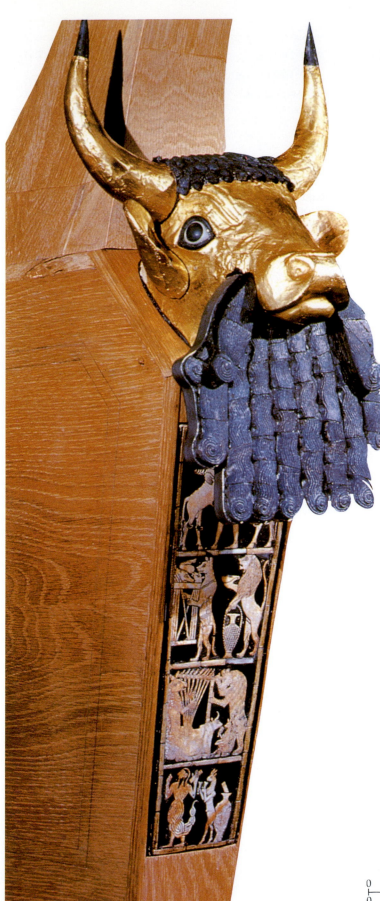

2.5 Soundbox of a lyre from a royal tomb at Ur, Iraq, c. 2550–2400 B.C. Wood with gold, lapis lazuli, and shell inlay, height 17 ins (43 cm). University Museum, University of Pennsylvania, Philadelphia.

The decorative panel shows mythic animals bearing food and wine to a banquet. An ass plays a version of the bull's head lyre, while at bottom a scorpion man gives a dinner oration to musical accompaniment.

was revived in the seventh century B.C., Nebuchadnezzar II [neh-buh-kahd-NEZZ-er] (ruled 604–562 B.C.) rebuilt the capital. It included the imposing Ishtar Gate, made of turquoise bricks, and a great ziggurat described as having seven levels, each painted a different color.

The last and greatest Near Eastern empire was that of the Persians, established by the conqueror Cyrus II (ruled 559–530 B.C.). His successor Darius built a palace at Persepolis that boasted towering columns and a grand staircase, decorated with a procession of figures bearing taxes and tribute from Mesopotamia's rich cities. It was an unmistakable statement of Persian

2.6 Reconstruction drawing of the ziggurat of Ur-Nammu at Ur, Iraq, c. 2100 B.C.

Rising from the Mesopotamian plain, the ziggurat lifted the altars of Sumerian worshipers toward the sacred region of the gods. Comparable "sacred mountains" can be seen in the pyramids of Egyptian and Mesoamerican civilizations.

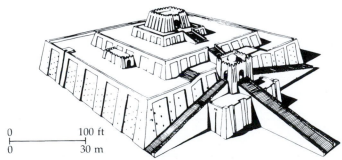

0	100 ft
0	30 m

Myth

Ancient humans celebrated their most important beliefs in myths, stories that explained in symbolic terms the nature of the cosmos and humans' place in the world. Myths arose from the earliest humans' evident belief in a higher reality, a sacred dimension beyond or beneath human experience. Myths described the beings of this hidden world, the gods themselves and the extraordinary humans who communed with the divine. A culture's mythic lore passed orally from one generation to the next, evolving with each telling to reflect changes in the people's life world. This lore included myths proper as well as folk tales, legends, fables, and folk wisdom, all elaborated in a bizarre symbolic logic akin to that of dreams. Eventually cultures recorded their myths in written epics and sacred scriptures, the forms in which we inherit these stories today.

Myths served as the science and philosophy of ancient peoples, explaining cosmic mysteries in the graphic terms of human experience – virtue and trickery, birth and death, and sex and war. For example, myths described the world's creation in vivid scenes that often seem bizarre to the modern mind. In the Maya *Popol Vuh*, the gods create humans first from mud, then from wood. But the heaven's rulers are so disappointed with the result that they obliterate the world in a dark, resinous downpour. Finally the gods shape a suitable race of humans from ground maize: "of yellow corn and of white corn they made their flesh; of corn-meal dough they made the arms and the legs of man," reads the ancient text. The gods then command humanity to honor them with prayer, blood sacrifice, and artful gifts.

The Maya creation story reflects themes common to mythic thinking: the world's destruction by fire or flood, humans' obligation to sacrifice to the gods, and humanity's penchant for violating divine commands. In myths and their related rituals, humans celebrated the cosmic order and communed with the divine forces that controlled their lives. Myths explained catastrophic events and individual misfortune as part of the fabric of divine purpose.

Anthropologist Bronislav Malinowski saw myths as social charters in narrative form, the equivalent of today's political constitutions and social histories. Myths were "not merely a story told but a reality lived," he claimed. This lived reality is evident in some of the oldest human artifacts, such as the woman or goddess from Willendorf (Fig. **2.7**). The sculpted female body, especially in pregnancy and birth, offered symbolic connection to the earth's fertility and the renewal of life. Even where women were oppressed in the ancient world, goddesses such as the Babylonian Inanna-Ishtar and the Egyptian Isis inspired cultic reverence.

Modern thinkers have studied myth as the vehicle of spiritual and psychological truth. Religious scholar Mircea Eliade argued that myths revealed a "sacred history," a mysterious and sublime truth that cannot be explained by rational or scientific language. Pioneer psychologist C. G. Jung claimed that myths expressed universal mental images, or **archetypes**, images that also appear in dreams, literature, and art. Even today, mythic truth – the stories and lore of a sacred dimension beyond our experience – lies at the core of religious and spiritual belief.

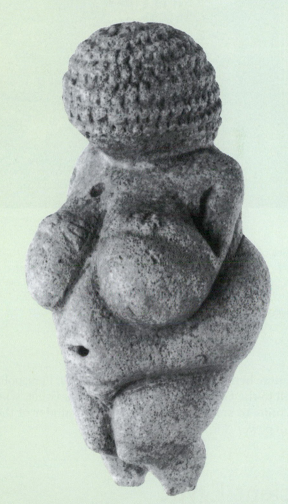

2.7 Woman from Willendorf, Austria, c. 30,000–25,000 B.C. Limestone, height $4^1/_2$ ins (11.5 cm). Naturhistorisches Museum, Vienna.

The swelling forms of the figure's breasts, belly, and thighs are symbolic of the female's (and therefore of the earth's) fertility. Small figures like this one could well have been used as charms in easing the pains of childbirth.

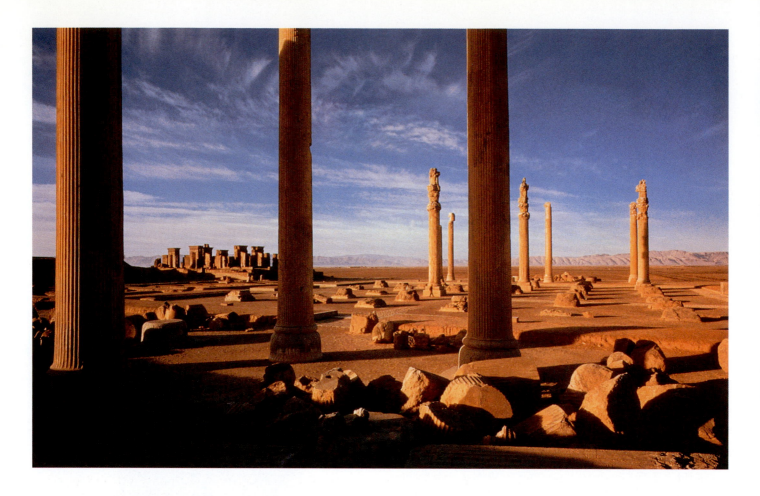

2.8 Ruins of Persepolis, Iran, c. 500 B.C.
The Persian empire included nearly all the ancient Near East, from the Black Sea to Egypt; expansion westward into Europe was blocked by Greek resistance. Classical Greek sculptors may well have seen and imitated the decoration of the Persian palace in the friezes they created on classical temples.

domination. In the fourth century B.C., however, Persepolis itself fell to the Greek general Alexander the Great, who left its ruins to stand in the desert as a reminder of the vanity of power (Fig. **2.8**).

Ancient Egypt

Explain the religious function of Egyptian art.

In contrast to the upheaval and diversity of the Near East, the people of Egypt created a remarkably stable and homogeneous civilization that endured some 3,000 years. Geographically, Egypt was unified by the Nile River and enriched by its annual floods. Politically and religiously, it was united under the rule of the **pharaohs**, god-kings who erected stupendous monuments along the banks of the Nile. The vitality of Egypt's religion fostered an achievement in the arts that still inspires awe today.

Egypt: Religion and Society

The Greek historian Herodotus said the Egyptians were the most religious people he knew, and their religious faith inspired much of Egypt's greatest art. Like most ancient peoples, the Egyptians believed in many gods, a form of religion known as **polytheism**. Some gods (often portrayed as animals) had only local powers. Other deities played roles in mythic dramas of national significance. The myth of Isis and Osiris, for example, reenacts the political struggle between lower and upper Egypt. The god Seth (representing upper Egypt) murders and dismembers his brother Osiris. But Osiris's wife Isis gathers his scattered limbs and resurrects him in the underworld. Henceforth, Osiris rules the realm of life after death. Seth, meanwhile, is defeated by the falcon-god Horus, in whose name Egypt's pharaohs ruled the realm of the living.

The early Egyptians believed that life continued unchanged after death, an expectation that gave rise to the great **pyramids** of the Old Kingdom (see chart), monumental tombs built to contain the bodies of the pharaohs. The Great Pyramids at Giza (Fig. **2.9**) were

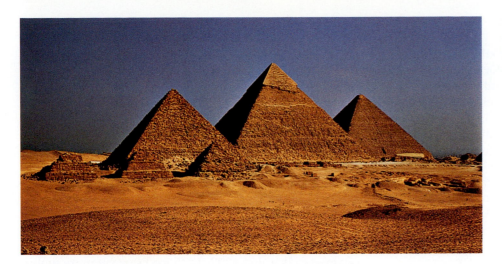

gigantic constructions of limestone block. The largest covered 13 acres (5.2 ha) at its base, and was built of more than two million huge stone blocks. Shafts and rooms in the interior accommodated the pharaoh's mummified body and the huge treasure of objects required for his happy existence after death. The pyramids were part of a vast funerary complex that included lesser buildings and processional causeways lined with statues (Fig. **2.10**).

Attention to the spirits of the dead remained a central theme of Egyptian religion and art. Though they never duplicated the pyramids' scale, rock-cut tombs were carved into the rocky cliffs along the Nile in the so-called Valley of the Kings during the Middle Kingdom period. These tombs were hidden to protect them (unsuccessfully) from grave robbers.

ANCIENT EGYPT

Date (approx.)	Period	Events
3150–2700 B.C.	Early Dynastic (Archaic)	Egypt united; first hieroglyphic writing
2700–2190 B.C.	Old Kingdom	Great Pyramids at Giza
2200–c. 2160 B.C.	First Intermediate	Political division; literary flowering
2040–1674 B.C.	Middle Kingdom	Rock-cut tombs
1675–1553 B.C.	Second Intermediate	Hyksos invasion
1552–1069 B.C.	New Kingdom	Amarna period; Temple of Abu Simbel
1069–702 B.C.	Third Intermediate	Political decline; Assyrian conquest

The Arts of Egypt

Even in the wall painting, informal sculpture, and other arts that made their lives colorful and pleasant, the Egyptians were conservative and restrained. The one exception was during the brief reign of **Akhenaten** [ahk-NAH-tun] (ruled 1379–1362 B.C.), who introduced new religious ideas and fostered a distinctive artistic style of great intimacy. Shortly after he came to power, Akhenaten broke with the dominant cult of Amon-Re and its powerful priesthood at the temple complex in Thebes, where Akhenaten established a new royal residence, or **court**. He fostered the worship of the little-known god Aten, the sun-disc, whose life-giving powers he praised in a famous hymn:

> Earth brightens when you dawn in lightland,
> When you shine as Aten of daytime;
> As you dispel the dark,
> As you cast your rays,
> The Two Lands are in festivity.
> Awake they stand on their feet,
> You have roused them;
> Bodies cleansed, clothed,
> Their arms adore your appearance.
> The entire land sets out to work,
> All beasts browse on their herbs;
> Trees, herbs are sprouting,
> Birds fly from their nests,
> Their wings greeting your *ka*.[1]

The Great Hymn to Aten was inscribed on a tomb at **Amarna**, the site about 200 miles (320 km) up the Nile from Thebes where Akhenaten established a new court. Distanced from the temples of Karnak and Luxor, the court at Amarna fostered a style of unprecedented intimacy. Images depict the royal family – Akhenaten, his queen Nefertiti, and their children – lounging beneath the life-giving rays of the sun-disc. The pharaoh kisses one child, while Nefertiti bounces another on her knee.

Akhenaten's religious and artistic innovations were short-lived. His successor Tutankhamen [too-tahnk-AHH-mun] (1361–1352 B.C.) – whose tomb was such a rich and famous discovery in the twentieth century – restored the cult of Amon-Re and destroyed most of the buildings dedicated to Aten. A late blossoming of Egyptian art under Ramesses II (ruled 1292–1225 B.C.) saw yet more monuments to power and richly decorated tombs.

It was not uncommon for Egyptian queens to attain considerable status and power within the royal court. Early in the New Kingdom, Queen Hatshepsut ruled all of Egypt for two decades (1479–1458 B.C.), and memorialized herself with a huge colonnaded temple near the Valley of the Kings. The famous site of Abu Simbel, carved into the side of a cliff, bears witness to another prominent queen: there, equal in size to the colossal statue of Ramesses II, was the figure of his favored queen **Nefertari**. Tradition holds that Nefertari assisted Ramesses on diplomatic missions that helped expand the Egyptian empire.

Queen Nefertari's tomb in the Valley of the Queens represents Egyptian art at a height of the nation's international power (Fig. **2.11**). The richly carved and painted walls depict the descent of the queen's *ka*, or spirit, into the underworld. Gently led by the figure of Isis, the queen greets the pantheon of Egyptian gods, still celebrated in their ancient animal aspects. From each deity, Nefertari's spirit acquires the powers that prepare her soul for final judgment before the imposing figure of Osiris. The delicate artistry of Nefertari's tomb celebrates the continuity of a religious belief and artistic tradition that had evolved for thousands of years.

The height of Ramesses II's rule was followed by a long decline in Egypt's power, as foreign incursions alternated

c. 5000 B.C.	Human settlements arose in the Andes
c. 2525 B.C.	Great Pyramids begun at Giza, Egypt (**2.9**)
c. 2300 B.C.	Dancing figure, Indus Valley (**2.13**)
c. 1500 B.C.	Olmec civilization arose in Mesoamerica
1379–62 B.C.	Temple to Aten built in Egypt
c. 560 B.C.	Gautama Buddha born in northern India
480 B.C.	Confucius active in China
400–200 B.C.	Indian epics of the *Ramayana* and *Mahabharata*

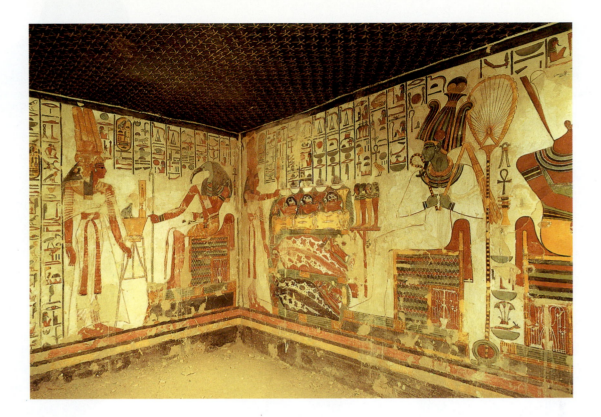

2.11 Painting from the tomb of Queen Nefertari at Thebes, Egypt, 1290–1224 B.C. At the left, the crowned queen approaches the ibis-headed god Thoth, the divine scribe who records human deeds. To the right, Osiris is seated on the throne where he judges the souls of the dead. Nefertari's figure is carved in a high relief that captures the contours of fingers, legs, and facial detail.

with periods of independence. Invading from Nubia to the south, a Kushite kingdom briefly controlled all of Egypt (early eighth century–671 B.C.). The Kush empire, with its unique blend of Egyptian and Nubian culture, ruled the middle Nile region for another thousand years. Lower Egypt fell to the Assyrians and then to the hated Persian empire, until Alexander the Great's conquests in 332 B.C. drew Egypt into the Hellenistic world.

Asia and America

Identify shared patterns of development in early human civilizations.

In the third millennium B.C., the rise of agriculture and urbanization supported rapid development in every center of human settlement, from Asia to the Americas. As in the ancient Near East, early civilizations in Asia arose in great river valleys. In the Western Hemisphere, human advancement followed a path similar to Old World civilizations.

The Indus Valley

In the rich Indus Valley of southern Asia (today's Pakistan and India), the ancient world's largest civilization thrived for a thousand years. The **Indus Valley** (or Harappan) **civilization** (2600–1750 B.C.) supported a network of comfortable cities that traded across a broad swath of the Indian subcontinent. Modern excavations at Mohenjo-Daro and Harappa have revealed the remains of unfortified cities laid out on an orderly grid plan (Fig. **2.12**). With public baths, sanitary sewers, and large assembly halls, the Indus Valley cities offered comforts that some city-dwellers might wish for today.

The remains of Indus Valley civilization reveal a thriving cultural life but, surprisingly, nothing of the elaborate temple cultures found at other ancient centers. Scenes on sculpted seals indicate that Indus residents venerated sacred trees and horned animals such as their humped cattle. Other Harappan sculpture was probably made for personal enjoyment. Two remarkable male torsos, one a dancing figure, capture the interacting planes and rounded shapes of the human form (Fig. **2.13**). In their mastery of dynamic tension, these small figures are a landmark in human artmaking.

About 1750 B.C., the spacious Harappan cities suffered a decline that scholars long attributed to foreign invasion but which is now blamed on climate change. About the same time, a warlike, horse-riding people who called themselves **Aryans** migrated into southern Asia. From Aryan language and lore arose the **Vedas** [VAY-duhz], India's founding religious scriptures and one of humanity's

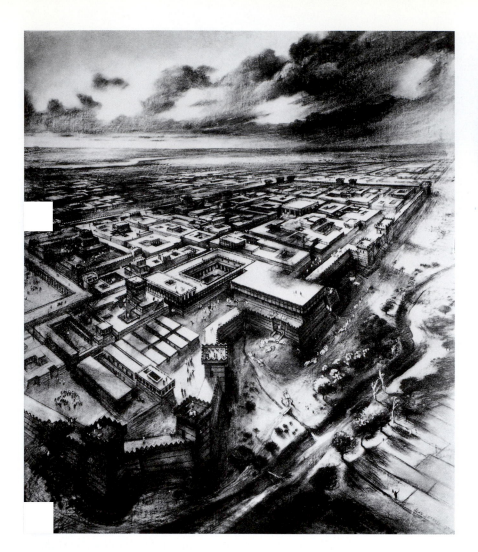

2.12 Reconstruction of the Great Bath, granary, and houses, Mohenjo-Daro, Indus Valley (modern Pakistan), c. 2100–1750 B.C. Courtesy of Liverpool Museum, Merseyside and Bridgeman Art Library.

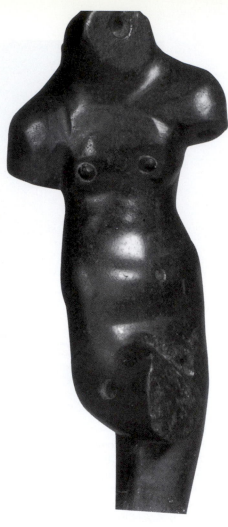

2.13 Dancing figure, Harappa, Indus Valley, c. 2300–1750 B.C. Limestone, height 3⁷/₈ ins (9.8 cm). National Museum of India, New Delhi.
Compare the torsion and vitality of this small figure with the rigid formality of the Egyptian royal couple in Fig. 2.10.

most ancient surviving religious traditions. The oldest Vedic texts are hymns to the sky-gods and prayers to accompany fire-sacrifice, the principal Vedic ritual. About 800 B.C., Vedic sages composed philosophical commentaries, known as the *Upanishads*, that speculated on the unity of the individual soul and the universe. The Vedic tradition blossomed again between 400 and 200 B.C. with the composition of the popular epics *Mahabharata* and *Ramayana*. This rich body of scripture and poetry became the basis for India's dominant faith, Hinduism, which took shape in the sixth century B.C. Hinduism sanctioned a rigid class or caste system, through which virtuous souls might ascend in a cycle of death and rebirth. Hinduism's beliefs were the foundation of other Asian faiths, including Buddhism (see page 92).

Bronze Age China

Of all the ancient civilizations discussed here, only China can trace its unbroken development from the present day to its Bronze Age beginnings. Agriculture in ancient China dates to around 5000 B.C., town life to around 4000 B.C. Chinese civilization appeared in the valleys of the three great rivers of its central region.

Bronze Age China divides its history between two great dynasties. The **Shang** [shahng] Dynasty (c. 1500–1045 B.C.) was a warrior culture whose rulers built walled cities and gigantic tombs in the Yellow River Valley. Their principal artistic media were carved jade (a hard green stone) and cast bronze. Shang bronzes included ritual vessels (Fig. **2.14**) and great bells decorated with fantastic animals,

including a complex design called the *taotie*, which may be an animal mask or two dueling dragons.

The Shang fell to the conquering **Zhou** (1045–221 B.C.), a feudal kingdom whose king reigned as the Son of Heaven. Like the Shang, the Zhou [tchoh] practiced a form of ancestor worship and excelled at the manufacture of ritual bronze objects. As evidence of his extraordinary love of music, one Zhou ruler was buried with a carillon of sixty-five bronze bells, among hundreds of other musical instruments. The later Zhou period was marred by warring factions, until the Warring States period (402–221 B.C.) finally splintered the dynasty.

2.14 Ritual wine vessel or *hu*, Shang Dynasty, c. 1300–1100 B.C. Bronze, height 16 ins (40.6 cm). Nelson-Atkins Museum of Art, Kansas City, Missouri. Purchase: Nelson Trust., 55-52
The ambiguous, mask-like design on this vessel, the *taotie*, can be interpreted as a face with the flaring nostrils of an ox, or as two dragons with serpent tails facing each other in profile.

Civilizations and Progress

When modern genetic science determined that humans are genetically nearly identical, it threw new light on an old question of human history: why have different civilizations progressed at different rates? Why, as one scholar has asked, did Europeans colonize the peoples of America, starting around 1520, rather than vice versa?

Old and sometimes ugly answers to this question referred to religious or racial superiority. Modern anthropologists and archaeologists claim the answers are rooted in the material conditions of human civilization. It was no accident, for example, that humans first achieved large-scale agriculture and animal domestication in the ancient Near East. This region had a stock of wild plants, animals, and metal ores that were easily adapted to human use (ancestors of the almond and the hog, for example), as well as a friendly climate and a diverse geography.

Settled urban life also produced a surplus of goods that motivated the invention of writing, necessitated complex political organizations, and supported the first large-scale agriculture – all cultural bonuses added to environmental advantage. The region's good fortune in the availability of crucial metal ores stimulated the technologies of metalworking. These components of human progress spread easily across Eurasia (the land mass stretching from Japan to Spain) because of another natural blessing – a geography that eased migration along those moderate latitudes.

By comparison, human settlement in other continents faced considerable barriers. Africa's and America's elongated north–south orientation, their equatorial forests (and in the case of the Americas, a mountainous central isthmus) prevented the easy interchange of goods and technology. The stock of domesticable plants and animals was less robust, and populations remained smaller. Without a surplus of wealth, written accounting systems were less important. Many cultures outside Eurasia never bothered to invent complex writing systems at all.

By the year 1000 B.C., the fate of human civilizations across the globe had already been deeply molded by geography and culture. Although they were all probably descended from the same small tribe of ancestors, the human societies of Eurasia, Africa, and America were destined to progress at different rates for thousands more years. When Renaissance Spain collided with Incan society in Peru, it was not the Incas' gold, but rather Pizarro's gunpowder, that decided the battle.

CRITICAL QUESTION
Describe a situation in which you might feel yourself torn between an obligation to your community or nation and the responsibility you feel to the good of humanity the world over. What factors would you consider in resolving this tension reasonably?

Ancient America

Modern humans migrated into the Americas, or New World, some 20,000 years ago or possibly even earlier, probably along a land bridge between Siberia and Alaska. The exact course of human immigration and occupation is still poorly understood, but by 7000 B.C., New World peoples were domesticating crops such as maize, squash, and cotton. The first settled urban centers appeared in Mesoamerica (today's Mexico and Central America) and along the Andes mountain range in South America. Distinctive and often highly advanced civilizations rose and fell in these two regions, supporting urban capitals and populations that may have equaled Old World cities in size and achievement.

In Mesoamerica, a civilization called the Olmec arose on the eastern coast of Mexico around 1500 B.C. Some scholars call the Olmecs the Americas' "mother culture" because their cosmology, calendar-making, and pyramid construction influenced so many others. In a distinctive artistic style, the Olmecs carved stone images of the jaguar and the feathered serpent, both important to Mesoamerican religious belief. The Olmecs also sculpted huge helmeted heads, some 8 feet (2.4 m) tall, probably images of chieftains whom they regarded as gods (Fig. **2.15**).

Later Mesoamerican cultural centers would bear the imprint of Olmec style and thought. In the high mountain valleys of today's Mexico, a mysterious culture built the region's most sacred city, Teotihuacan, where Mesoamericans believed the gods themselves had been born (see page 121). The most spectacular Mesoamerican city was the Aztec imperial capital of Tenochtitlán, a spectacular floating city of pyramid altars and lush gardens. The Spaniard chronicler Bernal Díaz would write that Cortés' soldiers "who had been in many parts of the world, in Constantinople, and all over Italy, and in Rome" had never seen "so large a marketplace and so full of people, and so well regulated and arranged."[3]

In the Andes, recent discoveries show that human settlements as early as 5000 B.C. had mastered the cultivation of crops, irrigation, and large-scale construction. The Andes' first great cultural flowering came with the Chavín, contemporaries of the Olmecs, centered in the coastal regions of today's Peru. The Chavín culture created ceremonial complexes of pyramidal altars and erected huge carved monoliths. Their iconography, typical of Andean civilization, included sacred animals like the caiman, serpent, and cat. The Andes' greatest ancient city was Tiahuanaco (also Tiwanaku), located on the high plateau near Lake Titicaca. At its height around 400 B.C., this city's population may have reached 40,000 and its imperial power extended north along the Andean coast. Tiahuanaco's highly stratified society anticipated the rule of the Inca a thousand years later, when the Andean region was unified in a brief but remarkable empire.

In North America, human settlement was more diffuse and took a smaller scale, with important centers in the desert Southwest and the Mississippi River basin. Few North American peoples practiced large-scale agriculture or built the monumental urban centers of their sister civilizations to the south. One fascinating monumental construction was a great serpent mound in the Ohio River Valley. Small-scale art focused on decorated pottery; stone carving was rare.

Compared to their little-known beginnings, the ending of the New World civilizations is all too familiar. In the sixteenth century, European conquerors subjugated Aztec and Inca empires and laid waste to their glittering cities. Native populations were devastated by European diseases, suffering death rates as high as ninety-five percent. In spite of resistance, the survivors fell to Europeans' colonial rule, often losing all but a faint memory of their continent's glorious achievement.

2.15 Colossal head, from San Lorenzo, La Venta, Mexico. Middle Formative period, c. 900 B.C. Basalt, height 7 ft 5 ins (226 cm). La Venta Park, Villahermosa, Tabasco, Mexico. The Olmec carved colossal heads like this one.

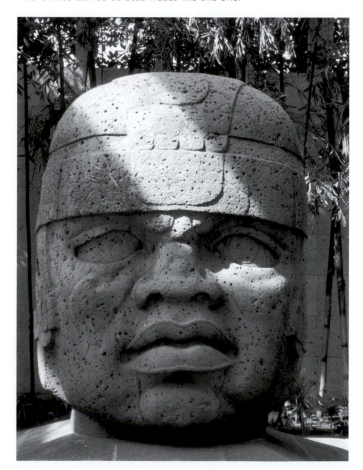

CHAPTER SUMMARY

The First Humans The first humans appeared about 100,000 years ago and developed a culture that revered the forces of nature and remembered the dead. The first human expression in the arts took the form of elaborate cave paintings, with their dynamic animal figures, and small sculptures of clay and stone, often depicting powerfully symbolic female figures. Megalithic complexes such as Stonehenge in England – the first monumental human buildings – indicate early humans' profound religious connection to the universe.

Mesopotamia The first great cities appeared in the Bronze Age Near East, on the fertile river plains of Mesopotamia. Here the Sumerians developed the first forms of writing and recorded their mythic thought in the *Enuma elish*. Myths were also celebrated in rituals on huge temple-altars (ziggurats). The succession of great empires that dominated Mesopotamia included the Babylonian, with its law-giving king Hammurabi, and the Persian, remembered for its great palace at the capital Persepolis.

Ancient Egypt The geography of Egypt – protected by desert and unified by the Nile River – fostered a stable civilization ruled by pharaoh-kings. Egypt's complex myths and rituals centered on the afterlife. To contain the mummified dead, the Egyptians built huge pyramids and elaborately decorated tombs. To honor the gods, they constructed vast temple complexes at Karnak and elsewhere. Egyptian arts reached a high point under the unorthodox pharaoh Akhenaten and in the gracefully decorated tomb of Nefertari.

Asia and America In the Indus Valley of southern Asia, a highly developed civilization built the ancient world's largest and most advanced cities. This so-called Harappan civilization was supplanted by Aryan settlers, whose great legacy was the Vedic tradition of mystical prayers and hymns. In China, the Bronze Age dynasties of the Shang and Zhou left masterpieces of jade and bronze, the foundation of China's immensely rich artistic tradition. In the ancient Americas, a succession of civilizations rose and fell at centers in today's Mexico and the Andes highlands.

3 Ancient Greece: The Classical Spirit

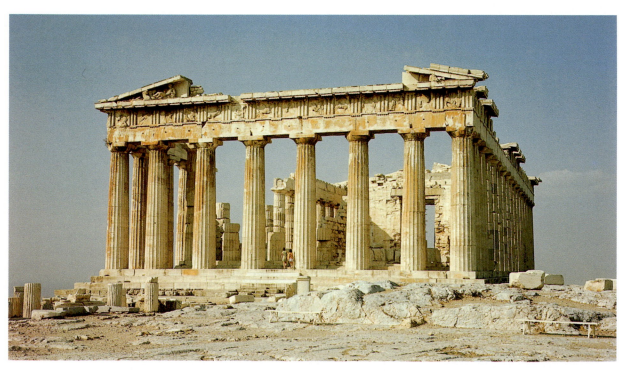

3.1 The Parthenon, Athens. As the Athenian leader Pericles predicted, the ruins of the temples of Athens still stand as "mighty monuments of our power, which will make us the wonder of this and of succeeding ages."

Even in ruins, the Parthenon of Athens stands perfectly balanced and noble in its proportions (Fig. **3.1**). The temple stood above Athens as the city reached a pinnacle of cultivation and achievement seldom equaled in history. The Parthenon's harmonious outlines embody the **classical spirit** of ancient Greece (Fig. **3.2**): the belief that human intelligence could bring order to the world and that art could capture the essence of human form and feeling. From its height in ancient Athens, this spirit spread across the Mediterranean, becoming a standard by which later civilizations would measure themselves.

Early Greece

Describe early Greek civilization and its most celebrated artistic achievements.

Of all the civilizations of the ancient world, one came to have the greatest influence on Western societies – that of the ancient Greeks, honored for their enduring achieve-

c. 2500 B.C. Beginning of Minoan civilization, Crete

c. 1550 B.C. *Mask of Agamemnon*, Mycenae (**3.5**)

c. 1250 B.C. Mycenaeans conquer Troy

ments in art, literature, philosophy, and science. Greek civilization originated in two Bronze Age civilizations of the eastern Mediterranean, the **Minoan** (c. 2500–1250 B.C.) and **Mycenaean** (c. 1600–1150 B.C.) cultures. Both were eventually destroyed by natural calamity and invasion, and after a "dark age" there arose the earliest Greek civilization proper (900–480 B.C.).

The early Greeks were at first backward in comparison to their Mediterranean neighbors, but they developed quickly, stimulated by contact with Egypt and Persia, and soon built colonies along the northern Mediterranean. They formed an ethnic identity around memories of

3.2 Ancient Greece.

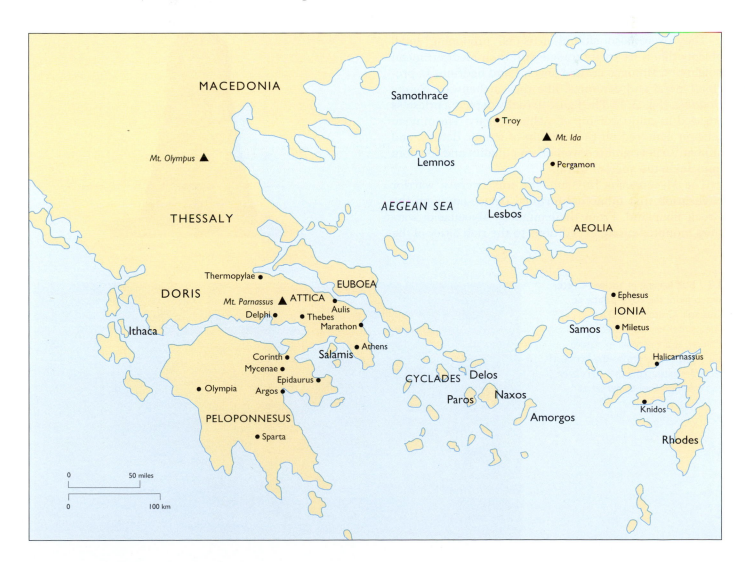

the Mycenaean and Aegean cultures that lay in ruins around them. Those memories eventually focused on a single legendary event – the siege of Troy – a tale that they embellished in poetry and in art.

The Aegean World

The Minoans [muh-NOH-un] established an expansive and distinctive civilization on the Mediterranean island of Crete, strategically connecting the Aegean basin and the rich cultures of Egypt and Mesopotamia. They were a spontaneous and pleasure-loving people skilled in fine arts, whose power and prosperity depended on a powerful navy. Their civilization reached a high point of social and artistic development around 1400 B.C. The Minoans constructed sprawling palace-cities of brightly colored and undefended buildings. Archaeologists named the island civilization after the legendary King Minos, whose queen bore the feared monster, the Minotaur. The bull was an important part of Minoan religious ceremony, which featured the spectacular sport of bull-leaping (Fig. **3.3**). Male and female athletes grasped the horns of a charging bull and performed a somersault over its back. As this example suggests, the Minoans preferred outdoor entertainments.

They were also skillful artisans, producing small objects that were easily traded with their Mediterranean neighbors. Minoans crafted jewelry and figurines in precious metal and ceramics, like the earthenware *Snake Goddess* (Fig. **3.4**). The figure actually depicts a priestess engaged in cultic worship of a Minoan deity. The Minoan religion centered on the worship of female deities, and Minoan society granted women an equality and freedom unusual in the ancient world.

The Mycenaeans [my-suh-NEE-uns] were a warrior civilization that inhabited fortified palace-cities on the Greek mainland. From their citadels, Mycenaean warriors mounted pirate expeditions to the rich cities of the Aegean basin. Later Greek stories of the Trojan War dimly recalled Mycenaean expeditions in search of plunder and slaves. Modern archaeology confirms the possibility of a Mycenaean expedition to Troy in Asia Minor, which was burned around 1250 B.C.

3.4 *Snake Goddess,* from the royal palace at Knossos, Crete, c. 1600 B.C. Faience, height 11 ins (30 cm). Archeological Museum, Heraklion.
The bare bodice and flounced skirt were part of Minoan religious costume. The snakes in the priestess's hands and the owl on top of her head were symbols of sacred power in ancient goddess-centered religions.

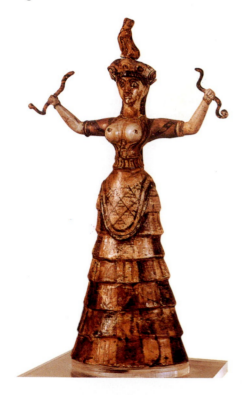

3.3 Bull-leaping in ancient Crete, fresco from the royal palace at Knossos, Crete, c. 1500 B.C.
The painter has portrayed the athletes as if in a multi-exposure photograph: one grasps the horns, a second vaults across the bull's back, and the third finishes her stunt.

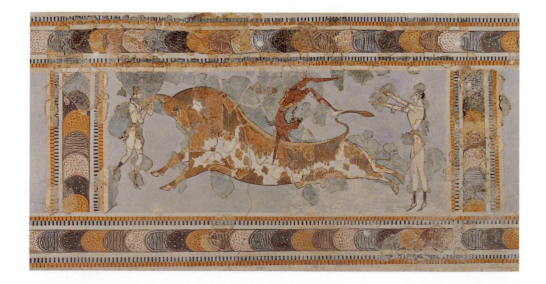

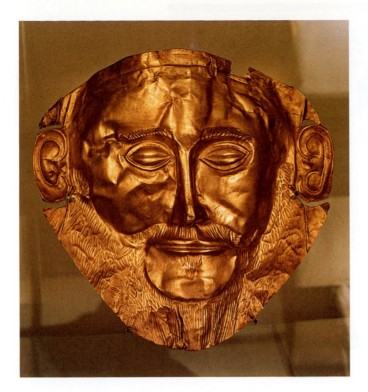

3.5 "Mask of Agamemnon," from a grave in Mycenae, c. 1500 B.C. Beaten gold, height 10 1/8 ins (26 cm). National Archeological Museum, Athens.

Such portraiture, delicately wrought in the region's most precious metal, was reserved for Mycenaean royalty. In other ancient cultures (Egypt, China), such costly objects were buried with the owner to ease his life in the afterworld.

Excavations inside the Mycenaean palaces reveal a civilization of fantastic wealth that was fascinated by death and the afterlife. At Mycenae, archaeologists have unearthed labyrinthine shaft graves where Mycenaean royalty was entombed. The rows of graves inside the fortress's main gate most likely served as a circle of honor for ancestral heroes. The face of one such hero is visible in the famed "Mask of Agamemnon" (Fig. **3.5**), discovered by the archaeologist Heinrich Schliemann in 1876.

The Mycenaeans' predominance in the Aegean was brief. About 1150 B.C., a century after the supposed Trojan expedition, invaders may have entered Greece from the north, destroying the Mycenaean palaces and dispersing their civilization. Only a few Mycenaean centers (Athens, for one) remained intact. Following Mycenae's fall, Greece entered the Dark Age (about 1150–900 B.C.), a period when writing, artistic crafts, and other cultural skills were lost. Out of the turmoil of the Dark Age, a people emerged whom we call the Greeks.

Early Greek Poetry

At centers on the Greek mainland and across the Aegean to Asia Minor, Greek-speaking communities gradually reestablished themselves in the wake of the collapse of Mycenaean civilization. By 733 B.C., Greek city-states were sending expeditions to establish settlements abroad, and by 600 B.C. Greek colonies were scattered from the Black Sea to Sicily.

Though geographically diffuse and politically contentious, the early Greeks were unified by language, religion, and legend. The most important poetic works of early Greece told of the siege of Troy, an ancient city in Asia Minor. The story was told in two remarkable poems entitled the *Iliad* and the *Odyssey*, both attributed to the poet Homer and possibly composed in the eighth century B.C. The ancient Greeks acknowledged Homer as the greatest poet of the Greek language. Modern scholars, however, cannot agree on whether a poet named Homer ever existed, or if the two Homeric poems had the same author. Nonetheless, they recognize the poems as the first masterpieces of Western literature.

The Homeric poems are both **epics**, long narrative works that recount deeds on a heroic scale, centered on a hero who defines a sense of ethnic or national identity. Homer's epics are the wellspring of Greek storytelling, much like the Babylonian *Epic of Gilgamesh* (c. 2000 B.C.), and the Indian *Mahabharata* (c. 400–200 B.C.), in Babylonian and Hindu cultures. Later generations retold their hero's deeds – Gilgamesh's search for eternal life, Arjuna's dialogue with the god Krishna – to celebrate their language and national identity, and also to explore the essential truths of human experience. Homer's epic heroes were Achilles [ah-KILL-eez], the greatest warrior of the Greek forces at Troy, and Odysseus [oh-DIS-ee-us], the great adventurer who voyaged home from Troy. Homer's heroes served as models of rightful action and skillful speech, much as biblical heroes did for Jews and Christians. Indeed, educated Greek men could still quote the speeches of Homer's warriors seven centuries after the Mycenaean palaces had fallen into ruin.

In the *Iliad*, ethnic warfare between Trojans and Greeks (called Achaeans [ah-KEE-uns]) provides the setting for a deeply human drama of honor, love, and tragic loss (Fig. **3.6**). The proud hero Achilles quarrels with his chieftain Agamemnon and angrily withdraws from battle. When his closest comrade is killed, Achilles rejoins the fray, defeating the Trojan prince Hector and defiling his body. Homer follows this gruesome confrontation with a scene of great tenderness and sympathy, when King Priam of Troy steals into the Achaeans' camp to ask Achilles for his son's body. In spite of its hero's cruelty and violence, Homer's saga of human pride and error ultimately confirms the nobility of human life.

3.6 Paris abducting Helen, scene from a red-figure vase, 500–480 B.C. Height 8¹/₂ ins (21.5 cm). Courtesy, Museum of Fine Arts, Boston, Francis Bartlett Fund (1912). Early Greek art drew images from legendary accounts of the Trojan War. Legend justified the Greeks' assault on Troy as an attempt to reclaim their queen, Menelaus's wife Helen, here abducted by the Trojan prince Paris.

So he [Priam] spoke, and stirred in the other [Achilles] a passion of grieving for his own father. He took the old man's hand and pushed him gently away, and the two remembered, as Priam sat huddled at the feet of Achilleus and wept close for manslaughtering Hektor[a] and Achilleus wept now for his own father, now again for Patroklos.[b] The sound of their mourning moved in the house. Then when great Achilleus had taken full satisfaction in sorrow and the passion for it had gone from his mind and body, thereafter he rose from his chair, and took the old man by the hand, and set him on his feet again, in pity for the grey head and the grey beard, and spoke to him and addressed him in winged words:"… Such is the way the gods spun life for unfortunate mortals, that we live in unhappiness, but the gods themselves have no sorrows. There are two urns that stand on the door-sill of Zeus. They are unlike for the gifts they bestow: an urn of evils, an urn of blessings. If Zeus who delights in thunder mingles these and bestows them on man, he shifts, and moves now in evil, again in good fortune. But when Zeus bestows from the urn of sorrows, he makes a failure of man, and evil hunger drives him over the shining earth, and he wanders respected neither of gods nor mortals."[1]

HOMER
Iliad, Book XXIV

a. Hektor (Hector), son of Priam, and the Trojans' greatest fighter, killed by Achilles to avenge the death of Patroclus.
b. Patroklos (Patroclus), Achilles' best-loved companion, killed by Hector while wearing the armor that Achilles had lent him.

Sappho's Lyric Poetry When the Greeks tired of the epic's high drama and elevated style, they could turn to **lyric poetry**, which took its name from the lyre, the stringed instrument used to accompany the recitation of these poems (Fig. **3.7**). Lyric poems were brief, often written for a specific occasion, and expressed the speaker's inner thoughts and feelings more directly than the epic. While an epic bard might sing his poem at a royal court, lyric poetry was probably reserved for less formal occasions, such as a dinner banquet among friends.

The most renowned of Greek lyric poets was Sappho, who lived on the Aegean island of Lesbos around 600 B.C. Sappho was the leader of a circle of female friends devoted to music and poetry. Many of her poems, most preserved as fragments, speak passionately to younger members of this group. Sappho's surviving poetry preserves the immediacy and passion that made her the most admired lyric poet in the ancient Greek world.

In the fragment quoted here, Sappho contrasts a woman's gentle love for friends and family with her subservient love for a man called to war. Yet Sappho's regret does not cloud her tender love for Anaktoria, whose beauty surpasses the military splendor of the battlefield.

CRITICAL QUESTION
Imagine the ways in which today's civilization would change if all writing and the capacity for literacy disappeared and we became an oral culture. Are modern societies becoming less literate by relying on visual and "virtual" means of communication?

Some say cavalry and some would claim
infantry or a fleet of long oars
is the supreme sight on the black earth.
 I say it is
the girl you love. And easily proved.
Did not Helen[a], who was queen of mortal
beauty, choose as first among mankind
 the very scourge
of Trojan honor? Haunted by Love
she forgot kinsmen, her own dear child
and wandered off to a remote country.
 O weak and fitful
Woman bending before any man:
So Anaktoria, although you are
Far, do not forget your loving friends.
 And I for one
Would rather listen to your soft step
and see your radiant face – than watch
all the dazzling horsemen and armored
 Hoplites[b] of Lydia.[2]

SAPPHO

a. Helen, wife of Menelaus.
b. Hoplite, an armored foot soldier.

Religion and Philosophy in Early Greece

When the Homeric hero Achilles complains of the sorrows sent by Zeus, he expresses the common Greek belief in the gods' power over human destiny. In fact, dying warriors in the *Iliad* reconcile themselves to defeat and death by explaining that the gods had simply chosen that moment for their death. The deities of Greek religion were highly anthropomorphic – shaped like humans – and took an active role in the lives of mortals. In the *Iliad,* for example, the gods Apollo and Hera visit pestilence and disaster on those who displease them. To win the gods' favor, pious Greeks engaged in animal sacrifice at altars and temples, assisted by temple priests and attendants, as did most religious believers in the ancient world. The Greeks' single most important religious institution was the oracle at Delphi, where priestesses bent over the pool of Apollo and divined the god's answer to questions of believers.

Because early Greek communities were so widely dispersed, there was considerable variety in their beliefs and practices, reflecting local traditions. Around 700 B.C., the poet Hesiod [HEE-see-ud] sought to consolidate and synthesize Greek belief in his poem *Theogony,* which means "the making of the gods." Following models from the ancient Near East, Hesiod described the cosmos as originating in a succession of generations of gods, beginning with "Chaos" and the mother of all being, Gaia:

> Verily at the first Chaos came to be, but next wide-bosomed Earth, the ever-sure foundations of all the deathless ones who hold the peaks of snowy Olympus, and dim Tartarus in the depth of the wide-pathed Earth, and Eros (Love), fairest among the deathless gods, who unnerves the limbs and overcomes the mind and wise counsels of all gods and all men within them.[3]

By 600 B.C., Greek thinkers began to supplement the vivid stories of Greek myth with more philosophical speculations on the nature of things. Like the mythmakers, these earliest Greek philosophers, active chiefly in the Greek cities of Asia Minor (today's Turkey) and Italy, asked themselves, "What is the nature of the cosmos?"

3.7 Citharode and listeners, from a vase painting by the Attic master Andokides, c. 530 B.C. Louvre, Paris.
A lyric singer accompanies herself on the *cithara,* a larger and more elaborate version of the lyre. Lyric poetry was composed for official occasions – to praise the gods at a festival or honor an athlete – as well as for more intimate settings.

Their answers reflected a new **rationalism** – that is, a belief that human reason is the surest source of truth about the world. Some, the so-called **materialists**, reasoned that the natural world must be derived from a primal stuff. The early materialist Thales [THAY-leez] of Miletus (c. 624–546 B.C.) held that all nature was composed of water. The materialists also sought the principles of change by which matter changed from one form to another.

A different branch of early Greek philosophy followed the teaching of Pythagoras (active sixth century B.C.), the most venerated early Greek philosopher. Pythagoras was a charismatic teacher who advised a disciplined life of silence and restraint and believed in the transmigration of souls. His most influential teachings involved the mathematical structure underlying the physical world. According to a later commentator, Pythagoras supposed "the elements of numbers to be the elements of all things and the whole heaven to be a musical scale and a number." Later followers credited him with important practical discoveries, including a geometric theorem and the expression of musical tones as mathematical ratios (see page 61).

Much like the Greeks' artistic methods, their philosophical thinking evolved rapidly in the years around 500. Parmenides (born c. 515 B.C.) claimed that the cosmos was actually composed of one primal and universal substance – what Parmenides called the "what-is" – a philosophical belief called **monism**. From his monistic position, Parmenides regarded all sense experience as complete illusion, an extreme rationalism. Greek **pluralists** like Empedocles (c. 495–435 B.C.) argued that the "what-is" actually consisted of four fundamental elements – earth, air, fire, and water. Finally, the **atomists** returned to Parmenides' monism by claiming that tiny particles called atoms (*atoma* means "things indivisible") made up everything in the cosmos. The entire world – the gods as well as humans and their natural surroundings – had come into being through the mindless collision of atoms spinning through the void.

The stunning advances of early Greek philosophy were often mixed with ethical teachings. Pythagoras advised his followers to eat no meat, lest they devour the soul of an ancestor, and Empedocles believed that, by living purely during successive lives, humans could achieve immortality. Their inventive rationalist speculations set the stage for the philosophical revolution of fifth-century Athens, led by the sophists and Socrates (see page 62).

Art in Early Greece

From 650 to 490 B.C., the Greeks developed a distinctive style in the visual arts, now called **Archaic**. Although the Archaic style in Greece borrowed liberally from more advanced Egyptian and Persian civilizations, the Greek artisans transformed these borrowings into an art concerned with natural beauty and the human form.

Since few early Greek wall paintings survive, we know early Greek painting chiefly through pottery vases. Manufactured at commercial centers like Corinth and Athens, these vases were initially decorated with abstract geometric designs. The **geometric** technique, as it is now called, demonstrated the Greeks' interest in intricate, rationalized patterns. Soon, painters incorporated rudimentary human figures, most likely adapted from Egyptian painting, that showed an increasing **naturalism** – the attempt to represent objects as they appear in nature (Fig. **3.8**).

The most advanced form of vase painting was the **red-figure technique**, in which the background of a scene was entirely painted (appearing as black) and the figures

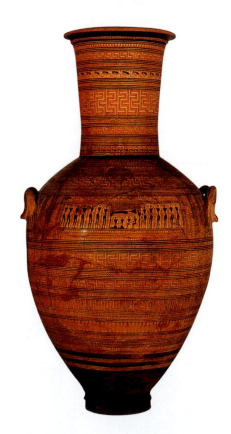

3.8 Dipylon vase (Attic geometric amphora), c. 750 B.C. Height 5 ft (1.53 m). National Archaeological Museum, Athens. From their earliest arts – vase painting and figurative sculpture – the Greeks demonstrated their fascination with rationalism and the human figure. This geometric-style Greek vase employs complex meanders and other designs to enclose the central scene of a funeral bier and mourners. The monumental vase served as a grave-marker.

were left unpainted (appearing as red) except for fine details of anatomy. The red-figure technique permitted subtle effects of bodily movement and expressive storytelling. Red-figure vases like the "Euphronios vase" (Fig. 3.9) illustrate early Greek artists' command of the full range of human feelings and activity.

Archaic sculpture showed a similar development from formalized representation to naturalism. The most common form of Archaic statue was the **kouros**, a

c. 800–650 B.C.?	Composition of Homeric epics
c. 615 B.C.	*Kouros* from Attica (**3.10**)
c. 600 B.C.	Sappho, lyric poet
c. 550 B.C.	Pythagoras, numerical basis of music

3.9 Euphronios, *The Death of Sarpedon*, c. 515 B.C. Red-figure calyx-krater, terracotta, height 18 ins (46 cm), diameter 21³/₄ ins (55 cm). The Metropolitan Museum of Art, Lent by the Republic of Italy (L.2006.10). Photograph ©1999 The Metropolitan Museum of Art
Blood streaming from his fatal wounds, the Homeric warrior Sarpedon is borne to the underworld by the figures of Death and Sleep. The red-figure painting technique permitted greater naturalistic detail than earlier methods.

freestanding nude male youth that served as a grave-marker or stood outside a temple. The early *kouros* in Fig. 3.10 shows the rigid symmetry and geometric hair-dressing that the Greeks had borrowed from Egyptian statuary. The figure stands in a typical pose, with arms held stiffly at the sides, fists clenched, and the left foot placed in front of the right. The human form here is an exercise in stylized geometry.

Late in the Archaic period, sculptors began to soften the rigid geometry of the Archaic style, lending their

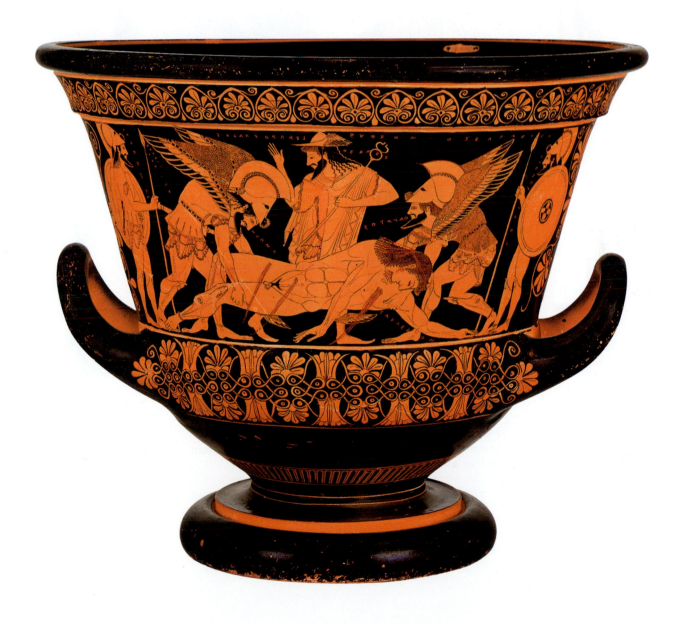

figures more supple curves. The *koré* [KOH-ray], or female version of the *kouros*, was less stringent in design, in part because the *koré* was always clothed (Fig. **3.11**). The drapery created more varied lines, although the hair is still arranged in stylized geometric patterns. The lips are pulled back in the "Archaic smile," perhaps to lend the face more animation. The *Calf Bearer* (*Moschophoros*; Fig. **3.12**) most likely stood next to an altar on the Athenian acropolis. The late Archaic sculptor crafted a poignant physical bond between human and beast: the calf's ear touches the youth's head and its haunch presses against his braids. The rationalized design and symmetry of the Archaic style is softened by human interest and subtle naturalism. The decisive turning point between the Archaic and classical style in sculpture came in the *Kritios Boy* (Fig. **3.13**), where its sculptor had learned to represent the human figure in motion. Dating to just before the Persian Wars, this figure no longer rigidly faces forward. Rather it turns slightly in space and its weight shifts to one leg, cocking the hips and shoulders.

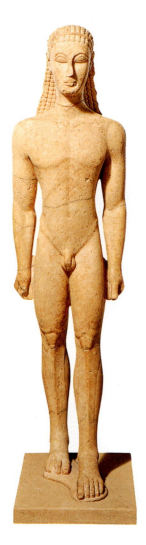
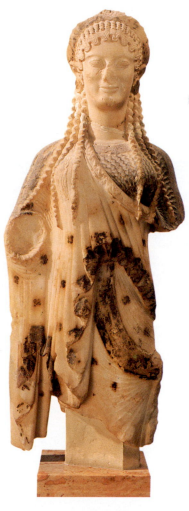
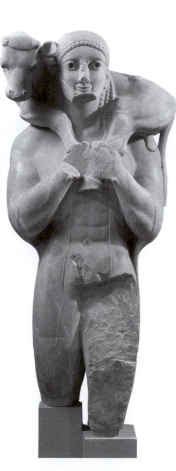

3.10 *Kouros* from Attica, c. 590 B.C. Marble, height 6 ft 4³/₄ ins (1.94 m). The Metropolitan Museum of Art, New York, Fletcher Fund, 1932. (32.11.1). Photograph ©1997 The Metropolitan Museum of Art
Usually painted to enhance their naturalism, the Greek *kouroi* (pl. of *kouros*) were the ideal of youthful male beauty. This Archaic sculpture shows the early Greek interest in symmetry and geometric design.

3.11 *Koré* from Chios, c. 520 B.C. Marble, height 22 ins (56 cm). Acropolis Museum, Athens.
In Archaic and early classical sculpture, the female figure was always clothed. Compare the drapery of this *koré* to the more fluid treatment in the Parthenon goddesses (see Fig. 3.22).

3.12 *Calf Bearer* (*Moschophoros*), c. 570 B.C. Marble, height 5 ft 5 ins (1.65 m). Acropolis Museum, Athens.
By the mid-sixth century B.C., Greek Archaic sculpture was increasingly naturalistic (compare Fig. 3.10), as seen here in the related forms of the youth and his sacrificial burden.

3.13 *Kritios Boy*, c. 490 B.C. Marble, height 34 ins (86 cm). Acropolis Museum, Athens.
Here the frontal stance of the *kouros* dissolves and the figure turns ever so slightly in space. The Archaic smile of earlier sculptures has disappeared.

The lines of the torso are softened and filled, as if the statue had taken a breath. Although still highly idealized, the *Kritios Boy* declares the masterful naturalism of classical Greek art.

The Classical Period

Briefly tell the story of Athens' Golden Age.

The **classical period** in Greece opened with the Greeks' victory over the Persian army in 490 B.C. Athenian soldiers prevailed, with brave stands at Thermopylae and Marathon. When the Persian force returned in 480 B.C., the Athenians had to abandon their city and watch it burned by enemy soldiers. But Athens had its revenge a few days later at the Battle of Salamis (between the island of Salamis and the Athenian port of Piraeus), when Athenian naval commanders slyly lured the Persian navy into a trap and destroyed it .

The Athenians interpreted their victories as a sign that Athens was destined to lead all Greece. Indeed, Greece now entered a period of achievement virtually unparalleled in the history of Western civilization. This classical age lasted until the death of Alexander the Great in 323 B.C. It brought remarkable accomplishments in theater, architecture, sculpture, and philosophy, and helped to define the essential character of Western civilization.

Athens in its Golden Age

Athens was the glory of classical Greece, a vibrant center that spawned geniuses of the arts and ideas. Between 480 B.C. and its military defeat in the Peloponnesian Wars in 404 B.C., Athens enjoyed a period of prosperity and accomplishment known as the **Golden Age**. The heart of Athens, as with every Greek city, was its *polis*, a term usually translated as "city-state." To the Greeks, the *polis* meant the citizens themselves, including their civic values and aspirations. The Greek philosopher Plato assumed that a properly organized *polis* would produce perfectly happy citizens. When Aristotle, the late classical philosopher, said that the human was a "political animal" (a *zoon politikon*), he meant that it was human nature to live in a *polis*.

Membership of the Athenian *polis* was limited to adult male citizens of the city, excluding all women, slaves, and non-native residents. In a city like Athens, with a population of perhaps 250,000, the *polis* may have been no larger than ten or twenty thousand men. Within this limited group, however, Athenians of the Golden Age practiced a vigorous democracy, or "rule by the people" – they chose important offices by lot and decided important questions by majority vote of the whole *polis*. Athenian government was thus in some ways more democratic than today's common system of elected representatives.

480 B.C.	Greeks defeat Persians at Salamis
c. 450 B.C.	Myron, *Discus Thrower* (**3.26**)
447–432 B.C.	Parthenon, Athens (**3.16**)
438–432 B.C.	*Three Goddesses*, Parthenon, Athens (**3.22**)
432–404 B.C.	Peloponnesian Wars, Athens defeated
421–409 B.C.	Erechtheum, Athens (**3.20**)
c. 340 B.C.	Praxiteles, *Hermes and Dionysus* (**3.24**)
c. 150 B.C.	Agesander, Athenodorus, and Polydorus of Rhodes, *Laocoön and his Two Sons* (**3.36**)

Still, as the civic leader Pericles [PAIR-uh-kleez] proclaimed, in Athens "the claim of excellence is also recognized; and when a citizen is in any way distinguished, he is preferred to the public service, not as a matter of privilege, but as the reward of merit."[4]

Pericles led Athens to a pinnacle of political power and influence. After the Persian Wars, for reasons of defence, Athens formed an alliance with other Greek city states called the Delian League. Athens soon began to bully the other members; and by the mid-fifth century B.C. the Delian League had become an Athenian empire.

WINDOWS ON DAILY LIFE

The Plague of Athens

In the second year of the Peloponnesian [pell-oh-poh-NEE-zhun] Wars, a plague struck Athens, devastating its population and disrupting social and religious customs. The historian Thucydides [thyoo-SID-uh-deez] reports that bodies filled the temples and sacred precincts.

The sacred places also in which they had quartered themselves were full of corpses of persons that had died there, just as they were; for as the disaster passed all bounds, men, not knowing what was to become of them, became utterly careless of everything, whether sacred or profane. All the burial rites before in use were entirely disregarded, and they buried the bodies as best they could. Many from want of the proper appliances, through so many of their friends having died already, lost all shame in burying the dead; sometimes, when a man had prepared a funeral pile, another came and, throwing his dead on it first, set fire to it; sometimes they tossed the corpse which they were carrying on the top of another that was burning, and went off.[5]

THUCYDIDES
The History of the Peloponnesian War

The Athenians' arrogant hunger for power led them into a disastrous war with Sparta, their chief rival and a great military power. The Peloponnesian Wars (431–404 B.C.) resulted in the loss of the Athenian navy and its surrender to Sparta in 404 B.C. After the war, Athens retained its prominence as a cultural center – Pericles had proudly called it the "school of Hellas" – but it never regained the power and creative energy of its Golden Age.

Women in Classical Athens The adult women of Athens – whether they were wives, slaves, or prostitutes – were all excluded from the city's public affairs. Nearly all female citizens were married. Their duties as wives were restricted to organizing the household, supervising slaves, and performing domestic labor (Fig. 3.14). Pericles said that the happiest wife was one about whom nothing was said, either good or bad. Athenian wives lived in quarters

3.14 Grave stele of Hegeso, c. 410–400 B.C. Marble, height 4 ft 11 ins (1.5 m). National Archaeological Museum, Athens. This stele, or gravestone relief, depicts a Greek matron adorning herself with jewelry. After marriage, Athenian women customarily led secluded lives of child-rearing and domestic labor.

And we shall assuredly not be without witnesses; there are mighty monuments of our power which will make us the wonder of this and of succeeding ages.

Pericles of Athens, fifth century B.C.

separate from the men and customarily did not even share the evening meal with their husbands.

An Athenian man was more likely to spend the evening with a *hetaera* [he-TAIR-a], the term for foreign women employed as courtesans, entertainers, and prostitutes. Some *hetaerae* were highly educated and skilled as dancers and musicians, able to act out Greek legends in dance or recite poetry. *Hetaerae* provided entertainment and companionship for men at evening banquets and are depicted on vase paintings as engaging in animated debate. They may also have been the only women permitted to attend the Greek theater. The most famous of the *hetaerae* was Aspasia [ah-SPAY-zhuh], the companion of Pericles from 445 B.C. until his death. Aspasia bore Pericles a son and was suspected of advising him on political affairs. Because of her influence, she attracted the worried criticism of Athens' orators and playwrights.

Classical Greek Art

Analyze the Parthenon as a symbol of Athens' civic pride and humanist self-confidence.

The classical style in Greek art (c. 480–323 B.C.) found its highest expression in sacred architecture and the sculpted human form. Greek temples were monuments of religious devotion and civic pride. Temples stood at the heart of sacred centers like Delphi and Olympus, where pious Greeks gathered for worship and celebration. In cities, Greeks built temples to their patron deities on the acropolis (literally "high city"), high ground that served also as a citadel (Fig. 3.15). The classical period saw exquisite examples of two great building styles, the Doric and Ionic.

In classical Greece, sculpture remained largely a civic art rather than a private pleasure, often decorating the temples, treasuries, and altars that crowded sacred precincts. In style, the classical age achieved a marriage of idealism and naturalism that would influence sculptors for millennia.

The Athenian Acropolis

All of classical Greece enjoyed a great flowering of architecture and sculpture, but its artistic center was in Athens, flush with imperial confidence and wealth.

3.15 Model reconstruction of the Athenian acropolis. View from the northwest. Plaster copy of the original model by G. P. Stevens, American School of Classical Studies. Scale 1:200. Royal Ontario Museum, Toronto.

The sacred buildings of the Athenian Golden Age expressed the city's wealth and power, especially since the construction was funded with taxes on her allied states. At the highest point of the acropolis was the Parthenon, a refined example of the Greek temple style.

In 447 B.C., Athens began to rebuild the acropolis temples burned by Persian attackers. The building program began with the **Parthenon**, a temple dedicated to the city's patron deity, Athena (Fig. **3.16**). It was one of the largest temples built in Greece during the classical period, supervised by the leading citizen-artists of Athens and fashioned by craftsmen from all over Greece.

3.16 Ictinus and Callicrates, the Parthenon, Athens, 447–432 B.C. Pentelic marble, length 228 x 104 ft (69.5 x 31.7 m), height of columns 34 ft (10.36 m).

While austerely grand as a ruin today, the Parthenon appeared much gaudier in classical times, with its sculptures brightly painted in red, gold, and blue.

The temple's construction and sculptural decorations represent a high point of the classical style in the arts. Its basic form, like most Greek temples, was **post-and-lintel**. The post-and-lintel form consisted of a series of columns (posts) with beams (lintels) laid across the top. Walls and a roof were added to this basic skeleton. The types of Greek temples were distinguished by their decoration of the vertical column and the horizontal beam, called the **entablature**. The decoration of column and entablature was classified according to the classical **orders**, or styles: the Doric order communicated a stolid strength and simplicity; the Ionic order possessed an aura of refinement and sophistication; and the Corinthian order, developed in the

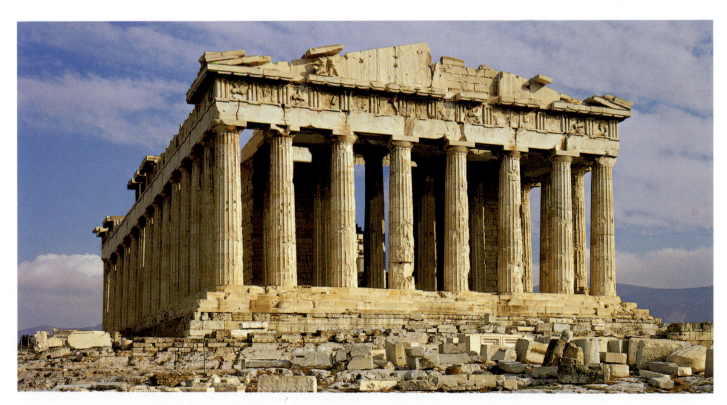

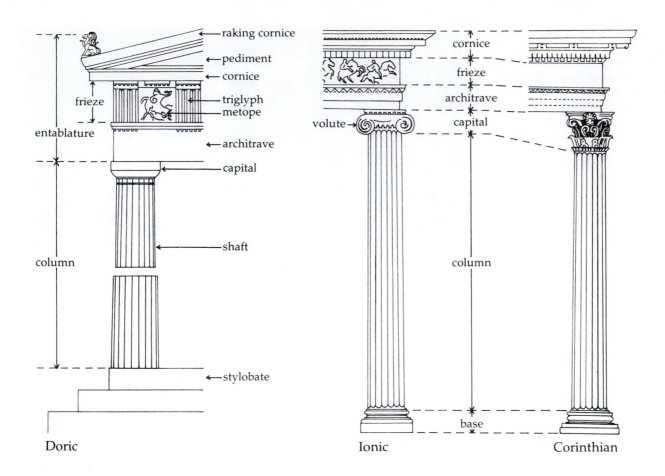

Doric

Ionic

Corinthian

- raking cornice
- pediment
- cornice
- triglyph
- metope
- architrave
- capital
- shaft
- stylobate

frieze
entablature
column

cornice
frieze
architrave
capital
volute →
column
base

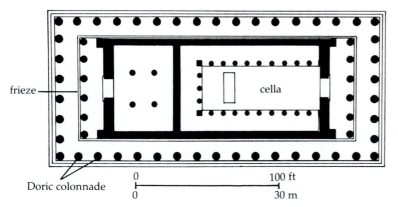

frieze

cella

Doric colonnade

0 100 ft
0 30 m

3.17 (*above*) **The Greek orders.**
The classical architectural orders varied according to their decoration of the vertical and horizontal elements (column and entablature).

3.18 (*left*) **Plan of the Parthenon.**
The Parthenon shows evidence of a recurring mathematical ratio of 1:2 + 1, as in the number of columns (8:17).

3.19 (*below*) **The Parthenon's refinements, exaggerated for effect.** The diagram is based on N. Balanas, *Les Monuments de l'Acropole*, pl. 2, fig. 2.

later Hellenistic period, projected imperial wealth and grandeur (Fig. **3.17**).

The Parthenon was the most advanced example of the Doric order, the climax of two centuries of architectural development. Its Doric columns rested directly on the temple's step and were topped by heavy, square-block capitals. Deep grooves called **flutes** were carved into the column's shaft, creating a shifting play of light and shadow as sunlight struck the column from different angles. The columns surrounded the enclosed inner room, or **cella** (Fig. **3.18**), that held the huge cult statue of Athena by the leading sculptor of Athens, Phidias (c. 490–432 B.C.).

The Parthenon's construction showed subtle deviations from regularity. Apparently, Greek architects wished to balance their precise rationalism against the need for aesthetic appeal to the eye. Throughout the building the numerical ratio of 1 : 2 + 1 recurs, evident in the number of columns across the end (eight) and along the sides (seventeen). The Parthenon's columns bulge slightly, as if they strain under the weight of the roof, and they also lean inward slightly. The corner columns are slightly thicker and closer to their neighbors, as if to compensate for space visible between them. The temple floor rises about 4 inches (10 cm) in the center on all four sides (Fig. **3.19**). These refinements were not unique to the Parthenon, but they were seldom combined with such stunning results.

After the completion of the Parthenon, the Athenians turned to other buildings on the acropolis. They built a massive gateway called the Propylaea [pro-puh-LEE-uh], with ramps leading through a temple-like building. The Propylaea was notable for its combination of the Doric and Ionic orders. Late in the Peloponnesian Wars, the Athenians began the Erechtheum [er-ick-THEE-um], an Ionic temple that encompassed several sacred sites. The Erechtheum was built on two levels and had two porches, one in the Ionic style with a continuous frieze, and the other with columns in the shape of maidens, called **caryatids** [kair-ee-AT-ids]. The caryatid columns

of the south porch bear the heavy entablature on baskets atop their heads (Fig. **3.20**). The Erechtheum was, in its irregular design, a rather idiosyncratic example of the Ionic order. More typical was the Temple of Artemis in Ephesus (in today's Turkey), built around 550 B.C. but later destroyed. Its roof was supported by a forest of 127 gigantic Ionic columns, and ancient commentators compared its glory to the pyramids of Egypt and the gardens of Babylon.

Classical Sculpture

Greeks of the Archaic and classical periods used sculpture chiefly to decorate their sacred buildings – either as freestanding statues that stood in or near temples and altars, or as relief sculpture attached to buildings. The development from Archaic to classical style is just as vivid in architectural sculpture as in the *kouros* (see Fig. 3.10) and the *Kritios Boy* (see Fig. 3.13). A temple had two decorative elements: sculptural groups occupying the **pediment**, the triangular space formed by the roof's gable, and a sculpted **frieze**, the name given to any continuous band of relief sculpture. Pedimental groups were usually sculpted in the round and rested on a broad ledge (Fig. **3.21**). The Doric order featured a frieze of geometric panels called **triglyphs** alternating with pictorial scenes called **metopes**. The metopes were carved in high relief,

3.20 Mnesicles, Erechtheum (from south), Athens, c. 421–409 B.C. Marble, length of temple 37 ft (11.3 m), width 66 ft (20.1 m).
Instead of fluting to emphasize their stature, the caryatid columns have the fluid vertical lines of their gowns.

3.21 Section view of the Parthenon, reconstructed, showing the pediment, Doric frieze, and cella frieze.
The pediment sculptures stood in the recessed pediment, sheltered by the roof's edges. The cella frieze – nearly 40 feet (12.2 m) above ground and shaded by the ceiling – must have been difficult to view. All the sculptures were probably brightly painted.

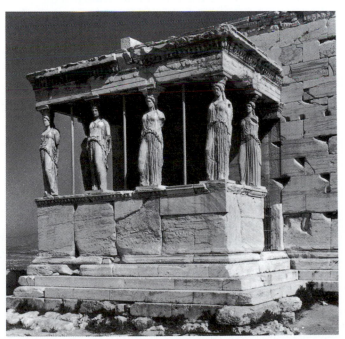

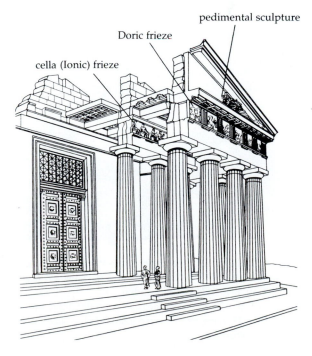

pedimental sculpture

Doric frieze

cella (Ionic) frieze

3.22 *Three Goddesses*, from the Parthenon's east pediment, c. 438–432 B.C. Marble, more than life-size. British Museum, London. Though missing their heads and arms, these figures still express Greek classicism's balance between naturalism and idealized beauty. Note how the finely carved drapery defines the figures' poses and their dynamic connection to the central event of Athena's birth.

3.23 *Lapith and Centaur*, metope from the Parthenon's outer frieze (south face), c. 448–442 B.C. Marble, 3 ft 11 ins x 4 ft 2 ins (1.19 x 1.27 m). British Museum, London. Such scenes of the Doric frieze may have symbolized the Athenians' victory over the Persians, or, more generally, Greek civilization's triumph over barbarism.

meaning that the figures project from the background (see Fig 3.23). In the Ionic order, the exterior frieze was typically one continuous sculpted scene that sometimes extended around the entire structure.

The Athenian Parthenon's sculptural program was more a statement of civic pride and achievement than a tribute to the goddess. Supervised and probably designed by the sculptor Phidias, its figures were a triumph of the high classical style. On the pediments were figures depicting events in the life of Athena: the goddess's birth full-grown from Zeus' head (on the east) and (on the west) Athena's competition with the god Poseidon.

The pediments' graceful and life-like figures contain the essence of classical Greek sculpture. On the east pediment, for instance, the *Three Goddesses* (Fig. **3.22**) are divine witnesses to Athena's remarkable birth. Beneath the graceful and fluid lines of their garments, the deities have the solid form of Athenian matrons. The drapery defines each figure individually, unifies the group, and carries the news of Athena's birth outward to the pediment's corner. Phidias' challenge in the metopes was to create a dramatic action with only two figures, compressed onto a small block (Fig. **3.23**). The figures and background were brightly painted and sometimes adorned with brass detailing, such as horses' reins.

The Parthenon was unique among Doric temples in having a second frieze that ran along the cella wall and across the inner columns. The Parthenon's cella frieze was a stroke of genius, a sculpted advertisement of Athenian civic virtue, which ran for more than 500 feet (152 m). The frieze is carved in low relief, with figures projecting only slightly from the background, and depicts a noble procession of Athenian citizens, reminiscent of the city's festival to Athena held every four years.

Classical Humanism

The peoples of ancient civilizations lived in a world where the power of nature and the power of rulers dwarfed ordinary human effort. In the face of these forces, the ancient Greeks proclaimed the nobility of human intelligence and action, believing fiercely in the human ability to understand and control the world, a belief called **classical humanism**. Classical humanism was reflected in every aspect of Greek life. The tragic poet Sophocles, in his play *Antigone*, offers this hymn to the powers of humanity:

> *Numberless wonders,*
> *terrible wonders walk the world but none the match for*
> *man —*
> *. . . The blithe, lightheaded race of birds he snares*
> *the tribes of savage beasts, the life that swarms*
> *the depths —*
> *with one fling of his nets*
> *woven and coiled tight, he takes them all,*
> *man the skilled, the brilliant! . . .*
> *And speech and thought, quick as the wind*
> *and the mood and mind for law that rules the city —*
> *all these he has taught himself*
> *and shelter from the arrows of the frost*
> *when there's rough lodging under the cold clear sky*
> *and the shafts of lashing rain —*
> *ready, resourceful man!* [6]

Classical humanism expressed the Greeks' soaring confidence in their civilization, bolstered in fifth-century Athens by wealth and power. Artists and thinkers focused their attention on the human and became more skeptical about traditional belief. When the philosopher Protagoras (see page 62) said, "Man is the measure of all things," he referred to the belief that truth and value were determined by human standards, not by the gods. Such humanist belief helped to create the noble characters of Greek tragedy and the marble beauties that adorn the Greek temples (Fig. **3.24**).

Although the Greeks' humanist confidence eventually faded, the idea of humanism remained a powerful legacy. It was often revived in later ages of great confidence or skepticism. Renaissance thinkers and artists challenged the medieval Church by studying the culture of Greek humanism. Modern existential philosophers maintained that humans were absolutely free to create themselves — a radical humanism. Protagoras's motto is as contemporary and controversial today as it was 2,500 years ago.

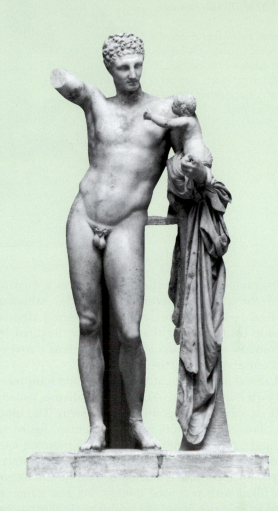

3.24 Praxiteles, *Hermes and the Infant Dionysus*, c. 340 B.C. Marble copy of original, height 7 ft 1 in (2.16 m). Archaeological Museum, Olympia.
Praxiteles mastered the relaxed stance and fluid S-shaped torso that were typical of late classical sculpture. Note the engaging human action of the infant god Dionysus reaching for something — probably a bunch of grapes, now missing — that Hermes holds above him.

CRITICAL QUESTION
What human powers or skills give our civilization the greatest humanist confidence today? What catastrophes or failures have reminded us of the limits of our power to control our destiny?

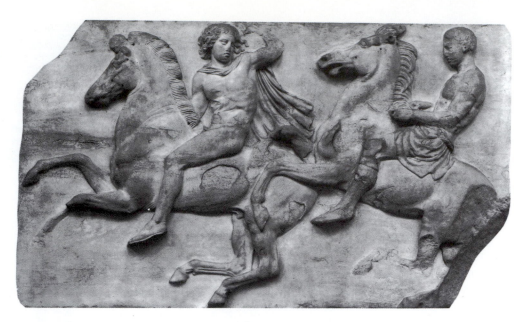

3.25 *Athenian Horsemen*, from the Parthenon's inner frieze (west face), c. 442–432 B.C. Marble, height of panel 3 ft 7 ins (1.07 m). British Museum, London.
The Parthenon cella frieze celebrated the heroism and nobility of Athenian citizens. The number of horsemen (approx. 192) matches the number of Athenians who died fighting the Persians at Marathon.

Nude horsemen sit astride their horses with a bearing typical of the classical period (Fig. **3.25**). Athenian maidens lead a parade to the thrones of Zeus and Athena, who preside benignly over the celebration. Inspired by their supremacy among Greeks, the Athenians dared to portray themselves among the gods.

The classical period's greatest freestanding sculptures are likewise a heroic union of human and divine, usually an athlete or warrior or a god in human form. The most admired classical sculptors set the human figure in complex and expressive motion, while maintaining harmony and balance. Myron's *Discobolus* (*Discus Thrower*) (Fig. **3.26**), for example, is poised to release his discus and thus filled with potential energy. Yet his stance is restrained so that the figure is as calm as the Parthenon horsemen (see Fig. 3.25).

The bronze warrior discovered near Riace [ree-AH-chay], Italy, is possibly the work of Phidias himself and one of only a few original bronze statues surviving from the classical period (Fig. **3.27**). Cast in exacting detail, the *Riace Warrior* projects the supreme confidence and powerful athleticism of the hero.

The late classical sculptor Praxiteles (born c. 390 B.C.) was famed for his humanized portraits of the gods, among them his life-like versions of Aphrodite [af-ro-DYE-tay], the goddess of love. Praxiteles [prax-IT-uh-leez] exploited

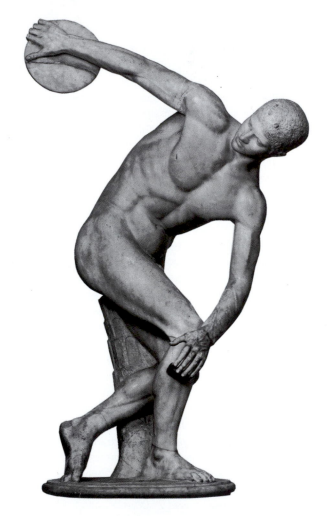

3.26 Myron, *Discobolus* (*Discus Thrower*). Roman copy after bronze original, c. 450 B.C. Marble, life-size. Museo Nazionale, Rome.
Myron's idealized athlete is poised in the moment just before he unleashes the discus. The Archaic style's geometric symmetry has given way to a figure of complex arcs and angles.

3.27 *Riace Warrior*, mid-5th century B.C. Bronze with glass-plate, bone, silver, and copper inlay. Height 6 ft 6 ins (2 m). Museo Nazionale, Reggio Calabria, Italy. Note the balance of the warrior's pose, a shield on his left arm as against a spear in his right hand (both now missing). The torso's animated S-curve is created by placing the figure's weight on the right foot, which causes the pelvis and shoulders to tilt in opposite directions. Such figures were Greek ideals of male prowess and nobility.

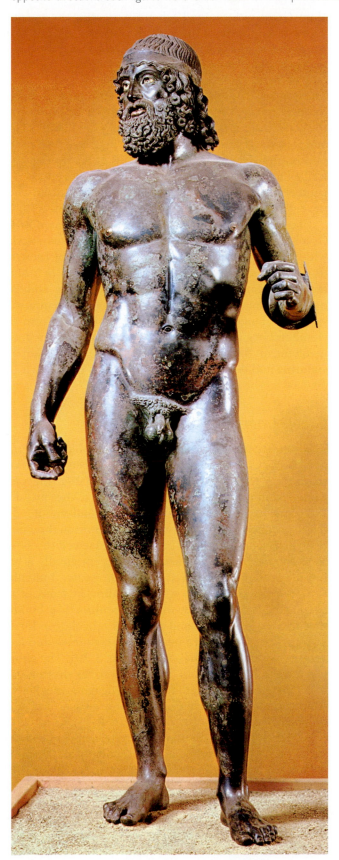

late classical sculptors' newfound freedom in portraying the female nude. The alluring *Aphrodite of Cnidos* (Fig. 3.28) is depicted, her gown removed, an arm resting on an urn. The *Aphrodite* shows the pronounced S-curve, called in Italian **contrapposto**, that had originated in the high classical style a century earlier. The result was the final stage of late classical naturalism.

3.28 Praxiteles, *Aphrodite of Cnidos*. Roman copy after original of c. 350–340 B.C. Marble, height 6 ft 8 ins (2.03 m). Vatican Museums, Rome.

An example of the naturalism of late classical Greek sculpture. The original statue was probably colorfully decorated with gilded hair and jewelry, and rouged cheeks. Compare the posture and gesture of this female form to the athletes and warriors of a century earlier (see Figs. 3.26, 3.27).

Greek Theater and Music

Describe the most important types of Greek theater.

Many Greek cities joined Athens in creating the architecture and sculpture of the period. However, Athens alone bears the honor of inventing the Greek theater. Seated beneath their acropolis, Athenians witnessed the birth of one of Western literature's first great dramatic forms. Theater was the medium in which Athenians reflected on their culture's most essential questions: the powers of the gods, the course of human destiny, the nature of love and justice. It was at once drama, poetry, religion, and philosophy. Their solemn spectacles of passion and suffering have been acted out countless times in succeeding centuries, yet later imitations of Greek tragedy would never wholly recreate its complex artistic form.

Classical tragedy and comedy both originated in the Greeks' worship of Dionysus [dye-oh-NYE-sus], god of wine, revelry, and intoxication. Worshipers of Dionysus disguised themselves with masks, dressed in animal costumes, carried oversized fertility symbols, and sang hymns of praise to the god. The most solemn hymns were sung and danced by a chorus of performers. From this elemental beginning evolved the Greek **tragedy**, a drama involving mythic characters whose pride leads them into suffering and death. Athenian tragedy as we know it had evolved by the early fifth century B.C.

Greek Tragedy

The performance of Greek tragedy was unlike the performances we experience today. Staged in open-air theaters seating up to 15,000 spectators (Fig. **3.29**), the plays were solemn religious occasions where the priest of Dionysus presided. Wealthy citizens underwrote dramatic productions, and playwrights submitted their plays in a yearly competition. The audience viewed the action from the *theatron*, or "viewing place," originally a bare hillside and later covered by stone seats. Individual actors spoke their lines while standing in front of the **skenē** (the root of our word "proscenium"), a building that housed the props and provided a backdrop for the action. The actors wore heavy wool costumes and large masks that amplified their words (Fig. **3.30**). The **chorus** of twelve to fifteen actors chanted its songs rhythmically to a flute's accompaniment, while engaging in a solemn dance on the **orchestra**, the circular area surrounded by the *theatron*.

Although many Athenians wrote tragedies, the works of only three great tragedians are known, each responsible for new accents in the tragic idiom. **Aeschylus** [ESS-kuh-lus] (525–456 B.C.) reduced the role of the chorus and added a second actor, making true dialogue possible. The most famous of Aeschylus's seven known works is a three-play cycle called the *Oresteia*. In this gory saga,

King Agamemnon returns from the Trojan War to be murdered by his wife Clytemnestra, who then is killed by her son. The murderous cycle finally ends when Athena intervenes and decrees that the rule of law will replace justice by vengeance. As was typical in Aeschylus's dramas, human suffering and guilt eventually led to the recognition of divine wisdom.

The most admired and prolific Athenian playwright was **Sophocles** (c. 496–406 B.C.), whose career coincided with the Golden Age of Athens. Sophocles may have written 123 tragedies in all, although only seven are known. Sophocles added a third actor and created more tightly unified plots than Aeschylus. Sophocles' *Oedipus the King* was the most admired tragedy of the classical period.

3.30 The dramatic poet Menander holding a mask. Roman copy of a late Hellenistic original. Museo Gregoriano Profano, Vatican Museum, Vatican State.
The poet holds a mask suitable for playing a tragic king like Agamemnon or Oedipus. A satyr's mask rests on the table.

It told the story of a man prophesied to murder his father and marry his mother, and like most classical tragedies, it retold a legend already familiar to the audience. In this story, Oedipus's [ED-i-pus] royal parents try to evade the divine prophecy by having their child killed. A soft-hearted shepherd saves the infant, who is adopted in neighboring Corinth. As a young man, Oedipus unknowingly murders his true father. His cleverness wins him the throne of Thebes and an unwitting marriage to his own mother, the queen.

Sophocles begins his tragedy of Oedipus after these fateful events are complete, dramatizing Oedipus's agonizing search for his own identity. In the beginning, Oedipus seems to be a paragon of humanism, a man whose intelligence and nobility raise him to the level of a god. Oedipus's self-confidence is later shown to be **hubris**, an arrogant pride that ignores the limits on human understanding. The gods' power over human lives is vindicated in spite of all efforts to evade it. When Oedipus stabs out his own eyes, his action symbolizes the blindness of human intelligence and the folly of defying the gods.

To the philosopher Aristotle (see page 64), *Oedipus* contained the essential elements of tragedy, which Aristotle analyzed in his *Poetics*. When tragedy's main character commits "some error of judgment," taught Aristotle,[7] he suffers a reversal of fortune and recognizes his folly. This spectacle achieves the tragedy's purpose, a cleansing, called **catharsis**, of the audience's fear and pity. As Aristotle's analysis indicates, Greek tragedy was a drama of primal suffering and fear, and few Greeks left the theater unaffected.

The last great Athenian tragedian was **Euripides** (c. 480–407 B.C.), who saw the city succumb to plague, war, and internal division. Euripides' tragedies were filled with realism and biting social comment, often using unorthodox characters and plots. Sophocles himself

acknowledged that his own plays showed people as they should be, while the plays of Euripides showed people as they were. Euripides' characters are often gripped by violent passions. His *Medea* depicts the mythic sorceress who murders her own sons in vengeance against a husband who has abandoned her. Euripides' own death was no less gruesome and bizarre. He was torn to pieces by dogs belonging to the king of Macedon, in whose palace he had taken refuge.

Greek Comedy

Although tragedy dominated the Greek theater, ancient Greeks enjoyed comedies of great wit and irreverence. **Comedy** is a dramatic form that humorously portrays everyday themes and characters. Originating in Dionysian fertility rites, Greek comedy featured choruses dressed as animals and actors in obscenely padded costumes. Comic plots were usually fantastic, yet included bawdy dialogue, slapstick shenanigans, and biting comment on the contemporary scene.

The greatest comedian of the Athenian Golden Age was Aristophanes [air-i-STOFF-uh-neez] (c. 445–c. 383 B.C.), who wrote comic satires on philosophy, war, and the relations between the sexes. Aristophanes' *Clouds* depicts the philosopher Socrates sitting in a basket suspended in air. In *Lysistrata* the women of Greece engage in a sex strike to halt the Peloponnesian Wars. Because its subject matter was less high-minded than that of tragedy, comedy did not enjoy the same prestige. In fact, Aristotle hardly mentioned it in the *Poetics*. Comedy was, however, enthusiastically adapted in Hellenistic and Roman times.

In the Hellenistic period (323–146 B.C.), comedy played the role that the social comedies of today's television and film do. The Athenian Menander (342–292? B.C.; see Fig. 3.30) was a master of tightly plotted action, full of twists and surprises, where a slave might turn out to be free-born, or where impossible lovers suddenly marry. During the Hellenistic period, theaters were equipped with a raised stage and an elaborate backdrop containing several doors for appearances and disappearances. Because Hellenistic comedy abandoned the religious overtones of earlier Greek theater, it proved a more broadly appealing entertainment.

Greek Music and Dance

Music and dance played an essential role in Greek public and private life. Both were incorporated into sacred festivals and other public occasions. The militaristic Spartans even used military-style dances, with a costume of combat gear, as a part of military training. While educated slaves and prostitutes provided musical entertainment at Athenian men's dinner banquets, any well-educated young Greek person was likely to be taught both dance and music. The philosopher Plato believed that a child's

THE WRITE IDEA
Compose a definition of "tragedy" as you use the term and illustrate with an example of a tragic event or situation. Compare your use of the term to the ancient Greeks' concept of a tragic fate.

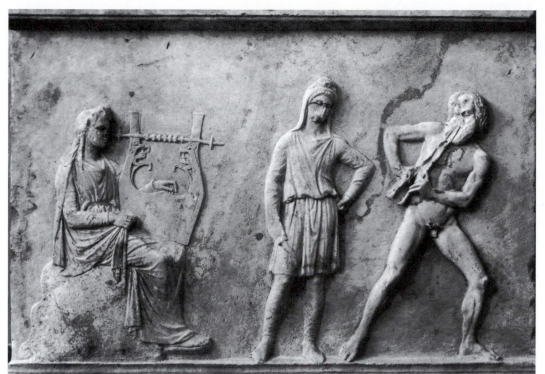

To the ancient Greeks, music contained the principles of harmony that unified both nature and human society. They associated the lyre with Apollo, god of light and knowledge, and the reed pipe (or *aulos*) with Dionysus, god of intoxication and patron of tragedy.

early education should consist only of gymnastics and music, a sufficient discipline for the body and soul.

The term music actually meant "of the Muses," the Muses being the goddesses who inspired the creative arts. Music was especially important in poetry, which was usually sung with musical accompaniment. Lyric poets sang their works while plucking the strings of the lyre, an instrument with five to seven strings on a U-shaped bow and a sounding board made of tortoiseshell. Dramatic poetry called for the use of a double reed pipe called the *aulos* (Fig. **3.31**), played as the tragic chorus chanted and danced about the orchestra. The *aulos* continued to be used in drama through the Roman era.

Greek theories of music have influenced Western civilization more than Greek music itself, since its actual sounds and performance cannot be reconstructed. The Greeks preferred a seven-tone musical scale, with intervals between tones that could be expressed as the ratios 1 : 2, 2 : 3, and 3 : 4 (the octave, third, and fourth). The Pythagoreans took this as evidence of a musical–mathematical structure within the entire cosmos, based on the mystical properties of the number 10 (the sum of 1, 2,

> The unexamined life is not worth living.
>
> Socrates, Athens, fifth century B.C.

3, and 4). More practically, ancient Greek musicians employed scales called **modes**, combinations of eight notes of varying intervals. Each mode was further subdivided into four-note groupings called tetrachords (Fig. **3.32**). Music in the different modes and even the different musical instruments was thought to arouse different emotional states and even to shape human character. The philosopher Plato developed a doctrine of **ethos** (root of the modern term "*ethics*"), which held that music could be used to train human character and influence behavior. In his ideal state, Plato preferred musical modes he believed would induce courage and moderation and banned music that fostered effeminacy. To the Greek mind, music – more than any other Greek art – embodied the balanced harmony of reason and feeling.

> Man is the measure of all things, of things that are that they are, and of things that are not that they are not.
>
> Protagoras, Athens, fifth century B.C.

3.32 Greek modes.
Each four-note group was supposed to arouse different feelings in the listener.

Classical Greek Philosophy

Summarize the aims of philosophy, as understood by Socrates and Plato.

The ancient Greeks' fascination with rational inquiry gave rise to the enterprise of **philosophy**, which in Greek meant "love of wisdom." The early Greek philosophers (see page 45) had been primarily concerned with natural philosophy, the rational examination of the physical universe. In the classical period, however, philosophy's attention turned to human morality and social being. This new concern with human affairs set the stage for Socrates, Plato, and Aristotle, the Greeks who defined the essential questions of Western philosophy.

The Sophists and Socrates

The first philosophers to change Greek society were the **sophists**, professional teachers who embodied the humanist spirit of skepticism and self-reliance. Where the early Greek philosophers had composed dry treatises, the sophists debated with their students about such practical matters as love, justice, truth, and beauty. The sophists were attracted above all to Athens, the vibrant "school of Hellas." Here they employed themselves as teachers to the sons of wealthy families, and taught public speaking and debate, the skills of Athenian democracy. The sophists' skepticism reflected the confident sophistication of Athens in the Golden Age. Protagoras (480–411 B.C.), a well-known sophist, pronounced, "Man is the measure of all things," meaning that truth was always relative to the individual person's knowledge and perceptions. Laws, customs, concepts of right and wrong, were all the creation of humans, not the gods.

While Protagoras gave voice to the new humanist spirit, other sophists fostered cynicism. They taught their pupils to gain advantage through verbal trickery, a technique still called "sophistry." Our knowledge of the sophists is obscure, since few of their writings were preserved. We know them chiefly through the vehement anti-sophist writings of Plato.

The sophists' abuses rankled their rival **Socrates** (469–399 B.C.), the Athenian who founded classical Greek philosophy without writing a word. Like the sophists, Socrates examined human affairs and taught through questioning. Socrates' philosophical technique, called the Socratic method, was based on question and answer in which the careful definition of terms ("love," "justice," "the good") produced insights into the truth. Unlike his rivals, Socrates believed firmly that absolute truths could be known and taught, although he denied that he himself possessed correct knowledge. He described himself as a "midwife" for knowledge born from the minds of his students. Socrates' pot-bellied figure was a familiar sight to Athenians, pestering complacent citizens and playing the gadfly that stung Athens into action. "The unexamined life is not worth living," Socrates is quoted as saying.

In 399 B.C., however, the philosopher became bitterly and fatally entangled in affairs of state. In the turmoil following the military defeat of Athens, Socrates was tried for religious and moral offenses, and sentenced to die. His trial was apparently motivated by anti-intellectual resentment and enmity toward Socrates' anti-democratic associates.

Future philosophers would view Socrates' life and death as a model of principled integrity, of *areté*, or virtue in action. He refused to take payment for teaching or to flee from the city whose laws he had respected all his life. In Plato's *Crito*, Socrates resolutely rejects his friends' urging to escape from prison. Such an action would violate the moral principles of a lifetime, principles worth more to Socrates than his own life. Socrates vowed that death would bring his final release from ignorance and desire, the philosopher's ultimate goal.

Plato

Because Socrates wrote no books, we know his teachings chiefly through the works of his student **Plato** (427–347 B.C.), whose vast writings and influence make him one of history's most important philosophers. Plato left Athens after Socrates' death and spent ten years composing his ideas in philosophical dialogues. These include the *Apology* and the *Crito*, which describe Socrates' last days. Plato continued to employ the dialogue as a form of philosophical debate in later works, where the character Socrates becomes a voice for his own ideas.

Plato's dialogues engaged anew with an enduring problem of Greek thought: the tension between change and permanence. Like the Pythagoreans, Plato held that the changing reality known by the senses was founded on a higher reality of permanent Forms (in Greek, *eide*). In his famous Theory of Forms, Plato drew a line across creation, dividing all things known through sense experience from things known through rational contemplation. Sensible objects – every cat, dog, and pot of stew – were all in an impermanent and imperfect state of Becoming. If humans would set aside their unreliable senses and apply their reasoned intelligence, they could glimpse a perfect world of Being – unchanging truths like geometric figures, perfect beauty, and ultimately the Good. For Plato, philosophical inquiry led the virtuous soul across the "divided line" from opinion and doubt toward certain knowledge of the Forms.

Plato illustrated this progress in a famous passage from *The Republic* entitled the "Allegory of the Cave." The Allegory describes ordinary citizens as prisoners chained in a cave, who see shadows flicker across the wall and believe the images are real. Only a few brave and virtuous souls free themselves, recognize the world of illusion in which they have been captive, and clamber out of the cave into the light of truth.

Confucius and Philosophy

It was not just ancient Greek philosophers who concerned themselves with the question of individual virtue and social cohesion. Across the Eurasian world, in the advanced urban civilizations of middle and eastern Asia, other thinkers formulated alternatives to traditional myth and ritual. In Persia, it was Zoroaster; in India, it was Gautama Buddha (see page 92); and in China, it was the philosopher Kong-Fuzi, better known as Confucius (551–479 B.C.). Within the span of time from Socrates to Aristotle in Greece, these Eastern thinkers proposed revolutionary ideas that continue to shape our thinking today.

Like Plato and Aristotle both, Confucius emphasized the individual citizen's responsibility within society. His teaching defined the duty of the gentleman (or "superior man") to fill his assigned role with ethical integrity and respect for tradition. He urged China's rulers to give up their aristocratic concept of exalted birth and inherited privilege. They should adopt instead a personal ethic of wisdom and humanity, Confucius counseled, and rule by example and moral persuasion rather than coercion. Confucius's ideal ruler had something in common with Plato's philosopher-king, though it was practical virtue that guided the Confucian gentleman, not the contemplation of ideal truth.

This individual virtue was termed *jen* [run], meaning "human-heartedness." *Jen* required the cultivation of individual benevolence and humanity, as expressed in a life of right action. The cultivation of *jen* led to a respect for custom and propriety (*li* [lee]), another essential Confucian idea. *Li* included obedience to one's parents and to the rulers of the state, and was also demonstrated in the arts, which honored and preserved abiding traditions.

Confucius viewed the cultivation of harmony and order in the individual soul as the only means to an orderly society. The state could not create justice among citizens who did not seek justice in their own hearts. In *The Great Learning*, a synopsis of Confucius's moral and social program, the teacher said, "From the emperor down to the common people, all, without exception, must consider cultivation of the individual character as the root. If the root is in disorder, it is impossible for the branches to be in order."[8]

It was this stress on "cultivation of individual character" that Confucian thinking shared with Socrates and classical Greek philosophy. Mere obedience to the gods and ritual sacrifice were not the most important signs of virtue. To be in harmony with one's family and one's society – this was the way to right living.

In the "Allegory," Plato was no doubt portraying Athens' imperfect and foolish citizens, who had executed Socrates for trying to lead them from the darkness of error. Plato's *Republic* described the perfect *polis*, a utopia governed by enlightened authoritarianism rather than Athenian-style democracy. *The Republic* begins with a debate about true justice and ultimately connects the orderly society to a properly ordered and virtuous soul. The human soul should govern itself by reason, using moral courage to rule its appetites and attaining "self-mastery and beautiful order" by "harmonizing" its three parts.[9] Likewise, there are three parts to the ideal society: philosopher-kings who rule wisely; militant guardians who enforce their rule; and ordinary citizens who perform all physical labor.

Plato's *Republic* was full of unorthodox ideas: poetry should be abolished and women should exercise naked alongside the men. But it was still concerned with the Socratic agenda of practical human concerns. Plato's later works returned to the cosmic questions of early Greek philosophy, often adapting Pythagorean ideas. In his *Phaedo*, which dramatizes Socrates' last hours, he proposes that the human soul is reincarnated at birth. The newborn loses its perfect knowledge of the Good but can recollect the truth through reasoned thought. In the *Timaeus*, a work that influenced medieval science, Plato describes a cosmos created in a perfect mathematical and musical order. This is, in fact, an inquiry into the Good; it attunes the philosopher's soul to the perfect harmonies of the cosmos.

Having formulated his ideas in philosophical dialogues, Plato did a most practical thing. He returned to his native city and founded a school called the Academy that reestablished Athens as the intellectual capital of the Mediterranean world.

CRITICAL QUESTION

How might Plato have criticized the organization of today's democratic governments?

Aristotle

The Academy's most renowned student was **Aristotle** (384–322 B.C.), who challenged Plato's teachings and became, alongside Plato, a towering figure in world philosophy. Together Aristotle's works form an encyclopedia of Greek knowledge about the world, including treatises in science, ethics, logic, politics, and literature, among other disciplines. As a philosopher, Aristotle prized careful observation of the world as it actually existed. At his school in Athens, called the Lyceum, he assembled a library of maps and manuscripts and a museum of natural specimens. His teaching had direct impact: he briefly tutored the young Macedonian prince Alexander (the Great), who would soon conquer the Mediterranean world.

Aristotle's *Metaphysics* begins with the pronouncement that all humans "by nature desire to know." In his *Nichomachean* [nik-oh-MAHK-ee-un] *Ethics*, Aristotle defined human happiness as the act of knowing. *Eudaimonia* ("well-being") was something achieved in the exercise of humans' deepest nature: their intellectual capacity to know truth. Much as Plato thought the best kings would be philosophers, Aristotle believed the happiest people were people philosophizing. In consonance with Greek ideas of measure and harmony, Aristotle defines virtue as the deliberate and rational choice of a "mean" between extreme vices. With regard to pleasure, for example, the rational choice is temperance, a mean between excessive self-indulgence and self-denial.

In metaphysics (the study of ultimate being), Aristotle disputed Plato's claim that an object's form existed in a separate realm of universal Forms. The form of a manufactured object, such as a table, is immanent, or contained in the object. The material stuff of a table is mixed with the form – the shape and purpose – given it by a carpenter. The objects of nature, such as a tree or apple, take the shape given them by the Prime Mover, the creator God who is the world's "first cause." Thus, every creature of nature is imprinted with the purpose or good that the Prime Mover intended for it at creation.

In his *Politics*, too, Aristotle opposed his mentor Plato's ideas. For Aristotle, the human was "by nature a political animal" and the state a creation of nature.[10] This meant that Greek political institutions like property, slavery, and the subordination of women were natural, too. Aristotle evaluates the chief forms of governance

(kingship, aristocracy, and democracy) in achieving the purpose of the state – a "good and self-sufficing life." Aristotle concludes that a constitutional democracy best suits the Greeks, giving power equally to the virtuous and the wealthy.

Ironically, Aristotle would see the demise of Greece's independent city-states at the hands of Macedonian conquerors who had been his patron and pupil. The niceties of his political theory were swept aside by the armies of a new empire.

The Hellenistic Age

Compare Hellenistic civilization with the classical Greek civilization that preceded it.

The classical age in Greece ended when the general Philip of Macedon (ruled 359–336 B.C.) managed to subdue and unite the independent Greek city-states. Philip was succeeded in 336 B.C. by his twenty-year-old son Alexander the Great (356–323 B.C.), a pupil of Aristotle, who became one of the world's greatest conquerors. Alexander was a great lover of classical civilization. In the wake of his military conquests, Greek culture was diffused across a vast Mediterranean empire. This Hellenistic, or "Greek-like," culture dominated the eastern Mediterranean world for the next thousand years.

Beginning in 333 B.C., Alexander launched a whirlwind campaign against the great empires of Persia and Egypt (Fig. 3.33). Without losing a battle, he brought their vast territories and resources under his rule. His armies continued into what is now India until the hero succumbed to a fever in 323 B.C. On his death, Alexander's military empire was divided into three large kingdoms, which adopted the Persian-style government of absolute monarchy and a strong central state.

The Hellenistic Legacy

Hellenistic civilization was a composite of Greek and Near Eastern elements that differed substantially from its classical predecessor. Politically, the Greek city-states lost the self-sufficiency that had encouraged the burst of classical creativity in Athens. At the same time, standards of living rose, and women gained wider respect and legal standing.

In the arts and letters, Hellenistic civilization lacked the audacious originality of classical Greece. Hellenistic kings collected classical manuscripts in great libraries that served as centers of scholarship. The most famous of these libraries was in Egyptian Alexandria, a sprawling cosmopolitan city with perhaps one million inhabitants. Artists were keen to imitate and elaborate the forms and ideas of classical Greece, and in theater the dramatists

proved most inventive in comedy, developing Menander's comedy of manners (see page 60). In philosophy, the influence of Athens and Plato's Academy continued while philosophical schools formed around new ideas. Epicurus (341–271 B.C.), for example, claimed that humans could live happily by understanding nature and pursuing moderate pleasure. "Pleasure is the beginning and end of living happily," pronounced Epicurus, affirming the body as a proper source of pleasant sensation. However, Epicureanism [epp-uh-KYOO-ree-un-ism] did not teach the hedonistic pursuit of sensation at all cost. Unbridled pleasure was certain to result in pain, Epicurus warned, and so the wise person learned to moderate desire. The aim of an Epicurean's moral conduct was *ataraxia,* "untroubledness" or "tranquillity." Epicurus's theory of nature was heavily influenced by the early Greek materialists (see page 46). He taught that nature resulted from the chance collision of atoms and obeyed purely mechanistic laws. There was nothing to fear from the gods; they did not control events or punish wrongdoing.

The philosophy of stoicism also originated in Hellenistic Athens. It was named for the *stoa,* or porch, in Athens where its adherents gathered. Its founder Zeno (c. 335–262 B.C.) was a student of the Platonic Academy and an admirer of Socrates' ethical teaching. In the stoics' view, the material world was composed of a fiery divine substance called the *logos.* Divine reason inhabits and rules the entire cosmos, and hence every event in the world-process is a consequence of reason. The natural law of reason is the necessary and inescapable cause of all events and all actions. As with the Epicureans, the stoics' ethical teachings were rooted in their view of the cosmos. The stoics held that, because divine reason controlled the universe, humans should strive to live in harmony with the rational laws of nature. Stoics found happiness –

3.33 *Alexander at the Battle of Issus,* from the House of the Faun, Pompeii, 2nd century B.C. Copy after original painting of c. 320–311 B.C. Mosaic, 8 ft 10 ins x 16 ft 9 ins (2.69 x 5.11 m). Museo Nazionale, Naples.
In the decisive battle of 333 B.C., the bareheaded Alexander (at left) leads a cavalry charge that causes the Persian king Darius to flee. Alexander's conquests and his love of classical Greek civilization spread Greek culture across the Mediterranean world and beyond.

or at least a sense of well-being – in calming their passions and performing the duties of their social role. Events beyond one's control ought to be regarded with indifference, or *apatheia.* Even the death of a loved one should not disturb the wise person's emotional detachment from the workings of a rational cosmos. Stoicism was to find wide application in the Roman era and in Christian philosophical thinking.

In the arts, influence shifted from Athens to imperial cities like the Hellenistic capital Pergamon, in present-day Turkey, a center of art and learning and an example of Hellenistic skills in city planning. The city's rulers funded a great library and commissioned new sculpture in a Hellenistic style that achieved a new realism of presentation, often portraying ordinary individuals sympathetically (see Fig. 3.35). Official sculpture, like the

336–323 B.C.	Conquests of Alexander the Great
c. 300 B.C.	Menander, Hellenistic comic playwright
c. 180 B.C.	Altar of Zeus, Pergamon
146 B.C.	Roman conquest of Greece

3.34 *Athena Slaying Giant*, detail of frieze from the Altar of Zeus, Pergamon, c. 180 B.C. Marble, height 7 ft 6 ins (2.29 m). Antikensammlung, Staatliche Museen, Berlin.

The mythic battle of Greek gods and giants appealed to Hellenistic sculptors' taste for drama and emotion. Amid the battle's turmoil, Athena lifts a giant by the hair to slay him. Compare the more restrained classical style of the Parthenon's *Lapith and Centaur* (Fig. 3.23).

3.35 *Dying Gaul*, Roman copy after bronze original, c. 225 B.C. Marble, height 35¹/₂ ins (91 cm), length 6 ft 3 ins (1.91 m). Museo Capitolino, Rome. Compare the pose and mood of this Hellenistic statue with the classical *Riace Warrior* (Fig. 3.27). What different emotional responses might the two works cause in a viewer?

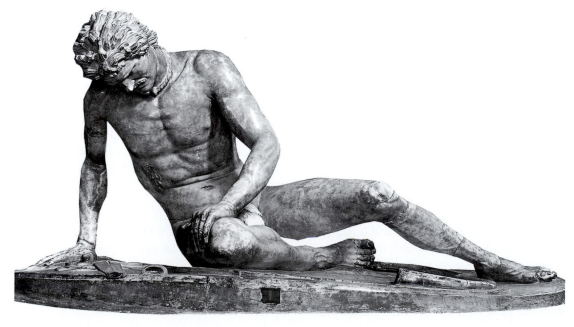

frieze on the Altar of Zeus (Fig. **3.34**), also showed the Hellenistic interest in conflict and emotional drama. The patrons of Hellenistic sculpture were often private individuals, rather than city-states as in the classical age. For this reason, Hellenistic sculptures emphasized the individuality of their subjects and strived for a direct emotional impact on the viewer. The *Dying Gaul* (Fig. **3.35**) is one of a statue group commissioned by a Hellenistic ruler to commemorate his battlefield opponents. The soldier has just committed suicide with his sword, which lies within his reach. The sculptor has made no effort to idealize the subject. Instead, the figure's heroic resignation is communicated by individualizing detail, such as his coarse hair and his necklace.

The most dramatic of Hellenistic sculptures may be *Laocoön and his Two Sons* (Fig. **3.36**), which portrays a Trojan priest and his sons as they are drowned by serpents. The treatment of the *Laocoön* [lah-OH-koh-on] is more turbulent and impassioned than any classical sculpture. The figures' violent struggle creates a sense of dramatic conflict and emotion. The face of Laocoön shows the agony of one terrible moment, rather than the calm balance of a timeless pose, such as in Myron's *Discus Thrower* (see Fig. 3.26).

Philosophy and science in classical Greece had been an independent pursuit. In the Hellenistic age, rulers generously patronized learning and founded scientific institutions like the Museum and Library in Alexandria, Egypt. The concentration of learning in Hellenistic cities fueled a burst of scientific discovery in astronomy, medicine, and mathematics. During this period, Euclid (c. 300 B.C.) devised his system of geometry and it was asserted for the first time that the planets revolved around the sun. The brilliant mathematician Archimedes (c. 287–212 B.C.) invented such marvelous devices as a screw for lifting water. Even during the Roman era, Greek scientists continued their investigations. The most important was Ptolemy (c. 100–178), whose complex scheme describing the planetary motion remained in use for 1,500 years.

The Hellenistic period was also the first to look back on classical Greece as the standard against which to measure its accomplishments. Scholars meticulously edited classical manuscripts and undertook the first

3.36 Agesander, Athenodorus, and Polydorus of Rhodes, *Laocoön and his Two Sons*, c. 150 B.C. Marble, height 8 ft (2.44 m). Vatican Museums, Rome.
Trace this dynamic sculpture's crisscrossing diagonal lines overlaid with the contorted serpent's body. Laocoön had tried to warn the Trojans against accepting the Greeks' fateful gift of a wooden horse.

textual criticism. They compiled the scholarly editions of Homer's epics and other classical Greek literature that would be the primers of the Mediterranean world's next great imperial power – Rome. Hellenistic scholars, scientists, and artists revered classical Greece even as they sought to surpass it – an attitude that the Romans would share.

CHAPTER SUMMARY

Early Greece Classical Greek civilization originated in two great Bronze Age civilizations of the Aegean Sea, the Minoan (c. 2500–1250 B.C.) and Mycenaean (c. 1600–1150 B.C.) cultures. Each dominated the Aegean world, then suffered ruin. From the Dark Age following this decline arose early Greece (c. 900–480 B.C.). The first great poetic works of early Greece were Homer's epic poems, the *Iliad* and the *Odyssey*, which recounted the deeds of heroes from the legendary Trojan War. Lyric poetry was often performed for public ceremonies, but also achieved great intimacy and tenderness in the works of Sappho.

In religion, the Greeks believed that the gods were actively involved in humans' lives. Early Greek philosophy engaged in speculation on the nature of the cosmos, seeking either the material basis of physical reality or the underlying numerical order of things. The vase painters and sculptors of early Greece showed increasing mastery of human anatomy and naturalism. In the so-called Archaic period especially (650–490 B.C.), sculpture underwent a rapid stylistic evolution.

The Classical Period The classical period (480–323 B.C.) of ancient Greece began with the triumph of Athens over Persian armies. Under the political leadership of Pericles, Athens entered a Golden Age (480–404 B.C.), developing a vigorous democracy that, despite its achievements, denied most women any rights and eventually brought ruin on itself.

Classical Greek Art Temple construction and decoration was the focus of Greek art in the classical period, as seen in the buildings of the Athenian acropolis. The Parthenon's Doric grandeur represented the classical balance between rational design and humanistic vitality. Other Athenian acropolis buildings demonstrate both Doric and Ionic features.

Greek sculpture chiefly served religious and civic purposes, especially the decoration of temples. The Parthenon's sculpture is a high point of classical style. Freestanding classical sculpture typically portrayed an idealized physical type – a nude god, warrior, or athlete – in a stance suggesting prowess and restrained energy. Late classical sculpture first began to portray the nude female figure.

Greek Theater and Music Music and dance were an essential part of Greek life and of a Greek's education. Musicians played versions of the flute and lyre to accompany dramatic and poetic performance. Greek philosophers prized the mathematical order beneath the Greek system of chords, while Plato described the Greeks' belief in music's effect on human character (*ethos*).

Classical Greek Philosophy In classical Athens, philosopher-teachers called sophists began examining human affairs – morality, law, and politics – with skepticism and practicality. The Athenian Socrates adapted the sophists' method of skeptical inquiry and debate, but declared that absolute truth could be known and taught.

Socrates' exemplary life and death was a powerful influence on future classical philosophy, especially on his student Plato, whose written dialogues elaborated Western philosophy's first great philosophical system. Plato argued that the virtuous soul must abandon sense experience and seek to know the Forms, intelligible by reasoned contemplation. His *Republic* described an ideal society ruled by philosophers who sought to free their fellow citizens from the "cave" of ignorance. The thought of Aristotle, Plato's student, described an encyclopedia of Greek knowledge about the world and would deeply influence Western thought. Aristotle rejected Plato's dualistic doctrine of the Forms but prized rational thought as humans' most virtuous activity.

The Hellenistic Age The Hellenistic age (323–145 B.C.) saw the spread of Greek civilization to the eastern Mediterranean world, in the wake of Alexander's conquests. Hellenistic science and learning advanced under the patronage of rulers who founded great libraries and museums. The Hellenistic philosopher Epicurus urged followers to find "tranquility" in moderate pleasures, while Zeno counseled the stoic acceptance of fate. Hellenistic art achieved a new realism and emotional directness. The Hellenistic elaboration of classical ideas and achievements set the stage for Roman civilization, which would enthusiastically absorb Greek art and ideas.

4 Ancient Rome: The Spirit of Empire

4.1 Colosseum, Rome, c. A.D. 72–80. Long axis 620 ft (189 m), short axis 513 ft (156 m), height 160 ft (49 m).

The Colosseum was a triumph of Roman engineering and a tribute to the Romans' taste for bloody popular spectacles. The decorative relief columns are reminders of Rome's artistic debt to Greek art. But the complex arrangement of arches and vaulting that supported seating for 50,000 spectators was a purely Roman invention.

Sprawling imperial Rome – a city crowded with stupendous buildings (Fig. **4.2**), alive with pleasures and entertainment – was the hub of a world that stretched from England to Iraq. Here was where Roman emperors paraded their war captives. Here was where Romans brought their plundered Greek treasures. Here was where future empires would look for an example of greatness. This was the **imperial spirit** of Rome: the power to impose the city's law on subject peoples, the will to civilize them in the Roman way, the sense of destiny that Rome could bring peace and order to the world.

4.2 Scale model of ancient Rome. Museo della Civiltà, Rome.
Rome at the height of its power, crowded by imperial buildings: at upper right, the Colosseum; center, the emperor's palace and race course; and upper left, the Forum of Trajan.

The Drama of Roman History

Trace Rome's historical development from early republic to imperial power.

Few peoples have been as conscious of their history as the ancient Romans, and few histories have been reenacted as often as ancient Rome's. Shakespeare's Brutus, standing over the murdered Julius Caesar, asks how many times their scene will be enacted on the world's stage. He spoke more prophetically than even Shakespeare could have known. The drama of Roman history has provided the script for revolutions and conquests many times over. Even the collapse of Rome's empire has been compared to the decline of the British and Russian empires in recent history.

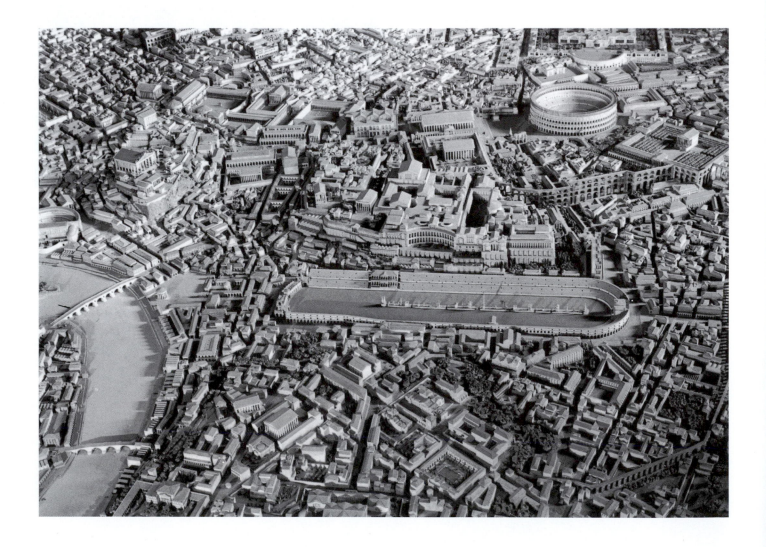

The Rise of Republican Rome

The Romans' sense of history began with the city's founding, set by legend in 753 B.C. However, Roman cultural development dates from the era of Etruscan domination. The Etruscans were a resourceful people of central Italy, who dominated the Italian peninsula in the sixth century B.C. When the last Etruscan king was expelled from Rome around 510 B.C., the Romans were left with a valuable Etruscan legacy. Although its origins are obscure, Etruscan art (Fig. **4.3**) shows a vigor and confidence that the Romans would not match for some centuries. Etruscan skills in engineering and architecture, including the use of the arch for construction, were also part of their legacy.

In 509 B.C., the Romans established a **republic** – a government of representatives chosen to act for the people at large. Etruscan rule had left the early Romans with a distaste for kings, and they intended republican government to protect them from the abuses of monarchy. In modern times and for similar reasons, revolutionaries in eighteenth-century North America and France founded republics modeled after the Roman republic.

From 509 to c. 250 B.C., two struggles propelled Roman history: externally, the Romans set out to conquer the Italian peninsula, establishing themselves as a leading Mediterranean power; internally, the Romans struggled over the distribution of political power within the republic. The struggle was won at first by the conservative upper-class **patricians** [pah-TRIH-shuns], who ruled through the Roman Senate. Gradually, the opposing class of poor commoners (called **plebeians** [pleb-EE-uns]) gained political power and constitutional recognition of their rights.

Once the Romans had achieved control of Italy, they turned to subdue their Mediterranean rivals. Rome's chief opponent was the north African commercial and naval power of Carthage. The Romans defeated the Carthaginians in a series of three wars called the Punic [PYOO-nik] Wars (264–146 B.C.), the last of which ended in the vengeful razing of Carthage and Rome's total domination of the western Mediterranean. By this time, Rome's eyes were already turning east, and in 146 B.C. Romans conquered the Greek capital of Corinth. In the decades that followed, Rome's empire absorbed virtually the entire Hellenistic world, with its wealth, libraries, and art treasures.

4.3 *Apollo*, from the Portonaccio Temple, Veii, Etruscan, c. 520–500 B.C. Terracotta, height 5 ft 9 ins (1.75 m). Museo Nazionale di Villa Giulia, Rome.
This Etruscan statue resembles the Archaic Greek *kouros*, especially in its striding stance and formalized smile. Greek colonies in southern Italy exerted early influence on Etruscan and Roman cultures.

Imperialism

The concepts of **empire** and **imperialism** suggest both great achievement and hateful oppression. An empire is a large territory or a number of territories dominated by a single political authority. The imperial authority may be a city-state such as Rome, or a nation such as Great Britain, which once controlled a vast empire including the present-day United States and Canada. Now, some call the United States itself an imperial power, dominating the smaller nations of Central and South America and the Caribbean.

Imperial authority often brings cultural progress and political unity to the diverse territories under its rule. For example, the Indian parliament still uses English, the language of its imperial oppressor, as a principal language, and only the English language transcends India's regional and cultural divisions. Ancient Rome also brought the rule of law and a cosmopolitan culture to its imperial territories. Rome's provinces enjoyed these gifts at the cost of bowing to the Roman eagle and worshiping the Roman emperor.

The ancient Romans built their empire with an aggressive and well-trained army and a talent for efficient administration. By 265 B.C., the Romans controlled all of the Italian peninsula. Within a hundred more years, they controlled much of Europe and the entire Mediterranean rim (Fig. **4.4**). Like the westward expansion in the United States during the 1800s, Rome's rise to power seemed to fulfill a divinely sanctioned national destiny. Unlike North American pioneers, however, Rome did not usually displace the residents of conquered territories. Instead, it instituted Roman law and culture alongside native customs and offered citizenship to the social elite of subject nations. Rome's imperial system was so vast and effective that it thrived

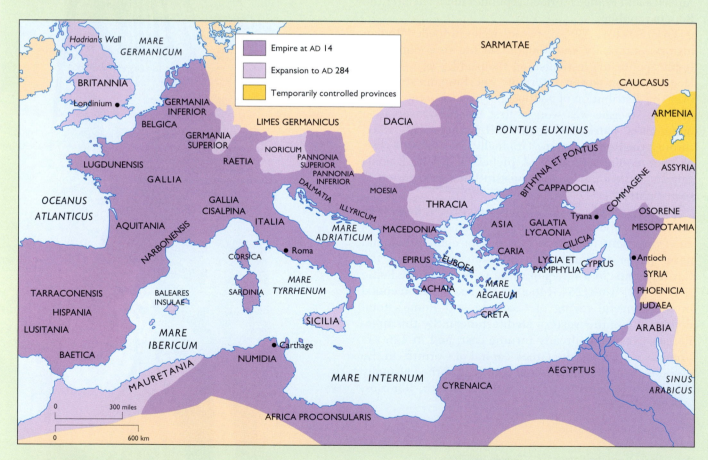

4.4 The Roman Empire.

under good emperors, such as Caesar Augustus (see Imperial Rome, below) and Trajan [TRAY-jun] (see page 77), and survived under bad ones, such as Caligula and Nero (see Notable Roman Emperors, page 74).

Later empires and would-be emperors measured themselves against the standard of Roman greatness (Fig. **4.5**). Examples from recent history are the French military genius Napoleon (see page 325), who adopted the symbols and fashions of imperial Rome, styling himself a world conqueror in the Roman mold, and Adolf Hitler (see page 386), who boasted that his Nazi regime would last a thousand years. Napoleon honored his victories with a triumphal arch in Paris that was twice the size of any in Rome, while Hitler's architect designed a still larger arch for Berlin.

4.5 Arch of Trajan, Benevento, 114–17. Marble, height 51 ft (15.55 m).
In ancient Rome, the triumphal arch became a symbol of imperial power and achievement. Compare this arch with that built by Napoleon Bonaparte in the early 1800s (Fig. 12.4).

753 B.C.	Rome founded
c. 530 B.C.	The Buddha's sermon at the Deer Park, Benares, India (**4.29**)
509 B.C.	Roman republic established
520–500 B.C.	Etruscan *Apollo of Veii* (**4.3**)
146 B.C.	Rome conquers Carthage, Greece
27 B.C.–A.D. 14	Octavian rules as Emperor Caesar Augustus

By the second century B.C., Rome was no longer an agrarian city peopled by yeoman farmers and small merchants. It had become a vast and wealthy empire with large professional armies. Tantalized by the prospect of ruling this empire, power-hungry leaders convulsed Rome in a series of civil wars (90–31 B.C.). Private armies clashed in distant provinces, while thousands died in political assassinations and reprisals. The leading player in this turbulent era was Julius Caesar (100–44 B.C.), a charismatic figure who reformed Roman law and reorganized its public administration. Playing on his military successes in Gaul (modern France), Caesar had himself named dictator for life in 46 B.C. However, he was assassinated two years later by senators fearful that he would establish a monarchy. Caesar's death set off another bloody civil conflict, from which his adopted nephew Octavian emerged victorious. Octavian (63 B.C.–A.D. 14) defeated his uncle's assassins and then faced his own former ally, Mark Antony. In 31 B.C., Octavian vanquished the forces of Antony and his sponsor Cleopatra, the Egyptian queen, leaving Rome to his own command.

Imperial Rome

During the early republican era, the Romans remained uncivilized, at least compared with their Greek contemporaries. At the time of the Athenian Golden Age, the Romans were little more than rude farmers and villagers. In the late republican era, contact with Hellenistic Greece stimulated the first bloom of Roman literature. The Romans' greatest cultural achievements did not begin until the reign of Octavian, who called himself Caesar Augustus (ruled 27 B.C.–A.D. 14). Although the Senate called him Rome's "First Citizen," Augustus was in fact dictator of Rome from 27 B.C. onward. His reign

Romans, concern yourselves with commanding the nations; your arts shall be to impose the rule of peace, to spare the submissive, and to crush the proud.

Advice to the founders of Rome, in Virgil's *Aeneid*

Name	Ruled	Significance
Augustus	27 B.C.–A.D. 14	Established emperor as dictator of Roman society; promoted peace and traditional Roman values.
Nero	A.D. 54–68	Patronized the arts and built "Golden House"; blamed Christians for devastating fire in Rome (A.D. 64).
Hadrian	117–138	Most cultivated of the emperors; built the Pantheon and a grand villa at Tivoli.
Marcus Aurelius	161–180	Wrote *Meditations*, significant work of stoic philosophy; led military campaigns against foreign invaders.
Diocletian	284–305	Divided empire into four parts for more efficient administration; retired to palace in Split (present-day Croatia).

inaugurated the long succession of Roman emperors who would rule the Western world for five centuries.

Caesar Augustus established a period of relative peace and prosperity commonly called the **Pax Romana**, which lasted until the death of Emperor Marcus Aurelius [oh-REEL-yuss] (in 180). During his reign, Augustus carefully consolidated his imperial power, even while he preserved the illusion of republican rights and senatorial prerogatives. In the arts, he sponsored a building program that would make Rome the equal of the grand Hellenistic capitals it now controlled. Augustus proclaimed proudly that he had found Rome a city of bricks and left it a city of marble.

Augustus's protégé, the epic poet Virgil (70–19 B.C.), stated Rome's cultural ambitions with more modesty. In his poem the *Aeneid*, Virgil acknowledged that other races would "hammer forth more delicately a breathing likeness out of bronze, coax living faces from the marble, [and] plead causes with more skill." "Romans," wrote Virgil, "concern yourselves with commanding the nations; your arts shall be to impose the rule of peace, to spare the submissive, and to crush the proud."[1]

Despite Virgil's proclamation, Caesar Augustus and, later, his successors were determined to develop a distinctive Roman civilization, even if much of it had to be borrowed from the Greeks. Two essential observations can be made of the Roman civilization of the late republic and the empire: first, the Romans avidly absorbed classical

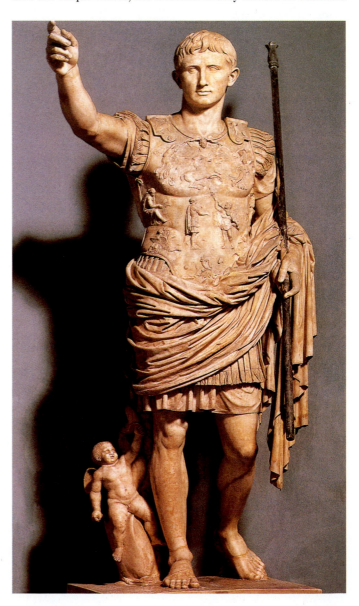

4.6 *Augustus of Primaporta*, c. 20 B.C. Marble, height 6 ft 8 ins (2.03 m). Vatican Museums, Rome.
Caesar Augustus propagated official images throughout his empire, fostering a personal cult of the emperor. The emperor's armor breastplate depicts his greatest diplomatic achievement – the return of Roman army standards captured by a foreign rival.

> ### THE WRITE IDEA
>
> Writing as a citizen of the United States, compose a brief defense of U.S. imperial power and its positive effects on the lives of smaller nations. Then, discuss the same topic as if you were a citizen of a nation strongly influenced by the United States, for example, Panama or the Philippines.

Greek and Hellenistic civilization; and second, they remained resolutely practical and utilitarian in their attitude toward the arts and philosophy. For the Romans, culture had to serve the useful ends of justifying imperial power and providing comfort and entertainment for Roman citizens.

The Art of an Empire

Analyze the political message in examples of Roman imperial art.

After the leadership of Julius Caesar, virtually every Roman leader strove to leave a memory of himself in stone. The emperors of the Roman Empire built statues and buildings that were both political advertisements and artistic statements, impressing upon their people a message of their power and generosity expressed through the styles of classical and Hellenistic Greece. By adopting the Greek-style arts, the Romans could associate themselves with the prestige of classical Athens and Alexander the Great.

During the reign of Augustus, the art of the Roman Empire began to flourish. Artists skillfully adapted classical Greek sculpture to the emperor's propaganda purposes. Augustus and his successors built elaborate new complexes at the center of Rome, the grandest of which was the Forum of Trajan, built at the height of Rome's power in the second century A.D.

Sculpture as Propaganda

Augustus was the first Roman ruler to place statues and busts of his own image in public squares and buildings. The so-called *Augustus of Primaporta* (Fig. **4.6**), discovered in a provincial Roman town, is typical of these official portraits. Augustus's face is slightly idealized, though still recognizable. The dolphin at his side alludes to the goddess Venus, mother of the Trojan hero Aeneas, from whom Augustus claimed descent. By associating the emperor with gods, heroes, and Roman history, this work of art is effective propaganda.

A more elaborate work of sculptural propaganda was the *Ara Pacis Augustae* (Altar of Augustan Peace) (Fig. **4.7**). The *Ara Pacis* [AH-ruh PAH-kiss] was built to

4.7 *Ara Pacis Augustae* (Altar of Augustan Peace), Rome, 13–9 B.C. Marble, 36 × 33 ft (11 × 10 m).
The Romans effectively adapted Greek classicism to convey a social and political message. This elaborately symbolic work represented Augustus's political program of peace and agrarian values. The right front panel depicts a key scene from the life of Aeneas, the legendary hero from whom Augustus claimed descent.

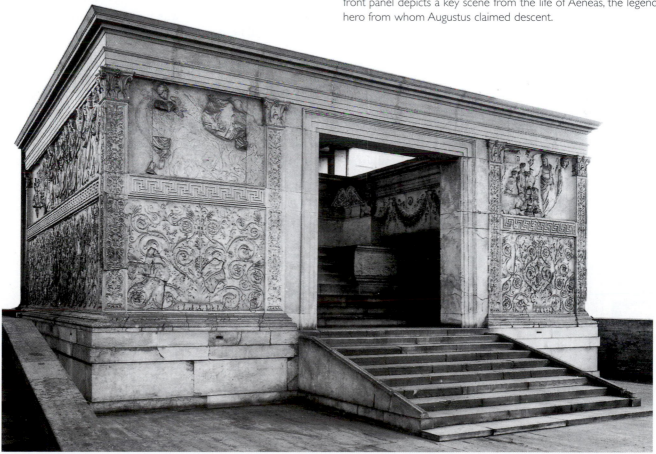

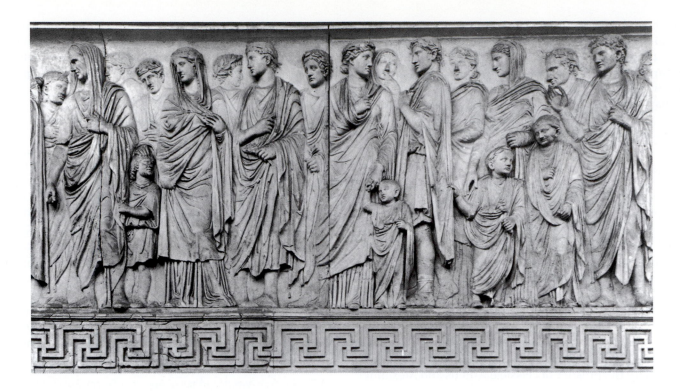

4.8 *Imperial Procession*, detail of the *Ara Pacis Augustae*, Rome, 13–9 B.C. Marble relief, height approx. 5 ft 3 ins (1.6 m).
The altar's sculpted screen shows how effectively the Romans adapted the classical Greek style to the purposes of imperial propaganda. Compare this imperial procession scene, which here shows members of Augustus's family, to the Parthenon cella frieze, whose mounted horsemen glorified the dead heroes of Athenian military victories (Fig. 3.25).

commemorate Augustus's safe return from a campaign in Gaul. In a larger sense, it celebrated the emperor's twin goals of general peace (after a century of civil war) and a return to Rome's agrarian traditions. The altar itself and the wall enclosure are decorated with relief sculpture, probably executed by Greek artists. On the screen enclosure, an elaborate two-part frieze consists of floral designs and the procession led by Augustus to consecrate the altar (Fig. 4.8). Even the altar's site was symbolic of Augustus's program of peace – it was built in a park that had once been a drill field for the Roman army.

The Forum of Trajan

The most impressive monument to Augustus's reign was the forum he built at the center of Rome, of which little now remains. A **forum**, originally a "marketplace," was the social and political center of a Roman city. Rome's oldest forum, the republican Forum, was the site of important

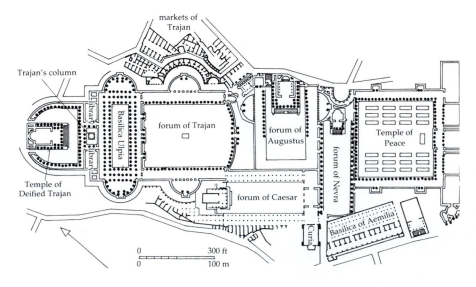

4.9 Plan of the imperial forums, Rome.
Built to glorify imperial rulers, the forums crowded Rome's center with Greek-style temples and other public buildings (compare Fig. 4.13). The largest forum was Trajan's, dominated by the imposing Basilica Ulpia; a large Greek-style temple dedicated to Trajan; and the unique Column of Trajan (see Fig. 4.11).

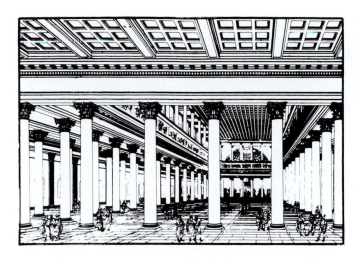

4.10 Apollodorus of Damascus, Basilica Ulpia, Forum of Trajan, Rome, 113. Reconstruction drawing of the interior.
The flat-roofed basilica was a traditional Roman building used for legal proceedings and other public affairs. Because of its large, rectangular central hall, later Roman architects would adapt the basilica to the building of Christian churches (see page 112).

temples and law courts, as well as shops, banks, and schools. Julius Caesar and Augustus both built new forums, glorifying their own names, adjacent to the old republican Forum.

It was the Emperor Trajan (ruled A.D. 98–117) who built the grandest of the imperial forums (Fig. **4.9**), a suitable monument to the peace and prosperity that characterized his reign. The Forum of Trajan included an expansive marketplace, a hall of justice, and two libraries, one each for Greek and Latin texts. The hall of justice of Trajan's Forum, named the Basilica Ulpia (Fig. **4.10**), was a typical Roman **basilica** – a rectangular public hall, usually with a flat ceiling. The Basilica Ulpia's roof was supported by double rows of handsome Corinthian columns. Traffic circulated outside the columns, and court was held in semicircular niches recessed in the end walls. The basilica was a traditional Roman building, old-fashioned even in Trajan's day but still expressing the imperial grandeur of Rome.

The centerpiece of Trajan's Forum was the Column of Trajan (Fig. **4.11**), a sculpted column depicting scenes of the emperor's victories over the rebellious Dacians (in present-day Romania). The campaign was a suitable topic

4.11 Apollodorus of Damascus, Column of Trajan, Rome, 106–13. Marble, height of base 18 ft (5.5 m), height of column 97 ft (29.6 m).
One of Rome's most remarkable achievements in sculpture, this column's spiraling narrative depicts a military campaign with typical Roman realism. In Trajan's time, the column could be viewed from the upper stories of opposing libraries and from the Basilica Ulpia.

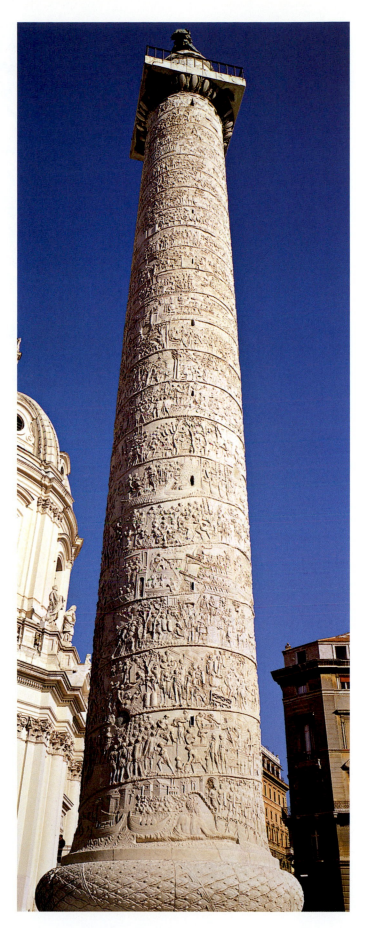

4.12 *Trajan Addressing His Troops* (the *Adlocutio*), detail of Trajan's Column, Rome, 113. Height of figures approx. 27^1/$_2$ ins (70 cm).

Sculptors unified the column's long narrative with recurring appearances of the emperor, who here addresses the troops prior to battle. Note the larger scale of the figure of Trajan (center top), which identifies him clearly, and the realistic details in the figures' dress and posture.

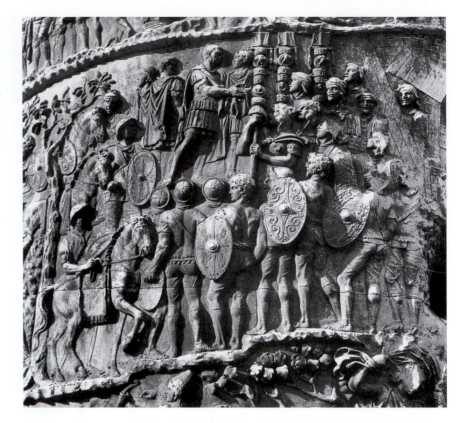

The World Citizen

As the Mediterranean world and ancient Near East were unified by conquest – first Alexander's (see page 64) and then the Romans' – philosophers began to think beyond the limits of ethnic and national boundaries. It was probably the Cynic philosopher Diogenes who first declared, "I am a citizen of the world" (in Greek, *kosmou polites*), in Diogenes' case most likely in order to justify his contempt for the laws of his city-state. The stoics, however, turned this cosmopolitan view into a positive philosophy. When the stoic philosopher Epictetus told his followers to be "citizens of the world," he expected them to obey the cosmic laws of divine reason as faithfully as they followed their city's laws. Stoics were the first Western thinkers to recognize the essential unity of humans – at least male humans – as one brotherhood. Since they were bound in common citizenship, cosmopolitans were obliged to care for one another without regard for nationality. A world citizen's character is "to hold nothing as profitable [only] to himself; to deliberate about nothing as if he were detached from the community…"[2]

In the Roman era, the cosmopolitan ideal was rooted in the practical problems of applying Roman law across an empire of many different local traditions. Roman stoics naturally felt some tension between loyalty to the "fatherland" (*patria*) and to the world order. The cosmopolitan ideal reemerged in Western thought when early modern Europe drew together the world under its colonial rule. In the eighteenth century, the Enlightenment thinker Immanuel Kant imagined the evolution of human society toward a "perpetual peace" established and governed by the rule of reason. The tension between patriotism and cosmopolitan humanitarianism persists in the contemporary age, when we use humanitarian aims rather than national self-interest to justify our military actions.

CRITICAL QUESTION

Describe a situation in which you might feel yourself torn between an obligation to your community or nation and the responsibility you feel to the good of humanity the world over. What factors would you consider in resolving this tension reasonably?

for imperial propaganda: the gold from Dacian mines funded public welfare and imperial construction during Trajan's reign. The column is, nonetheless, a remarkable work of art. The narrative sculpture spirals around the column to a length of more than 650 feet (200 m). The story is told in a continuous scene (Fig. **4.12**), as if to recount a series of uninterrupted events. The realistic details include the construction of pontoon bridges and the beheading of captive troops. While the sculptural style is still governed by Augustan classicism, the form – a continuous narrative in sculptural relief – had no precedent in the Greek world. Only the art of Chinese scroll painting, probably developed about the time of the late Roman Empire, created visual narratives of a scope similar to Trajan's Column.

The Romans as Builders

For all their splendor, many of ancient Rome's great buildings (Fig. **4.13**) were dedicated to practical ends: the basilicas served as areas where Romans could settle their legal and political affairs; the temples accommodated religious ceremonies (a matter of civic obligation); the baths were where men exchanged gossip while lounging in the pools; and in the library women might read a Hellenistic romance. Many Roman public buildings were used daily and served multiple purposes, in contrast to classical Greece, where most significant buildings had only a religious function. The Romans constructed their public buildings on a grand scale, decorating the buildings' interiors with colored marble, gilded statues, and wall paintings. The grandeur and comfort of Roman buildings depended on the Romans' revolutionary innovations in construction, particularly the use of concrete and the arch.

The Romans developed the **arch** into a highly flexible architectural form, which could be used in many types of constructions. The arch was superior to the post-and-lintel design of Greek temples (see Fig. 3.16) for a simple technical reason – too much weight on the stone lintel would cause it to snap. Because in an arch the stones are compressed and not bent, it can bear more weight than the post-and-lintel. The arch's simplest use was in bridges, such as the Pont du Gard in France (Fig. **4.14**), in which three series of arches are stacked on top of each other. While arched bridges and aqueducts were essential to commerce and everyday living, Roman architects learned to use the arch for more daring constructions. The **barrel vault** (Fig. **4.15**) could bear tremendous weight and was often used as a structural support in buildings' foundations.

4.13 Temple of Portunus (also known as Temple of Fortuna Virilis), Rome, late 2nd century B.C.

The Roman Greek-style temple was a ubiquitous type of Roman building that typically stood facing a forum or other public area. In contrast to classical Greek temples, the Roman type was raised on a podium with a front stairway. Freestanding columns defining the portico, or porch, give way to relief columns along the sides of the cella.

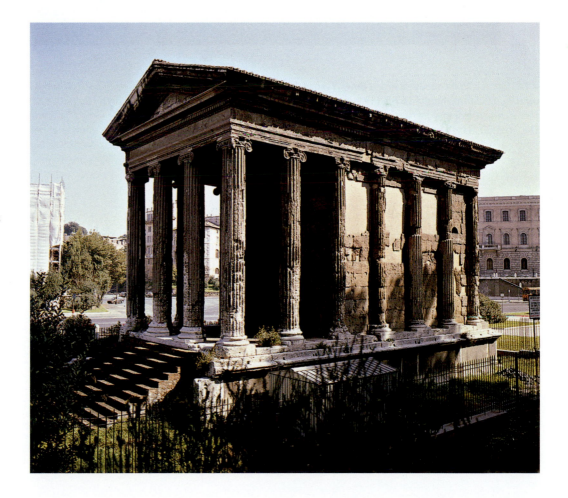

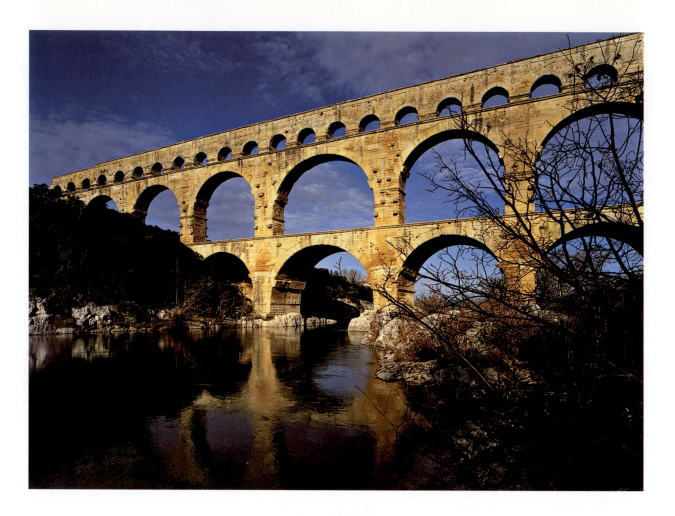

4.14 (above) Pont du Gard, near Nîmes, France, late 1st century B.C. Stone, height 162 ft (49.4 m).
The arch was essential to Roman engineering of roads and bridges. The Pont du Gard's graceful arches bore traffic and fresh water to a provincial Roman city, assuring its quality of life and its connection to Roman authority.

4.15 (below) The arch and its applications.
In the basic **arch** (a), wedge-shaped stones called *voussoirs* transferred the weight to load-bearing vertical piers. An extended continuous arch, open at either end, created a **barrel** or **tunnel vault** (b). The intersection of two barrel vaults formed a **cross vault** (c), open on four sides and supported by piers at the four corners. In a **dome**, a series of arches intersected around a central axis.

The **cross vault** was usually connected in a series of three vaults (compare Fig. 4.16) to form an open rectangular hall, with ceilings as high as 180 feet (55 m). The **dome** created a spacious and majestic interior space, of which the grandest was in the Pantheon (see Fig. 4.20).

Equal in importance to the arch was the use of concrete in Roman building. Concrete was a mixture of rubble and a mortar that hardened when mixed with water. Concrete was customarily used with brick to construct a building's core; the exterior was then decorated with a marble veneer. This enabled the Romans to construct buildings with the grand appearance of Greek classicism but without the expense of a quarried stone core.

The flexibility and economy of Roman construction and the cramped conditions of building in Rome produced buildings of a different nature from those of classical and Hellenistic Greece. Instead of creating spectacular

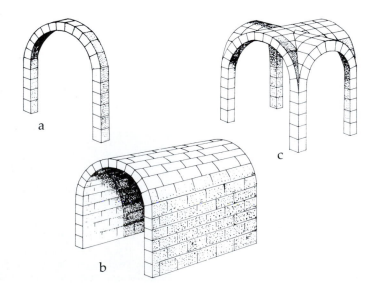

4.16 Reconstruction drawing of the Basilica of Constantine (after Huelsen).

exterior settings, like the Parthenon's in Athens, the Romans created spacious interiors with lavish marbles, mosaics, and gilding, and emphasized the usefulness of their buildings, in keeping with the practical spirit of Roman civilization.

The most spectacular interiors are those in buildings devoted to recreation. The Roman baths were the ancients' combination of health spa, beauty salon, public library, and shopping mall. The baths' central hall consisted of connected cross vaults soaring high above the floor. These vaults were supported on either side by barrel-vaulted chambers, like the ones that remain from the Basilica of Constantine (Figs. **4.16** and **4.17**). Under this

spectacular vaulting, decorated with colored marble and paintings, were pools of hot, warm, and cold water. The Baths of Caracalla also housed a separate swimming pool, gymnasium, massage and steam rooms, restaurants, and a library. It is no wonder that Romans flocked to the baths, and that an elaborate system of aqueducts was required to supply these baths with water.

The Romans loved entertainment as much as they loved pleasure, and theaters, amphitheaters, and racetracks

4.17 Basilica of Constantine (or Maxentius), Rome, c. 306–13. Brick and concrete.

The high vaulted ceilings and large windows allowed light to flood the spacious interior, illuminating the colorful mosaic decoration. This basilica, the only law court built in the grand style of the Roman baths, was the last great pagan building of ancient Rome.

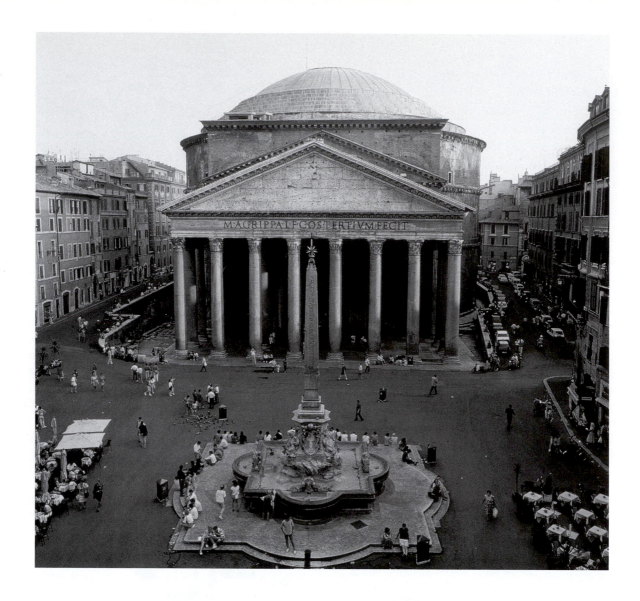

were spread throughout the city. Romans crowded their stadiums for entertainments that were every bit the match of today's stadium events. The most famous Roman amphitheater was the Colosseum (Fig. **4.1**), which dominated the skyline of imperial Rome from its location near the republican Forum. The Colosseum's outer walls rose nearly 160 feet (49 m) high. The arena floor could be landscaped for wild animal combats. The Romans preferred their entertainment to be spiced with violence and gore. According to the historian Suetonius, 5,000 wild beasts were slaughtered in a single day at the Colosseum's inauguration. Thousands of gladiators and some Christian martyrs also met their deaths on the Colosseum's sand floor. Such scenes of Roman cruelty make the padded combat of today's sporting events seem rather tame by comparison.

The Pantheon The beauty and grandeur of one Roman building far outweighed its usefulness. The Pantheon (Fig. **4.18**) was famed for its magnificent dome, rising

4.18 (*above*) Pantheon, Rome, c. 120. Height of portico 59 ft (18 m). The Pantheon's perfect geometry and lavish interior decoration made it one of antiquity's most admired buildings. To Romans, its interior hemispherical dome symbolized the unity of the cosmos and of the Roman imperial world.

4.19 (*below*) Pantheon, Rome. Plan and cross-section. The building's interior dome and supporting drum contain a perfect sphere.

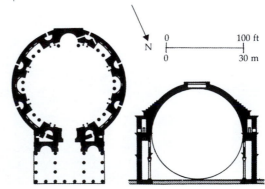

above the interior in a perfect hemisphere, resting on a cylinder of exactly the same diameter (144 feet; 44 m; Fig. 4.19). For a Roman, to stand under this magnificent dome was like standing under the heavens themselves.

The Pantheon was built around 120 by the emperor Hadrian at the height of Rome's imperial power. The temple was dedicated to the seven planetary gods, although Hadrian also used it for Senate meetings and other ceremonial occasions. Seen from the outside, the Pantheon now appears rather dull, since it has been stripped of its marble covering and its bronze pedimental relief sculpture. Inside, however, the observer can still sense the building's original beauty (Fig. 4.20). The dome was punctuated by a 30-foot (9 m) opening called an **oculus**. The oculus was the principal source of light inside the building and also repeated the interior's geometric motif. Around the walls were niches, containing divine statues and recesses behind Corinthian columns of colored marble. With its geometric rhythms and soaring interior, the Pantheon seemed to merge all of creation in a perfectly harmonious whole.

4.20 Cutaway view of the Pantheon

Roman Art and Daily Life

Analyze what the arts of painting and sculpture reveal about the lives of ordinary Romans.

The imperial buildings of Rome tell us much about the Romans as engineers, conquerors, and administrators, but little about them as ordinary people. Christian historians later condemned the licentious style of Roman living, blaming Rome's fall on sinful ways. In fact the daily life of the average Roman was relatively modest and centered on the family. The Romans' domestic character and customs are best revealed in the arts of painting and portrait sculpture. Their taste for public entertainment – theater, music, and dance – is evident in the theaters and amphitheaters of even a small city like that excavated at Pompeii.

Roman Daily Life

In ancient Rome, family ties were the basis of social identity. The male head of the family, known as the paterfamilias [PAH-ter fah-MEE-lee-us], controlled the family's membership and its fortunes. A newborn infant was not legally a family member until the paterfamilias had

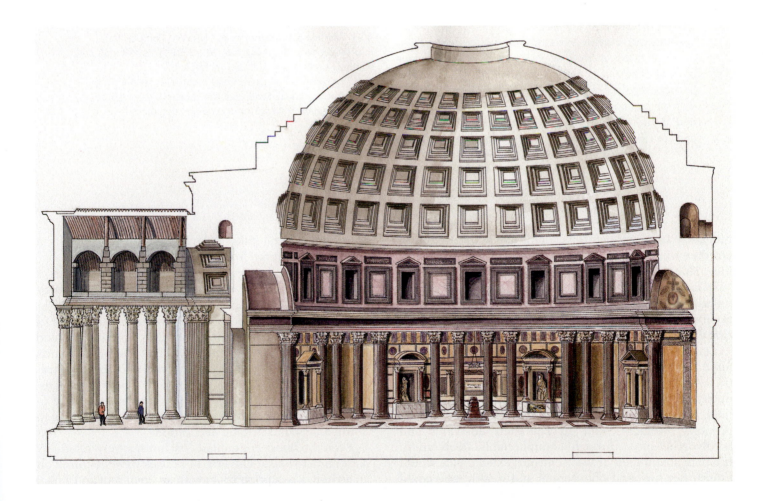

A Marriage Contract of the Roman Era

In the Roman era, marriage among the upper classes customarily required only a simple contract between husband and wife (Fig. **4.21**). A Roman wife maintained control of her own property, including the right to her dowry should the husband seek divorce. The marriage contract below bound a couple living in Alexandria, the cosmopolitan Hellenistic capital, in the first century B.C.

Let Apollonia be the wife of Philiscus, having been persuaded by him that it is fitting for her to be his wife, and let her have mastery in common with him over all their possessions. And let Philiscus provide for Apollonia all the things that she needs and her clothing and all the rest that is suitable for a married woman to have provided for her — and let him do this wherever they live, according as their means allow. And let him take no other wife but Apollonia, and no concubine, and let him have no boyfriends or beget children from any other woman so long as Apollonia is living nor inhabit any other household than the one over which Apollonia rules; nor let him repudiate her or do violence to her or treat her badly or alienate any of their property in a manner which is unfair to Apollonia. If he is caught doing any of these things … then let him pay back immediately to Apollonia her dowry of two talents and four thousand drachmas of bronze. By the same token, let Apollonia not be permitted to spend the day or the night away from the house of Philiscus without his knowledge, nor may she sleep with another man, nor may she squander their common household property, nor may she disgrace Philiscus in the ways in which men get disgraced. But if Apollonia willingly does any of these things, let her be sent away from Philiscus, and let him repay to her the dowry simply within ten days of her departure.[3]

4.21 *Portrait of a Magistrate and His Wife*, Pompeii, Italy, mid-1st century. Mural painting, $22^7/_8$ x $20^1/_2$ ins (58 x 52 cm). National Archaeological Museum, Naples.
This Pompeiian couple were well-educated, as seen from the scroll, stylus, and wax tablet that they hold. Roman married couples frequently portrayed themselves together.

recognized the infant and given it his name. Unrecognized children were sometimes given for adoption to other families. More commonly, newborns (especially girls) were "exposed," that is, left in the forum to die or be adopted as foundlings. Bearing a family name through adoption was no disadvantage: the young Octavian became Rome's first emperor after he had been adopted by Julius Caesar.

Married women enjoyed relative freedom, but still suffered confined social roles. Roman women accompanied their husbands in public, often to banquets and other public occasions. As in Greece, they supervised the household, but in Rome women might also hold and inherit property. Women could divorce their husbands and be divorced, often through a simple public declaration. If her husband died or was sent into exile, a wife would inherit her husband's household and wealth. She could

entertain suitors, take a lover, or cloister herself in mourning, sheltered from the world's hypocrisy.

The houses, forums, theaters, and amphitheaters of one entire Roman city were preserved by a great accident of history, the destruction of Pompeii [pom-PAY-ee] in 79. Pompeii was buried under a 15-foot (4.6 m) layer of ash when the nearby volcano Mount Vesuvius erupted and spewed its ash over the city. The town's inhabitants were smothered by toxic gas, and their bodies left hardened volcanic casts where they fell. The Pompeiians' houses and domestic possessions were first excavated in the eighteenth century, offering a glimpse of the Roman household and its artistic decoration.

Even the finest Pompeiian city houses were relatively dark and crowded. The largest houses were centered on an **atrium**, a reception room with an open roof and a pool

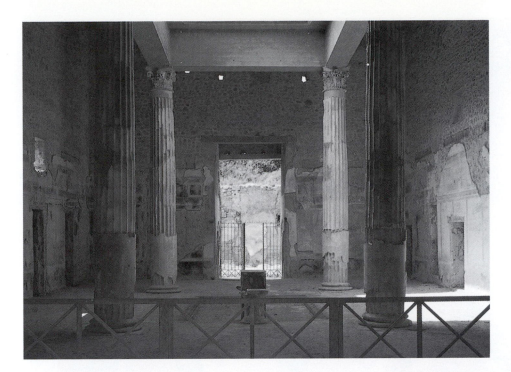

4.22 Atrium, House of the Silver Wedding, Pompeii, Italy, early 1st century A.D.
A volcanic eruption suffocated Pompeii's inhabitants but left the town's buildings remarkably intact. This house belonged to a wealthy Pompeiian family and was considerably more luxurious than the norm. Imposing Corinthian columns surround a pool in the house's atrium.

beneath. The atrium in the House of the Silver Wedding (Fig. **4.22**) is exceptional in its size and grandeur. The other rooms were windowless, and usually several people slept in the same room. The most pleasant aspect of the finer houses was an adjacent garden, surrounded by a colonnade, where Pompeiians dined.

An important feature of a Roman household was that part of the dwelling or its furnishings set aside for the veneration of the family and ancestors. In prominent or wealthy families this would take the form of the most original of the Roman arts – portrait sculpture, which was commissioned to honor and remember beloved and illustrious family members. This portrait sculpture showed the Roman era's keen interest in realism, with an intense attention to individual detail and in some cases a psychological insight into character. Early Roman portraits captured the rugged naturalism of republican Rome, when Romans proudly extolled the virtues of courage, patriotism, and hard work. The bust of Cicero (Fig. **4.23**) suggests the hard-headed realism and self-reliance of this leader of the republican era.

In fine Roman households, however, the primary decorative feature was often the walls themselves, which were decorated with lavish paintings in a variety of styles. A famous example is contained in the so-called Villa of the Mysteries (Fig. **4.24**) in Pompeii, named for the wall painting in its spacious dining room. The paintings apparently depict the reenactment of scenes from the life of the god Dionysus. Other wall paintings from the same period create elaborate architectural perspectives, probably to lend rooms a sense of spaciousness. Such pictures show that Roman artists could master large subjects, including

4.23 Bust of Cicero, 1st century B.C. Marble, life-size. Uffizi, Florence.
Inspired by the Romans' veneration of their ancestors, Roman sculptors excelled in portraiture. Here the late-republican orator and philosopher Cicero is portrayed as a man of principle and deep conviction.

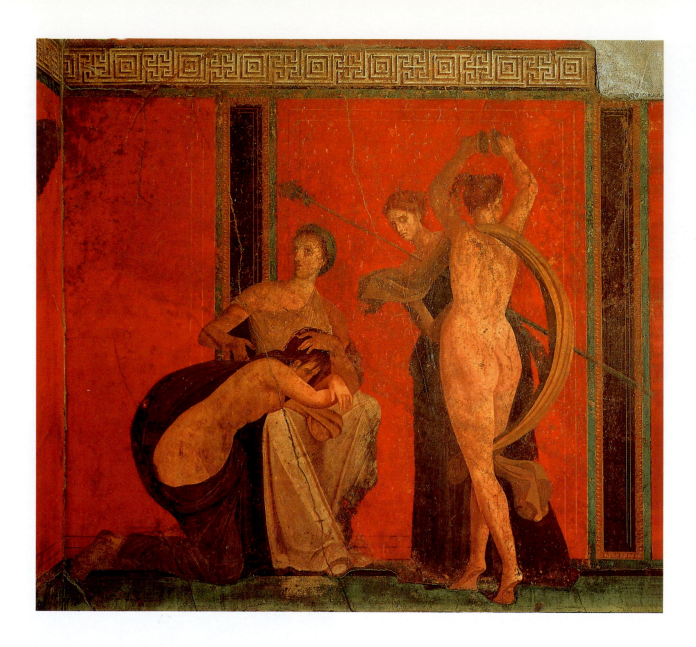

4.24 *The Dionysian Mysteries* (detail), Villa of the Mysteries, Pompeii, Italy, c. 60 B.C.
The scenes depict the rites of initiation into the cult of Dionysus. At right a nude worshiper of Dionysus dances ecstatically, while the initiate (left) prepares for a ritual flagellation. Another figure holds a *thyrsus*, the staff carried by Dionysus and his devotees.

the human figure. In general, however, wall paintings of this period were not pictorial masterpieces and were derived from superior Hellenistic examples. The Romans were more interested in pleasant domestic surroundings than in high standards of artistic beauty.

A minor Roman art related to painting was **mosaic**, pictures made from tiny bits of colored marble or ceramic cemented to a floor or wall. Like so many Roman arts, mosaic developed in ancient Greece and was avidly imported to Roman cities. Hellenistic designs often consisted of geometric patterns or mythological scenes. One of the most imitated pavement mosaics was the *Unswept Floor* (Fig. **4.25**), attributed to the Hellenistic artist Sosus. With his delicate bits of mosaic tile, Sosus created realistic effects such as the chicken's leg, the fish's skeleton, and the snail's shell. In later Rome, mosaic was used for the more exalted purpose of religious art.

4.25 Sosus, *Unswept Floor* (detail). Roman copy of Hellenistic original, 2nd century B.C. Mosaic. Vatican Museums, Rome. Like much Roman decorative art, this realistic floor mosaic was copied from an original by Sosus at Pergamon, the Hellenistic capital.

Roman Theater and Music

The ancient Romans considered public entertainment to be a birthright of the Roman citizen. In Rome itself, lavish public shows helped occupy the sometimes threatening masses of poor and unemployed. In the provinces, theater and sporting spectacles were a measure of the good life. Roman music was largely an accompaniment to theater, sport, and banqueting.

The origins of Roman drama lie probably in ancient religious dances. The development of a genuine theater,

however, began with the influx of Greek culture. The first Roman play with a plot was attributed to a Greek slave of the third century B.C., and nearly all known Roman plays, both comedy and tragedy, are derived from Greek originals. Comedy and tragedy coexisted in the Roman theater, although comedy was more popular, and both became important influences on later drama.

Romans borrowed their comedy directly from the comic theater of Hellenistic times, with its stock characters and slapstick comic devices. Audiences were well acquainted with Hellenistic comedy's misers, braggart soldiers, and good-hearted prostitutes. The first well-known Roman comic playwright was Plautus (c. 254–184 B.C.), whose plays apparently all followed Greek plots. Plautus [PLAH-tus] relied heavily on the comedy of exaggerated and absurd situations known as **farce**, a style that satisfied the Romans' taste for coarse humor. Roman audiences were known to ask for a performing bear show between acts of a play. Despite his audiences' low demands, Plautus's plays are still admired for their wit and literacy.

A more important innovator in Roman drama was Terence (193–159 B.C.), who developed character more fully than was usual in Hellenistic comedy. Terence instituted more complicated double plots, often revolving around mistaken identities. A favorite device was a boy and girl who think they are twins but still fall in love. In the final scene they are revealed as adopted orphans who are free to marry. Like his predecessors, Terence set his plays in Greece and used Greek characters – it was easier to mock the folly of the Greeks than that of his Roman audience. Terence's plays were widely read throughout the Middle Ages and frequently adapted: the medieval canoness Hrotsvit (see page 143) wrote Christianized versions of Terence's plays, and Shakespeare rather frankly borrowed one of Terence's plots in his *Comedy of Errors*.

The most important Roman tragedian was Seneca (c. 4 B.C.–A.D. 65), who adapted Greek stories by making them more sensational and moralistic. In Seneca's version of *Oedipus*, a pregnant Jocasta rips her incestuous offspring from the womb. Roman tragedy's gruesome plots appealed to the same coarse Roman tastes as comic farce. Its melodramatic exaggeration was, again, much imitated in the English theater of Shakespeare's era.

Under the Roman Empire, the popularity of relatively literate playwrights such as Plautus and Terence faded, to be replaced by bawdier theatrical entertainments. There was rugged competition for audiences in imperial Rome. Spectators were known to leave the theater in mid-performance to see a gladiator contest nearby. To keep the public's interest, playwrights and theaters turned to simpler dramatic forms such as **pantomime**, in which actors used no words. A pantomime might be performed entirely by one actor, accompanied by a chorus. Roman comedy incorporated elements of farce, the use of improbable situations, exaggeration, and physical horseplay to draw the audience's laughter. In the late empire,

theaters resorted to elaborate and often obscene spectacles. The excess of these displays led the early Christian Church to threaten to expel those believers who attended the theater. The Roman theater continued to decline, and in the fifth century barbarian emperors halted dramatic performances altogether.

Roman theaters (Fig. **4.26**) were often gigantic physical structures with multi-storied stages. Their auditoriums

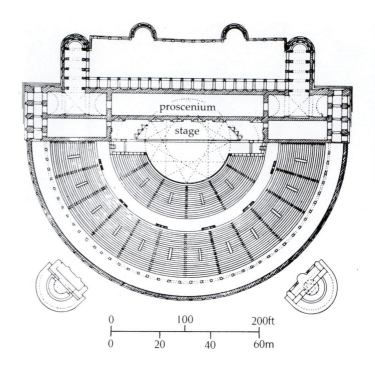

4.26 *(right)* Plan of the Theater of Marcellus, Rome, 23–13 B.C.
Besides conventional drama, Romans mounted elaborate spectacles, such as mock sea battles that required the theater or amphitheater to be flooded. Typically, stage and seating were joined to form a single, freestanding architectural unit.

4.27 *(below)* Roman theater at Aspendos, 2nd century. Reconstruction drawing of the *scaenae frons*.
The Roman stage's elaborate, two-storied *scaenae frons* was ornately decorated with pedimented niches, statues, and gilded columns and doors. The several doors allowed the stage to serve easily as a street scene, a common setting for Roman comedy.

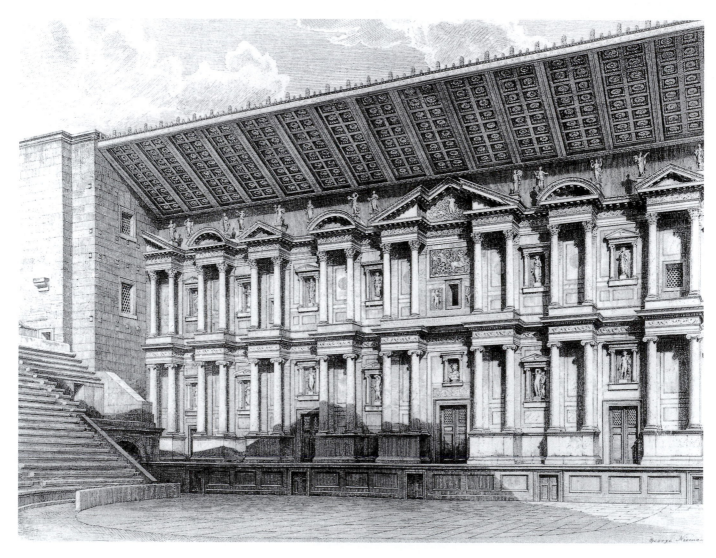

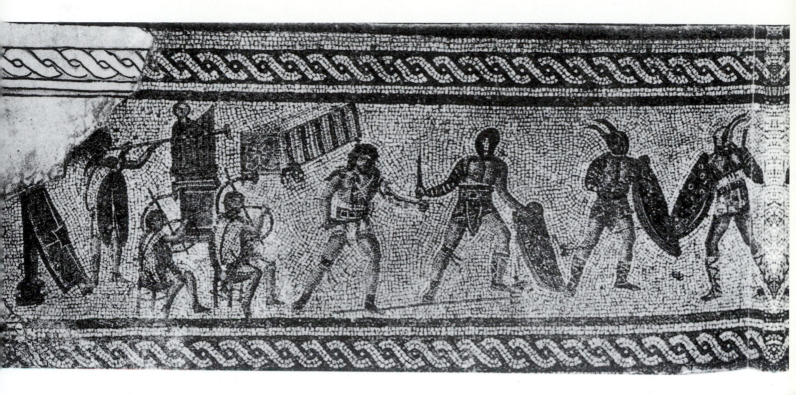

4.28 Gladiatorial contest, accompanied by orchestra. Mosaic from villa near Zilten, North Africa, c. 70. Museum of Antiquities, Tripoli. Roman public entertainment of the most deadly kind often involved musical accompaniment. Here, musicians perform on a long trumpet; two curved *corni* (horns); and a *hydraulis*, or organ.

could accommodate as many as 60,000 spectators. The stage was narrow and was raised several feet (1–2 m). Behind the stage, a façade called the *scaenae frons* [SAY-nay fronz] rose two or three stories high (Fig. **4.27**). By the first century B.C., some theaters were equipped with a curtain that was raised from a slot in the stage floor.

As with the Greeks, Roman tragic and comic actors wore masks and wigs. Masks were necessary in part because men played all the roles. Actors had little social standing and were often slaves, kept by their masters for entertainment.

Roman music and dance were strongly associated with bawdy entertainments and orgiastic banquets. The Romans almost certainly imitated the musical forms and instruments of Greek civilization. However, there is little evidence that they shared the Greeks' interest in musical theory. Like the Greeks, the Romans believed that music could have a great emotional effect on the listener. In fact, Roman orators were known to have musicians stand behind them and strike the desired tone at a particular moment in their speech. In their military processions Romans played a **tuba**, a long, straight trumpet, probably invented by the Etruscans. The Romans later also used a horn (Latin *cornu*) with circular tubing, something like today's French horn.

The most spectacular musical instrument used by the Romans was an organ called the *hydraulis* [high-DRAW-liss]. The *hydraulis* had a wide harmonic range and produced piercing tones, easily heard across the expanses of a Roman amphitheater (Fig. **4.28**). Christians later associated the *hydraulis* with religious persecution, which the Romans carried out as public entertainment and accompanied with music. Because of this stigma, the organ was banned from Christian churches for several centuries. The Romans also adapted versions of the Greek *aulos* (pipes) (see page 61) and the *cithara* [SITH-uh-ruh], a large twelve-stringed lyre. Such instruments were used to accompany poetry in the Greek fashion and were sometimes combined in orchestras for large-scale musical entertainments.

The Romans as Poets and Thinkers

Identify the principal achievements of Roman poetry and philosophy.

Like most other Roman arts, Latin poetry grew up under the powerful influence of Greek civilization. Still, the lyric poet Catullus and the epic poet Virgil created their own significant variations on Greek poetic forms. In poetic satire, Roman poets made their most unique contribution to the Western literary tradition. Roman philosophy was governed by the Romans' sense of the practical

and the necessary. From the diverse strands of Hellenistic Greek philosophy – especially Epicureanism and stoicism – the Romans took what best suited their national character.

Early Roman Poets

Poets in late republican Rome imitated the polished forms and meters of Hellenistic verse. Their poetic works circulated among an educated elite that was well versed in Hellenistic literature. The lyric poet Catullus (c. 84–c. 54 B.C.) was part of that elite, an urbane, versatile poet, who wrote a variety of wedding songs, elegies, and gossipy personal lyrics. He had studied the Greeks well – among his works is a translation of a fragment by Sappho (see page 44).

Catullus is best remembered as a love poet for the twenty-five poems concerning his love affair with "Lesbia," actually an aristocratic woman named Clodia. Catullus's poems frankly disclosed his feelings, from the foolish enthusiasm of new love to the final bitter recrimination.

> Enough, Catullus, of this silly whining;
> What you can see is lost, write off as lost.
> Not long ago the sun was always shining,
> And, loved as no girl ever will be loved,
> She led the way and you went dancing after.
> Those were the days of lovers' games and laughter
> When anything you wanted she approved;
> That was a time when the sun truly shone.
> But now she's cold, you must learn to cool;
> Weak though you are, stop groping for what's gone,
> Stop whimpering, and be stoically resigned.
> Goodbye, my girl. Catullus from now on
> Is adamant; he has made up his mind:
> He won't beg for your favor like a bone.
> You'll feel the cold, though, you damned bitch,
> when men
> Leave you alone. What life will you have then?
> Who'll visit you? Who'll think you beautiful? Who'll
> Be loved by you? Parade you as his own?
> Whom will you kiss and nibble then?
> Oh fool,
> Catullus, stop this, stand firm, become stone.[4]

CATULLUS
To an Unfaithful Lover

The poet Ovid [AHH-vid] (43 B.C.–A.D. 17) was banished from Rome in late life. His crime may have been to witness a sexual impropriety by the emperor's granddaughter. Ovid's poetic masterpiece was the *Metamorphoses*, a sprawling collection of stories from classical and Near Eastern sources. The *Metamorphoses* was a source for some of the best-known works of later European writers, including Geoffrey Chaucer's *Canterbury Tales* and William Shakespeare's *A Midsummer Night's Dream*.

Roman Epic and Satire

Under Caesar Augustus, Latin literature enjoyed its "golden age," in some forms equaling its Greek predecessors. Of course, the greatest Greek poems were Homer's epics, and the golden age produced Rome's answer to the *Iliad* and *Odyssey*. The great Roman epic was the *Aeneid* [ee-NEE-id], composed by the poet known as Virgil (70–19 B.C.). Virgil was already an established poet when he began the *Aeneid*, and had written poems celebrating traditional Roman values. With the *Aeneid*, he not only wrote a sprawling tale of passion and heroism but also served Augustus's propagandistic aim of justifying imperial power and predicting a future of peace and order.

The *Aeneid* (composed 29–19 B.C.) tells of Aeneas, a Trojan warrior who leaves his burning city to travel to Italy. Aeneas is destined to subdue Italy's hostile residents and blaze a glorious path for the Roman race. In his story, Virgil combines the themes of the *Iliad* (the story of a great war) and the *Odyssey* (the story of a hero's adventurous journey):

> This is a tale of arms and of a man. Fated to be an exile, he was the first to sail from the land of Troy and reach Italy, at its Lavinian shore. He met many tribulations on his way both by land and on the ocean ... [And] he had also to endure great suffering in warfare.[5]

The *Aeneid*'s unifying theme is destiny, and the poem bestowed upon Aeneas a destiny that anticipated Augustus's own. Roman tradition held that Aeneas was chosen by the gods to found the Latin race. In a similar way, Virgil's epic suggested that Augustus was destined to establish a great and peaceful world empire. Virgil skillfully weaves the history of Rome into the legendary account of Aeneas. In his journey, Aeneas continually glimpses the spirits of Rome's future heroes and the scenes of future Roman victories. His destiny is to inaugurate a history that Augustus will bring to completion.

The epic's most famous and touching episode is Aeneas's encounter with the passionate Queen Dido [DYE-doh], which stirs a conflict between Aeneas's

CRITICAL QUESTION

Do you believe that destiny controls some part of your life's course? The life of your family? Or nation? Discuss the ways that destiny might affect the course of a career, love, war, politics, and history.

destiny and his personal desires. Dido is the widowed queen of Carthage, in northern Africa, where Aeneas has been shipwrecked. Aeneas succumbs to his desire for the queen, but after a year, is reminded by the gods of his destiny to reach Italy. As Aeneas's ships sail from Carthage, Dido curses him from atop a funeral pyre. Her wretched death would inspire artists and composers for 2,000 years.

> Terrible Spirits of Avenging Curse! Angels of Death awaiting Elissa! All of you, hear me now. Direct the force of your divine will, as you must, on the evil here, and listen to my prayer. If that wicked being [Aeneas] must sail surely to land and come to harbor, because it is the fixed and destined ending required by Jupiter's own ordinances, yet let him afterwards suffer affliction in war through the arms of a daring foe, let him be banished from his own territory, and torn from the embraces of Iulus [Aeneas' son], imploring aid as he sees his innocent friends die, and then, after surrendering to a humiliating peace, may he not live to enjoy his kingdom in days of happiness; but may he lie fallen before his time unburied on a lonely strand. That is my prayer and my last cry, and it comes from me with my life-blood streaming.[6]

<div align="right">

VIRGIL
Aeneid, Book IV

</div>

Roman Satire In one literary form, the Romans claimed superiority over the Greeks. They excelled in verse **satire**, the artistic form that wittily ridicules human folly or vice, often with the aim to improve individuals or society. One of Rome's greatest satirists was Horace (65–8 B.C.), a contemporary of Virgil's. He wrote two books of satires in the mid-30s B.C., adopting a casual style and avoiding the mockery of individuals. One satire recounts a journey with friends (including Virgil), while another tells humorously of his attempts to escape a boorish friend. Horace's most famous satire compared the virtues of city and country life, ending with the well-known fable "The Town Mouse and the Country Mouse." Horace himself preferred country living and retired to an estate given him by a patron. His satires and other writings (including a famous essay on the art of poetry) would become perhaps the most widely read literature of ancient Rome.

In contrast to Horace's gentle manner, the satires of Juvenal [JOO-vuh-null] (c. A.D. 55–c. 127) are savagely ironic in their criticism of Roman life. Juvenal attacks the corruption and hypocrisy of Roman society at the height of its wealth and self-indulgence. Few aspects of Roman society escaped Juvenal's satirical whip: sexual depravity; the extravagant banquets of the rich; the influence of Greek immigrants; the folly of tyrannical emperors. In this passage, he asks what employment he might find in a city perverted by patronage and deceit:

> What should I do in Rome? I am no good at lying.
> If a book's bad, I can't praise it, or go around ordering
> copies.
> I don't know the stars; I can't hire out as assassin
> When some young man wants his father knocked off for a
> price; I have never
> Studied the guts of frogs, and plenty of others know better
> How to convey to a bride the gifts of the first man she
> cheats with.
> I am no lookout for thieves, so I cannot expect a
> commission
> On some governor's staff. I'm a useless corpse, or a cripple.
> Who has a pull these days, except your yes men and
> stooges
> With blackmail in their hearts, yet smart enough to keep
> silent?
> . . . Never let the gold of the Tagus,[a]
> Rolling under its shade, become so important, so precious
> You have to lie awake, take bribes that you'll have to
> surrender,
> Tossing in gloom, a threat to your mighty patron forever.[7]

<div align="right">

JUVENAL
From the Satires

</div>

a. Tagus, a river in Spain and Portugal.

Juvenal's mockery reaches a climax in the famous tenth satire, where he exposes the vanity of human desire for wealth and fame. His call for a life of patient humility would be echoed by the Renaissance satirist Erasmus and the satirical geniuses of eighteenth-century Europe.

Philosophy in the Roman World

As in so many other areas, Roman philosophy was at first largely derived from Hellenistic Greek teachings (see page 65). A most important figure in this transmission was the versatile rhetorician and politician Marcus Tullius Cicero (106–43 B.C.; see Fig. 4.23), who adapted Greek stoic thought in his writings on happiness and the nature of the gods. Cicero's unmatched achievement was in the stylish speeches composed as he strove to save Rome's republic from dictatorship. Cicero's speeches were the Roman works most widely studied and admired in later eras.

A less popular but no less important work from the republican era was the didactic poem *De rerum natura* (*On the Nature of the Universe*), written in Latin by the poet Lucretius [loo-KREE-shus] (98–c. 55 B.C.). Lucretius's poem elaborated Epicurean thought in the classical world's most systematic work of philosophical materialism. Lucretius's description of the movement and collision of atoms as they combine to form the physical universe had a moral purpose. He hoped to relieve his readers of their guilt and the fear of death. The gods have

The Rise of Buddhism

By the force of its imperial might, Rome spread through the Western world two religions: first, its public religion of grand temples and sacrifices to Greco-Roman deities, and then the Near Eastern faith of Christianity adopted in the fourth century. In Asia, military conquest led to the rise of a different faith, the Buddhist teaching of withdrawal from family and public life, in the effort to achieve a detached enlightenment.

It was the Indian conqueror Ashoka (ruled c. 270 B.C., the time of the Hellenistic empire and Rome's first Punic War) who renounced his brutal military expansionism and declared universal religious tolerance throughout his empire. Ashoka encouraged Buddhist missionaries to carry the faith into southeast Asia (especially present-day Thailand and Cambodia).

Buddhism is rooted in the life and teaching of Siddhartha Gautama [sid-DAR-tuh GOW-tuh-muh] (c. 560?–480? B.C.),

known as the **Buddha** [BOO-duh], meaning "the enlightened one." According to Buddhist tradition, the young prince Gautama was perplexed by the problem of human suffering (in Pali, *dukkha*). Leaving his family and royal obligations, he sought the advice of Hindu sages, who counseled him to fast and meditate. But this asceticism brought no satisfaction. Finally, while sitting under a tree (the *bo* tree), Gautama attained enlightenment (*bodhi*) – a perfect understanding of the middle way between desiring and self-denial. The Buddha entered upon a life of preaching, showing by example and teaching how others might achieve enlightenment (Fig. **4.29**).

The Buddha's forceful and confident teaching (called the *dharma*) is summarized in the "Four Noble Truths," his fundamental assertions about the nature of existence:

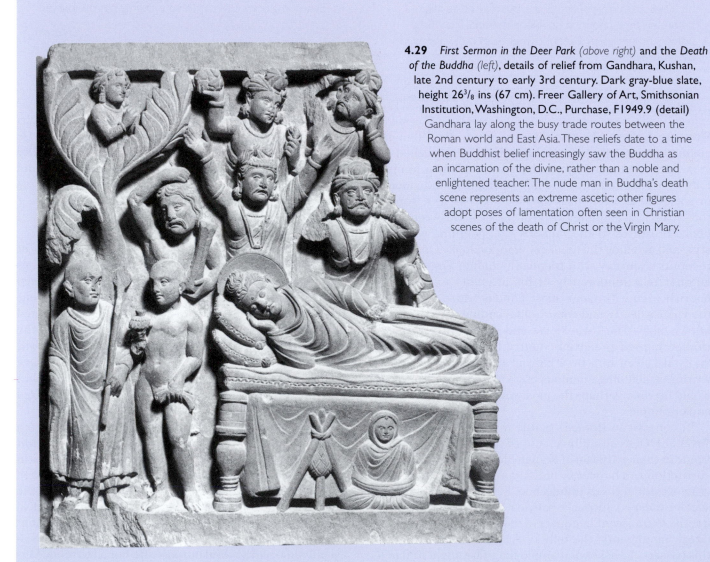

4.29 *First Sermon in the Deer Park* (above right) and the *Death of the Buddha* (left), details of relief from Gandhara, Kushan, late 2nd century to early 3rd century. Dark gray-blue slate, height 26³⁄₈ ins (67 cm). Freer Gallery of Art, Smithsonian Institution, Washington, D.C., Purchase, F1949.9 (detail)
Gandhara lay along the busy trade routes between the Roman world and East Asia. These reliefs date to a time when Buddhist belief increasingly saw the Buddha as an incarnation of the divine, rather than a noble and enlightened teacher. The nude man in Buddha's death scene represents an extreme ascetic; other figures adopt poses of lamentation often seen in Christian scenes of the death of Christ or the Virgin Mary.

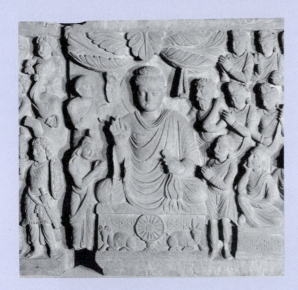

- life is permeated by suffering (*dukkha*);
- suffering originates in selfish craving or grasping;
- suffering can be ended by the cessation of craving or desire, including the craving for enlightenment;
- the way to cessation of craving lies in a discipline of mindfulness and ethical living.

Much like Roman stoicism, the Buddha's philosophy counseled followers to minimize their bodily and material desires and to concentrate on that which lay within the individual's own power. And like Aristotle's ethical philosophy (see page 64), Buddhism marked a path between the extremes of striving and detachment, the so-called "middle way." Buddhists pursued this aim by a discipline called the Eightfold Path, requiring clarity of mind, measured action, and a regimen of meditation. Along this path, the dedicated believer might attain enlightenment and, at death, be released from the cycle of rebirth. This release brought the ultimate state of tranquillity called *nirvana* – the extinction of both being and non-being.

The teachings of Gautama Buddha in southern Asia, Confucius in eastern Asia, and Socrates and Plato in the Mediterranean world – roughly the period 600–400 B.C. – mark a revolutionary turn in human thinking. Philosophers have called it the Axial Age – the emergence of a new kind of ethical thinking that focused on individual action and integrity, rather than mythic heroes and ritual obligation. Yet it must be remembered that these new ideas were often spread by military domination and, as with Buddhism in the time of early Rome, imposed by imperial patronage or decree.

no power over our lives, he advised, and so cannot punish humans for our impiety. As for death, Lucretius wrote:

Suppose that Nature herself were suddenly to find a voice and round upon one of us in these terms: "What is your grievance, mortal, that you give yourself up to this whining and repining? Why do you weep and wail over death? If the life you have lived till now has been a pleasant thing – if all its blessings have not leaked away like water poured into a cracked pot and run to waste unrelished – why then, you silly creature, do you not retire as a guest who has had his fill of life and take your carefree rest with a quiet mind? Or, if all your gains have been poured profitless away and life has grown distasteful, why do you seek to swell the total? The new can but turn out as badly as the old and perish as unprofitably. Why not rather make an end of life and labor? Do you expect me to invent some new contrivance for your pleasure? I tell you, there is none. All things are always the same. If your body is not yet withered with age, nor your limbs decrepit and flagging, even so there is nothing new to look forward to – not though you should outlive all living creatures, or even though you should never die at all." What are we to answer, except that Nature's rebuttal is justified and the plea she puts forward is a true one?[8]

LUCRETIUS
From On the Nature of the Universe

Though he advised, "We have nothing to fear in death," Lucretius was not entirely consoled. He admitted that his resolute materialism was not able to still this "deplorable lust of life that holds us trembling in bondage to such uncertainties and dangers."[9]

For all its intellectual clarity, Epicureanism did not spread far in the Roman world. Epicureans violated Roman convention by welcoming slaves and women as members and by counseling withdrawal from social life and civic duty. Epicureanism survived mainly through the eloquence and rigor of Lucretius's *De rerum natura*.

Educated Romans were more easily drawn to the Hellenistic philosophy of stoicism, which taught that one must do one's duty, practice moral virtue, and submit to a divinely ordered destiny. Roman stoicism developed through several stages from its origins in Hellenistic philosophy (see page 65). As the Roman republic was replaced by imperial authority, stoicism became a medium for patrician resistance to the power of emperors.

Rest assured that we have nothing to fear in death. One who no longer is cannot suffer, or differ in any way from one who has never been born.

Lucretius, *On the Nature of the Universe*

One stoic philosopher, having angered the emperor Nero, was commanded to commit suicide and impassively complied. It was Nero's former slave Epictetus (c. 55–c. 135) who best embodied the moral philosophy of Roman stoicism. Epictetus declared for the brotherhood of all humanity and called on his followers to be "citizens of the world" (see Key Concept, page 78). Even a slave, who had no bodily freedom and who suffered his master's beatings, could be happy if he adopted a stoic detachment from events that he could not control. In this regard, stoicism broke with the Aristotelian ideal of happiness, which required a minimum of freedom and physical comfort.

Ironically, the stoic Roman character was finally revealed in the writings of the emperor Marcus Aurelius (ruled 161–180; Fig. 4.30). During the military campaigns that occupied the last ten years of his reign, Marcus Aurelius wrote twelve books of *Meditations* in the form of diary entries, possibly written in a military

4.30 Equestrian statue of Marcus Aurelius (ruled 161–180). Gilded bronze, height 16 ft 8 ins (5.1 m). Capitoline Museums, Rome.
This official statue of the stoic emperor confirms the Romans' interest in realistic portraiture. The honesty and critical self-examination of Marcus's philosophical writings are all the more notable when one remembers that the empire's inhabitants honored him as a god.

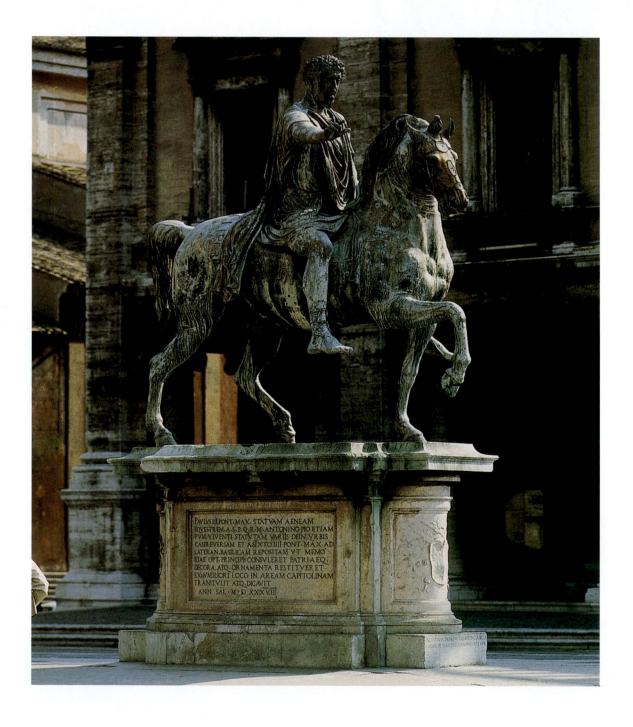

tent while his soldiers slept and tapers flickered in the breeze. In these surroundings, Marcus exhorted himself to act always with reason and restraint, to recognize the limit of his power over others, and to accept the necessity of death.

In the *Meditations*, Marcus Aurelius described a universe unified by a single natural law, the law of reason that governed all creatures. A human's most important task was to understand and obey this law of reason:

All things are interwoven with one another, and the bond which unites them is sacred; practically nothing is alien to anything else, for all things are combined with one another and contribute to the order of the same universe. The universe embraces all things and is one, and the god who pervades all things is one, the substance is one, the law is one, the Reason common to all thinking beings is one, the truth is one, if indeed there is one perfection for the kindred beings who share in this selfsame Reason.[10]

MARCUS AURELIUS
From The Meditations, Book VII

Even an emperor had to practice a disregard for the wrongs of others who harm only themselves. "I do my duty," he wrote; "other things do not disturb me." He assured his happiness by limiting personal desires, relying only on himself, although such happiness was gained at the cost of indifference to others' suffering.

The *Meditations'* tone of self-admonishment sometimes resembles the self-help manuals so popular today, as Marcus reminds himself to concentrate his energies on the present moment. True to the stoic belief, his emphasis was always on duty, surely an admirable moral guide for any ruler: "Firmly, as a Roman and a man should, think at all times how you can perform the task at hand with precise and genuine dignity, sympathy, independence, and justice, making yourself free from all other preoccupations."[11]

Rome's Division and Decline

The last centuries of the Roman Empire were marked by increasing division and a decline of the empire's cohesion. Diocletian [dye-oh-KLEE-shun] (ruled 284–305) recognized that the empire had grown unwieldy, and for administrative purposes divided it into eastern and western sections. Diocletian himself abdicated the imperial throne, and withdrew in retirement to a palace-fortress he had built at Spalatum on the Adriatic Sea (now Split, in present-day Croatia). The vigorous classicism still visible in Marcus Aurelius's portraits also was transformed. Sculptors reverted to a more formulaic representation of the human figure.

Rome itself, though sapped by corruption, remained the center of Mediterranean civilization. The first Christian emperor, Constantine, was to build a new capital in the east, but even in the Christian era, the city of Rome would remain the psychic center of Western civilization and eventually become the new capital of Western Christianity. All roads still led to Rome, and for centuries pilgrims of all religious and intellectual stripes would feel compelled to journey to the great city and taste of its spiritual riches.

CHAPTER SUMMARY

The Drama of Roman History Rome began its rise as a world power with the overthrow of Etruscan domination and the founding of the Roman republic. In the republican era (509–90 B.C.), Romans devoted themselves to military conquest and the resolution of internal conflicts. From 90 to 31 B.C., a period of civil war convulsed Rome, climaxing in the rise of Julius Caesar. His nephew Octavian finally established himself as the all-powerful Caesar Augustus, absolute ruler of a Roman Empire that reached its height during the Pax Romana (27 B.C.–A.D. 180).

The Art of an Empire Augustus's reign gave rise to an art dedicated to the glorification of empire. Borrowing from the styles of classical and Hellenistic Greece, imperial art celebrated the power and achievements of Rome's emperors. Augustan sculpture served as effective artistic propaganda, while the Forum of Trajan and its famous Column of Trajan were the ultimate imperial monuments. The splendor of ancient Rome depended on Roman architects' skill in the use of concrete and the arch. By combining the arch in vaulting, Roman builders created spacious and luxuriously decorated interiors. The most common types of buildings – baths, basilicas, amphitheaters – illustrated the Romans' interest in architecture's utilitarian value. Rome's most perfect building, however, was the domed Pantheon.

Roman Art and Daily Life Roman daily life encouraged the development of the arts of wall painting, mosaic, and portrait sculpture. Roman life can be reconstructed from the remains of the city of Pompeii, entombed in A.D. 79 by a volcanic eruption, and uncovered many centuries later by enthusiastic antiquarians. Pompeii's wall paintings and mosaics demonstrate the influence of Greek artists and the Roman preference for pleasant surroundings. Their portrait sculpture served the veneration of elders and showed a realistic insight into individual character.

In theater, Romans preferred the entertainment of comedy to tragedy's serious tone. Roman comedies were adapted from Hellenistic drama, and, similarly, the Roman theaters, with their tall architectural backdrops, were adaptations of Hellenistic ones. The playwrights Plautus and Terence perfected a comedy of complicated plots and stock characters. Roman music and dance were a professional affair, used to accompany military parades, entertainments, and banquets.

The Romans as Poets and Thinkers Roman poets borrowed liberally from Greek authors in the republican period, when the lyric poet Catullus wrote a candid cycle of love poems. Virgil's epic poem, the *Aeneid*, rivaled the works of Homer in its nobility of theme. Virgil's story of the Trojan hero Aeneas connects Rome's heroic past with its historic destiny to rule the world. In satirical verse the Romans surpassed their Greek predecessors, especially in Juvenal's *Satires*, which bitterly exposed the corruption and excesses of imperial Rome.

Roman philosophy was indebted to the Greeks but also reflected the clear-headed resolve and patriotic duty that Romans prized. The Epicurean Lucretius composed an eloquent statement of philosophical materialism, reassuring Romans that life was ruled by chance and ended in nothingness. The stoic Epictetus, a former slave, exhorted his followers to act as citizens of the world, while in his *Meditations* the stoic emperor Marcus Aurelius exhorted himself to do his duty and disregard anything beyond his immediate control.

By the third century, division and decline began to plague Rome's empire, up to then the largest and greatest of the Western world.

5 The Spirit of Monotheism: Judaism, Christianity, Islam

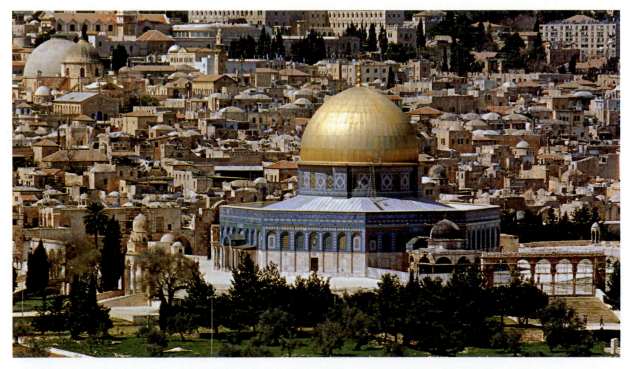

5.1 The Dome of the Rock, Jerusalem, late 7th century.

In Jerusalem, Muslim rulers and architects intended this splendid shrine and its companion mosque to rival the great churches of Jerusalem built by Constantine and his successors. The gilded dome encloses the rock where Jews believed Abraham prepared to sacrifice Isaac and where Muslims held that Muhammad ascended to visit heaven.

In the year 120, when the emperor Hadrian built the Pantheon, the great dome symbolized the unity of a cosmos that was inhabited by many gods. Five centuries later, when a Muslim ruler built the Dome of the Rock at the center of Jerusalem, its dome symbolized the one true God who ruled all things. The idea of a single, supreme, and all-powerful god – the spirit of **monotheism** – arose in a minor Near Eastern people called the Hebrews or Jews. From Jewish monotheism, however, grew two other great monotheistic religions, Christianity and Islam, each of which, by the year 750, had converted or subdued the peoples of the ancient classical world. What we know as Western civilization today grows from two roots: the classical spirit of ancient Greece and Rome, and the monotheistic spirit of Judaism, Christianity, and Islam.

The Judaic Tradition

Summarize the essential religious ideas of the Jewish people and their sacred scripture, the Hebrew Bible.

Beginning in the fourth century, the Roman Empire was transformed by its conversion to the new Christian religion. To understand the causes of this transformation, we retrace our steps to the ancient Near East, to the time of ancient Egypt, Babylon, and Persia. The Christian faith that would conquer Rome was rooted in the religious ideas of the ancient Israelites (also known as Hebrews or Jews). Few nations or peoples with so small a population as ancient Israel have so greatly influenced Western civilization. The Israelites' belief in one all-powerful God is the cornerstone of modern Judaism, Christianity, and Islam, the faiths that would dominate the Western world.

Politically and culturally, the Israelites were a minor nation of the ancient Near East. They shared the fates of other small nations in the region, suffering domination by the great powers of Egypt and Mesopotamia. Religiously, however, the Israelites were unique: they rejected their neighbors' polytheism and embraced monotheism, devoting themselves to one God, who acknowledged them as his chosen people. The special relationship between the Israelite nation and its God was chronicled in the Hebrew Bible, a masterpiece of religious literature that has infused Western civilization with many of its values and much of its wisdom.

> I the LORD am your God who brought you out of the land of Egypt, the house of bondage: You shall have no other gods besides Me.
>
> God to Moses on Mount. Sinai, Exodus 20:2–3

HISTORY OF THE ISRAELITES

12th century B.C.	**Settlement in Canaan**
	Biblical battle of Jericho
1000–922 B.C.	**United monarchy**
	Kings David, Solomon; first temple at Jerusalem
922–722 B.C.	**Divided monarchy**
	Division into northern and southern kingdom; much of Torah written and compiled
722–587 B.C.	**Assyrian conquest**
	Assyrians conquer northern kingdom; prophets active
587–c. 450 B.C.	**Babylonian exile**
	Destruction of Solomon's temple; forced exile
539–332 B.C.	**Restoration**
	Persians permit return to Jerusalem; Second Temple built 539–516 B.C.
332–63 B.C.	**Hellenistic**
	Hellenizing of Jews throughout Near East
65 B.C.–A.D. 135	**Roman**
	Roman army sacks Jerusalem and destroys temple (A.D. 70)

History and the Israelites

By the historical and archaeological evidence, the origins of the ancient Israelites are obscure. The Israelites' own epic account of their beginnings, as told in their Bible, is a stirring tale of trials and triumph. Tradition holds that Abraham was the first **patriarch**, or chieftain, and founder of the Israelite nation. According to the same tradition, the patriarch Moses led the Israelites in a dramatic exodus from Egypt (dated perhaps 1250 B.C.), which the Israelites interpreted as God's delivering them from their captors and tormentors. The exodus was triggered when God's angel of death visited the last of seven plagues upon the Egyptians, slaying their first-born children but sparing those of the Israelites. With Moses leading them, the Israelites fled into the Sinai desert, where he received directly from God the Ten Commandments that pious Israelites must obey. The first commandment established the principle of monotheism: "You shall have no other gods besides Me," commanded Yahweh (see Key Concept, page 101). In reward for their obedience to the law, God

5.2 Solomon's Temple, Jerusalem, c. 950 B.C. (reconstruction). Sacrifices at the temple of Solomon were the center of Israelite religious piety; the temple's destruction by a Babylonian army in 587 B.C. caused a national and religious crisis. The temple's innermost chamber, called the Holy of Holies, housed the Ark of the Covenant, a vessel containing artifacts of the divine law given to Moses.

pledged to the Israelites that they would settle in the land of Canaan (today's Israel and Palestine). In keeping the law of Moses and Hebrew ritual, the Israelites celebrated and affirmed their covenant with God.

By the 900s B.C., the Israelites' tribal egalitarianism had evolved into a monarchy. The uniting of Israel's tribes under a king marked the high point of the Israelites' national history. Their first great king was David (ruled c. 1000–961 B.C.), who centralized Hebrew worship at his court in Jerusalem. David was himself a talented musician and developed a liturgy of psalms of praise to God. King Solomon (ruled 961– 922 B.C.) consolidated and expanded the Israelites' power in a splendid reign, remembered by many Jews as a golden age. Solomon built an elaborate temple at Jerusalem, employing artisans and religious symbols from neighboring cultures. The temple and its replacement, destroyed in Roman times, are still the focus of Jewish devotion and nationalism today (Figs. **5.2**, **5.3**). Biblical authors would judge the righteousness of the Israelites by the righteousness of their king.

In the centuries after Solomon's reign, the Israelite kingdom declined and in 587 B.C. suffered an invasion by a Babylonian army that razed the temple and forced many Israelites into exile. The years of exile (587–c. 450 B.C.) had an immense cultural effect on the Israelites. They adopted a new calendar and a new language (Aramaic), and came to be called **Jews**, from the Aramaic name for

5.3 Jews praying at the Western Wall, Jerusalem. This foundation is all that remains of the Second Temple at Jerusalem, built in the sixth century B.C. and destroyed by a Roman army in the year 70. The Western Wall is contemporary Judaism's most sacred site, the physical reminder of Jews' national history and identity.

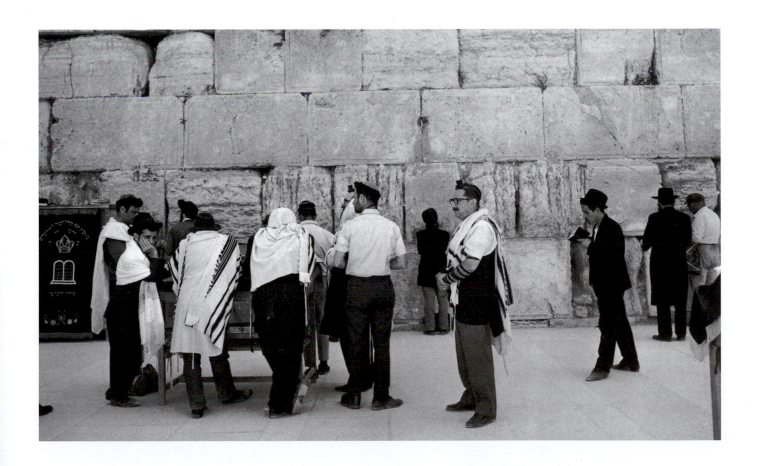

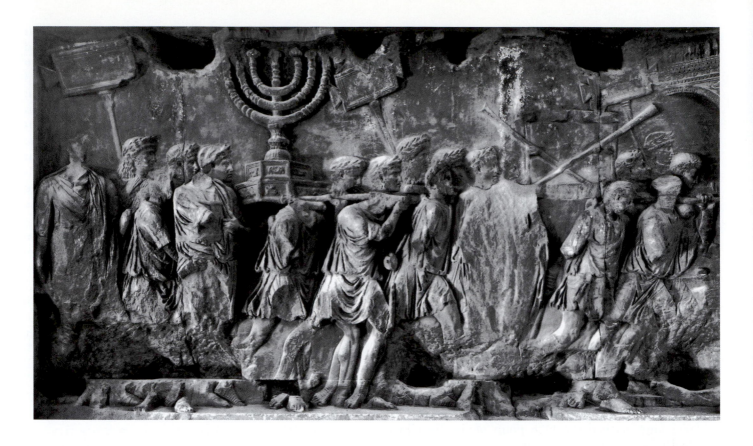

5.4 *The Spoils of Jerusalem*, relief from the Arch of Titus, Rome, c. 81. Marble relief, height 6 ft 7 ins (2 m).
Roman soldiers sacking Jerusalem in the year 70 carry off the menorah, the seven-branched candelabrum that is now a national symbol of Israel. The Second Temple's destruction profoundly disrupted Jewish religious life; out of the ensuing crisis emerged both rabbinical Judaism and the new Christian faith.

their homeland. Their religion absorbed elements from Babylonian and Persian belief, such as the notion of a Satan, an evil force opposing God. The Israelites interpreted the Babylonian exile in the same way as they did other national calamities, as God's punishment for their unfaithfulness.

Some Jews eventually returned to Palestine after the Persian conquest of Babylonia, but suffered successive domination by the Hellenistic and Roman empires. The rebuilt temple at Jerusalem was refurbished grandly by King Herod the Great (died 4 B.C.). However, repeated Jewish insurrections incited the Romans to storm Jerusalem in A.D. 70 (Fig. **5.4**). The temple was again destroyed and, following a second war from 132 to 135, the Romans forced the Jews to leave Judea – their homeland and religious center – an action known as the Diaspora [dye-ASS-por-uh], or "dispersion." Wherever they settled, most Diaspora Jews lived as a religious and cultural minority, resolutely preserving their language and faith in spite of frequent persecution.

The Hebrew Bible

The Israelites' God, named Yahweh [YAH-way], was present to them through his holy scripture, the compilation of history, poetry, and wisdom that is called the Hebrew Bible. The Hebrew Bible (from the Greek *biblos*, or "book") served much the same function for the Israelites as the Homeric epics did for the Greeks. The Bible was a stock of story and wisdom that was transmitted orally for centuries before being written down sometime after 1000 B.C.

The Israelites divided their scriptures into three major parts. The first five books constituted the Torah, or "instruction," a history of the early Israelite nation. The Prophets comprised writings of charismatic leaders such as Isaiah and Jeremiah, who reminded Israelites of their duty to God. Finally, the Writings included psalms and other wisdom literature.

The Hebrew Creation The Hebrew Bible's power and complexity are evident in the first chapters of Genesis, the two accounts of the creation (Genesis 1–3:24). The creation stories illustrate an important difference between the Hebrew God and his pagan counterparts – the Hebrew God was no longer associated with particular locales and aspects of nature, he was the original author of the world, the source of all creation, whose power was universal.

The first Genesis story (1–2:3) tells of a majestic creation that spans six days. Biblical scholars believe this story was written by Israelite priests during the Babylonian

exile, after they had heard other creation myths on the same grand scale. In this account, God's creation progresses from a primal world of nothingness to an orderly hierarchy of all creatures. Here, the creation of humanity is a generic, universal act in harmony with the story's tone. Human beings form the capstone of God's universe, the pinnacle of a divinely fashioned order:

> Then God said, "Let us make man in our image, after our likeness; and let them have dominion over the fish of the sea, and over the birds of the air, and over the cattle, and over all the earth, and over every creeping thing that creeps upon the earth." So God created man in his own image, in the image of God he created him; male and female he created them. And God blessed them, and God said to them, "Be fruitful and multiply, and fill the earth and subdue it; and have dominion over the fish of the sea and over the birds of the air and over every living thing that moves upon the earth."[1]

GENESIS 1:26–28

The second Genesis story (2:4–3:24) is attributed to a biblical author called the Jahwist, who typically wrote with drama and economy. The Jahwist recounted the memorable episode that proved so influential in Judeo-Christian civilization – the story of Adam and Eve. God forbids Adam and Eve, without explanation, to eat of the tree of the knowledge of good and evil. A serpent appears to tempt Eve to taste of the forbidden fruit and its powers.

> He [the serpent] said to the woman, "Did God say, 'You shall not eat of any tree of the garden'?" And the woman said to the serpent, "We may eat of the fruit of the trees of the garden; but God said, 'You shall not eat of the fruit of the tree which is in the midst of the garden, neither shall you touch it, lest you die.' " But the serpent said to the woman, "You will not die. For God knows that when you eat of it your eyes will be opened, and you will be like God, knowing good and evil."[2]

GENESIS 3:1–5

KEY CONCEPT

Monotheism

The Israelites gave the Western religious tradition the unique concept of **monotheism**, the belief in one all-powerful and beneficent god. The Hebrew Bible describes the Israelite God as an all-powerful enigma, the author of all creation, yet himself un-created. Through Moses, God prohibited his followers from representing him in statues and even declined to be named directly. The Israelites called him originally by the sacred consonants YHWH, pronounced as "Yahweh." Despite these mysteries, the faithful believed God revealed himself again and again, commanding their obedience and rewarding their righteousness.

God's most important revelation was the Ten Commandments, which Moses received on Mount Sinai and which became the basis for all Hebrew law. The Commandments established the leading principles of Israelite tribal life. The first was a principle of universal justice, that all humans were governed by one divinely sanctioned law. From this followed a second principle, that all humans (or at least all Israelites) were equal before God's law and worthy in God's sight. Compared to the strict class societies of the ancient world, the Israelites were notably egalitarian, and believed that the principles of their society obliged them to treat the poor and unfortunate with kindness and generosity.

Hebrew moral teachings may be summarized as ethical monotheism, the belief that obedience to God's law implies righteous action in all aspects of moral life. Any sin is disobedience to God and deserves divine punishment. These ethical ideas were developed in later Christianity and Islam. The Hebrew ethical tradition differed significantly from the ethics of Aristotle and other classical philosophers, who believed moral conduct lay in a balance between extreme actions. For the Hebrew tradition, moral conduct lay in rigorous obedience to God's command.

In the ancient world, Hebrew monotheism offered a powerful religious alternative to the dominant polytheism. But monotheism also generated some perplexing theological questions. For example, if God was the source of all things, was he therefore the origin of evil? If God could intervene in history, then why did he not halt war and catastrophes? How did one judge among the religions that each claimed to obey the God of Abraham? Such questions still confront the heirs of Hebrew monotheism: modern-day Jews, Christians, and Muslims. Like the ancient Israelites, modern believers still struggle to understand God's mysterious power and obey his stringent law.

CRITICAL QUESTION

What, in your opinion, is the ultimate cause of evil in the world? How might this cause be reconciled with the belief in a benevolent and all-powerful God?

THE HEBREW BIBLE

The Torah	The Prophets	The Writings
Genesis	Joshua	Psalms
Exodus	Judges	Proverbs
Leviticus	1st & 2nd Samuel	Job
Numbers	1st & 2nd Kings	Song of Songs
Deuteronomy	Isaiah	Ruth
	Jeremiah	Lamentations
	Ezekiel	Ecclesiastes
	Twelve Minor	Esther
	Prophets	Daniel
		Ezra
		Nehemiah
		1st & 2nd
		Chronicles

Adam and Eve succumb to temptation and suffer expulsion from the Garden of Eden. God declares that as punishment Eve will suffer the pain of childbirth and Adam the toil of labor.

The Jahwist's story illustrates what the Israelites believed was humanity's most fundamental failing: the disobedience of God's command. Yet the story also contains essential themes found in the myth and legend of the ancient world. In Adam and Eve, we see the human interest in moral knowledge, the desire to escape death, and the violation of a divine taboo, all common themes of ancient myth. These Hebrew creation stories are not only models of concise storytelling – they also echo the most potent ideas of ancient literature, from the Greeks' Oedipus legend to the Egyptian tales of the afterlife.

The God of the Covenant Most of the Hebrew scriptures recount God's relationship with his chosen people, the Israelite nation. The Israelites viewed this special bond as a covenant, or agreement, between God and themselves, whereby the Israelites were bound to obey God's law, while God promised to favor and defend his chosen nation. Much of the Torah was devoted to a historical account of this troubled but indissoluble bond between God and Israel. Thus, in the Hebrew Bible, religious faith and national history overlap.

The Israelites' covenant with God was confirmed by decisive moments in their history. One such moment was Abraham's sacrifice of Isaac (Genesis 22), in which God commands the aged patriarch Abraham to sacrifice his favored son. Proving his complete obedience to God, Abraham holds the knife to Isaac's throat before God's angel intervenes and halts the killing. Throughout their history, the Israelites celebrated and affirmed the covenant with God in religious ritual. Even today at Passover, for example, modern Jews commemorate an incident from the Egyptian captivity, in which God's angel of death slew the Egyptians' first-born children but spared those of the Israelites.

God's command to moral righteousness was enforced by **prophets** (in Hebrew *navi*), who were fervent mouthpieces of divine judgment. Israelite prophets often opposed the official cult of priests and the temple, criticizing ritualized observance of the law. Prophets such as Isaiah and Jeremiah stressed inner obedience to God and the creation of a just society. The prophets frequently predicted a future of redemption, as in Isaiah's famous saying, "And they shall beat their swords into plowshares, and their spears into pruning hooks; nation shall not lift up sword against nation, neither shall they learn war any more" (Isaiah 2:4).

Job and the Trials of Israel

The trials of the Israelite nation were symbolically represented in the story of Job – a righteous man, once favored by God, who loses his family and fortune through a series of calamities. The Book of Job, dated somewhere between 600 and 400 B.C., is one of the Hebrew Bible's most richly poetic books and compares the humans' narrow moral viewpoint with the immense majesty of God's power. Three friends come to console Job, plying him with the conventional wisdom of Hebrew morality. One says Job must have sinned greatly to deserve so terrible a punishment from God; another proposes that Job's suffering is a test of his faith and that he will be rewarded in the end. Convinced of his own righteousness, however, Job demands that the Almighty show him the nature of his sin. God answers Job but refuses to justify himself in human terms. Instead, he reminds his servant Job of God's incomprehensible power and majesty. Confronted by the vastness and eternity of God's universe, Job acknowledges that his own sufferings are as nothing.

Then the Lord answered Job out of the whirlwind:
"Who is this that darkens counsel by words without
 knowledge?
Gird up your loins like a man,
I will question you, and you shall declare to me.

"Where were you when I laid the foundation of the earth?
Tell me if you have understanding.
Who determined its measurements – surely you know!
Or who stretched the line upon it?
On what were its bases sunk,
or who laid its cornerstone,
when the morning stars sang together,
and all the sons of God shouted for joy?

"Or who shut in the sea with doors,
when it burst forth from the womb;
when I made clouds its garment,
and thick darkness its swaddling band,
and prescribed bounds for it,
and set bars and doors,
and said, 'Thus far shall you come, and no farther,
and here shall your proud waves be stayed'?"[3]

JOB 38:1–11

The Book of Job echoed the lament of an Israelite nation that, in the centuries after the Babylonian exile, still suffered the yoke of conquest and persecution. During the period 200 B.C. to A.D. 50, many Jews expected an **apocalypse** [uh-POCK-uh-lips], a cataclysmic revelation of God's will that would liberate and redeem Israel. At the apocalypse, they believed God would judge all humanity and restore the Jewish temple at Jerusalem as the center of the world. The Jews associated the apocalypse with the appearance of a **messiah**, meaning one "anointed" by God, who would overthrow Israel's foreign rulers and restore the glories of David's kingdom. To these potent expectations, founded on Hebrew nationalism, Jesus and his followers would appeal with great success.

The Rise of Christianity

Explain the appeal of Christian teachings and practices in the late Roman world.

It seems unlikely that belief in an obscure Jewish prophet would supplant the diverse paganism of the late Roman world. In its first two centuries, the new religion of Christianity was just one of many religious cults practiced in the vast Roman Empire. By the early fourth century, however, the Christian faith counted a Roman emperor among its converts, and by 400, Christianity was the Roman Empire's official religion.

c. 960 B.C.	Temple of King Solomon, Jerusalem
587 B.C.	Babylonians destroy temple; Israelites in exile
c. 4 B.C.	Jesus born in Palestine, crucified A.D. 30
A.D. 313	Emperor Constantine legalizes Christianity
A.D. 397–401	Augustine, *Confessions*

Historians cannot fully reconstruct the history of early Christianity. Nevertheless, we know that by the second century many early Christians believed that Jesus of Nazareth was the divine Son of God, who had been resurrected from the dead to save all humanity. Believers in Jesus were promised forgiveness of sins and everlasting life after death. Christians eagerly expected the imminent end of time, when Jesus would come again to reward the faithful and judge the wicked. From these fundamentals of faith, Christianity successfully broadened its appeal as it spread through the Roman Empire. The rise of Christianity can be divided into three phases:

- the life of Jesus of Nazareth, the Jewish prophet whom Christians claimed to be both man and god;
- early Christianity as it spread from Palestine to the Greco-Roman cities of late antiquity;
- Christianity as the dominant religion of the Roman Empire.

Jesus of Nazareth

Jesus of Nazareth was a Jewish teacher and healer whose life and person became the center of the Christian faith. His teaching attracted a few devoted followers before he was executed by Palestine's Roman authority. Jesus' public life preaching to the poor folk of rural Palestine was so brief that no contemporary source refers directly to his ministry. Virtually all that we know of Jesus must be gleaned from the Gospels, the four accounts of his life and teachings composed a generation after his death. These accounts are professions of Christian faith rather than historical records of Jesus' life.

Jesus was born at a time (c. 4 B.C.) when the Jewish nation was deeply troubled by Roman oppression and ripe with messianic expectations. His preachings that a

You have heard that it was said, "An eye for an eye and a tooth for a tooth." But I say to you, Do not resist one who is evil. But if any one strikes you on the right cheek, turn to him the other also.

Jesus, in the Sermon on the Mount, Matthew 5:38–39

"kingdom of God" would soon be established appealed to his followers' apocalyptic hopes. The kingdom of God would radically alter human relations and bring a divine judgment of humanity. To prepare for the coming apocalypse, Jesus urged his followers to abandon their property and families, love one another without reservation, and meet evil with passive resistance.

The Gospels portray Jesus as a skillful teacher. His graphic language and simple stories appealed to his poor, uneducated followers, and he frequently used illustrative stories called **parables** to dramatize his vision of God. In the parable of the "prodigal son" (Luke 5:11–32), for example, a foolish son wastes his inheritance on riotous living. On returning home repentantly, the son is forgiven by his loving father, who had feared he was lost. Jesus' parables illustrated through analogy the nature of God and his kingdom. He stressed that God loved and forgave his faithful servants, as the father did his profligate son.

The teachings of Jesus are summarized in the Sermon on the Mount (Matthew 5–7), a compilation of sayings that reinforced his relation to the Hebrew tradition and scripture. The Sermon on the Mount called for an intensification of ethical monotheism, the ancient Hebrew obligation to respect and care for everyone in the community. Jesus said he had come "not to abolish the law and the prophets, but to fulfill them." By intensifying their love for others, said Jesus, his followers prepared themselves for entry into the impending kingdom of God. Like earlier prophets, Jesus also demanded a righteousness of the heart. Conspicuous acts of faith and formal obedience to the law were not sufficient. A sinful thought was as evil as a sinful action.

"You have heard that it was said, 'You shall not commit adultery.' But I say to you that every one who looks at a woman lustfully has already committed adultery with her in his heart. If your right eye causes you to sin, pluck it out and throw it away; it is better that you lose one of your members than that your whole body be thrown into hell."

"You have heard that it was said, 'An eye for an eye and a tooth for a tooth.' But I say to you, Do not resist one who is evil. But if any one strikes you on the right cheek, turn to him the other also; and if any one would sue you and take your coat, let him have your cloak as well; and if any one forces you to go one mile, go with him two miles. Give to him who begs from you, and do not refuse him who would borrow from you." [4]

GOSPEL OF MATTHEW 5:27–29, 38–42

The last days of Jesus' life were to become the pivotal moment of the Christian faith. The official Gospels tell that he entered Jerusalem to the acclaim of its citizens. Though he declined the mantle of a political messiah – a new David come to restore Israel's independence – Jesus' apocalyptic teachings had apparently alarmed the Roman authorities. They seized Jesus and crucified him, a method of execution reserved for political offenders. But this humiliating public death was, paradoxically, the starting point of a powerful new religious faith. Jesus' followers would claim that he rose bodily from the dead, a resurrection proving that Jesus was indeed the messiah (in Greek *Christos*). The earliest believers anticipated that the resurrected Jesus would return in a "second coming" to redeem the faithful and usher in the kingdom of God.

The Growth of Christianity

Messianic belief in Jesus was largely consistent with Jewish apocalyptic nationalism, and it evidently thrived in small communities of Jews in Palestine and the eastern Greco-Roman world (Figs. **5.5**, **5.6**). In its first decades, the new faith's most effective advocate was the apostle Paul (died 64?), whose tireless travels and passionate letters to believers promised them imminent redemption at the hands of a risen Christ. Paul's letters exhorted the faithful to piety and advised them on matters of marriage, charity, and ritual. More importantly, he argued that non-Jews could join the faith without submitting to the male circumcision and dietary restrictions required by traditional Judaism.

The Jewish world in which Paul lived was shattered in 70 when a Roman army sacked Jerusalem and destroyed the Second Temple, the center of Jewish ritual. In the wake of this political and religious cataclysm, Jewish faith reshaped itself under the leadership of the Pharisees, community leaders who assumed the role of *rabbi*, or "teacher." The new faith, which we now call **rabbinical Judaism**, stressed pious obedience and study of the Torah, in place of the Temple sacrifices that once had been every Jew's obligation. The reading and veneration of the Torah became ritualized in places of worship called synagogues,

THE NEW TESTAMENT

Gospels

Matthew, Mark, Luke, John

The Acts

Letters of Paul

Romans, 1st & 2nd Corinthians, Galatians, Ephesians, Philippians, Colossians, 1st & 2nd Thessalonians, 1st & 2nd Timothy, Titus, Philemon

Other Letters

Hebrews, Epistle of James, 1st & 2nd Peter, 1st, 2nd, & 3rd John, Jude

Revelation

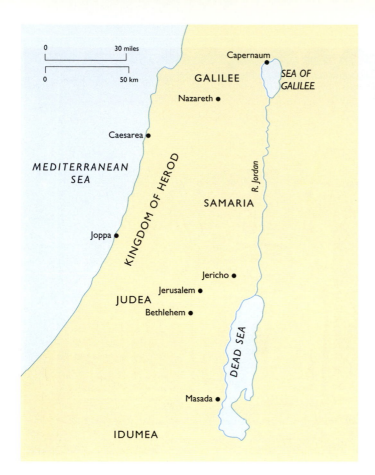

and rabbinical scholars wrote scriptural commentaries that were attuned to Judaism's new circumstances. Though alienated from its traditional center in Palestine, this revived Judaism won new converts and unified Jewish communities throughout the late Roman world.

The second temple's destruction also profoundly affected early Christianity. The official Gospels, most likely all written after 70, show signs of the crisis and an ensuing rivalry between Christian belief and Pharisaic Judaism. By the early second century, a distinctively Christian faith had emerged, professing the divinity of Christ and centered on communal celebrations of the **Eucharist** [YOO-kuh-rist], a reenactment of the Last Supper (Fig. **5.7**) that Christ shared with disciples.

Early Christianity shared elements of belief and ritual with other mystery religions in the late Roman world.

5.5 (*left*) Israel at the time of Jesus.
Modern archaeology has found that 1st-century Palestine was dominated by thriving Greco-Roman cities like Caesarea and Sepphoris, near Jesus' hometown of Nazareth.

5.6 (*below*) The spread of Christianity.
Once Rome's emperors adopted Christianity, the faith spread quickly as Rome's official religion. In Ireland and eastern Europe, new believers adopted Christianity and classical Greco-Roman culture as one system of belief.

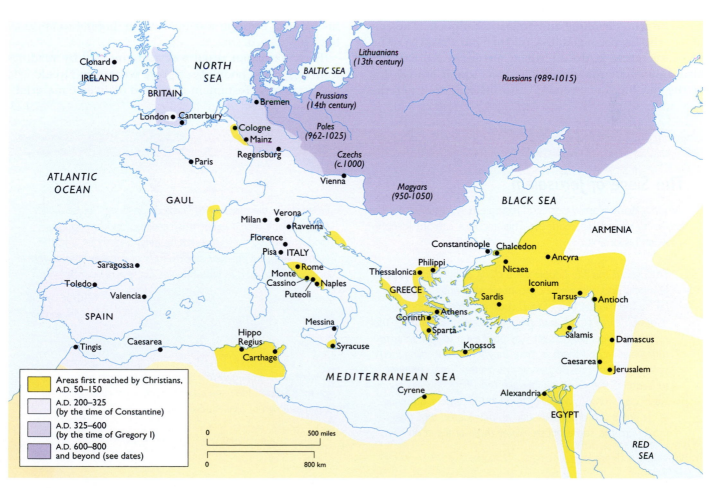

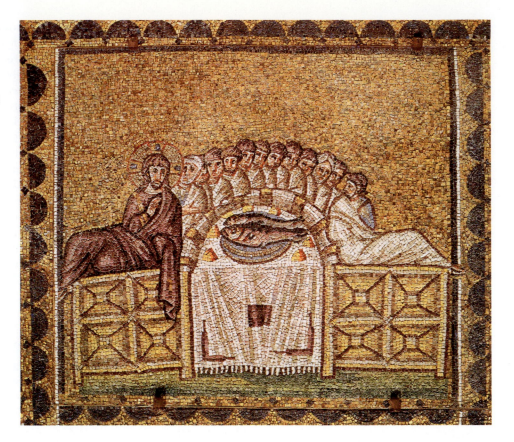

5.7 *Last Supper*, Sant' Apollinare Nuovo, Ravenna, Italy, c. 520. Mosaic.
Roman mosaicists adopted a new iconography based on Bible stories and Christian symbols. Here a typical Roman banquet scene is recast as the Last Supper, with the purple-robed figure of Christ opposite the traitor Judas. Christ has just announced, "One of you will betray me," and the disciples look expectantly at Judas.

Worshipers of Dionysus, for example, celebrated their god with wine-drinking and orgiastic banquets. The cult of Isis, the Egyptian goddess, told of a murdered god who was resurrected in the afterlife. Converts to Christianity also underwent the rite of baptism, which erased sins of the old life and prepared the believer to enter the kingdom of God. The emperor Constantine postponed his baptism until he was near death, hoping to erase all but a few days of sin.

Early Christian ritual was accompanied by readings from a growing body of scripture written in Greek. The Christian New Testament consisted of diverse materials.

WINDOWS ON DAILY LIFE

The Siege of Jerusalem

When a Roman army besieged Jerusalem in A.D. 70, starvation drove its citizens to madness. This account is from Josephus, a Jewish historian:

Throughout the city people were dying of hunger in large numbers and enduring indescribable sufferings. In every house the merest hint of food sparked violence, and close relatives fell to blows, snatching from one another the pitiful supports of life. No respect was paid even to the dying; the ruffians searched them, in case they were concealing food somewhere in their clothes, or just pretending to be near to death. Gaping with hunger, like mad dogs, lawless gangs went staggering and reeling through the streets, battering upon doors like drunkards, and so bewildered that they broke into the same house two or three times in an hour.

Need drove the starving to gnaw at anything. Refuse which even animals would reject was collected and turned into food. In the end they were eating belts and shoes, and the leather stripped off their shields. Tufts of withered grass were devoured, and sold in little bundles for four drachmas.[5]

JOSEPHUS
The Jewish Wars

CRITICAL QUESTION
In what ways do people still claim divine sanction or approval for their actions? How are calamities and misfortune often still taken as a sign of divine judgment?

The letters of Paul were the earliest Christian writings, while the four official Gospels and Luke's Acts of the Apostles (written c. 70–120) were professions of Christian faith written as biography and history. The New Testament ended with the apocalyptic Book of Revelation, a powerfully symbolic vision of Christ's second coming. The Christian scriptures, which eventually incorporated the Hebrew Bible, recorded God's active intervention in the lives of the faithful and promised them redemption.

Christianity in the Late Roman Empire

By the third century, Christianity had established itself firmly as a leading cult in the Greco-Roman world. Christian churches successfully established tight-knit, supportive communities in the disorderly world of late antiquity. New believers embraced Christianity's benevolent monotheism and welcomed its promise of resurrection after death. To the empire's slaves and lower classes, Christianity granted an equal membership in the community of faith; to the wealthy – especially women – it offered freedom from oppressive family and social obligations. Widows seem to have occupied esteemed positions and women apparently served as church officers.

The religious diversity of the late Roman Empire is illustrated by Dura-Europos, a town in Roman Syria (modern Iraq) that was partially buried in 256. Excavations at Dura-Europos [dyoor-a yoo-ROPE-us] uncovered temples to more than a dozen Greek and Roman gods, as well as smaller sanctuaries of Judaism, Christianity, and other cults. Despite God's ban on images, the Jewish synagogue was decorated with wall paintings of biblical scenes. The Christian church, actually a converted house, contained painted scenes of the women who discovered Jesus' empty tomb and of Christ performing miracles.

Early Christian art (Fig. **5.8**) indicated a willingness to synthesize the new faith with dominant styles and imagery of late Roman art. Christian wall paintings depicted Jesus in the guise of Orpheus, the musician of Greek mythology who descends into hell and charms the

5.8 Painted ceiling from the catacomb of SS. Pietro e Marcellino, Rome, 4th century.
Some of the first Christian art appeared in catacombs, underground chambers where early Christians worshiped and buried their dead. Here, around the central figure of Christ, the artist depicted the story of Jonah and the whale, a Hebrew tale that stressed deliverance of the sinful.

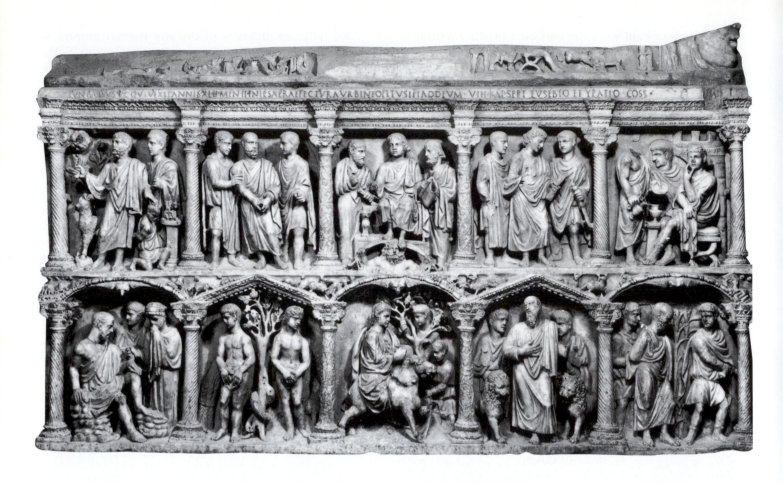

5.9 Sarcophagus of Junius Bassus, 359. Grottoes of St. Peter, Vatican.

The carved sarcophagus was a Roman tradition readily adapted to Christian use. Here, with figures in a finely carved classical style, scenes of affliction and sin (Job with the counselors, Adam and Eve in Eden) alternate with scenes of redemption (Christ entering Jerusalem, the prophet Daniel among the lions).

god of the underworld. Christians also depicted events from the Hebrew Bible that emphasized deliverance and salvation, such as Jonah in the belly of the whale. Early Christians developed an arcane set of symbols that became sacred images, known as **icons**. The fish, for example, represented the initial letters of "Jesus Christ, God's Son, Savior" in Greek: I-CH-TH-Y-S, "fish." Fish imagery also echoed Jesus' promise to his apostles that "I will make you fishers of men" (Matthew 4:19). The merger of Judeo-Christian symbolism and the classical style is evident in the sarcophagus [sar-KOFF-ah-gus] (coffin) of Junius Bassus, a fourth-century Roman official (Fig. **5.9**). In the center top scene, for example, Christ's throne in heaven is supported by the Roman god of the sky. Daniel, the late Hebrew prophet, stands like an Athenian philosopher among the lions.

Constantine and Christianity A turning point in Christianity's rise came under the reign of Constantine [KON-stan-teen] (ruled 312–337), the first emperor to embrace the Christian faith (Fig. **5.10**). The night before a crucial battle, Constantine was said to have seen a fiery cross against the sun, with the words below "In this sign you will conquer." Following his victory, Constantine issued the Edict of Milan (313), which legalized Christianity and ended official persecution. While paying homage to the official pagan gods, Constantine had his sons brought up as Christians and made his new capital, Constantinople [kon-STAN-ti-noh-pull] (the ancient city of Byzantium; now the Turkish city of Istanbul), the first Christian city.

With one exception, every Roman emperor after Constantine favored Christianity, and by the end of the fourth century the religion had entered a new phase in its development. These Christian emperors built lavish new churches, advancing the synthesis of Christianity and the pagan tradition. With Christianity's new status came an impulse to compromise. Christian leaders now represented the power of the Roman state that had once persecuted them. In the first century A.D., the Christian faith had begun as a radical teaching to impoverished Palestinian Jews. By the fifth century, it had become the wealthiest and most powerful social institution of the Western world.

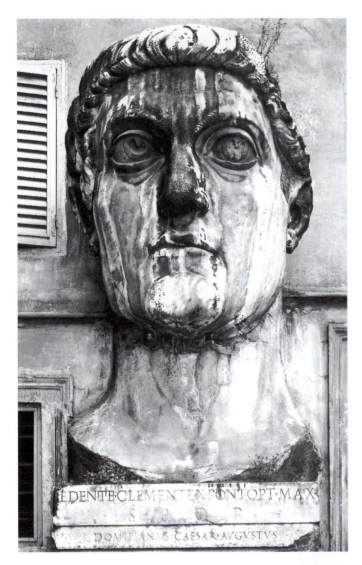

5.10 Head of Constantine, from a colossal statue that stood in the Basilica of Constantine, Rome (see Fig. 4.17), 313. Marble, height of head 8 ft 6 ins (2.59 m). Palazzo dei Conservatori, Rome. Inclined to visionary mysticism, the emperor Constantine founded dozens of Christian churches in Rome and Constantinople, the new capital of his empire.

Philosophy: Classical and Christian

Explain Augustine's views on human nature and human history.

The world of late antiquity saw a gradual and sometimes troubled merger of classical and Christian philosophy. The philosophy of Neoplatonism, the last great Greek philosophy, was expounded in the schools where both pagans and Christians studied. By 400, a new synthesis emerged in the writings of Augustine of Hippo. As Augustine and other Christian clergy became politicians and civic leaders in the late Roman world, they adapted classical ideas to the intellectual challenges of the new faith.

From Classical to Christian

The classical world's last great philosophical system was founded on the Neoplatonist teachings of Plotinus (205–270), compiled in the *Enneads*. Adapting ideas from both Plato and Aristotle, Plotinus described all creation as flowing from a single and perfect source, the One or the Good. In Plotinus' view, the One was beyond being and defied description. From it emanated an orderly hierarchy of being, descending from *Nous* (intellect) to the World Soul to the material world. A virtuous human life involved the soul's effort to return to the One through rational contemplation and suppression of material desires. Plotinus did not regard bodily desire as sinful or evil; the flesh merely retarded the soul in its mystic quest to know the One and the Good. Plotinus' system maintained the Platonic distinction between soul and body, but argued for a monist unity in all of existence. Both ideas appealed to later Christian thinkers.

In the fourth century Neoplatonists actively defended traditional Roman religion and often conflicted with Christian believers. For example, Hypatia [hyuh-PAY-shuh] (c. 370–415), late antiquity's most significant woman philosopher, led a lively Neoplatonist school at Alexandria in Egypt. She made significant contributions to mathematics and astronomy, but suffered a hideous murder at the hands of Christian zealots. Hypatia's death and the burning of Alexandria's famous libraries ended the city's preeminence as a center of classical learning.

Through the fourth century, Christian intellectuals gradually did harmonize their beliefs with classical traditions, affirming Plato's division of body and soul (see page 62) and the stoics' restraint of passion and acceptance of divine will. The agents of this philosophical compromise were the so-called Fathers of the Church, whose writings formed the **patristic** tradition (from Latin *pater*, "father"). One legacy of patristic scholarship was the Latin translation of the Bible by St. Jerome, whose version became the standard Bible of Western Christianity.

Augustine of Hippo

By far the most important patristic philosopher was Augustine of Hippo (354–430). Augustine's best-known writing is the *Confessions* (397–401), a remarkable work of spiritual introspection unparalleled in the classical literature of Augustine's day. It details Augustine's attraction to both Neoplatonism and Manicheism [man-i-KAY-ism], which saw the world as a conflict between good and evil. More important, the *Confessions* describe

Original Sin and Human Nature

Augustine believed that sinfulness and the need for repentance were the unrelenting truths of human experience. His beliefs engaged him in fierce debate over sin and human nature. Christian thinkers disagreed on whether baptism erased sinfulness or whether sin remained forever rooted in the human soul. Augustine answered this question with his doctrine of "original sin." A fundamental concept of Western views of human nature, **original sin** refers to Adam and Eve's first violation of divine command in the Garden of Eden (Fig. **5.11**). According to Augustine, when Adam and Eve ate the forbidden fruit, they condemned all humanity to a state of sinfulness. Because all humans descended from Eve, every human soul, including that of a newborn infant, was, by connection, inevitably wicked.

The Greek scholars of the Eastern Church (which later became the Greek Orthodox Church) disputed Augustine's concept of original sin. As they read the Bible, sin resulted from individual acts of will, and humans were justly punished according to the degree of their sin. However, according to Augustine, sin resulted from human nature, not from human action. The stain of sinfulness existed from conception and could not be erased by acts of repentance. Augustine's more radical interpretation won the day and his view of original sin became official doctrine. It remains a cornerstone of Western Christian belief today.

The concept of original sin had enormous importance in the Western view of human nature. It meant that humans could not naturally govern themselves or achieve a state of goodness by their own effort. As children, humans required the rigorous discipline of parental guidance; as adults, they required the limits imposed by law and a paternal government. Later philosophers would challenge Augustine's doctrine of human depravity, or corruption. Some eighteenth-century philosophers claimed that humans were naturally good and corrupted only by the influence of a depraved society. Augustine's definition of human nature still affects the way that parents rear children, schools instruct students, and governments rule their citizens.

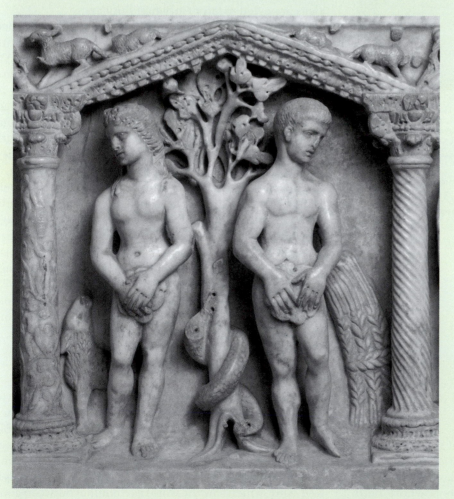

CRITICAL QUESTION

In your opinion, are humans naturally inclined to greed, rebellion, and evil? What forces, both inner and outer, cause humans to do good or evil?

5.11 *Adam and Eve*, detail of Sarcophagus of Junius Bassus, 359. Marble. Grottoes of St Peter's Basilica (Treasury Museum), Vatican, Vatican City.
Adam and Eve hide their shame in the moment when, according to Augustine, both sin and knowledge of good and evil entered the world.

Augustine's inner struggle against his own sinful will. In repentance, he remembers the youthful theft of some pears with the same bitterness as his years with the anonymous mistress who bore him a son. Of the theft, Augustine writes:

> Some lewd young fellows of us went and took huge loads, not for our eating, but to fling to the very hogs. And this, but to do what we like only because it was misliked.[6]

Of the mistress, whom he renounced at his family's insistence, he says, "The heart, to which she stuck fast, was cut and wounded in me, and oozed blood."

In probing "the depths of his soul," Augustine found that only God's immense grace could save him from sin. His own will was too weak. Human freedom, Augustine argued, was only the freedom of the will to commit sin. The *Confessions* portray Augustine's soul in a constant struggle against its desires, in constant conflict with its own sinful nature. Thus, Augustine's Christian view of the human soul differed sharply from the classical tradition in which it was rooted. For classical philosophers such as Socrates and the stoics, the wise soul could successfully live at peace with itself and the cosmos; the Christian's soul, said Augustine, was always at war with itself.

Augustine articulated Christianity's newest ideas with logical force and clarity. In his long treatise *On the Trinity*, for example, he addressed the logical difficulties of viewing God as both one and three. Augustine offers several elegant analogies between God and the human self. When we say, "I love myself," he reasoned, the "I" that loves, the "self" that is loved, and the love shared between them are all distinct but all aspects of the same self. Likewise, the Father, Son, and Holy Spirit are distinct aspects of one divine being.

Augustine's most comprehensive philosophical work, *City of God* (written 413–426), responded to the sack of Rome in 410 by a Germanic army. Pagan traditionalists blamed Rome's fall on the Christians, who refused to do public service or honor Roman deities. Augustine replied that Rome's decline was part of God's historical design for human salvation, a vision of history without precedent in ancient philosophy.

Augustine presented human history as a battle between two symbolic cities. The "city of the world" (*civitas terrena*) was peopled by pagans and Christian heretics. The "city of God" (*civitas dei*) was founded in heaven but encompassed the Christian faithful living on earth. According to God's plan of history, the earthly city would eventually be destroyed altogether and its inhabitants cast into damnation. Righteous Christians would live in a state of blessedness and universal peace at the end of history. Until this time, Augustine advised good Christians to "obey the laws of the earthly city whereby the things necessary for the maintenance of this mortal life are administered." With such words, Augustine commanded Christians to obey the very Roman state that barely a century earlier had bitterly persecuted them.

The Christian Empires: Rome and Byzantium

Summarize the artistic differences between the churches of Latin Christianity and the Byzantine world.

In the year 330, the emperor Constantine dedicated a grand new capital of the Roman Empire. Constantine had built his capital at the ancient Greek city of Byzantium and renamed it Constantinople, after himself. The consecration of a "new Rome" at Constantinople indicated a pivotal change in the late empire. From that moment, the Roman Empire divided into two parts that would suffer different historical fates. The Latin-speaking Western Empire, centered in Rome, suffered barbarian invasions and political turmoil. A Greek-speaking Byzantine Empire, centered in Constantinople, grew more prosperous and powerful. By the sixth century, the Byzantine emperor would rule the entire empire from his palace in Constantinople.

The empire's division also affected the newly influential Christian churches. Authorities in both the Latin and Greek churches fought bitterly against unorthodox ideas, especially the Arian heresy, which disputed the nature of Jesus as both fully divine and fully human. In 325 Constantine convened the first of several ecumenical councils to affirm orthodox doctrines and suppress the heresy. But gradually a disaffection grew between the Latin Church, with its centers of power in Rome and northern Africa, and the Greek Church, which was strongly allied with the powerful Byzantine emperors. The division expressed itself in growing theological and artistic differences that would eventually split the Roman Catholic (or "universal") Church and the Byzantine Orthodox Church.

St. Peter's and the Pope

Roman emperors had always favored their subjects with lavish public buildings, a policy that now benefited the newly legalized Christian Church. In Rome, Constantine endowed about fifteen new churches that rivaled the

pagan temples in their size and splendor. The largest and most important was St. Peter's (Fig. **5.12**), built on the Vatican hill outside Rome over the tomb of the apostle Simon Peter. The St. Peter's of Constantine (built c. 320–330) was to be Latin Christianity's most famous shrine for a thousand years, until it was demolished and replaced during the Renaissance.

St. Peter's was typical of basilica-style Christian churches, which were modeled after the Roman basilica (see Fig. 4.10), with its coffered ceilings and rows of columns (Fig. **5.13**). Worshipers entered the church through a wide, shallow **narthex**, or vestibule, and then traveled along the columned aisles. The church's central hall, called the **nave**, had an elevated roof and could accommodate several thousand standing worshipers. The architect of St. Peter's added a crossing **transept** at the altar to provide additional space for worshipers. This created a cross-shaped floor plan. Behind the altar was the **apse**, another holdover from the Roman basilica. The apse's half-dome was typically decorated with sacred images in paint or mosaic. St. Peter's basilica design was to become the basic pattern of Latin Christianity's greatest churches.

Constantine's generosity to the Church did not reverse the decline of Rome or protect it against the barbarians, nomadic peoples of northern Europe who swept over the Rhine River and threatened Roman farms and cities. Barbarian leaders, some already converted to Christianity, pressed in on the Western Empire, demanding tribute and territory. In 402 the Roman government was moved to the more easily defended town of Ravenna, on the Italian Adriatic coast. In 410 Rome itself was sacked by the Goths, shocking the entire empire, and in 476 the last Roman emperor was forced to abdicate in Ravenna, ending a line of rulers that had originated five centuries earlier with Caesar Augustus. By the sixth century, the old Roman Empire had become a patchwork of barbarian settlements, its central government and cities in ruin.

In Rome the vacuum of power was quickly filled by the pope, the Christian bishop of Rome. By the fourth century, the pope was acknowledged by Western Christians as the Church's supreme spiritual authority. As imperial order declined in the West, the pope and other bishops played a powerful civic role and were able to encourage lawfulness and censure abuses. In the eastern Byzantine Empire, on the other hand, the emperor's power remained unshakable and the Eastern Church was closely wedded to imperial authority.

Justinian and the Byzantine World

Compared with the upheavals in the West, the Byzantine Empire was a paragon of stability and conservatism. Its founder had equipped Constantinople with an imperial palace, a hippodrome, numerous churches, and the other trappings of Roman urban life. Constantinople quickly absorbed the Greek climate of cultivation, spirituality, symbolism, and intrigue, and grew into a vibrant cultural and intellectual center.

The Byzantine world (Fig. **5.14**) reached its height under the rule of the emperor Justinian (527–565), who achieved significant legal reforms and artistic renewal.

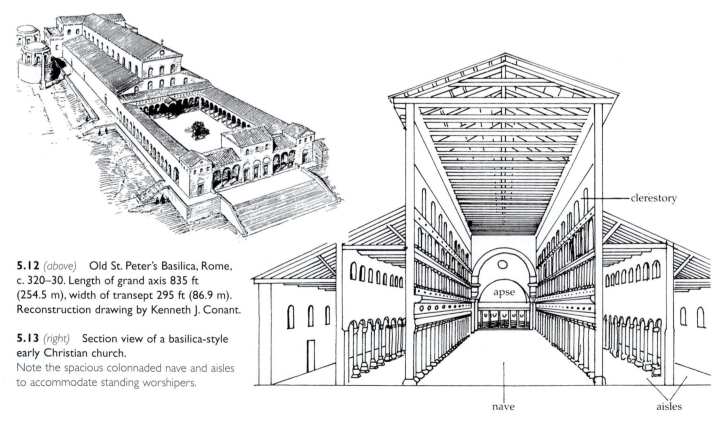

5.12 (*above*) Old St. Peter's Basilica, Rome, c. 320–30. Length of grand axis 835 ft (254.5 m), width of transept 295 ft (86.9 m). Reconstruction drawing by Kenneth J. Conant.

5.13 (*right*) Section view of a basilica-style early Christian church.
Note the spacious colonnaded nave and aisles to accommodate standing worshipers.

clerestory

apse

nave

aisles

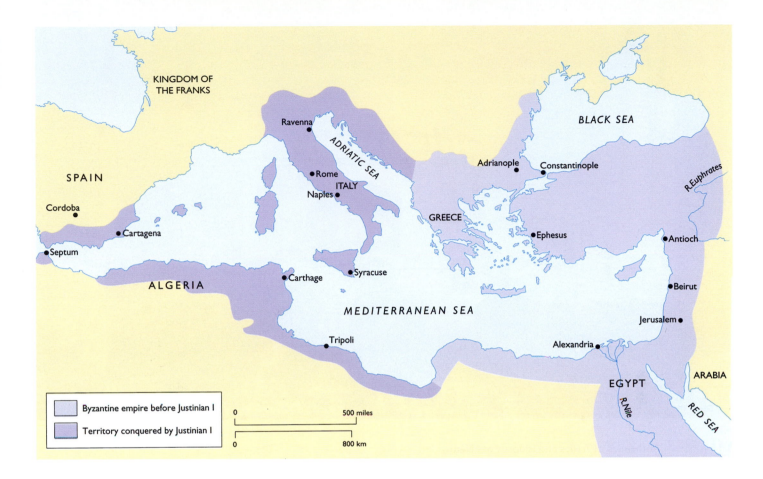

KINGDOM OF
THE FRANKS

BLACK SEA

Ravenna

ADRIATIC SEA

Adrianople Constantinople

SPAIN Rome
 ITALY
 Naples R. Euphrates

Cordoba GREECE
 Cartagena Ephesus Antioch

Septum

 Carthage Syracuse Beirut

ALGERIA Jerusalem

 MEDITERRANEAN SEA

 Alexandria ARABIA

 Tripoli EGYPT

Byzantine empire before Justinian I 0 500 miles
Territory conquered by Justinian I 0 800 km

R. Nile RED SEA

5.14 The Byzantine Empire under Justinian, 527–65.
Justinian briefly reunited the eastern and western parts of the Roman
Empire. Political authority in the West disintegrated over the next two
centuries, while the Byzantine Empire continued under a unified
political and religious regime.

Justinian [juss-TIN-ee-un] was a skillful negotiator, more
inclined to compromise than conquer. His armies over-
threw barbarian rule in the West and briefly reunited the
two empires. Justinian is best remembered for his vast
reform of Roman law, the so-called Code of Justinian,
which was the first thorough revision of Roman law since
Julius Caesar.

Justinian was notable also for sharing power with
his wife, Theodora, a confident and capable woman who
ruled as co-empress. Theodora [thee-oh-DOH-ruh] rose
to power from humble beginnings as an actress and cour-
tesan. The empress is credited with saving the emperor
when he faced a civil insurrection. Reportedly, Theodora
stopped her husband from fleeing the capital, saying of
her royal gown, "The empire is a fine winding sheet."
Inspired by her example, Justinian ordered his army com-
mander to slaughter 30,000 protesters in the hippodrome.
The emperor's rule was never again seriously threatened.

During this revolt a fire destroyed the center of
Constantinople, including the great church of Hagia
Sophia [hah-JEE-ah soh-FEE-ah] ("Holy Wisdom"). At

Justinian's direction and enormous expense, Hagia Sophia
(Fig. **5.15**) was quickly rebuilt on a gigantic scale. The new
church's designers, Anthemius of Tralles and Isidorus
of Miletus, were both mathematicians and scientists, not
professional architects. Their daring plan for a domed
interior astonished even Justinian, who took a personal
interest in the construction. Two work crews built simul-
taneously from the north and south. By Christmas 537,
less than six years after it was begun, the awesome new
Hagia Sophia was dedicated. It would remain the largest
church in the Christian world for 900 years.

The architects of Hagia Sophia stretched the tech-
niques of domed building to the very limit of possibility
(Fig. **5.16**). They expanded an existing Byzantine build-
ing form called the "domed basilica" – a rectangular hall
with a dome in the center. Using pendentive construction
rather than squinches (Fig. **5.17**), their design rose through
half-domes and curving walls to a dome more than 180 feet
(55 m) high. From the outside, Hagia Sophia's dome appears
to rest upon a mountain of masonry; on the inside (Fig.
5.18), the dome floats above the cavernous nave, sup-
ported by a combination of columns, arches, penden-
tives, and half-domes. Hagia Sophia's joining of mass and
space creates an aura of mystery and subtle cultivation,
well suited to the Byzantine spirit.

Hagia Sophia's interior decoration expressed the
Byzantine love of intricate design and sumptuous materials.

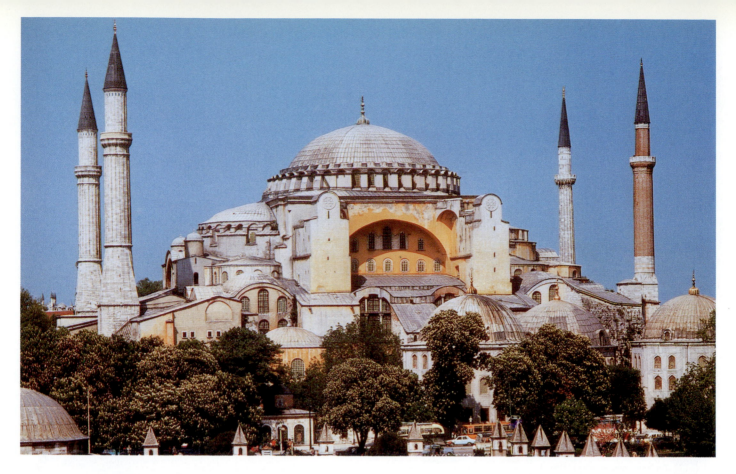

5.15 *(above)* Anthemius of Tralles and Isidorus of Miletus,
Hagia Sophia ("Holy Wisdom"), Istanbul (Constantinople), 532–7.
Justinian's gigantic church seemed a divine miracle to observers
in later centuries. Though today somewhat obscured by additional
buttressing, Hagia Sophia's dome rises on a series of supporting
half-domes. The minarets date from after the Turkish conquest of
Constantinople in 1453.

5.16 *(below)* Plan and section of Hagia Sophia, Istanbul, 532–7.
Exterior dimensions 308 x 236 ft (93.9 x 71.9 m).
The central dome was supported by half-domes on the east and
west sides, and filled arches on the north and south sides.

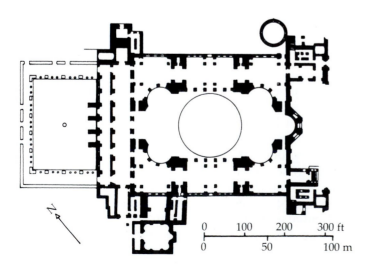

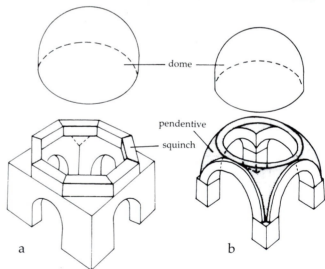

5.17 *(above)* Supporting a dome.
Byzantine architects typically employed one of two methods:
In (*a*) beams called **squinches** are placed diagonally across the
opening and support the dome. In **pendentive** construction (*b*),
triangular pendentives curve up and in from supporting piers,
forming a circular base for the dome. Compare with the Pantheon
(Fig. 4.19), in which the dome rests on cylindrical walls.

5.18 *(opposite)* Interior, Hagia Sophia, Istanbul, 532–7.
Height of dome 183 ft (55.8 m).
The interior of Hagia Sophia expresses the spirit of Byzantium
with its articulation of space to create a numinous atmosphere.
The shields bearing Arabic script were added when Muslims
converted the church to a mosque after 1453.

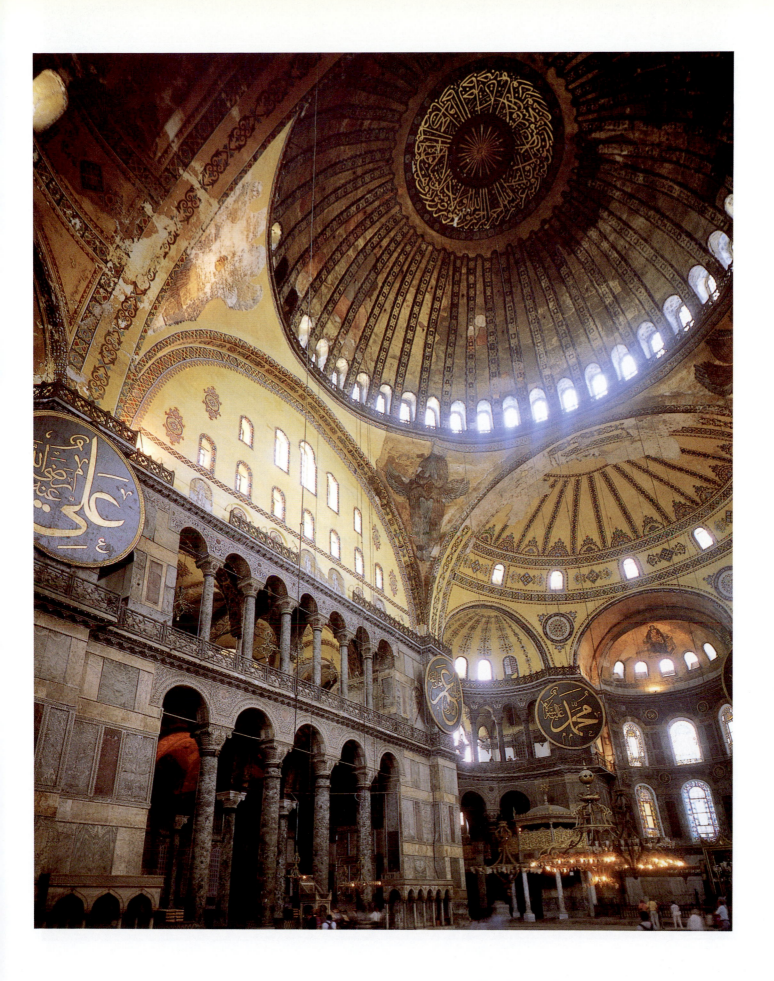

The foundation columns were topped by capitals with the undercut carving of the Byzantine order. The interior walls and domes were decorated with lavish mosaics that covered a total area of 4 acres (1.62 ha). Illuminated by rows of windows, including forty windows in the central dome, these mosaics reflected the brilliance of the Byzantine Church and court. A contemporary observer wrote, "The golden stream of glittering rays pours down and strikes the eyes of men, so that they can scarcely bear to look. It is as if one were to gaze upon the mid-day sun in spring, when it gilds every mountain height."[7]

Standing in his great church for the first time, Justinian compared his achievement to the temple in Jerusalem. The emperor is said to have murmured, "Solomon, I have surpassed thee." In the sheer ambition of its design, Hagia Sophia surpassed every building of classical times.

Ravenna: Showcase of the Christian Arts

By historical accident, the best-preserved early Christian art is found not in Rome or Constantinople, but in the small town of Ravenna on Italy's northeast coast. During the fifth and sixth centuries, Ravenna became a refuge for Roman emperors as well as barbarian rulers. After its capture in 540 by Justinian's army, Ravenna was briefly drawn into the Byzantine orbit and benefited from Justinian's generous patronage. For a century and a half, patrons from both Latin and Greek Christianity built their churches, mausoleums, and baptisteries in Ravenna. They left a record of Christian art that was untouched by later conquest or artistic renewal.

The earliest churches of Ravenna retained the Roman architectural vocabulary: columns, arches, mosaic decoration, and the rectangular basilica plan (see Fig. 5.13). These churches were usually plain brick on the exterior. On the inside, their apses and walls were richly decorated with scenes of the Christian faith.

The mosaics of Ravenna reveal the evolution of visual imagery and storytelling in early Christian art. Compared with pagan mythology, early Christianity offered mosaic artists a rather slim stock of stories and images. Artists depicted scenes and stories from the life of Christ, the lives of saints and martyrs, and Hebrew tales. The most familiar images represent Jesus in scenes from the Gospels: Christ as the Good Shepherd (Fig. 5.19), Christ feeding the multitudes, and Christ calling his disciples.

The noblest work of interior decoration at Ravenna is Sant' Apollinare Nuovo [sant-ah-poll-ee-NAR-ay noo-WO-voh; Fig. 5.20], which was built under the reign of the barbarian ruler Theodoric (445–526). Above the nave columns, stately processions of the saints and virgin martyrs (Fig. 5.21) bear gifts toward Christ and the Virgin Mary. The parade of virgins is led by the Three Wise Men, passing before palm trees that recall Christ's triumphant entry into Jerusalem, when he was supposedly hailed as a king (Mark 11:1–10). To please their imperial patrons, artists stressed such images of Christ's royalty

5.19 *Christ as the Good Shepherd.* Mosaic from the Mausoleum of Galla Placidia, Ravenna, Italy, 5th century.
In this brilliant mosaic, a scene of Christ as the good shepherd is composed to fit the half-oval shape of a lunette. The youthful Christ tenderly rubs a sheep's chin in this pastoral scene.

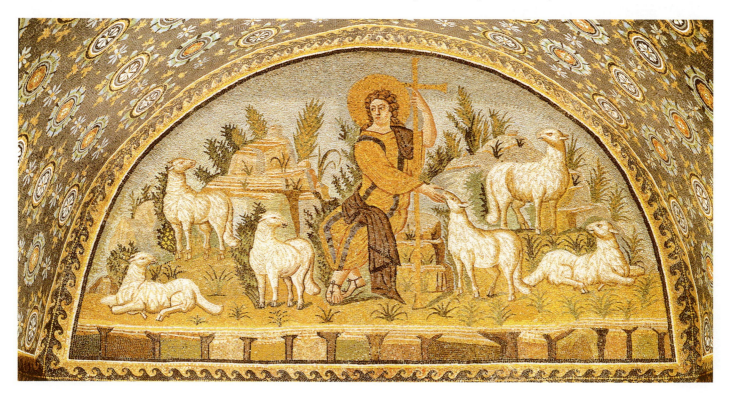

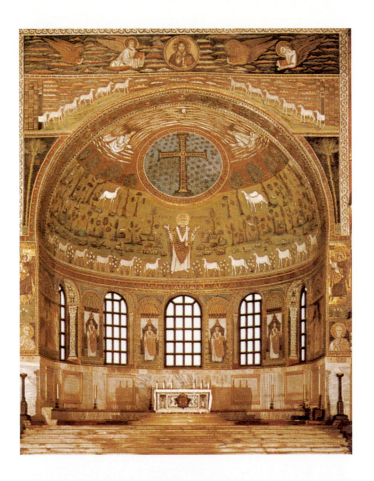

and majesty. The Ravenna mosaics' visual style indicates the weakening hold of Roman naturalism on early Christian artists. The virgins of Sant' Apollinare Nuovo are abstracted from the background in a way that emphasized their spirituality. This trend toward spirituality and symbolic representation intensified in later Byzantine art.

San Vitale of Ravenna The only truly Byzantine church in Ravenna is San Vitale (Fig. **5.22**), built during Justinian's reign and emphatically unclassical in its design and decoration. San Vitale [sahn vi-TAHL-ay] is an example of a **central-plan** church, so-called because its dome

5.20 (left) Interior, Sant' Apollinare Nuovo in Classe, Ravenna, Italy, c. 549.
The half-domed apse of basilica-style Christian churches created a theatrical setting for the Christian Mass, celebrated at the raised altar. The mosaic here presents Saint Apollinaris, first bishop of Ravenna, in the guise of Christ the Good Shepherd, with arms outstretched to welcome the faithful into paradise.

5.21 (below) *Procession of Virgin Martyrs*, c. 560. Mosaic. Sant' Apollinare Nuovo, Ravenna, Italy.
On the wall above this church's nave arcade, a mosaic scene depicts a procession of female martyrs to the new faith. The women are led by the three Magi toward the Virgin Mary and the Christ Child, sitting on a throne and guarded by archangels.

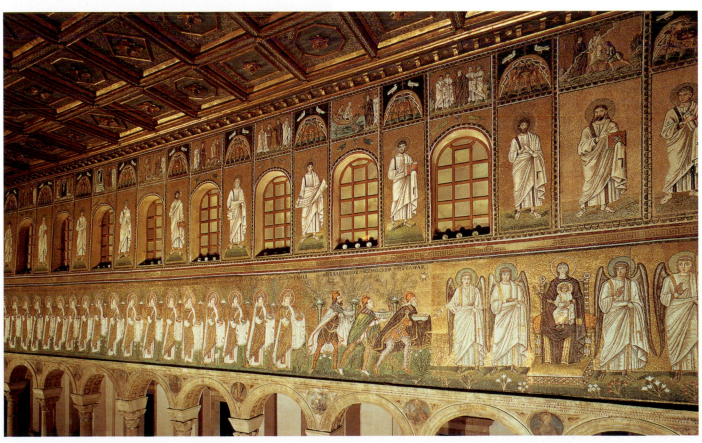

and walls are organized around a central axis (Fig. 5.23). The church is a double octagon: the domed inner octagon is supported by arches, while the outer octagon encloses a vaulted walkway. The second-story gallery accommodated

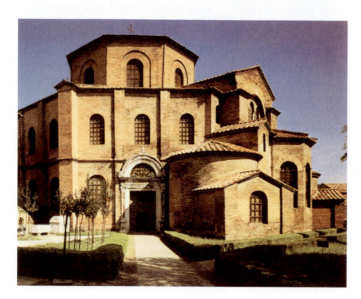

5.22 (*above*) San Vitale, Ravenna, Italy, c. 527–47. Diameter 112 ft (34.2 m).
Genuinely Byzantine rather than Roman, the church's octagonal design is compromised with a shortened nave (beneath the gabled roof in this view) and apse. Like Hagia Sophia, San Vitale has no true façade and its plain brick exterior gives little hint of the sumptuous decoration inside.

5.23 (*below*) Plan of San Vitale, Ravenna, Italy, c. 527–47.
Note the underlying octagonal plan, interrupted and embellished with a nave, apse, and atrium.

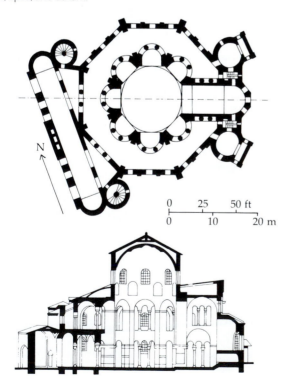

female worshipers, who were strictly segregated in the Byzantine liturgy. In all, San Vitale's design was compact yet complex, a modest but charming counterpart to the domed grandeur of Hagia Sophia.

The interior of San Vitale (Fig. 5.24) bears striking mosaic portraits of Justinian and Theodora with their courtly retinues. Justinian is flanked by clergymen (including the Archbishop Maximian) and by imperial soldiers (Fig. 5.25); the portrait represents the union of state power and Church power that distinguished the

5.24 (*below*) Interior looking toward apse, San Vitale, Ravenna, Italy, c. 527–47.
San Vitale's interior is perhaps the most complete and authentic example of Byzantine decoration from Justinian's era. Scenes of the emperor and his queen Theodora (see Figs. 5.25, 5.26) decorate the side walls of the apse, beneath a mosaic of Christ reigning in glory.

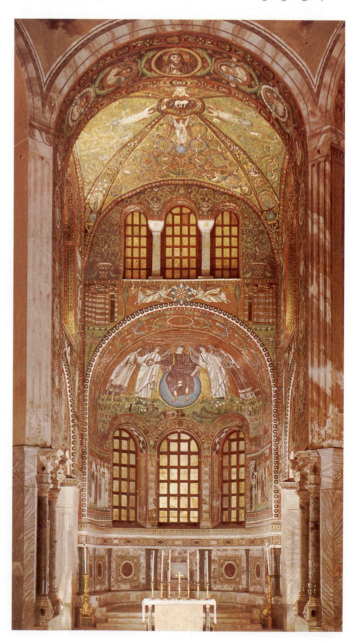

Byzantine from the Roman Church. The portrait of Theodora presents her as a regal figure, holding a jeweled chalice of the Eucharist, while a priest reveals at her right the baptismal font (Fig. 5.26).

The church of San Vitale was the ultimate fusion of imperial splendor and Christian piety. The later medieval emperor Charlemagne may have modeled his own royal chapel after San Vitale at Ravenna (see page 134).

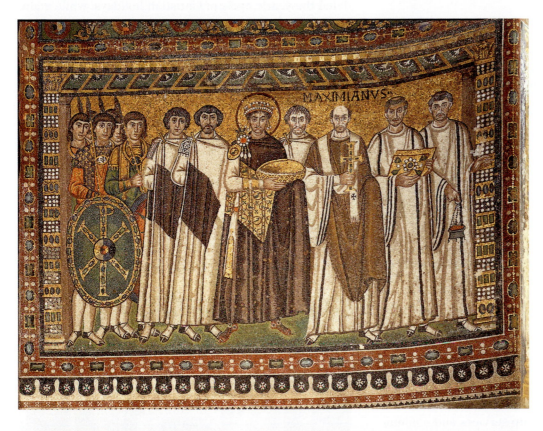

5.25 *Justinian and His Court,* c. 547. Mosaic. San Vitale, Ravenna, Italy.

These figures' exaggerated eyes and strictly frontal poses are features of Byzantine pictorial art, which moved toward greater spirituality and abstraction, away from classical-style naturalism. Emperor Justinian holds a bread basket symbolizing an element of the Eucharist (Last Supper). On the soldier's shield are the Greek initials *chi* and *rho*, the first letters of "Christ."

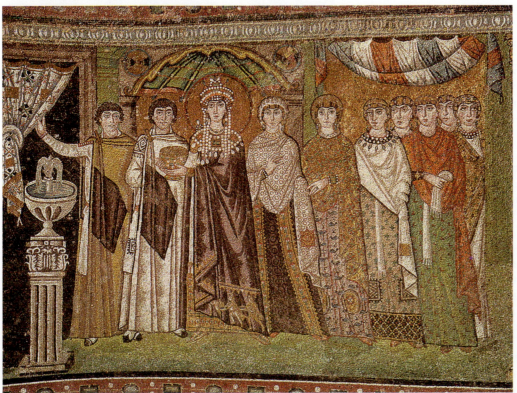

5.26 *Theodora and Retinue,* c. 547. Mosaic. San Vitale, Ravenna, Italy.

This scene of a regal Theodora faces *Justinian and his Courtiers* (see above) on the opposing wall. The shape of the jeweled chalice is echoed in the baptismal font at left; on the hem of Theodora's gown are the Three Wise Men bearing gifts to Christ, a favorite theme of imperial Christian art. Interpret the mosaic artists' even-handed treatment of emperor and empress in these matching portraits.

Christianity and the Arts

*Identify the religious and social reasons for
early Christians' hostility to the arts.*

Early Christians rather easily adopted Roman architecture and decoration in their churches. However, the other arts of pagan Rome – especially music and theater – inspired deep suspicion among the Church fathers. The Roman theater fostered a mocking irreverence that threatened Christian religiosity. In addition, the performing arts competed directly with the Church for the attention of the faithful. A bishop of Carthage even threatened to excommunicate any Christian who went to the theater instead of church on a feast day. Early Christianity's struggle with Roman music and theater was the first of Christianity's many battles with the spirit of artistic creation.

Early Christian Music

The ancient Roman world possessed a wealth of musical styles and instruments. Music accompanied virtually every public entertainment, from a bawdy farce to the slaughter of wild animals and Christians in the circuses. The Church associated instrumental music with such non-religious pastimes, and therefore banned musical instruments from church services. Thus early Christian music was almost entirely vocal music, and would remain so for centuries.

Early Christian music consisted of chanted hymns and psalms that accompanied worship services and communal meals. The earliest Christian singing may have paralleled the psalms and hymns sung in Jewish places of worship. However, local Christian churches were so independent that their sacred music varied widely in form and language. Chants and hymns were sung mainly in two ways – in **responsorial singing**, with the choir responding to a soloist, or in **antiphonal singing**, in which two choirs sang alternating verses. Both responsorial and antiphonal forms of chant and song became ingrained in the Christian musical tradition.

As authority in the Latin Church became more centralized, Christian song was gradually unified into distinct repertories of sacred melody. One style of chant, known as **Ambrosian chant**, was associated with the prestigious bishop of Milan, St. Ambrose, and was practiced in northern Italy. The most influential early Church music was the **Gregorian chant** (also known as plainchant or plainsong), a body of song consolidated in Rome during the seventh century, although tradition grants authorship to Pope Gregory I (590–604; Fig. **5.27**). By the eighth century a Roman school existed for training young men and boy singers of chant. In the ninth century, Gregorian chant was systematically compiled at the court of the Frankish Emperor Charlemagne (see page 150). Charlemagne's priests and monks tried to impose the Gregorian style on all of the Western Church, stamping out Ambrosian and other chant styles.

The Christian liturgy, or Mass, required different music according to the religious season. The Mass accommodated the yearly cycle of Christian holidays, while maintaining its basic conservative form. The chants were largely **monophonic** ("one-voiced"), consisting of a single melodic line, sung in unison, that rose and fell in a mystic undulation. Christian music, always tradition-bound, remained largely monophonic until the twelfth century.

Music was largely responsible for creating an attitude of devotion in Christian worshipers. The classical doctrine of ethos was still echoed in early Christian music. The main influence on the theory of music was the early Christian philosopher Boethius [boh-EETH-ee-us] (c. 480–c. 524). He theorized that the harmony of the

5.27 10th-century ivory book cover depicting Gregory recording chants.

Gregory's authorship of the so-called Gregorian chant was more legendary than historical. Tenth-century artists portrayed the early Christian pope as inspired by the Holy Spirit, represented by a dove.

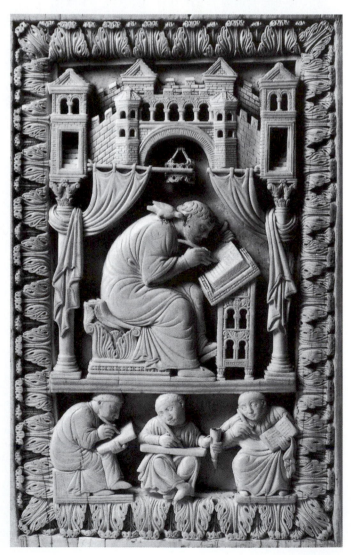

Teotihuacán: Sacred City of Mesoamerica

About the time that Christianity was transforming the capitals of the Mediterranean world – roughly 350–650 – a sacred city of Mesoamerica (present-day southern Mexico and Central America) was reaching the height of its influence. The city of Teotihuacán [TAY-oh-TEE-hwah-KAHN], located in the Valley of Mexico (about 33 miles/53 km northeast of modern Mexico City), was one of the ancient world's largest cities and one of the most sacred. Its residents believed it to be the birthplace of the world, the site at which the gods sacrificed themselves to create the sun and moon. Long after its decline as a city, Teotihuacán (the name meant, "where one becomes a god") would attract pilgrims and devotees for more than a thousand years. Aztec rulers of Mexico would later revisit the sacred places and reenact the founding events of their faith, much as Christian pilgrims visited the Church of the Nativity in Bethlehem or Muslims the Qa'aba in Mecca.

Teotihuacán's most important temples and palaces were arranged along a processional causeway, called the Way of the Dead (Fig. **5.28**), which served as a stage for ceremonial processions. The largest temples were the Pyramid of the Sun and Pyramid of the Moon, whose swelling forms mimicked the shape of the surrounding mountains. Beneath the Pyramid of the Sun was a natural lava cavern thought to be the womb from which the gods themselves were born.

The temples' terraced walls sloped up to rectangular panels that were carved with the ferocious heads of feathered or fiery serpents. Inside the city's palaces, painted murals depicted the Spider Woman, a figure still known in American Indian legend, and a Water Goddess whose headdress blossoms into a fertile profusion of butterflies and flowers. The mythical beings that decorated the temples and palaces of Teotihuacán were worshiped throughout Mesoamerica.

Teotihuacán suffered an unexplained decline about 650 when the city was burned, perhaps by invaders or perhaps by its own citizens in an act of ritual self-sacrifice. It continued as a shrine for later peoples until the Spanish conquered Mesoamerica in the sixteenth century.

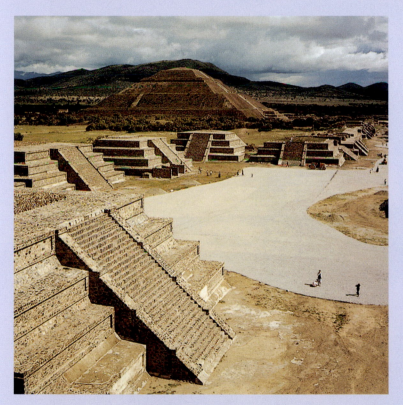

5.28 The Way of the Dead, Teotihuacán, Mexico, 1st–6th century.
Mesoamerican architects designed Teotihuacán's central precinct as an architectural stage for religious ceremony. The Temple of the Sun rising in the background was originally topped by a temple and altar. The stepped altars (foreground) radiate around the northern end of the ceremonial causeway called the Way of the Dead.

universe and soul was underlaid by music, and that this harmony rested on the numerical orderliness of musical tones and chords. Music was a demonstration of the order in God's creation. Boethius's treatise *De institutione musica* (*The Fundamentals of Music*, early sixth century) was the most widely read book of musical theory in the Christian Middle Ages.

Christianity Against the Arts

In the late empire, Roman theater had become increasingly lurid and spectacular. Sex acts were permitted on stage, and the emperor Diocletian decreed that a crucifixion be part of a theatrical performance. Even Augustine confessed, "I had a violent passion for these spectacles,

which were full of the images of my miseries and of the amorous flames which devoured me." Besides this sensual wickedness, Roman mimes and comic actors frequently aimed their mockery and sacrilegious outrages at the pious Christians.

Not surprisingly, early Christian authorities condemned the Roman theater more fiercely than any other art. Baptism was forbidden for actors (an exception was made for Justinian's empress, Theodora). Professional actors – never highly esteemed in the Roman world – virtually disappeared from Western society. The public theaters declined until, in the seventh century, state support was withdrawn and official theater expired in the western regions of the old Roman world. It would not appear again until the beginnings of Christian religious drama some 300 years later. Theater in the Western world survived in two forms: in the classical texts stored in libraries and read only by monks, and in the pagan folk festivals that gradually infiltrated the Christian calendar.

Early Christianity's hostility to the arts peaked in Byzantine iconoclasm [eye-KON-o-klaz-um], which reached its height from 730 to 843. **Iconoclasm**, meaning the "smashing icons," was a violent response to the popular taste for sacred images. The Byzantine faithful attributed healing powers to icons, usually mosaics or painted wooden screens (Fig. **5.29**). Byzantine theologians defended icons as a way to know spiritual truth through a

5.29 *Christ Pantocrator*, c. 1080–1100. Mosaic, Church of the Dormition, Daphne.
Byzantine Christians attributed healing and redemptive powers to icons, sacred images in mosaic like this image of a stern Pantocrator ("world ruler") or painted wooden screens. Many such images were attacked and mutilated during the iconoclastic controversy.

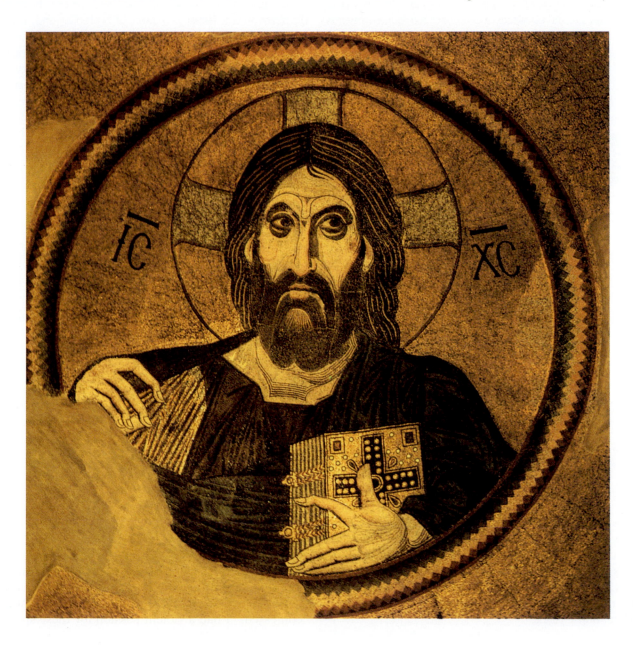

5.30 Iconoclast whitewashing an image. Manuscript illumination. British Library, London (ms. fl 9352 fol. 27v). A crisis in the Byzantine world precipitated the iconoclastic controversy, in which zealots attacked the Greek Church's traditional religious images. Here an iconoclast whitewashes a mosaic of Christ.

material form. However, the Byzantine emperor Leo III blamed icon-worship for the empire's military losses to the Arabs. In 730 he decreed that icons be removed from churches and palaces. With the emperor's sanction, the iconoclasts splintered iconic panels and painted over mosaics (Fig. **5.30**), often replacing gorgeous images with a rudely painted cross.

Although iconoclasm was official policy, it never enjoyed great popular support. When the controversy subsided in 843, icons soon reappeared in Byzantine churches. The episode echoed the Judeo-Christian tradition's old hostility toward the visual arts – "You shall have no graven images," commanded God – and anticipated future struggles between Christian faith and the creative arts.

c. 320–30	St. Peter's, Rome (**5.12**)
330	Constantinople founded as capital of eastern empire
c. 500	Sacred pyramids of Teotihuacán, Valley of Mexico (**5.28**)
527–65	Reign of Justinian
532–7	Hagia Sophia, Constantinople (**5.15**)
c. 547	Mosaics at San Vitale, Ravenna (**5.25**, **5.26**)
622	Muhammad's flight (*hegira*) from Mecca
622–722	Muslim conquests from India to Spain

The Rise of Islam

Identify the beliefs of Islam that supported the faith's militant expansion.

The internal dissension of the Christian empires of Rome and Byzantium proved to be mild compared to the onslaught of a new religious force in the Western world. Arising out of Arabia, the faith of Islam inspired a militant expansion that swept across the Near East to southwest Europe. Founded by the prophet Muhammad [moo-HAM-ad] (570–632), Islamic belief superseded ancient ethnic loyalties and forged a powerful unity among the Arab people. By the time of Muhammad's death, virtually the entire Arabian peninsula was converted to Islam and unified Arabs were poised to expand northward and westward (Fig. **5.31**). Muhammad's successors authorized campaigns of religious conquest against the armies of the Byzantine and Persian empires. The Arabs were skilled horsemen and fierce fighters, but they also believed that death in defense of Islam would bring them immediately to the rewards of paradise.

Within two centuries, Islam had expanded its borders east to the Indus River, encompassing much of what is now Pakistan. It stretched in the west to Spain, where its advance was halted by the Frankish army of Charles Martel, Charlemagne's grandfather, in 732. Synthesizing the cultures of its many peoples, Islam entered a "golden age" during which Islamic scholars and artisans surpassed their Christian and Eastern rivals.

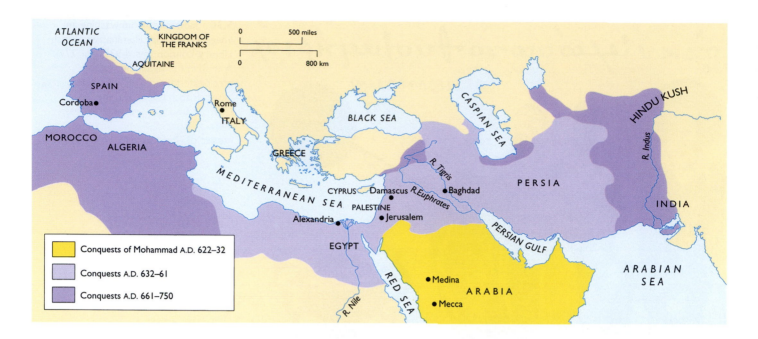

5.31 The rise of Islam.
Except for Spain, the regions conquered by 750, from India to Morocco, remain largely Muslim today. A later wave of expansion by Turkish Muslims pushed Islam deeper into central Europe and Asia.

The Foundations of Islam

La ilaha illa Allah; Muhammad rasul Allah – "There is no god but Allah, and Muhammad is his prophet." In Arabic, these words are the simple but powerful profession of faith in Islam, the world's youngest great religion. The word *islam* means simply "surrender to God." For believers of Islam, or Muslims, "surrender" requires belief in and obedience to the prophet Muhammad's teachings, which set out a strict religious and moral code.

The life of Islam's founder, the prophet Muhammad, is well known. He was born about 570 in the Arabian trader city of Mecca. In mid-life Muhammad received an angelic command to "rise and warn" the Arabian people in the name of their chief deity, **Allah**. About 613 Muhammad began preaching in Mecca and then had to flee his opponents in 622, settling in Medina, north of Mecca. This flight, called the **hegira** [HEEJ-ruh], is the event from which Muslims date their calendar. Eventually, Muhammad led a force against Mecca and successfully established the worship of Allah at Arabia's holiest shrine, the Qa'aba [KAHH-buh].

Muhammad's message, like that of Moses and Jesus, was radically simple and focused on obedience to God and respect for others. He proclaimed that Allah was the sole god and creator of the universe. All believers were equal before God, and were charged to treat each other with kindness and regard. A day of judgment was coming that would reward the faithful with infinite pleasures and punish the evil with eternal misery. The faith acknowledged the prophets of Judaism and Christianity – Abraham, Moses, and Jesus – as Muhammad's predecessors, but carefully emphasized the status of Muhammad as the last of God's spokesmen. From Muhammad's teachings evolved the essential tenets of Muslim faith, called the Five Pillars of Islam, which remain the unifying precepts of Islam throughout the world today:

- bearing witness to Allah as the one true God;
- prayer, normally five times daily while facing Mecca;
- almsgiving, both to the poor and to the Islamic state;
- fasting during the holy month of Ramadan;
- pilgrimage (the *hajj*) to the Qa'aba in Mecca.

The poor and infirm are excused from the obligations of almsgiving and pilgrimage.

The Qur'an Muhammad's most important act was to receive the revelations of God, recited to him by the archangel Gabriel over a period of twenty years. These revelations are inscribed in the Qur'an (Koran), Islam's scriptures (Fig. **5.32**). Written in Arabic, the Qur'an [KOR-ahn] is divided into 114 *suras* [SUH-ruhs], or chapters. It blends ecstatic praise of Allah with wisdom derived in part from Jewish and Christian sources.

> This is no invented tale, but a confirmation of previous scriptures, an explanation of all things, a guide and a true blessing to true believers.
>
> The Qur'an, Sura 12 *Joseph*

In most *suras*, Allah speaks directly to the faithful, as in Sura 55, when he describes the judgment of souls:

Mankind and *jinn*.[a] We shall surely find the time to judge you!
 Which of your Lord's blessings would you deny?
Mankind and *jinn*, if you have power to penetrate the
 confines of heaven and earth, then penetrate them!
 But this you shall not do except with Our own authority.
 Which of your Lord's blessings would you deny?
Flames of fire shall be lashed at you, and molten brass.
 There shall be none to help you. Which of your Lord's
 blessings would you deny?
When the sky splits asunder, and reddens like a rose or
 stained leather (which of your Lord's blessings would
 you deny?), on that day neither man nor *jinnee* will be
 asked about his sins. Which of your Lord's blessings
 would you deny?
The wrongdoers will be known by their looks; they shall
 be seized by their forelocks and their feet. Which of your
 Lord's blessings would you deny?
That is the Hell which the sinners deny. They shall wander
 between fire and water fiercely seething. Which of your
 Lord's blessings would you deny?

But for those that fear the majesty of their Lord there are
two gardens (which of your Lord's blessings would you
deny?) planted with shady trees. Which of your Lord's
blessings would you deny?[8]

THE QUR'AN
Sura 55 The Merciful

a. *jinn*, supernatural spirits who, like humans, would face divine judgment.

For Muslims, only the Arabic version of the Qur'an is God's true revelation and, because of its influence, Arabic became the universal language of Islamic faith and learning. However, as he worked to govern his new community,

5.32 Qur'an page written in Kufi script, from Great Mosque, Qayarawan, Tunesia, 950. Parchment, 9⁴/₅ × 13³/₄ ins (25 x 35 cm). Bibliothèque Nationale, Tunis.
The Arabic text of the Qur'an, here presented in decorative calligraphy, was also incorporated in Islamic art as a constant reminder of the commanding will of Allah.

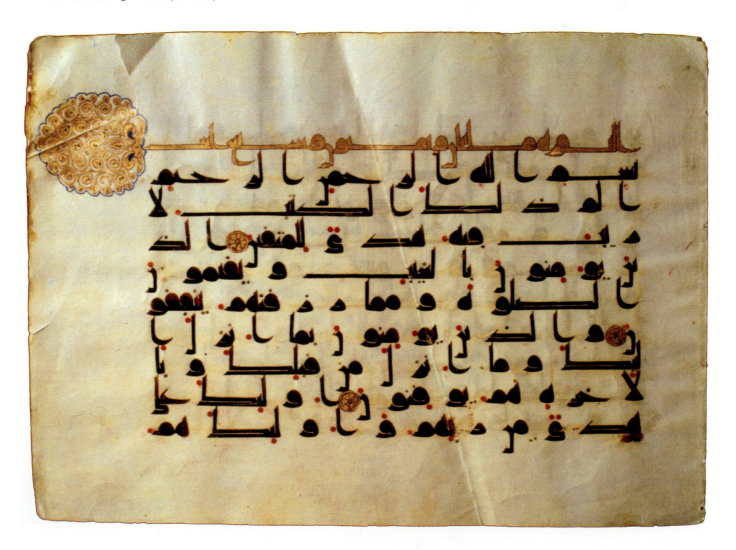

Muhammad made pronouncements and established new customs that entered Muslim tradition as *hadith*, or "reports" of the Prophet's deeds and sayings. By the 800s, Muslim scholars had defined Muslim law, or *sharia*, as resting on both the Qur'an itself and the interpretation and moral example of Muhammad. By about 900, Muslim intellectuals had reached consensus on the foundations of the "Muslim way," though questions about the application of Qur'an and the authority of *hadith* still animated the faith.

Islamic Arts and Science

In the eighth and ninth centuries, Islamic civilization achieved a remarkable synthesis of the many cultures within its bounds. By the early 800s, Islam's rulers (called **caliphs**) were Persian, not Arab. The caliphs occupied a splendid green-domed palace in their capital, Baghdad (founded 762), which grew to a city of more than a million. In Baghdad, Islam's artists and intellectuals drew from the rich traditions of Byzantine, Persian, Egyptian, and Indian peoples, as well as the Chinese, with whom Arab traders had regular contact.

Muslim art and architecture evolved directly from the tenets of the faith. The mosque, the Muslims' place of worship, was usually constructed on a simple plan: a large inner courtyard was surrounded by arcaded aisles to contain the faithful at prayer (Fig. **5.33**). The mosque at Córdoba in Spain (begun about 736) shows that Muslim architects willingly adapted the columns and arches of the Roman style (Fig. **5.34**). The mosque's aisles oriented the believer in the direction of Mecca, toward which the faithful must turn in prayer. Mosques – as well as Islamic pottery and fine art – were commonly decorated in

5.33 Great Ommayed Mosque, Damascus, Syria, c. 715.
The Muslim mosque had to provide space, in an open courtyard or under roofed cover, for the entire male population to observe Friday prayers. The mosque at Damascus featured domed roofs and an arcaded courtyard.

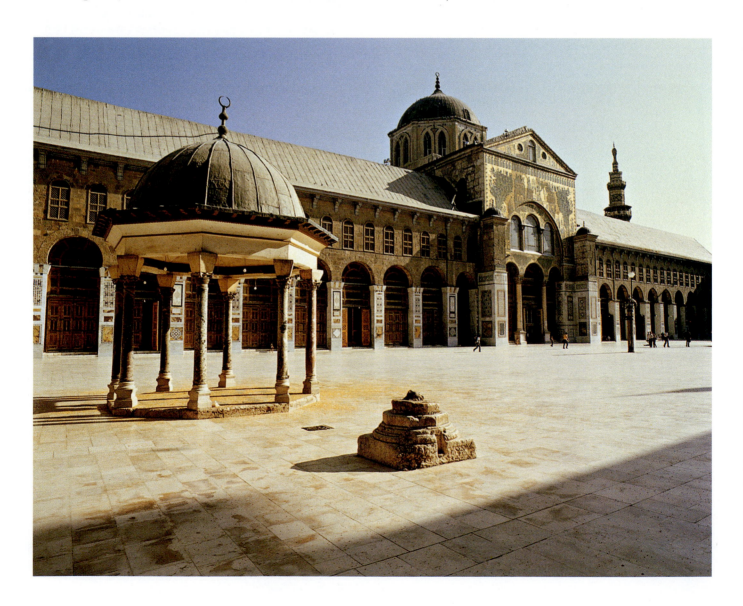

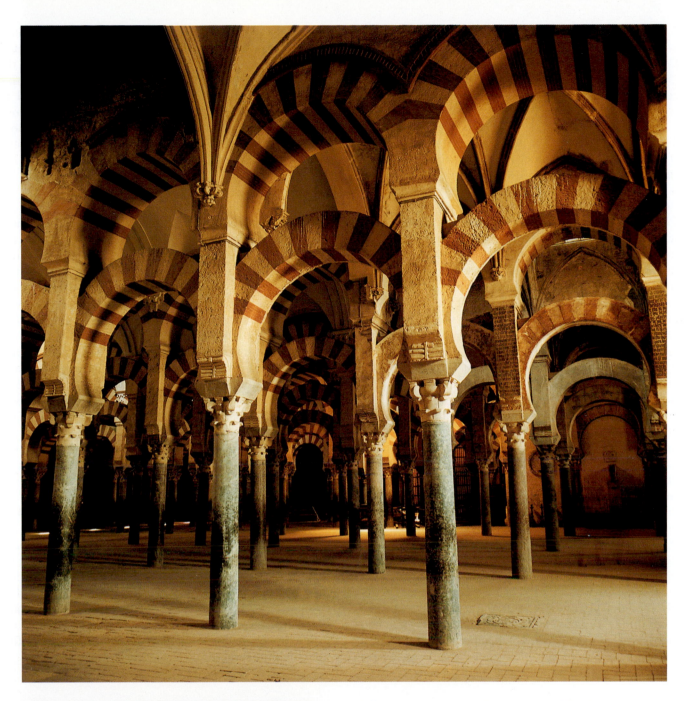

5.34 (*above*) Interior, Great Mosque of Córdoba, Spain, c. 736.

Muslim architects preferred the horseshoe arch and in Córdoba's Great Mosque stacked one arch on top of another. This ingenious system was originally devised to compensate for the relatively short columns, less than 10 ft (3 m) high, which are extended by masonry impost blocks.

5.35 (*left*) Exterior decoration, Great Mosque of Córdoba, Spain, 785–7.

The Muslim fascination for mathematics and astronomy is evident in the decorative arabesques of Islamic architecture. Note that the overlapping arches here mimic the appearance of the mosque's majestic interior.

abstract designs, in obedience to the Qur'an's prohibition against images of living things. The typical decoration was the **arabesque**, a design that repeated a basic line or pattern in seemingly infinite variations (Fig. **5.35**).

For a thousand years, Islamic civilization made important advances in science and mathematics, while also preserving the knowledge of Greek philosophy. Arabic physicians were licensed by the state and routinely performed surgeries for cancer and other diseases. The physician Razi (865–925) was the first to describe the clinical symptoms of smallpox. Arabic mathematicians shared the Islamic artists' fascination for abstraction and devised a numeral system based on the zero (Arabic *sifr*) and the mathematics of algebra (Arabic *al-jabr*). Arabic centers of learning preserved the heritage of classical philosophy, at a time when many works of Aristotle and Plato were unknown to the Christian world. In the ninth century, a caliph established an academy at Baghdad after being assured by the ghost of Aristotle that classical philosophy did not conflict with the Muslim faith. Baghdad was also long a center of Hebrew scholarship, thanks to Islam's tolerance for its Jewish minority. The later revival of science and philosophy in Christian Europe owed much to the efforts of Arabic civilization.

The rise of Islam initiated a long history of religious rivalry and uneasy coexistence in the Mediterranean world. Muslims often placed new Islamic shrines on sacred sites of conquered religions. The Dome of the Rock in Jerusalem, for example (see Fig. 5.1), was erected on the Temple Mount where Herod's temple had stood (see page 100). The rock where Jews believed Abraham had prepared to sacrifice Isaac was where Muslims held that Muhammad ascended to visit heaven. At the same time, Muslim conquerors were comparatively tolerant. In Muslim Córdoba (see page 126), the regional caliph recognized both Muslim and Christian feast days. War erupted frequently, however, and in coming centuries Christian and Muslim often took bloody vengeance on each other. A common religious heritage was insufficient to resolve the political and cultural tensions among Jews, Christians, and Muslims.

Dawn of the Middle Ages

Islam's victories completed a transformation of the ancient world that began with the barbarian invasions and the rise of Christianity. In the years from Constantine's conversion to Christianity to the Muslim conquest of Africa and Spain, the Greco-Roman world fell apart. Some of the pieces (Syria, Persia, north Africa) were swallowed up by Islam's advance, others (chiefly northern Europe) fell under the rule of vigorous barbarian tribes. The Mediterranean core of the Greco-Roman world (Rome and Byzantium) remained intact, although now thoroughly Christianized.

The classical world had come to an end, and was replaced by what we now call the Middle Ages – the "middle" time between the classical era and the Renaissance (see Chapter 8), which inaugurated our modern age. Some scholars date the medieval period from Constantine, the first Christian Roman emperor; others see its beginning in the barbarian sack of Rome in 410, or in the last Roman emperor's abdication in 476. Yet, these dates focus on the decay of Roman forces, not on the vigorous new forces – of Islam and the European barbarian kings – that would dominate the medieval period. Whatever the date of the dawning of the Middle Ages, the light revealed a Western Europe dominated by two powerful forces – the Roman Catholic Church and the warlords of northern Europe. The new "middle" age would be shaped by these two ambitious and often incompatible forces.

CHAPTER SUMMARY

The Judaic Tradition The Roman Empire's transformation by Christianity is rooted in the ideas of the ancient Jews, or Israelites. In their history, the Israelites saw a pattern of deliverance or punishment at the hands of their God, Yahweh. Israelite national life centered on the temple at Jerusalem, founded by the kings David and Solomon. The Israelites' contribution to Western religion was their concept of monotheism, which held that all were equal before an almighty God. The Hebrew Bible revealed God's nature and illustrated his covenant with the Israelites, who had to obey God's law. Repeatedly subjugated and exiled by imperial powers, the Israelites developed the apocalyptic hope that God would restore their nation's glory.

The Rise of Christianity Out of the Hebrew faith arose Christianity, which originated in Jesus of Nazareth's call for a radically loving and humble communal life. Jesus' followers, especially the apostle Paul, emphasized their belief that Jesus had risen from the dead and offered eternal life to Christians. The Christian scriptures included Paul's letters and the Gospel accounts of Jesus' life, which testified to Jesus' promise of redemption. The Roman emperor Constantine converted to Christianity and, by the end of the fourth century, Christianity had become the empire's official religion.

Philosophy: Classical and Christian Late antiquity witnessed a troubled merger of classical and Christian thought. Plotinus articulated the Neoplatonist view that all reality emanated from a single source, the One or the Good – an idea that appealed to Christians. The most important synthesis of classical and Christian ideas was achieved by St. Augustine, author of a compelling spiritual autobiography and a Christian philosophy of history. Augustine's concept of original sin had a powerful influence on Christian attitudes toward human nature and politics. His *City of God* envisioned a history that moved according to the majestic plan of God, leading to the final salvation or damnation of all humankind.

The Christian Empires: Rome and Byzantium The first Christian emperor, Constantine, completed Rome's division into Eastern and Western Empires. The Eastern, or Byzantine, Empire grew increasingly prosperous and powerful, while the Western Empire suffered the onslaught of barbarian armies. Churches built at Rome established a characteristic form of new Christian architecture, while the pope in Rome became the most effective official authority. In the East, Byzantium reached its height in the sixth-century reign of Justinian. During Justinian's rule, great churches built at Constantinople and Ravenna exhibited a fusion of Roman arts and Christian values.

Christianity and the Arts The Christian Church was deeply hostile to the pagan arts of music and theater. Early Christian music consisted of elaborate chants in differing regional styles that served to enhance celebrations of the Christian Mass, or liturgy. Christian leaders condemned and suppressed the theater. This hostility toward art climaxed in the iconoclastic controversy, when officials in the Byzantine Empire systematically destroyed religious mosaics and painted icons.

The Rise of Islam The Byzantine world was shaken by the rise of Islam, a new religious and political force. Founded by the Arabian prophet Muhammad, Islam worshiped the one god Allah with a regimen of daily prayer and devotion as prescribed by the Islamic scripture, the Qur'an. By 750, Islam had conquered a vast empire and was fostering a rich Islamic civilization. Islamic medicine and science saw important advances, while Muslim and Jewish scholars preserved classical learning.

6 The Early Middle Ages: The Feudal Spirit

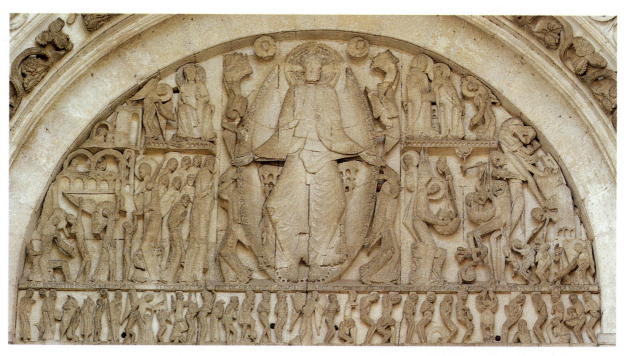

6.1 Gislebertus, *Last Judgment*, tympanum sculpture, west portal, Cathedral of St.-Lazare, Autun, France, c. 1120–35.

At the Last Judgment, Christ calls all souls to rise from the dead (across the lintel); while some are admitted to heaven (left), many more are weighed on the scales of righteousness (right) and damned to punishment.

I alone give order to all and crown the righteous;
Those who follow crime, I judge and punish.
Here, let those bound to earthly error be struck
 by terror.
The horror of those you see here will be their fate.

With these fearsome words, the image of Christ greets the medieval believers who passed beneath. From his throne, he judges the souls of the dead at the Last Judgment (Fig. **6.1**). Some are lifted through the gates of heaven. More – many more – are cast into the torments of hell.

The hierarchical order of this heaven and hell reflects the **feudal spirit** of the early Middle Ages. God and believer, lord and peasant, abbot and monk – all were bound in a system to defend against a violent and demon-infested world. The rise of a new empire in Europe and the Church's efforts to preserve the arts and learning were not always enough to protect the Middle Ages from the fiends of war, ignorance, and folly.

The Age of Charlemagne

Explain the interest of Charlemagne in books, churches, and the arts.

By the 700s, a vigorous new culture had emerged in the outer regions of the former Roman empire. In the British Isles and Scandinavia, pagan cultures blended with Roman and Christian influences. Monasteries in Ireland and England became significant centers of evangelism and learning. Their distinctive religious symbolism and decorative style gave a new stamp to Latin Christian civilization. A new synthesis of Northern styles and classical Mediterranean civilization reached its height around 800 in the rule of Charlemagne, who unified Europe in a Christian empire and fostered a renaissance in learning and the arts.

Northern Edge of the Early Middle Ages

The Roman Empire did not subdue Britain until the year 43 and never colonized Ireland or Scandinavia (today's Denmark, Norway, and Sweden). As Rome declined, vigorous Germanic warlords called Anglo-Saxons took power in Britain and Scandinavian raiders sailed as far as Byzantium and North America. In Ireland and Scotland, descendants of Europe's ancient Celtic culture adopted Latin Christianity while preserving their Celtic language and traditions.

Monasteries in Ireland and Britain proved to be fervent defenders of classical learning and centers of book production. In the early medieval world, books were exceedingly rare and costly. Christian monastic libraries held precious copies of classical works as well as sacred Christian texts. Often working in remote and crudely built monasteries, Irish and English monks piously hand-copied texts, decorating, or "illuminating," the pages in a style now called Hiberno-Saxon (from Hibernia, Latin for Ireland). Hiberno-Saxon artists preferred fantastic animal figures and decorations of intricately patterned **interlace**. A page from the *Book of Kells*, a famous gospel book, represents the text's initial letter "T" as a bizarre animal with clawed feet and serpentine neck. This animal devours another creature formed of colorful interlace that fills the "T's" inner curve (Fig **6.2**).

The delicacy of Hiberno-Saxon illumination makes a decided contrast to the violent action of the Anglo-Saxon epic *Beowulf* (composed c. 700), based on a story brought to England by Danish invaders. Its young warrior hero saves the court of the Danish king by slaying the monster Grendel and displaying its severed arm as a gruesome trophy. Beowulf must eventually enter a lake of demons and also subdue Grendel's mother.

As *Beowulf* shows, the Scandinavian or Norse culture possessed its own vivid mythic and heroic traditions. In the Norse sagas, we find the best evidence of the

6.2 *Tunc crucifixerant XPI*, Book of Kells, fol. 124r, late 8th or early 9th century. Illuminated manuscript on vellum, 9¹/₂ x 13 ins (24 x 33 cm). Library of Trinity College, Dublin, Ireland. © The Board of Trinity College, Dublin, Ireland

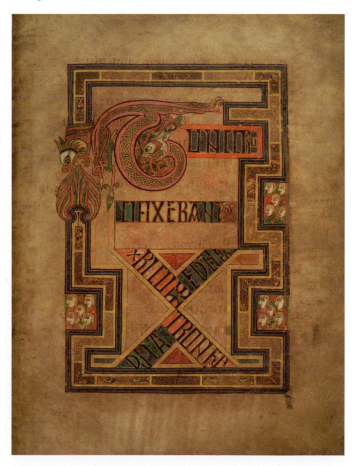

Germanic religion that preceded Christianity. The *Eddas*, poetic sagas composed in the Nordic Iceland about 1000, recount for example the apocalyptic destruction of the world of the gods. Norsemen had reached Iceland in their oar-powered longboats, invented about 800, and attacked Constantinople in 860. During the Viking age (800–1000), Norse raiders plundered the towns and monasteries of the British Isles and northwest Europe, disrupting the early medieval economy. The Vikings were fearless sailors who by 1000 had settled Greenland and explored North America.

Charlemagne's Empire

In northwestern Europe, a warlike people called the Franks had halted Muslim incursion by 750 and established a kingdom along the Rhine River (in today's Germany). When the forceful Frankish ruler Charlemagne [SHARL-main] (ruled 768–814) took power, he expanded his kingdom with an imposing force of mounted Frankish knights. His warrior nature was ruthless: he once beheaded 4,000 Saxon warriors to punish a rebellion and forced the survivors to convert to Christianity. In 800, Charlemagne made a pilgrimage to Rome where, on Christmas Day, the pope crowned him Holy Roman Emperor, the first acclaimed emperor of Europe since Roman times.

Charlemagne was not only a bold military leader and politician. His avid interest in learning and the arts created what scholars call the Carolingian [kair-o-LIN-jee-un] renaissance. The Carolingian (from *Carolus*, Latin for "Charles") renaissance briefly centralized a lively imperial culture at Charlemagne's court. Scholars of Charlemagne's palace school supervised reforms in Church music, oversaw the copying and illumination of books, and chronicled the life of Charlemagne. In concept, Carolingian art and ideas reflected an imperial ideal borrowed from ancient Rome and the still-reigning Byzantine emperors. In practice, Carolingian art works were nearly all produced at Charlemagne's palace school and at monasteries sponsored by the king. After Charlemagne's death, the talent dispersed and within a generation the Carolingian renaissance was extinguished.

The most influential intellectual in Charlemagne's circle was Alcuin of York (735–804), an Anglo-Saxon monk, librarian, and teacher. Alcuin [AL-kwin] is credited with reforming the Catholic orders of worship and supervising a new translation of the Bible. Perhaps most important, he fostered a general revival of learning under Charlemagne's reign. At the imperial court (which he called a "new Athens"), Alcuin tried to create an aura of biblical royalty and classical achievement, dubbing courtiers with nicknames such as "David" (Charlemagne) or "Homer" (Alcuin himself). He taught the king grammar and read to him from Augustine's *City of God*, Charlemagne's favorite book.

Alcuin's influence also indicates the importance of education and literacy in Charlemagne's empire. Charlemagne needed officials who could read his administrative orders, and since he recruited most of his officials from the clergy, Charlemagne advocated clerical education. He urged bishops and abbots to foster literacy in their domains and to promote clergymen based on learning and ability. In one district, priests were ordered to establish free schools for all boys – an early and short-lived attempt at universal education.

Carolingian Arts

At the center of the Carolingian renaissance was a vigorous "culture of the book." Carolingian painters and illustrators (Fig. **6.3**) consciously imitated the late Hellenistic and Byzantine styles imported from the Mediterranean world. However, the Carolingian artists, some of them immigrants from Byzantium, could not resist Hiberno-Saxon art's intricate fantasy and grotesque energy (Fig. **6.4**).

6.3 The four evangelists, from the *Gospel Book of Charlemagne*, early 9th century. Manuscript illustration. Palace School of Charlemagne, Aachen, Germany. Cathedral Treasury, Aachen. An illuminated page produced in the palace workshops of Charlemagne depicts the four gospel-writers with their symbols. The evangelists are shown in the pose of the medieval copyist, bent over a stand with quill in hand.

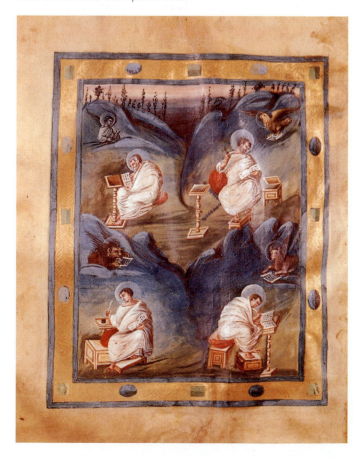

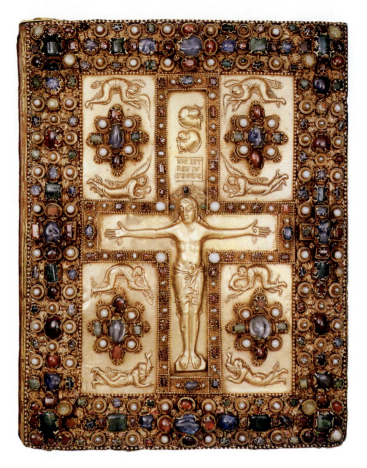

6.4 *Crucifixion*, from the front cover of the *Lindau Gospels*, c. 870. Gold and jewels, 13³/₄ x 10¹/₂ ins (35 x 27 cm). Pierpont Morgan Library, New York.
This crucifixion scene reflects the influence on the Carolingian artist of Hiberno-Saxon art in its dazzling and intricate arrangement of florettes of gems set in gold across the surface of the cover. The more classically inspired figures are the beardless, crucified Christ attended by angels above, and, in mirror-image below, the Virgin Mary, St. John, and Mary Magdalene (?).

One notable synthesis of these illumination styles was the *Utrecht Psalter* [OO-trekt SALT-er] (Fig. **6.5**), a collection of the psalms produced in the workshops of Ebbo, archbishop of Reims in France. The artist depicted each significant phrase as a separate vignette, connecting the vignettes with swirling clouds or landscape. At the scene's center, angels implore a sleeping God, "Rouse thyself! Why sleepest thou, O Lord? Awake! Do not cast us off for ever!" While imitating Roman-style fresco, the workshop artist at Reims animated his figures with a bizarre energy, suffusing the classical Mediterranean style with a mystic aura that emanated from the north.

In the age of Charlemagne, the art of life-size sculpture virtually disappeared, in part because of the iconoclastic controversy (see page 122). Sculpture did find an outlet in the demand for **reliquaries** (see Fig. 6.25), richly decorated containers of holy objects, or relics. Sculptural decoration was also incorporated into the Carolingian

THE WRITE IDEA

Describe the role that today's political leaders should take in supporting the growth of arts and ideas. Should we choose leaders who, like Charlemagne, show an interest and ability in cultural affairs?

culture of the book, since sculptors could decorate book covers without risking the sin of idolatry. The *Crucifixion* shown in Fig. **6.6** compresses the biblical scene into a unified action. Mary and other followers mourn Christ's suffering. Roman soldiers with a spear and wine-soaked sponge are flanked by rounded tombs, from which figures rise in praise of Christ's sacrifice. Above Christ's head are medallion figures of the sun and moon, representing eternal time. These Carolingian carvers were more interested in the subject's spiritual pathos than in naturalistic anatomy or pictorial realism.

6.5 Psalm 44, from the *Utrecht Psalter*, c. 820–40. Pen and ink on vellum, 12⁷/₈ x 10 ins (33 x 25 cm). University Library, Utrecht.
One of the most remarkable works of the Carolingian era, this psalter illustrates different verses of each psalm with a separate vignette. In Psalm 44, the psalmist's words, "Through thee we push down our foes," are illustrated in the quailing army at lower left. Tambourine players at right try to awaken a sleeping Lord.

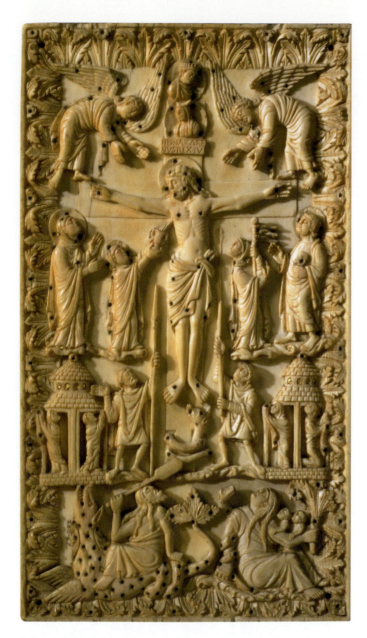

Charlemagne's court. The chapel is a double octagon (Fig. **6.7**), plain brick on the outside in the Byzantine style. Inside (Fig. **6.8**), the chapel has none of the airiness and grace of its Byzantine model – instead, the two-story inner octagon is supported by heavy stone piers. The king's marble throne stood in the gallery, from where Charlemagne could overlook the chapel's altars and the throng of courtiers who gathered below.

The palace at Aachen was an appropriate setting for the informal Carolingian court. Here the king and his teacher Alcuin traded riddles, and the king's daughters carried on love affairs with favored courtiers. In formal grandeur, Aachen fell short of the courts at Rome, Baghdad, and Constantinople. However, in the power and ambition of its ruler, the palace of Aachen was unrivaled.

Unlike Alexander's Hellenistic empire, which endured for two centuries, Charlemagne's kingdom was split by political dissension and war only a generation after his death. The Frankish kingdom splintered into regional territories, governed by powerful dukes and barons. The disintegration was propelled by a savage new wave of invasions that struck Europe in the ninth and tenth centuries. The Muslims from the south, the Hungarians from the east, and especially the Vikings, all terrorized European settlements and disrupted European society.

6.6 *Crucifixion*, from Metz, c. 850–75. Ivory plaque, 8¹/₅ × 4³/₄ ins (21 × 12 cm). Victoria and Albert Museum.
Even working on the scale of a book cover, sculptors in the Carolingian era achieved considerable expressiveness and narrative detail. The snake curled at the foot of the cross refers to Adam and Eve's original sin. Note the leafy border, which recalls the decoration of Corinthian columns.

At his palace complex at Aachen [AHKH-un] on the Rhine River, Charlemagne built a residence to reflect his imperial office. The palace at Aachen (in French, Aix-la-Chapelle [AYKS-lah-shah-PELL]) included a great hall for imperial business and a chapel modeled after Byzantine churches. Even before he was crowned emperor, Charlemagne imported a statue of a Roman king to stand before his palace. By the standards of Hagia Sophia or St. Peter's, the chapel was rather modest. However, its sensible eclecticism reveals the tastes of

6.7 Restored plan, palace chapel of Charlemagne, Aachen, Germany, 782–805.

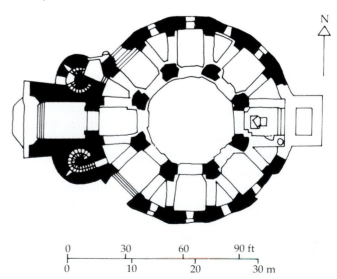

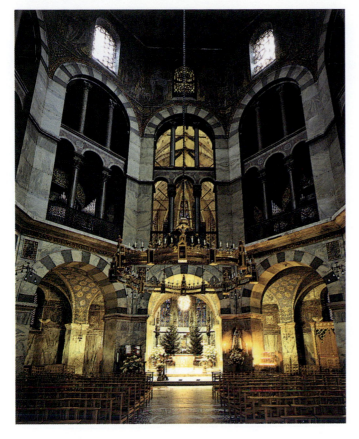

6.8 Interior, palace chapel of Charlemagne, Aachen, Germany, 782–805.
Charlemagne's chapel on the River Rhine was a more modest version of the Byzantine imperial style. Compare the arches with those of San Vitale in Ravenna, Italy (Fig. 5.24) and the Córdoba Mosque, Spain (Fig. 5.34).

Feudal Europe

Characterize the achievements of feudal culture in medieval Europe.

Under the pressure of Viking raids and territorial disputes, medieval Europe labored to preserve its communal life and sustain its fragile agrarian economy. Especially in France and England, which bore the brunt of the Viking onslaught, a decentralized patchwork of small estates evolved from Carolingian society. These rural estates were governed by a system in which land-owning nobles cooperated to defend their property. Largely self-sufficient, these medieval communities functioned effectively without the cities and centralized government that seem so indispensable to modern life. In this era, a European culture arose to reflect the military values of the land-owning class – a culture of epic battles and military conduct that may be called the feudal spirit. Meanwhile, in medieval Spain, a unique blend of

Muslim, Jewish, and Christian cultures was achieved under the relatively tolerant rule of Muslims.

Feudalism

Feudalism is the medieval social system based on the link between vows of military service and the ownership of land. Under feudalism, an aristocratic warrior elite ruled Europe chiefly by military force. The link between war and land was the feudal oath (Fig. **6.9**), which bound a lesser lord, or vassal, to serve a higher lord in battle. In return for his service, the vassal received title to a grant of lands (in Latin, *foedum*). The vassal assumed the right to rule and tax the peasants on his estate, which enabled him to maintain his expensive horses and weaponry, while enjoying the produce of its farms, vineyards, and villages. Virtually the entire life of the feudal nobility – war, marriage, political alliance – concerned the getting and keeping of land.

Life on a medieval estate centered on the castle – the residence of the lord's family and refuge for the estate's population in time of war. In the early Middle Ages, a castle was hardly more than a crude timber house encircled by a stockade. Later, after Christian crusaders (see page 156) had studied Byzantine and Turkish castles, noble residences became more imposing. Stone fortresses were carefully designed to defend against military siege. Still, no castle was impregnable. Attackers often tunneled underneath the castle walls, battered

6.9 The girding-on of swords, one part of a solemn ritual undertaken in the investiture of a knight. Ms. D XI fol. 134 vi. British Library, London.
Personal oaths of loyalty and service were of vital importance in holding together the feudal political system.

6.10 A 12th-century medieval calendar showing peasants at their labors. Rheinisches Landmuseum, Bonn, Germany.
Peasant life was governed by agrarian labor and cultural traditions rooted in pre-Christian times. Peasants owed their lord a specified amount of rent and labor in kind.

them with siege weapons, or simply waited for the defenders' water or food supplies to give out.

Compared with the lavish houses of Pompeii or Byzantium, European castles were rather sparsely furnished and decorated. The walls were typically painted with designs of flowers, or covered by embroidered wall hangings, such as tapestries from Flanders or France, which helped subdue wintry drafts. More elaborate tapestries, imported from Islamic regions, did not appear until the fourteenth century.

Outside the castle, the peasants of a feudal estate endured the backbreaking labor of plowing, planting, and harvesting food crops (Fig. **6.10**). To assure a captive labor force, feudal law prohibited serfs from marrying a daughter outside the village or giving a son to a monastery. In return, the lord was obliged to provide a feast for his peasants on harvest days and religious holidays, which occupied as much as one-third of the calendar.

Christian feast days were celebrated with song, dance, and other traditions rooted in ancient pagan ritual. One tradition was **mumming**, in which villagers disguised themselves as animal or human characters. The masked mummers marched silently into the household of a lord or other social superior, danced and celebrated, and then offered gifts to the host and took their leave in silence. Itself obscurely rooted in pagan celebrations, mumming

was the origin of masquerades and other masked dances. Like much early medieval peasant dance and music, it thrived on the edge of Christian orthodoxy.

The Arts of Feudalism

The feudal nobility of early medieval Europe encouraged an oral literature of military exploits and feudal values, similar to the Greek epics which had praised the heroes of the Trojan War. Feudalism's greatest war story was the *Song of Roland* (Fig. **6.11**), an epic that recounts a battle from Charlemagne's campaigns in Islamic Spain. The epic's hero is Roland, a lieutenant of Charlemagne, who fights bravely against an overwhelming force of Muslim knights (called Saracens).

The *Song of Roland* was written in Old French, composed as early as the ninth century and first recorded in the eleventh century. It was the most famous of many *chansons de geste* [shah(n)-SOH(n) duh ZHEST], tales of chivalric deeds sung by minstrels in Europe's feudal courts. The *chansons de geste* celebrated a knight's valor in battle and loyalty to his lord, ideas certain to please a

minstrel's host. Unlike the later medieval romances, the *chansons de geste* gave virtually no place to women: the only female in the *Song of Roland* is Aude, the hero's betrothed, who appears at the end and dies on hearing of Roland's death.

The *Song of Roland* is a considerably romanticized account of an episode from Charlemagne's Spanish campaign in 778. As the king's forces withdrew from Spain, his rearguard was ambushed by Christian Basque fighters at the pass of Roncevalles [roh(n)ss-VAHL] in the Pyrenees. According to Charlemagne's biographer, a certain "Hruodlandus, prefect of the forces of Brittany" was included among the Frankish dead. Medieval minstrels transformed this disastrous encounter into a tale of feudal courage, violence, and treachery, told in a manner to gain the admiration of medieval audiences. Instead of Basque peasants, the attackers are devilish Saracen knights, whom the courageous knight Roland impetuously engages. Overwhelmed by the Muslims, Roland finally recalls Charlemagne's main army, blowing his great horn (named Olifant) and bursting his temples with the effort. Delayed by treachery, Charlemagne rushes to Roland's side, to learn the hero has died in battle.

Despite its violence, the *Song of Roland* constantly invokes Christian values. Christianity provides the rationale for war against the Saracens, who are a mirror-image of the French in dress, manner, and values. Because they are pagans, however, the Muslims deserve to perish. At the moment of death, Roland tries to break his sword, Durendal, lest it become a trophy for a Saracen knight. He swears by the sacred Christian relics held within the sword's hilt and, in a knight's dying gesture, Roland offers his glove to God in submission, a sign of the poem's union of feudal and Christian values:

> Roland the Count strikes down on a dark rock,
> and the rock breaks, breaks more than I can tell,
> and the blade grates, but Durendal will not break;
> the sword leaped up, rebounded toward the sky.
> The Count, when he sees that the sword will not be
> broken,
> softly, in his own presence, speaks the lament:
> "Ah Durendal, beautiful, and most sacred,
> the holy relics in this golden pommel!
> Saint Peter's tooth and blood of Saint Basile,[a]
> a lock of hair of my lord Saint Denis,[b]
> and a fragment of blessed Mary's robe:
> your power must not fall to the pagans,
> you must be served by Christian warriors.
> May no coward ever come to hold you!
> It was with you I conquered those great lands
> that Charles has in his keeping, whose beard is white,
> the Emperor's lands, that make him rich and strong."
> . . . He turned his head toward the Saracen hosts,
> and this is why: with all his heart he wants
> King Charles the Great and all his men to say,
> he died, that noble Count, a conqueror;
> makes confession, beats his breast often, so feebly,
> offers his glove, for all his sins, to God. AOI.[c][2]

SONG OF ROLAND

a. Saint Basile, the founder of an important monastery.

b. Saint Denis, patron saint of France.

c. AOI, a refrain uttered at the end of stanzas; scholars cannot explain its meaning.

6.11 Illustration from a 15th-century manuscript of the *Song of Roland*. Musée Condé, Chantilly, France.

The *Song of Roland* embellishes a knight's death with the elements of chivalrous heroism: feudal treachery, combat with evil pagans, a loyal companion, and a sacred sword. The hero lies dying with his sword Durendal nearby, while Charlemagne's forces assault the Saracen force.

The Bayeux Tapestry

The *Song of Roland* may have been the inspiration for feudalism's most ingenious pictorial work, the Bayeux Tapestry (Fig. **6.12**). The Bayeux [beye-(y)UH] Tapestry is an embroidered wall hanging that celebrates one of medieval Europe's most decisive conflicts. The tapestry depicts William the Conqueror's victory over the English at Hastings, a battle that deeply affected English history, language, and religion.

William the Conqueror (c. 1028–1087) was a Norman, descended from Viking invaders who settled in northwest France. In a campaign of territorial expansion, William laid claim to the throne of England, then held by Edward the Confessor (ruled 1046–1066). William's rival was

6.12 Detail from the Bayeux Tapestry, c. 1073–88. Wool embroidery on linen, height 20 ins (51 cm), length of tapestry 231 ft (70.4 m). Town Hall, Bayeux, France.
The tapestry's embroidery renders the mêlée of battle in gruesome detail, including a severed head and an English foot soldier's assault on a horse. Note the treatment of the horse's rear legs in a contrasting color, a device suggesting spatial depth.

Harold, son of England's most powerful family. When Edward died, the disputed succession was decided by war, in typical feudal fashion. William's Norman army invaded England in 1066 and defeated the English at Hastings, killing Harold.

The Bayeux Tapestry recounts this chain of events in a complex pictorial narrative. It is actually not a woven tapestry, but a 231-foot-long (70.4 m) stretch of linen cloth embroidered with figures and captions. This kind of wall hanging commonly decorated feudal halls and depicted scenes from legend or history. The Bayeux Tapestry was probably designed by an English cleric who had studied illuminated manuscripts such as the *Utrecht Psalter* (then held at Canterbury Cathedral in England; see Fig. 6.5). The designer was clearly not a propagandist for one side or the other. For example, the tapestry depicts Harold's oath of loyalty to William, an event supporting William's claim to the English throne; yet, it also shows King Edward's death-bed designation of Harold as his rightful successor. The tapestry's stitching was probably

performed by female English embroiderers, an art famed throughout Europe as *opus Anglia*, or "English work." In both physical size and the span of its narrative, the tapestry rivals the great continuous friezes left by classical civilization, especially triumphal column of emperor Trajan (see Fig. 4.11), which could still be admired by medieval pilgrims to Rome.

The Flowering of Muslim Spain

Feudal Europe produced no court or city that could rival the scale and splendor of the medieval Muslim civilization to the south. On the Iberian peninsula, Muslim Spain – known by its Arab name, *al-Andalus* [ahl-AHN-dah-loos] – was an immensely cultivated world, remarkable because its Muslims, Jews, and Christians often coexisted peacefully. This multicultural society's achievements in architecture, poetry, and philosophy would deeply influence Western civilization.

Muslim armies from North Africa first conquered the Iberian peninsula in 711, and Muslim control was most extensive under Abd-ar-Rahman (912–961). Abd-ar-Rahman declared his independence of the Muslim authority in Baghdad and established al-Andalus as an autonomous realm. Its capital was Córdoba, a glittering city of 500,000 that rivaled Baghdad and Damascus. Court poets sang the praises of al-Mansur (ruled 979–1002), who sponsored an anthology of Hispano-Arabic poetry called the *Kitab al-Hadàig* (*Book of Orchards*). After 1000, Muslim political power in Spain declined, but its art and science continued to thrive. The poet Ibn Hazm (died 1064) composed idealized love poetry that influenced the troubadour poets of southern France. Grammatical treatises and religious commentaries of Andalusian scholars attained wide currency in the Muslim world.

The Spanish Muslims' tolerance of the Jewish minority fostered a "golden age" of Jewish civilization. As Jewish academies declined in the Near East, Spanish Jews (called **Sephardic** Jews) fostered centers of learning and built lavish synagogues in Córdoba and Granada. Jews attained posts of power and influence. The Jewish physician and diplomat Rabbi Hisdai ibn Shaprut (c. 915–c. 970) negotiated for Muslim rulers with delegations from Byzantium and the Saxon ruler Otto I. When a Christian ruler reconquered Toledo in 1085, Jewish scholars joined with Christian sages to establish the School of Toledo, a center for translating Arabic and Hebrew works into Latin. The School of Toledo was a conduit for the philosophical and scientific texts that inspired scholasticism, the intellectual renaissance of the later Middle Ages (see page 173).

Christian nobles pursued a campaign of reconquest (in Spanish, *Reconquista*) that gradually pushed back the borders of Muslim rule. Islam's last Spanish capital was at Granada, where the Muslim rulers built the Alhambra palace on a hill outside the city. The palace complex included government buildings, quarters for a large court, and, most notably of all, luxuriant gardens. Its centerpiece

970	Hrotsvit active as medieval dramatist
c. 980	Muslim poets thrive in Córdoba, Spain
c. 1073–88	Bayeux Tapestry (**6.12**)
1085	School of Toledo founded

was the Court of Lions (Fig. **6.13**), whose graceful colonnaded pavilions were used for musical performances and poetry readings. Muslim Spain's remarkable coexistence of cultures ended emphatically in 1492 with the final reconquest of Granada. Muslims and Jews were forced to convert to Christianity or be expelled; many Sephardic Jews migrated to north Africa, the Americas, and Poland.

6.13 The Court of Lions, the Alhambra, Granada, Spain, 1354–91. Originally planted with gardens, this courtyard is an architectural rendition of the pleasures of the Islamic paradise. The columned pavilions jut into the yard, creating an interplay of light and shadow. The lions were said to represent the "lions of the Holy War," meaning Muslim Spain's ongoing defense against the *Reconquista*.

Monasticism

Explain the monastic ideal in medieval Christian Europe.

From the beginnings of Christianity, believers felt called to renounce the world of material things and pursue a solitary existence of prayer and devotion (Fig. **6.14**). The first Christians to adopt this austere spiritual ideal were Egyptian hermits who retreated alone to the desert. With time, these solitary believers became known as monks (from the Greek *monos*, or "one"), and by the fourth century they had organized themselves in monasteries throughout the Christian world. By the sixth century the monasteries of Italy and northern Europe were established as oases of learning and outposts of missionary fervor in a pagan world. Christian monasticism was to become a powerful force in the Christianizing of northern and eastern Europe. Its influence on Western intellectual and artistic life is still evident today.

The Monastic Ideal

The monastic ideal – the renunciation of normal social life to pursue a life of solitary devotion to the spirit – thrives in many world religions. Besides Christianity, for example, Hinduism and Buddhism have encouraged the monastic life as the surest way to enlightenment and salvation. A Christian monk believed he was adopting the *vita apostolica*, the life of Christ's apostles, who left their

6.14 Giotto (?), *St. Francis Renouncing His Father*, c. 1296–1300. Fresco. Upper Church of St. Francis, Assisi, Italy.
The order of mendicant (begging) friars founded by St. Francis stressed humility and poverty. Here, the saint dramatically renounces his father's wealth by disrobing in the square at Assisi.

families to follow Jesus. Three vows were the essence of the monastic order – poverty, chastity, and obedience. Just as the original apostles had left their homes to follow Christ, so a person entering a monastic order forfeited all property and vowed to live in poverty. A vow of celibacy protected a monk from carnal temptations and concentrated his attention on matters of the spirit. A monk also vowed to obey religious authority. In pursuing the monastic ideal, a Christian renounced the natural community of family and friends and embraced a spiritual communion with God and like-minded companions.

The Rule of St. Benedict was a set of guidelines for monastic life that nearly all European medieval monasteries followed in some form. The rule was authored by Benedict of Nursia (480–c. 547), the founder of the first monastic order, in the early sixth century. St. Benedict's rule laid down concise, straightforward instructions that maintained monastic discipline and assured communal harmony. He admonished the abbot, the elected leader of the monastery, to govern his charges "according to each one's character and understanding" so that "he may not only suffer no loss in the flock, but may rejoice in their increase."

Benedict recommended a humble diet of bread and vegetables. Meat was permitted only in the infirmary, reason enough for a monk to suffer occasional illness. Monks were not supposed to drink wine. However, "since nowadays monks cannot be persuaded of this," Benedict advised that no more than half a pint a day should be allowed. Abbots were warned to see "that neither surfeit nor drunkenness result."

A monk spent many of his waking hours in prayer. The monastic day was punctuated by the offices, hours of prayer that were sounded by bell. Prayer began with the night office at 2 a.m., followed by Lauds at dawn, and four more offices throughout the day. Twilight brought Vespers. The day's last office, called Compline, was spoken after the evening meal. Monks would also chant psalms and listen to readings from sacred books and the lives of the saints. When followed rigorously, this routine of devotion assured a monk's focus on the life of the spirit.

The Plan of St. Gall A monastery's inwardness and self-containment were reflected in its architectural organization. Early medieval monastic architecture is best seen in the plan of St. Gall, an ideal plan for building a great abbey of the Carolingian age. Although St. Gall in

CRITICAL QUESTION

For what reasons might someone your age decide to enter the monastic life? What might be the rewards of poverty and spiritual devotion to a person who has grown up in contemporary society?

The Blood of Maya Kings

Christian religious belief was a powerful motivation and justification for warmaking in feudal Europe. Charlemagne's conquests wrested territory from the heathen Saxons and Magyars, and so were a triumph for Christian faith. In Central America, the Maya people engaged in war to capture enemy soldiers for ritual sacrifice. For the Maya of the Classic Period (300–900), humans were duty-bound to shed their own blood as sustenance for the gods. The Mesoamerican creation myths told how gods had sacrificed their own blood to create the universe. Humans must shed blood in return, if the gods were to grant a fertile earth and wombs.

The principal Maya centers were independent city-states, ruled by royal dynasties, and they were spread across the Yucatán peninsula (present-day Mexico, Belize, Guatemala, and Honduras). At the height of the Classic Period, there were a dozen Maya cities with populations as large as 40,000. Architecturally, the Maya centers featured stepped pyramid-temples (probably modeled on Teotihuacán's), as well as palaces with vaulted rooms, and ball courts where sacrificial rites took place. The remains of their civilization indicate remarkable achievements in astronomy, mathematics, and calendar-making.

Maya blood sacrifice was not only a reason for war, but also the occasion for religious spectacle, monumental building, and sumptuous art. Carved and painted murals on Maya buildings record the religious ceremonies in which royalty shed their own blood or priests offered the hearts of war victims, placed on public altars. At the city of Yaxchilán [yax-chi-LAN], a master sculptor depicted a king and queen in elaborate costume, engaging in a blood-letting ritual that was a royal duty to the gods (Fig. **6.15**). The royal blood was usually shed by piercing the tongue, earlobe, or penis. Numbed by intoxicants and loss of blood, the participants often experienced intense religious visions. Painted murals at other sites record the torture and sacrifice of the hearts of captive warriors.

Like Teotihuacán, the Maya centers of the Classic Period suffered a mysterious decline, perhaps attributable to environmental devastation. By 900, the time of the Viking invasions in Europe, nearly all the Maya cities lay in ruins.

6.15 Maya blood-letting rite, lintel 24 from Yaxchilán, Mexico, c. 725. Limestone, 43$\frac{1}{4}$ x 32 ins (110 x 81 cm). British Museum, London.
A Maya king holds a torch over his kneeling queen, who draws a rope strung with thorns through her tongue in a ritual blood-letting. The blood-soaked paper in the basket below will be burned to sustain the gods. Note the intricate textures of the royal garments and the compositional effect of the ceremonial torch.

Switzerland was not built exactly to this design, the plan served as a model for other abbeys built in the prosperous regions of Carolingian Europe (Fig. **6.16**).

The plan centered on a great church, which had an apse at each end and a pair of towers on the west. The nave was 300 feet (91 m) long and divided into chapels, since there was no need for space for a large congregation. To perform their offices, monks often entered the church from their dormitory, attached directly to the transept. The **cloister** (Fig. **6.17**) was an arched walkway opening onto a courtyard, which might serve as a classroom for instruction in music or theology or a gathering place for readings.

By the ninth century, the large monasteries had become feudal estates in their own right, holding lands that extended far beyond their walls. The monastic standard

N

A church	H barn	O school
B cloister	I workshops	P Abbot's house
C infirmary	J brewery and bakery	Q scriptorium and library
D chapel	K stables	R dormitory
E novitiate	L animal pens	S refectory
F orchard/cemetery	M hostel	T kitchens
G garden	N guest house	U cellars

of living rose accordingly. The plan of St. Gall included a large infirmary, ample lodging for guests, and, despite Benedict's injunctions against meat-eating, a piggery. Quarters were provided for the servants and artisans who performed menial tasks or labored in workshops. Monks themselves worked as cellarers, cantors, and above all, copyists in the **scriptorium**, where manuscripts were copied and preserved. Monastic scriptoria were the sole producers of books in the early Middle Ages.

6.16 *(left)* Plan of the monastery of St. Gall, Switzerland, c. 820.
This influential but idealized plan was probably more compact and coherent than any actual monastery of the early Middle Ages. The focus of monastic life was in the church, place of constant prayer and worship, and in the adjacent cloister.

6.17 *(below)* The cloister of St. Domingo de Silos, Spain, c. 1085–1100.
The cloister was both functional and symbolic: it provided a sheltered passageway and gathering place for monks or nuns, while symbolically shutting out the world's temptations and directing the community's attentions inward.

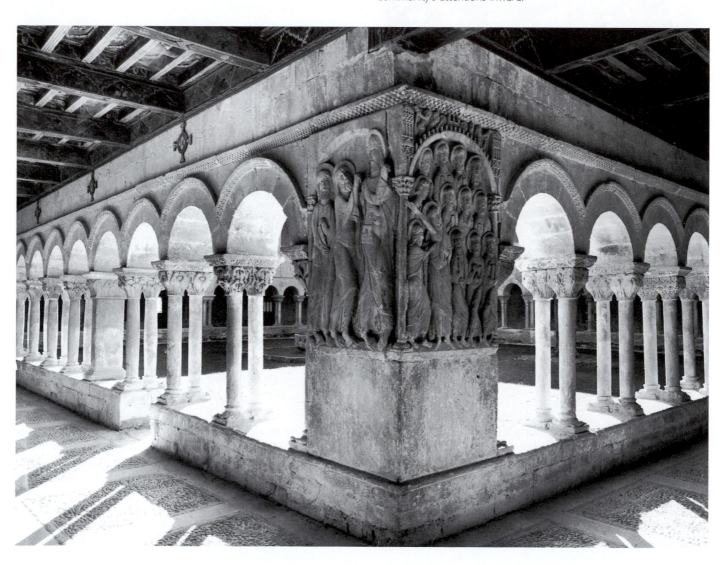

Hrotsvit and the Classical Tradition

The monastic scribes and scholars who copied the sacred writings of Christianity also helped to preserve the writings of classical authors. Although monastic life did not encourage artistic creativity, the classical tradition sometimes inspired literary imitators. Perhaps the most remarkable was Hrotsvit [(h)rots-VEET] of Gandersheim (active c. 970), a Saxon noblewoman who wrote witty adaptations of Roman comedies. Most likely, Hrotsvit's dramas were never performed, and instead were read in the small circle of educated women in the community at the abbey of Gandersheim in Germany. Hrotsvit's abbey was supported by wealthy Saxon rulers and accepted only daughters of aristocratic families. In the early Middle Ages, such female communities governed themselves and provided virtually the only avenue for women to pursue a scholarly life.

Hrotsvit probably entered the abbey of Gandersheim as a young girl and studied in its library of Greek and Roman authors. A gifted scholar, she began writing Latin verse "in the hope that my little talent given by God should not lie in the dark recesses of the mind and be destroyed by the rust of neglect; hoping, rather, that through the mallet of devotion, my little talent may sound the little tinkling chord of divine praise."[3]

Hrotsvit wrote a book of Christian legends in addition to Christianized adaptations of Roman dramas. The plots usually involved chaste Christian women being threatened by lascivious pagans, or harlots whose souls were saved by Christian love. In one play, a chaste wife prays for death rather than submit to a pagan's adulterous advances. The lustful Roman who intends to violate her dead body is converted at her tomb.

While Hrotsvit consciously imitated the style and plots of the Roman comedian Terence (see page 87), she also realized the dangers of Terence's harlots and temptresses to Christian readers. Hrotsvit's women were models of Christian virtue, to counteract the influence of Terence's style:

> Therefore I, the Strong Voice of Gandersheim, have not found it objectionable to imitate him in composition, whom others study in reading, so that in that very same form of composition through which the shameless acts of lascivious women were depicted, the laudable chastity of sacred virgins may be praised within the limits of my little talent.[4]

> Let him study to be loved rather than feared. Let him not be impetuous or anxious, autocratic or obstinate, jealous or suspicious ... and let him so temper all things that the strong may wish to follow, and the weak may not draw back.
>
> Advice to abbots from the Rule of St. Benedict

Not only was Hrotsvit the earliest significant medieval dramatist; in addition, her works provide a compelling alternative to the generally negative view of women in medieval Christianity.

The Romanesque Style

Explain how the Romanesque style served the different needs of emperors, abbots, and pilgrims.

Beginning about 900, a new line of emperors took power in Germany, reviving imperial traditions and founding impressive new churches. In the same period, an influential monastic order, centered at Cluny in France, sponsored reforms in Western monasticism. Inspired by the cult of saints and the Virgin Mary, pious Christians undertook pilgrimages to Europe's shrines, further stimulating new church construction. As one commentator remarked, it was as if Christendom were newly clothed in "a white mantle of churches," all in a style called the Romanesque.

Imperial Revival and the Romanesque Style

In Germany, the title of Holy Roman Emperor was revived by a succession of powerful Saxon rulers, the Ottonians. Beginning with Otto the Great (912–973), the Ottonian emperors actively promoted their claim to the imperial legacy of Charlemagne. Otto the Great held his election as Saxon king in Charlemagne's chapel at Aachen, while his grandson, Otto III, made a pilgrimage to Aachen in 1000, opening Charlemagne's tomb and bowing before the great ruler's seated corpse. The Saxon rulers restored political order to the German provinces, fought back Slavic invaders, and exerted their authority over the Church. Otto the Great deposed the pope who had crowned him and forced the election of a pontiff friendly to his political aims. The Ottonians became the first of many German rulers to interfere in papal affairs.

Ottonian ambitions also fostered a new style in sacred architecture. Historians now call this style **Romanesque** because it used distinctive elements of Roman architecture, such as the rounded arch and barrel vault. Romanesque churches were the first medieval European buildings to rival the buildings of imperial Rome in their size and beauty. The Romanesque style was characterized by massive walls and piers, and used rich sculptural and fresco decoration (Fig. **6.18**). The style appealed to the Ottonian emperors because of its associations with Roman imperial tradition.

In the Saxon town of Hildesheim, an ambitious bishop named Bernward (a former tutor and cousin to Otto III) built two large Romanesque churches – a cathedral and an abbey church. For the Benedictine church of St. Michael's,

6.18 *(above)* *Visitation*, detail of Catalan fresco, 11th–12th century. Episcopal Museum, Vich, Spain.
Romanesque churches, especially in Italy and Spain, were often showcases of fresco decoration. This is a vibrant depiction of the Virgin Mary's visit to her cousin Elizabeth, as described in Luke 1:39–45.

6.19 *(right)* Bronze doors, with scenes from the Old and New Testaments, c. 1015. Hildesheim Cathedral, Germany.
This Romanesque-style sculpture shows a typical interest in fluid lines and emotional expressiveness. The scenes are paired to create thematic parallels from the Old and New Testaments: the presentation of Eve to Adam (second from top, left) is matched with the angel announcing Christ's resurrection to the women at the tomb.

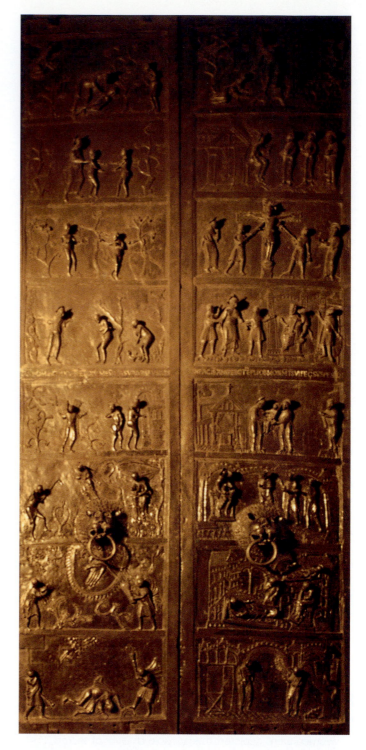

It was as if the whole world were shaking itself free, shrugging off the burden of the past, and cladding itself everywhere in a white mantle of churches.

French chronicler, writing of the year 1003

Bernward had cast great works of bronze sculpture that evoked the glories of Rome. One was a bronze relief column in the style of Trajan's Column in Rome, with spiraling scenes of the life of Christ. Another was a set of bronze doors, cast in delicate relief with episodes from the Old and New Testaments (Fig. **6.19**). The simplicity of design in these panels emphasizes the human feeling of the actors: scenes of the anguish of humans' first sin are paralleled with the joys of Christ's birth and triumphant resurrection.

The Romanesque Church: Monks and Pilgrims

The Ottonians' secular empire was nearly matched in wealth and expanse by the abbey of Cluny, a Benedictine abbey and monastic order founded in 910 in Burgundy, France. The Cluniac order became the most powerful and influential order of its time. The Cluniacs were exempted from control by local bishops and nobles; thus, the order was well situated to reform Europe's monastic houses and bring them under a centralized administration. Eventually Cluny controlled an empire of nearly 1,500 monasteries, both large and small. Reformist Cluniac popes helped restore the papacy's authority and prestige. Cluniac abbeys were enthusiastically built in the new Romanesque style. The vaulted Romanesque interiors offered an arena for the Cluniacs' processions, and an auditorium for their great choirs. Not to be outdone by the showy Ottonians, the Cluniacs modeled church façades after imperial Roman theaters. At Cluny itself, the abbey church of Cluny was rebuilt three times in less than two centuries, expanding to accommodate the monastery's growing numbers. The final church, now known as Cluny III, was the centerpiece of a spiritual city, a "new Jerusalem" that must have seemed like an earthly version of Augustine's city of God (Fig. **6.20**). Its massive stone construction and decoration consciously mimicked the buildings of classical antiquity. The vaults of the central nave (Fig. **6.21**) reached 98 feet (30 m) above the floor. A seventeenth-century admirer wrote of Cluny III that "if you see its majesty a hundred times, you are overwhelmed on each occasion."

For Ottonian rulers and Cluniac abbots, the Romanesque program expressed grand political designs. But it also responded to popular feeling, especially an upsurge in pilgrimage (see Key Concept, page 148). Along the four great "roads" to Santiago de Compostela, in Spain, great churches sprang up to house sacred relics and accommodate the thousands drawn to venerate them.

6.20 (left) Reconstruction of the Romanesque monastery and third Abbey Church of Cluny, France, c. 1157.
The powerful abbey of Cluny in southeast France built a succession of three great abbey churches, at a cost that nearly bankrupted the order. The last one, Cluny III, was immense, with a double transept and chapels clustered around the nave and transept arms.

6.21 (above) Nave, third Abbey Church of Cluny, France, 1095–1100. Reconstruction drawing by Kenneth J. Conant.
The cavernous nave, with its austere rhythm of ribbed vaulting, provided a dramatic setting for Cluniac chants and processions. The decorative Corinthian capitals and fluted pilasters are frank imitations of ancient Roman architecture.

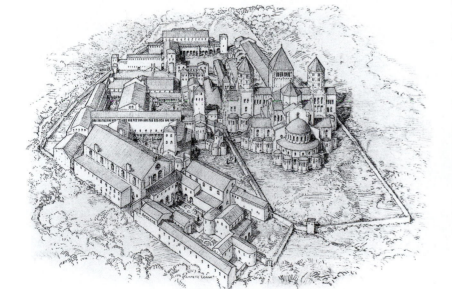

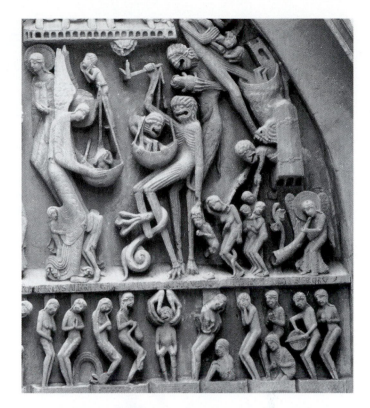

The church of St. Sernin [san(h) ser-NAN(h)] at Toulouse (Fig. **6.22**) typifies the pilgrimage churches' design and decoration. Its floor plan (Fig. **6.23**) indicates the special needs of a pilgrimage church. A spacious nave was required to accommodate the masses of pilgrims who gathered during the pilgrimage season. Chapels lined the apse and transept, where the faithful could file by and view the relics displayed there. Three **portals** and wide **ambulatories**, or walkways around the choir, allowed easy circulation of the pilgrim traffic, without disrupting services being held in the choir. Even with these accommodations, a pilgrimage church was likely to have been a noisy and crowded place during the travel season.

St. Sernin, like the other great Romanesque churches, possessed monumental solidity and an ordered hierarchy of parts. To the pilgrims and monks who filled this church, the graceful subordination of half-domes in the apse and chapels must have been evidence of God's ordered creation, while the massive nave piers and walls seemed like ramparts against a world of sin and temptation.

Romanesque Sculpture

While the churches of Charlemagne's era were usually decorated with painting, the Romanesque style increasingly preferred relief sculpture, in the fashion of ancient Rome. The Romanesque visual style was inspired more by the fantastic shapes of Anglo-Saxon art (see Fig. 6.2) than by Roman classicism. Romanesque sculptors appealed to the believer's imagination with vivid storytelling and an inventive visual style. Mystical events and grotesque beasts adorned the doors beneath which pilgrims walked, no doubt craning their necks at these wonders.

6.22 (opposite) Crossing and apse, St. Sernin, Toulouse, France, c. 1080–1120. Height of tower 215 ft (65.5 m).
The great Romanesque church at Toulouse was an important way-station on the most traveled pilgrimage routes.

6.23 (right) Plan of the church of St. Sernin, Toulouse, France, c. 1080–1120.
The basic cross-shaped Christian church was expanded to serve medieval pilgrims. An ambulatory carried pilgrims around the choir, where priests could say Mass even during the busiest hours. Large portals, or doors, were added to the transept, creating grand entrances to the north, south, and west. Chapels placed along the apse and transept each contained an altar.

6.24 Gislebertus, *Last Judgment*, detail of tympanum sculpture, west portal, Cathedral of St.-Lazare, Autun, France, c. 1120–35. Among Romanesque sculptors, Gislebertus was a master of engaging narrative detail. Note the frightened soul who cowers in the hem of the angel's robe at left and the serpents gnawing the breasts of a woman rising from the grave.

It was the great portal of a Romanesque church that bore its principal exterior sculpture. A portal's sculptural theme was established by the **tympanum**, the large semicircular space above the door. At Autun [OH-tan(h)], in central France, one tympanum bore a great scene of the Last Judgment, carved by a master sculptor named Gislebertus [GEEZ-luh-BAIR-tus] (see Fig. 6.1). As Gislebertus's Christ judges the blessed and the damned, horrible demons try to tip the scale that weighs a soul (Fig. **6.24**). On the beam beneath the tympanum, called the **lintel**, Gislebertus

Pilgrimage

By the year 1000, secure from feudal war and invasion, Europe witnessed a new enthusiasm for **pilgrimage** – the journey to a saint's shrine or other sacred place. In summer, with the planting done, pious Europeans set out by the thousands to the shrines of the saints and the Virgin Mary. Their principal destination was Santiago de Compostela, the shrine of St. James located in northwest Spain, a safer journey than the one to Rome or Jerusalem. Guidebooks instructed the pilgrim in proper dress and equipment (a tunic, staff, and leather purse), warned of dangers, and testified to relics' miraculous powers. Pilgrims went home with a badge, such as the palm of Jericho or the cockleshell of St. James, as proof of their devotion.

Medieval Christian pilgrimage was rooted in the cult of saints, the pious veneration of the Christian saints and their relics. Christians had long believed that from their seats in heaven saints could heal sickness, perform miracles, and intercede for a soul at the Last Judgment. With an arduous pilgrimage to the saint's shrine, a believer earned the right to invoke a saint's intercession. A pilgrimage might also serve as penance for a sin or crime. The greatest medieval cult was devoted to the Virgin Mary, the Queen of Heaven and thus a powerful advocate of poor sinners. Many of Europe's great cathedrals were dedicated to Mary as "palaces of the Virgin." Popular belief in the Virgin's miraculous powers still draws Christian pilgrims to sites such as Lourdes (in France) and Guadalupe (in Mexico).

Pilgrimage aroused a lively commerce and sometimes bitter competition in relics – saints' bones, slivers of the cross, vials of Christ's blood, and other sacred objects. An important relic brought prestige and income to an abbey or town. After repeated attempts, for example, the Benedictine monks at Conques stole the bones of Ste. Foy (Fig. **6.25**) from a rival abbey. Instantly, their church became a beacon to pilgrims. When European Crusaders sacked Constantinople in 1204, they plundered the Byzantine emperor's substantial collection of relics. One prize was a crown of thorns supposedly worn by Jesus at the crucifixion.

The journey to a sacred shrine is an important motive in many of the world's religions. Muslim pilgrims on the *hajj* flood to Mecca by the millions. Hindus traditionally journey to the banks of the Ganges or other sacred waters of the faith. The site of the Buddha's enlightenment at Bodh Gaya in India is the first among Buddhism's chief pilgrimage destinations. In all these religions, a pilgrimage brings believers in contact with the sacred.

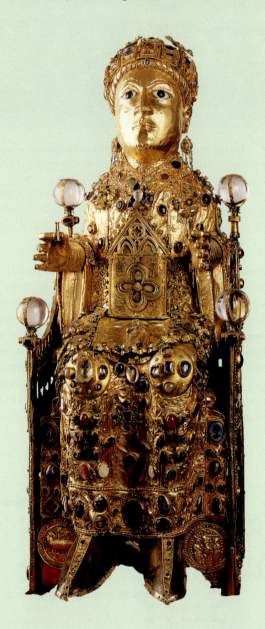

THE WRITE IDEA

Tell the story of a journey that changed your life or gave you important insight into yourself. Was it necessary to leave your everyday surroundings to have this experience?

6.25 Reliquary statue of Ste. Foy, Conques, France, late 10th–11th century. Gold and gemstones over a wooden core, height 33¹/₂ ins (85 cm).
This spectacular figure reliquary, a container in the shape of the saint's body, was displayed in a great assembly of such figure reliquaries in 994.

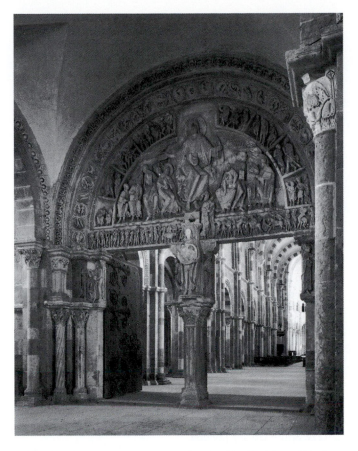

6.26 Narthex door, tympanum, Church of La Madeleine, Vézelay, France, c. 1120–32.
Note how the Romanesque style entirely surrounded the church's entrance with sculpted images. The coordinated scenes of tympanum, lintel, and archivolts here depict aspects of a single Christian theme or story.

6.27 *Mystic Mill: Moses and St. Paul Grinding Corn*, nave capital sculpture, Church of La Madeleine, Vézelay, France, c. 1130.
In this column capital, the Romanesque sculptors showed a plastic, sometimes grotesque sense of the human form. Observe how the curling lines of St. Paul's hair and beard (right) merge with the abstract lines of his garment.

shows the hands of God grasping a screaming sinner. The sculptor intended such vivid images to instruct illiterate churchgoers in the horrors that awaited the sinful at the Last Judgment.

While Gislebertus worked at Autun, anonymous artisans were decorating the sumptuous pilgrimage church of La Madeleine at nearby Vézelay [vay-zuh-LAY], which reputedly held the bones of St. Mary Magdalene. The tympanum at Vézelay (Fig. **6.26**) shows Christ transmitting his saving power to the apostles, the eventual founders of the Christian Church. Christ's otherworldliness is emphasized by the sculpture's low relief and by the almond-shaped symbol of eternity that encloses him. The apostles are ranged on either side of Christ in the order of their significance. Across the lintel below, citizens and creatures of the world's different regions are sculpted in high relief. In the **archivolts**, the decorative moldings that frame the arch, there are symbols of the seasons and the astrological zodiac, representing the universe of time and space over which Christ has dominion. Space for life-size sculpture was provided by the post between the doors, called a **trumeau** [troo-MOH], and by pedestals on the door jambs.

In the interior at Vézelay, sculptural decoration is limited to the capitals of columns, as was typical of the Romanesque style. Sculptors molded their scenes to fit the available space, without regard for naturalism or classical proportion. In the *Mystic Mill* (Fig. **6.27**), Moses pours grain (symbolizing the old law of the Hebrews) into a grinder, while below him, Paul bags the ground meal (representing the new law of the Gospels). Paul's contorted body follows the curvature of the capital, and the background foliage contributes to the fantastic effect. The scene is evidence that, in Romanesque sculpture, symbolic meaning prevailed over naturalistic appearance.

Against the soaring stone masses of a church's nave, Romanesque sculpture displayed a rich texture of symbols and stories, a style that seemed alarmingly sensuous to some observers. The French theologian St. Bernard of Clairvaux [clair-VOH] complained especially of lavishly decorated monastic churches. "O vanity of vanities," wrote Clairvaux. "The church is resplendent in her walls, beggarly in her poor; she clothes her stones in gold, and leaves her sons naked; the rich man's eye is fed at the expense of the indigent."[5]

Early Medieval Music and Drama

Show how the invention of musical notation altered the way that music was taught and sung.

The great Romanesque churches provided an awe-inspiring setting for the Catholic Mass, a spectacular ritual of music and ceremony. For illiterate peasants and pilgrims, sacred music was an accompaniment to the spectacles of the Christian liturgy. The evolution of medieval music was determined by slow innovation and the need for a system of musical notation. At the same time, medieval drama evolved from the seasonal rituals to be found in the Mass.

Musical Notation

The most widespread medieval Church music was based on the flowing lines of Gregorian plainchant that had been codified under Charlemagne (see page 120). The traditional Gregorian chants changed slowly in the early Middle Ages. The music was taught and performed in monasteries, themselves conservative institutions, and the chants were taught through oral instruction. The range of early medieval music was limited by the memories of medieval choristers. The first cautious innovations came as singers added short chains of notes, called **melismas**, to syllables of key words in the text. Thus, a six-note melisma might be sung on the last syllable of "Alleluia." Melismatic chant, as it was called, gave a modest flourish to the basic Gregorian chant.

By the ninth century, the body of sacred music was outgrowing the limits of oral instruction. As one monk wrote from St. Gall, "When I was still young, and very long melodies – repeatedly entrusted to memory – escaped from my poor little head, I began to reason with myself how I could bind them fast." The solution was to add words to the melisma as an aid to memory. These devices were called **tropes**, musical additions to the traditional Gregorian chant. The most important tropes were set to words, usually a biblical phrase.

The proliferation of musical tropes eventually complicated the problems of musical instruction. Monastic cantors and choristers had to learn chants for all the Church seasons, plus melismatic variations and tropes, plus a body of psalms and occasional music. It was no wonder, then, that monastic schools devoted so much time to musical education (Figs. **6.28** and **6.29**).

Medieval musical theorists responded to the challenge with new systems of musical notation. Since most monks and nuns were trained to read, it was no difficult task for them to learn a system for reading music. The most

6.28 *Monks in choir.* Illustration from Cotton Domitian A XVII, fol. 122v. British Library, London.
European medieval culture was imbued with a constant reverence for God and the constant fear of divine judgment. In monastic communities, monks customarily devoted several hours daily to singing Mass and other forms of prayer.

important steps in musical notation are credited to a Benedictine monk named Guido of Arezzo [GWEE-doh of ah-RETZ-oh] (c. 991–c. 1033), who devised a six-note scale and an ingenious memory device called **solmization**. Solmization associated each tone with the first syllable of a familiar hymn. The musical scale was sung on the syllables *ut, re, mi, fa, sol,* and *la*, which could be written above the words of the musical text.

Guido's most important invention was the musical **staff**, in which each line and space represented a tone in the scale. A key letter, or **clef**, set the tone for one line and hence for all the staff's lines and spaces. In the Middle Ages, the customary clefs were F or C, often drawn in red. Since most chants in medieval times required a range of

> The church is resplendent in her walls, beggarly in her poor; she clothes her stones in gold, and leaves her sons naked; the rich man's eye is fed at the expense of the indigent.
>
> Bernard of Clairvaux, "Apologia" to William, Abbot of St.-Thierry

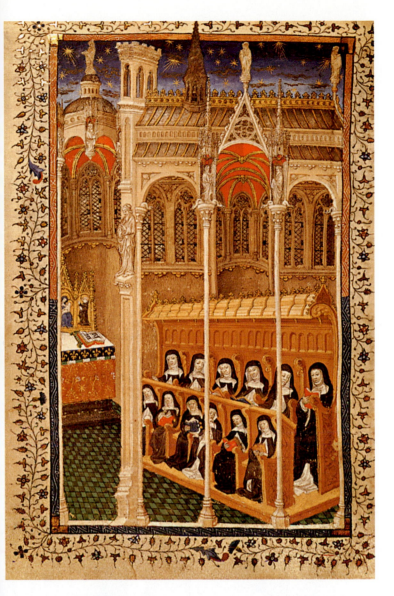

6.29 *Nuns in choir.* Illustration from Cotton Domitian A XVII, fol. 177v. British Library, London.
Like monks, nuns received an intensive musical education so that they could perform the offices of the Church. Though most female composers remained anonymous, the abbess Hildegard of Bingen earned wide fame for her musical compositions and mystical writings.

only eight or nine notes, Guido's single four-line staff (Fig. **6.30**) was sufficient. (The modern staff, Fig. **6.31**, adds a fifth line.) Guido's fame was such that the pope invited him in 1028 to instruct the Vatican choir in his methods.

Despite Guido's renown, the early centers of musical innovation were located outside Italy, especially at the abbeys of St. Gall in Switzerland and Cluny in France. The monasteries that had long guarded Christian civilization through writing were now able to preserve Christianity's glorious music through musical notation. Thus, we know far more about medieval sacred music than we do about the secular musical tradition, which at this time was still largely unwritten.

Medieval Notation

6.30 The Guidonian staff.
The four-line staff attributed to Guido allowed composers to represent precisely musical tones and intervals.

Modern Notation

6.31 The modern staff.
Adapted from medieval notation, the modern staff accommodates a wider range of tones. The sign for treble (upper) clef is adapted from "G" in medieval script, the bass (lower) clef from "F."

Hildegard of Bingen: Musical Mystic

European monasticism produced its share of geniuses – musicians, scholars, spiritual leaders – but few are more intriguing than Hildegard of Bingen (1098–1179), an influential German abbess who composed a considerable body of mystical poetry and music. In 1151, Hildegard, a bold and confident spiritual leader, organized a secession of her abbey's nuns (with their dowries) from their male-governed abbey and founded a new independent monastery at Bingen. The abbess's correspondents included the Holy Roman Emperor and fellow mystics Bernard of Clairvaux and Elizabeth of Schöngau [SHE(R)N-gow].

Hildegard's imaginative works included a morality play set to music (in effect, a medieval opera), and a grand mystical vision entitled *De operatione Dei* (*The Book of Divine Works*). The *Book* laid out an elaborate cosmology that was revealed to Hildegard in painful, ecstatic visions that seized her for seven years, beginning in 1163 (Fig. **6.32**). Unlike the rationalist arguments of the philosophers, Hildegard's insights were expressed in powerful images – for example, the world conceived as an egg surrounded by luminous fire.

Hildegard's musical works were no less vivid. Her compositions employed the standard Church modes, eight scales of notes that were loosely associated with classical Greek sources. Poetically, Hildegard's songs were rich in

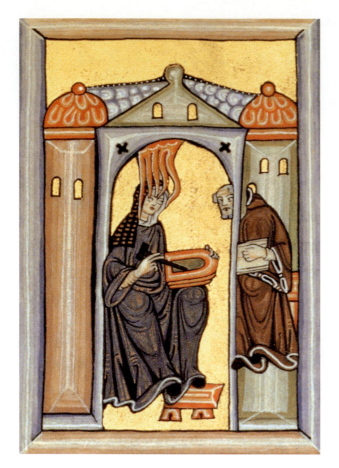

6.32 Hildegard of Bingen. *Scivias*, plate 1: the Seeress. Abbey of St. Hildegard, Rüdesheim am Rhein, Germany.
Hildegard's literary and musical achievements drew talented women from all over Germany to her convent. The abbess is shown receiving her first vision, while a monastic scribe records her testimony.

mythic associations. In one hymn to the Virgin Mary, she describes the mother of Jesus in imagery suggesting the Greek deity Demeter, goddess of the earth's fertility:

Hail to you, O greenest, most fertile branch!
You budded forth amidst breezes and winds
In search of the knowledge of all that is holy.
When the time was ripe
Your own branch brought forth blossoms. . . .[6]

HILDEGARD OF BINGEN

Hildegard's most famous hymn, "O Ecclesia," was sung in praise of St. Ursula, a fifth-century saint who refused marriage in the name of her faith and then perished with 11,000 other women at the hands of unbelievers. Like the Virgin Mary, Ursula embodied a woman's devotion to God, to whom she cries in Hildegard's hymn, "I have desired to come to you, and to sit with you in the heavenly nuptials." Members of Hildegard's convent would have sung this hymn on the saint's day at the office of Lauds, the hour reserved for singing psalms. Hildegard's companions raised their voices in praise of a Christian woman's charismatic faith and bravery before death.

Drama in the Medieval Church

Like many medieval Europeans, Hildegard thought music was the highest expression of human devotion to God. Little wonder that medieval music was also the vehicle for the rebirth of European theater, largely dormant since late Roman times. In fact, the first known medieval dramas were scenarios dramatizing the Mass – scenes of Christ's birth, death, and resurrection.

Monastic records show that sometime during the tenth century, the monks of St. Gall acted out the dialogue of an Easter text. The text, entitled in Latin *Quem queritis* ("Whom do you seek?"), dramatized the scene in which three women came to dress Christ's crucified body

6.33 *Nativity*, c. 1130–40. Ivory panel, $15^3/_4 \times 4^5/_8$ ins (40 × 12 cm). Schnütgen Museum, Cologne.
Scenes from the Gospel of Luke's birth narrative provided popular plots for medieval sacred drama. The shepherds were commonly portrayed as clownish bumpkins, who respond in ignorant astonishment to the angel's announcement of Christ's birth.

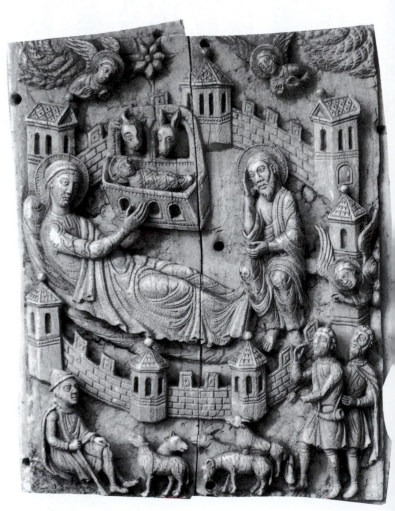

Mysticism

The religion of the everyday — prayer, sacrifice, ritual, or the reading of sacred texts — defines the routine activity through which most believers are content to know God. But, in nearly every faith, some believers have sought a more immediate and complete experience of the transcendent. **Mysticism** is the name for this pursuit of direct contact with an ultimately unknowable and mysterious divine presence. The name derives from *mysterion,* the Greek word for the secret knowledge revealed to initiates when they were admitted to a mystery cult. The practices of mysticism — the search for secret knowledge — are nearly as various as they are universal across the world's religious traditions.

Mystical thinking appeared early in Christian belief, which is so fraught with paradoxes of faith. The Pseudo-Dionysius, a sixth-century Eastern writer, wrote of God as "a darkness clearer than light." Dionysius counseled that by rejecting all names and properties that might describe God, believers could press through to an illumination beyond the darkness of un-knowing. "By the ceaseless and limitless going out of yourself and out of all things else you will be led in utter pureness rejecting all and released from all, aloft to the flashing forth, beyond all being, of the divine dark," he advised in the treatise *Mystical Theology.*[7]

Typically, Christian mystics taught a stepwise discipline of ascetic denial and contemplation that would lead to mystical illumination. "I have discovered that the place where you are found unveiled is girded about with the coincidence of contradictories," wrote Nicholas of Cusa, a German mystic, describing the "wall of paradise that bounded God's mystery."[8] But others, such as Hildegard of Bingen, experienced their mystical insight through visionary experience. "And it came to pass," wrote Hildegard, "that the heavens were opened and a blinding light of exceptional brilliance flowed through my entire brain. And so it kindled my whole heart and breast like a flame not burning but warming … and suddenly I understood the meaning of the exposition of the books…."[9] Hildegard illustrated her visionary work *Scivias* with paintings of her visions of the transcendent realm.

Mystics often tested the boundaries of orthodox belief, and not only in the Christian tradition. A lively mystical tradition called Sufism arose in Islam's first centuries, but its practitioners often ran afoul of official orthodoxy. During a mystical transport, the ninth-century Persian mystic al-Hallaj cried out, "I am divine Truth" — and was promptly executed for heresy. The German medieval scholar Master Eckhart (c. 1260–1327) declared in a sermon that: "a holy soul is one with God. Go completely out of yourself for God's love, and God comes completely out of himself for love of you. What remains there is a simplified One."[10] Eckhart's descriptions of his soul's union with God earned him a charge of heresy. He died while awaiting a church trial.

With its religious paradoxes and ascetic monks, the Christian Middle Ages offered fertile ground for mystical experience. But even in the scientific rationalist culture of the contemporary age, the desire for secret truths and contact with an ultimate reality remains unquenched.

CRITICAL QUESTION

Describe a situation in which you might feel yourself torn between an obligation to your community or nation and the responsibility you feel to the good of humanity the world over. What factors would you consider in resolving this tension reasonably?

(see Mark 16). The angel who guards Christ's empty tomb speaks to them:

1st Voice:	Whom do you seek in the sepulcher?
2nd Voice:	Jesus of Nazareth.
1st Voice:	He is not here; he is risen as foretold when it was prophesied that he would rise from the dead.
2nd Voice:	Alleluia! The Lord is risen!
All Voices:	Come and see the place.

According to the St. Gall script, monks were costumed to represent the three women and the angel, and the church altar symbolized the empty sepulcher. With this rudimentary mime, theater first appeared in the medieval church as part of the ritual drama of the Catholic Mass. Like melismas and tropes, the early music-dramas served to embellish the conservative core of medieval liturgy.

In the next three centuries, such music-dramas evolved and expanded into longer plays. By the twelfth century, medieval playwrights had created a repertory of about fifteen standard sacred plays. These included renditions of the Three Wise Men, Herod's Slaughter of the Innocents, and the Raising of Lazarus. Written by choirmasters and performed in musical Latin, the plays were usually brief. Still, clerical playwrights developed stock characters and spectacular action that appealed to church audiences (Fig. 6.33). The popular *Play of Herod* featured rowdy sword-play and the histrionic ranting of King Herod the Great, frustrated in his search for the Christ Child. Centuries

later, Shakespeare's Hamlet would warn his actors not to "out-Herod Herod" in overplaying their scene.

The venue for these playlets was the church itself. Scenes were either staged on elevated platforms in the choir, with players moving from one scene to another, or sets were placed around the church in doorways, arches, or bays, with the audience following from one scene to the next. Costumes were at first just the regular vestments appropriate to the Church season. In time, however, the plays required more elaborate costumes: the *Play of Daniel* called for lion costumes and the *Raising of Lazarus* dictated that Mary Magdalene don the "habit of a whore." While the actor wearing this costume might well have been a man, music-dramas were performed in both convents and abbeys.

Church drama eventually developed a theatrical vigor that overshadowed the solemn rites it was intended to represent. Church officials were unhappy with the "worldliness" brought into the sanctuary by the plays. By the early thirteenth century, for reasons not entirely known, theater productions were moved outside of churches into the town, although the Church remained an important sponsor of theater into the late Middle Ages.

The Medieval Philosopher

Analyze the role of Abelard in altering the conventions of medieval theology.

Like theater and music, early medieval philosophy was cultivated in the monasteries – the centers of medieval learning. Christian philosophers chiefly addressed philosophical problems encountered within Christianity. The translation of Arabic philosophers and the writings of

Aristotle stimulated more skeptical and contentious attitudes, especially in the cathedral schools. A pivotal figure in this change was Peter Abelard [AB-eh-lard], famous for his passion as well as his philosophy.

Early Medieval Philosophy

One of the period's most original thinkers was John the Scot, called Erigena (active mid-ninth century), who migrated from Ireland to the Frankish court of Charlemagne's grandson in 851. Erigena knew Greek, a rarity in medieval Europe, and his Christian philosophy reflected his reading of Neoplatonist treatises (see page 109). In his most famous work, **On Nature**, Erigena described four great categories of being. The first was God the creator, the second contained the Platonic Ideas that bore God's creative design, and the third was the material world, made in the shape of the Ideas. Human nature spanned the second and third, since the human soul was cloaked in a body but took part in the heavenly realm of ideas. Erigena's fourth category of being was God (again) as the final end of creation, toward which all created things must return at the end of time. Though he quoted the Bible profusely, Erigena's philosophy was more a Neoplatonist pantheism – the belief that God exists in all things – than orthodox Christianity. Eventually the Church banned its teaching.

A far more orthodox thinker was St. Anselm of Canterbury (1033–1109), author of a famous ontological proof of the existence of God (that is, a proof from the nature of being). Anselm argued that it was impossible to imagine God as "that than which nothing greater can be conceived" and then to deny that this greatest being truly exists. Logically and therefore in fact, God's nature requires that God exists. Anselm's philosophical conservatism reflected his career in the Church as Benedictine

6.34 Medieval scholars studying in Latin, Hebrew, and Arabic at a school in Sicily. Italian, c. 1200. Bürgerbibliothek Bern, Codex 120 II, f. 101r.

Schools in Sicily, Italy, and Spain (at Toledo, for example; see page 139) were vital in the transmission of Arabic and Hebrew scholarship to Christian Europe. Latin versions of Aristotle's writings were often based on Arabic translations, not on the original Greek, and depended on the collaboration of scholars from different faiths.

monk, abbot, and finally archbishop, a considerably different experience. For him, faith in Christian teaching was the starting point, not the result, of philosophical speculation. Anselm's famous motto was *credo ut intelligam* – "I believe in order to understand."

In the Arabic world, philosophers were able to read classical Greek texts, especially Aristotle, a great advantage over a thinker like Anselm. The most original of the Arabic-language philosophers was Ibn-Sina [EE-bunn SEE-nuh] (980–1037), known in Latin as Avicenna [ah-vuh-CHENN-uh]. Ibn-Sina claimed to have read Aristotle's *Metaphysics* forty times before he finally understood it. He also compiled an immense encyclopedia of medical knowledge that was widely used by European physicians. The greatest philosopher of Muslim Spain was Ibn-Rushd (1126–1198), known in Latin as Averroës [ah-VER-roh-us], whose commentary offered the definitive medieval interpretation of Aristotle's philosophy. Ibn-Rushd's attempts to reconcile Muslim faith with Aristotle's natural philosophy were not always welcome. Muslim theologians once incited a mob to attack him, and his philosophical writings were burned by an intolerant caliph. The conflict of reason and faith also engaged the scholar Moses Maimonides (1135–1204), a Sephardic Jew who wrote his *Guide for the Perplexed* in Arabic. Maimonides' [may-MAHN-i-deez] *Guide* offered advice for regaining one's lost faith in God through the use of reason. Maimonides also wrote extensive commentaries in Hebrew on the Torah, including the "Ladder of Charity" still employed by pious Jews. Maimonides counseled the faithful that the lowest level of charity was to give grudgingly. The highest was to help the needy before they became impoverished, by offering them a loan or employment.

The new atmosphere provoked an interest in dialectic and disputation. Schoolmasters adopted a method called the *questio* which subjected a traditional commentary to spirited debate. The *questio* produced more comprehensive summations of medieval philosophy, but disturbed the traditionalists, who complained about the schoolmasters that, "as if the works of the holy Fathers are not enough, they dispute publicly against the sacred canons concerning the incomprehensible Deity; they divide and rend the indivisible Trinity; and there are as many errors as there are masters."

In the Muslim world, philosophy always remained at some distance from religious authority. In medieval Christian Europe, the grip of Church teaching on philosophy began to loosen. Cathedral schools in the towns came to rival the monasteries as centers of learning. Christian philosophers also benefited from new translations of Aristotle's writings and Arabic commentaries, produced by important schools of translation in southern Europe (Fig. **6.34**).

Abelard

The most famous schoolmaster was Peter Abelard (1079–1142), a pivotal figure in medieval philosophy. Abelard was trained at the cathedral schools of several French cities and taught at several others, always quarreling with intellectual authorities. He established himself by writing commentaries on Aristotle's logic and dialectic.

Part of Abelard's fame rests on an incident that had little to do with philosophy. While teaching in Paris in 1119, he began a love affair with Heloïse [ay-loh-EEZ], a young pupil of exceptional intelligence and education (Fig. **6.35**). Abelard's autobiography, *A History of My Calamities*, recounts their ill-fated love. "Under the pretext of study," Abelard wrote of his lessons with Heloïse, "we spent our hours in the happiness of love, and learning held out to us the secret opportunities that our passion craved." Their union ended when Abelard was assaulted and castrated by friends of Heloïse's powerful uncle. The lovers both withdrew to a monastic life, and later exchanged passionate, sometimes bitter love letters. Their correspondence reveals that Heloïse was the philosopher's match in strength of will and intellectual honesty. As he wrote to her, "For you, although you are a woman, are one of those creatures whom the prophet Ezekiel saw who should not only burn like coals of fire, but should glow and shine like lamps."[11]

Aside from this famous romance, Abelard was a thinker of originality and courage. Above all, Abelard used his dialectical method to examine important points of Church doctrine. His best-known work was *Sic et Non* (*For and Against*), which posed theological questions and then quoted conflicting Church authorities. The effect was to expose inconsistencies in Church teachings. In the manner of schoolmasters, Abelard examined the articles of Christian faith as one might a scholar's disputation. One of the liveliest philosophical debates in Abelard's day was the nominalist controversy. **Nominalism** denied the existence of "universals," the Platonic idea of "red," for example, that denotes all red. According to nominalists, "red" was a name for the resemblance among all red things. The opposite position was realism, which ascribed existence to "redness," claiming that an object's properties had an objective existence. Abelard compromised with a position called conceptualism. He described universals as "utterances," verbal terms or concepts that exist in the mind but not in the real world.

6.35 *Abelard Teaching Heloïse.* Manuscript illumination from the *Roman de la Rose* by Jean de Meun, 13th century. Musée Condé, Chantilly.
The love affair of this medieval teacher and his pupil inspired the medieval literary imagination. An account of their affair is included in the *Roman de la Rose*, a hugely popular erotic allegory.

Despite Abelard's arguments, the realists eventually carried the day. Realism made it easier to claim the actual existence of religious concepts like the Holy Trinity. But Abelard's brand of conceptualist skepticism survives in modern debates around the philosophy of mathematics and science. Abelard's daring reasoning earned him frequent condemnation from Church authorities but also the devotion of students who followed him wherever he wandered. No other medieval master succeeded so brilliantly, strictly by the power of his teaching and writing.

The Medieval Spirit and the First Crusade

Peter Abelard's career illustrates the expansive new spirit in European medieval life around 1100. Church authorities had successfully established a "Truce of God" that limited warring among feudal lords. Advances in agriculture – especially the iron plow and the horse collar – stimulated prosperity and increased population. Towns thrived from greater commerce and the flow of pilgrims to local shrines. Historians mark this period as beginning the "high" Middle Ages, roughly 1100–1300.

Ironically, this waxing spirit led to medieval Europe's bloodiest and most controversial moments – the First Crusade. It began in 1095, when Pope Urban II impulsively called on Christian knights to capture the Holy Land from its Muslim rulers. The pope warned that a new Turkish regime was desecrating Christian shrines and molesting pilgrims to Jerusalem. Although the threat was exaggerated, Europe's response to Urban's appeal proved astounding. The call inaugurated the first of the **Crusades**, wars fought to defend Christians against non-believers or to recover Christian lands. During the following three centuries the Crusades enlisted feudal knights in search of adventure, pilgrims expecting salvation, and even an army of children believing their innocence might recover Jerusalem.

In 1099, the First Crusade ended in an orgy of brutality when Christian knights slaughtered Jerusalem's Arabs and Jews. The chronicler Fulcher of Chartres recorded an eyewitness description of the carnage: "On top of Solomon's Temple," he wrote, "about ten thousand were beheaded. If you had been there, your feet would have been stained up to the ankles with the blood of the slain. … They did not spare the women and children."[12]

Abandoning their lofty ideals, the Crusade's commanders promptly divided their conquered territory into feudal estates. Within a century, however, Muslims had

> If you had been there, your feet would have been stained up to the ankles with the blood of the slain. What more shall I tell? Not one of them was allowed to live. They did not spare the women and children.
>
> Fulcher of Chartres describing the sack of Jerusalem, 1099

regained Jerusalem and subsequent Christian crusaders were unable to match the bloody victory of 1099.

The Crusades continued through the high Middle Ages, finding opponents and victims among Christians as well as Muslims. Though fraught with cruelty and folly, the Crusades would also open new paths of commerce and learning, helping to awaken Europe to the glories of the Gothic age.

CHAPTER SUMMARY

The Age of Charlemagne In the early Middle Ages, Anglo-Irish monasteries on Europe's northern edge preserved classical learning and devised a delicate Hiberno-Saxon style of decoration. Seafaring Norse cultures produced a vigorous heroic literature, including the Anglo-Saxon epic *Beowulf*. Charlemagne, the Frankish king, unified much of continental Europe in one realm. Imitating Roman emperors, Charlemagne fostered learning and the arts, as seen in the Carolingian "culture of the book" and his palace chapel at Aachen, which included a chapel modeled consciously after Byzantine churches. After his death, Charlemagne's European empire disintegrated under the force of Muslim and Norse invasions.

Feudal Europe A feudal system emerged to govern medieval Europe, which was ruled by a land-holding class of warrior knights. The feudal estate, encompassing both nobles and peasants, was the center of communal life. The fusion of medieval Christianity and feudalism is illustrated in the epic poem *The Song of Roland* and the Bayeux Tapestry. Muslim rule brought a remarkable coexistence of Muslims, Jews, and Christians. Muslim Spain fostered a lively intellectual culture and such artistic achievements as the Alhambra palace.

Monasticism One of the strongest forces in medieval life was Christian monasticism, the practice of living in spiritual solitude. Followers of the monastic ideal took vows of poverty, celibacy, and obedience, withdrawing to the sheltered community of the cloister. Monastic orders built elaborate complexes to house hundreds of monks and nuns. Monasteries were centers of intellectual activity, where ancient manuscripts were copied and studied. The cloistered scholar Hrotsvit of Gandersheim drew on Roman models to create the first Christian literary drama.

The Romanesque Style The medieval Romanesque style in building developed under the tenth-century reign of the Ottonian emperors in Germany and the powerful abbots of Cluny. The Romanesque style appealed to the Ottonians' desire for churches of imperial grandeur, while also accommodating the Cluniacs' monastic ceremonies. Medieval enthusiasm for pilgrimage and the cult of the saints also stimulated Romanesque construction. As seen in Gislebertus's decoration at Autun and at the sumptuous church at Vézelay, the Romanesque style encouraged a sculpture of intense spirituality.

Early Medieval Music and Drama Both medieval music and drama evolved from the Catholic Mass. The increasing complexity of Gregorian chant required a system for teaching and writing music. The most important innovations of musical notation, including the first musical staff, are attributed to Guido of Arezzo. Mysticism – the belief that divine truth is beyond the power of reason to comprehend – inspired the charismatic Hildegard of Bingen in visions and song. The impulse to dramatize liturgical music and Bible stories eventually led to a vigorous sacred drama in Europe. As music-dramas grew more theatrical, Church authorities finally excluded them from the churches.

The Medieval Philosopher Medieval philosophy thrived in monastic centers and urban cathedral schools, where philosophers taught new methods of theological argument and analysis. John the Scot (called Erigena) articulated a Christian version of Neoplatonist metaphysics. The conservative thinker Anselm of Canterbury subordinated philosophical speculation to the dictates of faith and Church doctrine. The most popular teacher from these schools was Peter Abelard, famous for his love affair with Heloïse and for his part in the nominalist controversy, which disputed the link between mental concepts and reality. By the twelfth century, new forces in European life were challenging the authority of feudalism and monasticism. As the high Middle Ages (1100–1300) began, Western Europe was energized by the First Crusade, a Christian expedition to conquer the Holy Land. Successive Crusades would help transform Europe's economic and intellectual life.

7 The Late Middle Ages: The Gothic Awakening

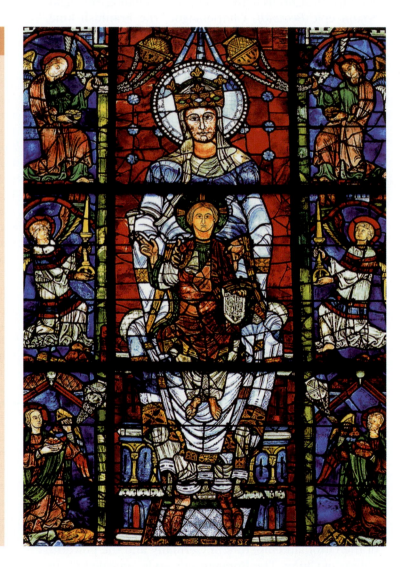

7.1 *Notre-Dame-de-Belle-Verrière (Our Lady of the Beautiful Glass)*, Chartres Cathedral, France, 12th century. Stained-glass window.

The Virgin Mary sits on the throne of heaven, the Christ Child in her lap, adored and praised by heaven's angels. At Chartres, a garment supposedly worn by the Virgin at Christ's birth attracted pilgrims to the town's splendid Gothic church.

Queen of the skies and regent of the earth
And sovereign empress of the realms of hell,
Receive me, Mary, though of little worth,
Yet heavenward bent, a child of Christian birth.[1]

With these humble words, a medieval Christian addressed the Virgin Mary, mother of Christ and Queen of Heaven. Like the earth goddesses of old, the Virgin showered her blessings upon all who appealed to her mercy: prosperity to the merchant, wisdom to the scholar, healing to the sick, forgiveness to the sinner. From the walls and windows of medieval Europe's churches, she gazed upon the faithful with a mother's kindness (Fig. **7.1**).

Under the Virgin's benevolent reign, it seemed that medieval Europe had awakened from a nightmare of feudal war and ignorance. In this **Gothic awakening** – the age of the later Middle Ages in Europe (1150–1400) – towns and kingdoms thrived, grand churches were built across Europe, and a new spirit of learning and beauty suffused

the Western world. It was an age to match the regal beauty of the Virgin herself.

The Gothic Awakening

Describe the primary factors in the cultural awakening of the late Middle Ages.

In the later Middle Ages, more of Christian Europe roused itself from a traditional life governed by a conservative Church and the feudal estate. Crusading expeditions

7.2 The Crusades.
European crusaders' initial success established feudal kingdoms in the Near East. Although the Crusades ultimately failed in regaining European control of the Holy Land, the campaigns reinforced social changes already under way in Europe.

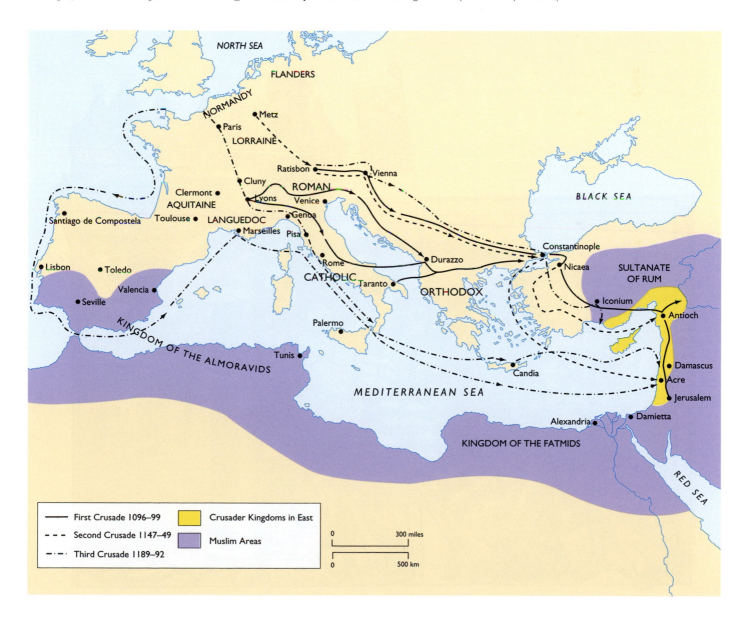

—— First Crusade 1096–99	▨	Crusader Kingdoms in East
– – – Second Crusade 1147–49	▨	Muslim Areas
–·–·– Third Crusade 1189–92		

The Gothic Awakening 159

(Fig. **7.2**) brought contact with the Islamic world and loosened the stable hierarchy of feudalism. European society began to move to the quicker rhythms of its growing towns and cities. This new current in European life is called the "Gothic awakening," after the artistic style that it stimulated and supported.

The Crusades and the Decline of Feudalism

By 1200, the Crusades were having unintended consequences for life in Europe. Crusaders (Fig. **7.3**) returned to their homelands with Arab and Asian foods and cloths, creating a new demand for these goods and enlarging Europe's money economy. Italian ports such as Venice and Genoa profited both as departure points for crusading expeditions and as the crossroads for Mediterranean commerce. Contact with Arabic civilization and learning was stimulating an intellectual revolution in Europe's schools and universities.

Though they were led by feudal lords, the Crusades eventually undermined feudalism and coincided with bitter disputes between the Church and secular leaders. The fiercest disputes concerned Church offices and the Church's vast wealth. Feudal nobles wanted to appoint their bishops and tax Church property within their own territory. Pontiffs sought in turn to regain those powers for Rome. The pope's greatest weapon against troublesome rulers and their subjects was excommunication, the power to bar Christians from receiving the Church sacraments, such as marriage, confession, and the Eucharist.

This clash between Church and crown had sometimes dramatic, sometimes bloody consequences. When Henry II of England (ruled 1154–1189) tried to expand the power

7.3 French knights under Louis XI besieging Damietta, Egypt, Seventh Crusade, 1249. Ms. Fr. 13568 fol. 83. Bibliothèque Nationale, Paris.

of his royal courts, he quarreled with the Archbishop of Canterbury, Thomas à Becket. Believing the king wished to be rid of this "troublesome priest," Henry's followers hacked Becket to death at the altar of Canterbury Cathedral (Fig. **7.4**). In another episode, the Holy Roman Emperor Henry IV stood three days in the snow outside the pope's residence begging his forgiveness in a quarrel over the emperor's powers. During the period called the Great Schism (1378–1417), there were actually two popes at the head of the Christian Church, one at Rome and the other at Avignon, in France. Each pope had the support of opposing factions and righteously excommunicated his counterpart. The Great Schism represented a low point of papal prestige.

As the power of the popes waned, the power of the kings increased, especially in England, France, and Spain. Monarchs such as Henry II of England and Louis XI of France enlarged their royal power and domains at the expense of feudal lords. Monarchs granted charters to cities, offering the cities autonomy from feudal obligations in exchange for the right to tax urban commerce. Such policies stimulated the cities' prosperity and enhanced royal might at the nobility's expense. War became too expensive, involving heavily armed knights and cannon, for lesser nobles to pursue. Power was increasingly centralized in a single authority, more like the other advanced civilizations in Eurasia and the Americas.

The Rise of Towns and Cities

The Gothic awakening was most dramatic in Europe's towns and cities. Although small by today's standards (Paris had a population of about 50,000), the cities of medieval Europe recovered the vitality lost in the Roman Empire's decline. In contrast to the great cities of antiquity, medieval towns were crude, filthy places. Rats and pigs ran in the narrow streets, and residents enjoyed no facilities comparable to a Roman bath. Yet for the price of this walled squalor, city-dwellers gained important freedoms: urban residents were free from feudal bonds and protected from the rapacious armies of kings and dukes.

The town's citizens, called **burghers** (from *burg*, meaning "town" or "fortress"), jealously guarded their liberties. Burghers sought guarantees from their sponsors in the form of a charter or constitution, forerunners of today's national constitutions. In France, the number of chartered cities increased tenfold in a hundred-year span. Such cities were a significant factor in the generation and development of ideas and provided a haven for schools and universities that vied for the age's most famous scholars. Towns such as Champagne and Chartres held great fairs, where local products could be exchanged for costly goods from Italy or the East. Medieval town-dwellers formed a growing social group known as the middle class, who thrived on a traffic in goods and ideas that neither pope nor king could control.

7.4 Murder of St. Thomas, 13th-century miniature. Carrow Psalter Ms W.34 f15v. Walters Art Museum, Baltimore. Ambitious medieval kings often clashed with Church leaders. The independent-minded Thomas à Becket, Archbishop of Canterbury, was gruesomely decapitated by King Henry II's agents as he prayed at the cathedral altar. To atone for the murder, Henry II is said to have worn a hair shirt for the rest of his life.

1096–99	First Crusade, sack of Jerusalem
1144	Dedication of choir at St.-Denis, Paris
1194–1240	Chartres Cathedral, France, rebuilt in Gothic style (**7.8**)

The Gothic Style

Explain how, to a medieval Christian, the beauty of a Gothic-style church symbolized God's presence in the world.

Stimulated by the Gothic awakening, the towns and monasteries of northern France and southern England launched a sacred building program that, relative to their size and wealth, has few historical parallels. Within a span of a hundred years beginning about 1150, dozens of great churches were begun or remodeled in a daring new style that we now call Gothic. The style was characterized by soaring vertical lines and jewel-like stained-glass windows, a synthesis of stone and glass inspired by the most profound religious feeling. The new churches glorified Notre Dame, or "Our Lady the Blessed Virgin," to whom most were dedicated. They also reflected the prestige of the abbot or local bishop who said Mass at the altar. The Gothic building program reflected not only religious fervor but also the dynamics of power and wealth in the Gothic age.

The Gothic Style and Divine Light

The Gothic style in architecture was first realized by Abbot Suger (c. 1085–1151), who rebuilt his church's choir to emphasize light and luminosity. Abbot Suger [SOO-zhay] subscribed to a medieval belief that God revealed himself through the material world, allowing God's spiritual truth to be understood through the study of material things.

Light – brilliant but immaterial – offered the abbot the perfect analogy to God's spiritual being. Like the spirit of God, the beauty of light was reflected in precious gems and golden reliquaries. Light could even symbolize the mystic incarnation of Christ: God's holy spirit had passed through Mary's womb without altering her virgin purity, much as light filtered through a stained-glass window. For Suger, the mysticism of light symbolized the deepest mysteries of medieval Christianity, a belief that is inscribed at his abbey church at St.-Denis [san(h) duh-NEE], Paris:

The dull mind rises to truth through that which is material.[2]

In 1137, Abbot Suger began rebuilding his abbey church. By ingenious technical innovation, he was able to surround his new church choir with walls of colored glass, which seemed like a shimmering miracle of color and light. The abbot connected his architectural invention with the *lux nova*, the "new light" of Christ's coming. He wrote:

For bright is that which is brightly coupled with the bright,
And bright is the noble edifice which is pervaded by the new light.[3]

7.5 Gothic-style construction.
The technical basis of the Gothic style was the pointed arch and cross-ribbed vaulting. The rounded arches of the Romanesque style, (*a*) and (*b*), were limited in width and height. Vaults of pointed arches (*c*) could span a wider, rectangular bay, while rising to a uniform height (*d*).

7.6 Section of Gothic nave and diagram of buttresses.
The slender ribs of the cross-ribbed vaulting helped reduce the roof's weight and expense, while giving visual emphasis to the vault's soaring lines. The exterior stone piers, or buttresses, were connected to the exterior walls by flying buttresses. The buttressing counteracted the roof's weight and thrust (outward push).

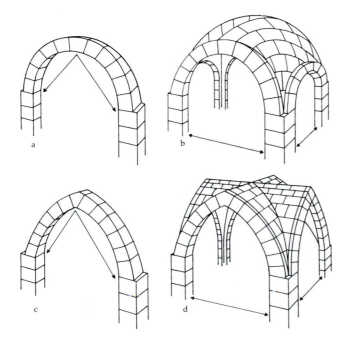

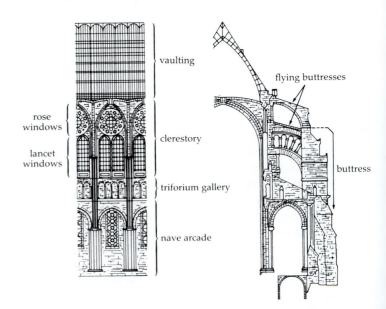

functional: they made possible the churches' daring heights, and also made the churches a visual metaphor for the orderliness of God's world (Fig. **7.7**).

The Cathedral at Chartres

In the century after Suger rebuilt St.-Denis, Gothic cathedrals arose in the towns around the Île-de-France, the royal domain surrounding Paris. The towns of the Île-de-France competed in building higher and more

7.8 West façade, Chartres Cathedral, France, 1194–1240. South spire, c. 1180, height 344 ft (105 m); north spire, 1507–13, height 377 ft (115 m).
The three parts of the exterior façade – portal and two towers – reflect the interior's relatively narrow nave and its flanking aisles. The original north spire was destroyed by fire and replaced in the late-Gothic "flamboyant" style.

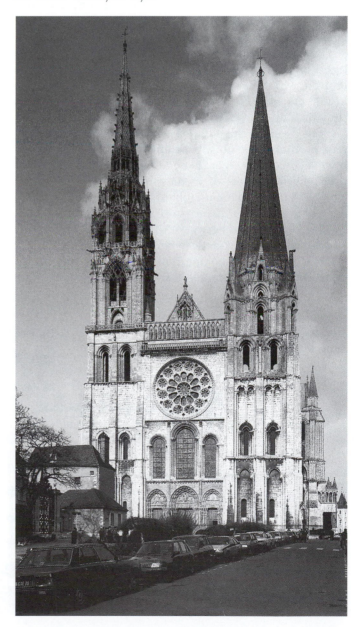

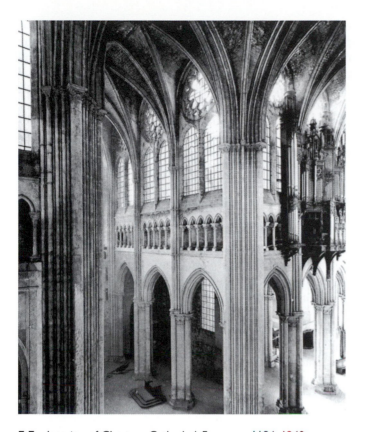

7.7 Interior of Chartres Cathedral, France, c. 1194–1240, showing nave arcade, triforium, and clerestory windows.
The interior design of the Gothic-style church was clearly defined in three sections – nave arcade, triforium gallery, and clerestory window. These sections were unified by the delicate ribs, which rose without interruption from the nave floor to the ceiling vaulting.

St.-Denis's walls of translucent glass depended on a subtle combination of three architectural elements: the pointed arch, the ribbed vault, and the flying buttress. Abbot Suger and his architect (who is unknown) merged these elements in a daring innovation that defined the Gothic style in architecture. The Gothic **pointed arch** replaced the Romanesque style of rounded arches, which were limited by width and height (Fig. **7.5**). The ceilings were supported by **ribbed vaulting**; literally, thin skeletons of stone that were erected first and then filled with a layer of ceiling masonry. In the Romanesque style, the ceiling's weight was supported by massive piers along the nave. The Gothic architects moved these heavy piers to the exterior, creating stone arms that braced the nave wall called **flying buttresses** (Fig. **7.6**). The system of buttresses and flying buttresses supported the ceiling's weight and counteracted its outward thrust, permitting the nave walls to be filled with glass instead of masonry and creating the luminous effects of St.-Denis's choir.

The Gothic style's structural elements – the pointed arch, ribbed vaulting, and external buttresses – created a framework of soaring lines that lift the eyes and the spirit. The Gothic ribs and arches were both decorative and

splendid cathedrals. The contest ended in a construction disaster at Beauvais, where the choir collapsed in 1284. While the new style was soon imitated throughout Europe, its origins were unmistakably French, and it was then called simply the "French style."

The cathedral at Chartres [SHART-(r)] (Fig. **7.8**) surpassed all others in the perfection of its architectural design, stained glass, and sculpture. Located in a rich farming town southwest of Paris, Chartres Cathedral was one of Christian Europe's holiest shrines, housing the tunic that believers claimed was worn by the Virgin Mary at Christ's birth. When the town's Romanesque cathedral was burned down in 1194, the Virgin's tunic was rescued from the ruins of the building unharmed. Chartres's citizens interpreted this miracle as a sign that the Virgin desired a new shrine in her honor. Funds were solicited throughout Europe to rebuild Chartres's church. The faithful responded so generously that the church's new Gothic nave was completed in 1220, barely twenty-five years after reconstruction began.

Chartres's new floor plan (Fig. **7.9**) maintained the basic form and dimensions of the earlier Romanesque church, which had partly survived the 1194 fire. Gothic architects added broader and more elaborate portals on the north and south porches of the transept. The choir, located behind the altar, was screened off from the nave, which was noisily occupied by merchants and townspeople. The coexistence of secular and sacred activity was typical of medieval cathedrals, and for a while, Chartres's wine merchants sold their goods within sight of the altar.

The differences between Gothic and Romanesque styles are more dramatic when one stands inside the Gothic cathedral. Looking down the nave, one sees – instead of massive Romanesque stone walls – a harmony of soaring lines and gem-like luminosity. Like the floor plan, the Gothic church's vertical design has a three-part division. The **nave arcade** is formed by weight-bearing piers, whose mass is disguised by vertical shafts. Above the arcade are the **triforium**, an arcade of pointed arches sometimes opening onto a gallery, and the tall **clerestory** windows. The visible structure of the nave interior represented the beauty and proportion of God's ordered cosmos, a visible manifestation of divine truth. Chartres Cathedral was not the highest or most daring example of the Gothic style. However, its pious beauty made the splendor and meaning of God's revelation manifest to the human senses.

In earlier Byzantine and Romanesque churches, paintings and mosaic had decorated the masonry walls. The stone walls of the Gothic church were filled instead with stained glass, an art in which Chartres surpassed all its Gothic rivals. Chartres's windows contained 22,000 square feet (2,050 m²) of colored glass, filling the interior with a subdued light that symbolized God's mysteries. The windows represented quite literally the word of God. Each one depicted a biblical story, the life of a saint, or a principle of Church doctrine. A Gothic cathedral's windows therefore created a visual "Bible of the poor," instructing the illiterate citizens and pilgrims who worshiped there.

A rose window (Fig. **7.10**) stood over each portal, representing both the sun, the source of light, and the Virgin Mary, the perfect "rose without thorns." The rose windows were outlined by finely carved stone **tracery**, a rose-shaped frame that was assembled in place and then filled with glass. **Lancet windows**, shaped like pointed arches, filled much of the remaining wall space. In all the windows, the pieces of colored glass were held by thin lead strips and reinforced by iron bars. The

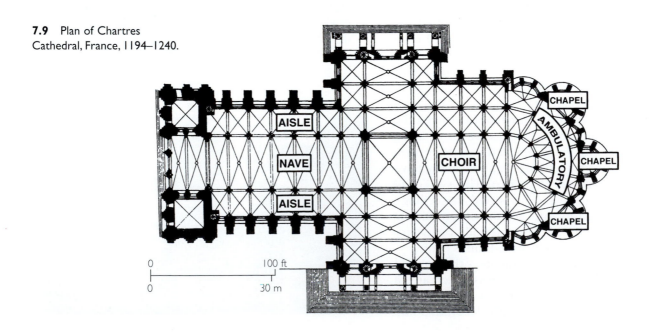

7.9 Plan of Chartres Cathedral, France, 1194–1240.

AISLE
NAVE
AISLE
CHOIR
AMBULATORY
CHAPEL
CHAPEL
CHAPEL

0 100 ft
0 30 m

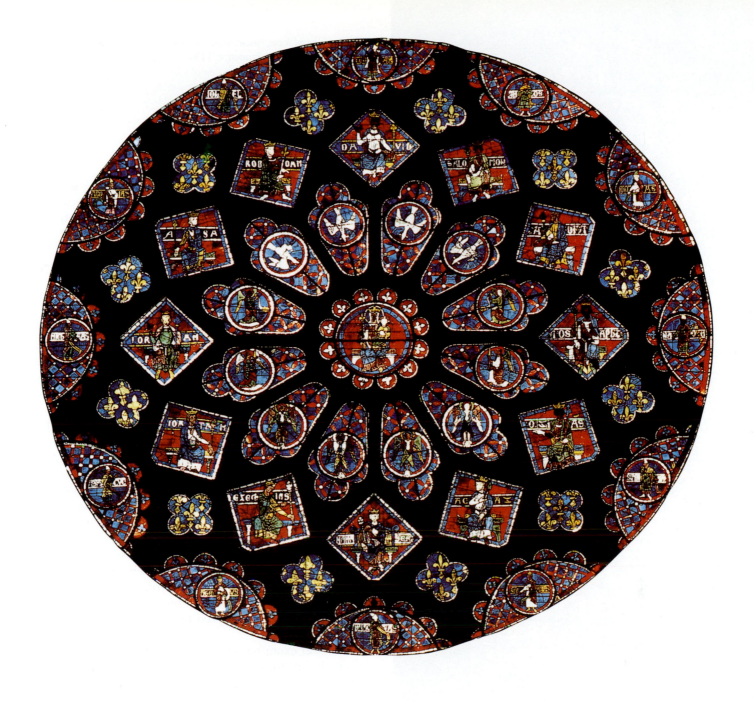

7.10 Rose window, north portal, Chartres Cathedral, France, 1223–6. Diameter 44 ft (13.4 m).
At the center of the rose are Mary and the Christ Child, surrounded by angels and Old Testament kings.

citizens of Chartres's trade and craft guilds underwrote the cost of many of the Cathedral's windows. Some forty-three different trades are represented in "signature" scenes in Chartres's windows.

The most admired window at Chartres is the *Notre-Dame-de-Belle-Verrière* [NOHT(r) DAHM duh BELL vair-ee-AY(r)], or "Our Lady of the Beautiful Glass" (see Fig.

7.1). The predominant colors of blue and red were the favorites of Gothic glassmakers – they symbolized the Virgin and altered the external light to the shade of ruby and sapphire gems. The *Notre-Dame-de-Belle-Verrière* captured the tenderness and mercy that medieval worshipers attributed to the Virgin.

In another window, the *Tree of Jesse* (Fig. **7.11**) over the west portal, religious devotion was blended with the practical truths of politics. Read in the medieval fashion (left-to-right, bottom-to-top), the window shows the Old Testament lineage of Christ. The figures are framed by lily flowers, symbols of the French king who subsidized the window – no doubt a king's wish to remember his own

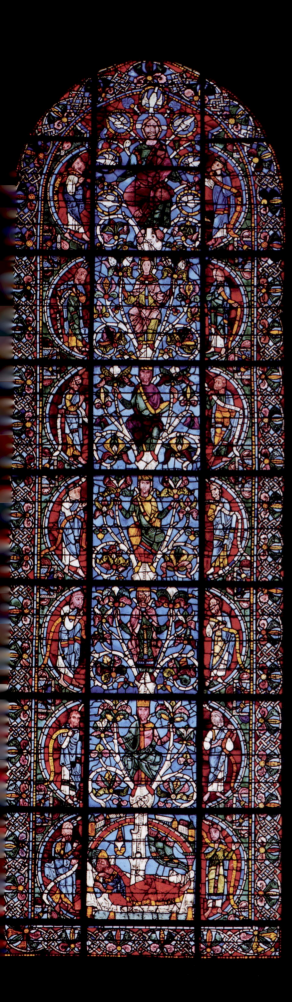

7.11 *Tree of Jesse*, lancet window, west portal.
Chartres Cathedral, France, c. 1150.
In a conventional medieval image of Christ's royal ancestry,
a tree sprouts from the loins of Jesse, father of the Hebrew king
David, and emanates at top in the Virgin Mary and Christ himself.
Observe the elaborate floral imagery.

royal lineage in that of Christ's. Thus, the *Tree of Jesse* offered the viewer a lesson in both medieval faith and medieval politics.

Gothic Sculpture

On the outside of Chartres Cathedral, the sculpted figures on the massive three-door portals were as detailed and systematic as the writings of the theologians who taught at Chartres's cathedral school. Most likely, the school's teachers supervised the design of Chartres's exterior sculpture. The carved symbols and stories were carefully coordinated to attract and instruct the pilgrims who entered the shrine.

The famed west or "royal" portal of Chartres (Fig. **7.12**), for example, depicts the glory and power of Christ in three aspects. The tympanum over each door states its theme. On the right, the Madonna and Child represent the Incarnation of Christ – that is, Christ's manifestation in the flesh through the womb of Mary. On the left door is Christ's Ascension into Heaven, his return to the realm of spirit. Over the center door, Christ in His Majesty reigns as king over heaven, ringed by symbols of the four Evangelists (authors of the Gospels). The themes of royal birth and majesty are repeated from the *Tree of Jesse*, one of the lancet windows set above these doors. In some cases, the exterior sculpted figures mirror scenes from the windows.

A closer examination of these doors reveals a complex symbolic meaning. On the right door, for example, the incarnation is told as the *Life of the Virgin Mary*, a theme of special significance at Chartres. The tympanum scene of the Madonna and Child mirrors the famed window *Notre-Dame-de-Belle-Verrière*. On the lintel below are scenes from Mary's life, including the Annunciation, the visitation of St. Elizabeth, the birth of Christ, and the presentation of the Christ Child at the temple. On this door, the archivolts contain symbols of the seven liberal arts, the curriculum of medieval learning (see page 173). The liberal arts refer both to the cathedral school and to Mary herself, who was considered patron of all learning.

The Gothic spirit effected changes in sculpture that resembled the evolution of ancient Greek sculpture (see Chapter 3), from stylized austerity to a more lifelike humanism. At Chartres, this evolution is best illustrated in the **jamb** sculptures that flank the doors. On the west

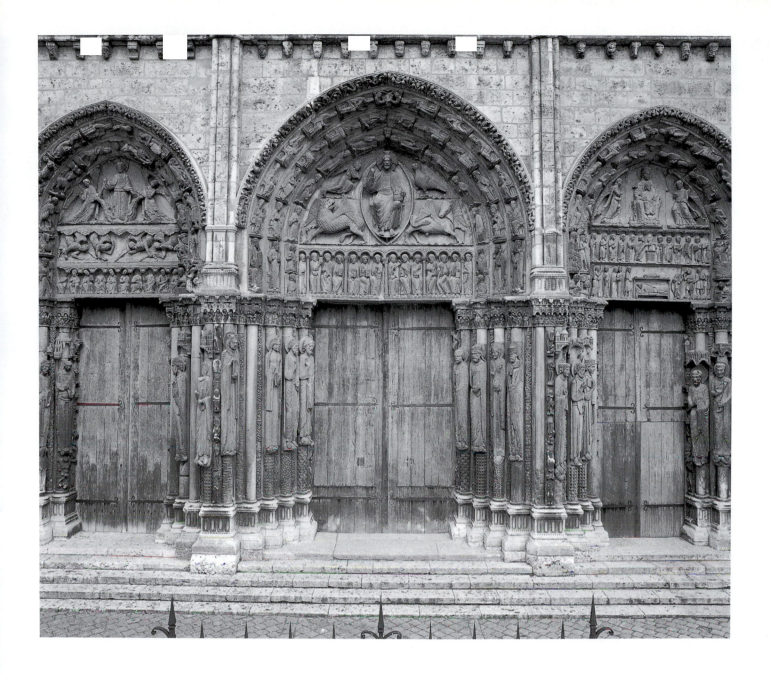

7.12 The three doors of the west portal, Chartres Cathedral, France, c. 1145–70.

The three tympanum scenes depict Christ's birth (right); his ascension into heaven (left); and his reign in heaven (center), where symbols of the four Evangelists surround him and the twelve apostles fill the lintel below.

doors, still sculpted in the Romanesque style, the ancestors of Christ are rigid, austere, and clearly bound to the columns behind them. The later Gothic sculptures of the north and south doors are more animated and natural-looking. The most dramatic of these, *Abraham and Isaac* (Fig. **7.13**), shows young Isaac bound for sacrifice and Abraham raising the knife to slay him. Both look up, as if toward the angel who stays Abraham's hand.

German sculptors who had trained in French workshops bore the Gothic sculptural style to their homeland, often giving their statuary a frank emotionalism. A master sculptor at Naumburg in central Germany furnished his cathedral with a set of scenes and figures that were rare in their naturalism and emotionalism. The life-size figures of Ekkehard and Uta (Fig. **7.14**), noble patrons of the church and ancestors of the Bishop of Naumburg, appear to keep watch over the faithful. In his treatment of posture and facial detail, the Naumburg master gave his figures the quality of sculptural portraits.

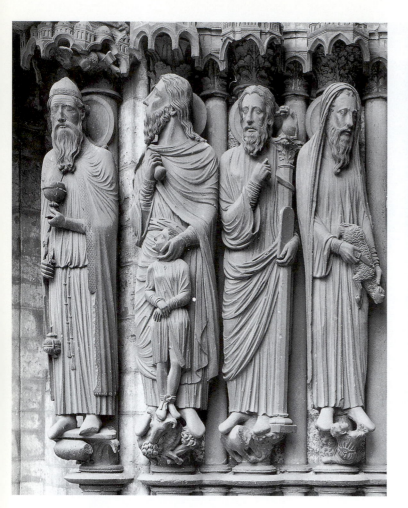

7.13 *Abraham and Isaac*, Chartres Cathedral, France, 1205–40. Compared to the stiffly elongated figures of the Chartres portal (see Fig. 7.12), this jamb sculpture creates an animated drama. Preparing to sacrifice his son, Abraham turns toward the angel who instructs him instead to slay the ram (below).

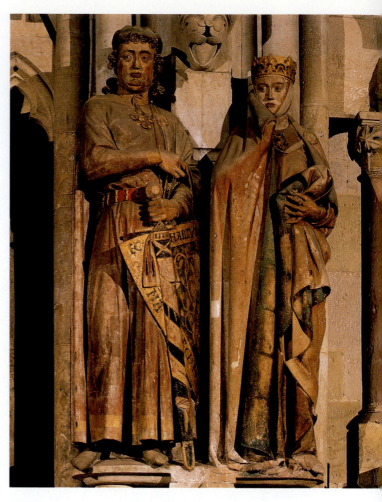

7.14 *Count Ekkehard and Countess Uta*, Naumburg Cathedral, Germany, c. 1240–50. Later Gothic sculptors like the "master of Naumburg" increasingly lent their figures individualized expression and vitality. This self-possessed noble couple, attached to columns on the cathedral's interior, indicates the Gothic style's growing realism.

Music and Theater in the Gothic Age

Identify the most important changes in Gothic sacred music and theater.

The Gothic church achieved a rich texture of artistic elements – architecture, stained glass, and sculpture – that were drawn from older medieval traditions. A similar process of evolving traditions brought changes in theater and music during the Gothic age. Musicians devised complex new accents in sacred music, without abandoning traditional chants. Their sophisticated musical techniques affected the course of Western music for centuries. Sacred drama moved outside the church, even though its popular spectacles maintained their religious emphasis. Thus, the Gothic forms of music and drama grew from deep roots in Christian faith and symbolism, even as they became more worldly.

The Evolution of Organum

The most striking development in medieval music was the evolution of **polyphony** ("many voices") from traditional, monophonic plainchant. Polyphony involves two or more melodic lines playing simultaneously. It may have arisen in secular music, as singers "doubled" the melody with a second voice. While polyphony probably began in musical improvisation, it was gradually incorporated into the composed music of sacred chant. This medieval invention of polyphony sets Western music apart from virtually all the world's other musical traditions.

The earliest references to medieval polyphony are in a ninth-century musical handbook, which describes Church singing in two voices. This early polyphony was

designated **organum**, perhaps because it resembled the sound of an organ. In organum's most basic form, two voices moved in a parallel direction, creating **parallel organum** (Fig. **7.15**). Parallel organum consisted of a principal melody (usually a traditional chant) and a second, "organal" voice sung below the principal melody. The second voice moved at set intervals (usually an octave, fourth, or fifth) below the basic chant.

Gothic composers began to elaborate on this simple but revolutionary musical invention. They cautiously experimented with different intervals (such as the third), made the two voices move in contrary motion, and added rhythmic variety. By the late eleventh century, a new version of organum had been developed, called **organum duplum** (Fig. **7.16**). In duplum, the traditional plainchant melody was shifted to the lower voice and sung in long, held notes. This lower voice was called the "tenor" (from Latin *tenere*, "to hold"). Above the tenor, the "duplum" voice sang freer, more complex musical phrases. Duplum organum was Western civilization's first truly polyphonic music, since the two distinct melodic lines moved independently of one another.

Despite its novelty, duplum organum was firmly rooted in musical tradition. The tenor voice intoned a traditional plainchant, a spiritual reminder of Christianity's musical roots. The duplum melody was often composed of melismatic phrases that were also derived from earlier Church music. These developments made possible the great syntheses of medieval music that composers achieved at the cathedral schools during the twelfth and thirteenth centuries.

The Notre Dame School The Gothic era's leading musical inventors gathered at the cathedral of Notre Dame in Paris, where they were called the "Notre Dame School of Music." Here a master composer named Léonin [LAY-oh-nan(h)] (c. 1163–1201) worked in the years of Notre Dame Cathedral's construction. Léonin compiled an influential book of sacred music in duplum organum called the *Magnus Liber Organi* (*Great Book of Organum*), important above all for recording the improvisational singing techniques of this period. It is most likely that Léonin did not actually compose the *Magnus Liber*'s contents but organized and notated what he had learned as a master singer.

Léonin's successors at Notre Dame and other schools continued to enrich the growing body of organum music. Pérotin [PAIR-oh-tan(h)] (active early thirteenth century) is credited with adding a third (Fig. **7.17**) and sometimes fourth voice above the tenor. In Pérotin's complex works, the organal passages were often balanced against sections of the plainchant melody sung in unison. The rich and sometimes dissonant harmonies of the upper voices were punctuated with forms of **cadence**, the musical resolution at the end of a phrase.

Pérotin's innovations in musical structure and tonality accelerated the development of late medieval music, a complex music which came to be called *cantus firmus*

Tu pa-tris sem-pi-ter-nus es fi - li - us.

7.15 (*left*) Parallel organum.

7.16 (*below left*) Organum duplum.

7.17 (*below*) Organum triplum.

O Ma - ri - a, vir-go Da - vi - di - ca.

O Ma - ri - a, ma - ris stel - la.

Veritatem

Vir - gi - num flos, vi - tae spes u - ni - ca.

Ple - na gra - ti - ae.

Buddhism in Asia

Under the rule of Frankish kings, Christianity was established in medieval Europe as a religion of monastic discipline and a popular faith that mixed easily with pagan belief. In a similar fashion, Buddhism spread eastward through Asia in two guises: a monastic asceticism and a teaching of compassion and salvation.

The first of these paths, based on the Theravada ("Doctrine of the Elders"), adhered to the original teaching of the Buddha. The follower of Theravada [thair-uh-VAH-dah] sought the liberation of self through meditation and moral discipline, a path that required withdrawal into a monastic order (the Sangha). Lay people were obliged to support the Sangha, while postponing their own pursuit of a saintly life. Adherence to the Theravada spread to Sri Lanka (Ceylon) in the third century B.C. and from there to southeast Asia (Burma, Thailand, Vietnam).

A more popular Buddhist faith took shape in the Mahayana, or "Greater Vehicle," which fostered the deification of the Buddha and emphasized personal salvation rather than ascetic denial. In the Mahayana [mah-hah-YAH-nah], some believed that the Buddha continually visited the world in new incarnations. Others appealed to the powers of **Bodhisattvas** [boh-dee-SAHT-vah], pious and generous saints who postponed their own entry into nirvana in order to save others. Cults of various Bodhisattvas encouraged

mythic embellishment of the Buddha's teachings, including the belief in a paradise (the Pure Land of the West) waiting after death. A later Chinese version of this belief promised that the Maitreya Buddha (Buddha of the Future) would return to earth and establish paradise in this life. With less emphasis on Hindu ideas of karma and reincarnation, the Mahayana faith was easily embraced in China and Japan, where it was blended with Taoist teachings to create Ch'an (Japanese Zen) Buddhism.

The enthusiasm for the Buddhist faith in Asia encouraged elaborate artistic expressions. The great temple of Borobudur (Fig. **7.18**) in Java (in present-day Indonesia), for example, was constructed as a vast holy mountain, rising in nine terraces to a sealed chamber containing an image of the Buddha. The central chamber and the surrounding peaks all take the form of a bell-shaped **stupa** (literally, "hair knot"), a rounded sacred enclosure used in Hindu and Buddhist architecture. The temple plan's concentric square and circles, symbolizing the wheel of life, were adopted in other great temple complexes of southeast Asia, such as Angkor Wat (Cambodia) and Ananda (Burma).

7.18 Stupa of Borobudur, Java, Indonesia, Sailendra Dynasty, 835–60. Lava stone, perimeter of lowest gallery 1,180 ft (359.6 m), diameter of crowning stupa 52 ft (15.8 m).

("fixed song") because of the tenor's melodic fixity. The *cantus firmus* posed new problems of musical composition and training. Coordinating several voices required greater rhythmic precision and stimulated the rise of rhythmic modes. The different organal voices had to be governed by a stricter rhythmic measure, or else the music would come crashing down on their ears. The intricate texture of *cantus firmus* also demanded a more advanced musical notation and training, techniques that were developed and propagated by the Notre Dame Cathedral school. Pérotin's three- and four-voice organum was not always appreciated by Church authorities, who feared that the congregation would go insane from the "riot of the wantoning voice" and the "affectations in the mincing of notes and sentences."

Gothic Theater: From Church to Town

By the eleventh century Church authorities were complaining about drama in the church, which was spiced by raging Herods and violent massacre scenes. One German abbess objected to "the clang of weapons, the presence of shameless wenches and all sorts of disorder" that liturgical plays brought to her church's nave. As its scripts and staging became more elaborate, sacred drama outgrew the Catholic Mass that it was supposed to illustrate.

7.19 Scenery for the Valenciennes Mystery Play, 1547. Contemporary drawing. Bibliothèque Nationale, Paris.
The stage provided for elaborate stage effects, including fire spouting from the mouth of hell (right).

The simple scenarios depicting three women at Christ's tomb had become elaborate recreations of the Journey of the Wise Men and the Slaughter of the Innocents. Consequently, sacred drama was shifted outside the church to the town squares, where it was acted by ordinary citizens instead of priests and nuns, and often written in the spoken vernacular instead of Latin.

Like the building of a cathedral, staging a play in the Gothic era was a cooperative effort between the Church and the people of the town. Theatrical productions were based on religious stories and nearly always coincided with religious holidays. The most common occasion for civic drama was the Feast of Corpus Christi, celebrated in late spring. At Chartres, trade guilds and civic leaders had helped to pay for building the town's cathedral. In other towns, these same groups helped to produce the local Corpus Christi drama cycle. A play involving Noah's Ark would be assigned to the local carpenters, and goldsmiths and money-changers would costume and portray the Three Wise Men. As these examples show, drama festivals were sanctioned and supervised by Church authorities, but depended on hundreds of townspeople to plan, finance, and stage their productions. The scale of participation commanded by the medieval Church might well be the envy of directors of civic theater today.

The actual plays demonstrated a medieval blend of sacred and secular concerns. **Mystery plays** were cycles of plays depicting biblical stories (Fig. 7.19). A cycle usually centered on the Passion of Christ, but might also reenact the fall of Adam and Eve, the sacrifice of Isaac, or the Flood. The dramatic climax came when Christ descended through the gaping mouth of hell and defeated

a buffoonish devil. Christ then sat in judgment upon the wicked and the pure. A mystery cycle was typically an elaborate affair, lasting several days, with spectacular stage effects such as flying angels and hellish flames.

Another type of play, called the **miracle play**, recounted the lives of saints from childhood to death and often included vivid scenes of battle and torture (Fig. **7.20**). The **morality play**, which appeared in the fifteenth century, depicted the struggle between the vices and virtues over a sinner's soul. The best-known morality play, *Everyman*, represents an ordinary man's struggle to escape the summons of death. *Everyman* required little scenery and scarcely more than an hour to perform. The play was well suited to the fledgling bands of professional actors who were beginning to entertain in Europe's palaces and town squares.

Despite their diversity, the plays of the Gothic era shared some essential traits. First, theater in this age was thoroughly popular. It was written and performed in the **vernacular**, the language spoken by common people, and the plays involved hundreds of citizens in the production itself. The audience may well have been the town's entire population. Second, the mystery and miracle plays emphasized spectacular staging rather than subtleties of dramatic text. Like the citizens of ancient Rome, medieval townspeople preferred a grand show to literary niceties. Although performed outside the church walls, Gothic theater stood very much in the Church's shadow.

7.20 Scene of the Martyrdom of St. Apollonia, from a 15th-century miniature by Jean Fouquet. Musée Condé, Chantilly, France.

A scene from a miracle play depicting the life and martyrdom of St. Apollonia. The play's director (in miter hat, center right) holds a prompt book and directs the music with his baton. Elaborate scenic scaffolds enclose the stage at the rear.

The New Learning

Describe the social atmosphere and course of study at a typical medieval university.

CRITICAL QUESTION

What projects in your community involve the kind of civic co-operation demonstrated by a medieval dramatic production? What do such projects reveal about the values of your community?

The cities of the Gothic age gave birth to a new learning, based on scholasticism (see Key Concept below), and it was pursued in cathedral schools and in a new social institution called the university. Within the university's lecture halls, scholastic philosophers achieved a grand synthesis of Christian doctrine and the Western philosophical tradition.

The Universities

The medieval university was quite unlike anything in the ancient world: a self-governing organization of scholars formed to teach and certify a professional class of lawyers and clerks. Medieval universities were governed either by their faculties or by their students, who together formed the *universitas*, or "whole body." Most universities offered the basic baccalaureate (bachelor's degree), while specializing in one of three advanced studies – theology, law, or medicine. University education, however, almost entirely excluded women. The late medieval decline of independent convents and abbeys for women further reduced women's opportunity for advanced learning.

Though they were all men, medieval university faculties and students were a remarkably international group. The preeminent medieval university was at Paris, recognized by the French king in 1200. Paris was famed for its theological faculty and was dubbed "mother of the sciences" by one pope. Universities at England's Oxford and Cambridge modeled themselves after Paris, while the university at Bologna specialized first in law, then in medicine.

Although relaxed and wholly voluntary, life at a medieval university was rather strenuous by today's standards. A typical day began at 5 a.m. with prayers and study, followed by lectures, a group debate, and then further study before bed. Because few students had textbooks, their courses consisted mainly of the master's lectures. Lectures (from the Latin *lectio*, or "reading") in theology consisted of a master reading from the Bible or a

KEY CONCEPT

Scholasticism

Like many of the Gothic arts, philosophy in the later Middle Ages developed by crossing the boundary between the sacred and secular. The rise of the cathedral schools and disputatious scholars such as Peter Abelard (see page 155) stimulated a philosophical movement called scholasticism. **Scholasticism** encompassed the philosophical debates and methods of learning practiced by theologians during the later Middle Ages. Scholasticism's skepticism and vitality thrived outside the monastic cloister, in the cities' schools and universities.

Although scholasticism was not a unified system of thought, the scholastics did share some fundamental principles for understanding God's truth and his universe. They wanted to incorporate philosophy (the study of truth in general) into theology (the study of God's word). In effect, this made theology a comprehensive system of all human knowledge. Also, scholastics relied on the Greek philosopher Aristotle (see page 64) as a model of logical method, and considered the pagan Greek philosopher to be an authority equal to the Bible itself. Finally, the scholastics practiced a method of formal argument by which issues could be debated logically and systematically – a method that gave consistency and rigor to medieval philosophical disputes.

Scholastic teachers were famed for the audacity of their reasoning and the size of their student following. These teachers often wandered from school to school, comparing themselves to the sophists of ancient Greece (see page 62). Peter Abelard, who reckoned himself "as the only true philosopher left in the world," attracted students whether he taught at the cathedral school in Paris or a monastery in the wilds of western France.

Nowadays, because of its emphasis on logic and argument, medieval scholasticism suffers from a reputation for arid debates about obscure topics, perhaps in the same way that today's university researchers sometimes suffer ridicule for their obscure and seemingly irrelevant projects. Scholastic philosophers wrote in a specialized and artificial language that non-experts could barely understand, and their argumentation lacked the personal and engaging tone of early Christian writings such as Augustine's *Confessions*. However, the scholastics' disputations addressed issues that still concern today's thinkers: the nature of law, the authority of the state, the definition of life. The scholastics themselves were the precursors of today's university intellectuals, who in their academic enclaves often debate the same vital issues.

standard commentary, followed by his own interpretation (Fig. **7.21**). At Bologna in northern Italy a master could be fined for extending his lecture even a minute past the allotted time.

A course of study usually began in the liberal arts, primarily the *trivium* of grammar, logic, and dialectic. Ideally, the *trivium* comprised the introductory course of study, to be followed by instruction in the *quadrivium* of arithmetic, geometry, music, and astronomy. A young scholastic demonstrated his learning in the disputation, a form of philosophical debate modeled on Plato's dialogues. In a disputation, the master announced an issue for discussion, and then his advanced students answered objections from the audience. Finally, the master himself closed the discussion with a definitive and authoritative answer. Student examinations were entirely oral, and they were usually held during Lent, the season of fasting and self-denial.

The Rediscovery of Aristotle In the Gothic age, scholastic learning was invigorated by access to Arabic civilization and its deep knowledge of classical philosophy and science. Thanks to schools of translation in southern Europe (see page 154), medieval Europeans could read for the first time the masterpieces of Greek mathematics and astronomy. Most important were translations of the so-called "new" Aristotle, the Greek philosopher's writings on nature and human affairs. European scholastics immediately began to assimilate Aristotle's views into

a comprehensive philosophy of ethics, law, and nature. By 1250, Aristotle's dominance in the universities was so complete that he was known simply as "the Philosopher."

Thomas Aquinas

The most influential scholastic thinker was Thomas Aquinas (1125–1174), who achieved a vast synthesis of medieval theology and Aristotelian philosophy. Aquinas [uh-KWEYE-nuss] said he wanted to make "a science of faith." His greatest work was the *Summa Theologica* (begun 1266), a summation of medieval knowledge about God's plan for the natural and human world. The *Summa* showed Aquinas's genius for creating harmony and order among diverse philosophical elements. The result was a thoroughly Christian philosophy that still influences thinkers in politics, education, and law.

For Aquinas, the spheres of divine revelation and human reason were distinct but not contradictory. "Reason does not destroy faith but perfects it," he wrote. According to Aquinas, humans came to know God's world

7.21 A master lecturing university students, from a medieval edition of Aristotle's *Nicomachean Ethics*. Manuscript illumination, German, 14th century. Staatliche Museen, Berlin.

In European universities, all teaching and learned writing were done in Latin, so an English-born scholar could study as easily in Bologna as in Oxford. Note that some students follow the lecture in their own books, while others converse or doze. Compare this scene with instruction and learning in today's universities.

both through the Bible's revealed truth and the logical workings of human understanding. God, the highest reality, would always remain a mystery to human reason, hidden even in the words of Christian scripture. Still, Aquinas argued, God revealed himself in other ways, through the works of nature and the workings of human reason. He held that God and nature were one, forming a harmonious order that was intelligible to the human powers of reason. Thus the study of nature led ultimately to an understanding of God.

Aquinas's synthesis may be illustrated by a common example. Observing a wren from his window, Aquinas could study the bird for itself as a creature of nature, as Aristotle might have. However, Aquinas would also know (as Aristotle would not) that the wren was a part of God's hierarchical order of creation. Aquinas's knowledge of the bird was itself part of God's purpose, which intends for humans to employ their powers of reason.

For Aquinas, the hierarchy of human knowledge reflected the order of creation. His understanding of God's mystery was supported and confirmed by his knowledge of the natural world. Thus, the natural philosophy of Aristotle was complemented by Aquinas's rich and flexible understanding of divine purpose. Like the world created by God, Aquinas's *Summa Theologica* was encyclopedic in its scope and hierarchical in its organization. His master work described a universe in which everything had its proper and logical place, although the *Summa* was left unfinished, appropriately enough, since one's praise of God could never be complete.

Court and City in the Late Middle Ages

Illustrate the ideas of courtly love as they appeared in medieval music and poetry.

Life at the medieval court – the residence of royalty and nobles – achieved a new sophistication in the later Middle Ages. With feudalism's decline, new powers and wealth accrued at the royal courts in London, Paris, Prague, and Spain. These courts and their major satellites stimulated a revived interest in poetry and storytelling. Rather than epics of bloody combats, the late medieval minstrels and writers were more likely to tell a story of romantic adventure. Medieval romances, as these stories were called, gave rise to a culture of love, courtesy, and graciousness in some medieval courts (Figs. **7.22**, **7.23**). Associated with courtesy was an elaborate code of knightly conduct called chivalry (see Key Concept, page 178).

In Europe's growing cities, poets exploited the atmosphere of freedom to interpret medieval traditions. Two poetic masterpieces – the *Divine Comedy* of Dante

MEDIEVAL PHILOSOPHY		
Anselm of Canterbury	1033–1109	Preached faith as the basis for all understanding
Peter Abelard	1079–1142	Defended freedom to doubt and question as a means to truth
Ibn-Rushd	1126–1198	Reconciled Aristotle's scientific thought with Muslim scriptures
Thomas Aquinas	1125–1174	Taught that revelations of faith were not contrary to truths of reason

Alighieri (1265–1321) and the *Canterbury Tales* of Geoffrey Chaucer (c. 1340–c. 1400) – synthesized the Middle Ages' sacred and secular traditions, both of them utilizing the pilgrimage as their primary literary and philosophical metaphor.

Courtly Love and Medieval Romance

The term **courtly love** describes an elaborate code of behavior governing relations between the sexes at medieval courts. According to the rules of courtly love, the young man pledged spiritual devotion and servitude to his love, usually a noblewoman. The lady, who was usually already married, felt flattered by the lover's attentions, but had to reject him. Knowing that his desire must remain unsatisfied, the lover's mood shifted between joy and despair, devotion and betrayal. The male troubadour's songs and poems alternated between praise for his lady's beauty and complaints about her cruelty. The female troubadour often praised her suitor's character and warned him against betrayal.

The culture of courtly love reached its zenith at the courts of the gracious and influential Eleanor of Aquitaine (c. 1122–1204). Eleanor was a powerful duchess who became the queen of two kings and was the mother of two sons who became kings. In 1170, the fiery and independent Eleanor was estranged from her royal husband, Henry II of England. She withdrew to her feudal lands in France and revived her court at Poitiers [PWAH-tee-ay]. Here Eleanor established elaborate rules of courtly dress, manners, and conversation.

Scholars are not sure whether Eleanor's prescriptions had any real influence on behavior at Poitiers or elsewhere. The rules of love are recorded in *The Art of Courtly Love* (*Tractatus de Amore*), written about 1180 by Andreas Cappellanus. Andreas defined love as "a certain inborn suffering derived from the sight of and excessive meditation upon the beauty of the opposite sex,

which causes each one to wish above all things the embraces of the other and by common desire to carry out all of love's precepts in the other's embrace." Andreas ends his treatise with a faintly mocking list what love's "precepts" might be:

- *Marriage is no real excuse for not loving.*
- *He who is not jealous cannot love.*
- *The easy attainment of love makes it of little value; difficulty of attainment makes it prized.*
- *Every lover regularly turns pale in the presence of his beloved.*
- *Love can deny nothing to love.* [4]

Even if the rules of courtly love were never seriously practiced, they reveal significant paradoxes of medieval society. Since marriage was a social obligation for medieval nobles, it was seldom an occasion for romantic fantasy and tenderness. Instead, romance was expressed through the quasi-adulterous games of courtly love, which made the lady a powerful lord and the male lover her servant. In this way, courtly love fancifully inverted the normal medieval arrangement of male–female power.

The paradoxes of courtly love found poignant expression in the songs of troubadours, the lyric poet-singers of the region of Provence in southern France. The troubadours' love songs celebrated medieval courtly life and idealized the troubadours' aristocratic patrons. Their style was quickly imitated in Germany by the *Minnesänger*, and in northern France by the *trouvères*. Through the bitter-sweet love songs of these poet-composers, the conventions and popular stories of courtly love spread throughout late medieval Europe.

The origins of troubadour song lie probably in the Arabic love poetry of the Muslim culture in Spain. Troubadours mixed the sensual images of Arabic poetry with the Neoplatonist idealism of popular philosophy. The most famous troubadour was Bernart de Ventadorn [vahn-ta-DORN] (c. 1150–c. 1180), who serenaded Eleanor of Aquitaine at the court of Poitiers. In his poems, Bernart's unquenchable hope for love was often mixed with despondency and rejection, as seen in these stanzas of "Quan vei la lauzeta mover":

When I see the lark beating
Its wings in joy against the rays of the sun
That it forgets itself and lets itself fall
Because of the sweetness that comes to its heart,
Alas! Such great envy then overwhelms me
Of all those whom I see rejoicing,
I wonder that my heart, at that moment,
Does not melt from desire.

Alas! How much I thought I knew
About love, and how little I know,
Because I cannot keep myself from loving
The one from whom I will gain nothing.
She has all my heart, and my soul,
And herself and the whole world;
And when she left, nothing remained
But desire and a longing heart. [5]

BERNART DE VENTADORN

Women troubadours (*trobairitz* [TROH-bair-itz] in the Provençal language) were frequently noblewomen themselves, like Beatriz de Dia [BAY-uh-treez duh DEE-ah]

7.23 Limbourg Brothers, "May," illustration from *Les très riches heures du Duc de Berry*, MS 65/1284 f. 5v, early 15th century. Vellum, 11 1/2 x 8 1/4 ins (29.4 x 21 cm). Musée Condé, Chantilly, France. From a famously illustrated book of religious devotions, this page shows courtiers enjoying the "May jaunt," a pageant celebrating the verdant May landscape. This book was produced for the Duke of Burgundy, who kept one of medieval France's most lavish courts.

Chivalry

Medieval romances painted a fanciful picture of chivalrous knights who dueled for the favor of their lady. In fact, chivalry (from the French *chevalier*, or "horseman") was a code of conduct that governed medieval warfare; it dictated the rules of mercy and fair play. Under the rules of chivalry, medieval knights pledged to serve God and their lord faithfully, and to treat others with courtesy and generosity.

Chivalry most likely sprang from the need to enforce vows of feudal loyalty. By accepting knighthood, a warrior promised not to kill his lord, sleep with the lord's wife, or surrender his lord's castle. Violations of this trust were punished swiftly and brutally. Ganelon, who betrays Roland in the medieval epic *Song of Roland*, is executed by having his limbs torn apart by horses. In the later Middle Ages, chivalry expanded to include religious devotion and service to ladies. Thus, chivalry evolved as a means of civilizing the rough fighting men of feudal Europe, who were otherwise little inclined to acts of kindness and courtesy. In philosophical terms, chivalry established a compromise between medieval warfare and the principles of Christian love.

The cult of chivalry involved an elaborate program of activity to occupy knights during peacetime. The Spaniard Ramón Llull's *Book of the Order of Chivalry* (late thirteenth century) described the chivalric ideal:

A knight should ride warhorses, joust, go to tournaments, hold Round Tables, hunt stags and rabbits, bears, lions, and similar creatures: these things are a knight's duty because to do them exercises a knight in the practice of arms and accustoms him to maintain the order of knighthood.[6]

Chivalric tournaments (Fig. **7.24**) were spectacular competitions that also involved feasting, pageantry, and dance. The competitions resembled military combat, often resulting in serious injury or death. A skilled combatant could enrich himself by capturing horses and armor, or by claiming ransoms from his vanquished opponents. Thus, chivalry opened a narrow path of social advancement in medieval society.

Chivalry led to the creation of a well-trained and ambitious class of professional warriors in medieval Europe, who responded to calls for a military campaign or a crusade to the Holy Land. As part of this military culture, great epic poems such as the *Song of Roland* told of valor and loyalty in battle. Possibly not since the Greece of Homer's epics had warfare and military values so dominated Western civilization as in the medieval "age of chivalry."

CRITICAL QUESTION

Discuss the idea that training a military elite such as the medieval knighthood increases the likelihood of war. Does military training today provide opportunities for social advancement, as it did in the Middle Ages?

7.24 Medieval tournament scene from the Manasseh Codex. Universitätsbibliothek, Heidelberg, Germany.
Medieval tournaments involved combat nearly as deadly as warfare itself. Here a lady arms her champion for the contest, while courtly spectators applaud.

(born c. 1140), wife of the Count of Poitiers. Women troubadours often spurned the poetic euphemism preferred by male singers, instead demanding a forthright profession of their lover's feelings. These lines from Beatriz assert her own worth and fidelity while questioning her lover's fidelity:

> My worth and noble birth should have some weight,
> My beauty and especially my noble thoughts;
> So I send you, there on your estate,
> This song as messenger and delegate.
> I want to know, my handsome noble friend,
> Why I deserve so savage and so cruel a fate.
> I can't tell whether it's pride or malice you intend.[7]

The troubadours and *trobairitz* nurtured a blossoming romance literature in late medieval Europe. The medieval **romance** was a long narrative in verse that told of chivalric adventures and courtly lovers. The same romance stories were revised and elaborated by different medieval authors. The most popular French romance was the *Roman de la Rose* (*Romance of the Rose*), begun by one poet around 1240 and extended by another about 1275. The *Roman de la Rose* was an allegorical tale of ideal love, adventure, and social satire, widely read and imitated throughout Europe.

An equally famous romantic elaboration was the tale of the legendary King Arthur and his court. Eleanor of Aquitaine's daughter encouraged her court poet Chrétien de Troyes [KRAY-tee-an(h) duh TWAH] (active 1160–1190) to embellish the Arthurian legend along the lines of courtly love. Chrétien responded, somewhat reluctantly, with his *Lancelot, or the Knight of the Cart.* Chrétien's *Lancelot* introduced the famous love affair between Lancelot, King Arthur's lieutenant, and Guinevere, his queen. These Arthurian lovers became a kind of romantic trope, reappearing in different romantic contexts (see Dante's Lovers, page 180).

The greatest female writer of medieval romance was also connected to Eleanor's court. Marie de France (active 1160–1215) may have been the half-sister of Henry II and probably lived at English courts. Among other forms, Marie de France composed verse narratives called *lais*, written in medieval French. Of the dozen *lais* that survive, several show a concern for women's experiences that was unique in the romance tradition. Some of Marie de France's heroines escape from their possessive husbands by creating a fantasy of spiritual and fulfilling love.

CRITICAL QUESTION
What rules seem to govern love in today's romantic relationships? Are these rules related to medieval traditions? How do they work to the advantage of women and men?

The Frenchwoman's poems circulated widely among European storytellers, perhaps helping to achieve a measure of civility and equality between the sexes.

Music in the Late Middle Ages

By the fourteenth century, the monophonic songs of troubadour and *trouvère* were being supplanted by a more refined secular music. Increasingly, secular songs were given polyphonic settings and were enriched by rhythmic complexities. Developed in northern France, this new style was called the **Ars nova**, or "new art."

The master of the *Ars nova* style was Guillaume de Machaut [gee-YOHM duh mah-SHOH] (c. 1300–1377), whose works achieved an unprecedented unity and refinement. Machaut composed in all the principal forms of his day, including monophonic *lais* and a great Mass titled *Messe de Nostre Dame.* He also applied the principles of *Ars nova* to the **motet**, a polyphonic song form in which the higher voices sang different poetic texts. The name is based on the French *mot* [moh], or "word," probably because words were so essential to the motet's beauty. Machaut's sacred motets were typical: an instrument played the lower part (the slow *cantus firmus*), while voices sang the freer upper parts, often with texts in Latin and French.

Though he retired as a cathedral administrator, the bulk of Machaut's music was secular, composed mostly for the dukes and kings whom he served as poet, musician, and secretary. Like today's popular songs, Machaut's poems were sung in stanzas, accompanied by a lute or a recorder. His song "Doulz Viaire Gracieus" ("Sweet gracious countenance") is a love song that might be addressed as easily to the Virgin Mary as to a lady love. The brief song shifts easily from traditional triple time to the new duple (two-beat) meter. Harmonically, it is colored with sharp and flat tones. Though they were barely perceptible to the ear, such *Ars nova* refinements appealed to the educated sensibilities of Machaut's courtly audiences.

Guillaume de Machaut died just as the Catholic Church was rent by the Great Schism (see page 161). Machaut's career shows that, in place of a corrupt and discredited Church, Europe's courts and cities had become leading centers of power and patrons of the arts.

Dante's Divine Comedy

Dante Alighieri [DAHN-tay al-ig-YAIR-ee] was born in the dynamic medieval city of Florence in Tuscany (central Italy), where he was richly educated in the politics, poetry, and philosophy of his day. When Florence's bitter political divisions caused Dante's exile in 1300, he undertook the composition of his *Divine Comedy,* a three-part epic that recounts the poet's vision of the afterlife. The *Comedy* is not only a kind of poetic *summa* of medieval values; it is also a synthesis of medieval poetic

techniques, including courtly love poetry and the classical poetic tradition.

In Dante's epic poem, the poet's own journey through the afterlife is an elaborate metaphor for the pilgrimage through life. In the *Inferno* (Fig. **7.25**), Dante is guided into the pit of hell by the classical poet Virgil (see page 90), a symbol of human reason and the classical poet whom Dante most admired. In the *Purgatorio*, the travelers climb the mountain of purgatory, encountering souls whose sins are not yet forgiven. In the *Paradiso*, Dante takes the hand of his idealized lady, Beatrice [bay-uh-TREE-chay]. At the center of heaven, Dante is permitted to look briefly at the blazing glory of God himself. As the pilgrim in his own epic, Dante faces the trials of the ordinary Christian believer. To reach his destination, he must master his own sinful nature, submitting to the commands of human reason (Virgil) and sacred truth (Beatrice).

The *Divine Comedy* synthesized religious symbolism with Dante's views on politics and language. The entire poem was written in a three-line stanza form called *terza rima* [TAIR-zuh REE-muh]. The holy number three reappears in the 33 cantos of each main section, which (when added to an introductory canto) equal another "perfect" number, 100. The pilgrim's conversations with

the souls allow Dante to espouse his personal political belief that Europe should be governed by a secular emperor, not the pope. Significantly, Dante composed the *Divine Comedy* in the Italian vernacular (spoken language), rather than in Latin.

Dante's Lovers Dante's poetic style was shaped by Florentine love poetry and he borrowed characters and stories from the European romance tradition. In the *Inferno*'s most famous episode, Dante meets Paolo and Francesca [POW-loh, fran-CHAY-skah], lovers murdered in their bed by Francesca's husband (Paolo's brother). At Dante's request, Francesca describes the moment of their first love, when they sat reading the medieval romance of Lancelot and Guinevere.

> "Love, which in gentlest hearts will soonest bloom
> Seized my lover with passion for that sweet body
> From which I was torn unshriven to my doom.
>
> Love, which permits no loved one not to love,
> Took me so strongly with delight in him
> That we are one in Hell, as we were above.[a]
>
> Love led us to one death. In the depths of Hell
> Caïna waits for him who took our lives."[b]
>
> "... One day we read, to pass the time away,
> Of Lancelot, how he had fallen in love;
> We were alone, innocent of suspicion.
>
> Time and again our eyes were brought together
> By the book we read; our faces flushed and
>
> To the moment of one line alone we yielded:
>
> It was when we read about those longed-for lips
> Now being kissed by such a famous lover,
> That this one (who shall never leave my side)
>
> Then kissed my mouth, and trembled as he did.
> Our Galehot[c] was that book and he who wrote it.
> That day we read no further."[8]

> DANTE ALIGHIERI
> *From Inferno, Canto V*

a. The pair's bodiless souls are bound together and blown about hell by hot winds, symbolic of the passion that destroyed them in life.

b. Caïna, a region of Dante's hell reserved for murderers of their own kin. Giovanni Malatesta, Francesca's husband and Paolo's brother, will dwell here because his violent sin is more serious than the lovers' lustful passion.

c. Galehot, the go-between who urged Lancelot and Guinevere on; also, in Italian, the word for "pander."

7.25 Diagram of Dante's *Inferno*.

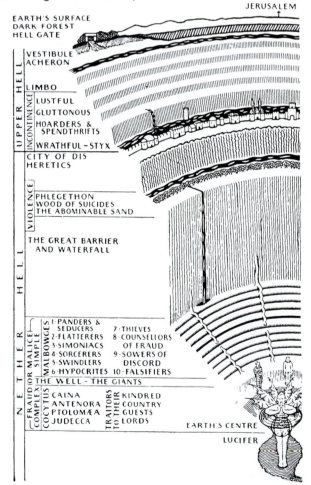

vision, Dante says, he is turned, with "feeling and intellect balanced equally," inevitably toward divine love.

Dante's *Comedy* was an immediate and popular success among literate Italians, and its Tuscan-flavored language set a standard for modern spoken Italian. Just fifty years after Dante's death, an inscription by the poet Giovanni Boccaccio praised Dante as a "dark oracle of wisdom and of art."[10]

Chaucer's Canterbury Pilgrims

Like Dante, Geoffrey Chaucer (Fig. 7.26) was a versatile poet, wise in the ways of the world, a diplomat and courtier in London, who wrote his poetic works to entertain a circle of courtly friends. His masterpiece was the *Canterbury Tales* (begun c. 1387), a set of stories told by a group of imaginary pilgrims journeying to Canterbury in southeast England. Chaucer sketches his pilgrims with knowing irony and wit. Each is journeying to Canterbury for a different reason, revealing the spectrum of human motivation, from religious piety to vain self-delusion. The pilgrims also reveal a cross-section of English society, including the dissolute and hypocritical as well as the pious and noble. Chaucer describes them and recounts their tales with a marvelous sense of irony and insight into human psychology.

The *Paradiso* is suffused with a more exalted and spiritual love. Guided by Beatrice, a symbol of human beauty, love, and grace, Dante discourses with Thomas Aquinas and heaven's other saintly inhabitants. The great poem ends with a lyrical prayer to the Virgin Mary, who permits Dante to gaze for a moment upon God. Because of that

7.26 Geoffrey Chaucer (c. 1340–1400) as pilgrim.

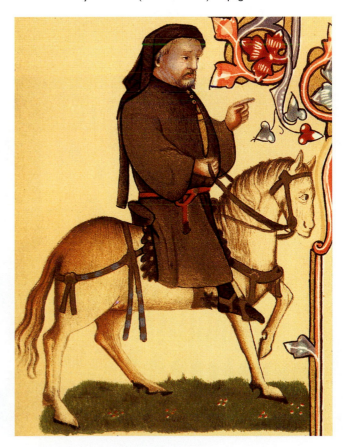

In its literary form, Chaucer's great work borrows from the *Decameron* of the Italian poet Giovanni Boccaccio [jyoh-VAH-nee boh-KAH-chee-oh] (1313–1375), in which the occupants of a country villa, gathered to escape the plague, entertain themselves by telling stories. Originally, Chaucer intended that each of the thirty pilgrims should tell four stories, but only twenty-four tales and a prologue were actually completed.

One of Chaucer's most memorable characters is the Wife of Bath, who has outlived five husbands and seeks a sixth on her journey. Her frank sensualism is a direct challenge to the medieval Church's teachings about women. To those who condemn women who do not seek the chastity of the convent, she says:

> As in a noble household, we are told,
> Not every dish and vessel's made of gold,
> Some are of wood, yet earn their master's praise,
> God calls His folk to Him in many ways.[11]

Chaucer's insight into such ordinary folk makes the *Canterbury Tales* a kind of "human comedy" as profound

1280–90	Cimabue, *Madonna Enthroned* (**7.28**)	
1303–21	Dante, *Divine Comedy*	
1305–6	Giotto, Scrovegni Chapel frescoes (**7.30**)	
1405	Christine de Pisan, *Book of the City of Ladies*	

as Dante's magisterial work. The two poets' appreciation of human diversity and their worldly understanding of human nature engendered the two literary masterworks of late medieval culture.

The Late Gothic

Identify crucial developments in late medieval Europe.

The fourteenth century was a turbulent age in Europe, marked by war and the pestilence of the Black Death, an epidemic of the bubonic plague that wiped out one-third of Europe's population at mid-century. For the survivors, ironically, living standards improved as wages rose and food was more plentiful.

As Europe recovered from the Black Death, poets and artists pushed forward a new style in the arts. In letters, the poet Petrarch recovered the classics and defined a new poetic style, while the philosopher Christine de Pisan eloquently defended the heritage of women. In the arts, an "International Gothic" style emerged, and Giotto's revolutionary innovations won him praise as the one "through whose merit the lost art of painting was revived."

Reclaiming the Classical Past

Increasingly in the fourteenth century, intellectual life centered in Europe's towns and courts, where it was less restricted by Church doctrines. The Italian poet and

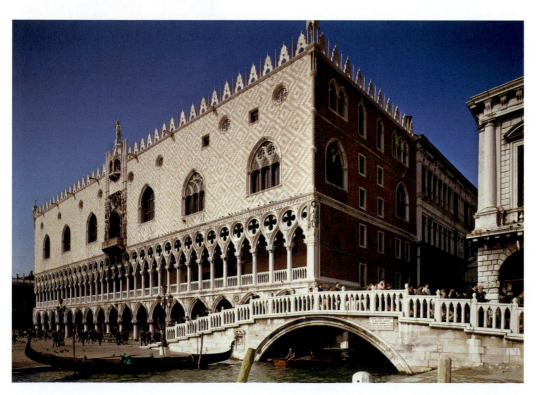

7.27 View of Doge's Palace, Venice.
The Doge's Palace seemed to stress the Venetian republic's command of the Mediterranean. In the second story of its two-story arcade (a row of arches), the columns blossom into quatrefoil medallions that counteract the weight of the upper story.

scholar Francis Petrarch (1304–1374) used this freedom to emphasize the continuity between the Christian faith and the teachings of classical Greece and Rome. This attitude of compromise between classicism and Christianity was called **humanism**, and it would dominate the thinking and art of the next century in Italy. Aside from his studies of classical languages and writings, Petrarch [PET- rark] also defined a lyrical new style of poetry. He perfected a form of the **sonnet** (a fourteen-line poem), dedicating many to his mysterious beloved named Laura. Laura succumbed to the plague in 1348, and in this sonnet, Petrarch praises her beauty while mourning her loss.

The eyes that drew from me such fervent praise,
The arms and hands and feet and countenance
Which made me a stranger in my own romance
And set me apart from the well-trodden ways;

The gleaming golden curly hair, the rays
Flashing from a smiling angel's glance
Which moved the world in paradisal dance,
Are grains of dust, insensibilities.

And I live on, but in grief and self-contempt,
Left here without the light I loved so much,
In a great tempest and with shrouds unkempt.

No more love songs, then, I have done with such;
My old skill now runs thin at each attempt,
And tears are within the harp I touch.[12]

FRANCIS PETRARCH

One of the fourteenth century's most remarkable careers was that of Christine de Pisan (1364–c. 1430), who grew up in the French royal court and eventually supported her family by writing poetry, moral philosophy, and a king's biography. Her most important work was *The Book of the City of Ladies* (1405), which retold the lives of goddesses and heroic women. The "city of ladies" was a heavenly bastion against the contempt for women that Christine found in such medieval works as the *Romance of the Rose*. Christine adopted the dialogue, following the classical philosophers Plato and Boethius, as the literary form for her reasoned arguments. While adapting Augustine's "heavenly city" as a metaphor for the afterlife, she included pagan figures among her heroines – something the Church fathers would never have approved.

Giotto and the International Gothic

Fourteenth-century Italy was an economic and artistic crossroads. Geographically, Italy's merchants and traders were well positioned to profit from commerce with the rich Byzantine and Eastern empires. Especially the maritime city of Venice, with its powerful navy, dominated

Europe's trade with the East. Venice built a grand palace for its elected duke, or doge, the feathery double arcade of which seemed to float on Venice's lagoon. The Doges' Palace (Fig. **7.27**) frankly showed the influence of Islamic building, while its open arches contrasted sharply with the fortress-like civic buildings of Florence or Pisa, Venice's commercial rivals.

These diverse influences culminated in a rich diversity of late medieval styles in the arts often called "International Gothic." Though not a unified style, the International Gothic often reflected a Byzantine influence, as in the gilded surfaces and otherworldly atmosphere of the *Madonna Enthroned* (Fig. **7.28**) by Cimabue (c. 1240–1302?). Cimabue's [chim-uh-BOO-ay] gigantic

7.28 Cimabue, *Madonna Enthroned*, 1280–90. Tempera on wood, 12 ft 6 ins x 7 ft 4 ins (3.81 x 2.24 m). Uffizi, Florence. Cimabue's Byzantine-influenced style contains only hints of a natural space; note the construction of the throne and the Madonna's feet placed obliquely on different steps. Compare to Giotto's slightly later version (Fig. 7.29).

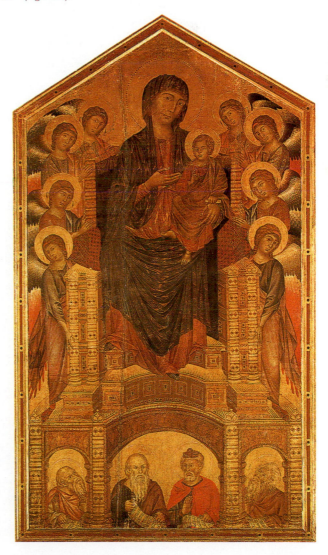

7.29 Giotto, *Madonna Enthroned*, c. 1310. Tempera on wood, 10 ft 8 ins × 6 ft 8 ins (3.25 × 2.03 m). Uffizi, Florence. Giotto's revolutionary technique used shading to create a feeling of volume and depth. Note other visual clues – the foreground angels, receding lines, obscured background figures – that contribute to the sense of spatial realism.

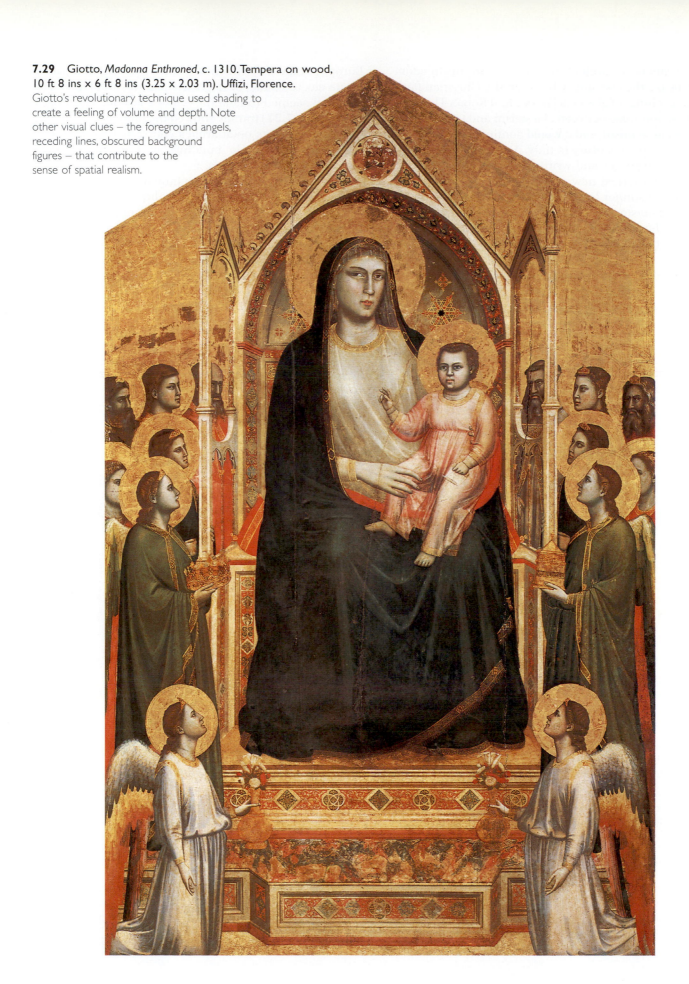

panel compromises the Byzantine style with only the suggestion of natural space and human emotion. In general, the central figures, the throne, and the angels all inhabit a spiritual world set apart from the observer.

Similarly intense (and expensive) surfaces characterized paintings produced for patrons in London, Paris, and Prague, the capital of Bohemia (in today's Czech Republic). At the festive court of the Duke of Burgundy in southeast France, artists produced a splendidly decorated calendar, or "book of hours," which depicted the life of both the nobility and peasants.

It was an Italian painter named Giotto di Bondone (c. 1266–1337), who revolutionized painting in the late Middle Ages. Giotto [JYAH-toh] was a contemporary of Dante and probably trained in a Florentine workshop.

His break with the medieval pictorial style can be seen in his own version of the *Madonna Enthroned* (Fig. **7.29**). Compared with Cimabue, his teacher, Giotto gives his figures a new volume and vitality. The drapery now falls more naturally over the Madonna's knees and breasts. The throne is clearly three-dimensional, with angels and saints positioned emphatically beside and behind, realizing a new coherence and realism of visual space.

Giotto's masterpiece was a three-part cycle of paintings in the Arena, or Scrovegni, Chapel in Padua, Italy. Italian Gothic churches provided large expanses of wall, which painters decorated in the ancient art of fresco (painting directly onto a wet plastered wall surface). For the frescoes of the Scrovegni Chapel, Giotto chose three great narrative themes: the Life of the Virgin, the Life of Christ, and the Passion of Christ. Each series contained scenes of tenderness and drama, which appealed to Giotto's interest in human emotion.

Even to Giotto's contemporaries, the pictures of the Scrovegni Chapel were stunningly new. Giotto radically simplified his compositions, eliminating detail in order to amplify a scene's visual and emotional effect. In the *Pietà* [pee-uh-TAH] (*Lamentation*; Fig. **7.30**), the mourners'

7.30 Giotto, *Pietà* (*Lamentation*), c. 1305–6. Fresco, 7 ft 7 ins x 7 ft 9 ins (2.31 x 2.36 m). Scrovegni Chapel, Padua.
Giotto gave his scenes emotional force by compositional devices, such as the mountain ridge's bold diagonal slash. The line draws the eye toward Christ's head and connects Christ's sacrifice to the symbolic tree in the upper right.

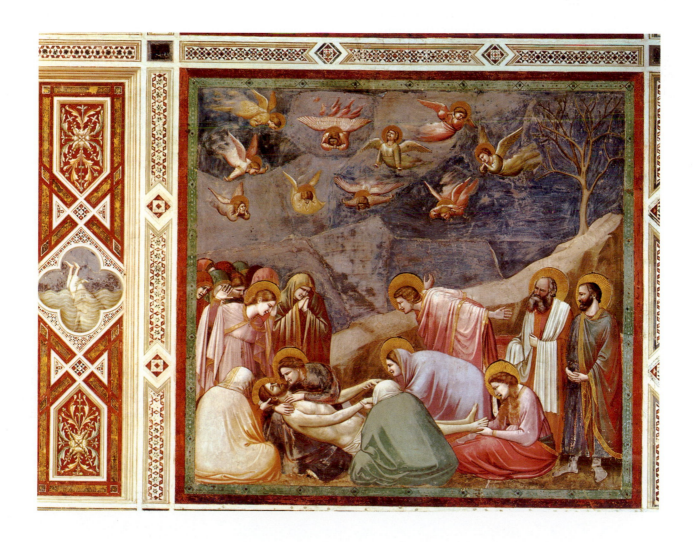

eyes converge on the poignant figures of the dead Christ and his grieving mother, while their faces and gestures reflect individualized emotional responses.

Such realism and technical innovation defined a new visual style that artists would adopt in the next generation, the era we call the Renaissance. Even more importantly, Giotto's interest in human emotion and individuality anticipated the values that would arise in the newly prosperous and sophisticated cities of fourteenth-century Europe, the centers of the Renaissance's cultural revolution.

CHAPTER SUMMARY

The Gothic Awakening The Gothic awakening was stirred by events that transformed medieval European society. The Crusades opened contacts to the Islamic world and loosened the ties of feudal society. Feudalism itself weakened as medieval monarchs in France and England consolidated their power and struggled for influence with popes and bishops. Medieval towns and cities thrived on the new commerce, gaining important freedoms from feudal obligation.

The Gothic Style The towns and cities around Paris were the site of a splendid new style of building, the "French" or Gothic style. At the royal abbey of St.-Denis, Abbot Suger combined architectural elements in a style that gave new prominence to light, the symbol of divine beauty. At Chartres and other cities of the Île-de-France, soaring Gothic cathedrals and churches symbolized the order of God's universe and celebrated the beauty of the Virgin Mary. Pilgrims were drawn to these splendid new buildings, hoping to find healing or salvation. The Gothic churches' stained-glass windows vividly depicted the stories and teachings of the medieval Church, serving as a "Bible of the poor." Exterior sculpture evolved from Romanesque austerity to increasing naturalism and vitality.

Music and Theater in the Gothic Age In the cathedral schools, musicians devised more complex forms of sacred music, especially the organum, which introduced polyphony in Western music. Composers of the Notre Dame School of Music compiled a great collection of organum that traced its development. Meanwhile, medieval theater moved from church to town, while keeping its Christian themes and subjects. The Gothic era's spectacular drama cycles and mystery plays were civic pageants, involving the whole town in dramatic production.

The New Learning Medieval towns also fostered the rise of the university, where medieval scholars achieved a new synthesis of Christian teaching and classical philo-sophy called scholasticism. Scholasticism was stimulated by Europe's rediscovery of Aristotle through the translations and commentaries of Arabic scholars. Ibn-Rushd and Moses Maimonides explored the conflicts of faith and reason that also concerned Christian scholars. The scholastic theologian Thomas Aquinas reconciled the doctrines of revealed truth with the natural and social philosophy of Aristotle.

Court and City in the Late Middle Ages Late medieval court life helped foster a culture of courtly love, romantic tales, and refined music. The code of chivalry governed combat and required loyalty to a knight's lord and courtesy to his lady. At courts in southern France, troubadours celebrated the joys and agonies of courtly love in song. The medieval romance elaborated stock romantic stories such as the Arthurian legends and stimulated the genius of Marie de France. Guillaume de Machaut applied the musical techniques of *Ars nova* in composing refined songs for his courtly audience.

Dante Alighieri's *Divine Comedy* and Geoffrey Chaucer's *Canterbury Tales*, both medieval master-pieces, both employed pilgrimage as a central metaphor. Dante's journey through the afterlife is guided by symbols of pagan reason and Christian truth and synthe-sizes the Gothic age's philosophical and religious concerns. Portrayed with humor and worldly understanding, Chaucer's Canterbury pilgrims seek redemption for their sins and failings.

The Late Gothic Europe's turbulent fourteenth century was marked by rampant plague, but also by a new prosperity and intellectual dynamism. In this atmosphere, poets and scholars such as Petrarch and Christine de Pisan allied Christian belief with the values of the classical past. Venice and other cities and courts supported a diverse artistic style called "International Gothic." The Italian painter Giotto introduced a new pictorial and emotional realism into Western painting that anticipated the Renaissance style.

8 The Renaissance Spirit in Italy

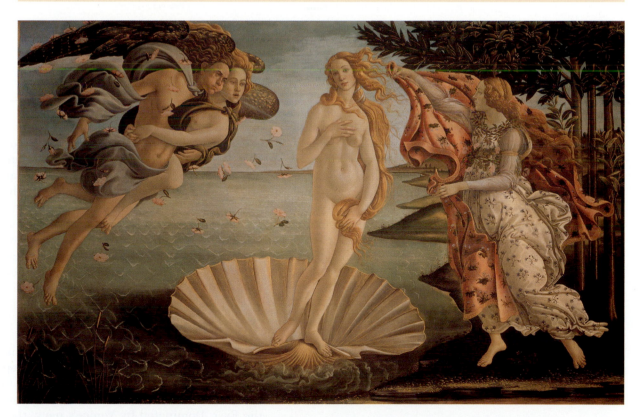

8.1 Sandro Botticelli, *Birth of Venus*, 1485–86. Tempera on canvas, 5 ft 8 ins x 9 ft 1⅝ ins (1.73 x 2.79 m). Galleria degli Uffizi, Florence, Italy

Botticelli's depiction of Venus was one of the first large-scale depictions of classical mythology since antiquity. The newborn goddess is blown to shore by the wind god Zephyr and cloaked in a floral drape by a goddess of the seasons.

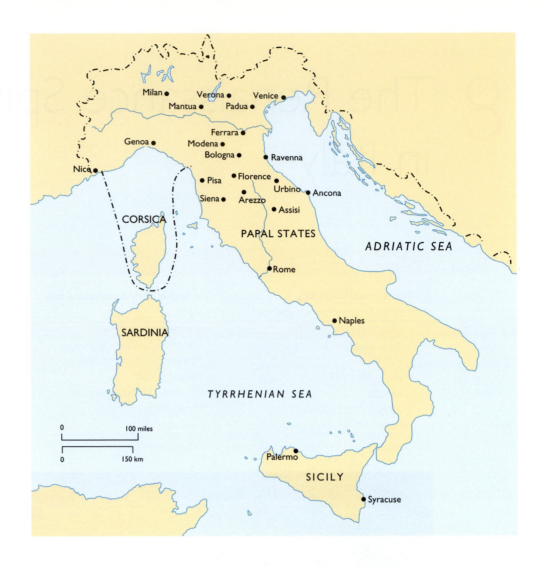

8.2 Renaissance Italy.
The cultural achievements of the Renaissance originated in Italy's prosperous and independent cities, which were centers of trade, manufacture, and banking.

Like the goddess Venus, blown ashore by the breath of a classical god (Fig. **8.1**), a spirit of rebirth and renewal visited Italy about 1400. The **Renaissance** spirit in Italy combined a love for classical beauty and wisdom with an innovative spirit and unfailing belief in human reason and creativity. Across Italy from about 1400 to 1600, this spirit inspired some of history's greatest achievements in art. At their height, Renaissance Florence and Rome rivaled classical Athens in their artistic and intellectual genius. In this great flowering of the human spirit, it seemed as though Italy had been visited by the goddess of beauty.

The Renaissance in Italy

Describe the conditions in Italian cities that nurtured the creative spirit of the Renaissance.

The Renaissance in Italy sprang from a vigorous interest in the culture of the ancient Greeks and Romans and a conviction that the achievements of classical antiquity were being restored in this new age. Hence the name Renaissance, which means "rebirth," a term first applied to the period in the early nineteenth century. The Italian Renaissance was a period of spectacular advances in learning and the arts, led by artists such as Leonardo, Michelangelo, and Raphael, whose genius impressed kings and popes, leaving works of unmatched excellence. One contemporary Italian described the Renaissance as a "new age, so full of hope and promise, which already rejoices in a greater array of nobly-gifted souls than the world has seen in the thousand years that have preceded it."

The Italian City-States

The cultural revolution of the Italian Renaissance was underwritten by the wealth of Italy's independent city-states in this period (Fig. **8.2**). Italy had long been the conduit for commerce and travel between Europe and the East. Dominated by Venice's navy, the Adriatic Sea provided access to the Byzantine Empire, to the wealth and learning of Turkish civilization, and to the riches of India and China. Ships from Genoa and Italy's other

Renaissance Humanism

In contrast to the medieval Christian view of humans as sinful and depraved, Italian Renaissance thinkers praised the human character as God's highest creation. The Renaissance humanists combined respect for classical learning with supreme confidence in human ability. This humanism played a role in the age's greatest achievements, and is evident in the statues modeled after ancient nudes and in the translations of classical authors.

In Renaissance times, a **humanist** was simply a student of Greek and Roman literature, history, rhetoric, and ethics. These subjects comprised the *studia humanitatis*, or the "course that made one human." In the *studia humanitatis*, scholars reconciled Christian belief with the moral teachings of the ancients. Renaissance humanists also challenged the medieval notion that the material world contained only temptation and evil and, instead, glorified the beauty and order in nature – as can be seen in Leonardo's drawing of the geometric proportions of the human body (Fig. **8.3**).

The definition of Renaissance humanism has now broadened to mean the age's glorification of human powers. The human capacity for knowledge and creativity made humans almost the equals of God. The Florentine humanist Pico della Mirandola [PEE-koh dell-ah meer-AHN-doh-lah] (1463–1494) exalted human freedom in his *Oration on the Dignity of Man*, in which God says to humanity:

> We have made you neither of heaven nor of earth, neither mortal nor immortal, so that with freedom of choice and with honor, as though the maker and molder of yourself, you may fashion yourself in whatever shape you shall prefer. You shall have the power to degenerate into the lower forms of life, which are brutish. You shall have the power, out of thy soul's judgement, to be reborn into the higher forms, which are divine.[1]

Of course, such a divinely sanctioned human freedom presented both opportunity and risk. According to Pico's God, humans could develop and apply their powers until they became like the angels. Yet, humans could also fall into cruelty and corruption, if they ignored the moral teachings of ancient philosophy and the Church. Several prominent figures of the Renaissance agonized in fear that they had gone too far in glorifying the human spirit.

While Renaissance humanism did not immediately affect the lives of common people, its belief in human reason and scholarship soon stimulated monumental changes: the Bible translations of the sixteenth-century German reformer Martin Luther (see page 222) depended on his humanist training in ancient languages. Humanist printers, such as Aldus Manutius of Venice, who published translations of Plato and Roman dramatists, used their printing presses (Fig. **8.4**) to spread Renaissance ideas throughout Europe. Although its flame was lit by a handful of Italian artists and thinkers, Renaissance humanism inspired human achievement for centuries after its high point.

8.3 Leonardo da Vinci, *Proportions of the Human Figure* ("Vitruvian Man"). Galleria dell' Accademia, Venice.
In this famous image, Leonardo plotted the human figure within a circle and square, recalling the principles of classical rationalism.

8.4 A German print shop from Jan van der Straet's *Nova Reperta* by Theodor Galle. Copperplate.

The printing press revolutionized learning by radically reducing the cost of books. The most famous Italian printer was Aldus Manutius of Venice, who fed the Renaissance humanists' hunger for classical writings with translations of Plato and the Roman playwrights.

western ports plied the Atlantic, bearing wool from England and other materials for the workshops in Italy.

Italy's independent city-states were governed in various ways. Some, such as Milan and Ferrara, were ruled by hereditary nobles, while others, such as Venice and Florence, proudly declared themselves – in title at least – as republics, with governments elected by the citizens. In fact, power was tightly controlled by ruling elites of **merchant princes** – wealthy citizens who sometimes held public office but more often wielded power from behind the scenes. The most famous and prominent family of merchant princes were the Medici [MAY-dee-chee] of Florence, established by Cosimo de' Medici (1389–1464). While serving as the pope's banker, Cosimo obtained a lucrative mining monopoly and went on to build a highly successful commercial empire. Perhaps out of concern for his soul, he spent half his fortune on artistic patronage and religious charity, yet his family had wealth enough to dominate Florentine politics for a century after his death.

Though economically dynamic, Renaissance Italy's cities were often bitterly divided by political factions and plagued by war with their rivals. In 1478, a rival family tried to assassinate Lorenzo de' Medici, Cosimo's grandson, during Mass in Florence Cathedral. Though his

brother was killed, Lorenzo evaded the assassins and saw that they were publicly hanged in the city square. Political ambition and economic competition spurred Italy's five largest states – Florence, Milan, Venice, the Papal States, and the Kingdom of Naples – to continual war. To fight their wars, Italian city-states often employed mercenary military commanders called *condottieri* [kon-DOT-tee-air-ee], who frequently used their victories to seize power for themselves. The ruthless and mercenary strategies of the *condottieri* inspired the Florentine Niccolò Machiavelli to write his famous treatise *The Prince,* a foundation of modern political science (see page 206).

Patronage of the Arts and Learning

The wealthy rulers of Italy's cities and courts spent lavishly on the arts and learning. Especially in Florence, artistic patrons were guided by the Renaissance idea of civic humanism (Fig. **8.5**). Civic humanism derived from the republican ideals of the ancient Romans and especially from the writings of Cicero (see page 91). It bound Florence's citizens to balance their pursuit of self-interest – something the Medici never failed in – against their obligation to the civic good. The virtuous citizen engaged in the city's politics and employed his wealth to benefit all its citizens. The Medici family, for example, rebuilt churches, sponsored hospitals and other civic projects, and commissioned public art works (Fig. **8.6**). Cosimo de' Medici subsidized an academy of Renaissance learning that attracted to Florence scholars from all over Europe. The Medici patriarch, himself a humanist scholar, collected a famous treasury of ancient books and manuscripts (Fig. **8.7**). In 1453, the Medici collection swelled with Greek manuscripts brought by scholars fleeing the Turkish occupation of Constantinople.

> And when a free people are offered this possibility of attaining offices, it is wonderful how effectively it stimulates the talents of the citizens. When shown hope of gaining office, men rouse themselves and seek to rise; when it is precluded they sink into idleness.
>
> Leonardo Bruni, Renaissance humanist

8.5 *(above)* Circle of Piero della Francesca, *An Ideal City*, mid-15th century. Oil on panel, 23¹/₂ × 79 ins (59.7 × 200.6 cm). Palazzo Ducale, Urbino

This view of a city perfectly balanced and harmonious embodies the Renaissance idea of civic humanism.

8.6 *(below)* Sandro Botticelli, *Adoration of the Magi*, c. 1475. Tempera on wood, 3 ft 7¹/₂ ins × 4 ft 4³/₄ ins (1.1 × 1.34 m). Uffizi, Florence. Botticelli honored his Medici patrons by portraying them as Wise Men worshiping the newborn Christ. Note how the classical-style ruins, the rustic shed, and the pyramid-shaped rock formation give the scene spatial depth and a classical flavor.

8.7 Michelangelo Buonarroti, Laurentian Library, San Lorenzo, Florence, begun 1524, staircase completed 1559.
The Medici were avid antiquarians, commissioning this severely classical library by Michelangelo to house their collection of ancient manuscripts. Michelangelo's staircase and vestibule employ a classical vocabulary in an arbitrary and illusionistic design – staircases leading nowhere, columns supporting nothing – that anticipates Renaissance mannerism.

The flowering of arts in the Renaissance grew from a flexible system of patronage by which wealthy families and individuals employed artists. A Renaissance patron normally engaged an artist through a written contract that outlined the work's specifications and a schedule of payments. The wealthiest patrons might maintain an artist at their court, expecting the performance of certain duties, such as supervising building projects or directing a choir (see Fig. 8.33). Though women were generally discouraged from artistic professions, with wealth and high birth they did at least become avid patrons. The courts of Lucrezia Borgia, and Isabella d'Este (see Key Concept, page 210) at Mantua, were famed for their glittering musical culture. The Renaissance system of patronage sometimes brought troubled relations between artists and their patrons. In his *Lives of the Painters* (1550), the biographer Giorgio Vasari told of a painter who was locked in a room to finish a commission. The recalcitrant artist escaped through the window to spend three days

1434	Cosimo de' Medici controls Florence
1453	Greek scholars flee Constantinople, settling in Florence
1469–92	Lorenzo de' Medici, patron of learning and the arts, governs Florence
1486	Pico, *Oration on the Dignity of Man*

THE WRITE IDEA
Write a definition of human nature as you understand it, including the most significant differences between humans and animals. Compare your definition with Pico's description of human nature in his *Oration on the Dignity of Man*.

in Florence's taverns and brothels. In another example, Pope Julius II, impatient with Michelangelo's progress on the Sistine Chapel ceiling (see page 216), once threatened to throw the artist off his scaffolding. Michelangelo replied quietly but forcefully, "I think not, my lord."

In Florence, the high point of the Renaissance came with the reign of Lorenzo de' Medici (ruled 1469–1492) (Fig. 8.8) called "the Magnificent," who not only patronized the arts but was himself an accomplished poet. Lorenzo was the favored son of Florence's lively Renaissance culture. He was tutored by the classical scholar Marsilio Ficino [fi-CHEE-noh] (1433–1499), the age's leading translator of Plato. Lorenzo later said that, without knowing Plato, one could not be a good citizen or a good Christian. When, at age twenty-one, Lorenzo was asked to assume political leadership of the city, he responded to his duty with the commitment of a good civic humanist.

Lorenzo's civic obligations did not distract him from the arts. He loved music and wrote bawdy lyrics to be sung in the street or the saddle. Following Dante's lead, Lorenzo composed in his native Tuscan language, not in

8.8 Andrea del Verrocchio, *Lorenzo de' Medici*, 1478/1521. Terracotta, 25⅞ × 23⅞ ins (65.8 × 59.1 cm). National Gallery of Art, Washington, D.C., Samuel H. Kress Collection 1943.4.92. Lorenzo de' Medici, grandson of Cosimo, presided over the late bloom of Renaissance culture in Florence. Verrocchio, a favorite of the Medici, was the teacher of Leonardo da Vinci.

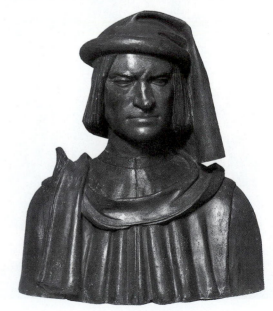

CRITICAL QUESTION
Do wealthy citizens of today's cities have an obligation to support civic projects and public works of art? Should tax laws regarding wealth and large inheritances encourage the well-to-do to support the arts and the public good?

the stuffy Latin of scholars. His hedonistic carnival songs were sung at Florence's raucous carnival celebrations. They capture the pagan spirit of Florentine life, caught up with the sensual pleasures of love and festivity.

Ladies and gay lovers young!
Long live Bacchus, live Desire!
Dance and play; let songs be sung;
Let sweet love your bosoms fire;
In the future come what may!
Youths and maids, enjoy today!
Nought ye know about tomorrow.
Fair is youth and void of sorrow;
But it hourly flies away.[2]

LORENZO
Song of Bacchus

WINDOWS ON DAILY LIFE

The Violence of Renaissance Youth

Swordplay and other violence were common in the rough-and-tumble urban life of Renaissance Italy. In his autobiography, the Florentine goldsmith and sculptor Benvenuto Cellini [tcheh-LEE-nee] (1500–1571) describes this duel between his fourteen-year-old brother and an older rival in the streets of Florence.

They both had swords; and my brother dealt so valiantly that, after having badly wounded him, he was upon the point of following up his advantage. There was a great crowd of people present, among whom were many of the adversary's kinsfolk. Seeing that the thing was going ill for their own man, they put hand to their slings, a stone from one of which hit my poor brother in the head. He fell to the ground at once in a dead faint … I ran up at once, seized his sword, and stood in front of him, bearing the brunt of several rapiers and a shower of stones. I never left his side until some brave soldiers came from the gate San Gallo and rescued me from the raging crowd….[3]

BENVENUTO CELLINI
The Life of Benvenuto Cellini (1558–1562)

Lorenzo became the patron and protector of the most prominent artists and intellectuals of the early Renaissance. As youths, Leonardo da Vinci and Michelangelo, who was discovered by Lorenzo copying a Roman statue in his gardens, may have dined at the family table. Lorenzo also saw that the painter Botticelli and the sculptor Verrocchio received generous commissions for their work. When the scholar Pico della Mirandola was tried for heresy in Rome, Lorenzo invited him to Florence and protected him from the pope. The golden age of the Florentine Renaissance came to an end, however, with the decline of the Medici fortune and the death of Lorenzo in 1492.

The Arts in Early Renaissance Italy

Describe the technical innovations in the arts and music that helped define the Florentine Renaissance style.

Towering above Florence was a symbol of Renaissance humanism, the marble-ribbed dome of the Cathedral, designed by the young architect Filippo Brunelleschi (Fig. **8.9**). The dome acted as a beacon to artists and scholars. Young artist prodigies such as Leonardo da Vinci and Michelangelo Buonarroti came to apprentice in Florence's workshops and academies, while some of Europe's leading composers served in its courts.

Florence 1401 – A Renaissance Begins

One might well say the Renaissance began in Florence in 1401. In that year, city officials called artists to compete for the honor of decorating the doors of the city's Baptistery. The Baptistery was an eight-sided medieval building that stood before Florence's cathedral. Its massive east doors were to be adorned by gilded bronze panels. In the contest to design a panel depicting Abraham's sacrifice of his son Isaac (Genesis 22), the chosen design (Fig. **8.10**) was that of Lorenzo Ghiberti [gee-BAIR-tee] (1378–1455), a young Florentine metalworker. To Florentine humanists, Ghiberti's nude figure of Isaac seemed directly lifted from a Roman fresco. Its classical qualities were reason enough to praise Ghiberti's panel above all its competitors.

Over the next fifty years, all of Florence watched Ghiberti's progress as he cast panels for both the north and east doors (Fig. **8.11**). The Baptistery doors proved to be a fitting challenge to the Renaissance master, since the creative process involved so many different arts: skill in drawing and architectural design to compose the scenes; sculptural technique to shape the wax models for the figures; and finally, expertise in metalworking to supervise the meticulous casting, finishing, and gilding

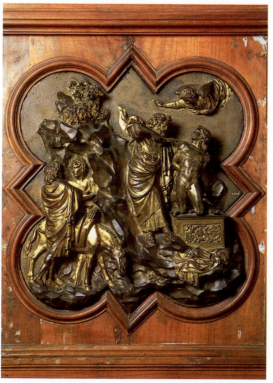

8.9 *(above)* Florence Cathedral (Santa Maria del Fiore), begun 1296. Dome by Filippo Brunelleschi, 1420–36; façade remodeled late 19th century. Overall length 508 ft (154.9 m), height of dome 367 ft (111.9 m).

The soaring cathedral dome by Brunelleschi, completed in 1436, became the city's trademark. The bell tower (or *campanile*) was designed by Giotto in the previous century. The octagonal roof of the Baptistery is visible at left.

8.10 *(left)* Lorenzo Ghiberti, *Sacrifice of Isaac*, 1401. Gilt bronze, 21 x 17¹/₂ ins (53 x 44 cm). Museo Nazionale, Florence.

This panel won for Ghiberti the lucrative honor of decorating the doors of Florence's eight-sided Baptistery (see above). Contest judges praised the dramatic unity of Ghiberti's composition and the energetic nudity of Isaac's form, which stretches back to receive the knife's blow. Compare this composition to Giotto's scene of the *Pietà* (Fig. 7.30).

8.11 *(opposite)* Lorenzo Ghiberti, *Gates of Paradise*, east doors of the Cathedral Baptistery, Florence, 1425–52. Gilt bronze, height 17 ft (5.2 m).

Ghiberti's north and east doors for the Florence Baptistery were touchstone works of the early Renaissance; the project of designing and casting the doors occupied Ghiberti for nearly his entire career.

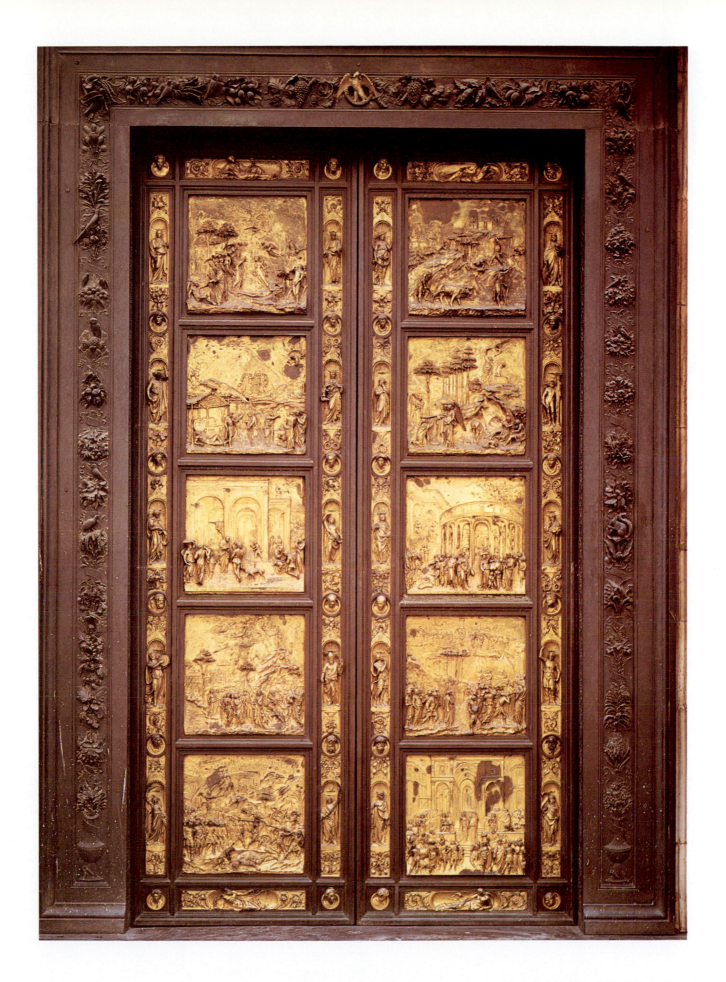

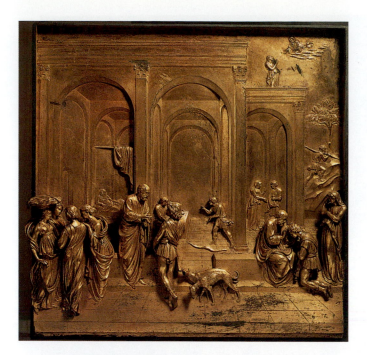

8.12 Lorenzo Ghiberti, *Jacob and Esau*, left center panel from the *Gates of Paradise*, Cathedral Baptistery, Florence, c. 1435. Gilt bronze, 31¼ ins (79 cm) square.

Ghiberti framed the biblical story of Jacob and Esau within an arcade that demonstrated the new science of perspective. A kneeling Jacob receives Isaac's blessing at right; Isaac appears again at center left, explaining the deception to Esau, who has returned from the hunt.

of the panels themselves. Thus, Ghiberti's doors became a catalogue of the evolving Renaissance style in the arts. Later, the young Michelangelo so admired the master's accomplishment that he dubbed the east doors the "Gates of Paradise," a name they still bear.

The panel *The Story of Jacob and Esau* (Fig. **8.12**) from the *Gates of Paradise* indicates Ghiberti's mastery of the arts. The panel depicts the biblical story of Jacob (Genesis 25–27), who purchased his brother Esau's birthright and deceitfully obtained the blessing intended for Esau. The figures of the *Gates of Paradise* seem to move beneath their garments, reminiscent of classical Greek statues (see Fig. 3.22). Following the new rules of optical **perspective**, Ghiberti unified the story's different episodes in a single architectural space, for example, in the tiled courtyard and receding arches in the panel of *Jacob and Esau*. Only the painter Raphael, in his *School of Athens* (see Fig. 8.36), matched Ghiberti's use of architecture as a setting for dramatic action.

Brunelleschi's Domes

The losing finalist in the Baptistery competition was the aspiring young Filippo Brunelleschi (1377–1446), who would become Florence's greatest Renaissance architect.

Rather than mourn his defeat, Brunelleschi [BROO-neh-LESK-ee] went to Rome to sketch and measure ancient buildings. He returned to Florence and received the commission to build a domed roof over Florence's cathedral altar (see Fig. 8.9). For years, the cathedral's massive drum had been uncovered because no architect knew how to span such a wide space.

Brunelleschi's solution produced a building that truly appealed to Florence's civic vanity. The design was a double roof, with inner and outer shells connected by a hidden system of buttresses and reinforcement (Fig. **8.13**). The double shell was unlike anything built in antiquity. With its crowning lantern, the finished dome rose 367 feet (112 m) above the floor, inspiring one observer to say that it seemed to rival the hills surrounding Florence. The soaring red-tiled roof was outlined by swelling marble ribs, with each section underscored by a round clerestory window (Fig. **8.14**). The visual effect was a triumph of simplicity and reason.

The cathedral commission established Brunelleschi's reputation as an architect, and he soon set to work serving the wealthy families of Florence. For the powerful Pazzi [POT-zee] family, rival of the Medici family, Brunelleschi built the Pazzi Chapel (Fig. **8.15**) in the courtyard of a Florentine monastery. The Pazzi Chapel's arcaded porch and domed roof were clearly inspired by Roman architecture. Both inside and out, the building's dimensions were multiples of a basic module, creating a mathematical regularity reinforced by the recurring geometric shapes (especially the circle and square). Inside the Pazzi Chapel the dramatic use of gray stone (called *pietra serena*) lends a peaceful simplicity to the pilasters and arches (Fig. **8.16**).

The grace and piety of their chapel did not extend to the characters of the Pazzi family themselves. In 1478, the Pazzi tried to assassinate Lorenzo de' Medici in the cathedral on Easter Sunday. Lorenzo survived, and twelve Pazzi conspirators were hanged.

Florentine Painting: A Refined Classicism

Early Renaissance Florence was justifiably famous for its painters, whose techniques established a striking new visual style in the arts. To satisfy their patrons' demands, Florentine artists were trained in anatomy (to create life-like figures), modeling (to suggest volume in round objects), and perspective (to organize and unify the pictorial space). The Florentine painters were especially known for their technique in fresco, suited to decorating the walls of Florence's new churches and chapels.

The most influential innovator was Tommaso di Giovanni, known as Masaccio [mah-ZAHH-chee-oh] (1401–28), whose mastery of perspective and three-dimensional modeling affected every artist who trained in Florence. Masaccio quickly applied the new system of linear perspective (see Key Concept, page 202). His *Holy*

8.13 (*above*) Brunelleschi's double-shell design for the dome of Florence Cathedral.
Brunelleschi's dome embodied the humanism of the Italian Renaissance – a respect for classical models mixed with a celebration of human ingenuity. A system of internal braces connected the outer roof and interior ceiling, supporting the dome without the elaborate buttressing of Gothic design.

8.14 (*above, right*) Filippo Brunelleschi, dome of Florence Cathedral, 1420–36. Height 367 ft (112 m).
Brunelleschi's cathedral dome spanned a wider space than the Pantheon in Rome (see Fig. 4.20) and reached higher than any Gothic cathedral. The red-tiled roof and swelling marble ribs project a classical simplicity and disguise the complex internal construction.

8.15 (*left*) Filippo Brunelleschi, façade of the Pazzi Chapel, Santa Croce, Florence, c. 1429–33.
A work of serene classicism, the Pazzi Chapel shows Brunelleschi's careful study of ancient Roman buildings. The Corinthian columns, pilasters, and frieze designs were all copied from classical models.

Florentine painting took on a more learned and refined aspect in the works of Sandro Botticelli [BAH-ti-CHELL-ee] (1444–1510), a member of the Medici circle. The goddess in his *Birth of Venus* (see Fig. 8.1) was modeled after a statue in the Medici collection. Botticelli was also likely inspired by classical descriptions of a painting by Apelles, the ancient Greek master, depicting "Aphrodite rising from the sea."

In his *La Primavera* (*Birth of Spring*) (Fig. 8.19), Botticelli blended classical mythology with Christian

8.17 Masaccio, *Holy Trinity*, 1425. Fresco (now detached from wall), 21 ft 9 ins × 9 ft 4 ins (6.67 × 3.17 m). Santa Maria Novella, Florence
Masaccio sets the crucifixion in a barrel-vaulted niche that applies linear perspective with such mathematical precision that it could be built exactly as drawn. Compare the architectural setting of Raphael's *School of Athens*, Fig. 8.36.

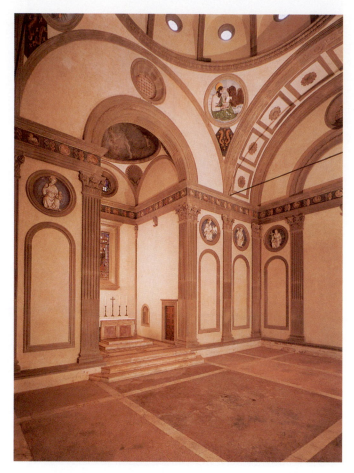

8.16 Filippo Brunelleschi, interior of the Pazzi Chapel, Santa Croce, Florence, c. 1429–33.
The use of gray *pietra serena* emphasizes the geometric shapes and proportions of the chapel's interior. The recurring pilasters, and the continuous frieze and molding, all unify the interior space.

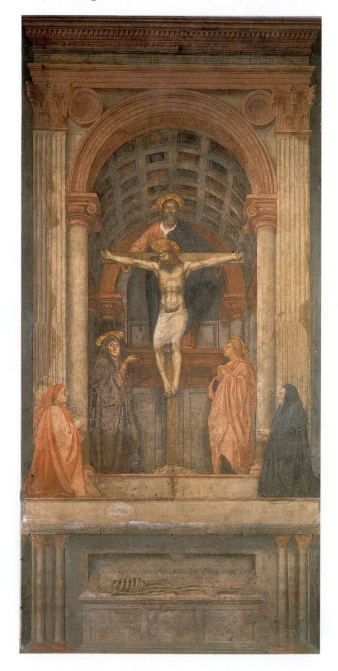

Trinity (Fig. 8.17) encloses the crucifixion of Christ in a barrel-vaulted architectural setting. The patron and his wife kneel in realistic space before the opening, while the Virgin and John are seen from below, in foreshortened perspective. Above the figure of God the Father, painted piers and vaulting render a perfectly believable architectural space.

With his lifelike modeling of human figures and their clothing, Masaccio advanced Italian painting beyond the threshold set by Giotto. The central group in *The Tribute Money* (Fig. 8.18) are given solidity and depth by the light and dark shading in the figures' robes, a technique called *chiaroscuro* [KYAH-ruh-SKOO-roh]. *Chiaroscuro* enabled Italian painters to render three-dimensional objects by the convincing use of shadow. The painting's illusion of depth is enhanced by blurring the distant hills and trees, a technique called **atmospheric perspective**, which Masaccio invented. Finally, the impression of space is reinforced by **linear perspective** in the building at right. Masaccio's paintings in the Brancacci [brahn-KAH-chee] Chapel served as a "school of art" for future geniuses of Renaissance art.

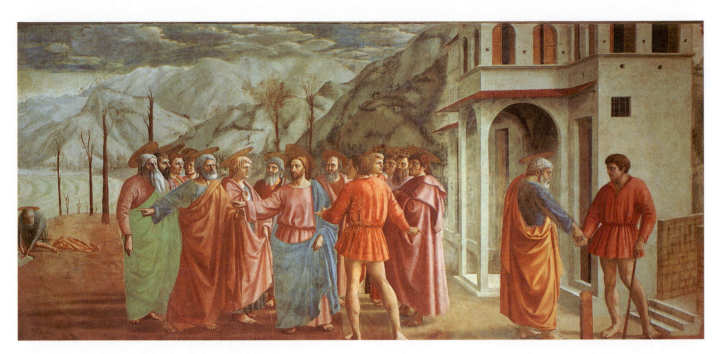

8.18 *(above)* Masaccio, *The Tribute Money*, c. 1427. Fresco (after restoration, 1989), 8 ft 4 ins x 19 ft 8 ins (2.54 x 5.9 m). Brancacci Chapel, Santa Maria del Carmine, Florence.
Masaccio's frescoes in this Florentine chapel pioneered the techniques of Renaissance painting. As recounted in Matthew 17:24–7, a tax collector demands a tax from Christ and his apostles (center); at Christ's direction, Peter finds a coin in a fish's mouth (left); Peter then pays the tax, rendering "unto Caesar what is Caesar's" (right).

8.19 *(below)* Sandro Botticelli, *La Primavera* (*Birth of Spring*), c. 1478. Tempera on panel, 6 ft 8 ins x 10 ft 4 ins (2.03 x 3.14 m). Uffizi, Florence.
Botticelli synthesizes his classical subject with Christian and contemporary themes. The painting's symbolic references include the orange fruits (an allusion to the Medici family crest), the bed of flowers (for the city of Florence), and Venus's red and blue garments, which associate her with the Virgin Mary.

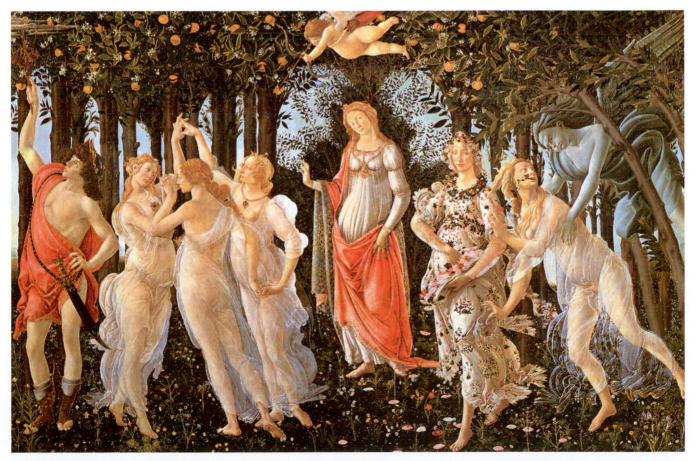

symbols in a visual document of Renaissance humanism. Though the painting's precise meaning is disputed, scholars agree that the central figure is Venus, the classical goddess of love and fertility, who raises her hand in benediction over the scene. Both this gesture and the color of her robe associate Venus with the Virgin Mary, the Christian embodiment of maternal love. On the right, Zephyr, the god of wind, pursues a nymph who is miraculously transformed into Flora, goddess of the flowers. In the foreground, the classical Three Graces celebrate spring's arrival in filmy garments; to the far left stands the god Mercury and above the impish Cupid prepares to shoot his arrow into the scene.

Italian Renaissance Music

European music in the early Renaissance continued to take the forms preferred in the Middle Ages:

- the Mass and other liturgical music;
- sacred motets, with texts in Latin;
- secular song.

An important figure in the transition from medieval to Renaissance music was Guillaume Dufay (c. 1398–1474), a French native who served many patrons in Italy. Dufay [doo-FAY-ee] served in the glittering court of Burgundy in France, where his music was prized for its lyricism and charm. Dufay also spent several years in Italy composing a famous motet entitled *Nuper rosarum flores*, which was sung at the dedication of Florence's cathedral in 1436.

In Florence, humanist intellectuals such as Marsilio Ficino, Lorenzo de' Medici's tutor, attempted to reproduce ancient Greek music. These scholars were familiar with classical musical theory, but had no idea what Greek music actually sounded like. They performed chanted translations of classical poetry, accompanied by a lyre. This half-sung recitation of poetry, called **monody**, served to inspire the more colorful musical form of opera invented in Florence later in the Renaissance.

The opportunities for patronage in prosperous Italian courts drew musicians trained in the schools of northern Europe. Lorenzo de' Medici favored the well-traveled Flemish composer Heinrich Isaac (c. 1450–1517), who also served at courts in Germany. Isaac's musical talents were eclectic, exploiting many musical forms and influences. While in Florence, he set to music more than a hundred Italian songs and composed about forty masses. Isaac's most famous work is a lyrically polyphonic song entitled *In Innsbruck muss ich dich lassen* (*In Innsbruck I must leave you*). Northern composers like Isaac learned to ally their technical brilliance in polyphony with the Italian humanist love for poetry. The result was a new importance for language in both sacred and secular music.

Renaissance Italy's festive streets and courts rang with polyphonic song forms such as the **frottola** (pl. *frottole*)

and the madrigal. The *frottola* [FROTT-oh-lah] – a ballad-like song with refrain – arose under the patronage of Isabella d'Este of Mantua (see page 210), and spread to other Italian courts and cities. Although *frottole* were often composed for four voices, the parts were usually based on a few musical chords, allowing them to be sung also by a single voice, accompanied by a lute.

The explosion of Italian song fostered a virtuoso style of singing, nurtured at the court of Ferrara. There a famous "ladies' consort" of four female singers perfected a polished singing style well suited to the **madrigal**, a secular song form usually in four parts. Ferrara's famed ensemble inspired composers throughout Europe, who dedicated their madrigals to the Duchess of Ferrara, hoping that their works "might receive the true and natural spirit of music from such divine voices and such a noble consort."[4] Italy's new commercial printers exploited the popularity of Renaissance song by publishing books of *frottole* and madrigals, advertising them as "suitable compositions for all occasions and situations of amorous and courtly life" (Fig. **8.20**).

The first woman to publish her music, Maddalena Casulana (c. 1540–c. 1590), eventually published a series of three books of madrigals, the first one being reprinted three times in her lifetime. Maddalena knew well how to earn the favor of her patrons. In a dedication to Isabella de' Medici, Duchess of Bracciano, she hopes that her compositions would "show the world (for all that has been granted to me in this profession of music) the vain error of men" who believe themselves the sole "possessors of the high arts of the intellect."[5]

Early Renaissance Sculpture

By the 1490s, the century-long ascendancy of Renaissance Florence was threatened by decline. Lorenzo de' Medici's neglect of family finances threatened the Medici's hold on political power, and the incompetence of Lorenzo's successor exposed Florence to its political enemies and to popular challenge within. The political turmoil of these years actually served as a stimulus to the city's sculptors. Renaissance sculpture achieved a new heroic power portrayed in the works of Donatello and the young Michelangelo. Eventually, however, the decline of the Medici family and civic turmoil in Florence shifted the center of Renaissance culture to Rome.

1401	Ghiberti wins Baptistery competition, Florence (**8.10**)
1420	Brunelleschi begins cathedral dome, Florence (**8.14**)
1480s	Portuguese explorers' contact with Benin, West Africa
c. 1485	Leonardo, *Madonna of the Rocks* (**8.31**)
1490	Isabella d'Este, patron of music at Mantua
1513	Machiavelli, *The Prince*

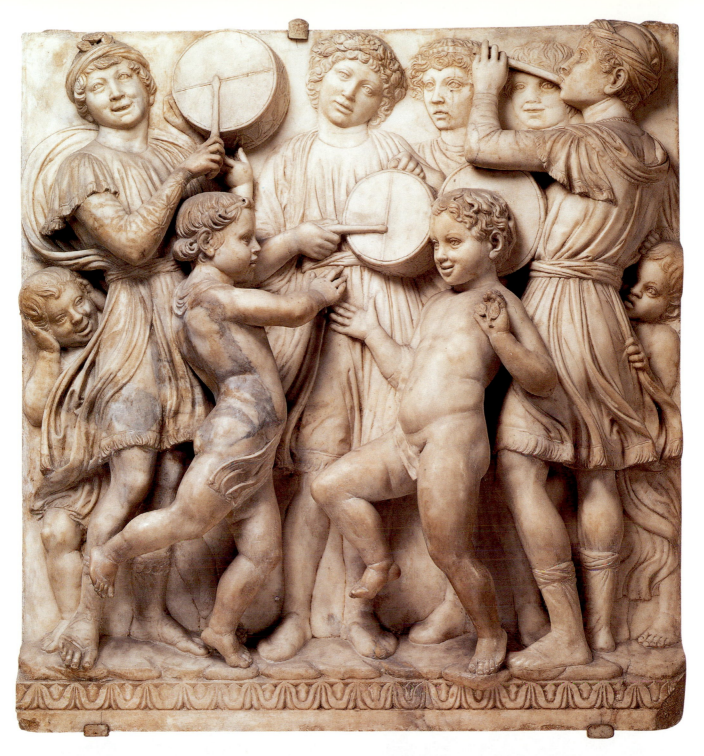

8.20 Luca della Robbia, *Cantoria*, 1431–38. Marble, 10 ft 9¹/₈ ins × 12 ft 4¹/₂ ins. Museo dell'Opera del Duomo, Florence.
This relief scene of youthful musicians playing an assortment of Renaissance instruments originally decorated the *cantoria*, or "singing gallery," for the cathedral of Florence.

The dominant figure in early Renaissance sculpture was Donatello (1386–1466), who virtually reinvented the freestanding nude in the classical style. Donatello assisted Ghiberti on the Baptistery doors of Florence cathedral and accompanied Brunelleschi on his trips to Rome to study antique sculpture and building. Donatello left an imposing legacy of stone and bronze statuary – works that decorate Florence's cathedral and palaces.

Donatello's revival of antique sculpture is most striking in his *David* (Fig. **8.24**). This statue was the first life-size, freestanding bronze nude since classical times. Donatello's *David* stands with one foot on Goliath's head, clad in boots and a Tuscan hat. Although the theme is biblical, the sculptor's treatment is entirely pagan. He adopted the S-shaped pose of classical Greek statuary, but not its treatment of anatomy. The adolescent lines of

The Science of Perspective

The Renaissance's greatest advance in the pictorial arts was the invention of **perspective** – a pictorial technique for representing a two-dimensional scene so that it appears to be three-dimensional. As Masaccio showed in his *Tribute Money* (see Fig. 8.18), painted objects could be shaded to create the illusion of volume, or slightly blurred to create the illusion of distance. Painters achieved the most dramatic illusion of depth with **linear perspective**, in which a picture's straight lines all converge toward a vanishing point.

Although Brunelleschi probably invented linear perspective, it was his colleague Leon Battista Alberti (1404–1472) who codified linear perspective's elaborate rules. In the treatise *On Painting* (1435), Alberti detailed a system for projecting a pictorial scene onto a grid of perspective lines. Perspective

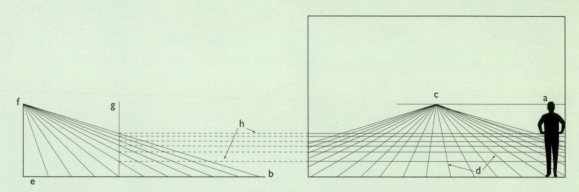

8.21 *(above)* Design of Alberti's perspective construction, according to recent discoveries.
Alberti's perfected system involved a single vanishing point for lines perpendicular to the canvas, and additional points on either side at which oblique lines seemed to converge (*a* height of person, *b* base line, *c* vanishing point, *d* orthogonals, *e* "little space," *f* distance point, *g* vertical intersection, *h* transversals).

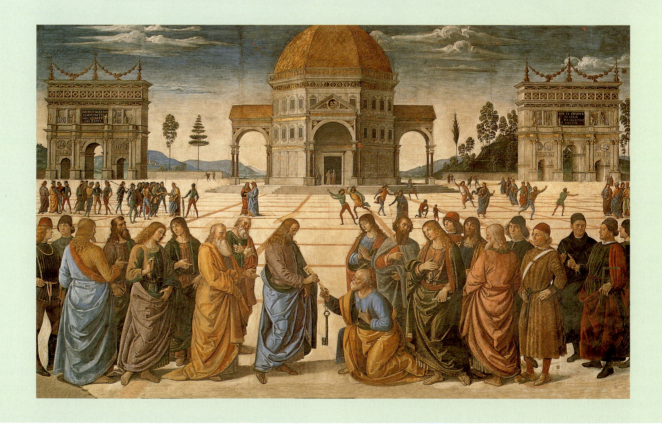

(Fig. **8.21**) involved one or two vanishing points for lines perpendicular to the canvas, and additional points on either side at which oblique lines seemed to converge. Perugino's *Christ Giving the Keys to St. Peter* (1482) is a perfect application of Alberti's direction (Figs **8.22** and **8.23**). A courtyard laid out on converging perspective lines defines a pictorial space of perfect symmetry and order, anchored by the triumphal arches and the central church. In the foreground, Christ hands to Peter the key symbolizing the foundation of the Christian Church. The diagrammatic perspective underscores the painting's dramatic moment: our eye is drawn upward from the key into the church's central door, which contains the picture's vanishing point.

In an age when artists were also engineers and mathematicians, perspective offered a scientific way of mapping and mastering the world. Its principles echoed the ancient Greeks' belief that mathematical values were the foundation of the universe. It established the individual's mind and eye as the origin of knowledge and perception. Renaissance perspective was, in sum, the visual equivalent of Renaissance humanism, confirming both the wisdom of the ancients and the glory of human intelligence.

8.22 (*opposite*) Pietro Perugino, *Christ Giving the Keys to St. Peter*, 1482. Fresco, 11 ft 5¹/₂ ins x 18 ft 8¹/₂ ins (3.5 x 5.7 m). Sistine Chapel, Vatican, Rome.

8.23 (*below*) Perspective lines of Perugino's *Christ Giving the Keys to St. Peter*.

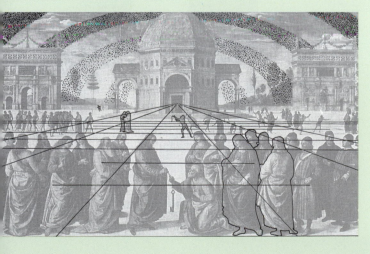

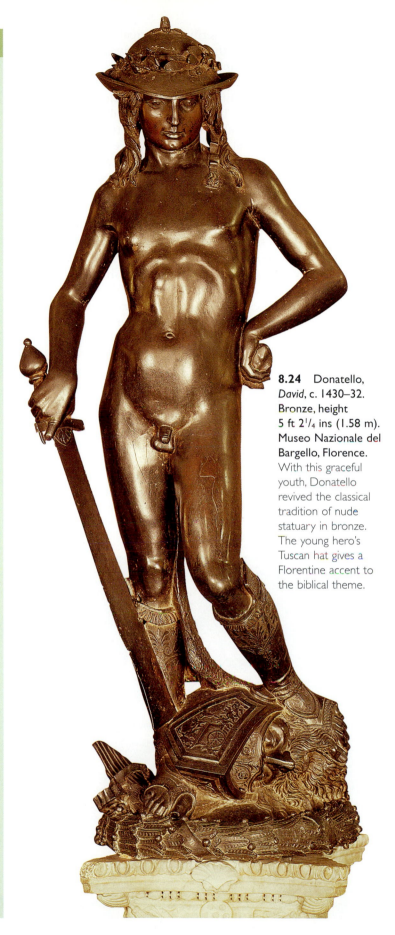

8.24 Donatello, *David*, c. 1430–32. Bronze, height 5 ft 2¹/₄ ins (1.58 m). Museo Nazionale del Bargello, Florence. With this graceful youth, Donatello revived the classical tradition of nude statuary in bronze. The young hero's Tuscan hat gives a Florentine accent to the biblical theme.

David's torso could be described as lyrical, almost sweet. The contrast between the youth's extravagant hat and Goliath's burly head emphasizes David's boyishness rather than his heroic strength.

By the age of twenty-two, Michelangelo Buonarroti [BWAH-na-RAH-tee] (1475–1564) had already established himself as a rival to Donatello. In the late 1490s, Michelangelo was called to Rome, where he executed a work every bit as lyrical as Donatello's *David*. Michelangelo's *Pietà* (Fig. **8.25**) was a graceful interpretation of the Virgin mourning the dead Christ. The Madonna's face is like that of a maiden's, its purified beauty unmarked by age or grief. Yet, from this delicate apex, the Madonna's form broadens into a massive pedestal for the body of Christ. Posed against the cascading drapery of his mother's garment, Christ's nudity becomes an emblem of suffering and grief. In the *Pietà* Michelangelo makes artistic technique serve the pathos of his subject, as Giotto had done in his earlier fresco version

8.25 (below) Michelangelo Buonarroti, *Pietà*, 1498–9. Marble, height 5 ft 9 ins (1.75 m). St. Peter's, Rome.
Consider the emotional impact achieved by Michelangelo's distortion of the figures' relative scale: the adult body of Jesus cradled in Mary's gigantic lap. How might a more realistic scale be less affecting to the viewer?

8.26 (right) Michelangelo Buonarroti, *David*, 1501–4. Marble, height 18 ft (5.49 m). Accademia, Florence.
Compare Michelangelo's heroic Renaissance nude to the bronze *Riace Warrior* of ancient Greece (Fig. 3.26). Note the similarities and differences – subject, style, material, treatment of the figure etc. – in these two representations of the male heroic ideal.

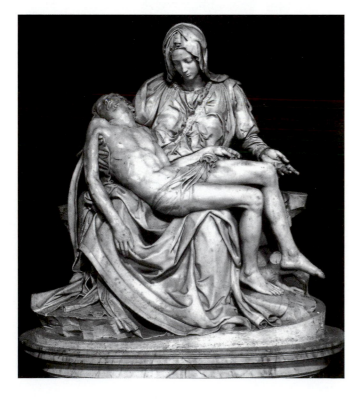

(see Fig. 7.30). With this statue, the young Michelangelo announced his own extraordinary talent and ambition, and a new heroic scale in Renaissance art.

Michelangelo's heroic aspirations were first realized in his statue of *David* (Fig. **8.26**), a statement of the sculptor's – and his city's – audacious confidence. Florence's city fathers had lured Michelangelo back from Rome with the opportunity to carve, from a giant block of marble, a male statue for Florence Cathedral. Michelangelo chose to create a David that combined classical values with a biblical subject. The slayer of Goliath is portrayed in the style of a Greek god, who looks defiantly over the countryside in search of his enemy. The muscled torso of the naked figure suggests monumental energy, while the right

THE WRITE IDEA

Describe the inner qualities of character that you think Michelangelo was trying to express in the idealized physical form of his statue of David.

hand is calm as it loosely grasps a stone. The combination of energy and control recalls the balance of classical sculpture (see Chapter 3), yet what distinguishes Michelangelo's statue is the heroic force that exceeds the classical rules of measure and moderation. It also expressed Michelangelo's confidence in the Florentine republic,

GLOBAL PERSPECTIVE

The Great Zimbabwe

The vestiges of Roman architecture and sculpture that surrounded Renaissance Italians were indisputable evidence of ancient Rome's greatness. However, when modern explorers first discovered the ruins of Great Zimbabwe, in southeast Africa, human memory of this noble civilization had evaporated. Europeans doubted that Africans could have built such imposing structures. Eventually, archaeologists confirmed that Great Zimbabwe was a great kingdom that traded its natural wealth for costly Arabian and Chinese goods.

The complex at Great Zimbabwe (from a word meaning "house or court of the king") was a royal center, residence of a sacred ruler, where other chieftains gathered for assemblies. It included outlying living quarters for the king's wives and courtiers. At the center was the Great Enclosure or Elliptical

Building, surrounded by an outer wall more than 30 feet (9 m) high, containing some 900,000 granite blocks (Fig. **8.27**). The Great Enclosure probably served a ceremonial purpose, possibly as a site for initiation rites for marriage-age boys and girls. One feature is a conical tower that may have represented a granary, symbol of royal and perhaps male power. Yet more distinctive are several soapstone sculptures of seated birds, mounted on pillars, that resemble nothing else known in Africa.

The civilization of Great Zimbabwe reached its height after 1200, supplying gold, copper, and iron to traders in nearby ports on the Indian Ocean. The king of Zimbabwe probably commanded a realm of some one hundred stone-walled towns. The kingdom's natural bounty allowed them to purchase fine Chinese pottery, glass beads, textiles, and other fine goods for royal consumption. The region's decline probably came from failing agriculture, and the stone-walled centers were abandoned around 1450.

8.27 Great Enclosure wall and conical tower, Great Zimbabwe, Zimbabwe, c. 1470.
The Great Enclosure was probably the residence of Zimbabwe's great chief and may also have been used in ceremonial rites of initiation. Nearby are smaller stone-walled enclosures where wives and visiting chiefs likely resided.

restored after the Medici's fall in 1494. When the stupendous figure was unveiled, the Florentines chose to place it in the city square, next to Donatello's statue of the Hebrew heroine Judith. Donatello's work bore the inscription, "Kingdoms fall through luxury, cities rise through virtues; behold the neck of pride severed by humility." Donatello's and Michelangelo's defiant works of art were intended as talismans against tyranny.

The Decline of Florence

The end of the fifteenth century saw a decline in Florence's status as a center of innovation in the Renaissance. The voice of this decline belonged to the fiery monk Savonarola (1452–1498), whose fierce sermons made him virtual dictator of the city for four years (1494–1498). Savonarola [sah-VAH-nah-ROLL-ah] condemned the pleasure-seeking paganism of Florentine Renaissance culture. As proof of Florentine sinfulness, he cited a popular melody in praise of the Virgin Mary, entitled "Queen of Heaven." The same tune, Savonarola complained, served as a love song to the "Queen of my heart." With his puritanical message, Savonarola rose to power in the vacuum created by Lorenzo de' Medici's death in 1492.

In 1497, Savonarola's supporters created a great "bonfire of the vanities" in Florence's town square, and piled the fire high with dice, playing cards, cosmetics, indecent books and pictures, and other evidence of Florence's sinful luxury. However, just one year later, Savonarola was defeated by his rivals and was burned at the stake as a heretic near the site of his "bonfire."

While wealthy Florentines reverted quickly to their lavish gaiety, Savonarola's message was not entirely forgotten. This message affected the age's greatest figures, including Botticelli, who destroyed the nude paintings in his workshop and afterward painted only religious themes, and Michelangelo, who forty years later, while working on a scene of the *Last Judgment*, said he could still hear Savonarola's condemnations ringing in his ears.

Renaissance Genius

Analyze the ways in which Machiavelli and Leonardo were Renaissance humanists.

Just as the civic humanists predicted, the dynamic urban life of Renaissance Florence encouraged genius to flourish. Two figures unique in their achievements were the artist Leonardo da Vinci (1452–1519) and the political historian Niccolò Machiavelli (1469–1527). In his masterpiece of worldly political theory, *The Prince,* Machiavelli coldly articulated the rules by which Renaissance Italians practiced politics, hoping he might aid his countrymen in combating tyranny. Leonardo pursued idiosyncratic and

groundbreaking ideas in the arts, science, engineering, and mathematics that made him a paragon of Renaissance grace and intelligence.

Machiavelli and Humanist Politics

Renaissance Italy was a viper's nest of political intrigue and cynicism, apparently unguided by principles of Christian or classical virtue. The one observer who grasped the logic of Italy's history was Niccolò Machiavelli [MAH-kee-ah-VELL-ee], a Florentine diplomat who described the harsh realities of power in Italy in his masterpiece of political philosophy entitled *The Prince* (1513). *The Prince* was the first attempt in the Christian era to

8.28 Tito, *Niccolò Machiavelli.* Palazzo Vecchio, Florence.
Though his name is now a synonym for devious and ruthless politics, Machiavelli in fact remained loyal to his native Florence in spite of torture and exile. Machiavelli's *The Prince* (1513) offered advice to Florence's new Medici ruler.

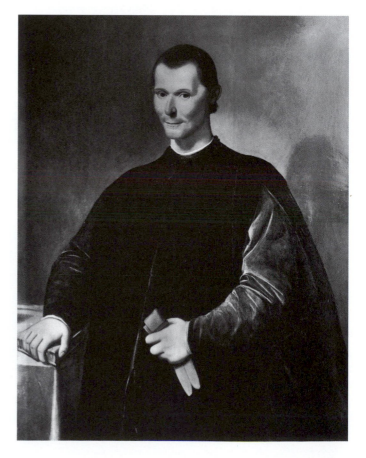

analyze politics from an entirely secular viewpoint. Like the classical Greek philosopher Plato in *The Republic*, Machiavelli reflected on his age's politics in the hope of saving a declining form of government. Where Plato was an idealist of political philosophy, however, Machiavelli was the clear-headed realist (Fig. **8.28**).

Machiavelli was an active Florentine diplomat for fourteen years, until he was dismissed from his diplomatic post in 1512, when the Medici returned to power. Writing (as Dante had) in exile from his native Florence, Machiavelli coldly analyzed the motives and methods of political power. In *The Prince* he describes the ideal "prince," or ruler, of an Italian city-state, modeled on the cruel Cesare Borgia, illegitimate son of Pope Alexander VI, who plotted with his father to unify Italy under his control. Though Borgia's plans were foiled, Machiavelli urged Italian rulers to be equally ruthless in seizing and preserving power. A ruler should model himself after the fox and the lion, he wrote: "One must be a fox in avoiding traps and a lion in frightening wolves."[6] He believed that only strong rulers could keep Italy's city-states free from foreign domination. Such ruthless politics earned Machiavelli a reputation for cold-heartedness, and he was condemned for counseling ambition, cruelty, and deceit in the pursuit of political aims. This trait has carried over in the term "Machiavellian," which describes a person believed to be unscrupulously pursuing political gain at any cost. Yet, Machiavelli demonstrated a humanist conception of political behavior. Politics embodied rational action in a world where humans were responsible for their behavior – a concept in keeping with the time, and guided by the classical authors.

Machiavelli's analysis of politics can still throw light on the actions of people in power today. In advising rulers on the use of cruelty, Machiavelli wrote:

> I believe that this depends on whether cruelty is used well or ill. It may be said to be well used (if we may speak of using well a thing in itself bad) when all cruel deeds are committed at once in order to make sure of the state and thereafter discontinued to make way for the consideration of the welfare of the subjects. Bad use of cruelty we find in those cases where the cruel acts, though few to begin with, become more numerous with time. Those who practice the first kind may find some defense for their state in the eyes of God and man, but, as for the second class, it is impossible for them to stay in power. Whence it is to be noted that a prince occupying a new state should see to it that he commit all his acts of cruelty at once so as not to be obliged to return to them every day, and thus, by abstaining from repeating them, he will be able to make men feel secure and can win them over by benefits.[7]
>
> MACHIAVELLI
> *From The Prince (1513)*

THE WRITE IDEA

Describe an instance in your own life or in history that illustrates the maxim, "The end is all that counts." In this instance, what made the end or aim so compelling that it justified any means of achieving it?

But Machiavelli acknowledged that fortune, more than political calculation, determined one's political fate, writing that "men will prosper so long as they are in tune with the times and will fail when they are not." Judged by his own standard, Machiavelli was unfortunate. When Florence's republic fell in 1512, he was tortured briefly and exiled. He could not please either of Florence's rival factions. His service to the republic made him suspicious to the Medici family, while his overtures to the Medicis tainted him in the republicans' eyes. Machiavelli died in 1527, a few months before the Holy Roman Emperor Charles V's troops sacked Rome, realizing Machiavelli's worst fears about foreign domination of Italian politics.

Leonardo da Vinci

The most diverse and enigmatic talent of the Renaissance was Leonardo da Vinci [da VEEN-chee], whose genius fascinated his contemporaries as much as it does the modern age. Trained as a painter and sculptor in Florence,

8.29 Page from Leonardo's *Notebooks*, 1510. Pen and ink. Royal Collection, Windsor, © 2000 Her Majesty Queen Elizabeth II. Leonardo's interests in anatomy, mechanics, engineering, and botany were not uncommon for a Renaissance artist, who was expected to be able to design a hoist as readily as to paint a portrait.

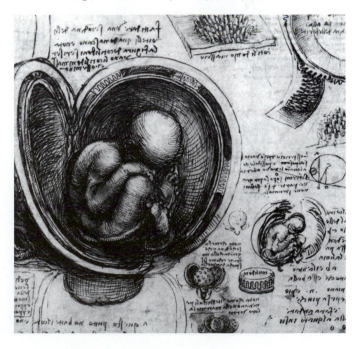

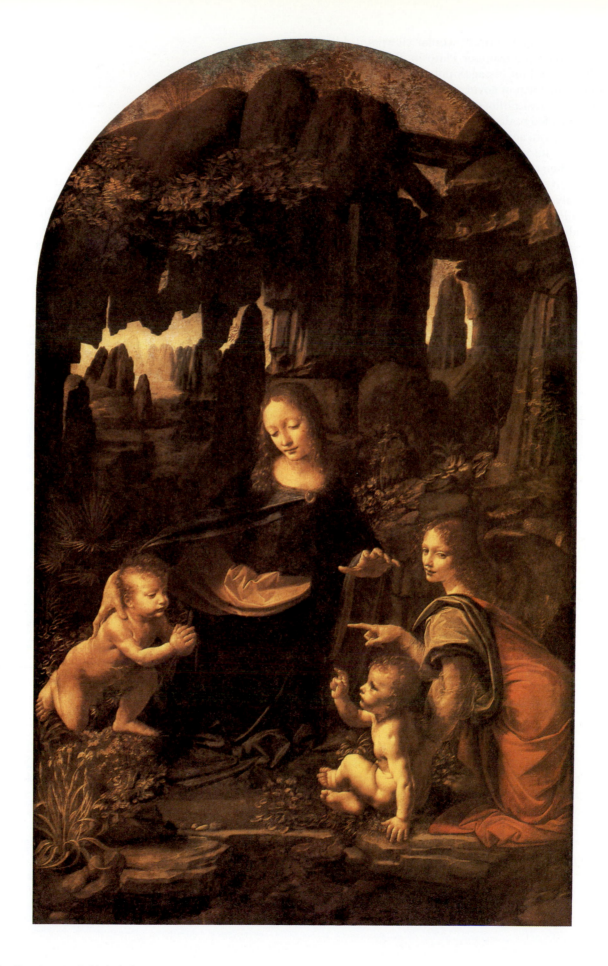

Leonardo abandoned that vibrant city to seek new interests. He served the Duke of Milan as a designer of fortifications and water projects and ended his life in service to the King of France. Never loyal to one city or patron, Leonardo was consumed by an insatiable appetite for knowledge about the world. In his notebooks, projects, and paintings, he demonstrated an understanding of the world that still amazes. Western civilization has probably never known a greater or more restless intelligence.

Leonardo filled the pages of his *Notebooks* (Fig. **8.29**) with thousands of sketches and designs that attest to his keen insight. Leonardo was fascinated with the natural world in all its aspects. His notebooks contain sketches and written descriptions of such things as the movements of water, and of the foetus in the womb, the motion of birds in flight, and the circulation of blood. His fascination

8.30 (*opposite*) Leonardo da Vinci, *Madonna of the Rocks*, c. 1485. Oil on panel, 6 ft 3 ins x 3 ft 7 ins (1.91 x 1.09 m). Louvre, Paris. Compare the mood created by Leonardo's mystical landscape – the grotto and the distant river – to Raphael's architectural background in the *School of Athens* (Fig. 8.36). How is each setting well-matched to the painting's theme?

8.31 (*below*) Leonardo da Vinci, *Mona Lisa*, c. 1503–5. Oil on panel, 30 x 20 ins (76 x 53 cm). Louvre, Paris. The sitter's bemused calm contrasts to the spectacular landscape, with its craggy peaks and misty rivers. Leonardo's skill in portraiture made him the most sought-after painter of his age, even though he completed only a handful of pictures in his long career.

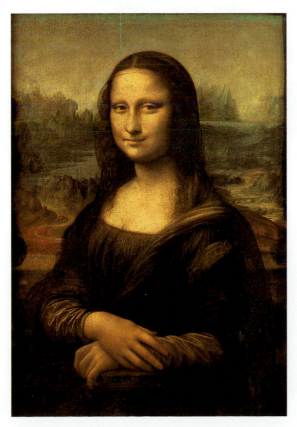

with the human body and his interest in the mathematics of nature are represented in a famous drawing of a human figure graphed within a circle and square (see Fig. 8.3). "Let no one read this book who does not know mathematics," he wrote in his *Treatise on Painting*.

Believing that machines were more reliable than men, Leonardo designed countless devices that were ahead of his time. His notebooks outline versions of such modern technology as the tank, submarine, and airplane. Mechanically, Leonardo's machines were perfectly designed, though they lacked a means of propulsion. Yet, in his lifetime, most of Leonardo's designs remained unrealized – Leonardo was himself more interested in the theoretical solution of a problem than the full-fledged execution of an idea. His scientific insights, which might have revolutionized anatomy and mechanics, remained locked in his unpublished notebooks.

Leonardo's mastery of drawing and pictorial mood ranks him as one of the greatest painters ever to live. In his *Madonna of the Rocks* (Fig. **8.30**), for example, Leonardo captured a graceful beauty reminiscent of Botticelli's *Birth of Spring* (see Fig. 8.19). Leonardo surpassed his predecessor in the complexity of foreground and background and the deeply symbolic effects of light and dark. The foreground group of the *Madonna* includes the infant John the Baptist, the Virgin Mary, an angel, and the Christ Child. The group forms a solidly classical triangle, a favorite compositional technique of the Renaissance. The gestures of praying, pointing, and benediction unify the group psychologically. Behind the central group, through an arch of rocks, a mysterious landscape opens into an infinity of time and distance. Across the whole picture is a hazy aura created by the use of **sfumato** [sfoo-MAH-toh], a shading technique in which outlines are slightly blurred. *Sfumato*, also used to supreme effect in the *Mona Lisa* (Fig. **8.31**), imitated the effects of human vision, and was Leonardo's own variation on the *chiaroscuro* technique developed by Masaccio and other early Renaissance masters.

Leonardo defended painting as the highest art and claimed that painting permitted unlimited range to the artist's imagination. "If the painter wishes to see enchanting beauties," or "from high mountain tops he wants to survey vast stretches of country," Leonardo wrote, the painter "has the power to create all this." Indeed, he concluded, "whatever exists in the universe, whether in essence, in act, or in the imagination, the painter has first in his mind and then in his hands."[8] Leonardo was so intrigued by the material world, so imaginative in seeing its beauty and logic, that his tantalizing legacy in the arts still fascinates.

The Renaissance Man ... and Woman

To many of his contemporaries, Leonardo embodied the ideal of the Renaissance courtier: witty, handsome, learned, and skillful in many arts. Leonardo could have been the model for the ideal gentleman described in *The Book of the Courtier* (1528) by Baldassare Castiglione (1478–1529). Castiglione [kass-TEE-lee-OH-nay] defined the Renaissance ideal of the *uomo universale* ("universal man") skilled in the arts and sciences valued by the Renaissance. The *uomo universale* [WO-mo oon-ee-ver-SALL-ay] had to be adept at soldiering and riding, well-bred, and handsome. He should be able to dance, read music, quote ancient authors, and woo a lover. And the Renaissance man had to do all this with a carefree disdain that Castiglione called *sprezzatura* [sprets-a-TOOR-a].

While Castiglione's courtiers agreed about the qualities of a Renaissance man, they loudly disputed those of a Renaissance woman. One speaker passionately claimed that women could match the perfection of the Renaissance man, that women "do not wish to become men in order to make themselves more perfect but to gain their freedom and shake off the tyranny that men have imposed on them by their one-sided authority."[9] The woman who best realized this Renaissance ideal of courtliness and independence was Isabella d'Este [DESS-tay] (1474–1539). Isabella had the education, family connections, and refined tastes of a Renaissance aristocrat. By the age of fourteen she was an accomplished dancer, had studied Virgil, and seen the dramas of Plautus and Terence performed in her father's court. As duchess of Urbino, Isabella was an enthusiastic patron of the arts, especially music. She also proved herself an able political manager, much to her husband's discomfort – after six years as a political prisoner, the duke returned to find his city running a bit too well under the rule of a woman.

The Renaissance "universal person" embodied the classical ideal of *virtú* – a person, like Isabella, who could master the practical problems of government; like Leonardo, produce elegant works of imagination; and then, like Frederico da Montefeltro, withdraw to his study to read and contemplate (Fig. **8.32**). Renaissance *virtú*, or excellence lay in the versatility of the person, in contrast to the modern ideal, which prizes specialized abilities and single-minded determination. Rather than nonchalance, modern artists and executives display their fierce competitiveness and power of concentration. Renaissance and modern societies seem to demand different – one might say opposing – qualities from their model citizens.

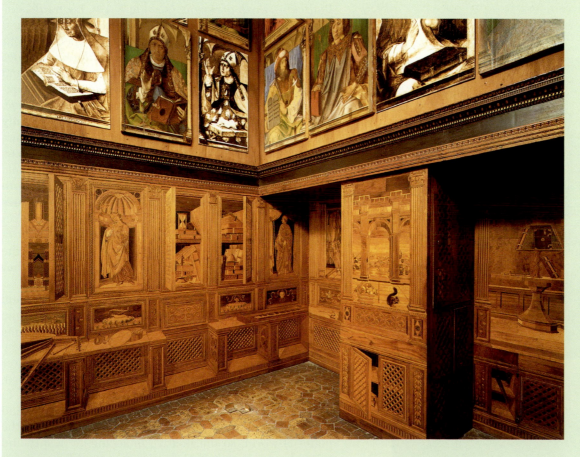

8.32 *Studiolo* of Frederico da Montefeltro, 1476. Palazzo Ducale, Urbino. Renaissance princes often installed elaborately crafted *studiolos*, small rooms for reading, conversation, and quiet entertainment. This fashionable *studiolo* was lined with inlaid wood designs (called intarsia) that subtly reproduced the pictorial effects of Renaissance painting.

The High Renaissance in Rome

Compare the heroic style of the Renaissance in Rome with the early Renaissance style in Florence.

While the Italian Renaissance blossomed in Florence, the age bore its greatest fruit in the city of Rome. Rome had long been famed for its dedication to high living and fine art. About 1500, it witnessed an outburst of artistic creation and imitation that transformed the city. The period known as the High Renaissance saw the masterful application of techniques and ideas developed in Florence. The achievements of Raphael and Michelangelo in painting, Josquin des Préz in music, and Leonardo da Vinci in several arts, make this an unsurpassed age of heroic genius. The center of activity of the High Renaissance was Rome, but it also spread to other cultural centers of Europe (Fig. **8.33**).

8.33 Hans Burgmair, *Maximilian with His Musicians*, illustration from *Der Weisskönig*, 16th century. Woodcut.
Renaissance musicians migrated to the courts of patrons such as Maximilian, the Holy Roman Emperor. Among the instruments shown here are early versions of the harp, organ, trombone, flute, and viola.

Josquin des Préz

In his papacy (1513–1521), Leo X liked to meditate in the Sistine Chapel while his choir filled the hall with music as glorious as Michelangelo's ceiling painting. The pope's music was provided by his *cappella*, the group of musicians (exclusively male) who provided a court with music for all sacred services and other occasions. Through the *cappella*, boys were given a thorough musical education and often found their way to the musical profession. A musical girl, on the other hand, had to be taught privately or to enter a convent, both less advantageous for professional advancement.

In the repertoire of Leo's choir were almost certainly several motets and Masses composed by Josquin des Préz

1486	Josquin des Préz active in papal choir, Rome
1503–13	Reign of Pope Julius II
1506	Bramante begins new St. Peter's, Rome (**8.44**)
1508–12	Michelangelo, Sistine Chapel ceiling, Vatican Palace, Rome (**8.40**)
1547	Michelangelo named architect of St. Peter's, Rome (**8.46**)

[zhoss-KAN(h)-day-PRAY] (c. 1440–1521), who served the popes for more than a decade (c. 1486–1501). Born in northern France, Josquin (Fig. **8.34**) was the greatest composer of the High Renaissance, blending the rich polyphony of his native northern Europe with sweet Italian lyricism. Josquin parlayed his mastery into a truly international musical career: besides the papal court, he served in the courts of Paris, Milan, and Ferrara.

Josquin's compositions were admired for their harmonious architecture and for their match between words and

8.34 Portrait of Josquin des Préz, published in 1511.
Martin Luther wrote of Josquin des Préz: "He is the master of the notes. They must do as he wills; as for the other composers, they must do as the notes will."

music. By Josquin's time, composers were freeing themselves from the standard texts and melodies of the medieval tradition. They composed all the voices of a composition at once, tying them more closely together both rhythmically and harmonically. Josquin's genius lay in melding the north European style of complex polyphony (several melodies played simultaneously) and the Italian preference for chordal harmonies (based on three-tone chords).

8.35 (right) Example of imitation, from a motet by Josquin des Préz. Here the soprano voice introduces the melodic idea; then other voices enter in succession (alto, tenor, bass), singing the same melody.

8.36 (below) Raphael, *School of Athens*, 1509–11. Fresco, 26 x 18 ft (7.92 x 5.48 m). Stanza della Segnatura, Vatican Palaces, Rome. Here Raphael pays homage to the wisdom of the classical past; his tribute to Christian learning occupies the wall opposite the *School of Athens*. Note the horizontal division between the painting's human actors and the classical architectural setting; and the vertical division between the philosophical theme of abstract thought (left) and practical knowledge (right).

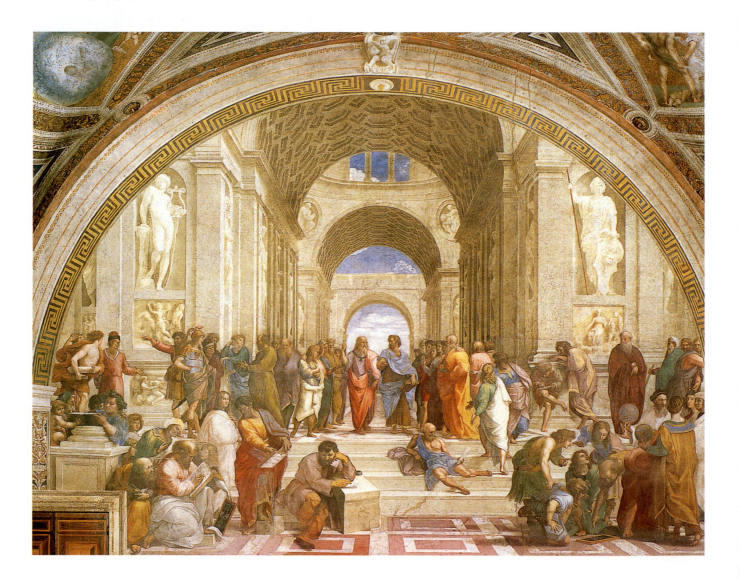

Josquin's preferred form was the motet (see page 179), of which he composed more than a hundred examples. The motet form was popular among Renaissance composers because of the freedom it offered from the stricter traditions of the Mass. Josquin used that freedom to create sweet harmonies and explore the musical qualities of words. In particular, Josquin excelled at **word-painting** – matching a descending melody to words of grief, or a quickened rhythm to an expression of joy. Josquin also made frequent use of the contrapuntal technique known as **imitation**, in which one voice states a melody that is duplicated in turn by succeeding voices (Fig. **8.35**). Such imitation marks the opening of the motet *Ave Maria ... virgo serena* (*Hail, Mary ... serene virgin*) (1520), where the voices build and overlap in an architecture of melody. Josquin frequently balances counterpoint against simpler chordal passages, and voices are paired to emphasize the clarity of the text.

Josquin's musical complexities demanded an attentive and educated audience, which he found at Europe's most prestigious courts. He inspired such admiration among humanist patrons and musical contemporaries that they compared him to the titanic Michelangelo.

Raphael

In 1509, Pope Julius II followed his architect's advice and commissioned a young painter to decorate his apartment chambers. The artist, known as Raphael, was already famed for a series of graceful Madonnas painted in Florence. Working under the pope's patronage, Raffaello Sanzio (1483–1520) became Renaissance Rome's busiest and most beloved artist. Besides painting, Raphael used his talents on projects for the pope, such as the excavation of Roman ruins and the construction of the new St. Peter's basilica. In a city of intrigues and jealousies, Raphael was loved for his good humor and modesty. When he died at thirty-seven ("of too many women," grumbled one rival), he was the most popular artist of the Renaissance.

As a painter, Raphael was known for the clarity and spiritual harmony of his works, which eloquently embodied the High Renaissance style. His most famous work, the *School of Athens* (Fig. **8.36**), is a virtual textbook of Renaissance painting, a synthesis of humanism and Renaissance technique. The *School of Athens* depicts a gathering of the great pagan philosophers. The two central figures are Plato, who points to the world of ideal forms above, and Aristotle, reaching for the natural world below. On either side, figures representing ancient philosophy are arranged in lively symmetry, balanced between the abstract and the practical. To Plato's right, for example, a brown-cloaked Socrates ticks off arguments on his fingers and Pythagoras checks proportions on a slate. On Aristotle's side, practitioners of the applied sciences include the astronomer Ptolemy holding a globe in the right foreground. The diverse group is unified by the great arch that encloses the whole scene. The barrel

vaults recede to a vanishing point between the heads of Plato and Aristotle. The painting's overall effect is of learning, tolerance, perfect harmony, and balance.

Raphael's last great painting, the *Transfiguration* (Fig. **8.37**), demonstrates the rapid development of the Renaissance style. Raphael divides the image into two religious dramas, the transfiguration of Christ on Mt. Tabor and Jesus' disciples' failed attempt to cure an epileptic boy thought to be possessed by demons. Unbelief and contention suffuse the dark lower register, which bristles with the contorted postures and crisscrossing lines. In the midst of this anguished failure, however, some figures point toward the miraculous event above. There, a few faithful disciples are permitted to gaze directly at a Christ transfigured by divine light and joined by the prophets Moses and Elijah. Raphael creates a grand pictorial scheme through the interlocking triangular arrangement

8.37 Raphael, *Transfiguration*, 1517. Oil on panel, 15 ft 1 ins × 9 ft 1 ins (4.6 × 2.8 m). Vatican Museums, Rome.
Compare the restful and balanced arrangement of figures in Raphael's *School of Athens* (Fig. 8.36) to the concentrated and complex drama of this foreground scene. Note especially the lines created by the figures' gestures and gazes.

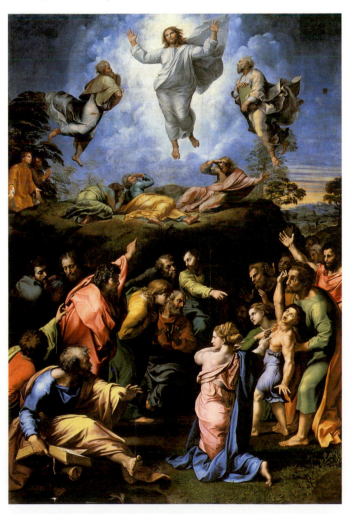

of the figures, rather than by a diagrammatic architectural setting. The painting shows the restive harmonies of the High Renaissance about to burst into the innovations of mannerism (see page 250).

Michelangelo in Rome

In 1505, Michelangelo was ordered to Rome by Pope Julius II, who wished the brilliant young sculptor to build his tomb. Michelangelo's designs demonstrate the heroic scale anticipated by his Florentine *David*. For the tomb the sculptor envisioned a gigantic façade rising in three stages, decorated with forty life-size statues. The designs for the tomb represent the Neoplatonist passage from material to spiritual existence, recalling Plato's three-part division of the soul. The unfinished sculptures intended for

8.38 Michelangelo Buonarroti, *Moses*, 1513–15. Marble, height 8 ft 4 ins (2.54 m). San Pietro in Vincoli, Rome.
Michelangelo intended this awesome figure as the central figure of a great tomb for his patron, Pope Julius II. The finished statue has some of Julius's fearsome demeanor. Note the statue's poised energy, evident in the tensed legs and the left arm's bulging muscles and sinews. The horns on his head are a consequence of a biblical mistranslation.

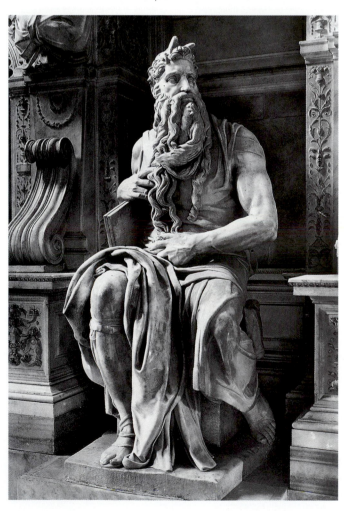

8.39 Plan of the Sistine Chapel ceiling.

East wall with entrance

e5_8.39
REUSE_e4_8.39
FILM
LINE

N ←

The frescoes on the ceiling	Prophets and Sibyls
1 God Separates Light and Darkness	10 Zechariah
2 God Creates the Sun and the Moon and the Plants on the Earth	11 Delphic Sibyl
	12 Isaiah
	13 Cumaean Sibyl
3 God Separates the Water and Earth and Blesses His Work	14 Daniel
	15 Libyan Sibyl
	16 Jonah
4 Creation of Adam	17 Jeremiah
5 Creation of Eve	18 Persian Sibyl
6 Fall of Human Race and Expulsion from Paradise	19 Ezekiel
	20 Eritrean Sibyl
7 Sacrifice of Noah	21 Joel
8 The Flood	22 David Slaying Goliath
9 The Intoxication of Noah	23 Judith with the Head of Holofernes
	24 The Brazen Serpent
	25 The Punishment of Haman

8.40 *(opposite)* Michelangelo Buonarroti, Sistine Chapel ceiling, 1508–12. Fresco, 44 ft x 128 ft (13.41 x 39.01 m). Vatican Palaces, Rome.

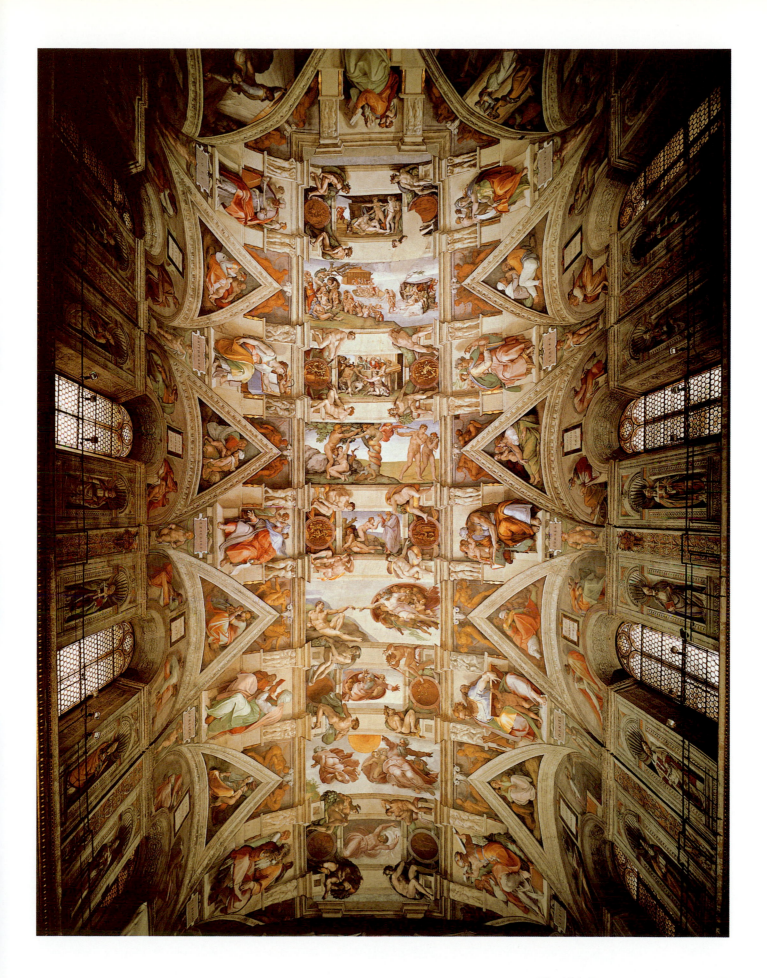

the tomb reinforce this Neoplatonist motif. Known as the *Captives*, these sculpted figures appear to struggle against the stone which binds them, just as the soul strives against the restraints of the flesh. Michelangelo's grandiose tomb remained unfinished, although the project occupied him for thirty years. Michelangelo himself referred to this project as his "tragedy."

One sculpted figure from Julius' tomb ranks among Michelangelo's greatest works. The *Moses* (Fig. **8.38**) embodies the fierce power called *terribilità* that Michelangelo himself possessed in abundance. Moses holds the tablets of commandments received from the hand of God. Looking over his shoulder, Moses sees the Israelites worshiping a pagan idol. Possessed by righteous anger, he rises to dash the tablets of God's law and condemn his tribe. The muscular pose of *Moses* embodies the fierce power of God's judgment, and even his beard is like a living thing, animated by anger. Next to this work of mature vigor, Michelangelo's *David* (see Fig. 8.26) seems like a lyrical poem of youth.

In 1508, Julius directed Michelangelo to interrupt the tomb project and paint the ceiling of the Sistine Chapel. Michelangelo protested that he was a sculptor, not a painter. Nevertheless, here, in the same chapel where Josquin had sung, Michelangelo created a visual poem on the powers of creation and the frailty of human flesh that was to become his most famous work.

For the Sistine Chapel ceiling (Figs. **8.39**, **8.40**), Michelangelo employed a complex philosophical and religious scheme, probably with advice from papal scholars. Among its guiding ideas were a Neoplatonic symbolism of light and dark, and the Old Testament's prefiguring of Christ's coming. The central panels depict scenes from Genesis – the Creation, the Fall, and the story of Noah. Arranged around the narrative scenes are figures that symbolize the reconciliation of Christian and classical ideas – Hebrew prophets to represent divine revelation, and Roman sibyls (pagan prophetesses) to symbolize human wisdom. In the corners are four narrative scenes that foretell the coming of Christ. The various parts are delineated by an architectural border and nude "athletes."

Despite its obscurity, the Sistine Chapel ceiling is clearly a work of Renaissance humanism. It combines classical and Christian ideas, recognizing in humanity the tension between a divine spirit and sinful flesh. When read from the Creation to the story of Noah, the central panels tell how the divine beauty and order of creation were corrupted by human weakness. The frailty of human will is visible in the shamed and shriveled Adam and Eve as they are driven from paradise (Fig. **8.41**).

8.41 Michelangelo Buonarroti, *Temptation and Expulsion from the Garden*, detail of the Sistine Chapel ceiling, 1509–10. Fresco. Vatican Palaces, Rome.

The forbidden tree divides these two fateful scenes: on the left Adam and Eve reach eagerly for the fruit of moral knowledge; on the right, they cower in fear as God's angel drives them from the garden.

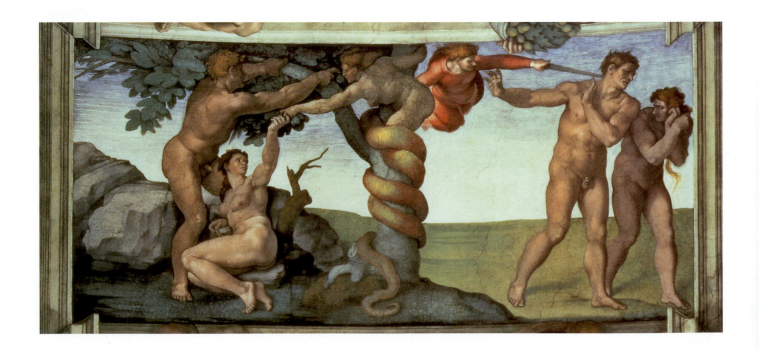

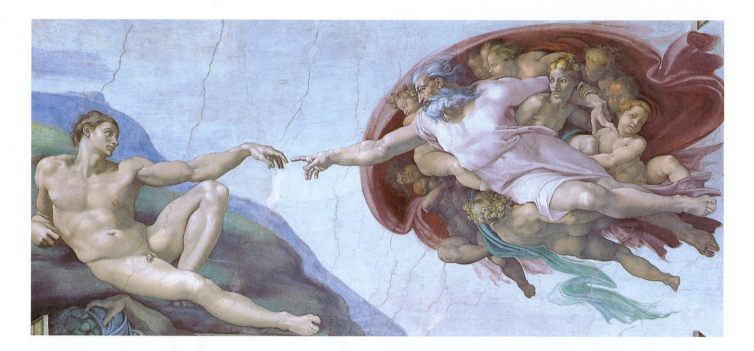

8.42 Michelangelo Buonarroti, *Creation of Adam*, detail of the Sistine Chapel ceiling, 1508–12. Fresco. Vatican Palaces, Rome.
In the ceiling's pivotal central panel, the creator God trails a cloak that contains Eve and all the rest of future humanity. Adam lies passively against a lifeless hillside, bound to the earth.

However, Michelangelo actually painted the panels in reverse order. Read from Noah to the Creation, the central panels show the triumph of the creative spirit, as Michelangelo becomes more confident of his vision and overcomes the cramped composition of earlier scenes. In the *Creation of Adam* (Fig. **8.42**), God moves toward a languid Adam with a commanding divinity. He holds Eve in the crook of his arm and trails a cloak that contains all of future humanity. The final paintings show God creating the cosmos from a void, scenes that remind us of Michelangelo's own heroic creativity.

The New St. Peter's

Michelangelo spent his last years devoted to architecture. In 1547, he was appointed chief architect of St. Peter's, a project that had already suffered delays and complications. The rebuilding of St. Peter's had begun under Pope Julius II. The old basilica, first built by the Emperor Constantine, had become a crumbling hodgepodge of old-fashioned designs. In a bold act of Renaissance confidence, Pope Julius II ordered that the great church be demolished and replaced with a modern design. When the cornerstone of the new St. Peter's was laid in 1506, it began the High Renaissance's largest and most expensive undertaking. The mammoth project would take more than 150 years to build and would occupy the epoch's leading architects.

As chief architect for the new church, Pope Julius II first engaged Donato Bramante (c. 1444–1514). Bramante produced a symmetrical design shaped like a Greek cross and centered around a flattened dome. His inspiration had come from Brunelleschi's dome in Florence, and from the sketches of Leonardo, which included a central-plan church much like Bramante's. Bramante's plan was never built. The classical symmetry of its exterior is suggested, however, by the architect's Tempietto (Fig. **8.43**), a shrine he completed in another part of Rome in 1502. The Tempietto's delicately classical proportions would have been enlarged to a gigantic scale in the new St. Peter's.

Bramante's plan of monumental simplicity was expanded and revised by his successors (including Raphael) (Fig. **8.44**). When Michelangelo assumed the project in 1547, he returned to the idea of a symmetrical, Greek-cross plan – a central dome surrounded by four arms of equal length. The dome itself was actually built much as Michelangelo envisioned. On the exterior, it is ribbed in the style of Brunelleschi and unified by repeating pairs of Corinthian columns circling the base and giant pilasters on the outer wall. On the interior, the dome rises in gilded splendor over the altar of St. Peter (Fig. **8.45**). However, where Michelangelo's Greek-cross plan would have been dominated by the dome, later architects instead lengthened the nave and added a giant façade, obscuring the dome in the front view (see Fig. **8.44**). On the exterior, Michelangelo's intentions are visible today only when St. Peter's is viewed from the rear (Fig. **8.46**).

The construction of a new St. Peter's revealed the Renaissance spirit at its best and worst. The grand church was a monumental project, influenced by classical models but conceived on a heroic Renaissance scale. However, the ambitions of patrons and designers (a total of twelve

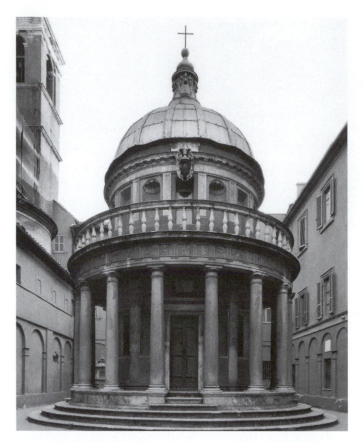

8.43 Donato Bramante, Tempietto, San Pietro in Montorio, Rome, 1502. Height 46 ft (14 m), diameter of colonnade 29 ft (8.84 m). Here, on a small scale, we see the domed symmetry and overt classicism that Bramante would employ in his designs for the new St. Peter's. A Doric colonnade circles the building (it is a shrine marking the site of St. Peter's martyrdom) and a balustrade eases the transition to the central dome.

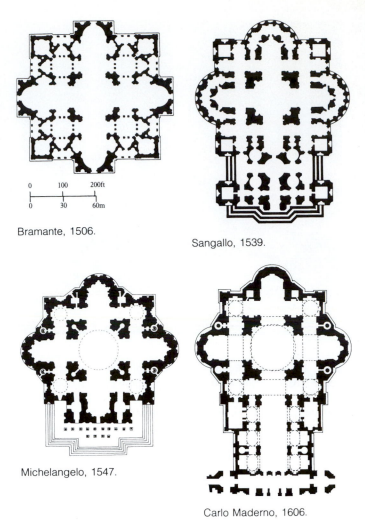

Bramante, 1506.

Sangallo, 1539.

Michelangelo, 1547.

Carlo Maderno, 1606.

8.44 Plans for the new St. Peter's, Rome, 1506–1606. The Italian Renaissance's most daring and expensive project was the reconstruction of Europe's holiest Christian shrine. The Greek-cross plans of Bramante and Michelangelo were compromised in Maderno's completed version, which added the traditional long nave and extended the church's length to more than 600 ft (183 m).

architects and twenty-two popes) far exceeded their ability to execute. Actual construction was hampered by the Church's limited treasury and by a conflict of architectural purposes. Like the sketches in Leonardo's *Notebooks*, St. Peter's was more perfect in conception than in reality.

An Age of Giants

We cannot fully explain the concentration of artistic talent in Italian cities of the fifteenth and sixteenth centuries. Wealth, classical influences, and cultural ferment cannot account for the birth – within a few miles and a few years – of talents like Leonardo and Michelangelo. Consequently there has been a tendency to lionize the Italian Renaissance. Many historians date the beginning of modern civilization from this one time and locale even though much in Renaissance Italy was an extension of the Middle Ages that preceded this fertile era. This was, however, a place and time of great achievement. Fifteen

centuries earlier, the ancient Romans had imported the beauty and genius of ancient Greece. In the Renaissance, Italy itself became the source of beauty and learning – a fount of cultural achievement in its own right and a glorious triumph of the human spirit.

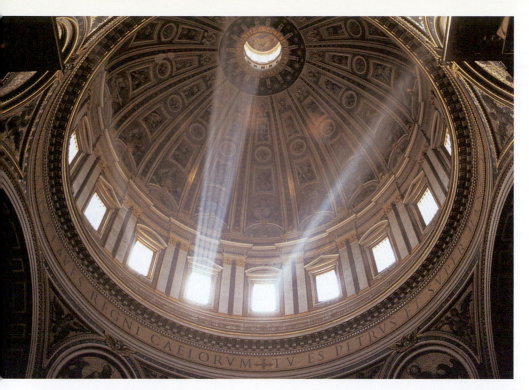

8.45 (left) St. Peter's, Rome, interior of dome.
The dome's symbolism as the dome of the heavens and the perfect circle is stressed by the repetition of circular shapes (arches, medallions, oculus). Compare this gilded brilliance to the church's austere classical exterior (below).

8.46 (below) Michelangelo Buonarroti, St. Peter's, Rome, view from west, begun 1547. Dome completed by Giacomo della Porta, 1590. Height of dome 452 ft (137.8 m).
Michelangelo intended the church to be dominated on all sides by the massive dome, as it is in this view, which shows only the three short arms of the Greek-cross plan. Note the restrained classical decoration: there are gigantic Corinthian pilasters on the ground story and double engaged columns around the dome, separating pedimented windows.

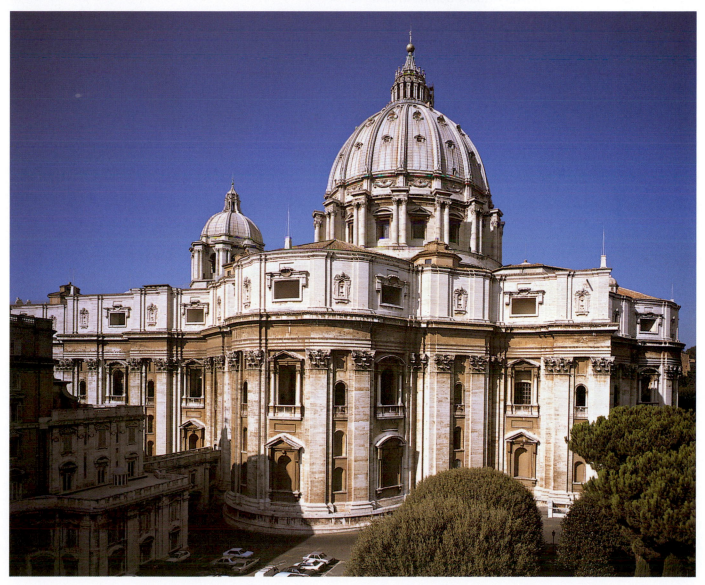

CHAPTER SUMMARY

The Renaissance in Italy The Italian Renaissance ("rebirth") began in the prosperous Italian city-states of the fifteenth century. Renaissance humanism arose from an interest in classical antiquity and a desire to match the intellectual and artistic achievements of ancient Greece and Rome. While they enjoyed economic prosperity, Renaissance Italy's city-states were also prone to war and political violence. Italy's merchant princes were guided by the principles of Renaissance civic humanism in their political activism and their extravagant patronage of the arts and learning. In Florence, the early Renaissance culminated in the reign of Lorenzo the Magnificent, the first patron of Michelangelo, a poet in his own right, and a paragon of civic humanism.

The Arts in Early Renaissance Italy Beginning about 1401, the Italian Renaissance witnessed a remarkable blossoming of the arts in Florence and other Italian city-states. Ghiberti's gilded Baptistery doors demonstrated the evolving Renaissance style, including the technique of perspective. Florence's landmark cathedral dome was the ingenious creation of Brunelleschi, its leading Renaissance architect. Florentine painters made revolutionary strides, led by Masaccio's use of perspective and Botticelli's reconciliation of Christian and pagan ideas. Music in Italy combined the polyphonic textures of northern European composers (Dufay, Heinrich Isaac) with the Italians' love of sweet melody and vivid poetry. Music, in forms such as the *frottola*, adorned Italian courts and filled the streets. Early Renaissance sculptors were the artists most directly affected by the Greco-Roman classical tradition. Donatello revived the ancient tradition of the freestanding nude, while Michelangelo's early sculptural masterpieces, including his monumental *David*, combined biblical themes with a classicism of heroic scale. Such works were condemned in Renaissance Florence by the reformer Savonarola, who zealously chastised the Florentines for their luxury and corruption.

Renaissance Genius By applying Renaissance humanism to treacherous Italian politics, the Florentine Machiavelli produced a masterpiece of political philosophy. *The Prince* counseled Italian rulers to pursue their aims with clear-eyed realism, combining knowledge of the historical past with a ruthless sense of purpose. The Renaissance ideal of the "universal man" was represented by the enigmatic genius Leonardo, whose *Notebooks* reveal a restless and diverse intelligence. Leonardo's meticulous observation of the natural world produced insights in anatomy and mechanics. His mastery of painting technique produced a handful of masterpieces that are icons of world art.

The High Renaissance in Rome In the High Renaissance, European artists were drawn to Rome where papal patrons offered immense opportunities for achievement. The composer Josquin des Préz, called "master of the notes," blended northern polyphony and Italian lyricism in his sacred motets and secular songs. The painter Raphael decorated the pope's dwellings at the Vatican with works of perfect balance and harmony. Michelangelo created the awesome figure of *Moses* for the tomb of Pope Julius II, and painted the Sistine Chapel ceiling.

The High Renaissance's greatest undertaking was the building of a new St. Peter's in Rome. The new basilica was topped by Michelangelo's great dome, a synthesis of Renaissance classicism and heroic ambition.

9 Reformation and Late Renaissance

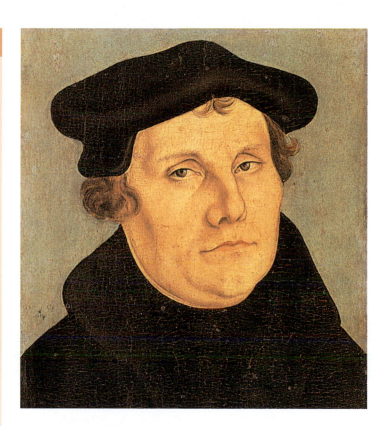

9.1 Lucas Cranach the Elder, *Portrait of Martin Luther* (detail), c. 1526. Oil on wood, 15 x 19 ins (38 x 24 cm). Uffizi, Florence. The pious Augustinian monk Martin Luther set off a religious revolution in 1517 when he questioned the Church's teachings on confession and forgiveness. Luther's Ninety-five Theses challenged the theological basis for the sale of papal indulgences — written guarantees of forgiveness. Within months, German printers made Luther's dry theological argument a bestseller.

Tradition holds that, in October 1517, a plump young professor nailed a notice to the wooden door of the castle church in Wittenberg, Germany. With his hammer, Martin Luther (Fig. **9.1**) drove a wedge between the Mother Church and her German followers. He was challenging the practices of the Roman pope, whose agents were selling salvation to German peasants. If the pope could so easily grant entry into heaven, Luther asked indignantly, why did he not freely release all the souls from purgatory, regardless of whose relatives could pay? And, the German princes added, why should Germans' hard-earned coin flow back to Rome to fund its extravagant artistic projects?

Luther's challenge would widen into a religious movement called the **Reformation**, the pivotal event of a troubled and transitional time when militant religious zeal coexisted in Europe with tolerance and love of learning. The reform movement eventually divided Christian Europe into Protestant and Catholic nations, while the political and commercial dynamism of Northern Europe began to define the early modern world.

The Reformation

Summarize the beliefs that led Protestantism to separate from the Roman Catholic faith.

For centuries, German emperors had quarreled with popes over the power they shared in European Christendom. But it took the bookish challenge of the university scholar Martin Luther (1483–1546) to split Christian Europe in two (Fig. **9.2**). Luther's critique of corruption and error in the Roman Church exploded into a religious revolt called the **Reformation** – the movement that divided Western Christianity into the Roman Catholic and the new Protestant faiths. The Reformation spawned many "reformed" creeds, whose followers were called **Protestants** because of their protest against Catholic doctrine. The Reformation's effects were broader than the Church itself. Theologically, the Reformation revived the Christian debate over free will and human nature. Intellectually, it elaborated the ideas of Christian humanist scholars, although reformers and humanists sharply disagreed on some issues. Socially, the Reformation appealed to a German people who resented the Catholic Church's heavy taxation. Martin Luther's revolt eventually touched every aspect of European life.

Luther's Challenge

Martin Luther published his famous Ninety-five Theses in 1517, as propositions for theological debate among the university scholars in Wittenberg. The religious issues he addressed were not new: What power did the Roman Church exercise over individual believers? What foundation did its doctrines have in biblical scripture? Luther would answer these questions in a succinct and radical maxim: *Scriptura sola, fide sola, gratia sola* ("Only scripture, only faith, only grace"). With the phrase *scriptura sola,* Luther rejected every aspect of the Catholic faith not grounded in biblical teaching. This rejection applied especially to the **sacraments**, those ritual acts – such as communion, penance, and matrimony – that conferred divine grace on the believer. Because the sacraments could be administered only by a priest, the Church controlled the believer's access to salvation. Luther argued that only baptism and the Eucharist (communion) had biblical precedent. On the same basis, he also repudiated the celibacy of priests and the authority of the pope. In the phrase *fide sola* Luther's challenge went deeper. He cited the apostle Paul – "For by grace are you saved by faith … not of works" (Ephesians 2:8–9) – to question whether any act of piety was enough to earn salvation. If salvation was an undeserved gift of divine grace (*gratia sola*), Luther argued, then no devout German had to buy a papal indulgence or pay the Church's taxes.

Luther's message of religious freedom and nationalism exploded onto Europe in a series of pamphlets published in 1520. Luther asserted the individual believer's right to appeal directly to God, without a priest as intermediary. He declared that Christian believers were bound only to the word of God, not to the doctrines and institutions of the Church. And, mindful of the politics in religion, he pleaded with Germany's princes to take the lead in reforming the Church. By the end of 1520, Luther's writings had sold more than 300,000 copies, a figure that attests to Luther's popularity and to the literacy of his German followers.

A generation earlier, such a brash reformer might quickly have been burned at the stake. Luther, however, was saved by circumstance. In Rome, Pope Leo X was too busy with his artistic projects to bother with this "monkish squabble." Also, Church authorities hesitated to anger Luther's political sponsor, a powerful German noble. When finally, in 1521, Luther was threatened with excommunication, he burned the papal edict in Wittenberg's town square. Summoned to a trial before the Holy Roman Emperor, Luther entered the city of Worms [vorms] like a conquering hero, amidst walls plastered with his portrait and pamphlets. To the demands that he recant, Luther replied defiantly: "I neither can nor will

THE WRITE IDEA

State, as clearly as you can, your five most fundamental beliefs about the nature of the divine, the nature of human beings, and their relationship with each other. Do your beliefs have anything in common with Lutheran ideas?

recant anything, since it is neither right nor safe to act against conscience. God help me. Amen." Luther's political protector sheltered him from imperial condemnation; in hiding, he undertook a translation of the New Testament into German, giving his lay followers the chance to read God's word for themselves.

The Appeal of the Reformation

Luther's challenge was theological in its substance, but political and social in its appeal. His writings contained an underlying message of freedom and equality: that God offered divine grace equally to the rich and poor, clergy and lay, and that believers could speak directly to God and interpret the Bible themselves. Such radical ideas

had unforeseen consequences in Germany. Luther's ideas helped to inspire peasant revolts that German rulers bloodily suppressed, with Luther's tacit approval.

Protestantism also succeeded in making the Christian faith accessible to the common believer. Luther translated the New Testament into ordinary German, enabling a pious Lutheran family to read the Bible in their own language. For Protestant worship, Luther wrote simple hymns such as *Ein' feste Burg ist unser Gott* (*A Mighty Fortress*

9.2 Religious divisions in 16th-century Europe.
Except in England, the Lutheran Reformation thrived where the commercial middle classes were the strongest and absolutist rulers did not enforce religious orthodoxy.

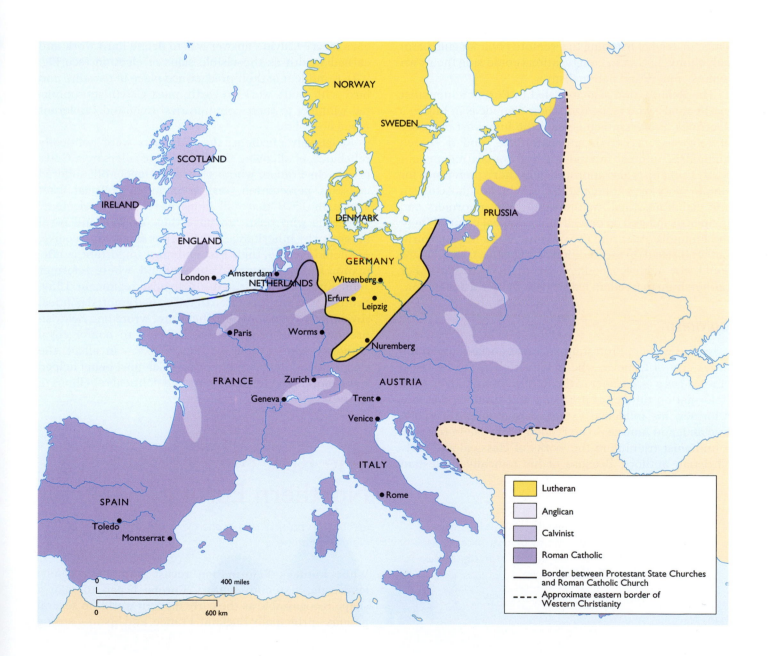

Legend:
- Lutheran
- Anglican
- Calvinist
- Roman Catholic
- Border between Protestant State Churches and Roman Catholic Church
- Approximate eastern border of Western Christianity

First Phrase of Chorale

Ein' fe - ste Burg ist un - ser Gott

Opening Tenor Phrase of Cantata

Ein' fe - - - - ste Burg ist un - ser Gott

9.3 Martin Luther, opening measures of *Ein' feste Burg ist unser Gott* (*A Mighty Fortress Is Our God*), a popular Lutheran hymn. Hymns based on simple melodies and written in German helped involve Protestant congregations more directly in worship.

Is Our God) (Fig. **9.3**), based on familiar popular melodies. Thus, instead of listening to a remote choir singing Latin polyphony, Lutheran congregations could sing their own hymns of piety and nationalism.

The Reformation also appealed to Europe's humanist intellectuals, who recognized their own ideas in Luther's doctrines. Protestantism echoed the humanist criticism of religious corruption and ignorance, and it shared humanists' interest in studying and translating ancient texts. Humanists also approved of Luther's preference for simple piety over the Church's quibbling scholasticism and elaborate ritual. At the same time, reformers and humanists differed on crucial philosophical points. Where the humanists asserted the nobility of the human spirit, Luther insisted (in the tradition of Augustine) that humans could not achieve goodness by their own effort. For Luther, human freedom led straight to moral damnation.

Calvinism

A second wave of Protestant successes originated in the Swiss city of Geneva, where John Calvin (1509–1564) emerged as a new leader of the Reformation. Calvin was a Reformation thinker of precision and subtlety, and as a reformer, his influence extended to France, Scotland, England, and America. The French-born Calvin received a humanist training in the works of classical and early Christian authors. Because of his radically Protestant

> All kings were at first elected, and those who today seem to have their crowns and royal authority by inheritance receive, or should receive, their first and most important confirmation from the people.
>
> French Calvinist political treatise, 1579

CRITICAL QUESTION
In today's society, who ought to be responsible for the moral regulation of community life? From what sources and principles should we derive laws that govern moral behavior?

views, he was forced to leave predominantly Catholic France, and settled in Geneva, which welcomed his strict moral teachings. Calvin's *Institutes of the Christian Religion* (1536) defined Protestant doctrine and became the Reformation's most widely read theological work. It elaborated the principle of **predestination**, the belief that God determines before their birth which Christians will gain salvation. If believers could not affect their destiny by good works – "by faith alone," cried Luther – then God must designate the saved before birth. But how would Calvinist believers know if they were among the righteous elect? Calvin's answer was to define hard work and earned wealth as the visible signs of election (see Fig. 9.4). Confident of their predestined place in paradise and busy with God's work on earth, most Calvinists submitted willingly to their communities' rigid and intolerant social discipline.

Religiously obedient, the Calvinists were politically rebellious, challenging the authority of rulers over God's people. In France, where Calvinist Huguenots suffered constant persecution, one anonymous political tract vowed in 1579 that "all kings were at first elected." Monarchs who seem "to have their crowns and royal authority by inheritance," the author asserted, "receive, or should receive, their first and most important confirmation from the people."[1] In Scotland, where reformer John Knox had instituted a Calvinist regime in 1559, Scottish Calvinists asserted that God had granted political sovereignty to his people. Therefore, wrote one Scottish firebrand, "the people have the right to confer royal authority upon whomever they wish"[2] – in effect, the right to elect their own king. Such Calvinist belief helped set in motion the religious wars and political rebellions of the next century.

The Rise of Northern Europe

Identify the political and economic causes of the rise of Northern Europe.

While Luther's Reformation recast Europe's religious landscape, sixteenth-century Europe began to take a shape recognizable as the early modern world. In several nations – principally England, France, and Spain – strong

The "Protestant Ethic": God, Work, and Wealth

The Reformation's success among the prospering town-dwellers of northern Europe created an apparent paradox. Enterprising Protestant merchants and artisans busily enriched themselves, while they condemned the greed of priests and popes. In modern times, the sociologist Max Weber coined the term **Protestant ethic** to describe the ascetic industriousness encouraged by Calvinist theology. In his controversial study *The Protestant Ethic and the Spirit of Capitalism* (1904), Weber argued that the Calvinists' single-minded effort and self-denial helped nurture northern Europe's budding capitalist economy.

The Protestant ethic was rooted in the anxieties brought on by Calvinist religious ideas. If believers could not earn salvation, Weber asked, how could they know if they belonged to God's "elect" — those destined for salvation and everlasting life? The Calvinists' answer, said Weber, was to define hard work and wealth as the visible signs of election. Thus, wealth was a sign of God's blessing, so long as it was not misused in idleness, leisure, or the spontaneous enjoyment of material possessions. This Protestant ethic, with its mixture of acquisitiveness and asceticism (Fig. **9.4**), encouraged small-scale capitalism and may have contributed to Protestants' material success.

The English Puritans who migrated to North America brought this Calvinist attitude with them. Today many people will recognize it in some North Americans' approval of a strong work ethic and disapproval of a life of contemplation or pleasure-seeking.

Weber's thesis has been discounted by modern sociologists, however, because it proved no causal relation between Calvinist doctrine and economic behavior. It is true that capitalist economies have succeeded mightily in such places as Hong Kong and Japan, where acquisitiveness and asceticism stem from Eastern religions, not Calvinism. Yet the essential features of Weber's Protestant work ethic — work, self-denial, the moral virtue of wealth — are still visible in Western attitudes and behavior today, and maintain a form of religious significance.

THE WRITE IDEA

Describe your own views about the relation of work, prosperity, and moral virtue. What moral judgments do you make about the poor? The indolent? The wealthy?

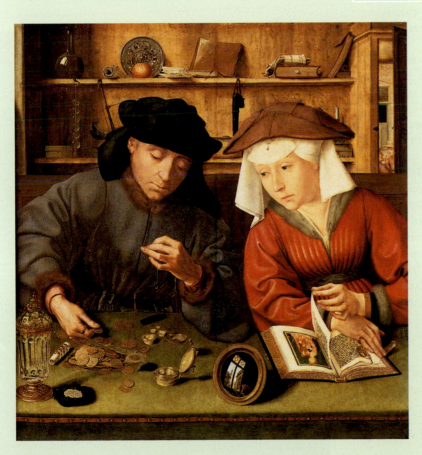

9.4 Quentin Massys, *Moneychanger and His Wife*, 1514. Oil on wood, 28 x 26³/₄ ins (71 x 68 cm). Louvre, Paris.
Calvinism's approval of material prosperity explains the sociologists' term "Protestant ethic" — the religious sanction of industriousness, asceticism, and moral high-mindedness that characterized Europe's merchant and shop-owning classes. This Renaissance portrait illustrates the danger that acquisitiveness, symbolized by the husband's hoard, may distract the pious wife from her devotional.

monarchs established centralized nation-states by subduing feudal rivalries and ending dynastic wars. The same monarchs fostered commerce within their borders and sponsored voyages of exploration that opened Africa, Asia, and the New World to European domination. Power and wealth shifted dramatically from the Mediterranean world to northern Europe and its Atlantic seaports. In the courts and cities of northern Europe, there was no dramatic "rebirth" of classical learning and art, although for convenience historians refer to this period as a "Northern Renaissance." Instead, northern patrons imported Italian artists and styles while also supporting local and national tastes in culture.

Kings, Commerce, and Columbus

The nation-states of England, France, and Spain dominated the European continent during the sixteenth century. The monarchs of these strong nations had each consolidated power in their own way. In France, Louis XI (ruled 1461–1483) regained territories from England and strengthened his power to levy taxes. In Spain, Ferdinand and Isabella combined their regional thrones in 1479 and ended the Muslim rule in southern Spain. They were succeeded by a line of Spanish monarchs called the Hapsburg Dynasty, who eventually controlled territories through much of Europe. Henry VII of England (ruled 1485–1509) ended a period of civil war and established the Tudor Dynasty, which later included the famous monarchs Henry VIII and Elizabeth I.

Europe's strong monarchs encouraged a commercial revolution that brought wider prosperity to northern European towns and cities, often at the expense of Mediterranean trading powers like Venice. Europe's rulers removed traditional restraints against enterprise. The Church relaxed its rules against charging interest on loans, allowing banking houses to accumulate enormous profits and foster trade and manufacture. Traditional communal farms were divided and planted for cash crops. Many peasants either became landowners or sought their fortunes as laborers in the growing towns. Martin Luther's father, for example, was a displaced German peasant who found work as a miner and eventually acquired his own mines and foundries. His wealth allowed him to afford a university education for his son Martin, who changed the course of Western civilization.

CRITICAL QUESTION

Discuss the paradoxes of Holbein's portrait *The Ambassadors* (see Fig. 9.6). What does it say about the spirit of science and exploration and the inevitability of death? In what ways are we reminded of death in the midst of technological and scientific confidence?

An entirely new factor in the sixteenth-century commercial revolution was Europe's exploration and colonization of the Americas. Financed by Ferdinand and Isabella of Spain and guided by new inventions in navigation, the explorer Christopher Columbus (1451–1506) opened the "New World" to European conquest in 1492. Spanish *conquistadores* subdued the Aztec and Inca empires of central and South America, and seized their fantastic treasures of precious metal objects. The indigenous American peoples were devastated by European disease, and many were enslaved to work in gold and silver mines. The influx of precious metals temporarily made Spain the wealthiest nation in Europe, and fueled the commercial revolution. Portuguese explorers mapped new sea routes along the African coast to India and the East Indies, linking Europe to longstanding Muslim trade ports. This commercial traffic shifted Europe's trade to the Atlantic ports of London in England and Amsterdam in the Netherlands, and shifted the balance of economic power away from Italy.

9.5 Jean Clouet (?), *Francis I*, c. 1525–30. Tempera and oil on wood, 37³/₄ x 29¹/₈ ins (96 x 74 cm). Louvre, Paris.
A humanist and a generous patron of the arts, Francis I negotiated with Erasmus to establish the Collège de France, a French academy. Despite his humanist principles, he ordered the slaughter of French Protestants after a Lutheran indiscreetly posted a religious bulletin on his bedroom door.

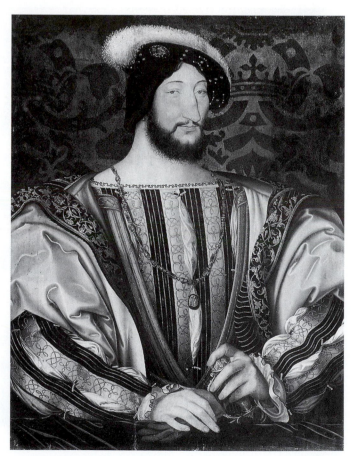

The Northern Renaissance Courts

Economic prosperity and royal power created an extravagant court life in northern Europe's royal palaces, attracting artistic talent from all of Europe. The French king Francis I (Fig. **9.5**) sheltered Leonardo da Vinci at his château in Amboise in the Loire Valley in France and invited the Italian mannerist painters to his court. Henry VIII favored the German portraitist Hans Holbein [HOHL-bine] (Fig. **9.6**), native of the vibrant Renaissance city of Augsburg.

While Northern Renaissance kings engaged in substantial building programs, their architecture generally

9.6 Hans Holbein the Younger, *Allegorical Portrait of Jean de Dinteville and Georges de Selve (The Ambassadors)*, 1533. Oil and tempera on wood, 6 ft 9$\frac{1}{8}$ ins × 6 ft 10$\frac{1}{4}$ ins (2.06 × 2.09 m). National Gallery, London.

These Renaissance ambassadors reflect the prosperity brought by northern Europe's commercial revolution and overseas exploration. They proudly stand next to the instruments that guided Europe's merchant fleets – telescope, globe, astrolabe. The court painter Hans Holbein has also incorporated allusions to Europe's religious discord – the open hymn book and the lute with a broken string – and a *memento mori* (reminder of death), the haunting skull hovering in the foreground. This is distorted by a trick of perspective so that it can only be properly read if seen from the side.

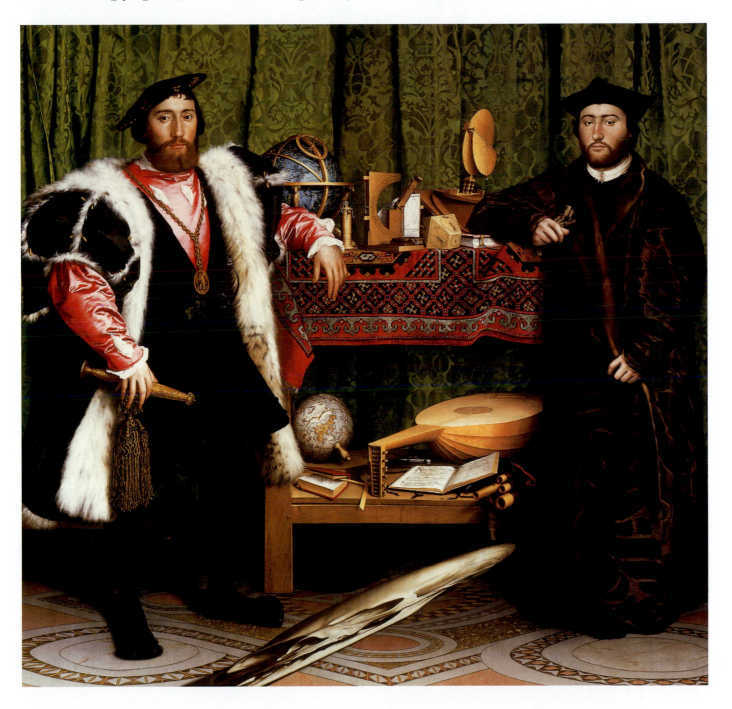

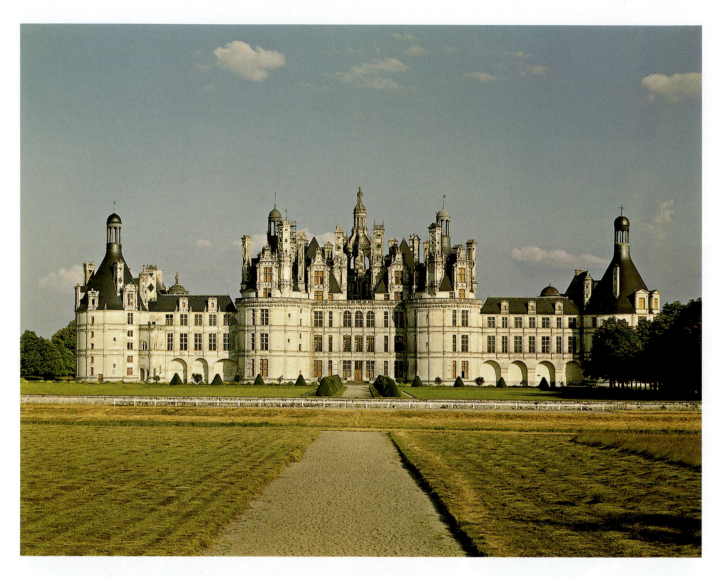

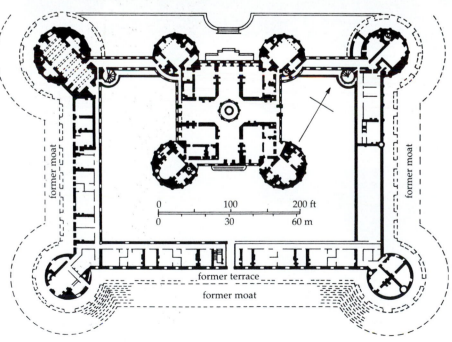

9.7 Château de Chambord, France, begun 1529 to the designs of Domenico da Cortona and Trinqueau: façade *(above)* and plan *(left)*. Designed by an Italian architect for the French king, Chambord's symmetrical and unified plan was marked by round turrets at the corners. The rationality of its design is compromised by the irregular eruptions of dormers and chimneys. Italianate classical moldings and balustrades unify the building's central section. How does Chambord's plan compare to the designs for the new St. Peter's in Rome (see Fig. 8.44)?

The Ottoman Empire

When Columbus made his famous voyage westward toward India, there was good reason that he did not sail east. Eastward passage to Asia from Spain was blocked by the formidable Ottoman Empire, which by 1500 had conquered the ancient Byzantine Empire and ruled most of Islam's capitals west of Persia. During the time of the Reformation, the Ottoman expansion aggressively threatened the heart of Europe, reaching at one point the walls of Vienna. In the Muslim world, the Ottomans' domination lasted into the nineteenth century, leaving an indelible mark on the politics of today's Middle East.

Nomadic Turkmen had first entered the Islamic world in the twelfth century as mounted soldiers of the caliph in Baghdad. They settled in Anatolia (today's Turkey), pressing on the weakened Byzantine state and repelling a crusade in 1444. In this era, Ottoman rulers relied on a loyal corps of infantry called the **Janissary**, made up of youths recruited from Christian households. Led by the Janissary corps, Ottoman armies conquered southeastern Europe and finally took Constantinople itself in 1453. The great walled city – built by a Roman emperor and center of a Greek Christian empire – would become Islam's greatest capital under the new name of **Istanbul**.

Ottoman rule reached its height under the rulers Selim I (ruled 1512–1520) and his son Suleyman the Magnificent (ruled 1520–1566), now called "sultan." Selim's armies assumed control of the Middle East's venerable Arabic cities – Baghdad, Cairo, and Jerusalem – and the Arabian shrines of Mecca and Medina. As intellectuals and artists migrated to Istanbul, the Ottoman capital became a robust Muslim city and Muslim civilization in turn added a Turkish layer to its existing Arabic and Persian cultures. The sultan Suleyman [S00-luh-mahn], known to Ottomans as "the Lawgiver" for his legal reforms, sponsored a building program that established a definitive Ottoman style. His master builder Sinan designed a series of mosques modeled after the Hagia Sophia (see page 113), the great domed Byzantine church from the sixth century. Sinan sought to "perfect" Hagia Sophia's irregular proportions into a geometrically regular arrangement of circles and squares. In such majestic buildings as the Selimiye in Edirne (Fig **9.8**), Sinan created his own formulaic model for the Turkish-style mosque – all to the glory of God and his sultan masters.

In its later years, Suleyman's reign was marked by a measure of tragic folly. His armies extended Muslim rule into Hungary and were on the verge of victory in a siege of Vienna in 1529. But far from home and fearing the Austrian winter, the Ottoman commanders withdrew. Never again would Suleyman and Islam reach so near the heart of Christian Europe. The sultan's passionate love for a woman of his harem, Roxelana, also brought him sorrow. A master of palace intrigue, Roxelana helped convince Suleyman that he was threatened by those closest to him. Both his eldest son and his lifelong friend and advisor were executed on Suleyman's orders. After Roxelana's death, Suleyman ended his rule in feeble old age, the most powerful ruler in the world but bereft of those he had loved.

As Europe's smaller nation-states were creating the early modern world, the Ottomans' vast realm remained cohesive but relatively stagnant. Its very efficiency suppressed the dynamic change by which Europe surged ahead. When the European imperial powers divided the Ottomans' empire after World War I, they formed several of today's Mideast nations from its territories.

9.8 Sinan, Selimiye Mosque, Edirne, Turkey, 1568–74.
The Ottoman Empire's greatest architect, Sinan, here achieved the geometrically perfect design of a square base capped by a circular dome. This interior view shows some of the eight great pillars, connected by arches and half-domes, that support the dome.

struck a compromise between medieval traditions and Italian-style classicism. A telling example was Francis I's château at Chambord [shan(h)-BOH(r)] (Fig. **9.7**), in the Loire Valley. Chambord's busy mass of roof dormers, chimneys, and turrets suggests medieval haphazardness. The decorative details, however, are borrowed from Italian Renaissance models and the floor plan reveals an Italian Renaissance heart. Chambord was rare because an Italian architect had planned it from the beginning. More typical was the château at Fontainebleau, to which Francis simply attached an Italian-style façade.

On the walls of Northern castles and town houses hung treasures of this age's most sumptuous art, woven tapestry. Under the influence of Persian and Ottoman imports, European weavers especially in Flanders (today's Belgium) and France began producing large-scale tapestry around 1300. Cycles of tapestry scenes depicted every imaginable theme, both sacred and secular, woven in wool and silk thread. Such tapestry was so costly that a French duke once ransomed his life from an Ottoman sultan with two packhorses loaded with hangings. One famous example, *The Lady and the Unicorn*, shows a young lady receiving instruction from a unicorn in the pleasures of the five senses. In the sixth scene, titled "To My Only Desire" (Fig. **9.9**), a handmaiden offers the lady a box of treasures from her suitor. The unicorn and lion, both symbols of male power and desire, hold the corners of her canopy.

9.9 *The Lady and the Unicorn: "To my only desire"*, French school, late 15th century. Wool and silk, 12 ft 5³/₅ ins × 15 ft 1²/₃ ins (3.8 × 4.64 m). Musée National du Moyen Âge et des Thermes de Cluny, Paris.
This sumptuous tapestry is one of six in a cycle focusing on the theme of the lady and the unicorn and celebrating the pleasures of the senses. The meaning and sequence of "To my only desire" is obscure: the lady may be accepting a necklace from her lover or she may be renouncing the necklace and the pleasure it symbolizes.

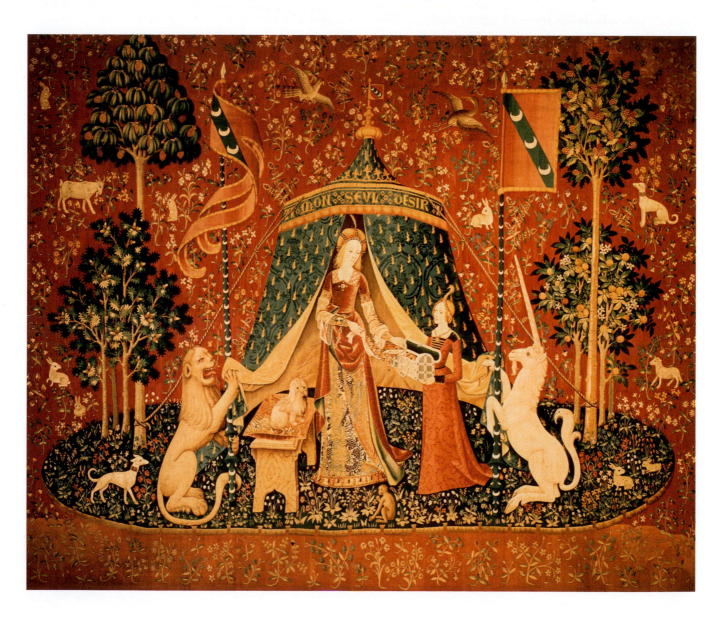

A Midwife's Advice

Diane de Poitiers [dee-AHN duh PWAT-ee-ay] was famed for her beauty and influence, as cherished companion of King Henry II of France (ruled 1547–1559), and also for her skills in medicine and midwifery. Here she gives advice to a friend about the wet nurse to the infant prince of France, the Duke of Orleans.

Madame my ally, I am well pleased about what has happened at Blois, and that you are in good health; as to that which I am overseeing, you would do well to do what is necessary there. The King and Queen are writing to you concerning the health of monsieur d'Orléans, and also to see whether the wet nurse has milk as good as required. For here they say that it is not good and that it upsets him, on account of which it seems to me that you would do well to investigate the situation, and if she is not good, to hire another for him. And I believe that if her milk has worsened since I saw her, it is because she has not conducted herself as she should have. It seems to me that if you make her drink cider or beer, that should refresh her thoroughly. I think that the doctors would agree with me on this. I trust you to put all this in good order. ...[3]

DIANE DE POITIERS
May 20, 1551

Art and Humanism in Northern Europe

Identify the northern artists and thinkers who most reflected Renaissance humanist values.

Northern European artists at first paid little attention to the revolutionary innovations of the Italian Renaissance. Northern painters were interested in an intense visual realism, rather than the intellectual unity and classical references of Italian art. Northern artists were eventually deeply affected by the age's intellectual ferment and religious reform.

Faith and Humanism in Northern Art

In the period of the Renaissance, northern European painters developed a stunning visual realism that matched, in its own way, the achievements of Italian Renaissance painters to the south. The techniques of northern realism differed from those of Italian art in important ways, however. Rather than fresco, Northern painters preferred the lustrous medium of oil paint, which enabled them to render small detail and to over-paint. Rather than plastered walls, Northern churches were often decorated with elaborate wooden altarpieces – cabinets with hinged doors that opened to display religious scenes.

The acknowledged master of Northern realism was Jan van Eyck (c. 1390–1441), a Flemish painter who excelled in jewel-like detail and vivid colors. Jan van Eyck's greatest altarpiece was the *Ghent Altarpiece* (Fig. **9.10**), begun with his brother Hubert. The panels depicting Adam and Eve (Fig. **9.11**), credited to Jan, show a new subtlety in handling light and space. Standing in niches, the figures are presented as they would be seen by a viewer standing at the altar, from below and to the side. Their torsos turn to recede backward into the space, while Adam's foot steps forward out of the niche. The figures' naturalism of gesture and subtle three-dimensionality make them the equal of any nudes painted in Renaissance Florence or Rome.

Van Eyck excelled as a portraitist for nobles and merchants in the prosperous Low Countries (today's Belgium and the Netherlands). In 1434 van Eyck was commissioned to paint the *Marriage of Giovanni Arnolfini and Giovanna Cenami* (Fig. **9.12**). Van Eyck surrounded the shrewd merchant Arnolfini and his demure young wife with symbols of their matrimony, each painted with a jeweler's precision. The dog represents marital fidelity. The single candle may stand for the one true light of Christ, who blesses their union. The fruit symbolizes the fertility that the newly-weds hope will grace their wedding bed, which is hung in a vibrant red. A convex mirror hanging in the center of the back wall reflects the entire room, including the artist and an assistant standing in the doorway. No painter of his day could rival van Eyck's mastery of light, color, and pictorial space.

In contrast to van Eyck's benign realism, the Netherlandish painter Hieronymus Bosch (c. 1450–1516) employed his brush to describe a dark vision of wicked and foolish humanity. Bosch's triptych (a three-part painting) titled is a fiery pictorial sermon against human depravity

1434	Jan van Eyck, *Marriage of Arnolfini* (**9.12**)
1500	Dürer, *Self-portrait* (**9.15**)
1509	Erasmus, *In Praise of Folly*
1517	Luther's 95 Theses, marks beginning of Reformation
1529	Francis I builds château at Chambord, France (**9.7**); Luther's hymn *Ein' feste Burg* published
1588	English navy defeats Spanish armada
1601	Morley publishes madrigals dedicated to English queen; Shakespeare, *Hamlet*

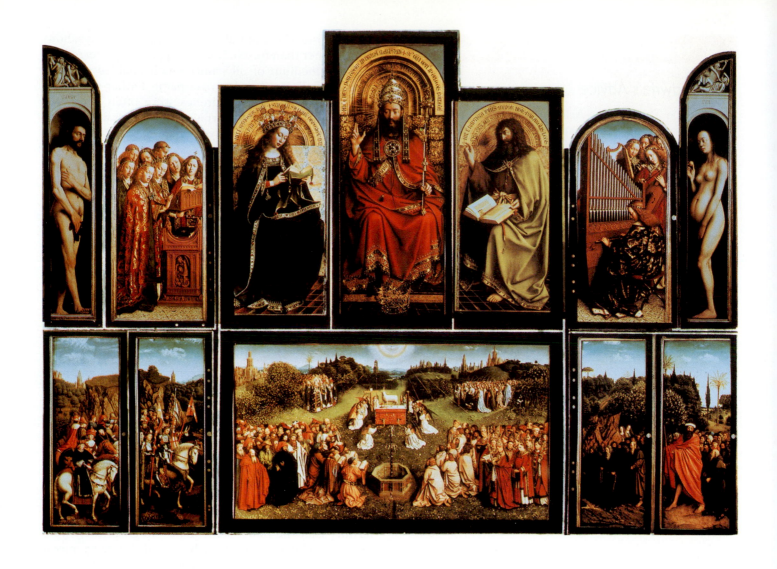

9.10 Hubert and Jan van Eyck, the *Ghent Altarpiece* (open), completed 1432. Cathedral of St. Bavo, Ghent, Belgium. Tempera and oil on panel, approx. 11 ft × 15 ft 1 in (3.35 × 4.6 m). The cabinet-like altarpiece, with its hinged panels, provided a very different format for pictorial composition compared with the broad walls of Italian churches. In this masterpiece by the van Eyck brothers, the upper portion depicts Christ reigning among the heavenly host; below, a pageant of worshipers approaches to adore the Lamb of God. The subtle detail of Flemish oil painting inspired avid imitation among Italian Renaissance artists.

(Fig. **9.13**). On the left panel, God creates Eve, the origin of sensual desire and, therefore, all human sinfulness. The central panel, traditionally titled "Before the Flood," is a bizarre catalogue of sensual indulgence and perversion. On the right, humanity justly suffers torments as vivid and grotesque as its former pleasures. Though his hallucinatory vision is associated with modernist surrealism (see page 398), Bosch's stern view of human sinfulness properly belongs to the age of Calvin.

As northern painters absorbed the lessons of the Italian revolution in painting, some maintained a religious mood of medieval intensity, as in Matthias Grünewald's *Crucifixion* (Fig. **9.14**), a panel of the *Isenheim Altarpiece*. Grünewald [GRYOO-nuh-vahlt] (1475?–1528) portrays the agonized figure of Christ as pocked by the effects of the bubonic plague (the altarpiece was commissioned by a monastery that cared for plague victims). His tortured figure communicates an intense piety and almost grotesque emotionalism that belong to the Northern Renaissance sensibility.

The first genuinely humanist artist of the Northern Renaissance was the German Albrecht Dürer (1471–1528), a master painter and graphic artist who also wrote treatises on pictorial technique. Dürer [DYOO-ruh(r)] was trained as an engraver in the imperial city of Nuremberg, a center of Germany's thriving printing trade. However, the young artist was not satisfied as an artisan who dutifully executed his patrons' orders. Like Leonardo da Vinci and the other Italian masters, he wanted to exalt the artist's standing as a thinker and creator. Dürer traveled twice to Italy, where he embraced Italian theories of

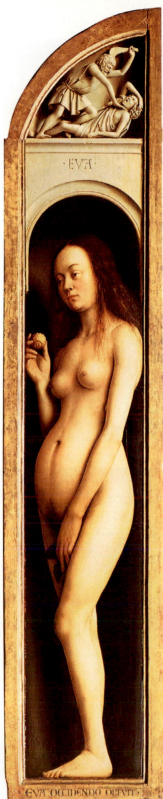

9.11 Jan van Eyck, *Adam and Eve*, detail of the *Ghent Altarpiece*, completed 1432. Cathedral of St. Bavo, Ghent, Belgium. Tempera and oil on panel, each panel 6 ft 8 ins × 18 ins (204 × 32 cm).

Compare van Eyck's Adam and Eve to Michelangelo's nudes in the Sistine Chapel ceiling (Fig. 8.41). The Flemish painter contains his figures within cleverly lighted architectural niches and provides a visual caption in the sculpted scenes of Cain and Abel above (see Genesis 4). How would you explain these images' comment on the nature of human sin?

9.12 (below) Jan van Eyck, *Marriage of Giovanni Arnolfini and Giovanna Cenami*, 1434. Oil on panel, 33 × 22½ ins (84 × 57 cm). National Gallery, London.

At the same time that Masaccio was pioneering a new pictorial depth and unity in Italian painting (see Fig. 8.18), van Eyck's portraits demonstrated a subtle command of pictorial detail. The portrait, which served as a pictorial wedding certificate, shows the couple surrounded by symbols of fidelity and fertility.

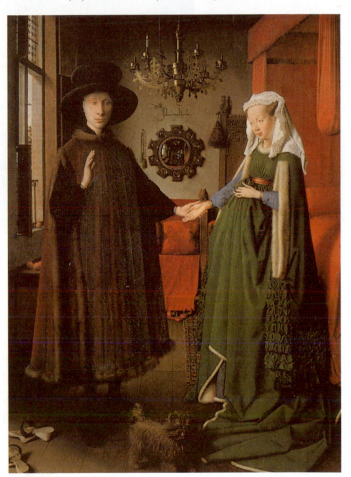

proportion and perspective and envied the prestige of his Italian counterparts – from Venice he wrote, "Here I am a gentleman; there I am a parasite."[4] More than the Italian Renaissance masters, Dürer praised the artist as genius and justified the artist's vocation:

> Through instruction we would like to be competent in many things, and would not tire thereof, for nature has implanted in us the desire of knowing all things … If we want to sharpen our reason by learning and to practice ourselves therein, having once found the right path we may, step by step, seek, learn, comprehend, and finally reach and attain unto some of the truth.[5]

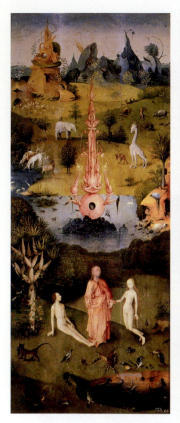
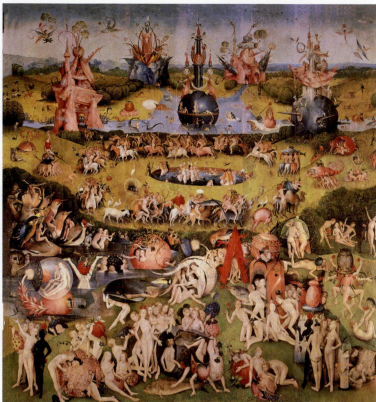
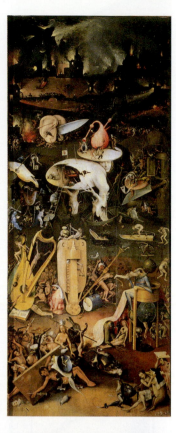

9.13 Hieronymus Bosch, *The Creation of Eve: The Garden of Earthly Delights: Hell* (triptych), c. 1510–15. Oil on wood, 7 ft 2⁵/₈ ins x 6 ft 4³/₄ ins (219 x 77 cm) (center panel), 7 ft 2⁵/₈ ins x 3 ft 2¹/₄ ins (219 x 97 cm) (each side panel). Prado, Madrid

Bosch was able to give visual reality to the most fantastic and grotesque creatures.

Dürer portrayed himself with a self-absorption bordering on vanity. In *Self-portrait in a Fur-collared Robe* (Fig. **9.15**), the artist's flowing hair and thoughtful face suggest an image of Christ, an idea reinforced by the subdued colors and pyramid-like composition, which lend the image a religious solemnity. Yet Dürer painted the beard and fur collar with a precision characteristic of Jan van Eyck.

Dürer achieved widest success in his woodcuts and engravings – graphic arts associated with the rise of the printing press. In sixteenth-century Europe, woodcuts and engravings had the immediacy of today's photography and video, and were frequently used as weapons

9.15 Albrecht Dürer, *Self-portrait in a Fur-collared Robe*, 1500. Oil on panel, 26¹/₄ x 19¹/₄ ins (67 x 49 cm). Alte Pinakothek, Munich.
The German Dürer consciously aspired to the heroic status attained by Italian artists like Raphael and Michelangelo. The long fingers of the right hand draw attention not only to the collar's delicate texture but also to the hand itself, the repository of Dürer's painting skill. The inscription says "I, Albrecht Dürer, painted myself with everlasting colors in my twenty-eighth year."

9.14 Matthias Grünewald, *Crucifixion*, exterior panel from the *Isenheim Altarpiece*, completed 1515. Oil on panel, 8 ft x 10 ft 1 in (2.44 x 3.07 m). Musée d'Unterlinden, Colmar, Germany. Northern painters often combined precise visual realism with an unrestrained religious emotionalism. Grünewald's *Crucifixion* follows medieval iconographic conventions: John the Baptist (right) points to the sacrifice of Christ while Mary Magdalene (kneeling) and the Virgin Mary, supported by the apostle John, mourn the tortured Christ. The *Agnus Dei* (Lamb of God) stands over the chalice that will hold the sacrificial blood of Christ.

in the age's political and religious controversies. For example, Dürer's engraving *Knight, Death, and the Devil* (Fig. **9.16**) may be an illustration of a religious text of his day. The northern humanist thinker Erasmus had warned the faithful in his *Handbook of the Christian Knight*, "You must be on guard when you eat or sleep, even when you travel in the course of worldly concerns and perhaps become weary of bearing this righteous armor."[6] Dürer's

resolute Christian knight sits astride a well-proportioned horse, and shows no fear of Death at his side, holding an hourglass, or of the grotesque devil disguised as a wild boar. The celestial city atop a mountain landscape may symbolize the inner moral virtue that is protected by the knight's armor.

In contrast to Dürer, Pieter Bruegel (c. 1525–1569) showed little interest in Italian technique and humanist debate. Bruegel [BROY-gull] expressed a profound affection for natural beauty and the simple life of Flemish peasants. His worldly subjects and attitude make Pieter Bruegel the north's first important post-Reformation painter.

Bruegel was fascinated by the lives of common folk and their relationship to the land. An early biographer told how the painter disguised himself as a peasant to join in village festivals. He depicted common people in many **genre** pictures, or scenes of daily life, that often achieved a breathtaking perspective and philosophical sophistication. In *The Hunters' Return* (Fig. **9.17**), the failure of the

piety and humility based on the Gospels. Ordained as a priest in 1492, he began a campaign to free the Church from corruption and scholastic pretension, while himself pursuing a life of quiet devotion and moral virtue.

Erasmus's best-known work was *In Praise of Folly* (1509), an exposé of the vanity and corruption in Renaissance society. *In Praise of Folly* was the Renaissance's greatest example of **satire**, a work that criticizes society through humorous exaggeration and parody. The book was a popular triumph, in Erasmus's lifetime appearing in forty-two Latin editions and in English and German translations.

In Praise of Folly takes aim at the hypocrisy and vanity of Renaissance society, and contrasts its vices with the inner piety and moral striving that lead to Christian salvation. Speaking in the satirical voice of Folly, Erasmus rails against the folly of war, especially as practiced by warrior popes such as Julius II. Folly reserves her most biting criticism for Erasmus's constant adversaries, the scholastic theologians. In the author's view, the pretensions of the scholastics kept them from true piety. Folly suggests that study of the Bible itself should replace scholastic commentaries and Church dogmas. While readers were delighted with Erasmus's mockery of lawyers, merchants, monks, and theologians, his satire earned him intellectual enemies throughout Europe, reason enough for the scholar to seek protection from the pope.

9.16 Albrecht Dürer, *Knight, Death, and the Devil*, 1513. Engraving, 9³/₄ x 7¹/₂ ins (25 x 19 cm).

Unlike most other Northern artists, Dürer used his art to engage in the religious controversies of his day. Though clearly inspired by Erasmus's praise of militant piety, the symbolism of this engraving is obscure. The dog may represent loyalty or vigilance, while the salamander (a creature supposedly invulnerable to fire) may allude to Savonarola, the religious zealot burned at the stake in Florence in 1498.

Erasmus's opinion on lawyers: … the most self-satisfied class of people, as they roll their rock of Sisyphus[a] and string together six hundred laws in the same breath, no matter whether relevant or not, piling up opinion on opinion and gloss on gloss to make their profession seem the most difficult of all. Anything which causes trouble has special merit in their eyes.

On the pope's court: Countless scribes, clerks, lawyers, advocates, secretaries, muleteers, grooms, bankers and pimps (and I nearly added something rather more suggestive, but I didn't want to offend your ears) – in short, an enormous crowd of people now a burden on the Roman See (I'm sorry, I meant "now an honor to") …

On scholastic theologians: … so happy in their self-satisfaction and self-congratulation, and so busy night and day with these enjoyable tomfooleries, that they haven't even a spare moment in which to read even once through the gospel or the letters of Paul. And while they're wasting their time in the schools with this nonsense, they believe that just as in the poets Atlas[b] holds up the sky on his shoulders, they support the entire Church on the props of their syllogisms and without them it would collapse.[7]

ERASMUS
From In Praise of Folly (1509)

a. Sisyphus [SIZ-i-fuss], the Greek condemned to roll a stone perpetually up a hill.
b. Atlas, the Greek god who supports the sky.

hunt is evident in the dogs' drooping tails. In emotional contrast, a group on the left prepares to slaughter a hog, a promise of feasting and gaiety. From this foreground action, the eye follows the trees down the hill to the skaters below and in the background. The skaters are oblivious to the returning hunters and seem insignificant against the vast winter landscape. A single bird floats across the sky, unifying the human drama with the timeless Alpine peaks in the upper right.

Erasmus and Humanism

The Northern humanist thinkers are often called Christian humanists to distinguish them from the classical humanists of Renaissance Italy. The most important and famous Christian humanist was Desiderius Erasmus (1466–1536), whose translations and writings embodied a spirit of piety and humble learning. Born in the Netherlands, Erasmus was trained early in a simple life of

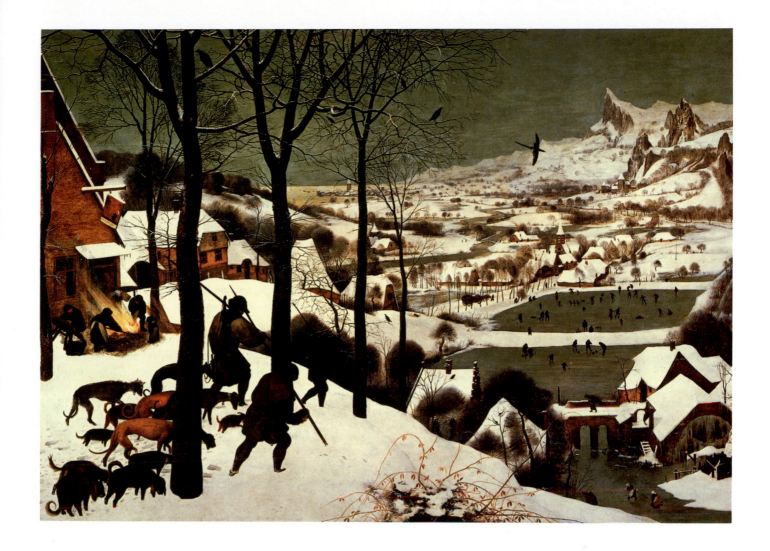

9.17 Pieter Bruegel the Elder, *The Hunters' Return*, 1565.
Oil on panel, 3 ft 10 ins x 5 ft 3³/₄ ins (1.17 x 1.62 m).
Kunsthistorisches Museum, Vienna.
The Fleming Bruegel chose to paint landscapes and scenes of daily life
in part because of Protestant hostility to religious art. This painting
was one of a series of calendar paintings, a medieval pictorial tradition
that marked the passage of nature's seasons. Analyze the relations
among the returning hunters, their village, and the natural world, as
depicted in the painting's complex spatial composition.

CRITICAL QUESTION
Are you inclined, like Erasmus, to remain loyal to groups or
institutions that you recognize are sometimes flawed? Or are you,
like Montaigne, basically skeptical about commitment and belief?

Erasmus considered his *In Praise of Folly* a trifle com-
pared to his translations of the Bible and the writings of
such early Church fathers as St. Jerome (Fig. **9.18**). In
1516, Erasmus made a revolutionary advance by publish-
ing a version of the New Testament in the original Greek,

THE WRITE IDEA
In outline form, describe the perfect society as you envision it.
How does your utopia reflect your beliefs and values as a person?

accompanied by his own commentary. Erasmus's Greek
Bible exposed substantial errors in the Church's official
Latin translation, and Church scholars vigorously attacked
it as a threat to the Church's religious authority.

Despite his differences with the Church, Erasmus
remained distant from Martin Luther's reforms, for rea-
sons of both philosophy and self-preservation – Erasmus's
patrons all opposed Luther. Philosophically, Erasmus
held the humanist view that people were, by free acts of
will, able to improve themselves morally. Luther, on the
other hand, saw humans as absolutely dependent on
God's grace for salvation. Erasmus finally voiced his dis-
agreement with Luther in a critical treatise entitled *De
libero arbitrio* (*On the Freedom of the Will*, 1524), which

9.18 Albrecht Dürer, *St. Jerome in His Study*, 1514. Engraving, $9^3/_4$ x $7^3/_8$ ins (24.7 x 18.8 cm).
The northern evangelical humanists took as their patron saint the 4th-century scholar and translator St. Jerome. Jerome had created the Latin Vulgate Bible that was Western Christianity's standard version until Renaissance translators like Erasmus and Luther provided alternatives.

Thomas More was chiefly interested in criticizing the greed, violence, and corruption in contemporary England rather than seriously proposing a utopian way of life. More's Utopia was a rather cheerless republic of industrious austerity. Its citizens all wore the same plain woolen clothing and went to bed at eight o'clock. Evening lectures offered education and self-improvement. Illicit sex was severely punished, because otherwise, More suggested, citizens would have no reason to get married. More reserved his sharpest criticism for greed. While Utopians meet their material needs with a few hours' labor, by contrast, English society seemed more like a "conspiracy of the rich to advance their own interests under the pretext of organizing society."

While Erasmus and More prized humble piety, the Christian humanist Michel de Montaigne (1533–1592) practiced skepticism and an unflinching self-examination. Montaigne [mohn(h)-TEN(y)] was born to a noble family in Bordeaux (in southwest France), received an exemplary humanist education, and served as a courtier and advisor. In 1571, however, he retired to his family home and began to write his *Essais* (*Essays*; 1580, 1588), conversational and introspective prose works that defined a new literary type: the **essay**.

Montaigne's essays were uniquely personal, full of anecdote and self-observation and ranging over every topic of concern to him – friendship, religious toleration, death, nature. Montaigne's most famous essay, *Apology for Raymond Sebond*, questioned the superiority of humans to other creatures, which was a commonplace of humanist thought. "When I play with my cat, who knows if I am not a pastime to her more than she is to me?" he asks in a famous illustration. Montaigne's skepticism toward the Renaissance's intellectual pretensions led him to rely chiefly on his own experience and observation – a starting point for the scientific attitude that would revolutionize European thought in the coming centuries (see Key Concept, opposite).

challenged Luther's fundamental belief in human sinfulness. Luther replied with his own pamphlet, pointedly titled *De servo arbitrio* (*On the Slavery of the Will*), which argued that nothing good came through human freedom. Erasmus agreed with the reformers that God's word was supreme and that piety was more important than good works. But he never abandoned his Catholic faith or his belief in human freedom and self-determination.

Utopians and Skeptics

Erasmus was not the only sharp-tongued humanist critic of northern Europe's social ills. His English friend Thomas More (1477–1535) described an alternative society of Christian justice and piety in his *Utopia* (1516), in essence a Christian answer to Plato's *Republic*. The title of More's book meant literally "no place." It described a fictional island where industrious citizens had solved the problems of war, poverty, and crime.

Skepticism

The Italian humanist Pico della Mirandola declared that humanity's place in creation was higher even than that of the angels. The essayist Michel de Montaigne would have viewed Pico's enthusiasm with sardonic skepticism. Humans don't dwell in the clouds, thought Montaigne, they are "lodged here, amid the mire and dung of the world." Only in their boundless presumption and vanity can humans imagine they are the equal of God.

Though he was not a systematic scientist or philosopher, Montaigne's conclusions about human knowledge were to have considerable influence on both. Through his essays, he became an important voice in the rise of **skepticism**, a systematic attitude of doubt toward any claim of knowledge. Humans should apply their intelligence to study of the world, Montaigne believed. While "our capacity can lead us to the knowledge of some things," he wrote, still "it has definite limits to its power, beyond which it is temerity to employ it."[8] With his knowledge of the classics, Montaigne could point to a tradition of skeptical thought in ancient Greece and Rome. A school of Hellenistic thinkers in fact sought to find peace of mind in the suspension of all judgments. Montaigne himself determined that, lacking certain knowledge of the world, we should live according to nature, custom, and the word of God.

Montaigne's skepticism was mixed with more than a little misanthropy, fueled in part by his own nation's religious discord. In his *Apology for Raymond Sebond*, Montaigne asked, "Is it possible to imagine anything so ridiculous as that this miserable and puny creature" – a man, that is – "should call himself master and emperor of the universe, the least part of which it is not in his power to know, much less to command?"[9]

Renaissance skeptics helped to justify the revolution in experimental science undertaken, most famously, in Galileo Galilei's observational astronomy and physics. Science was propelled by a practical and philosophical mistrust in traditional teaching and received opinions. All knowledge might ultimately be "presumption and vanity," to use Montaigne's words. But knowledge gained from direct observation and experience must be the least presumptuous and the most reliable guide to truth.

The Elizabethan Age

Describe the social and religious circumstances in England that contributed to the success of Elizabethan theater.

England was able to match the Renaissance achievements of Italy and Germany only in the late sixteenth century. By this time, navigational inventions such as the telescope had helped to expand England's maritime economy, while agricultural production had also increased. The new prosperity and political stability maintained by the English monarchy created the conditions for a renaissance in England. Although influenced by European fashions, it achieved its own artistic and philosophical expression in music and theater.

The Reformation in England

The English Reformation began as a political dispute that resulted in religious schism. King Henry VIII (ruled 1509–1547) appealed to the pope to dissolve his marriage with Catherine of Aragon, which had produced no male heir. When the pope refused, Henry split with the Roman Church, and established himself as head of the Anglican (English) Church, enabling him to divorce his wife by his own decree. He also confiscated monastic lands, and sold them at a large profit. While rejecting papal authority, the Anglican Church maintained its Catholic religious beliefs and vigorously opposed Lutheranism. The English king evenhandedly burned Protestants for religious heresy and Catholics for political treason. Under Henry VIII's successors, first Edward VI and then Mary I, Protestant and Catholic factions alternately gained the upper hand, each persecuting their religious opponents.

Finally under Elizabeth I (ruled 1558–1603; Fig. **9.19**), the Anglican faith was reinstated and religious toleration prevailed. Elizabeth demanded outward obedience to the official Anglican faith, while allowing Catholics to practice their faith secretly. As for the Protestants, Elizabeth frequently suppressed the Puritans, whose Calvinist doctrine threatened royal power. Thus, while the European continent was ravaged by bloody religious wars, England enjoyed relative religious peace, prosperity, and cultural revival – a period known as the Elizabethan Age.

This revival commenced in 1588 with the English naval victory over Spain, which boosted England's national spirit and maritime economy. At the same time, refugees from Europe's religious wars fled to English cities, joining the flood of peasants displaced from the countryside. London, the site of Elizabeth's lavish and pleasure-loving court, swelled with new inhabitants and became the capital of Elizabethan civilization.

9.19 Nicholas Hilliard, *Ermine Portrait of Queen Elizabeth I,*
1585. Oil on canvas, 41³/₄ x 35 ins (106 x 89 cm). Hatfield House,
England. Collection of the Marquess of Salisbury.

As evident from her costume here, the queen loved sumptuous
displays of wealth. The ermine on her sleeve is a symbol of
Elizabeth's virginity.

Theater in the Elizabethan Age

One art thrived above all others in Elizabethan times: the theater. Religious divisions in England's towns had virtually ended the production of medieval drama cycles by the mid-sixteenth century (see page 171). In their place, touring companies of professional actors presented plays in inn courtyards and other makeshift theaters. Actors' companies were often censored by town authorities, who feared for their citizens' morals. To thwart this censorship, acting troupes gained the sponsorship of prominent nobles, who also employed the company to perform at their courts. With a virtual monopoly on theatrical entertainment, the professional companies enjoyed commercial success and produced plays of high literary quality.

The era of prosperity of the Elizabethan theater began in 1576, when the Theatre in London was built. This was the first of London's public theaters, permanent houses whose popular plays attracted a diverse audience. The Theatre was later renamed the Globe (Fig. **9.20**), the famous "wooden O" where many of William Shakespeare's plays were first performed. London's public theaters were built on the Thames River's south bank, where they were free of the city's censorship. Here, theaters were also handy to such alternative entertainments as bear-baiting and prostitution. London's glittering Elizabethan society streamed across the Thames's bridges to see plays there – for a penny admission, even a humble apprentice might see dramatic spectacles that rivaled those of ancient Rome.

The public theaters reflected the needs of their diverse clientele and the demands of public performance. They were polygonal or circular structures, and could accommodate as many as 2,000 spectators. Because the stage jutted into the central yard, an actor standing downstage was surrounded on three sides by a noisy audience. Thus, Elizabethan actors favored a declamatory acting style,

9.20 Globe Theater, London, 1599–1613. Reconstruction drawing by C. Walter Hodges.
The Elizabethan theater was modeled after the inn courtyards where English actors had long presented their performances. The wealthiest patrons sat comfortably in the galleries, while common playgoers (including a cadre of pickpockets and prostitutes) stood crowded together in the "pit" in front of the stage. Note the ample stage machinery beneath the roof and a trapdoor (used in the ghost scene in *Hamlet*).

KEY
A. The "Hut", with machinery for lowering the Heavenly throne to the stage.
B. The "Heavens".
C. Top stage, sometimes used as a music gallery.
D. Upper stage.
E. Window stages.
F. Inner stage, sometimes called the "Study".
G. "Traps" leading down to the "Hell" under the stage.
H. "Gentlemen's Rooms" or "Lords' Rooms".
J. Storage lofts, dressing rooms, etc.
K. Dressing rooms.
L. Backstage area.
M. Main entrances to auditorium.
N. Doorways connecting with gallery staircase.
O. Entrance to galleries and staircases.

CRITICAL QUESTION

What kind of cultural event or entertainment in your community draws a mixed audience of different social classes or groups, like the Elizabethan theater? What does this reveal about the nature of the entertainment and the nature of the society you live in?

with broad gestures to demonstrate the character's emotional state. Also, the open-air arrangement of the theaters meant that actors had to be quick enough to finish a long play by dusk.

Elizabethan plays were a lively mixture of dramatic types that drew on both classical and medieval forerunners. Elizabethan comedies were modeled loosely on those of the Roman playwrights Plautus and Terence (see page 87), whose plays were read in Latin by schoolboys such as Shakespeare. Whatever its literary pedigree, Elizabethan comedy contained enough broad humor and slapstick to please the illiterate commoners in the pit. History plays, or chronicles, were also immensely popular in the patriotic aftermath of England's naval victory over the Spanish. The chronicles incorporated elements of the medieval mystery plays, with their panoramic biographies of saints and gory on-stage torture. Elizabethan tragedy borrowed from the sensational plots of the Roman writer Seneca (see page 87), often mixing themes of revenge with a severe Calvinist morality. Late Elizabethan tragedies were often set in Italy, which seemed the perfect setting for political intrigue, murder, and depraved sexuality. With its variety and inventiveness, the theater captured the essence of Elizabethan society, much as the gangsters and love stories of Hollywood films captured America in the 1930s and 1940s.

The Genius of Shakespeare

The most acclaimed dramatist of the English language is William Shakespeare (1564–1616), the genius of Elizabethan theater. Shakespeare was a provincial who, like many Elizabethans, came to London to seek his fortune. He found rich opportunities awaiting him in the theater. By the 1580s, several professional acting companies were well established and the public theaters were a commercial success. Christopher Marlowe (1564–1593), Shakespeare's most talented contemporary, had pioneered the verse forms of Elizabethan drama. Marlowe's play *The Historical Tragedy of Doctor Faustus* (first performed 1588) anticipated Shakespeare's great tragedies – such as *Hamlet*, *Macbeth*, *Othello*, and *King Lear* – in its psychological depth and epic sweep. Marlowe's Faustus is motivated by a boundless thirst for knowledge and power, which leads him into a bargain with the devil. The popularity of such works helped create the conditions for Shakespeare's success.

As a dramatist, Shakespeare disdained the classical rules of form favored by his university-trained rivals, who included his younger friend and protégé Ben Jonson (1572–1637). Shakespeare's plays were loosely plotted, with action that sprawled across weeks or even years. Instead of imitating Latin poetry, Shakespeare shaped Elizabethan speech into **blank verse**, using the five-stressed poetic line (pentameter) that in English had both naturalness and dignity. Shakespeare (Fig. **9.21**) may not have been a humanist, but to his contemporaries he was a poet of great humanity.

The play that best reveals Shakespeare's bond to the Renaissance is the tragedy *Hamlet*, the tale of the brooding prince. Called home to Denmark from his university studies, Hamlet is commanded by his father's ghost to avenge his murder at the hands of Hamlet's uncle. The uncle, Claudius, has been elected king and has married Hamlet's mother, the widowed queen. Hamlet is tortured by doubt and disgust, and he delays action by feigning

9.21 Frontispiece of the First Folio of Shakespeare's plays, 1623.

Shakespeare cared so little about the literary value of his plays that he retired to Stratford-upon-Avon without publishing them. The first complete edition, with a dedication by Ben Jonson, appeared seven years after Shakespeare's death.

Mr. WILLIAM
SHAKESPEARES
COMEDIES,
HISTORIES, &
TRAGEDIES.
Published according to the True Originall Copies.

LONDON
Printed by Isaac Iaggard, and Ed. Blount. 1623.

madness. Finally, he orchestrates a duel in which the innocent die along with the guilty.

In *Hamlet*, Shakespeare engages in his own dialogue with leading ideas of the Renaissance. Young Hamlet is a Renaissance gentleman fashioned after Castiglione's *Book of the Courtier* or Hilliard's *Youth Leaning Against a Tree* (Fig. **9.22**). Hamlet has an abundance of what Castiglione called *sprezzatura*, or accomplished style: he banters wittily with companions, improvises a court drama, and handles a sword with deadly effect. But Hamlet's character is also touched by the darker Renaissance skepticism of Montaigne, who questions whether humanity is much superior to the animals. Hamlet's famous praise of human nobility turns suddenly to pessimism and disgust:

> What a piece of work is a man! how noble in reason! how infinite in faculties! in form and moving, how express and admirable! in action, how like an angel! in apprehension, how like a god! the beauty of the world! the paragon of animals! And yet, to me, what is this quintessence of dust? man delights not me …[10]

9.22 Nicholas Hilliard, *A Youth Leaning Against a Tree with Roses*, c. 1590. Parchment, 5³/₈ x 2³/₄ ins (14 x 7 cm). Victoria & Albert Museum, London.
The Elizabethan idea of the gentleman and gentle lady borrowed liberally from Castiglione's *The Courtier* (see page 210). A well-bred young man like this, for example, had to be accomplished in music and dance, as well as swordplay and poetry-writing.

For all its rich philosophical overtones, Shakespeare's *Hamlet* was filled with engaging dramatic action. Educated theater-goers might savor themes of moral corruption and philosophical speculation, whilst the unlettered customer enjoyed a good show of verbal wit, pageantry, and swordplay. *Hamlet* was in every way a paragon of Elizabethan theater.

Elizabethan Music

Queen Elizabeth admired pageant and festivity, and her royal court was alive with music, dance, mime, and other spectacles (Fig. **9.23**). The Elizabethan court followed the fashion set by Castiglione's *Book of the Courtier* (see page 210). A courtier was expected to play a musical instrument, most likely the lute or virginal (a type of harpsichord favored by the queen), and to join in a vocal ensemble. The most popular songs and dances were imported from Italy but were usually imbued with English vitality.

The Elizabethan court's most gifted and versatile composer was William Byrd (1543?–1623), whose diverse productivity matched Shakespeare's output in drama. As a composer, Byrd was forced to contend with his country's religious divisions; he fended off the Puritans, who considered all sacred music mere "popish" ornament, and wrote music for both the Anglican Church and his own Catholic faith. Though he wrote three Catholic Masses, these works could not be performed publicly in Protestant England. Byrd also labored in service to royal and noble patrons, for whom he composed music for all occasions. Emulating Shakespeare's versatility in the theater, Byrd excelled in all the musical types, including the motet and the popular madrigal.

Books of Italian madrigals reached England by the 1580s and were eagerly translated in "Englished" editions. Imported to England, the madrigal showed itself well suited to English songs of love and lament. Elizabethan poets produced witty lyrics for madrigals and other popular songs. Musicians, like the other artists in Elizabethan times, successfully adapted forms borrowed from Italy to the tastes of their English public. The greatest English popularizer of madrigals was the composer and publisher Thomas Morley (1557–1602). He lived in the same London district as Shakespeare and set some of the playwright's verse to music. At the height of the madrigal's popularity, Morley published nine volumes of madrigals in seven years, including an anthology called *The Triumphes of Oriana* (published 1601). Oriana was a fanciful name for Elizabeth, the "maiden queen." In "As Vesta Was Descending," (Fig. **9.24**) composed by Thomas Weelkes, the antics of nymphs and shepherds at dusk ("Vesta," or evening) are the occasion for cheerful word-painting. In its final exclamation, "Long live fair Oriana," this madrigal shows itself perfectly adapted to the cult of adulation around Elizabeth I:

9.23 *Dancers Dancing Volta.* 16th-century engraving after Giovanni Mauro della Rovere.
Two pairs of Elizabethan dancers face each other in a *volta* (also *lavolta*), a dance that called for males to lift their partners on their thighs – a move considered scandalous in its day.

9.24 Thomas Weelkes, "As Vesta Was Descending," from *The Triumphes of Oriana*, 1601.
The Elizabethan craze for madrigals reached its height in Thomas Morley's collection (by different composers) honoring Queen Elizabeth. Note the use of word-painting here, the melodic line falling and rising on the words "descending" and "ascending."

As Vesta was descending,
She spied a maiden Queen the same ascending,
Attended on by all the shepherd's swain;
To whom Diana's darlings came running down amain
First two by two, then three by three together
Leaving their Goddess all alone, hasted thither;
And mingling with the shepherds of her train,
With mirthful tunes her presence did entertain.
Then sang the shepherds and nymphs of Diana:
Long live fair Oriana!

The Late Renaissance in Italy and Spain

Explain the reasons for the late Renaissance's conservatism in music and theater.

While northern Europe thrived in the sixteenth century, Renaissance Italy suffered political and economic decline. Luther's German revolt had jolted the papacy and in 1527 the mercenary army of the German emperor Charles V sacked Rome, plundering the city and stabling its horses in the Sistine Chapel. Italian Renaissance art also suffered losses. By 1520, Leonardo and Raphael were dead. Of the High Renaissance masters, only Michelangelo lived on, stifling others by his greatness while suffering his own profound religious doubts. Innovation persisted in Italian theater and in Venice, and the Roman Church gathered itself to answer the reformers' challenge.

Palestrina and the Counter-Reformation

The Catholic reaction against the Reformation was slow. When Catholic bishops finally met in the Council of Trent (1545–1564), they scrutinized Church doctrine and

practice. The result was called the **Counter-Reformation**, the Catholic Church's effort to reform itself and mount a religious offensive against Protestantism. Especially in Spain, the Counter-Reformation spawned a wave of Catholic religious enthusiasm. The revival's most important figure was Ignatius of Loyola (1491–1566) a Spanish nobleman whose *Spiritual Exercises* (1548) sought to imitate the sufferings and spiritual disciplines of the saints. The *Exercises* described a program of devotion and prayer by which the devout believer might reproduce the psychological experience of the saints and so partake in their piety. Ignatius' charismatic faith won him the pope's endorsement, and in 1539 he founded the Society of Jesus, or Jesuits. The militant and missionary Jesuit order dedicated itself to defending the Catholic faith against reformers and spreading Christianity to the New World.

Like the Inquisition – the Church office that enforced doctrine and punished heresy, the Council of Trent censored books and prescribed artistic standards. Regarding music, the Council of Trent declared:

> … in the case of those Masses which are celebrated with singing and with organ, let nothing profane be intermingled, but only hymns and divine praises. The whole plan of singing in musical modes should be constituted not to give empty pleasure to the ear, but in such a way that the words be clearly understood by all …[11]

This pronouncement by the council challenged two basic principles of Renaissance music: first, it criticized complex polyphony in the style of Josquin des Préz and other northern French and Flemish-born composers; second, it condemned the "intermingling" of religious and non-religious elements common in Renaissance sacred music.

The condemnation gave rise to a new conservatism among Italian composers. The composer best attuned to the changes was the Italian Giovanni da Palestrina (c. 1525–1594). He abandoned secular composition, saying of the composers of such works, "I blush and grieve to think that once I was of their number." Palestrina's recantation was opportune, for he later occupied several prestigious musical posts in Rome, and finally became director of the pope's Sistine Choir. Palestrina's stately and flawless compositions were the high point of sacred music in late Renaissance Italy.

Musically, Palestrina returned to sacred compositions based on traditional plainchant, while using more restrained dissonances than Josquin's. He composed the *Mass of Pope Marcellus* (1567) in six voices to demonstrate that complex polyphony need not violate the dictates of piety. In the *Kyrie,* for example, he balances upward movement of the melodic line immediately by downward movement. Within these stricter bounds, the music is always full and fluid. Palestrina's elegiac motet *Super flumina Babylonis* (*By the Rivers of Babylon,* 1581) matched the

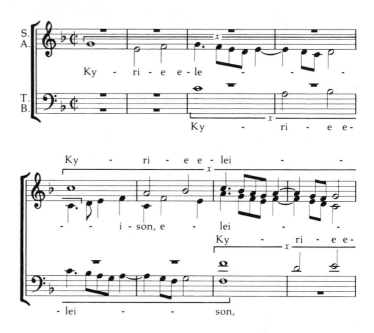

9.25 Palestrina, opening measures from *Missa Brevis,* "Kyrie," 1570. Note the step-like progress of the melodic line and the simplified polyphony, using only three voices.

musical rhythms perfectly to the mournful words of the biblical text (from Psalm 137). Palestrina's polyphonic imitation is always controlled, and imitative passages are balanced against chordal phrases. In Palestrina's sacred music, the voices blend into a whole of exceptional clarity and grace (Fig. **9.25**).

Renaissance Theater in Italy

It was no accident that most of Shakespeare's worldly-wise comedies were set in Italy and were based on Italian plots. Italian Renaissance plays not only defined a new type of comedy, but they were also published and distributed widely – making them another Italian import to Shakespeare's England.

Italian dramatists derived their innovative comedy from ancient Roman comedy (see page 87), with its stock characters and everyday situations. To the classical models of Plautus and Terence, however, the Italians gave a new coherence of plot, usually dividing the action into five acts and providing its events with realistic plausibility. The new variety of *commedia* was called *grave* ("serious") or *erudita* ("learned") comedy, because it was based on ancient models. But Italian playwrights quite freely incorporated local theatrical traditions and modernizing plots.

The realism of modern Italian comedy owed much to the Italians' inventions in stage design and machinery. Renaissance theater in Italy generated many of the innovations – stage devices, plot structure, comedic conventions

– that defined the modern European theater as a mirror of reality. Stage designers applied the perspective techniques of Renaissance painting to create the illusion of a deep, three-dimensional space on stage. On the temporary stages that were the norm – permanent theater buildings were rare in sixteenth-century Italy – scenic designers employed huge perspective backdrops. Movable painted wing scenery was angled inward to create the appearance of a long city street or a forest vista.

The Italians' innovative stagecraft, along with humanist research into Roman theater architecture, reached a climax in Andrea Palladio's design for the Teatro Olimpico (Fig. **9.26**). The Teatro Olimpico was a small-scale replica of an ancient Roman theater, with a multi-storied façade and decorative statues and columns. Palladio's permanent architectural stage sets provided spectators with the illusion of a deep space, the same perspective view as in Renaissance painting.

The inaugural production at the Teatro Olimpico was yet another influential Italian innovation with a classicist flavor – a translation of Sophocles' Greek tragedy *Oedipus the King*. A learned Florentine society called the Camerata had long devoted itself to the study of Aristotle's *Poetics* and the revival of Greek tragedy. The landmark production of *Oedipus* in 1585 incorporated dance and music by Andrea Gabrieli, but bore little resemblance to a performance in ancient Greece. The Camerata's classicist idea of Greek tragedy set to music would eventually blossom into a new theatrical art called opera.

9.26 Andrea Palladio and Vincenzo Scamozzi, Teatro Olimpico, interior, Vicenza, Italy, 1580–4.
Palladio's theater design combined overt imitation of classicism with illusionist perspective stage sets. The decoration of the stage's façade is a Renaissance conglomeration of classical elements, modeled after surviving Roman theaters (compare Fig. 4.27). The fixed architectural perspectives of this revolutionary theater were not widely imitated; instead, Italian theater preferred movable sets and painted scenic flats.

9.27 A *commedia dell'arte* performance at the French court, c. 1670. Collection Comédie Française, Paris.

Italian *commedia* players became so popular in France that French theater troupes had them banned. A *commedia* performance included such stock figures as the Harlequin (left of center, in his identifying brightly colored costume) and the slapstick pair of Pantalone and Pulchinella (far right). Note the illusionist perspective scenery, also an Italian invention, provided by stage sets and a painted backdrop.

The most popular Italian export of the Renaissance was a robust form of comic theater called the *commedia dell'arte* (Fig. **9.27**) – improvisational comedy in which actors invented dialogue to fit the bare outline of a plot. *Commedia* performances drew freely on popular novels, gossip, and current events. The usual scenario involved a cast of a dozen stock characters, including the innocent young lady, the spendthrift lover, and the stuffy doctor. For a few decades at least, *commedia dell'arte* troupes included female actors, and they took their brand of improvisational wit and physical comedy to audiences through much of Europe.

The Renaissance in Venice

Late Renaissance Venice was a liberal and cosmopolitan city, largely untouched by the age's religious conflicts. The wealthy aristocracy supported a rich artistic culture, and commissioned portraits and built country villas in neoclassical style. The city's grand St. Mark's Square was not only a splendid architectural landmark, but also the center of a rich musical culture. Based on a friendly accommodation between state and Church, Venetian civic life glittered with lavish processions, sumptuous festivity, and artistic brilliance. The Venetians' love of revelry suffused even supposedly religious occasions and subjects, such as Paolo Veronese's [vair-oh-NAY-zay] painting *Marriage at Cana* (Fig. **9.28**).

The grand style of Venetian music provided a suitable accompaniment to the city's habitual pomp and celebration. The city was served by a line of distinguished composers – first Flemish musicians and later native-born composers. The last of the Renaissance composers was Giovanni Gabrieli (1558–1612), whose uncle had composed the music for the Florentine Camerata's version of *Oedipus the King*. Like his predecessors, Gabrieli's

9.28 Paolo Veronese, *Marriage at Cana*, c. 1560. Oil on canvas, 21 ft 10 ins × 32 ft 6 ins (6.65 × 9.88 m). Louvre, Paris.
Veronese excelled in the large-scale festive scenes beloved among his Venetian patrons. Christ and the Virgin Mary, seated at center, are distinguishable only by their haloes; among the musicians (foreground) is supposedly a self-portrait of the artist with Titian. The architectural setting resembles a perspective theater set (see Fig. 9.27).

sacred music was strongly affected by the unique architecture of the city cathedral. Instead of just one choir space, St. Mark's basilica had two opposing choirs, each with its own organ. Venetian composers exploited this setting by devising a **polychoral style**, which used two or more groups of singers or instruments spaced some distance apart. In Gabrieli's *Canzone Duodecimi Toni* (1597), two brass choirs engage in stereophonic dialogue, employing a characteristic "canzona rhythm" of "LONG-short-short." As each section ends, the polyphonic melodic lines unite in a final chord (two or more tones played at the same time). These chordal endings were called **cadences**, musical resting points that provided a sense of resolution and completion. Gabrieli's pronounced cadences signaled a move away from the polyphony of Renaissance music.

The Venetians' grand style of living proved fortunate for its most prominent Renaissance architect, Andrea Palladio (1508–1580). Although he designed numerous churches, usually with a central plan and a classical temple façade, Palladio is best known for his country estates. Venetian economic troubles had forced many of its wealthy merchants to take up farming, and Palladio showed skill in adapting his classical style to building country villas for such patrons. Palladio's designs of classical symmetry and simplicity influenced architects into the nineteenth century.

Palladio's typical design for the country villa is evident in the Villa Rotonda (Fig. **9.29**), although this residence was a rural retreat and not a farmhouse. The rigorously symmetrical floor plan (Fig. **9.30**) consists of a circle within a square, with four identical classical-style porticos. Partly through Palladio's influence, such pedimented temple façades and central domes became a common feature of secular buildings in later periods. Palladio was an enthusiastic student of ancient Roman building, though his designs often freely combined classical elements. His *Four Books of Architecture* (1570), a copy-book of classical designs and decoration, became a textbook for architects over the two centuries that followed.

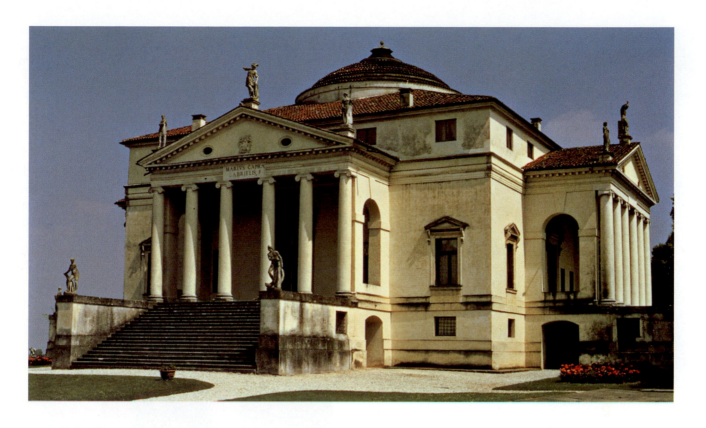

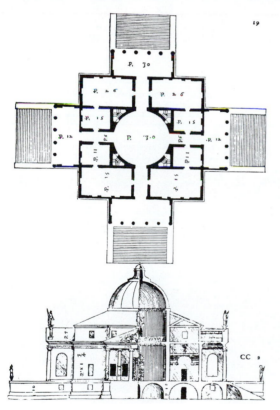

9.29 *(above)* Andrea Palladio, Villa Rotonda (Villa Capra), Vicenza, Italy, begun 1550. 80 ft (24.38 m) square, height of dome 70 ft (21.34 m).

The classical porticos on all four sides took advantage of the surrounding vistas. The hilltop site inspired, among others, Thomas Jefferson's Monticello in Virginia (see Fig. 11.24).

9.30 *(left)* Plan of the Villa Rotonda, Vicenza, Italy, begun 1550. From Palladio's *Quattro libri dell'architettura* (*Four Books of Architecture*), 1570.

Palladio's use of a central dome in a non-sacred building was unprecedented in the Renaissance and would influence the choice of domed buildings for residences and capitols throughout Europe and the Americas.

Late Renaissance Painting and Mannerism

Because the city's damp climate discouraged fresco, Venetian Renaissance painters preferred oil paint and with its rich hues produced works of mystery and grand spectacle. Venice's most mysterious painter was Giorgione [jyor-jee-OH-nee] (1478–1511), a master of pictorial mood. In the *Tempest* (Fig. **9.31**), for example, the city landscape manages to suggest both profound peacefulness and the foreboding threat of a storm. The figures in the foreground – the sentinel and the nude mother with infant – remain largely unexplained. They suggest the complementary qualities of strength and tenderness.

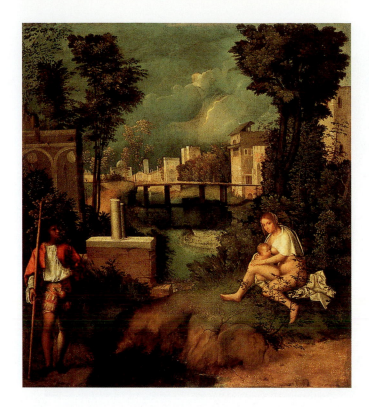

9.31 Giorgione, *Tempest*, c. 1505. Oil on canvas, 32¼ x 28¾ ins (82 x 73 cm). Galleria dell'Accademia, Venice.
The Venetian Giorgione excelled at creating elusive and sometimes enigmatic moods. Note the contrast here between the stormy background and the placid foreground figures. Allegorically, the painting's meaning is obscure: the stork on the rooftop and the mother's white cloak are traditional symbols of purity, while fortitude is suggested by the sentinel's staff and the broken columns.

The dynamism and tensions of Titian's painting show the effects of a style that arose in Florence and Rome around 1520 alongside conventional Renaissance classicism. This style, termed **mannerism**, employed exaggeration, distortion, and expressiveness in an elegant and inventive play on Renaissance conventions. Scholars originally applied the term derisively, implying a derivative or decadent style; they now regard mannerism as a search for new expressive method. The mannerists often toyed with the rules of perspective and proportion, highlighting a tension between pictorial illusion and spatial reality.

Apart from the possible hint at the Madonna and Christ Child in the form of the mother and infant, Giorgione's pastoral scene is entirely non-religious.

Giorgione's brief career contrasts with the life of Titian (c. 1488–1576), a master of color who became the wealthiest and most successful artist of his day. While Michelangelo's energies were absorbed by the new St. Peter's, Titian [TEE-shun] fulfilled commissions for the Italian aristocracy. One of his most striking works, *Bacchus and Ariadne* (Fig. **9.32**), is a celebration of the pagan spirit, painted to decorate a duke's country home at Ferrara in northern Italy. The wine god Bacchus impetuously leaps from his chariot to wed Ariadne. The entire picture is dominated by exuberant blue, gold, and pink, reflecting the mood of the revelers who crowd in from the right. The torsion and movement in the figures provide a sharp contrast to the restful harmonies of much High Renaissance painting.

The late Renaissance witnessed the international success of women artists such as Sofonisba Anguissola [ahn-gwee-SOH-lah] and Lavinia Fontana, both from northern Italy. Sofonisba (1532?–1625) excelled as an innovative portraitist whose works were sought by an international clientele. Her group portraits depicted the subjects engaged in conversation and play, rather than mutely facing the viewer (Fig. **9.33**). While Anguissola spent twenty years as a court painter in Spain, Fontana (1552–1614) worked at the papal court in Rome. The success of these artists encouraged male teachers to take women pupils, finally opening the profession of painting to talented young women.

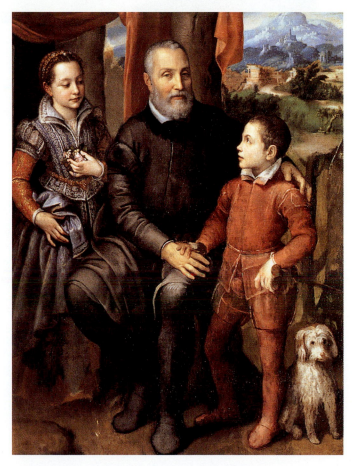

9.33 Sofonisba Anguissola, *The Artist's Family: Minerva, Amilcare, and Asdrubale*, c. 1557–8. Oil on canvas, 61¾ x 48 ins (157 x 122 cm). Nivaagards Malerisamling, Niva, Denmark.
Anguissola was among the first European portraitists to depict her subjects in moments of play or, as here, familiar intimacy.

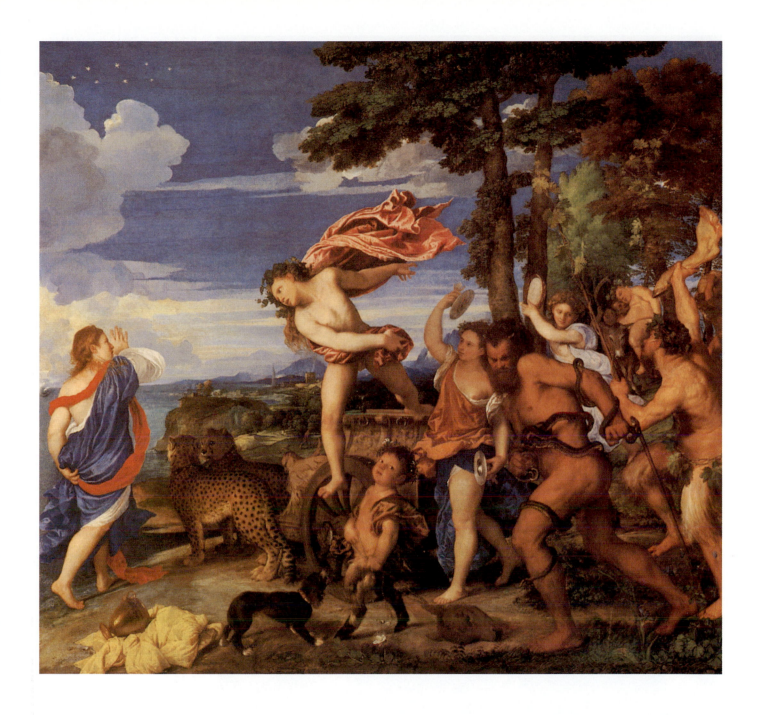

9.32 Titian, *Bacchus and Ariadne*, c. 1520. Oil on canvas, 5 ft 8 ins x 6 ft ⁷/₈ ins (1.73 x 1.85 m). National Gallery, London. The first Renaissance artist to earn a fortune by his skills, Titian excelled at every type of Renaissance subject, including portraiture and sacred themes. Here notice the painting's dynamic composition, created by dividing it diagonally. Bacchus' revelers fill one triangle at right, while Ariadne stands alone in the triangle on the left. The leaping Bacchus connects both triangles at the center.

The carefully refined distortions of the mannerist style are visible in the *Madonna with the Long Neck* (Fig. **9.34**) by Parmigianino [PAR-mee-juh-NEE-noh] (1503–1540). The central figures violate the rules of proportion that

had been elaborated by Renaissance studies of anatomy. The Christ Child lolls in his mother's arms like a corpse. The row of unfinished columns echoes the Madonna's vertical form, but the use of perspective is unorthodox, abandoning the carefully balanced pictorial space of the Renaissance style. The mannerist painter Jacopo Pontormo exulted in mannerism's stylistic license. His scene of the *Deposition* (Fig. **9.35**) contorts postures and compresses the pictorial space to create a sense of a cosmos violated by the death of Christ. The gazes and gestures of the participants in this sorrowful drama lead the viewer's gaze outward to the picture's borders, rather than inward to Christ's body.

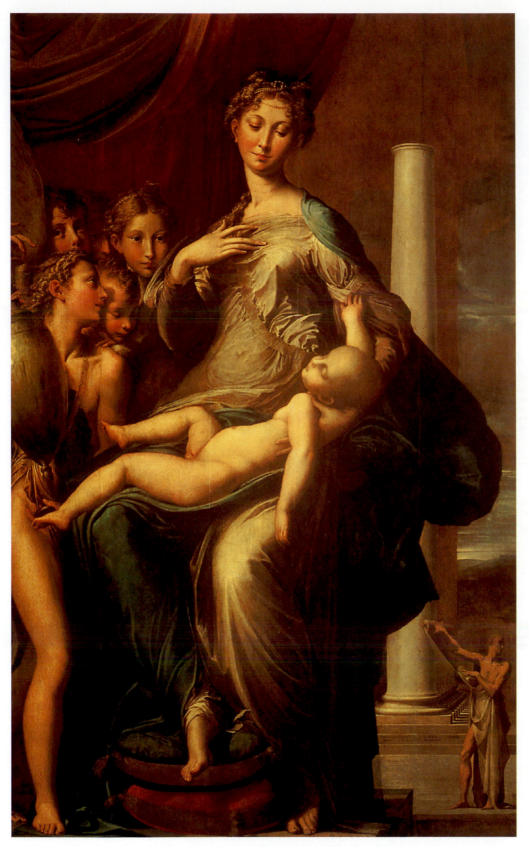

9.34 *(left)* Parmigianino, *Madonna with the Long Neck*, 1534–40. Oil on panel, 7 ft 1 ins x 4 ft 4 ins (2.16 x 1.32 m). Uffizi, Florence. Mannerist painters toyed with Renaissance techniques of spatial scale and proportion. In this image, compare the space at left, with its crowded band of angels, to the space at right, where the prophet Isaiah stands before the columns of an unfinished classical building.

9.35 *(opposite)* Jacopo Pontormo, *Deposition*, c. 1528. Oil on wood, 10 ft 3 ins x 6 ft 4 ins (3.13 x 1.92 m). Santa Felicità, Florence. Mannerist distortion of anatomy and compression of pictorial space lend a bizarre pathos to Pontormo's version of this conventional religious subject. The bearded figure in the upper right is a self-portrait of the artist.

9.36 *(opposite. below)* Jacopo Tintoretto, *Last Supper*, 1592–4. Oil on canvas, 12 ft x 18 ft 8 ins (3.65 x 5.7 m). San Giorgio Maggiore, Venice. The pious Tintoretto's works were fired with Counter-Reformation religious enthusiasm. The apostles and Christ are crowded behind an obliquely angled table, while the smoking lantern and ghostly angels illuminate ordinary servants and house pets attending the feast.

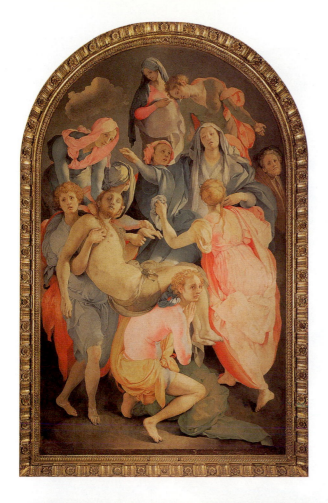

The mannerists' experiments with pictorial space freed the Venetian painter Jacopo Tintoretto (1518–1594) to present traditional Christian subjects in dramatic new ways. In Tintoretto's *Last Supper* (Fig. **9.36**), Christ is nearly lost among the disciples arranged along the table's plunging diagonal line. The lantern's smoke is transmuted into angels, much as the wine and bread of the Eucharist are mysteriously transubstantiated into the blood and body of Christ.

This stylistic ferment reached Spain in the person of El Greco (c. 1541–1614), who combined Renaissance technique with subjects of intense Catholic religiosity. Born Domenikos Theotocopoulos [THAY-o-to-KOH-po-luss] on the Greek island of Crete, the young El Greco (in Spanish, "The Greek") trained as a painter in Venice, where he absorbed the lessons of Titian and the Italian mannerists. Around 1570, he resettled in Toledo, Counter-Reformation Spain's most religious city, and there he spent his career painting portraits and religious subjects for Toledo's churches.

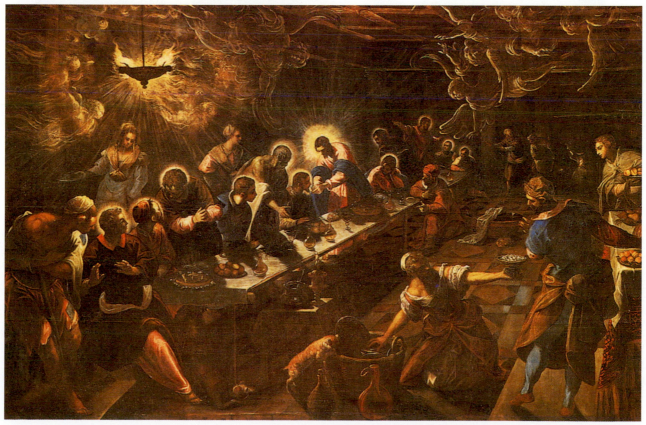

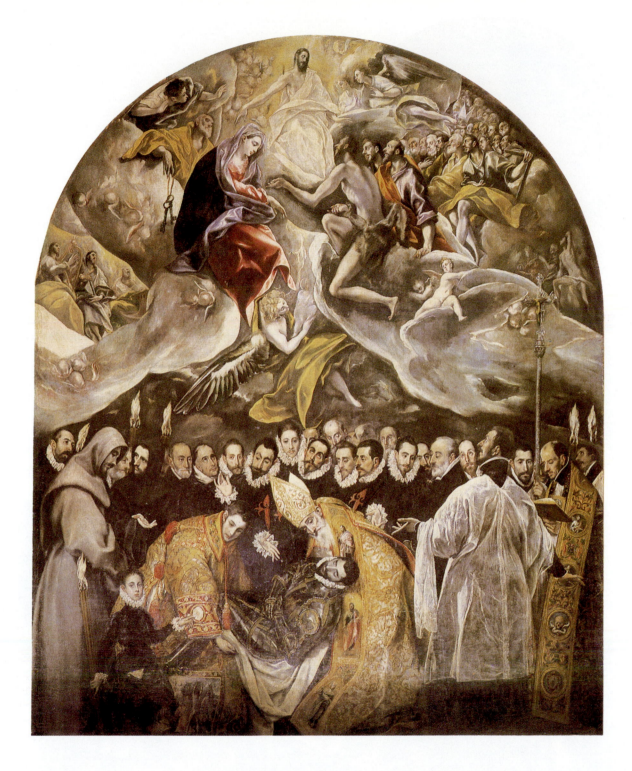

9.37 El Greco, *The Burial of Count Orgaz*, 1586. Oil on canvas, 16 ft x 11 ft 10 ins (4.88 x 3.61 m). Santo Tomé, Toledo, Spain.

Trace the picture's horizontal and vertical axes. Note the contrary motion along the vertical axis (the count's soul flying up to heaven, his armored body falling into the crypt below) and the vividly realistic style of the human mourners versus the mannerist stylization of the host of heaven.

Typical of El Greco's church commissions is *The Burial of Count Orgaz* (Fig. **9.37**), painted above the count's tomb in a small church. The painting shows El Greco's command of color and a philosophical depth reminiscent of Raphael. *The Burial of Count Orgaz* pays homage to a saintly knight at whose funeral St. Stephen and St. Augustine supposedly appeared. In heaven, El Greco shows the austere figures of the Virgin Mary and John the Baptist imploring Jesus to accept the count's soul. The clarity of color in the faces and costumes below yields to an acid contrast of blues, yellows, and greens in the heavenly host above. The painting's lower half states his debt to Titian, the Renaissance master; the upper half acknowledges his debt to mannerism. The dynamic whole announces a new stylistic synthesis that would be called the baroque.

CHAPTER SUMMARY

The Reformation In 1517 Martin Luther initiated a religious revolt called the Reformation that eventually split the Western Church into Protestant and Roman Catholic faiths. Luther's treatises disputed the authority of the pope and challenged religious practices that had no basis in Christian scripture. The Reformation appealed to its largely German followers with a message of simple piety and religious freedom, and a critique of religious corruption. A second wave of Protestant reformation was initiated in Switzerland by the John Calvin, whose strict teachings stressed a "Protestant ethic" – moral uprightness, thrift, and the predestination of a righteous elect. Calvinists in France and Scotland questioned the authority of kings and championed popular rights.

The Rise of Northern Europe As Lutheran reformers rocked northern Europe, its economic dynamism began to create the early modern world. A commercial revolution and the discovery of the New World helped European monarchs consolidate their power. These rulers – especially in Spain, France, and England – recruited Italian artists to design and decorate their courts, while also supporting the northern art of tapestry.

Art and Humanism in Northern Europe Working in oil, Northern Renaissance painters such as Jan van Eyck perfected a new kind of pictorial realism. Hieronymus Bosch used a hallucinatory realism in fierce pictorial sermons against human sinfulness. Northern artists' piety and emotionalism existed alongside the classicism of Dürer, the only northern painter concerned with Italian humanism. Bruegel avoided religious subjects, and frankly depicted the humble and timeless life of European peasants.

Northern Europe's greatest intellect, Erasmus, was an evangelical humanist who exposed the pretensions and hypocrisy of humanity in his satire *In Praise of Folly*. As a scholar, Erasmus translated biblical texts and engaged Luther in debates on human nature and freedom. Erasmus's English friend Thomas More criticized early modern society's shortcomings in *Utopia*, while, in his essays, the French skeptic Montaigne questioned intellectual vanity and relied on his own experience for insight.

The Elizabethan Age In England, Henry VIII's split with the Catholic Church aroused bitter religious divisions. When the wise queen Elizabeth I restored religious toleration, a new prosperity spawned the glittering Elizabethan Age. Elizabethan theater produced England's greatest dramatist, Shakespeare, a man of the theater who succeeded by his verbal inventiveness and theatrical instincts. As with the theater, Elizabethan music adapted Italian forms to English audiences and served the cult of Elizabeth. English composers excelled in the madrigal and other song forms.

The Late Renaissance in Italy and Spain In Italy and Spain, the Counter-Reformation reacted resolutely against the reformers. Ignatius of Loyola spurred a new wave of Catholic religious enthusiasm. The composer Palestrina reflected the new conservatism in his simplified and refined Renaissance polyphony. The Renaissance theater imitated classical dramatic forms and achieved significant advances in stage design. In Venice, the arts expressed the city's exuberant spirit and festive public life. Venetian composers developed a polychoral style suited to the unique architecture of the city's cathedral. The architect Palladio built grand residences and churches according to strict neoclassical rules. The versatile painter Titian used a mastery of color and Renaissance form to serve Venetian patrons, while mannerists in Italy and El Greco in Spain sought a new expressiveness in stretching and distorting the principles of Renaissance art.

10 The Spirit of Baroque

LA BASILICA VATICANA

10.1 Giovanni Piranesi, *Aerial view of colonnade and piazza of St. Peter's, Rome*, 1751. Copper engraving, $17^7/_8 \times 27^1/_2$ ins (45.5 × 70.1 cm).

Bernini's vast baroque square, with its monumental colonnade, symbolized the Counter-Reformation Catholic Church's invitation to renewed belief. One and a half million worshipers could gather here to receive the pope's blessing on holy days.

Like great arms reaching to embrace the faithful, the colonnade of St. Peter's in Rome beckoned all to wonder at the Catholic Church's great Renaissance project, now completed by the artistic genius Gianlorenzo Bernini (Fig. **10.1**). But even Bernini's mammoth square could not contain the dynamic new spirit of the baroque, driven by a restless search for truth and grand ambition in every capital of Europe. This spirit of baroque – the love of extravagant and monumental beauty, the tension between simplicity and embellishment, the conflict between science and faith – characterized the seventeenth century in Europe. While Baroque kings and popes built palaces and collected art, a new science was mastering the mysteries of the cosmos and reshaping the Western civilization. This dynamic era – roughly 1600 to 1700 – was the time when modern science and modern government were born. It left an indelible mark on the Western world.

The Baroque in Italy

Identify important features of Italian baroque art and music.

The tumultuous seventeenth century gave rise to an artistic style that reflected the age's dynamism and division. We now call this the baroque [bar-OKE] – originally a disparaging term that may be derived from a Portuguese word for a misshapen pearl. The baroque style took different forms in Europe's nations and colonies, reflecting the different audiences it had to satisfy in Italy, Spain, France, and the Netherlands.

In Italy, the Catholic Church had withstood the challenge of the Reformation and celebrated its victory with a flurry of new building and artistic patronage that exceeded even the splendor of the Renaissance. To a renewed religious devotion, the Italian baroque style added a love of ornamentation, a flair for the dramatic and theatrical, and a dedication to works of monumental scale.

Bernini and Counter-Reformation Rome

When Maffeo Barberini became Pope Urban VIII in 1623, he said to the artist Bernini: "Your luck is great to see Cardinal Maffeo Barberini pope; but ours is much greater to have Cavalier Bernini alive in our pontificate." Gianlorenzo Bernini (1598–1680) possessed an inexhaustible imagination and the energy to see his works through to completion. His sculpture infused Renaissance technique with the dynamism and emotional force of the baroque style. His *David* (Fig. **10.2**), for example, provides a vivid contrast to Michelangelo's Renaissance *David* (see Fig. 8.26). As the giant Goliath approaches, Bernini's David prepares to cast his stone, creating the diagonal twisting so typical of baroque sculpture and

painting. The determined grimace on David's face may be a self-portrait of Bernini's facial expression as he worked intensely at the stone.

Spurred by Rome's last great burst of Church-sponsored patronage, Bernini surpassed the Renaissance titans in ambition and virtuosity. Commissioned to complete and decorate St. Peter's basilica, Bernini built an immense altar canopy of gilded bronze, to stand beneath Michelangelo's imposing dome. Abandoning his predecessors' classicism, Bernini supported the canopy or *baldacchino* (Fig. **10.3**) with twisted columns, ornately covered with laurel leaves (an emblem of his Barberini patron). As a triumph of sculpture and architecture, the *baldacchino* [bal-da-KEE-noh] mediates between the human worshiper and the superhuman scale of Michelangelo's basilica.

Bernini's masterpiece of illusionism and virtuoso technique is the Cornaro Chapel. The chapel's sculptural

10.2 Gianlorenzo Bernini, *David*, 1623–4. Marble, height 5 ft 6¼ ins (1.68 m). Borghese Gallery, Rome.
The figure's tension and energy extend from the furrowed brow to the toes of the right foot, which clench the edge of the supporting plinth. The Cardinal Borghese, for whom this work was executed, was one of baroque Rome's most important art patrons. The cardinal's Roman villa is now an important museum.

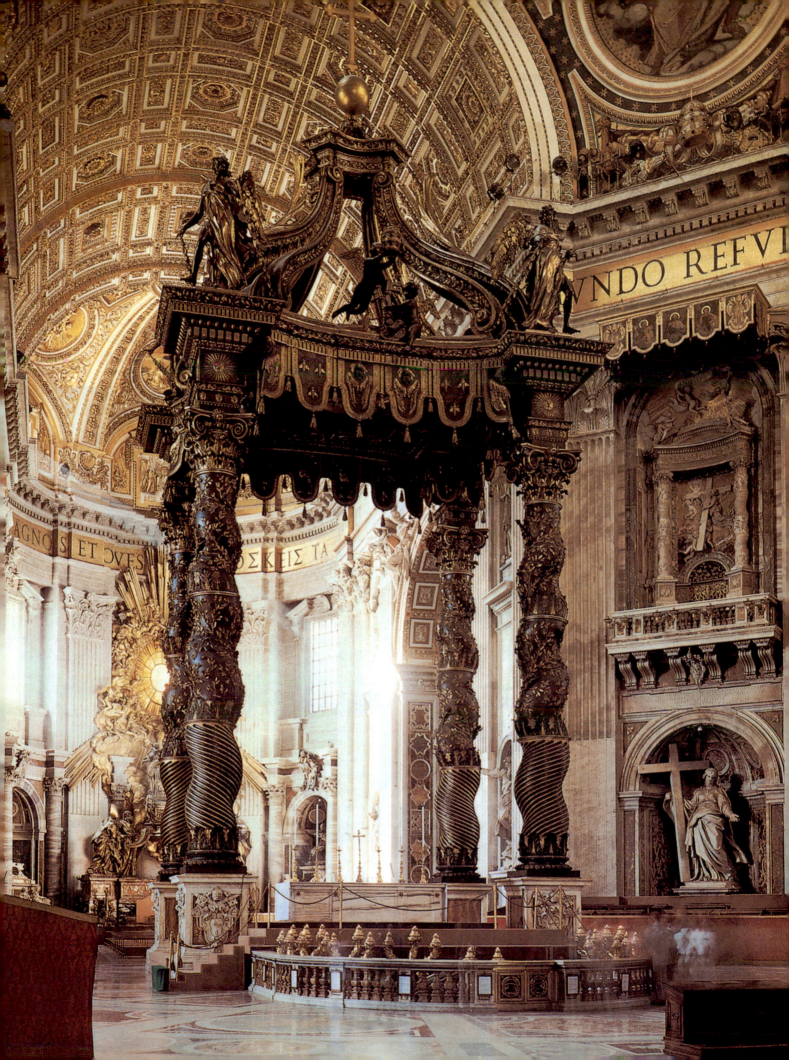

The Taj Mahal

As European conquerors and missionaries colonized the Americas, Islam had extended its influence into India. From 1526 to 1761, a succession of Muslim rulers in India established the **Mughal empire**, and under their reign India prospered from growing international trade. The first Mughal [MOO-gahl] conquerors originated in central Asia, descended from Mongols (hence the name Mughal or Mogul) but emphasizing their Turkish heritage. The Mughal rulers intermarried with Hindu nobility, and their civilization blended Muslim, Persian, and Indian cultures.

The most celebrated art work of the Mughal period was a tomb, the of Taj Mahal (Fig. **10.4**) at Agra in northern India. In general, Mughal rulers were more inclined to build monuments and tombs than Muslim mosques or shrines. The Taj Mahal [TAHZH muh-HAHL] followed a longstanding Turkish custom of commemorating a man's devotion to a woman — in this case, Mumtaz-i-Mahal, the favorite wife of Shah Jahan (ruled 1628–1658).

In form, the Taj Mahal is a cube surmounted by a bulbous central dome, with archways on the four sides leading into the octagonal central space. The white marble building rests on a pink sandstone base and is approached by long reflecting pools on two sides. The building's setting is perhaps its most spectacular aspect, overlooking a river and set between a hospice and a mosque.

On the exterior and interior, the Taj Mahal is decorated with arabesques inlaid with semiprecious stones, Qur'anic script, and stone floral mosaics. The decoration is a blend of Islamic themes and the native Indian skill in stonecutting. Symbolically, the entire complex is both a profession of love and a vision of the Muslim paradise. A Mughal poet said the Taj Mahal was "wrapped in a veil of concord with the air."

10.4 Taj Mahal, Agra, India, 1632–48.
The tomb of a Mughal emperor's wife, the Taj Mahal floats on a pedestal of pink stone, above a garden and reflecting pools that suggest the pleasures of Islamic paradise. Compare the Taj Mahal's symmetry and balance to European neoclassical buildings like El Escorial in Spain (Fig. 10.15) or St. Paul's Cathedral in England.

10.3 *(opposite)* Gianlorenzo Bernini, altar canopy ("Baldacchino") of St. Peter's, Rome, 1624–33. Gilt bronze, height approx. 100 ft (30.5 m). Gianlorenzo Bernini's decoration of the new St. Peter's was one of the greatest and most expensive undertakings of the baroque era. The undulating columns and volutes of Bernini's altar canopy provide a baroque counterpoint to the classical regularities of Michelangelo's dome and vaulting. Visible behind the canopy is the Throne of St. Peter, Bernini's last grand addition to the basilica.

10.5 Gianlorenzo Bernini, *Ecstasy of St. Teresa*, 1645–52. Cornaro Chapel, Santa Maria della Vittoria, Rome. Marble and gilt bronze, life-size.

In a depiction of St. Teresa's ecstatic vision, the angel of God pierces Teresa's heart with the barb of divine love. The drama seems to be illuminated by the light of God; actually, the light comes from a hidden window above the sculpture.

10.6 Gianlorenzo Bernini, Cornaro Chapel, Santa Maria della Vittoria, Rome, 1640s.
Observe Bernini's baroque fusion of the arts in the theatrical setting for the *Ecstasy of St. Teresa*. It includes a complex architectural niche for the main sculpture, backed by gilded rays of divine light; an elaborate ceiling painting; and, most unusual, sculpted figures of the Cornaro family in balconies at either side. The family views Teresa's dream as if it were a staged drama.

centerpiece, the *Ecstasy of St. Teresa* (Fig. **10.5**), depicts the saint's ecstatic union with God. In sensuous language, Teresa described her vision of an angel:

> In his hands I saw a great golden spear, and at the iron tip there appeared to be a point of fire. This he plunged into my heart several times so that it penetrated to my entrails. When he pulled it out, I felt that he took them with it, and left me utterly consumed by the great love of God. The pain was so severe that it made me utter several moans. The sweetness caused by this intense pain is so extreme that one cannot possibly wish it to cease, nor is one's soul then content with anything but God.[1]

In Bernini's depiction, the angel (which is also a cupid, symbol of erotic love) has withdrawn his spear. Teresa's lidded eyes and limp body demonstrate that she is overwhelmed by the "gentle wooing" of God, consumed in equal measure by sweetness and pain. The angel is draped in a swirling gown, while the sculptural group seems to float on a heavenly cloud. The sculpture's illusionism is underlined by its theatrical setting in the Cornaro Chapel (Fig. **10.6**), where sculpted figures of the Cornaro family witness Teresa's vision and respond with

10.7 St. Peter's, Rome, aerial view. Nave and façade by Carlo Maderno, 1606–12; piazza, colonnades designed by Gianlorenzo Bernini, 1656–63. Height of façade 147 ft (44.8 m), width 374 ft (114 m).
Carlo Maderno's gigantic façade, with columns more than twice the height of the Parthenon's in Athens, completed the century-long project begun by the Renaissance pope Julius II. The baroque master Gianlorenzo Bernini designed the colonnaded piazza, which resembles a giant keyhole, symbol of the keys to God's kingdom that Christ gave to St. Peter.

pious emotion and debate. The entire work is a kind of primer of baroque religious emotionalism.

In 1656 Bernini, already the age's greatest sculptor, undertook baroque Rome's last great monument: a public square in front of St. Peter's basilica. Bernini's piazza (Fig. **10.7**) had to begin at the wide façade; narrow to allow for existing buildings; and then widen into a broad plaza, where thousands could gather to receive the pope's

10.8 Plan of St. Peter's and piazza, Rome, 1656–63.

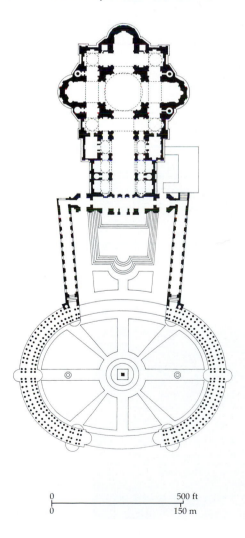

10.9 Francesco Borromini, Interior of dome of San Carlo alle Quattro Fontane, Rome, c. 1638. Width approx. 52 ft (15.8 m). Borromini's intricate dome caps a space that is no larger than a single pier of St. Peter's. Working in such compact dimensions, Borromini managed a design of baroque dynamism and illusionist effect.

blessing. Bernini's solution was a triumph of ingenuity. Flanking colonnades defined a trapezoidal forecourt, then opened into a gigantic ellipse like huge arms to enclose the faithful masses (Fig. **10.8**). Bernini completed St. Peter's with a triumphant baroque flourish, expanding its setting on a monumental scale and providing a dramatic entrance to the church of Bramante and Michelangelo.

Alongside such works of stupendous scale, Counter-Reformation Rome also nurtured artistic projects of subtlety and intricate sophistication. One was the Church of San Carlo alle Quattro Fontane (1638–1641), designed by Bernini's architectural rival Francesco Borromini (1599– 1667) (Fig. **10.9**). Borromini laid out the tiny church's ground plan in a complex scheme of overlapping

The Baroque in Italy **263**

triangles, circles, and ellipses. Above the undulating walls is an elliptical dome with coffers in eccentric shapes. The coffers shrink as they rise toward the central window, creating the illusion of a much higher dome.

Italian Baroque Painting

The Italian painter Michelangelo Caravaggio (1573– 1610) used dramatic contrasts of light and dark to depict realistic biblical scenes. Caravaggio's [kair-a-VAH-jee-oh] biblical characters looked so much like Italian peasants that his work was often rejected by his patrons, who preferred idealized, conventional treatments to the graphic realism and contemporary settings of his paintings.

The *Calling of St. Matthew* (Fig. **10.10**) depicts a rude tavern much like those that Caravaggio frequented in his brief, turbulent life. On the left, Matthew is shown among a group of finely dressed Italian courtiers, who count the day's tax collections. Into this humble room steps Christ himself, accompanied by St. Peter. Christ calls Matthew to leave a dark world of sin and error

(Matthew 9:9). The call is issued not from Christ's shadowed face, but in the warm shaft of light that flows from an unseen window. Caravaggio's message is much in the spirit of baroque religiosity: even a despised tax collector may be lifted from sin's darkness by the sudden light of God's grace.

Caravaggio's dramatic use of *chiaroscuro*, or effects of light and shadow, quickly influenced artists in Italy and eventually throughout Europe. In Italy, one inventive follower was the artist Artemisia Gentileschi [jen-ti-LESS-kee] (1593–1652), whose life and career demonstrate the challenges of being a female artist in Europe in the seventeenth century. As a pupil, Gentileschi was sexually abused by the painter employed by her artist father to train her. After a scandalous rape trial, Gentileschi resumed her career in Naples, taking Caravaggio's techniques to give dramatic effect to her paintings. One of Gentileschi's favorite themes was Judith and Holofernes, a Hebrew legend widely illustrated in Renaissance and baroque art. The Israelite heroine saved her besieged city by murdering Holofernes, commander of the attacking

10.10 Caravaggio, *The Calling of St. Matthew,* c. 1597–8. Contarelli Chapel, San Luigi dei Francesi, Rome. Oil on canvas, 11 ft 1 ins x 11 ft 5 ins (3.38 x 3.48 m). Caravaggio's dramatic use of light and dark defined a style eventually imitated by many others, including Rembrandt. Here, as Christ calls Matthew to discipleship, the tax collector (pointing to himself) responds with bewilderment. Christ's languid gesture is reinforced by the angled stream of light pouring into the room from the right. Note the picture's symbolic contrasts: light vs. dark, rich garments vs. simple cloaks, dueler's sword vs. disciple's staff.

10.12 Claudio Monteverdi, *Tu se' morta* (*You are dead*), recitative from *Orfeo*, 1607.

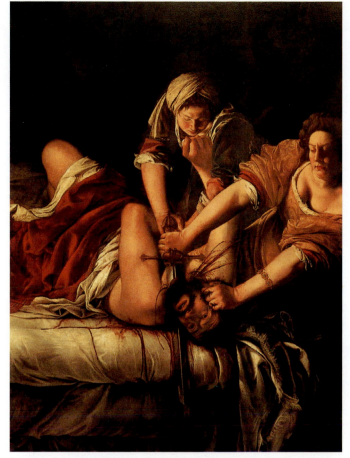

10.11 Artemisia Gentileschi, *Judith Slaying Holofernes*, c. 1620. Oil on canvas, 6 ft 6¹/₃ ins x 5 ft 4 ins (1.99 x 1.63 m). Uffizi, Florence.
Gentileschi painted several versions of the story of the Israelite heroine Judith, who slays an Assyrian general besieging her city. Note the "Caravaggesque" use of a dark background and brightly lit foreground action and the radiating lines that draw the eye to the central action.

Assyrian army (Fig. **10.11**). The brilliant foreground lighting pushes the action forward toward the viewer, increasing the sense of horror and violence.

The Birth of Opera

By the middle of the seventeenth century, Italy was already losing the preeminence in the visual arts that it had held since the early Renaissance. In opera, however, Italy was to retain its position of superiority. **Opera** is musical theater in which all or most of the dialogue is sung, usually accompanied by an orchestra and staged with elaborate costumes and sets. It thus fuses the arts of music, theater, painting, and dance, making it one of Western civilization's most complete and extravagant artistic forms. Opera was born in the experiments of the

Florentine Camerata (see page 246), grew to maturity in the baroque houses of Venice and Rome, and spread from Italy throughout Europe.

The first great operatic composer was Claudio Monteverdi (1567–1643), who was also a master of the madrigal and other musical forms. At the court of Mantua in 1607, Monteverdi [mohn-te-VAIR-dee] produced the first operatic masterpiece, *Orfeo* [or-FAY-o], based on the myth of Orpheus's journey to the underworld to rescue his beloved Euridice. Until this performance, opera had consisted of **recitatives** that told the story in a half-sung, half-spoken tone of limited emotional range. Monteverdi expanded the recitative musically to convey the intense feelings of his characters. In a famous solo, *Tu se' morta* (*You are dead*; Fig. **10.12**), Orpheus grieves his lover's death in a melodic line that draws him toward the underworld.

> You are dead, my life,
> and I breathe?
> You have left me,
> Never, never more to return,
> and I remain?[2]

Monteverdi applied the Renaissance technique of word-painting to reflect his characters' emotional state. More frequently than Palestrina, he used **chordal dissonances**, groups of tones that caused the listener to feel discomfort and to anticipate a resolution. This emotional expressiveness in Monteverdi's music corresponded to the interest in human emotion visible in Bernini's sculpture and Caravaggio's painting.

Throughout the seventeenth century, opera continued to develop as an art form. The expansion of recitative gave rise to the operatic **aria**, an independent song. The aria halted the story temporarily while the character revealed his or her feelings in song. The aria was often the occasion for crowd-pleasing virtuoso singing. Gradually, opera evolved into two forms – *opera seria* and *opera buffa*. *Opera seria* was based on the lofty mythological themes favored by courtly aristocrats, while *opera buffa* was comic opera that had broader appeal to the urban

Absolutism

The turbulence and emotion expressed in baroque art reflected deeper and more fatal divisions in seventeenth-century European society. Incessant war and civil disorder ravaged Germany, where the Thirty Years' War (1618–1648) destroyed one-third of the population. England was split by a bitter civil war between the Puritan parliamentarians and the royalists. In 1649 English Puritan rebels beheaded King Charles I (1600–1649), but only eleven years later agreed to a restoration of the English crown.

From this civil war and religious strife, the era's chief political problem emerged: how to maintain social order and the rule of law in the nations of Europe. One solution was to give absolute power to a monarch, who could then subdue the contending factions. This doctrine of **absolutism** dictated that a monarch exercise supreme political power and control over every aspect of national life. An absolutist monarch was able to end quarrels among political factions and impose uniform national laws and economic policies. Although today it is a synonym for tyranny, in the seventeenth century absolutism was a progressive and modern political idea.

Absolutism's leading philosophical defender came from the royalist ranks of divided England. In 1651, while the Puritans ruled England, Thomas Hobbes (1588–1669) published *Leviathan*, which defended the rule of a monarch from a realist and secular perspective. Hobbes's treatise reflected his deep pessimism about humanity. Without a king to rule them, Hobbes believed people could expect a barren life that was "solitary, poor, nasty, brutish, and short." The all-powerful sovereign, or "Leviathan," imposed a brutal but benevolent order on the life of an unruly nation.

One need not share Hobbes's pessimism to see the advantages of the absolutist state. In France, the royal bureaucracy improved the efficiency of government, raised a standing army of half a million, and generously supported the arts. France's king symbolized the nation's unity and international prestige. According to the famous motto attributed to Louis XIV (Fig. **10.13**), *L'état, c'est moi* – "I am the state" – personal homage to the king was an act of patriotism. Indeed, many features of modern political life now associated with republican democracies first arose under the absolutism of the seventeenth century.

CRITICAL QUESTION

Are you generally trusting or mistrustful of central government and authority? Under what circumstances and for what reasons do you support strong action by central government? When and why do you oppose it?

10.13 Hyacinthe Rigaud, *Louis XIV*, 1701. Oil on canvas, 9 ft 1¹/₂ ins x 6 ft 2⁵/₈ ins (2.78 x 1.9 m). Louvre, Paris.
A picture of absolute power: the flowing drapery decorated with the royal lily flower and the stability of Louis's stance, emphasized by the cane and chimney, all state emphatically the king's absolute command of the French nation.

middle class. Both forms were so popular that in 1637 the first public opera house opened in Venice. Similar theaters soon appeared in Rome, Naples, and throughout Europe (Fig. **10.14**), and Italian opera became an immensely popular international form.

Vivaldi and Italian Baroque Music Baroque Venice was a vital musical center in other regards. The Venetian Barbara Strozzi (1619–after 1664) was the first European composer to achieve renown strictly through publication of her works. Strozzi performed not for the public, but only for her learned and liberal father's gatherings of connoisseurs. The Venetian institution of the conservatory – a home and school for orphans – offered girls a new entry to the musical profession, besides family education or the convent. Indeed, the best-known Italian baroque composer, Antonio Vivaldi (1678–1741), spent virtually his entire career as musical director of a conservatory. Vivaldi's demanding works were probably first performed by young female musicians, at fund-raising concerts for the conservatory.

Vivaldi was a master of the baroque **concerto** (or *concerto grosso* [kun-CHAIR-to GROH-so]), a musical form

in which a small group of instruments plays in concert (or "conflict") with a larger orchestra. Vivaldi's most famous work is *The Four Seasons* (1725), a suite of four concertos still widely performed today. The first concerto, *La Primavera* (*Spring*), is in three movements, with alternating tempos (fast-slow-fast). In the first movement of *Spring*, violins dramatize the arrival of spring: its birdsongs, murmuring streams, and sudden thunderstorms. These dramatic episodes are connected by a recurring melody (called a *ritornello*, or "something that returns"), which provides an explicit regularity to the composition. Within this somewhat rigid structure, Vivaldi achieved brilliant variations and embellishments. Music publishers disseminated Vivaldi's music to all corners of Europe, where it was studied by Johann Sebastian Bach and other masters of the later baroque.

10.14 L. O. Burnacini, *Opera on the Cortina*, Vienna, 1665–6. Engraving. Historisches Museum der Stadt, Vienna.
Opera's commercial success in Italy led to the construction of lavish public opera houses throughout Europe. The rows of box seats permitted status-minded patrons to observe each other with as much interest as they viewed the performance.

The Baroque in Spain

Describe the transition from Renaissance to baroque in Spanish art.

In Spain, the baroque style was shaped by two decisive forces: the Catholic Counter-Reformation and the rise of absolutist monarchy. Spanish monarchs patronized major building projects and talented artists, making the Spanish court a center of Catholic piety and baroque style. The Spanish taste for baroque also shaped the colonial style of its American colonies. The atmosphere fostered two artists of universal genius: the painter Velázquez and the author Cervantes.

Spanish Baroque Architecture

Flush with American riches and fired by Counter-Reformation fervor, King Philip II of Spain (ruled 1556–1598), had a stark palace built at El Escorial, about 30 miles (48 km) outside the royal city of Madrid (Fig **10.15**). The building complex functioned simultaneously as a palace for the king, a tomb for the king's father, and a monastery dedicated to St. Lawrence. The entire scheme of the Escorial borrowed from the rigorous classicism of Michelangelo's design for St. Peter's in Rome (see Fig. 8.44) – a debt evident in the dome of the central church. Three generations of Spanish royalty decorated the Escorial's galleries in baroque splendor, financed largely by gold and silver plundered from the Americas.

In Spain's American colonies, governors and missionaries erected baroque-style churches to assert the authority of Christian culture and promote the inhabitants' conversion. At the Inca capital of Cuzco, in modern Peru, the Jesuit church of La Compañía (begun 1651) was literally built on top of ancient Inca walls. La Compañía's distinctive façade contained stacked arches within a unifying trefoil (or cloverleaf) arch and a curving entablature. In Mexico City, the great Cathedral of Mexico (1718–1737), Latin America's largest church (Fig. **10.16**), contained fantastically elaborate interior decoration. Its placement on the site of the Aztec Temple of the Sun, center of the Aztecs' sacred city of Tenochtitlán [tuh-NAHK-tit-LAHN], stated emphatically the triumph of Christian colonialism over native faiths. Baroque elements continued to predominate in Latin American building long after the style had faded in Europe.

Velázquez and Cervantes – Masters of Illusion

The Spanish court of the seventeenth century had a huge appetite for flattering portraits and ornate decoration. The only Spanish-born baroque artist to achieve distinction in royal service was Diego Velázquez [ve-LASS-kess] (1599–1660), court painter for Philip IV from 1623 to his death. As a painter, Velázquez achieved an unerring realism, communicated by bold color and brushwork. Despite his mastery, however, Velázquez was denied the social status that great painters such as Peter Paul Rubens (see page 276) enjoyed in other European nations.

The greatest work of Velázquez, *Las Meninas* (*The Maids of Honor*; Fig. **10.17**), presents itself as a genre

10.15 Juan Batista de Toledo and Juan de Herrera, Escorial Palace, near Madrid, Spain, 1553–84. Engraving. Louvre, Paris.

Like El Greco's paintings, the Escorial Palace was a bridge between Renaissance and baroque styles. The grid-like plan of the palace's inner sections had a gruesome symbolism: it represented the gridiron on which St. Lawrence was roasted to death.

10.16 Cathedral of Mexico (1718–37), Mexico City.
In the colonized New World, the Spanish baroque style symbolized Christian Europe's dominance over native peoples and their pagan religions.

picture, a scene of everyday life. The painting shows a casual moment in the artist's palace studio. Historians have identified the figures of the five-year-old Princess Margarita in her dazzling costume, her attendants, a pair of dwarfs, and the artist, standing before a canvas the size of *Las Meninas* itself. The most enigmatic figures are the king and queen, reflected in the mirror at the rear, and who may be sitting for their portrait. Just as possibly, they could be visiting the painter and thus honoring him in his studio. Velázquez deepens these ambiguities with the figure of the courtier who has opened a door and gazes back at the scene. The composition of *Las Meninas* is apparently accidental, yet it attains a nuance and complexity of composition that appealed to the sophisticated patrons of the baroque era.

The tension between art and life visible in *Las Meninas* also inspired the greatest literary work of the seventeenth century, *Don Quixote*. The idealistic knight Don Quixote [DON kee-HOH-tay] de la Mancha constantly confuses the real world with his chivalric fantasy. Yet he draws others into his idealized world and ennobles them,

much as Velázquez's palpable realism draws the viewer into his illusionary painter's studio.

The author of *Don Quixote* was Miguel de Cervantes (1547–1616), an impoverished veteran of foreign wars, slavery, and debtors' prison. Desperate to overcome the poverty of his own prosaic world, Cervantes [sair-VAHN-teez] created one of the great utopian heroes of Western literature. His character Don Quixote deals with the world as it ideally should be, not as it really is.

The hero of Cervantes' tale begins with an impoverished Spanish noble who has spent too many hours in his library reading popular chivalric romances. Inspired to become a wandering knight, Quixote dresses himself in a ludicrous suit of armor and gains the services of a squire, Sancho Panza. Together, this unlikely pair sally forth on a

10.17 Diego Velázquez, *Las Meninas* (*The Maids of Honor*), 1656. Oil on canvas, 10 ft 5¼ ins x 9 ft ¾ ins (3.18 x 2.76 m). Prado, Madrid.
Velázquez explored the relation between appearance and reality, art and the court, and the artist and patron, with unmatched subtlety.

By including himself with his royal subjects – the princess in the foreground, the king and queen reflected in the mirror on the rear wall – Velázquez slyly assured himself a kind of artistic immortality. The red cross indicates his membership in a noble order usually closed to artists, an honor that Velázquez avidly pursued.

series of adventures (Fig. **10.18**). Don Quixote, the gaunt and aristocratic knight, becomes so enamored of romantic fantasies that, in his eyes, a windmill is a giant and a rude tavern is a castle. Sancho Panza, the coarse peasant, is a realist who marvels at Quixote's delusions. The two extremes of idealism and realism illuminate one another, and highlight the limitations of each of these attitudes.

At this point they caught sight of thirty or forty windmills which were standing on the plain there, and no sooner had Don Quixote laid eyes upon them than he turned to his squire and said, "Fortune is guiding our affairs better than we could have wished; for you see there before you, friend Sancho Panza, some thirty or more lawless giants with whom I mean to do battle. I shall deprive them of their lives, and with the spoils from this encounter we shall begin to enrich ourselves; for this is righteous warfare, and it is a great service to God to remove so accursed a breed from the face of the earth."

"What giants?" said Sancho Panza.

"Those that you see there," replied his master, "those with the long arms some of which are as much as two leagues in length."

"But look, your Grace, those are not giants but windmills, and what appear to be arms are their wings which, when whirled in the breeze, cause the millstone to go."

"It is plain to be seen," said Don Quixote, "that you have had little experience in this matter of adventures. If you are afraid, go off to one side and say your prayers while I am engaging them in fierce, unequal combat."[3]

CERVANTES
From Don Quixote, Part I

10.18 Don Quixote attacking the windmills, from Cervantes' *Don Quixote*, 1863 edition, illustrated by Gustave Doré, Hachette, Paris.
Deluded by his reading of medieval chivalric romances, Cervantes' hero continually mistakes the prosaic inhabitants of his world for characters in imagined knightly adventures.

The novel, first published in 1605, was popular enough to inspire a plagiarized sequel by an anonymous author. Cervantes responded by writing his own Part II (published 1615), in which Quixote's adventures continue and the philosophical complexity of the novel increases. Quixote and Sancho are now famous for their exploits in Part I, and meet characters who seek to manipulate and deceive the heroes. In one telling episode, a friend of Quixote dresses himself as a "Knight of Mirrors," so that when they duel, Quixote is doing battle with his own reflected image. It is a duel that Velázquez might have liked to sketch. Quixote finally is unable to sustain his illusions, and his quest ends with a poignant scene. As Quixote, defeated and dying, relinquishes his chivalrous ambitions, it is Sancho Panza who urges him to revive his fantasies. To live in a disenchanted world is, as Sancho says, to die "in the hands of melancholy."

Throughout his tale, Cervantes explores the mismatch between appearance and reality, the boundary between truth and falsehood. In Counter-Reformation Europe, these were issues of life and death. In religion, the Inquisition – the Catholic tribunal that punished heresy – was executing heretics on the evidence of phantasms and enchantments as illusory as Quixote's windmills. In science, thinkers such as Copernicus [koh-PURR-ni-kuss] and Galileo (see page 286) had to gauge (like Sancho Panza) the mind's inventions against the prosaic evidence of experience. In art, painters told the deepest truths through the skilled manipulation of appearance. Intending to write a popular bestseller, Cervantes wrote a philosophical masterpiece concerning, as one scholar puts it, "the chief intellectual problem of his age."

CRITICAL QUESTION

What have you believed in your past that you now regard as an illusion, perhaps exposed to you now by disenchantment? How do you respond to Sancho Panza's lament that to live without illusion is to live "in the hands of melancholy"?

The Baroque in France

Identify the neoclassical elements of architecture, theater, and music at Louis XIV's court.

The spectacle of power was never better understood, or more carefully manipulated, than during the reign of Louis XIV of France. In 1660 Louis took personal control of the French government with the words, "Now the theater changes." Planning to make France a grand stage for his majesty and power, within a year he began the construction of his palace at Versailles [vair-SIGH]. Louis XIV proved to be a master in the guises of absolutist power, assuming such roles as the "Sun King" in a court ballet and commissioning a commanding portrait bust sculpted by Bernini.

An enthusiast of dance and theater, Louis XIV did not hesitate to enlist the arts in supporting his reign. He exerted absolutist control in cultural affairs via the **academies**, state-sponsored agencies that oversaw training of artists and performers, while also dictating standards of taste. Under Louis XIV, academies governed all the major arts, including theater, dance, opera, and painting and sculpture. Although they brought order to the patronage of art in France, the academies also imposed conservative rules that stifled artistic innovation. These rules depended on the revival of classical Greek and Roman forms, creating a style termed **neoclassical**.

Under Louis's patronage, the French arts finally threw off their dependence on Italian artists and models, enabling France to become an influential cultural center in its own right. For more than a century, France influenced the tastes of foreign rulers who aspired to the magnificence of the court at Versailles.

The Palace of Versailles

The Palace of Versailles was balanced and restrained in its design, yet lavish in scale and decoration – a compromise between baroque excess and neoclassical rules, the ultimate synthesis of styles. Louis XIV's minister Colbert once advised him that "with the exception of brilliant military actions nothing speaks so eloquently of the grandeur and cleverness of princes as buildings." Taking this advice to heart, in 1661 Louis began enlarging his father's hunting château near the village of Versailles, about 20 miles (32 km) outside Paris. The site offered the king's architects and planners the freedom they had lacked in remodeling the Louvre Palace in Paris. The original architect, Louis Le Vau [luh VOH], worked together with designers of the gardens (André le Nôtre) and interior decoration (Charles Lebrun). Later modifications, principally the long projecting wings, were made by Le Vau's successor, Jules Hardouin-Mansart [mahn-SAH(r)]. Together the designers created a unified and symmetrical design (Fig. 10.19), an architectural universe with the king at the center.

The palace complex at Versailles expanded to accommodate Louis XIV's changing vision of the absolutist court. The palace was originally intended as a retreat from the bustle of the Paris court. Soon, however, Louis demanded that the influential French nobility come to live with him at Versailles, where he could control their influence – a move that impoverished the nobility by extravagant living. Eventually the palace accommodated a population estimated at 50,000, including government officials, courtiers, and a sizeable royal family. Aside from the main palace, the Versailles complex incorporated royal stables for 12,000 horses and elaborate gardens covering several hundred acres. As a whole, Versailles projected absolutist power on a vast scale and according to a rationalized scheme that was to influence city planning for the next century.

The palace's garden façade synthesized neoclassical and Italian baroque elements as designed by Jules Hardouin-Mansart (Fig. 10.20). Neoclassical style is evident in the restraint of the three levels of the palace building: a plain ground arcade; the main level with its shallow columned porticos; and the upper level topped by elaborate statues and balustrade. The simplicity and charm of Mansart's façade are dwarfed somewhat by the palace's wings, which stretch nearly 2,000 feet (609 m) from end to end.

Mansart's greatest stroke of genius is visible inside the palace, in the famed Hall of Mirrors (Fig. 10.21). Here, overlooking the garden, Mansart built a row of floor-length windows and on the facing wall placed matching windows of mirrored glass. With its grand length, the brilliant light and gilded decoration of the Hall of Mirrors embodies the lavish splendor of Louis XIV's court.

10.19 *(opposite)* The Palace of Versailles, France, c. 1688. The symmetry and grandeur of the palace of Louis XIV symbolized the king's orderly rule over his nation. The monumental palace was the perfect setting for the spectacle and drama so beloved of baroque monarchs.

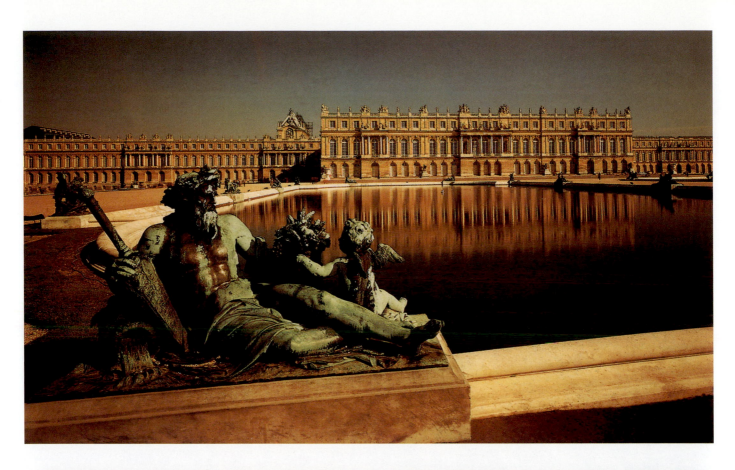

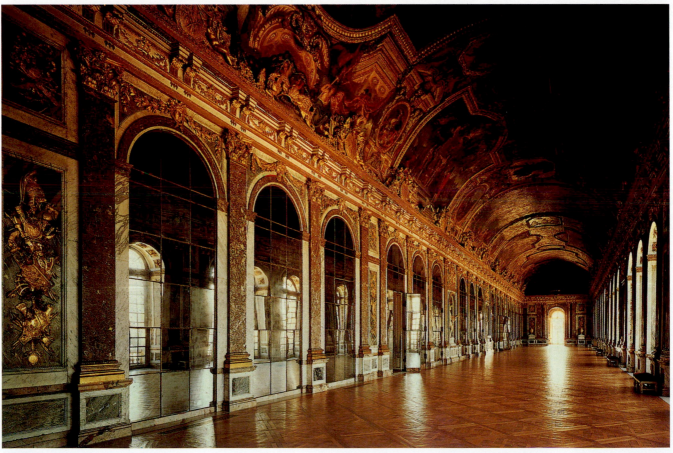

10.20 (opposite, top) Louis Le Vau and Jules Hardouin-Mansart, garden façade, Palace of Versailles, France, 1669–85.
Le Vau and Mansart's façade is a grand statement of the baroque neoclassical style – classical decoration in a building shaped entirely by the baroque taste for grandiosity and spectacle. Supplying the palace's fountains with water required the diversion of an entire river.

10.21 (opposite, bottom) Jules Hardouin-Mansart and Charles Lebrun, Hall of Mirrors, Palace of Versailles, France, begun 1676. Length 240 ft (73.2 m), width 34 ft (10.36 m).
The long hall provided a spectacular setting for the king's daily promenade from his bedroom at one end to his offices at the other. The arched mirrors opposite the exterior windows create a sense of spaciousness that belies the room's modest width.

Theater and Dance at Versailles

King Louis XIV generously patronized the theater and dance of his country, while enforcing stringent control. He granted dictatorial power over the performing arts to the academies, whose influence in the arts dates from 1636, when a royal minister asked a scholarly group called the *Académie Française* to judge a popular tragedy. The Academy quickly became official judge in matters of literary form and taste, imposing strict neoclassical rules on the theater. The Academy decreed that plays performed by Paris's emerging professional theater must be divided into five acts, obey the unities of time and place, and provide an uplifting moral.

Only an exceptional playwright could thrive under these restrictions. The age of Louis XIV could boast of two, the tragedian Jean Racine [rah-SEEN] and the comedian Molière [mohl-YAY(r)]. Jean Racine (1639–1699), following the path of his older competitor Pierre Corneille [kor-NAY-(ee)], presented classical themes in a consciously artificial academic style. Racine's tragedies were strictly governed by the neoclassical unities, concentrating the plot in a single main action and locale. The characters spoke in an exalted rhymed verse, as dictated by the Academy. His themes were usually drawn from ancient Greek tragedy, though Racine's noble characters were often subject to ordinary human weakness and passion. Despite academic restrictions, Racine's tragedies presented a compelling drama of characters driven by their own desires and folly. He was often criticized for being too realistic. The neoclassical tragedies of Corneille and Racine have remained in the standard repertoire of French theater until this day.

> With the exception of brilliant military actions nothing speaks so eloquently of the grandeur and cleverness of princes as buildings.
>
> Jean-Baptiste Colbert, minister to Louis XIV

Jean-Baptiste Poquelin, known as Molière (1622–1673), used his biting wit to attack the hypocrisy and vice of French society. Molière was a playwright, actor, and part-owner of his own theatrical company (Fig. **10.22**) and had early gained the favor of Louis XIV, who granted his company a theater inside the Louvre in Paris in 1658. Several of Molière's masterpieces were first performed at the court of Versailles. Among Molière's greatest comedies were *Tartuffe* (1664), the story of a religious hypocrite, and *Le Bourgeois Gentilhomme* (*The Would-be Gentleman*, 1671), which mocked France's boorish social climbers. Ironically, Molière was acting in his comedy-ballet *The Imaginary Invalid* (1673), the story of a hypochondriac, when he collapsed and died at Versailles. His plays were exceptional in their relentless wit and consistent moral attitude, and showed a careful observation of social manners of the time.

In music and dance, the French court's most important figure was Jean-Baptiste Lully [LOO-lee] (1632–1687), innovator in both French opera and the French court ballet, or *ballet de cour* [ball-AY duh KOOR]. In 1653, Lully was a dancer in the *ballet de cour* that gave young Louis XIV his name "the Sun King." Louis danced the role of the god Apollo, wearing a sun-ray headdress and a solar emblem on his chest. Establishing himself first as a ballet composer at court, by 1661 the Italian-born Lully headed the court's Royal Academy of Music. From this position Lully ruled as virtual dictator over French music, opera, and dance.

Under Lully's régime, French dance was professionalized and the *ballet de cour* evolved into a flexible and unified art form. Court ballets usually featured as interludes

10.22 Molière (Jean-Baptiste Poquelin) as Sganarelle in *The Doctor in Spite of Himself*. Engraving. Bibliothèque Nationale, Paris.
In satirizing French society's hypocrites and social climbers, the comic playwright Molière championed moderation and common sense.

10.23 Jean-Baptiste Lully, performance of the opera *Armide* (1686). Engraving. Bibliothèque Nationale, Paris.
Through his control of the Royal Academy of Music, Lully professionalized French music and dance. He used the staging devices of Italian theater to create spectacular entertainment for his patron, Louis XIV. Here a palace collapses beneath a flight of devils.

and entrées during the performance of a comedy or an opera. However, the playwright Molière incorporated ballet directly into the plot of his comedies, collaborating with the royal dance master and choreographer, Charles-Louis Beauchamp [boh-SHAN(h)]. Traditionally, court dancers were aristocratic amateurs. To train professional dancers, Lully established a dance school at the Academy, where Beauchamp developed the formalized foot and leg positions still used in ballet today. Beauchamp's positions were designed to present the dancers' movements effectively to an audience seated in front of a stage, rather than surrounding the dancers in a palace room or courtyard. Among the French court's other advances were the first appearance of professional women dancers in ballet (1681) and the publication of a manual of choreography (1700) that standardized dance notation.

Lully also proved a versatile operatic composer: in fourteen years he wrote twenty operas that remained standards for more than a century. Like French architecture, French opera grew up under the shadow of the popular Italian version. The French aristocracy preferred their opera with Italian-style elaborate staging and elevated mythological themes (Fig. **10.23**). Lully developed a national style in opera that suited the French desire for pomp and spectacle.

Painting in Baroque France

The seventeenth-century European nobility's favorite painter was a master of the baroque style, Peter Paul Rubens (1577–1640). His works decorated royal palaces from Spain to England, and the artist himself traveled frequently from his native Flanders (now Belgium) to the royal courts of Madrid, Paris, and London. Like Titian, the Renaissance master, Rubens earned a substantial fortune while serving his noble patrons.

Rubens's most famous commission illustrated his flair for dynamic composition and lavish color. In 1621, the artist was engaged to paint the life of Marie de' Medici, dowager queen of France. Ever the charming courtier, Rubens inflated the queen's life story into a monumental series of twenty-one canvases to hang in the new Parisian palace she was building. Rubens made it seem as if the gods themselves had sponsored her career. In one scene, Marie's future husband, King Henry IV, is presented with her engagement portrait by the god Mercury (Fig. **10.24**). Minerva, the helmeted goddess of wisdom, counsels him to accept the match, while Juno and Jupiter look on approvingly from the heavens. Rubens completed the gigantic commission in just four years, employing assistants to paint background detail while he himself painted the figures.

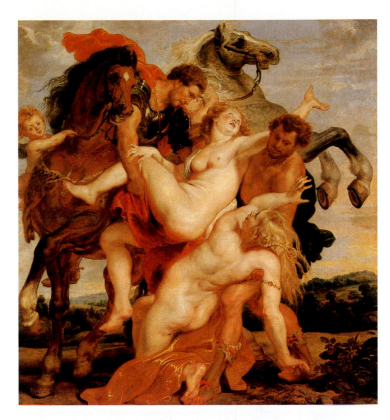

10.25 Peter Paul Rubens, *Rape of the Daughters of Leucippus*, c. 1618. Oil on canvas, 7 ft 3 ins × 6 ft 10 ins (2.21 × 2.08 m). Alte Pinakothek, Munich.
Rubens, a master of baroque dynamism, here presents a striking contrast of textures in the translucent flesh of the nude women, Castor's swarthy skin and shell-like armor, and the dappled horses. Trace the diagonal lines that meet at the painting's center, where the sisters' bodies nearly touch.

Rubens excelled in the favorite themes of European aristocracy: hunting scenes, histories, classical and mythological subjects, and portraits. Such scenes permitted the aristocratic patron to identify with figures of military and romantic prowess. In Rubens's *Rape of the Daughters of Leucippus* (Fig. **10.25**), the two gods Castor and Pollux visit earth to take two mortal women as wives. The two sisters' energetic resistance to their violent kidnapping is emphasized in the twisted forms of their bodies. The furious motion of the picture leads

10.24 Peter Paul Rubens, *Henry IV Receiving the Portrait of Marie de' Medici*, 1622–5. Oil on canvas, 13 ft × 9 ft 8 ins (3.96 × 2.95 m). Louvre, Paris.
Rubens served an international clientele of patrons with his busy workshop. In this scene from the life of Marie de' Medici, former queen of France, Rubens unifies different centers of dramatic interest – the gods Juno and Jupiter above, the portrait of Marie de' Medici itself, the goddess Minerva whispering in the king's ear, the playful cupids – with a sweeping spiral line.

CRITICAL QUESTION
Compare the violence of Gentileschi's *Judith Slaying Holofernes* with Peter Paul Rubens's depiction of the *Rape of the Daughters of Leucippus*. What do the two paintings say about the artists' attitude toward men, women, power, and sexuality?

upward, one sister being lifted awkwardly but inevitably toward heaven.

In contrast to the baroque dynamism of Rubens's paintings, the French painter Nicolas Poussin (1594–1665) was the essence of baroque neoclassicism, in both style and sensibility. While Rubens thrived among the intrigues of the court, Poussin [poo-SAN(h)] fled Paris and spent most of his career quietly in Rome. Poussin's paintings gave a new expression to the tradition of classicism; his human figures were as cool and precisely defined as classical statues.

The clarity of Poussin's style is visible in all his later pictures, which include *The Holy Family on the Steps* (Fig. **10.26**). In this painting, Elizabeth and her infant son John the Baptist – figured on the left – visit the Holy Family, who are framed by a rigorously neoclassical architectural setting. The light and shadow emphasize the pyramidal grouping of the figures. The repeated geometric shapes (rectangular pillars, ovoid vases, cylindrical columns) provide an explicit regularity of structure. Poussin's canvases so fully confirmed academic tastes that they soon became the model for all French painting.

10.26 Nicolas Poussin, *The Holy Family on the Steps*, 1648. Oil on canvas, 28¹/₂ × 44 ins (72.4 × 111.7 cm). Cleveland Museum of Art, 2000, Leonard C. Hanna, Jr., Fund, 1981.18.
The crisp lines and neoclassical settings of Poussin's images helped define French academic-style painting for two centuries. This painting's low horizon emphasizes the strong horizontal lines in the steps and temple roofs, balanced against the rounded vases and baskets. Note also the oddly positioned figure of Joseph at right, posed with an architect's drawing slate and measure.

The Protestant Baroque

Discuss the artistic forms and styles that the Protestant faith encouraged in the baroque era.

The predominantly Protestant regions of northern Germany and the Netherlands nurtured a range of achievements that was very different from that of the Catholic and absolutist nations. The German principalities were politically divided at this time, and suffered greatly from the religious strife and social devastation of the Thirty Years' War (1618–1648). Without absolutist monarchs to impose a national culture, as happened in France and Spain, German nobles often imitated imported French styles. Artists had to find patronage at small German courts or in Germany's prosperous cities. From such modest circumstances emerged the baroque composer Johann Sebastian Bach (1685–1750), who is now acknowledged as one of the world's most prolific musical geniuses (Fig. **10.27**).

By contrast, the Netherlands in this age experienced an upsurge of national feeling and cultural vitality, fueled by vigorous commerce and political independence. Formed from the Protestant northern provinces of the Low Countries, the Netherlands fought a long war, concluded finally in 1648, for independence from the Spanish monarchy. Their war experience left the Dutch suspicious of the extravagant absolutist courts and the Counter-Reformation Catholic Church. Their Calvinist churches were bare, but they decorated the walls of their town houses and public halls with paintings. The vigorous market in painting nurtured a golden age of artistic genius, most famously the painter Rembrandt van Rijn.

J. S. Bach – Baroque Genius

Bach excelled in the musical forms, both secular and sacred, that were regularly performed in Germany's courts and churches. His music typically exhibited two essential features of baroque concert music. One was elaborate **counterpoint**, that is, the combination of two or more melodies of equal importance. The term "counterpoint" is sometimes used as a synonym for polyphony, but traditionally is associated with the age of Bach. The second feature is the ***basso continuo***, a prominent bass line that harmonically supports the polyphonic lines.

Both counterpoint and *basso continuo* are prominent features of the six *Brandenburg Concertos* (1721), which Bach composed for a friend of his noble patron. In the *Brandenburg Concerto No. 2*, a solo ensemble of flute, oboe, trumpet, and violin engage in a polyphonic conversation. A *continuo* provides a harmonic ground. Like his predecessor Antonio Vivaldi, Bach employs a recurring *ritornello* to punctuate the ensemble's melodic explorations.

After serving in noblemen's courts for twenty years, in 1721 Bach was appointed music director and composer of the St. Thomas's choir school in Leipzig, a post of considerable civic and musical prestige. He composed music for the city's four major churches, served as organist for the church of St. Thomas, instructed the choirs, taught at the school, and undertook additional commissions for German nobles. Still, the composer found time to give music lessons to his children and hold musical concerts at home.

For each week's religious service at St. Thomas's church, Bach provided a **cantata**, a choral work which was provided the principal music of Lutheran worship. The text for the cantata was chosen for a particular Sunday or feast day, and celebrated the yearly cycle of the church calendar. Typically, the cantata contained recitative and aria-like forms, and served as a kind of sacred opera for the Lutherans. Bach frequently closed his cantatas with a familiar Lutheran hymn that the congregation might join in singing. For example, Cantata #80 (1715, revised 1740) was composed for the Feast Day of the Reformation and ended with a four-part setting of Martin Luther's famous hymn, "A mighty fortress is our God." The tireless Bach composed about 300 cantatas in all, enough for five complete cycles of the liturgical year.

Though Bach composed no operas, he was the author of a monumental masterpiece of musical storytelling, the *St. Matthew Passion* (1727). A "passion" recounted the last days of Christ's life, and its emotions ranged from the despair of the crucifixion to the triumphant joy of resurrection. The *St. Matthew Passion* is a gigantic work, calling for two orchestras, two choruses, organs, and solo voices. Bach renders the events of Christ's last days

10.27 Johann Sebastian Bach, c. 1746. Engraving.
Bach's younger contemporaries criticized his music for its old-fashioned baroque intricacy and virtuosity, although later generations highly praised these qualities.

and hours in music of an emotional range that shows he might well have succeeded in the opera houses of London or Vienna.

Bach's "Well-tempered Clavier"

Bach's music illustrated the development of a new system of composition in baroque music. As early as 1600, European composers had devised a system of musical keys to replace the traditional modes used by ancient and medieval musicians. In a musical key, the seven intervals between the eight notes of an octave scale are arranged according to a specific formula of whole and half tones (Fig. **10.28**). A musical key's principal pitch, called a **tonic**, serves as a tonal center to the entire composition. For example, a melody written in the key of C usually begins and ends on the tonic C. Baroque composers also learned to transpose a melody from one key to another without altering the tune, a technique called **modulation**. Bach composed a set of musical exercises, entitled the *Well-tempered Clavier* (1722), to prove that a clavier (any stringed keyboard instrument) could be tuned to accommodate all twenty-four major and minor keys. ("Tempered" refers to the tuning, not a mood.) The sense of order and the possibilities for infinite variation in this modal system appealed to the baroque taste for mathematical complexity.

Bach's compositions for the organ and other keyboard instruments exploited fully the major–minor key system, often in the musical forms of prelude and fugue. The **prelude** (also called *toccata*) is a free form designed to show off the keyboard player's virtuoso ability. The **fugue** is a polyphonic musical form in which a theme is developed

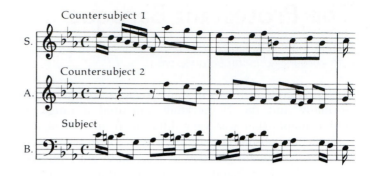

Soprano		S	C₁	S	C₁	S	C₂	S
Alto	S	C₁	C₂	C₂	S	C₁	C₁	
Bass			S	C₁	C₂	C₂	S	
Key	c	g	c	Eb	g	c	c	c

S subject C₁ countersubject 1 C₂ countersubject 2

10.29 Johann Sebastian Bach, *Prelude and Fugue in C Minor*, 1721 (top). Diagram of subject entries (bottom).

through elaborate counterpoint (Fig. **10.29**). The fugue typically begins with a theme (or "subject"), which is answered by another melodic line (the "countersubject"). The voices continue to build, repeating the subject or countersubject and exploring contrapuntal variations. Especially on the organ, which allows three voices (both hands and the foot pedals), Bach's compositions highlighted the virtuosity of composer and player, and appealed to the baroque love of intricacy and embellishment.

Rembrandt and Dutch Baroque Painting

In the baroque era, the Dutch republic – what we know now as the Netherlands – witnessed a free market in painting that bypassed the traditional channels of European artistic patronage. To please anonymous buyers who shopped for paintings in a gallery or market stall, Dutch artists offered individualized styles and subjects suited to modest domestic interiors. They preferred landscapes and cityscapes, portraits, still lifes, and genre subjects

10.28 The major and minor scales.
The keyboards show the formulas of whole and half tones for the major and minor key systems. For the key of C major, the progression C-D-E-F-G-A-B-C can be played on a piano's white keys. Minor keys (A minor is shown here) are built on a different progression of whole and half tones. The key signatures of the major and minor keys show which sharps or flats are required to maintain the proper sequence of whole and half tones.

1618–48	Religious wars in Germany
1632	Galileo, *Dialogue on the Two Chief Systems of the World*; condemned by Church 1633
1639	Descartes, *Discourse on Method*
1642	Rembrandt, *The Night Watch* (**10.33**)
1648	Taj Mahal, Agra, India (**10.4**)
1721	Bach, *Brandenburg Concertos*

such as tavern scenes and domestic interiors. The market could be cruel: the first great Dutch baroque painter, Frans Hals (c. 1581–1666), who was noted for his boisterous portraits of tavern characters, ended his career in poverty. On the other hand, women painters could enter the profession more easily than in countries where a royal academy controlled training and patronage. Judith Leyster (1609–1660), a contemporary of Rembrandt, was the first woman admitted to the painters' guild of her city. Rachel Ruysch (1664–1750) excelled at the popular genre of flower and fruit painting (Fig. **10.30**), and was still painting at the age of eighty-three.

The most remarkable painter of Dutch genre scenes was Johannes Vermeer (1632–1675). Vermeer's feel for

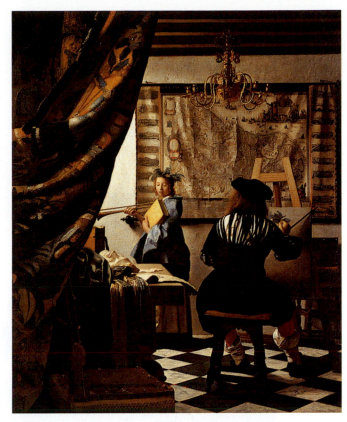

10.31 Johannes Vermeer, *The Allegory of Painting*, c. 1665–70. Oil on canvas, 4 ft ³/₁₈ ins × 3 ft 7¹/₄ ins (1.30 × 1.10 m). Kunsthistorisches Museum, Vienna.
Vermeer's paintings typically showed an interior scene of quiet drama, illuminated by a cool, brilliant northern light. The female figure, costumed as a muse, holds a trumpet and a history book that will someday announce the fame of the anonymous painter in the foreground. Ironically, Vermeer remained largely unknown in art history until the 1800s.

10.30 Rachel Ruysch, *Flowers in a Vase*, 1698. Oil on canvas, 23 × 17¹/₂ ins (58.5 × 44.5 cm). Städel Museum, Frankfurt am Main.
The popular genre of flower and fruit painting involved not only careful botanical observation, but also a moralizing undertone. Ruysch's flowers reminded her Dutch audience of the transience of physical beauty, and the worm on the table top – nature's *memento mori* – warned them of impending death and divine judgment.

the Dutch interior is apparent even in his most philosophical work, *The Allegory of Painting* (Fig. **10.31**), an intricate fabric of allegorical and visual patterns. The painter's model is costumed as Clio, the muse of history. The curtain drawn back on the left and the painter's fanciful costume enhance the painting's theatrical air. A cool light suffuses the entire scene. With this picture, Vermeer seemed to claim for himself and his modest art the respect accorded to tragedy and music, symbolized by the mask and sheet music on the table.

Vermeer was virtually unknown in his day but is now regarded as a master of light and color. There is often a subtle contrast between the naive intimacy of his subject and the objective tone created by light and composition (Fig. **10.32**).

Rembrandt van Rijn [van RINE] (1606–1669) spent most of his career in the Dutch capital of Amsterdam,

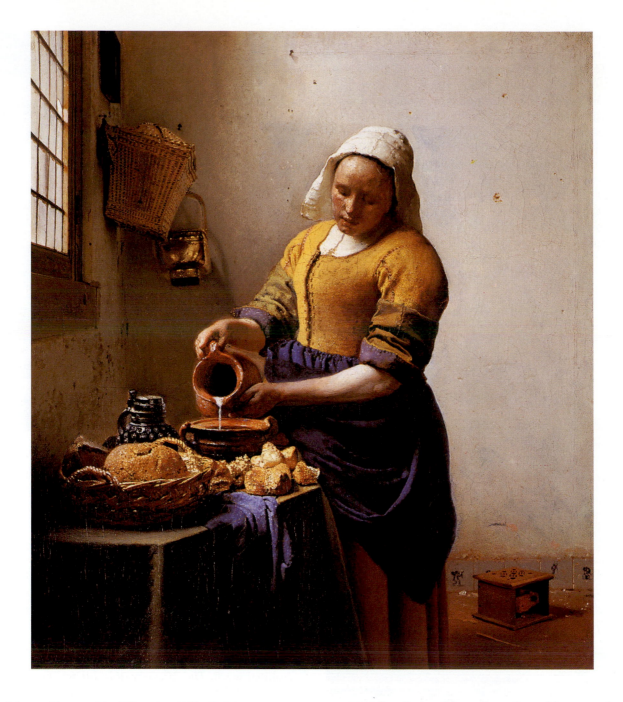

10.32 Johannes Vermeer, *The Milkmaid*, c. 1658–60. Oil on canvas, 17⁷/₈ x 16¹/₈ ins (45.5 x 41 cm). Rijksmuseum, Amsterdam. Vermeer's genre scene lavishes attention on simple objects and modest but enduring truths: bread, milk, and a maid's coarse dress (with its sleeves rolled). The blurred points of light and slightly enlarged foreground objects suggest that Vermeer composed his pictures with a *camera obscura*, a popular seventeenth-century optical device. Note how the modulated light across the back wall emphasizes the maid's figure and the repeated whites to suggest her innocence.

where for a while he enjoyed prodigious success. He was an artist who mastered all the popular subjects of his age, taking from the Italian school of painting his religious and historical themes, and from the Dutch school his scenes of ordinary life and studies of human character. He transcended his peers in the visual and psychological richness of his achievement.

The height of Rembrandt's popularity is represented by the *Sortie of Captain Banning Cocq's Company of the Civic Guard* (Fig. **10.33**), an example of the group portraits often commissioned by Dutch civic groups. The picture was known as *The Night Watch* until a cleaning in the 1940s revealed a daytime scene. Rembrandt shows the guard on march from the city gate, led by the handsome captain and his dandified lieutenant in white. The theatrical lighting strikes the curious figure of the girl, who adds a whimsical air to the solemn occasion. The popular notion that the painting was rejected by

10.33 *(above)* Rembrandt van Rijn,
*Sortie of Captain Banning Cocq's Company of the
Civic Guard* (*The Night Watch*), 1642. Oil on canvas,
11 ft 9¹/₂ ins × 14 ft 4¹/₂ ins (3.59 × 4.38 m).
Rijksmuseum, Amsterdam.

Rembrandt excelled at creating drama and
visual interest in large group portraits like this,
a standard subject of Dutch baroque painting.
Here the muskets, spears, and swords create
a complex rhythm of crisscrossing diagonals.
Note also where Rembrandt has illuminated
faces and figures arbitrarily, applying a theatrical
(rather than naturalistic) principle of lighting.

10.34 *(right)* Rembrandt van Rijn, *Christ Healing
the Sick* (*Hundred Guilder Print*), c. 1649. Etching,
10⁷/₈ ins × 15³/₈ ins (28 × 39 cm). British Museum,
London.

Rembrandt's religious art reflected his interest
in human psychology, particularly the variety of
common humanity. Christ stands at the center,
blessing the needy and healing the infirm, who
crowd through an arch (right). Well-dressed elders
at left criticize Christ's violation of the religious law
prohibiting work on the sabbath.

the group who had commissioned it is unfounded. It was displayed proudly in the company's meeting hall, although one critic claimed that "Rembrandt paid too much attention to the grand design he had invented and too little to the portraits he was commissioned to make." Nevertheless, the painting's size and complexity may be compared to the masterpieces of El Greco and Velázquez (see Figs. 9.37 and 10.17).

Perhaps because of changing artistic fashion, Rembrandt suffered a loss of patronage in the 1640s. At the same time, his wife died and he floundered in self-imposed personal and financial difficulties. During this period, Rembrandt created his most famous religious work, the etching of *Christ Healing the Sick* (Fig. **10.34**), also called the *Hundred Guilder Print*. In etching, lines are scratched on a wax-covered metal plate; the plate is

Empiricism

The philosopher John Locke's question was bold: "Let us then suppose the mind to be, as we say, white paper, void of all characters, without any ideas; how comes it to be furnished?" he asked in his *Essay Concerning Human Understanding* (1690). The answer was bolder still: "To this I answer, from experience."

No ideas except from experience – that is the philosophical motto of **empiricism**, and Locke's *Essay* was the most important statement of empiricism in seventeenth-century European thought. Locke argued that the human mind began as a *tabula rasa*, a blank slate. The mind was "furnished" with ideas from two sources of experience: the observation of external objects (sensation) and of its own inner workings (reflection). Every idea of human thought came from these sources. No ideas were innate. Locke's entire *Essay on Understanding* was,

therefore, a veiled attack on Descartes and his philosophical rationalism (see page 286). Where Descartes relied on "clear and distinct ideas" that were intuitively true, Locke dealt in ideas that were "determinate or determined" – determined by the mind's contact with experience.

The opposition of Cartesian rationalism and Lockean empiricism still inhabits scientific thought today – in debates on the acquisition of language, for example. But their disagreement is easily overstated. Both philosophers were pioneers in the **epistemology** of modern science – that is, the philosophical explanation of what humans know and how they know it. Locke's *Essay* provided an epistemological underpinning for science's empiricist practice. The Scottish philosopher David Hume (1711–1776) took empiricist skepticism a step further

10.35 Rembrandt van Rijn, *The Anatomy Lesson of Dr. Tulp*, 1632. Oil on canvas, 66⁵/₈ ins x 85¹/₄ ins (169.5 x 215.5 cm). Royal Cabinet of Paintings, Mauritshuis, The Hague.
An important application of empirical method in the realm of science was the dissection of a cadaver, and as such it formed a major academic occasion. Here it is depicted by Rembrandt with deference to the professor's vanity. The corpse's feet are most likely propped on a copy of *Vesalius' Anatomy*, the first modern work of human anatomy.

THE WRITE IDEA

Both Vermeer's *The Allegory of Painting* (Fig. 10.31) and Rembrandt's *Self-portrait* (Fig. 10.36) concern the artist's search for fame. Interpret what each seems to be saying about his artistic craft and himself. Compare the "face" that each presents to the world and to history.

treated with acid that "etches" the exposed metal; prints are then taken from the plate. The technique was well suited to Rembrandt's interest in light, and Rembrandt frequently reworked etching plates to enhance the effects of light and shadow.

Rembrandt painted himself more than sixty times, more often than any other major artist in the Western tradition. Early in his career, Rembrandt often presented himself as a worldly sophisticate, dressed in fashionable attire. Later on, the self-portraits served to promote his international renown as painter, as when Rembrandt portrayed himself as the Hellenistic painter Apelles (Fig. **10.36**). In his last decade, when age and troubles had punctured his vanity, Rembrandt painted himself dressed in humble painter's clothes. The painter examined even his own failure with unflinching psychological insight.

in his study of causation. In Hume's view, if one billiard ball strikes another, the movement of the first seems to cause the motion of the second. But how could we be certain that this succession of events would be repeated the next time? Hume argued that neither reason nor experience were able to establish a causal connection based on inductive observation alone. It was our "imagination" – not entirely a reasonable faculty – that actually created the belief in causality. "Even after we have experience of the operations of cause and effect," wrote Hume, "our conclusions from that experience are not founded on reasoning or any process of understanding."[4] Causation might, in fact, exist in the world, but our ideas about causal sequences were the inventive creation of our minds.

Empiricism would become a virtual dogma of the Enlightenment during the eighteenth century. The German philosopher Immanuel Kant (see page 305) spoke of awaking from his "dogmatic slumbers" to challenge empiricism in his *Critique of Pure Reason* (1787). Kant would insist that the mind actively shaped experience rather than merely registering impressions from the outside world. But twentieth-century philosophy would revive empiricist skepticism to challenge all metaphysical thinking, including Kant's. The empiricist tradition that John Locke inaugurated still supports modern scientific thinking and continues to shape our understanding of the human mind.

10.36 Rembrandt van Rijn, *Self-Portrait*, c. 1665. Oil on canvas, 45 x 37$^1/_2$ ins (114 x 94 cm). The Iveagh Bequest, Kenwood House, London.
Though his career had failed by this time, Rembrandt proudly painted himself as the famed Hellenistic painter Apelles, who, like Rembrandt, was criticized for his unnatural use of light. An ancient story told that Apelles had visited an absent friend and left only a perfectly drawn circle on the wall as his calling card.

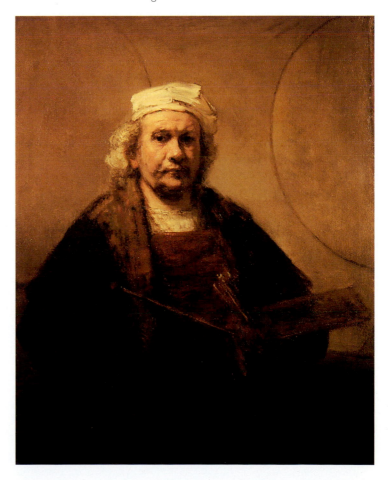

Let us then suppose the mind to be, as we say, white paper [tabula rasa], void of all characters, without any ideas; how comes it to be furnished? ... To this I answer, from experience.

John Locke, *Essay Concerning Human Understanding*

The New Science

Identify examples of science's link to mathematics in the discoveries of the Scientific Revolution.

In a period spanning the late Renaissance and baroque eras (about 1550 to 1700), Europe witnessed an intellectual movement that altered human history and, more than any other force, created the modern world. This movement was the **Scientific Revolution**, the historical process by which modern science triumphed as the authoritative method for investigating and describing the world. The modern scientific method rested on two principles:

- the empirical observation of nature as the means for arriving at scientific truths, and
- the verification of proposed truths through experiment and mathematical calculation.

Thinkers of the Scientific Revolution overthrew Aristotle's natural philosophy, long the basis of Western science, and eventually separated scientific truth from the doctrines of the Christian Church. The new scientists employed new instruments of scientific study such as the telescope and invented new forms of mathematics to make accurate and verifiable scientific predictions

The Scientific Revolution began in earnest with the publication in 1543 of *De Revolutionibus Orbium Coelestium* (*On the Revolutions of Heavenly Bodies*) by Nicolaus Copernicus (1473–1543). The Polish astronomer proposed a **heliocentric** theory of the universe: that is, the sun stands stationary at the universe's center with the planets (including Earth) revolving around it. Copernicus intended in his treatise to simplify mathematical calculation of the planets' movements, which had become absurdly complex in the reigning astronomical system, the latter being based on Ptolemy's ancient system (see page 67). In fact, Copernicus's tables of planetary motion were not much better, since he assumed (under the influence of Neoplatonic ideas) that the planets orbited the sun in perfect circles. Despite his error, *De Revolutionibus* was the stimulus for further scientific challenges, and a potent symbol of the coming revolution in scientific thought.

Copernicus' revolutionary theory spread quietly among scientists, inspiring an obscure German mathematician,

> This truth – I think, therefore I am – was so certain and so evident that all the most extravagant suppositions of the skeptics were not capable of shaking it.
>
> René Descartes, *Discourse on Method*

Johannes Kepler (1571–1630), to resolve its flaws. Again working from Neoplatonic assumptions, Kepler at first posited that the planets are arranged in a complex structure of geometric solids. But Kepler's system still could not account precisely for the planetary motions. Finally, while working as court mathematician in Prague, Kepler realized that the planets moved in elliptical orbits, not circles. In 1609 he published his *New Astronomy*, positing laws of planetary motion that finally overturned the classical model.

Tools of the New Science

Both Copernicus and Kepler employed scientific **deduction**, the discovery of a truth through logical calculation. In the same way, the English physician William Harvey (1578–1657) clinched his theory of the blood's circulation by mathematical calculation, without the benefit of direct observation.

Reasoning from particulars of fact, called **induction**, was essential to the discoveries of the Italian astronomer, physicist, and mathematician Galileo Galilei (1564–1642). Galileo constructed his own version of the newly invented telescope and observed moons around Jupiter, spots on the sun, and craters on the moon, all contradictions of conventional scientific wisdom.

Galileo parlayed his discoveries into an appointment as court scientist of the Medici and a favorite of the pope. But his belief in Copernican ideas soon incited the conflict between the new science and the Counter-Reformation. When Galileo exposed the absurdities of traditional astronomy in his *Dialogue on the Two Chief Systems of the World* (1632), the Church responded emphatically, threatening the scientist with trial and torture. Reluctantly, Galileo knelt in Rome and recanted his belief that "the sun is the center of the world and moves not, and that the earth is not the center of the world and moves."[5]

In retirement and under house arrest, Galileo continued his studies, using both deduction and induction, and wrote his most important scientific work, *Discourses on Two New Sciences* (1638), on the physics of moving bodies. Here Galileo completely overturned Aristotelian physics by treating the forces of motion as pure, mathematical quantities. Prudently, he published the book in the Protestant Netherlands, where the long arm of the Counter-Reformation did not reach.

Descartes and Newton

The troubles between Galileo and the Catholic Church caused the French mathematician René Descartes (1596–1650) to postpone publication of his own study of Copernicus. Descartes had already angered Church authorities with his provocative *Discourse on Method* (1639), a philosophical manifesto of the new science and

a preface to his discoveries in mathematics and science. Descartes's *Discourse* is still regarded as a profound statement of scientific confidence and rigor.

In the *Discourse on Method*, Descartes describes the painful uncertainty and skepticism of his youth. In his rigorous education and broad experience, he had found nothing that he could believe with conviction – skepticism had poisoned everything but mathematics. Descartes wondered why all knowledge cannot resemble those "long chains of reasoning, quite simple and easy," that geometry used in its proofs. Determined to find certainty, Descartes practiced doubt. He rejected as completely false any thought that could be doubted for any reason. This rigorous doubt took him to the essential core of human thought.

> But immediately afterwards I became aware that, while I decided thus to think that everything was false, it followed necessarily that I who thought thus must be something; and observing that this truth: I think, therefore I am, was so certain and so evident that all the most extravagant suppositions of the skeptics were not capable of shaking it, I judged that I could accept it without scruple as the first principle of the philosophy I was seeking.[6]

Descartes had arrived at the first principle of his scientific method – *Cogito ergo sum* ("I think, therefore I am"). From this principle, he could deduce other perfectly clear and distinct ideas, including the existence of God and the certainty of his own mathematical propositions.

10.37 Isaac Newton, *Mathematical Principles of Natural Philosophy*, title page of volume 1 of the English translation of the *Principia*, 1777.
Newton's *Principia Mathematica* (as it is known in the original Latin) introduced the universal laws of gravitation, which demonstrated that the earth and the heavens were bound in one unitary physical system. His physics finally overthrew a fundamental premise of Aristotle's classical world view.

With his methodical line of reasoning, Descartes had vanquished his own skepticism and expounded a philosophy of the new science.

Descartes's confidence in the rational mind was confirmed by the age's most important discovery, Newton's universal theory of gravitation. In his *Principia Mathematica* (*Mathematical Principles*, 1687) (Fig. **10.37**), the Englishman Isaac Newton (1642–1727) synthesized the discoveries of Galileo and other scientists in a unified theory. Newton asserted that all bodies – large and small, earthly and heavenly, natural and mechanical – were subject to the same gravitational force. He showed how gravity's pull could be quantified precisely. At first, scientists rejected Newton's theory in favor of Descartes's deductively derived system. Only in the eighteenth century was Newton's theory of universal gravitation widely accepted among scientists.

By the 1660s, the success and promise of the new science attracted government sponsorship. The Royal Society in England (founded 1662) and the Paris Academy of Sciences (1666) sponsored scientific activities and published scientific papers. Governments also built observatories and botanical gardens, hoping to harness science to the service of royal prestige and national prosperity.

The English Compromise

Identify the diverse elements that were synthesized in the English baroque style.

The baroque was a robustly international style in the arts. However, England did not so readily absorb artistic styles and philosophical ideas from the rest of Europe: the English hesitated to accept artistic fashions that hinted at the absolutism of France and the Catholicism of Italy. Thus, continental styles were often compromised with native English traditions. The English also applied their skill for compromise to their own political conflicts, emerging from a bitter civil war in the mid-1600s with a political system carefully balanced between the two opposing forces.

The English were not great artistic innovators. Their greatest architect, Christopher Wren, was an amateur, and the English baroque's most acclaimed composer was, in fact, the German George Frideric Handel, who had settled in London. On the other hand, the English excelled in poetry and politics.

English Baroque Poetry

It was in poetry that seventeenth-century England found its most original geniuses. Some critics rank John Donne [dunn] (1572–1631) close to Shakespeare in the richness of his poetic achievement. Donne's intellectualized style

and complexity of emotion place him in a group called the "metaphysical poets." A well-educated and widely traveled author, Donne was also a deeply religious man who applied his complex imagery to both sacred and secular themes. His famous poem *Death, Be Not Proud* is an affirmation of the triumph that salvation wins over death. Donne's love poetry is characterized by jarring associations and comparisons: in one poem, he compares the intertwined legs of lovers to the hands of a clock. The stanzas below are from one of his best-known love poems, *The Canonization.* Donne understood well the costs of love; in 1600 he sacrificed his career to marry the niece of his patron.

> Call us what you will, we are made such by love;
> Call her one, me another fly,
> We're tapers too, and at our own cost die,
> And we in us find the eagle and the dove.
> The phoenix riddle hath more wit
> By us; we too being one, are it.
> So, to one neutral thing both sexes fit.
> We die and rise the same, and prove
> Mysterious by this love.
> We can die by it, if not live by love,
> And if unfit for tombs and hearse
> Our legend be, it will be fit for verse;
> And if no piece of chronicle we prove,
> We'll build in sonnets pretty rooms;
> As well a well-wrought urn becomes
> The greatest ashes, as half-acre tombs,
> And by these hymns, all shall approve
> Us canonized for love …

JOHN DONNE
From The Canonization

John Milton (1608–1674) wrote works of truly baroque scale. His masterpiece *Paradise Lost* (1667) is an epic poem that recounts the original drama of Christianity: the fall of Adam and Eve from the garden of Eden. The learned Milton was well aware of his classical precursors in the epic form, and interwove his Christian saga with allusions to classical mythology and literature. He portrays the loss of Eden as a tragedy that will be redeemed by the coming of Christ, as indicated in the poem's famous opening lines:

> Of man's first disobedience, and the fruit
> Of that forbidden tree whose mortal taste
> Brought death into the world, and all our woe,
> With loss of Eden, till one greater Man
> Restore us, and regain the blissful seat,
> Sing, Heavenly Muse …

JOHN MILTON
From Paradise Lost

Milton was also an outspoken critic of absolutist government. His most famous secular work is the *Areopagitica* (1644), which defended the right to publish without government censorship. Milton fervently asserted his belief that truth could prevail in "a free and open encounter" with error.

Christopher Wren's London

The artistic compromises of late seventeenth-century England are perhaps best seen in the work of Christopher Wren (1632–1723). Until the 1660s, Wren was a professor of astronomy and founding member of London's Royal Society. Wren's architectural hobby became his profession when he was appointed as the royal surveyor of works and asked to modernize English architecture. In 1665 he traveled to Paris, where he encountered continental baroque architecture through Bernini (who was there to redesign the Louvre) and Mansart, the architect of Versailles.

Wren's architectural task gained urgency when, in September 1666, a great fire destroyed three-quarters of London, including the original cathedral of St. Paul's. The disaster presented Wren with an unprecedented opportunity to leave his artistic signature on an entire city. He spent the remainder of his life rebuilding London's parish churches, gracing the city with their distinctive spires and neoclassical simplicity.

WINDOWS ON DAILY LIFE

The Fire of London

Diarist Samuel Pepys [peeps] provides this eyewitness account of the devastating fire that consumed much of London in 1666.

So I down to the water-side, and there got a boat and through bridge, and there saw a lamentable fire. Poor Michell's house, as far as the Old Swan, already burned that way, and the fire running further, that in a very little time it got as far as the Steele-yard, while I was there. Everybody endeavouring to remove their goods, and fling into the river or bringing them into lighters [barges] that lay off; poor people staying in their houses as long as till the fire touched them and then running into boats, or clambering from one pair of stairs by the water-side to another. And among other things, the poor pigeons, I perceive, were loath to leave their houses, but hovered about the windows and balconies till they were, some of them burned, their wings, and fell down.[7]

THE DIARY OF SAMUEL PEPYS

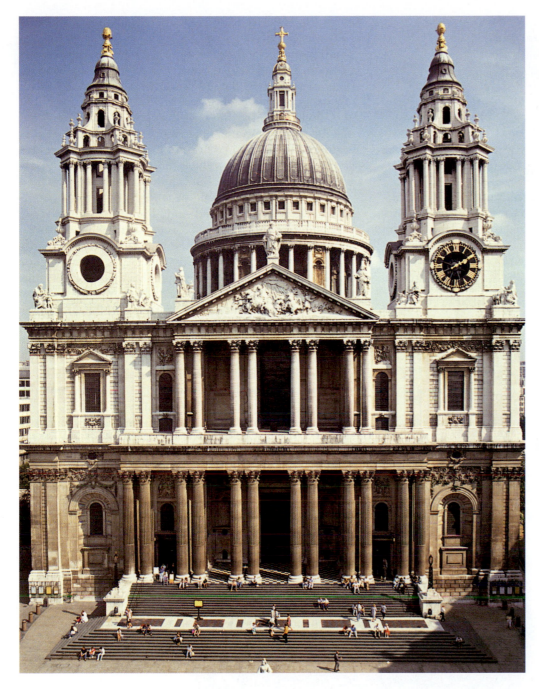

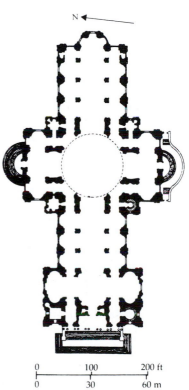

10.38 Christopher Wren, St. Paul's Cathedral, London, 1675–1710. Length 514 ft (156.7 m), width of façade 250 ft (76.2 m), height of dome 366 ft (111.6 m). Wren's eccentric combination of Gothic, Renaissance, and baroque neoclassical elements responded to the contending forces of seventeenth-century English culture. It is the only major British building of the Renaissance and baroque built by a single architect.

10.39 Plan of St. Paul's Cathedral, London, 1675–1710.

0		100		200 ft
0		30		60 m

Wren's largest assignment was the construction of the new St. Paul's (built 1675–1710). His designs had to mediate between his patrons' traditional tastes and his own preference for the prestigious neoclassical style of Versailles. Wren's compromises are visible in St. Paul's façade and floor plan (Figs. **10.38**, **10.39**). The neoclassical double portico is flanked by towers that use the principles of both Gothic and baroque styles. Above the portico rises the towering dome, indebted to Brunelleschi and Michelangelo, but somewhat obscured by the imposing façade. Wren's fusion of styles left unresolved tensions but evidently satisfied his patrons.

The interior of St. Paul's is only barely related to the exterior. Wren, often less architect than engineer, placed little value on this connection. The architect aimed for the central unity of a Renaissance design, while his clerical patrons insisted on a traditional Gothic floor plan. The interior's most distinctive feature is the domed crossing. The dome rests on eight arches, four on the sides opening to the nave, choir, and transepts, and four on the corners closed off with apse-like niches. In the church's overall design, Wren achieved a unique synthesis of Gothic, Renaissance, and baroque styles and created London's most admired architectural landmark.

Handel and Music in England

England nourished one native genius of musical drama – Henry Purcell (1659–1695), who wrote music of all sorts but excelled in music for English theater of the Restoration period. Purcell [PERSS-ull] wrote one great opera, *Dido and Aeneas* (1689), based on Virgil's great Latin epic (see page 90). In the opening aria, the queen of Carthage describes her love for Aeneas as a secret "grief":

Ah! Belinda, I am prest
With torment not to be Confest,
Peace and I are strangers grown.
I languish till my grief is known,
Yet would not have it guest.

From the outset, Purcell's aria conveys Dido's complex emotional state – love mixed with grief and resignation – with compact eloquence.

Purcell's achievement was overshadowed by the popularity of Italian-style opera in England and the career of George Frideric Handel, which illustrates the international character of the baroque style and shows how art forms could be adapted to the tastes and attitudes of audiences. Although German by birth, Handel (1685–1759) lived half his life in England and was honored as the nation's leading composer of the baroque period. As a youth, Handel learned the art of opera in Italy and then, in 1712, settled in London. There Handel was named musical director of the Royal Academy of Music (founded in 1720), which exploited the English fashion for Italian opera. London attracted the finest international opera singers, including Faustina Bordoni (1697–1781), who commanded the highest fees in Europe. Bordoni was able eventually to retire comfortably from her earnings. But Handel's Academy had failed within a decade of its founding, and the debt-ridden composer suffered a stroke and a mid-life career crisis.

Handel rescued his career by turning to **oratorio**, a narrative choral work containing the musical elements of opera, but without action, scenery, or costumes. For Handel, working on a tight budget, this was a perfect compromise. In his remaining life, Handel composed and produced many oratorios, most written on biblical themes and performed in public concert halls (Fig. **10.40**).

Handel's most famous oratorio was the *Messiah*, first presented in Dublin, Ireland, in 1742 and still among the most widely performed baroque works. The *Messiah* recounts Jesus' birth, his death and resurrection, and the promised redemption of all humanity. The religious feeling and grandeur of the story were matched by Handel's music. The famous chorus "Hallelujah" (Hebrew for "Praise God") combines intricate counterpoint and

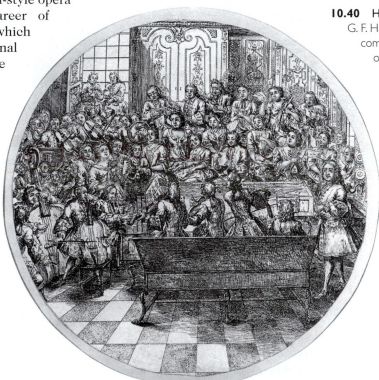

10.40 Handel directing a rehearsal. G. F. Handel revived his career by composing oratorios, a form that offered audiences the narrative scope and musical grandeur of opera, without the expense of operatic staging. Handel (far right) customarily used a choir of only about twelve singers and an orchestra of forty or so.

imitation with simpler chordal passages of dignified majesty. The chorus builds to a jubilant finale, with a unison so magnificent that the British king stood up on first hearing it. The commercial success of Handel's other oratorios was enhanced by the stirring Old Testament themes, which appealed subtly to the patriotism of his English audience.

Politics and Philosophy in England

The English had trouble applying the same spirit of balance and compromise to politics that they employed in the arts. In 1642, a conflict between the king and the elected parliament erupted in bloody civil war, pitting royalists against the middle-class Puritans. During the so-called "Long Parliament," the contending factions disputed the balance of power between England's hereditary monarch and its elected parliament. Finally, in 1660, monarchy was restored, but by 1688 King James II had so enraged his parliamentary opponents that the monarch fled London in fear of his life. In a political drama called the "Glorious Revolution" because the overthrow of a king had required no bloodshed, the parliament quickly installed a new king and queen from the Protestant Netherlands .

Just two years later, John Locke (1632–1704) published a philosophical justification of the Glorious Revolution. Locke's *Two Treatises on Government* (1690) argued that governments originated in the voluntary association and consent of humans acting in their rational self-interest. Like his predecessor Thomas Hobbes (see Key Concept, page 266), Locke predicated that human society had arisen from a "state of nature." Where Hobbes asserted humans were naturally greedy and violent, Locke claimed they were reasonable and cooperative. Hobbes's pessimistic view convinced him that only an absolute monarch – the "Leviathan" – could impose social order. Locke's more optimistic position located the beginnings of civil order in the **social contract** – an agreement in which humans traded the absolute freedom of the state of nature for the limited freedoms of civil society. By vesting a government with some powers of legislation and enforcement, Locke theorized, humans secured their most cherished freedoms. "And this puts men out of a state of nature into that of a commonwealth," wrote Locke, "by setting up a judge on earth with authority to determine all the controversies and redress the injuries that may happen to any member of the commonwealth."[8] Despite the empiricist principles that Locke applied to the theory of knowledge (see Key Concept, page 284), he claimed no empirical basis for the social contract. It was a philosophical hypothesis that explained in abstract terms the proper relation between the individual and the state.

Locke's theory of the social contract became a foundation of classical **liberalism** – the political doctrine that prizes individual rights and freedoms and strives for a constitutional government that secures individual autonomy. The idea of absolutism – that one person can rightly claim all power – violated Locke's liberal balance between individual rights and social order. "It is evident that absolute monarchy, which by some men is counted the only government in the world," he wrote, "is indeed inconsistent with civil society, and so can be no form of civil government at all."[9] From the social contract, citizens retained "unalienable" rights – to quote the American Declaration of Independence – that no government should ever violate. Theorizing that citizens might justly overthrow a tyrannical government to establish a state that respected individual rights, Locke was writing a license for political revolution. He set the tone for the combative age of reason to come.

> Wherever, therefore, any number of men so unite into one society, so as to give up each his executive power of the law of nature and to resign it to the public, there and there only is a political or civil society.
>
> John Locke, *Two Treatises on Government*

CHAPTER SUMMARY

The Baroque in Italy In Italy, the artist Bernini dominated Counter-Reformation baroque Rome. His architectural and sculptural works embodied baroque extravagance and dynamism, often fusing several arts into a single, complex whole. His rival Borromini designed new Roman churches of great subtlety and sophistication. In painting, Caravaggio's dramatic contrasts of light and dark and his graphic realism influenced generations of artists. Baroque Italy also was a center of musical innovation, nurturing the birth of opera and its first genius, Monteverdi, as well as the brilliantly embellished works of Vivaldi.

The Baroque in Spain Enriched by New World conquests, the rulers of Spain embraced the baroque style. Spanish architecture employed the baroque in service to religious austerity (at El Escorial) and a militant colonialism (in New World churches). The painter Velázquez served the Spanish royal court with works of fascinating complexity, while the great novel of Cervantes, *Don Quixote*, also explored the boundaries between illusion and reality, art and life.

The Baroque in France In seventeenth-century France, Louis XIV harnessed the baroque style to his absolutist designs. Louis's grand palace at Versailles served as a stage for projecting royal power, while combining baroque lavishness and neoclassical restraint. Louis patronized great masters of the performing arts, especially Molière in theater and Lully in dance and opera. The royal academies dominated artistic education and set standards of taste. In painting, Rubens and Poussin represented the two contrasting trends of baroque pictorial style, exuberant virtuosity versus neoclassical order and balance.

The Protestant Baroque In northern Europe, baroque artists had to please both aristocratic and urban middle-class audiences. Johann Sebastian Bach proved a prolific innovator of baroque music, excelling in both secular and sacred forms (*concerto grosso*, cantata, and fugue). Bach's work demonstrated the flexibility of the new major–minor key system that came to be widely employed in European music.

Without a royal court or wealthy nobility, the Dutch preferred the humble art of genre painting. The obscure master Johannes Vermeer rendered brilliantly lit interior scenes, while the more flamboyant Rembrandt painted group and individual portraits with great psychological insight and a theatrical command of light and dark.

The New Science The scientific discoveries of the Renaissance – especially Copernicus's proposal of a heliocentric universe – set off the seventeenth-century revolution in scientific thinking. The Scientific Revolution relied on empirical observation, validated by mathematics and experiment, to reach profound new insights into the natural world. Kepler posited new laws of planetary motion that finally overthrew classical models. Through observation, Galileo made new astronomical discoveries and revolutionized the science of moving bodies. Descartes's *Discourse on Method* offered a philosophical defense of scientific method and Newton synthesized the new science in his path-breaking theory of universal gravitation. Monarchs supported the new science through learned societies and academies.

The English Compromise Baroque England was a fertile ground for artistic innovation and political compromise. English baroque poets used richly embellished language to treat traditional themes of love and faith. Christopher Wren modernized English architecture with his combination of French neoclassicism and English traditionalism. Purcell composed a small masterpiece of musical theater, while the German-born Handel pleased the English public with his operas and grand oratorios. In politics, Locke's theory of the social contract justified England's precarious balance between individual freedom and the legitimacy of government.

The Spirit of Enlightenment

11.1 Antoine Watteau, *Pilgrimage to the Island of Cythera*, 1717. Oil on canvas, 4 ft 2¾ ins x 6 ft 4¾ ins (1.29 x 1.94 m). Louvre, Paris.

A pioneering example of the rococo *fête galante*: note the gently curving line from the head of Venus's statue (right) along the party of picnickers to the boat at left. Watteau's use of color may have been influenced by the introduction of pastel.

It is a scene of dalliance and fanciful pleasure. A smartly costumed boating party has spent the day on a mythic island of love, acting out a frivolous drama of flirtation and seduction (Fig. **11.1**). As the picnickers depart, the twilight seems to dim over an entire way of life: the leisured decadence of eighteenth-century Europe's nobility, who wittily amused themselves in elegant gardens, town houses, and country manors, while revolution brewed.

Not everyone in Europe and America was so idly engaged. In middle-class drawing rooms and coffeehouses, thinkers were fired by **a spirit of enlightenment** – the belief in the supremacy of reason over pleasure, and a conviction that humans could perfect society through the application of the intellect to human affairs. The thinkers of the Enlightenment published encyclopedias, pursued science, built neoclassical country homes, and eventually incited revolutions. In this age (c. 1700–1780), sober advocates of reason and enlightenment endured an uneasy coexistence with an aristocratic society devoted to artful pleasure.

The Rococo Style

Identify the qualities of eighteenth-century art that most appealed to art's patron classes.

When Louis XIV died in 1715, the French nobility fled the grand baroque Palace of Versailles, where it had been captive for fifty years. The wealthy settled in new Parisian town houses and adopted an informal and light-hearted style called the **rococo** [ro-ko-KOH], a softer and more delicate style than the baroque (Fig. **11.2**). The name "rococo" probably derives from the French *rocaille*, a shell-like decoration used in fashionable gardens; the very sound of the word indicates something of the artistic style: gay, witty, and often frivolous.

The Rococo in France

Intellectual and artistic culture in France centered on the Paris salon – a regular social gathering that provided occasion for dining, entertainment, and conversation. A salon was customarily sponsored by a wealthy woman and held once or twice weekly in her *hôtel* (the name given to an aristocratic town house). The aim of the salon, wrote contemporary observers, was to bring together "good company – a sort of association of the sexes" characterized by "the perfection of its charm, the urbanity of its usages, by an art of tact, indulgence, and worldly wisdom."[1] The most famous of Paris's salons was held by Madame Geoffrin [ZHOFF-ran(h)] (Fig. **11.3**), whose husband had made a fortune manufacturing ice-cream. Madame Geoffrin regularly entertained the leading figures of Parisian society. Prominent women in Berlin and

Vienna took up the fashion, and for several decades, upper-class women became sponsors of music, art, and intellectual debate.

The rococo style was reflected in Parisian town houses, or *hôtels,* the fanciful interior decoration of which (Fig. **11.4**) compensated for their modest exteriors. In these urbane and pleasant settings, the arts did not express profound ideas of political majesty or intense religious feeling. Instead, art could be witty and playful; succumb to melancholy or erotic fantasy; or distill the modest ideals of love, grace, and happiness. Rococo was art for pleasure and for decoration, and expressed perfectly the values and pastimes of the aristocracy.

The wistful mood of rococo painting was captured by Antoine Watteau (1684–1721), whose style set the tone for his eighteenth-century successors. Watteau [vah-TOH, wah-TOH] discarded the grand manner of the baroque

11.2 Clodion (Claude Michel), *Intoxication of Wine* (*Nymph* and *Satyr Carousing*), c. 1780–90. Terracotta, height 23¼ ins (59.1 cm). The Metropolitan Museum of Art, New York, Bequest of Benjamin Altman, 1913 (14.40.687). Photograph ©1980 The Metropolitan Museum of Art

The rococo style delighted connoisseurs with its intimate scale; soft colors and shapes; and playful, sensual themes. This work of frank eroticism depicts worshipers of Dionysus who have given themselves over to sensual delight.

11.3 (*left*) **Madame Geoffrin's salon, Paris.**
The imperious Madame Geoffrin oversees a musical performance at her Paris salon. Madame was known to cut short political discussions with a firm, "Well, that's very good!", thus avoiding the fate of one rival, whose guests so freely criticized the government that she was banned from the royal court.

11.4 (*below*) Gabriel Germain Boffrand, Salon de la Princesse, Hôtel de Soubise, Paris, c. 1740.
This room, an elegant showcase of rococo design, is built on an oval plan. Note the arch repeated in window, doorway, and mirror; and the delicate sculpted transition from wall to ceiling, here painted with murals in dreamy rococo style.

style, preferring instead peaceful scenes with pastel colors and dreamy atmospheres. His paintings were typically tinted with melancholy, such as *Pilgrimage to the Island of Cythera* (see Fig. 11.1). The painting (there are two similar versions) shows a fashionable party of picnickers ready to leave Cythera [SITH-a-ra], the mythical island of the love-goddess Venus. The celebrants have already decorated Venus's statue with flowers and exchanged their vows of love, and now turn reluctantly to leave their idyll.

Watteau's picture defined a new category of painting in the eighteenth century, the so-called *fête galante*, or "genteel celebration," of well-dressed and urbane revelers. Watteau drew the costumes and imagery of the *fête galante* from the *commedia dell' arte* (see page 247), but his scenes also mirrored the fashionable costumed entertainments of eighteenth-century aristocrats. Another technical advance in this era is credited to the Venetian Rosalba Carriera (1675–1757), who introduced pastel

1600s	Kabuki theater arises, Edo, Japan
1715	Louis XIV dies
1717	Watteau, *Pilgrimage to Cythera* (**11.1**)
1740–2	Richardson, *Pamela*
1762	Rousseau, *The Social Contract*
1786	Mozart, *Marriage of Figaro*
c. 1789	Vigée-Lebrun, *Self-portrait with Daughter* (**11.8**)

11.5 *(left)* Rosalba Carriera, *A Young Lady with a Parrot*, c. 1730. Pastel on blue laid paper, 23²/₃ ins x 19²/₃ ins (60 x 50 cm). The Art Institute of Chicago
Carriera perfected the use of pastel crayon, instead of oil paint, for portraits of the well-to-do in Venice, Paris, and Vienna. Here the parrot pulls at the subject's gown to accentuate her physical charms.

11.6 *(opposite)* François Boucher, *The Toilet of Venus*, 1751. Oil on canvas, 42⁵/₈ x 33¹/₂ ins (108.3 x 85.1 cm). The Metropolitan Museum of Art, New York, Bequest of William K. Vanderbilt, 1920 (20.155.9). Photograph ©1993 The Metropolitan Museum of Art
Boucher spent his career decorating France's royal residences under the patronage of the royal mistress, Madame de Pompadour. He treats this erotic theme as if it were a piece of theater: the curtain, the painted backdrop, the props and costumes, all enhance the mood of dalliance and playfulness.

crayon as a medium of portraiture (Fig. **11.5**). Carriera used pastel to create the soft tones and loose texture that suited the easy style of rococo. Her works were admired by Watteau and collected by the kings of Europe.

The more sensual and decorative side of rococo appears in the works of François Boucher (1703–1770). Boucher [boo-SHAY] was the favored painter of Louis XV's mistress Madame de Pompadour, a patron of progressive writers and artists who decorated the Palace of Versailles in rococo fashion. Boucher's *The Toilet of Venus* (Fig. **11.6**) was commissioned by Madame de Pompadour, who must have identified with the subject. The alluring goddess dreamily prepares herself for a visitor, as cupids coif her hair and toy with her jewels. Boucher achieved a luxurious surface with the gilded furnishings and glowing pinks and blues.

The frivolity and self-indulgence of the rococo style and its aristocratic patrons are clearly portrayed in *The Swing* (Fig. **11.7**) by Jean-Honoré Fragonard [frag-o-NAHR] (1732–1806), a genre scene of naughty gaiety. In her lavish gown, the young lady looks coquettishly at the young gentleman positioned to gaze up her billowing skirts. Fragonard contrasts the naughty pair to the dull cleric, who stolidly swings his charge in the background. In contrast to the mythic power of Rubens's *Rape of the Daughters of Leucippus* (see Fig. 10.25), there is no pretense of a transcendent purpose in Fragonard's picture. It is a work of frank sensuality – charming but ultimately trivial.

The artist identified with the indulgent last days of the French monarchy is Marie-Elisabeth-Louise Vigée-Lebrun (1775–1842). Vigée-Lebrun [VEE-zhay luh-BRUH(n)] was the portraitist and close friend of Marie Antoinette, queen of Louis XVI. She excelled in the delicate and flattering portraits preferred by the eighteenth-century nobility. Through the queen's influence, she was elected to the Royal Academy, which otherwise hindered the careers of women artists.

The sentimental self-portrait with her daughter (Fig. **11.8**) shows the sensitivity of Vigée-Lebrun's brush. A favorite of the court, Vigée-Lebrun made a dramatic escape from Paris during the French Revolution, fleeing the night that Marie Antoinette and the king were arrested. In exile from revolutionary France, Vigée-Lebrun

11.7 (opposite) Jean-Honoré Fragonard, *The Swing*, c. 1768–9. Oil on canvas, 32 x 25½ ins (83 x 66 cm). Wallace Collection, London. Fragonard's scenes of playful seduction and dalliance appealed to the urbane and complacent French aristocracy under the reign of Louis XV.

11.8 (below) Marie-Elisabeth H. Louise Vigée-Lebrun, *Self-Portrait with Her Daughter*, c. 1789. Oil on canvas, 51⅛ x 37 ins (130 x 94 cm). Louvre, Paris. Vigée-Lebrun's self-portrait in neoclassical coiffure and costume helped fuel the Greek vogue of the late 1700s, while also appealing to the eighteenth-century cult of sentimentality (compare Fig. 11.14).

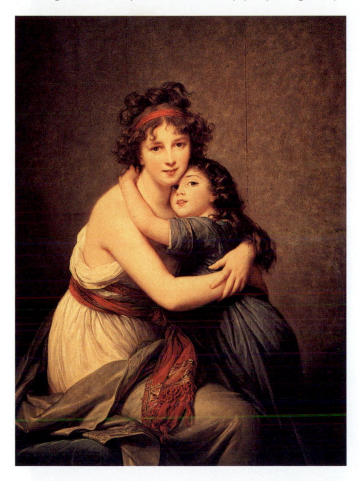

charmed the nobility of Europe's capitals and earned a large fortune painting their portraits. She returned in 1802 to become a prominent figure in Parisian society, sponsoring salons and writing her memoirs.

Eighteenth-century Dance In France, professional dance developed rapidly in the eighteenth century, propelled by the influence of the Paris Opera's professional dance school, which opened in 1713. The opera school produced a steady supply of well-trained dancers, including Marie Anne de Cupis de Camargo, whom Voltaire called "the first woman to dance like a man" – meaning she danced with the technical virtuosity of male dancers. To demonstrate her technique, Camargo discarded the high-heeled dancing shoes of Louis XIV's era and shortened her skirts so audiences could see her feet. Camargo's chief rival was Marie Sallé (1707–1756), who discarded the conventional hoop skirt and wig and danced the lead role in her ballet *Pygmalion* (1733) costumed in a cotton shift. Sallé's career alternated between the stages of rococo Paris and London.

Innovations in ballet training and costume were coupled with changes in the form and setting of the dance itself. In the baroque period, ballet had usually formed a pompous interlude in an opera or comedy, illustrating or adorning the larger dramatic work. During the eighteenth century, dancers created the *ballet d'action*, in which the ballet itself communicated dramatic action through dancers' movements. In *Letters on Dancing and Ballet* (1760), Jean Georges Noverre called for ballets to be "unified works of art" in their own right, with dance and music contributing to the narrative theme. Thus ballet emphasized less spectacular display and more emotional expression, changes made possible by new techniques and greater freedom of costume.

The Rococo in Germany and Britain

In German-speaking Europe of the eighteenth century, French influence seemed to be everywhere. In the imperial capital of Vienna, Emperor Joseph II enjoyed the same grand artistic diversions as his royal counterparts in Paris. In the Prussian capital, Berlin, the enlightened despot Frederick the Great recruited the philosophe Voltaire to advise him. And in Germany's small principalities, minor nobles imitated the language and culture of the Parisian stage and salons.

In German cities, as a middle-class counterpart to the Parisian salon, coffeehouses sprang up to satisfy a newfound taste for coffee, tobacco, and political debate. While the coffeehouses were principally a male domain, they did provide a setting for political discussion and social criticism. Coffeehouse patrons could also read the dozens of newspapers and journals that serialized novels, reported political events, criticized culture, and propagated Enlightenment ideas.

The rococo style found its most abandoned architectural expression in eighteenth-century German palaces and churches. Indeed, with its grand scale and intense religiosity, German rococo art is sometimes considered a late variation of the baroque style. In Catholic southern Germany and Austria, wealthy and powerful prince-bishops became ambitious sponsors of the new style. For the Bishop of Würzburg, the architect Balthasar Neumann [NOY-mahn] (1687–1753) designed a grand palace with a monumental staircase at its center (Fig. **11.9**). The staircase's ceiling painting, by the Italian painter Giovanni Battista Tiepolo (1692–1770), shows angels bearing the bishop's portrait to dwell among the gods, who reside in classical buildings much like the palace that Neumann

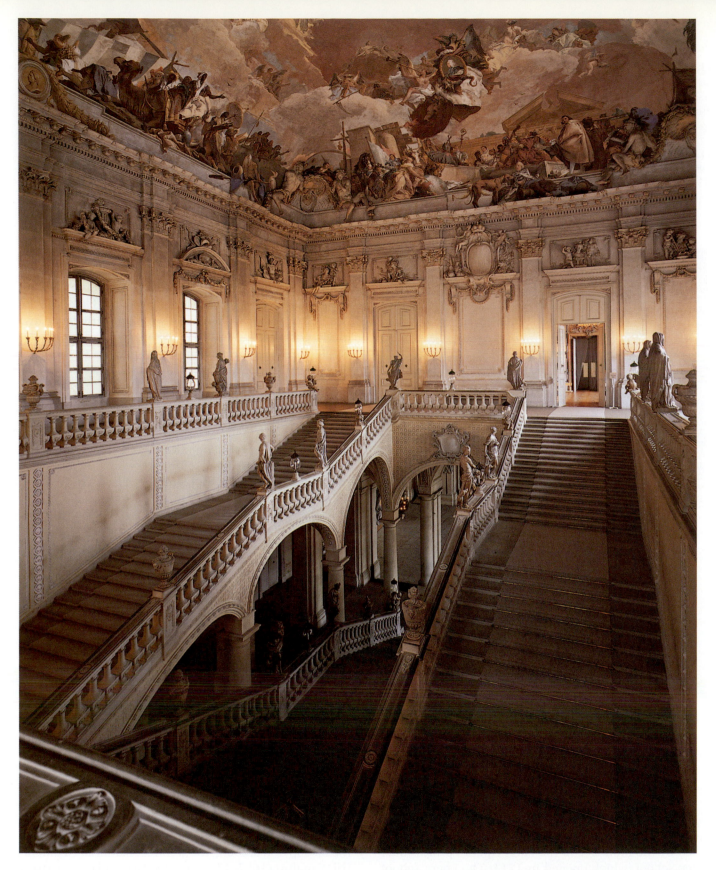

11.9 *(above)* Balthasar Neumann, staircase in the Residenz (Bishop's Palace), Würzburg, Germany, 1737–42.
This vast staircase – one of the largest ever built – rises gradually from darkness to light. Tiepolo's vast ceiling painting extends the illusion with sculpted athletes and painted temple pediment and scaffolding.

11.10 *(opposite)* Balthasar Neumann, interior of the Pilgrimage Church of the Vierzehnheiligen, near Bamberg, Germany, 1743–72.
Note the sculpted stucco and ceiling painting that soften the lines of the vaulting. The nave encloses in a large ellipse, a shape repeated in the island altar at center. Compare the rococo treatment of this pilgrimage church to Boffrand's design for a Paris residence (Fig. 11.4).

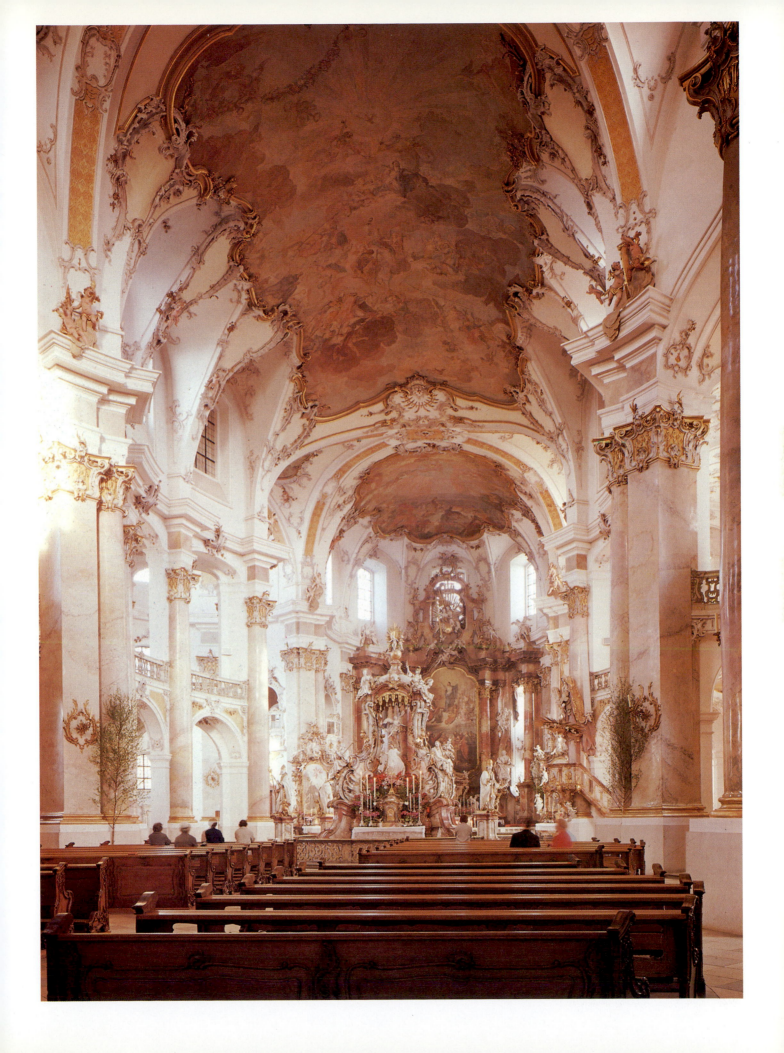

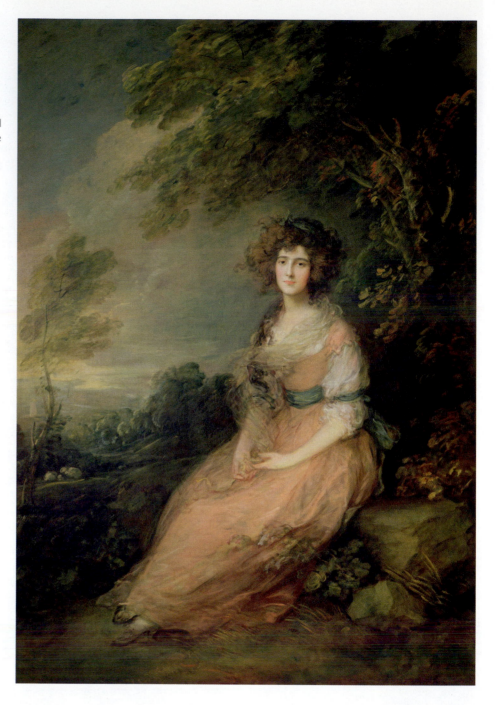

11.11 Thomas Gainsborough, *Mrs Richard Brinsley Sheridan*, 1785–87. Oil on canvas, 7 ft 2⅝ ins x 5 ft (2.2 x 1.5 m). Mellon Collection, National Gallery of Art, Washington

Gainsborough made his career painting portraits of British high society in London and the resort town of Bath. Compare his informal treatment of this sitter to the neoclassical style of his rival, Joshua Reynolds (Fig. 11.26).

has created for his patron. By contrast, Neumann's pilgrimage church of the Vierzehnheiligen [FEER-tsain-HIGH-lee-ghen] (the Fourteen Saints; Fig. **11.10**), in southern Germany, used none of this neoclassical vocabulary; instead, the interior is a riot of rococo shapes and colors. The church's floor plan consists of intersecting ovals that draw the pilgrim toward the elaborate oval altar. The Vierzehnheiligen's interior is the rococo aesthetic applied to religious experience – fanciful, sensuous, yet also deeply pious in its exaltation of the Catholic faith.

In England the wealthy classes adopted the rococo fashion in dress and in painting. Thomas Gainsborough (1727–1788) rejected the classicizing "grand manner" of his rival Sir Joshua Reynolds (see page 316), adopting a more candid and informal style. He places Elizabeth Sheridan (Fig. 11.11) in a vaguely pastoral setting and elongates her form slightly in a flattering way. The gauzy shawl curls around her like a summer breeze, framing Sheridan's gaze of melancholy and longing. Mrs. Sheridan had given up a singing career for marriage to the dramatist and politician Richard Brinsley Sheridan, a notorious philanderer. Gainsborough called these his "fancy pictures" – a romanticized and empathetic treatment of subjects in a rustic setting.

The Enlightenment

Summarize the Enlightenment philosophes' program for reforming eighteenth-century society.

The freedom and informality of eighteenth-century society created an explosive mixing of noble and middle classes. In the salons of Paris, France's nobility mixed with middle-class wits and philosophers. In the smoky coffee-houses of London, Edinburgh, and Berlin, men gathered to read newspapers and debate politics. Inevitably, new ideas percolated through these conversations, ideas that challenged political and religious orthodoxy.

The preceding century had brought irreversible changes in European attitudes: exploration and colonization had widened Europe's horizon of experience; the Scientific Revolution had opened new vistas of intellectual inquiry; and the Glorious Revolution in England had improved national life. Especially in France, the bastion of absolutism, the authority of Church and king paled in the scrutinizing light of reason.

The Philosophes

Eighteenth-century Paris became the cradle of the **Enlightenment**, a movement of intellectuals who popularized science and applied reason to human affairs. They educated and provoked with their writings, which included novels, plays, pamphlets, and, above all, the mammoth *Encyclopedia* (1751–1772). These thinkers of Paris called themselves **philosophes**, a French term applied to eighteenth-century thinkers who advocated reason and opposed traditional ideas. The philosophes' intellectual godfathers were Isaac Newton (see page 287), discoverer of the universal laws of gravitation, and John Locke (see page 284), champion of individual rights. The philosophes were materialist and empiricist in their philosophical attitude: they believed that everything had a material cause and that all ideas came from experience. Above all, the philosophes sought the practical application of human reason to real human problems.

Inspired by the Scientific Revolution, the philosophes searched for universal laws in every sphere of human affairs. They believed politics and history must also be governed by an equivalent to the law of gravitation. They praised science for its promise of boundless material prosperity, and scorned superstition, including most of Christian belief. They also believed that the chief barrier to human progress and happiness was not human nature, as Christianity taught, but social intolerance and injustice. The watchwords of the Enlightenment were freedom and reason.

The great project of the philosophes was the *Encyclopedia*, subtitled "A Classified Dictionary of the Sciences, Arts, and Crafts." The *Encyclopedia* was an ambitious attempt to compile systematically all human knowledge. The mammoth work appeared in twenty-eight volumes (including eleven volumes of illustrations) from 1751 to 1772. The editor, Denis Diderot [deed-uh-ROH], enlisted as authors the most progressive minds of his day: Rousseau, Montesquieu, Condorcet, Helvétius, and Voltaire, among others. With articles, both theoretical and practical, on topics from human language to surgery, the *Encyclopedia* was a fulfillment of the belief that reason should enhance humanity's material well-being. The Enlightenment's expansion of scientific knowledge, dramatized in Joseph Wright's painting *Experiment with an Air Pump* (Fig. **11.12**), confirmed the philosophes' belief that human knowledge was perfectible and that human progress was inevitable.

The philosophes' scientific attitude led them to doubt the articles of Christian faith; most philosophes abandoned the Christian Church altogether. Many philosophes were **deists**, who believed that God created the universe to operate by rational laws. A rational god would never intervene in nature's operations or reveal his will in a bible. "Deism is good sense not yet instructed by revelation, and other religions are good sense perverted by superstition," explained Voltaire in his *Philosophical Dictionary*. As for morality, said the sage, "reason and conscience were perfectly adequate" to guide human conduct. When the skeptical Scottish philosopher David Hume visited Paris, he was shocked by the philosophes' contempt for organized religion. Voltaire was the most vehement: "Every sensible man, every honorable man, must hold the Christian sect in horror."

Enlightenment and Freedom

Throughout Western society, thinkers sought to apply Enlightenment principles to the practical problems of human existence. In politics, economics, and ethics, thinkers asked how humans' natural freedom might serve the improvement of society.

In politics, the most influential example was the youngest philosophe, Jean-Jacques Rousseau (1712–1778), a radical and troubled man who became the Enlightenment's most popular writer. The son of a Swiss watchmaker, Rousseau [roo-SOH] joined Parisian society in the 1740s, where his ideas stirred controversy even among the philosophes. Rather than adopt the Enlightenment's dogmatic empiricism and rationalism, Rousseau prized the natural goodness of humanity and

THE WRITE IDEA

Write a diary entry of a philosophe who has traveled to your own historical time. What would the philosophe find most to criticize and to praise?

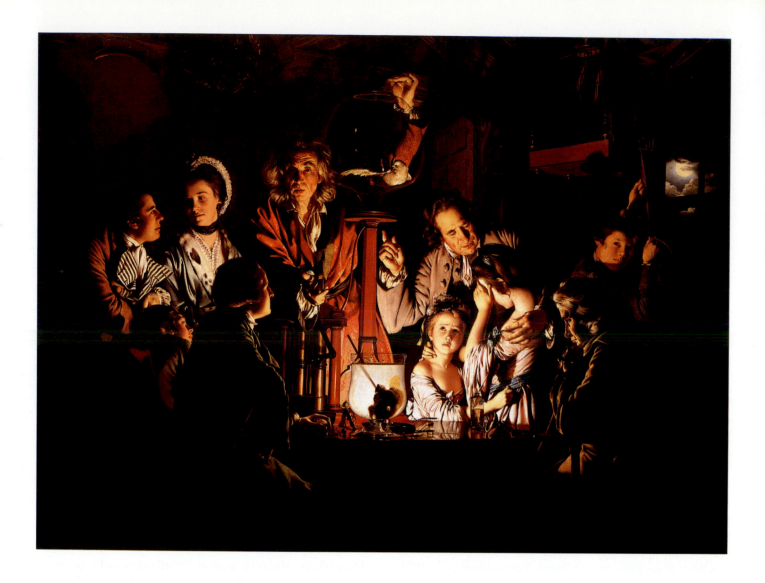

11.12 Joseph Wright, *Experiment with an Air Pump*, 1768. Oil on canvas, 5 ft 11⁵/₈ ins x 7 ft 11³/₄ ins (1.82 x 2.43 m). National Gallery, London.

In this view of Enlightenment science, a lark suffocates as the air is pumped out of the glass bell, showing that air is necessary for life. The children exhibit a mixture of scientific curiosity and sentimental feeling.

praised feeling over reason – one reason he was a forerunner of the romantic movement (see page 337).

Rousseau's philosophy rested on the worth of the human individual and the value of human freedom and equality. Following the social contract theory of the English philosopher John Locke (see page 284), Rousseau imagined that humans had lived in a state of nature as "noble savages" – creatures who were free, rational, and "naturally" good. In his educational treatise *Émile, or Education* (1762), the first sentence reads, "God makes all things good; man meddles with them and they become evil." Even so, Rousseau reasoned in *The Social Contract*, humans were right to exchange *natural* liberty for the *civil* liberty of organized society. In the unregulated freedom of nature, "which knows no bounds but the power of the individual," humans were ruled by mere personal impulse and self-interest. In civil society, liberty acquired a moral dimension:

> … we might add to the acquisitions of the civil state that of moral liberty, which alone renders a man master of himself; for it is slavery to be under the impulse of mere appetite, and freedom to obey a law which we prescribe for ourselves.[2]

Humans attained enlightened self-mastery, paradoxically, only under the sanction of what Rousseau called the

> Deism is good sense not yet instructed by revelation, and other religions are good sense perverted by superstition.
>
> Voltaire, *Philosophical Dictionary*

"general will." The **general will** was the collective interest of the citizens of a state, as guided by civic virtue and an interest in the public good. It was not simply the sum of individual desires and private interests, something represented today by opinion polls. Individual actions gained rational legitimacy when they were sanctioned by the organic whole of society – mere "possession" became rightful "property." In his concept of the general will, Rousseau broke with the tenets of classical liberalism, seeking to reconcile the individual's innate freedom and autonomy with a vision of the greater civic good.

The same moral impulse inspired the Scottish moral philosopher Adam Smith (1723–1790) to write his *Inquiry into the Wealth of Nations* (1776), one of the founding documents of classical liberalism. Stimulated by eighteenth-century Scotland's lively commerce of ideas and commodities, Adam Smith connected humans' desire for the good – their own good as well as others' – with their freedom to labor and produce. Smith attacked the paternalistic system of privileges and monopolies through which European monarchs were manipulating the new global trade. Smith argued that the economy instead should be governed by the principles of a "natural liberty" that he derived from classical liberal philosophy. He advocated an economic system in which "every man, as long as he does not violate the laws of justice, is left

KEY CONCEPT

Enlightenment

The goal of the Enlightenment as a philosophical movement was enlightenment of the individual – that is, the education of citizens so that they could exercise their powers of reason unhindered by tyranny and superstition. In 1795, the German philosopher Immanuel Kant defined enlightenment as the ability to reason for oneself, free from authority or received opinion. "Enlightenment is the liberation of humanity from its self-imposed state of immaturity," wrote Kant. He proclaimed as the maxim of enlightenment: "Sapere aude! [Dare to know!] Dare to use your own understanding!"[3]

Education was the way to enlighten individuals and society as a whole. In *Émile, or Education*, his novel depicting the enlightened upbringing of a boy, Jean-Jacques Rousseau asserted that a child needed only education in the powers of reason and the senses: "All that we lack at birth, all that we need when we come to the human estate, is the gift of education," he wrote in Book I. But even in Rousseau's romance, mature autonomy and independent thought do not guarantee happiness. Émile's marriage to Sophie, the girl reared as his modest and submissive mate, ends in infidelity and estrangement. The course of true enlightenment did not always run smooth.

Eighteenth-century thinkers were confident that enlightened education would eventually lead to world peace and general prosperity. The philosophe Condorcet (1743–1794) sketched ten stages in the historical progress of the human mind. "By appeal to reason and fact," asserted Condorcet [KOHN(h)-door-say], humans could achieve a limitless progress in culture and society. "The perfectibility of man is truly indefinite," he wrote.[4] Kant likewise predicted that enlightenment would lead humans toward a world government that guaranteed equal rights and universal education. Reviving the cosmopolitan ideal of the stoics (see Key Concept, page 65), Kant believed that world peace required only the application of sufficient human reason. "The problem of organizing a state, however hard it may seem, can be solved even for a race of devils, if only they are intelligent," Kant concluded.[5]

> Enlightenment is the liberation of humanity from its self-imposed state of immaturity … Sapere aude! Dare to use your own understanding! is thus the motto of enlightenment.
>
> Immanuel Kant

CRITICAL QUESTION

At what point in adult life did you achieve important progress toward enlightenment, as defined by eighteenth-century thinkers? How were your mature powers of understanding or action developed? What did you "dare to understand"?

perfectly free to pursue his own interest in his own way."[6] When individuals pursued their self-interest, as a whole their decisions would produce the greatest prosperity and happiness for all – as if guided by an "invisible hand," in Smith's famous phrase. Liberating producers and laborers from government sanction would, in "a well-governed society," assure that "universal opulence extends itself to the lowest ranks of people." It is not from the "benevolence of the butcher, the brewer, or the baker, that we expect our dinner," he wrote famously, "but from their regard to their own interest."[7]

The Enlightenment's emphasis on individual freedom and self-interest raised profound questions for moral philosophy. At the end of the eighteenth century, the German idealist philosopher Immanuel Kant (1724–1804) addressed this moral question directly. In the pursuit of enlightenment, Kant [kahnt] argued, individuals freed themselves from tradition and authority, including the authority of moral teaching (see Key Concept, page 305). But how might enlightened individuals choose to do right, instead of merely gratify individual interest or desire? According to Kant, enlightened moral decisions should obey the **categorical imperative**: "Act only on that maxim whereby you can, at the same time, will that it should become a universal law," as Kant stated it.[8] The categorical imperative required that reasonable people act as if their actions defined a moral law – as if their choices were "universalizable," or true and right for all. With his assertion of human moral freedom, Kant made each enlightened person a "universal legislator," responsible for creating universal moral law through reasoned individual action.

The Bourgeois Response

Identify the artistic styles and themes that appealed to the middle-class public of the eighteenth century.

Paris's most popular play in 1784 was a pointed response to the hereditary status of Europe's nobility. *The Marriage of Figaro* by Pierre Beaumarchais (1732–1799) criticized the arrogance of Europe's nobles and championed a morally upright servant. It contained a stirring indictment of aristocratic privilege: "Nobility, wealth, a title, positions, and all of it makes you so proud! What have you done for all these blessings?" Figaro asks his master, the Count. "You've had the trouble of being born, and nothing more."

In Paris, bourgeois audiences cheered Figaro's speech and the play's success was a sign of changing attitudes. As the middle classes gained influence, they demanded art that reflected their moral attitude and artistic taste: sober virtue and a straightforward depiction of life. Yet, like the nobility, they wanted education for their children, entertainment for their leisure, and tastefully decorated houses.

The Bourgeois Style in Painting

The bourgeois style in painting coexisted with the playful rococo style. The painter Jean-Baptiste-Siméon Chardin [shar-DAN(h)] (1699–1779), for example, countered the rococo style with a clarity of color and form. Chardin's paintings mostly depict ordinary scenes of the middle class, such as *Boy Spinning Top* (Fig. **11.13**). The subject and colors of his paintings are reminiscent of the seventeenth-century Dutch genre painting (see page 280) – adapted to the tastes of his French public. Chardin took great pleasure in the straightforward spatial order and palpable textures of his still lifes. His interior scenes present a world of domestic peace and contentment.

The most popular French painter of the mid-eighteenth century was Jean-Baptiste Greuze (1725–1805). Technically, Greuze [gruhz] was a lesser painter than Chardin, but he was a greater phenomenon in his day. His genre pictures appealed directly to the cult of *sensibilité* ("feeling" or "compassion"), which swept over jaded Parisians at mid-century. Many of his pictures, such as *The Bride of the Village* (Fig. **11.14**), presented touching family scenes that might well be tableaux from the bourgeois sentimental drama. In this moralizing picture, the father hands over his daughter's dowry while delivering a sermon on the virtues of fidelity. The philosopher Diderot, who helped to popularize Greuze's paintings, said the spectator of such pictures "was seized by tender feeling." With his pictorial anecdotes, Greuze aroused

11.13 Jean-Baptiste-Siméon Chardin, *Boy Spinning Top*, 1741. Oil on canvas, 26½ x 28¾ ins (67 x 73 cm). Louvre, Paris. Chardin painted mostly still-life and genre scenes that possessed charm, simplicity, and a subtle moralizing tone. Here a boy has set aside his studies to play with a toy he has kept in the drawer – a mild pictorial sermon on the dangers of idleness.

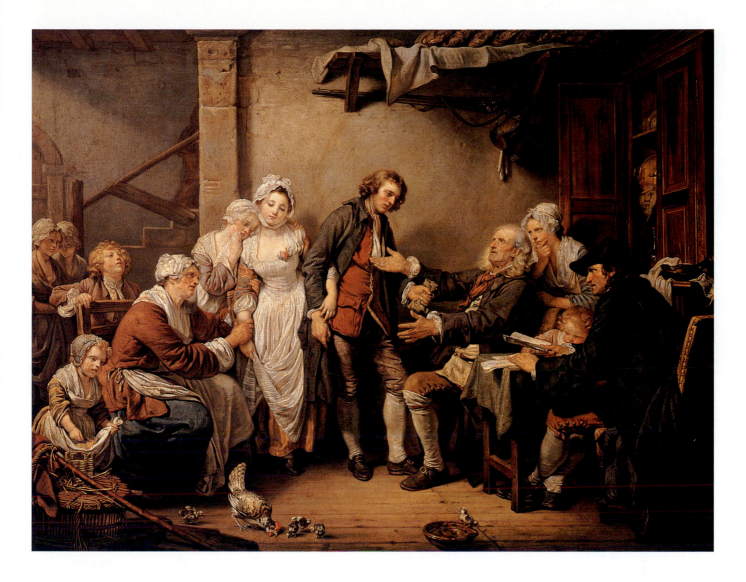

a nostalgia for a simpler provincial life among Parisian sophisticates.

The Rise of the Novel

A German philosopher once said of the novel that it was "the epic of the middle class," though, unlike the epics of ancient times, it did not retell tales from mythology or legend. Rather, the eighteenth-century **novel** was a long work of narrative fiction with realistic characters and settings – much as we know it today. Often taking the form of a journal or a series of letters (called an **epistolary novel**), the early novel provided ample latitude for its characters' introspection and moral self-examination.

> General literature now pervades the nation through all its ranks.
>
> Dr. Samuel Johnson

11.14 Jean-Baptiste Greuze, *The Bride of the Village*, 1761. Oil on canvas, 46¹/₂ x 36 ins (118 x 91 cm). Louvre, Paris. In contrast to the elegant but frivolous rococo, the European middle classes patronized works of sobriety and sentimentality. In Greuze's moralizing tableau, note the reactions of the principal females: the dreamy bride, the fretting mother, and (behind the father) the envious sister.

The novel's popularity grew with the rising tide of literacy in eighteenth-century Europe (Fig. **11.15**). In England, wrote critic Samuel Johnson, "general literature now pervades the nation through all its ranks," and every house is "supplied with a closet of knowledge."[9] Male literacy may have reached sixty percent by 1750. The new reading public (which included a growing number of women) patronized coffeehouses, lending libraries, and book clubs. Critics like Samuel Johnson (1709–1784) labored to guide the public's reading tastes. Johnson wrote a great dictionary of English and an influential introduction to Shakespeare, whom he defended as a native English talent.

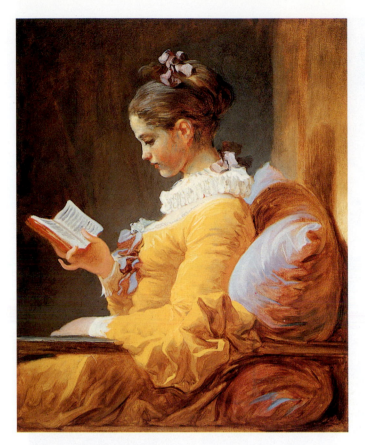

11.15 Jean-Honoré Fragonard, *A Young Girl Reading*, c. 1776. Oil on canvas, 32 x 25½ ins (81 x 65 cm). National Gallery of Art, Washington, D.C., Gift of Mrs. Mellon Bruce in memory of her father Andrew W. Mellon.
The eighteenth-century rise in literacy, especially among women, fueled the popularity of the novel. Novels gratified the bourgeois reader's expectations for an educational and moralizing literature, as well as a taste for romance and adventure.

Eager for self-improvement, the eighteenth-century middle classes wanted books to uplift them as well as entertain them, and the novel gratified the bourgeois reader's expectations for an educational and moralizing literature. In England the first great novel was Samuel Richardson's epistolary *Pamela, or Virtue Rewarded* (1740–1742), which provided just the moral inspiration that bourgeois readers were seeking. The book's heroine,

Pamela, is a simple country girl who must withstand the seductions of her wealthy employer. The psychological drama of her struggle is revealed through her letters, which form the bulk of the story. In a letter to her parents, Pamela sympathizes with young servant girls who have faced the assaults of their masters:

> But, dear father and mother, what sort of creatures must the woman-kind be, do you think to give way to such wickedness? Why, this it is that makes every one to be thought of alike: and, a-lack-a-day! what a world we live in! for it is grown more a wonder that the men are resisted, than that the women comply. ... But I am sorry for these things; one don't know what arts and stratagems men may devise to gain their vile ends; and so I will think as well as I can of these poor undone creatures, and pity them. For you see, by my sad story, and narrow escapes, what hardships poor maidens go through whose lot it is to go out to service, especially to houses where there is not the fear of God, and good rule kept by the heads of the family.[10]
>
> SAMUEL RICHARDSON
> *From Pamela (1740–1742)*

The most popular of these eighteenth-century sentimental novels was Rousseau's *Julie, ou la Nouvelle Héloïse* (*Julie, or the New Héloïse*, 1761), a bestseller that ran to seventy-two editions. Rousseau's novel was based on the famous medieval love story of Abelard and Heloïse (see page 155) and played on the racy themes of seduction and marriage between social classes. The virtue of Rousseau's heroine is suspect until she dies sacrificially in the last pages of the novel. All of Europe wept for Rousseau's *Julie*.

By the end of the century, the sentimental novel had evolved into a more subtle exploration of sensation and feeling. As perfected by Jane Austen (1775–1817), the so-called **novel of manners** was a carefully observed and gently satirical study of social life among the English gentry. In *Sense and Sensibility* (1811) and *Pride and Prejudice* (1813), Austen examined her heroines in the crucial moment of betrothal and marriage, as they sought a livable balance among affection, social standing, and personal integrity. Austen's finely wrought novels of manners gave the novel its first modern cast.

The Bourgeois Theater in Germany

The bourgeois response in Germany was tinged with both sentimentality and nationalism. Through the early eighteenth century, Germany's dozens of small courts slavishly imitated the culture of absolutist France, with its artificial manners and neoclassical tastes. A rebellion against French influence was led by Gotthold Ephraim Lessing (1729–1781), a critic and dramatist who single-handedly created a German national theater. Lessing was the founder of the *Aufklärung* [OWFF-klair-oonk], or

RISE OF THE ENGLISH NOVEL

Daniel Defoe (1660–1731)	*Robinson Crusoe* (1719), *Moll Flanders* (1722)
Henry Fielding (1707–1754)	*Tom Jones* (1749)
Samuel Richardson (1689–1761)	*Pamela, or Virtue Rewarded* (1740–1742)

Kabuki Theater

In Europe, increasingly middle-class theater audiences demanded a theatrical style that was more natural and candidly sentimental. But in Japan, during roughly the same period, a rising and confident merchant class supported a theater of exquisite and extreme artifice. The contrast between European sentimental drama and the Japanese **kabuki** theater demonstrates the variety of world cultures even under similar social conditions.

The kabuki [kuh-BOO-kee] theater (Fig. **11.16**) combined stylized acting with song, dance, colorful costume, and spectacular staging. It arose in Japan during the Edo period (1616–1868), as Japan emerged from feudal wars and the influence of the royal court at Kyoto waned. A new merchant class in Edo (Tokyo) and other commercial centers supported a vital new secular culture. These townspeople sought amusement in the entertainments of the *ukiyo*, the "floating world" of sensual pleasures – literally, entertainment districts containing restaurants, theaters, and brothels.

Kabuki was invented in this "floating world" in 1603, supposedly by a young female dancer named Izumo no Okuni. By the eighteenth century, kabuki was so popular that permanent commercial theaters were built to hold audiences of several thousand. At a time when European theater stressed simpler plots and staging, kabuki productions reveled in artifice. Elaborate theatrical devices – revolving stages, elevators, multiple curtains, intensely colored costumes, and elaborate scenery – made kabuki a visual spectacle. The kabuki stage's most distinctive feature was a ramp leading through the audience, called the *hanamichi*, or "flower path." The *hanamichi* [hahn-uh-MEE-chee] permitted theatrical entrances and exits by star actors, often with dramatic pauses and stylized poses. Kabuki staging borrowed its formalized gestures from the more traditional Noh drama, long popular with Japan's feudal warrior class. But the new genre also drew from the exuberant Japanese puppet theater, called *bunraku*.

Some kabuki actors specialized in impersonating female characters (females were banned from the stage early in kabuki's history). Others perfected a "rough" acting style suitable for gangster or soldier roles, or a "soft" style for playing merchants or lovers. The kabuki enhanced the actors' highly stylized gestures and poses with extravagantly colorful costumes and make-up. Typically, kabuki performances lasted for an entire day; a small orchestra provided a varied musical accompaniment to the action.

The stories of the kabuki theater included historical dramas, roughly equivalent to the history dramas of Shakespeare's theater, and domestic dramas with comic plots or tales of doomed lovers. In one typical plot, two lovers – a banished priest and a courtesan – both survive a mutual suicide attempt, but then continue their lives while each thinks the other has been lost. In its conventionalized plots, spectacular effects, and virtuoso performance, Japanese kabuki shares more with European opera than with realistic drama.

11.16 Utagawa Kunisada, scene from *Sukeroku*, c. 1835. Woodblock print (detail), whole block 8$^1/_2$ x 22$^1/_2$ ins (21.6 x 57.2 cm). Victoria & Albert Museum, London.

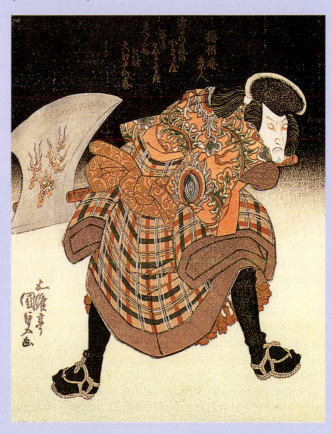

"enlightenment," in Germany. To him, the term implied not only philosophical enlightenment but also a clarified national spirit in the German states. Lessing's critical works condemned neoclassical formalism, while his plays depicted characters of more direct and genuine feeling. A typical example of this bourgeois sentimental drama was his *Miss Sara Sampson*, the Greek tragedy of Medea refashioned with a bourgeois heroine.

Lessing's sentimental drama prepared the way for an impassioned group of young German authors called the *Sturm und Drang* [STOORM oont DRAHNK] (Storm and Stress) movement. Writers of the *Sturm und Drang*

protested social injustice and praised rebellious genius. Dedicated to German nationalism, they hoped to free German culture from its insipid imitations of French neoclassicism. The movement's most important figure was Johann Wolfgang von Goethe (1749–1832). Goethe's [GUH(r)-tuh] sprawling play *Götz von Berlichingen* explicitly violated neoclassical norms and emulated Shakespeare's dramatic scope and diversity. Its hero, Götz [guhts], is a fiery medieval knight who joins a peasant revolt and thus proves a passionate commitment to justice and fairness. In Götz, Goethe gave to German theater its first great dramatic hero and a powerful expression of the *Sturm and Drang* movement.

Music in the Age of Enlightenment

Compare eighteenth-century musical forms to today's popular music.

By 1750 Europe's painters and sculptors had become artistic free agents, seeking commissions wherever they could find them. By contrast, especially in central Europe, musicians and composers were often still feudal servants in the household of a noble patron. Despite these strictures, the age of Enlightenment fostered an explosion of musical genius that we now call the Classical period in music (c. 1750–1820).

The first important Classical composers were Joseph Haydn and Wolfgang Mozart. Both were immensely prolific, composing music for court occasions, religious services, and public concerts that were the standard musical fare of the eighteenth century. The Austrian composer Haydn (1732–1809; Fig. **11.17**) spent nearly three decades as composer for the Esterházys, a family of Hungarian aristocrats. In service to his patrons, Haydn [HIGH-dn] composed with considerable range and originality within the limits of the Classical style. By the 1790s, he was recognized as Europe's leading composer, excelling in all the popular musical forms (see page 311).

Wolfgang Amadeus Mozart (1756–1791) began his adult career in service to the Prince-Archbishop of Salzburg. When the nobleman rudely discharged him in 1781, Mozart [MOH-tsart] eagerly migrated to the great musical capital of Vienna, where he hustled to support himself as a freelance performer, tutor, and composer (Fig. **11.18**).

Mozart and Opera

In Vienna the vivacious Mozart proved himself a master of the "*galant*" style, as it was then called – a music that was clear, lively, and "natural" compared to the artificial

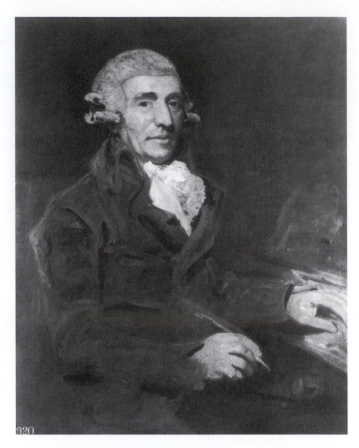

11.17 John Hoppner, *Portrait of Joseph Haydn*, 1791. The Royal Collection © 2005 Her Majesty Queen Elizabeth II.
Prince Nikolaus I Esterházy engaged Joseph Haydn as court composer and conductor from 1762 until the year of his death in 1790. Musical life at court was extremely lively during Nikolaus I's reign.

counterpoint of baroque styles. Mozart's compositions were carefully tailored to the tastes of his audience and were suited to performance in the small palaces and town houses of rococo society. His solo works for piano, such as the Piano Sonata in A major, showed off his virtuoso skill at the keyboard. The movements in this sonata – including one in minuet tempo and a rondo *alla turca* (in the Turkish style) – were chosen to please the audiences of Paris, where the piece was probably composed. In such works, Mozart had to balance his interest in musical innovation against the limitations of his audience's ear. In a letter, he once praised a set of his concertos for striking "a happy medium between what is too easy and too difficult; they are very brilliant, pleasing to the ear, and natural, without being vapid."

In Vienna, Mozart's most important audience was the enlightened Emperor Joseph II, who sponsored his entry into Viennese opera, a world of international prestige and cut-throat intrigue. Opera in Vienna had already felt the influence of reformers who wished to free German opera of ornamental singing and far-fetched plots. The reforms had the effect of widening opera's appeal to the mixed

First Theme

Figaro

Cin - que, die - ci, ven - ti,

tren - ta

Second Theme

Susanna

O - ra si__ ch'io__ son__ con - ten - ta

11.19 Wolfgang Amadeus Mozart, opening measures of the duet "Cinque … dieci," from *Le Nozze di Figaro* (*The Marriage of Figaro*), Act I, 1786.

Figaro's march-like melody expresses his sturdy and naive manliness; the witty and worldly Susanna offers a lyrical counter-melody.

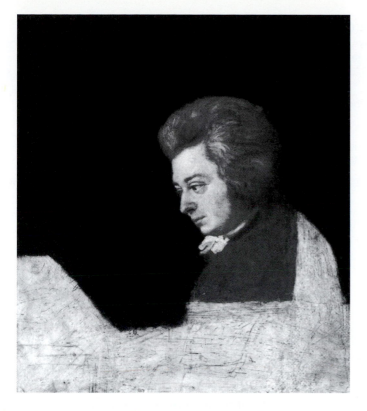

11.18 Joseph Lange, *Mozart at the Pianoforte*, 1789. Oil on canvas, 13¹/₂ x 11¹/₂ ins (35 x 30 cm). Mozart Museum, Salzburg.

The misery of Mozart's last years has been much exaggerated in the popular imagination, although he was unable to achieve the artistic independence that marked the later career of Ludwig van Beethoven.

aristocratic and middle-class audiences of Vienna and Prague. Mozart enjoyed his greatest successes in these musical cities.

Mozart proved a genius at balancing music and drama in opera. One of his operatic masterpieces, *Le Nozze di Figaro* (*The Marriage of Figaro*, 1786), captures the rococo mood of gaiety and frivolity, while also presenting a musical drama of sophistication and wisdom. The *libretto*, or dramatic text, was written by Lorenzo da Ponte in Italian – still the language used in most eighteenth-century opera. *The Marriage of Figaro* recounts the impending marriage of Figaro and Susanna, servants in the house of Count Almaviva (Fig. **11.19**). Susanna fears that the philandering count will force himself on her. Figaro alternates between determination to foil the count's intentions and suspicion of his fiancée. However, jealousy and anger never entirely obscure the opera's underlying humor and optimism. Its final scene – a virtuoso creation of ensemble singing – resolves all the mistaken identities and disguises, distrust and suspicion. When the count kneels to ask forgiveness, the whole party affirms its faith in a candid and worldly love.

Mozart's later operas are also acknowledged as masterpieces of the operatic form. *Don Giovanni* [DON jee-oh-VAHN-ee] (1787) recounts the demise of the famous lover Don Juan, whose romantic exploits are enumerated in the famous "Catalogue" aria, sung by his sardonic servant Leporello. In his last year, Mozart scored a popular success with *Die Zauberflöte* (*The Magic Flute*, 1791). Set in Egypt, the opera's magical atmosphere and light-hearted music delighted the Viennese public, while its symbolism celebrated the philosophical themes of harmony and enlightenment.

The Classical Symphony

It was Mozart's elder, Joseph Haydn, who developed the symphony in its Classical form. The **symphony** is an orchestral composition usually in four **movements** or sections. These movements are usually known by Italian terms that describe the tempo (speed) at which the music is played. The Classical symphony usually opens

POPULAR CLASSICAL MUSICAL FORMS

symphony	orchestral work, usually in four movements
concerto	work for single instrument and orchestra, usually in three movements with pattern of fast-slow-fast
sonata	work for solo piano or a piano with another instrument, usually in three or four movements
string quartet	work for violins, viola, and cello, usually in four movements

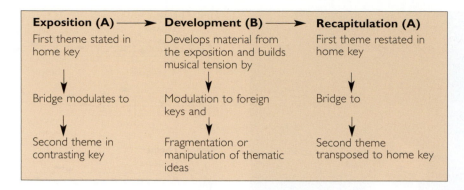

Exposition (A) →	Development (B) →	Recapitulation (A)
First theme stated in home key	Develops material from the exposition and builds musical tension by	First theme restated in home key
↓	↓	↓
Bridge modulates to	Modulation to foreign keys and	Bridge to
↓	↓	↓
Second theme in contrasting key	Fragmentation or manipulation of thematic ideas	Second theme transposed to home key

11.20 The sonata form.

with a fast movement, followed by a slow and lyrical movement, then a graceful dance in moderate tempo, and finally a fast and animated fourth movement. Haydn could achieve intricate musical effects in just the brief span of a minuet (a dance form), as in the Minuet and Trio from his Symphony No. 45 (1772). He was also a musical joker: his "Surprise Symphony" and the "Joke Quartets" (1781) violate the predictable patterns of Classical form for comic effect.

Each symphonic movement was also written in a specific formal pattern. As developed by Haydn, the Classical symphony's first movement is the most important, setting the musical tone for the entire work. This first movement was in the **sonata form** (Fig. **11.20**), which weaves two musical themes together in a three-part structure. In the sonata form, the two themes are first stated in the **exposition**, which presents the movement's basic musical ideas in a musical "argument." The first theme is stated in the home key, the second theme in a contrasting key. Then, in the **development**, the themes undergo various musical changes. The melodies may be broken apart, turned backwards or upside down, or played in different musical keys. Finally, the tensions created in the development are resolved in the **recapitulation**, when both themes are restated in the home key. The movement may finish with a brief *coda*, or "tail." The sonata form offered Classical composers an orderly, harmonious structure that could accommodate considerable musical variation.

The formal symmetry of the eighteenth-century Classical symphony is demonstrated in Mozart's precise symphonic compositions. In 1790, in the span of six weeks, Mozart composed three symphonies, including the Symphony No. 40 in G Minor. The symphony's first movement (Fig. **11.21**) begins with a **motif**, or melodic idea, of three rapid falling notes that create an insistent, almost neurotic energy. As was typical of the sonata form, the second theme (in a contrasting key) is more lyrical, even languid. The exposition is usually played twice. In Mozart's development, the first theme's three notes are sounded in different keys and build to a piercing climax. The tension is resolved in the recapitulation, as both themes return to the home key of G minor. The symphony demonstrates Mozart's ability to create effortless transitions between sections and to build a perfectly symmetrical structure for his musical ideas. The work embodies the musical "enlightenment" of the Classical symphony, with its emphasis on clarity and balance.

> There is but one way for the moderns to become great, and perhaps unequaled; I mean, by imitating the ancients.
>
> Johann Winckelmann

11.21 Wolfgang Amadeus Mozart, Symphony No. 40 in G Minor. First movement, first and second themes.

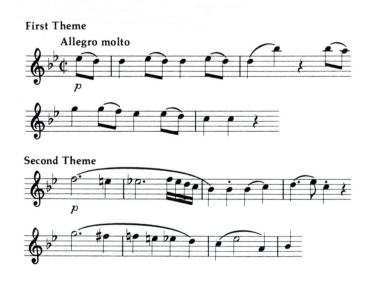

CRITICAL QUESTION

Of the three eighteenth-century styles in the visual arts – rococo, sobriety and feeling, and neoclassical – which appeals most to your own tastes? How is your taste reflected in the decorative and design choices you make?

The Neoclassical Style

Explain how neoclassicism could express both conservative and revolutionary values.

"There is but one way for the moderns to become great, and perhaps unequaled; I mean, by imitating the ancients." These were the words of the eighteenth century's greatest enthusiast of the "ancients," the German writer Johann Joachim Winckelmann (1717–1768), in his *Thoughts on the Imitation of Greek Works in Painting and Sculpture*. Like so many enlightened thinkers, Winckelmann [VINK-el-mahn] praised the Greeks to condemn something in his own age, in particular the feeble softness and capricious excesses of the rococo. Winckelmann's teachings helped define the **neoclassical** style of the later eighteenth century, which explicitly imitated the art of ancient Greece and Rome. This era's neoclassicism (see Key Concept, page 315) was abstract, with little firsthand knowledge of antique art, and it was moral, imposing universal ethical principles on art. Neoclassicism was also versatile: under different circumstances, it was used to revive the grandeur of Versailles, to demonstrate the good taste of the rising middle class, and to educate and civilize an unsophisticated provincial nation.

Neoclassical Architecture

The bible of neoclassical building was Palladio's *Four Books of Architecture* – a collection of meticulous drawings of ancient Roman buildings by the famous Italian Renaissance architect (see page 248). The English gentry built imitations of Palladio's villas on their estates, often combining neoclassical buildings with landscaped settings to achieve **picturesque** vistas. Henry Hoare's Park at Stourhead (Fig. 11.22) exemplifies the English taste for the picturesque, with its balance between neoclassical order and the rustic irregularity of nature.

Perhaps the purest example of neoclassical taste and cultivation was the Petit Trianon [PUH-tee TREE-a-non(h)] (Fig. 11.23), a residence built for Louis XV in the grounds of Versailles Palace. The architect, Ange-Jacques Gabriel, avoided repeating the pompous grandeur of the main palace and instead aimed for perfect balance and austere simplicity. Except for the four subdued pilasters, the

11.22 Henry Hoare, the Park at Stourhead, 1743–4.
In contrast to the formal gardens of Versailles, designers in England sought to reproduce the natural landscapes of the classical poets. Landscape designers strove for an effect called the "picturesque." Note in this view, the distant small-scale classical temple framed by the bridge, lake, and foliage.

11.23 Ange-Jacques Gabriel, the Petit Trianon, Versailles, France, 1761–4. This small residence in the grounds of the Palace of Versailles expresses the elegance and decorum of the eighteenth-century neoclassical style. Compared to the main palace, the scale and decoration here are restrained and the residence's interior was ingeniously arranged for comfortable living.

building is almost free of decoration. Nothing distracts from its geometric regularity.

The most ingenious of the neoclassical architects was neither French or English, but American. Thomas Jefferson (1743–1826), revolutionary philosopher and American president, was also an accomplished builder. While ambassador to France in the 1780s, he studied the neoclassical style and came to believe it represented European cultivation and enlightenment. Jefferson adapted the neoclassical style in his designs for buildings in America, such as his country estate Monticello (Fig. **11.24**), built much in the spirit of Palladio's Italian villas. Monticello's hilltop site, overlooking the mountains and farmland of central Virginia, can be compared with Palladio's Villa Rotonda (see Fig. 9.30). In some of Monticello's decorative details, Jefferson slavishly followed

Palladio's architectural drawings. In other cases, Jefferson showed his ingenuity as a designer. The home's connecting outbuildings are hidden below ground level, giving Monticello its elegant profile while serving its function as a farmhouse. The famous dome and the appearance of a single story (in fact there are three) were elements borrowed from the fashionable *hôtels* that Jefferson had seen in Paris.

1781	Houdon, *Voltaire* (**11.29**)
1784	Jefferson, completed Monticello, Virginia (**11.24**)
1784–5	David, *Oath of the Horatii* (**11.27**)
1790	Mozart, Symphony No. 40

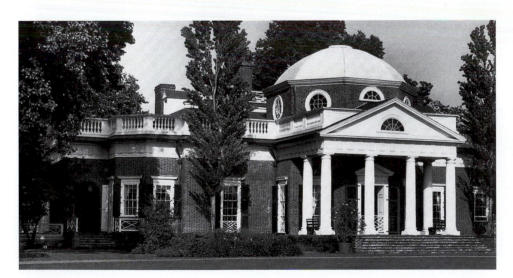

11.24 Thomas Jefferson, Monticello, near Charlottesville, Virginia, 1770–84; remodeled 1796–1806.

Compare the visual effect of Jefferson's neoclassical residence, with its use of native American materials (brick, wood), to the French palace, the Petit Trianon (above). Note the use of round windows and the fan-shaped Palladian window in the triangular pediment.

Neoclassicism

Western art had borrowed from the art of ancient Greece and Rome throughout history, but during the eighteenth century it swelled with a new enthusiasm for classical styles. This artistic fashion is called **neoclassicism**, meaning the conscious effort to revive the values of classical art and history. Compared with earlier classical revivals, eighteenth-century neoclassicism was particularly rigid and often austere. However, like other versions of classicism, it sought to recreate a world of timeless truth and beauty (Fig. **11.25**). It also had a great capacity for meaning different things to different people. To the royal court, it signaled a relief from the preciosity of the rococo style and a return to the grand style of Louis XIV. To the royal academies, it represented the authority of the past, a basis for teaching good taste and disciplined technique. To the newly educated middle classes, neoclassicism offered a high-minded moralism and a sure standard of taste and decorum.

It is no wonder, then, that an explosion of neoclassical paintings, buildings, and statues burst upon the later eighteenth century. The fashion was ignited by theorists such as Johann Winckelmann, who praised the "noble simplicity and quiet grandeur" of ancient Greece (without ever having seen a Greek temple). Enlightened citizens lived in the style of antique heroes, modeling their lives and their clothes after the ancient Greeks and Romans.

This vision of antiquity was usually derived from earlier versions of neoclassicism rather than from antiquity itself. In fact, neoclassical theorists were somewhat dismayed by excavations at the ancient cities of Herculaneum and Pompeii (begun in 1737). The bawdiness of actual Roman wall paintings did not match neoclassicism's idealized image of antiquity. Whatever the illusions about antiquity, however, neoclassicism expressed a desire for universal moral truths and enduring standards of reason and beauty. It responded to a common impulse in Western civilization: the desire to return to a simpler and more glorious past.

11.25 Angelica Kauffmann, *Cornelia Pointing to her Children as her Treasures*, c. 1785. Oil on canvas, 3 ft 4 ins x 4 ft 2 ins (1.02 x 1.27 m). Virginia Museum of Fine Arts, Richmond, Virginia, The Adolph D. and Wilkins C. Williams Fund.
Kauffmann was one of two female founding members of the British Royal Academy and excelled at history painting, the most prestigious category of eighteenth-century academic painting. This scene is taken from Roman history: when a visitor asked to see her family's jewels, Cornelia supposedly pointed to her two sons, who would become leaders of the Roman Republic.

Neoclassical Painting

The popularity of neoclassicism supported a thriving style in painting throughout Europe and North America. The English painter Sir Joshua Reynolds (1723–1792), first president of the British Royal Academy, pioneered a "grand style" of portraiture. Reynolds commonly showed his subjects sitting among antique statuary or portrayed as mythological figures. When a London politician commissioned a monumental portrait of his fiancée and her sisters, Reynolds painted the women as the classical Graces, performing ancient rites before Hymen, the Roman god of marriage (Fig 11.26). In praising the foundation of the Royal Academy, Reynolds argued that a painter's genius was demonstrated not by faithfulness to nature, but by the imitation of "authentic" models. The Swiss-born artist Angelica Kauffmann (1741–1807) made a career of the ancient history subjects that were a commonplace of academic exhibitions (see Fig. 11.25). Kauffmann, who lived in London for some years, eventually settled in Rome, where she befriended literary and artistic notables making the fashionable "Grand Tour" of Italian cities. With their high moral tone, Kauffmann's paintings appealed to a public that sought uplift in sentimentality, but also desired exalted subjects of antiquity.

Not until Jacques-Louis David [da-VEED], however, did the neoclassical style produce truly electrifying paintings. David (1748–1825) astounded the art public in 1784 with his stern tableau of Roman heroes, the *Oath of the Horatii* (Fig. **11.27**). Visitors to the painter's Rome

11.26 Joshua Reynolds, *Three Ladies Adorning a Term of Hymen*, 1773. Oil on canvas, 7 ft 6 ins x 9 ft 6 ins (2.3 x 2.9 m). Tate, London.

In works such as this, Reynolds defined a new kind of neoclassical presentation for his aristocratic subjects. The three sisters, portrayed as the classical Graces, dance around a statue of the goddess of marriage, decorating it with a looping garland of flowers. Compare this group portrait to Watteau's intimate scene of lovers in *Pilgrimage to Cythera* (Fig. 11.1).

11.27 Jacques-Louis David, *Oath of the Horatii*, 1784–5. Oil on canvas, 10 ft 10 ins x 14 ft (3.3 x 4.27 m). Louvre, Paris.
In this manifesto of neoclassicism, David's statuesque figures and simplified design captured neoclassicism's moral passion in paint. Compare the resolute stance of the men to the languid lines of the grieving women.

studio placed flowers before the picture as if it were an altar. King Louis XVI admired the work, and it was purchased immediately by the French government, though today the picture is often seen as a premonition of the French Revolution. In a scene from the history of Rome, three brothers pledge to defend the city's honor against the Curatius family of a neighboring town. The Horatian women – on the right – grieve because one is sister to the opposing family and another is engaged to a Curatius. In David's version, this gripping scene is purified of all ornament. The painting embodied the leading principles of neoclassicism: didactic purpose, purity of form, and deep passion restrained by good taste. In its simplicity and rigor, it was a declaration of neoclassicism's revolt against the whimsical style of the rococo.

The Age of Satire

Identify the aspects of eighteenth-century society that were criticized by the age's great satirists.

The Enlightenment was as critical of human folly as it was convinced that social evils could be corrected. The age was characterized by **satire**, the literary or artistic attitude that aims to improve society by its humorous criticism. Imitating the satirical poets of ancient Rome (see page 91), Enlightenment satirists lightened their attacks on social ills with wit, mockery, and comic exaggeration. Often, they broadcast their satire in the pamphlets, engravings, and adventure tales that were staples of the reading public of the time. In every case, eighteenth-century satirists hoped that laughing at social evils would help to correct them.

Swift

Jonathan Swift (1667–1745), perhaps the greatest Enlightenment satirist, was a deeply pessimistic man who spent his literary talents on efforts for social reform. As an Anglican churchman, Swift led a highly public life

that engaged him in the major political and social debates of his time. He was deeply sympathetic to the poverty and economic oppression in his native Ireland. In his famous pamphlet *A Modest Proposal* (1729), Swift made a bitterly ironic recommendation, that the children of the Irish poor be butchered, roasted, and served upon the Sunday dinner tables of their oppressive English landlords. Eating children, said Swift, would reduce surplus population and provide income for the children's impoverished parents. He even calculated the reasonable price a gentleman should pay for the "carcass of a good fat child."

I do therefore humbly offer it to public consideration, that of the hundred and twenty thousand children, already computed, twenty thousand may be reserved for breed, whereof only one fourth part to be males, which is more than we allow to sheep, black-cattle, or swine, and my reason is that these children are seldom the fruits of marriage, a circumstance not much regarded by our savages, therefore one male will be sufficient to serve four females. That the remaining hundred thousand may at a year old be offered in sale to the persons of quality and fortune, through the kingdom, always advising the mother to let them suck plentifully in the last month, so as to render them plump, and fat for a good table. A child will make two dishes at an entertainment for friends, and when the family dines alone, the fore or hind quarter will make a reasonable dish, and seasoned with a little pepper or salt will be very good boiled on the fourth day, especially in winter.[11]

JONATHAN SWIFT
From A Modest Proposal (1729)

Swift's satiric masterpiece was *Gulliver's Travels* (1726), a journal of the fantastic travels of Lemuel Gulliver. Its playful tone disguises a savage exposé of human folly and corruption. Swift recounts Gulliver's adventures in several lands, using each new encounter to mock human vices and political corruption. The bitterest episode describes Gulliver's encounter with the Houyhnhnms [HOO-ee-nimms], a race of horses "so orderly and rational, so acute and judicious" that they put humans to shame. The land of the Houyhnhnms is also inhabited by ignoble savages called Yahoos, who are prone to bickering, avarice, and gluttony. They possess, in other words, the worst features that Swift observed in his human companions.

Swift's view of the world combined the Enlightenment's critical spirit with the traditional Christian belief in human sinfulness. He saw human beings as all the more responsible for their folly and cruelty, since humans could reason while the Yahoos could not. As the Houyhnhnm master observes, when a creature "pretending to reason" is able to commit the horrors of modern war, human rationality may be worse than the Yahoos' brutishness. Compared to the philosophes, Swift was less convinced

that human decency and hard work could improve the world. In humans, he mused, reason is a quality "fitted to increase our natural vices."

Satire and Society in Art

Swift's mockery of eighteenth-century vice found its pictorial counterpart in the satirical paintings of William Hogarth (1697–1764). Hogarth is best known for several series of pictures telling stories of moral corruption. These pictorial narratives were engravings, which he sold by subscription to a middle-class public eager to laugh at the folly of their neighbors.

Hogarth's series *Marriage à la Mode* (1744) mocked the bourgeois social climbers and degenerate nobles who

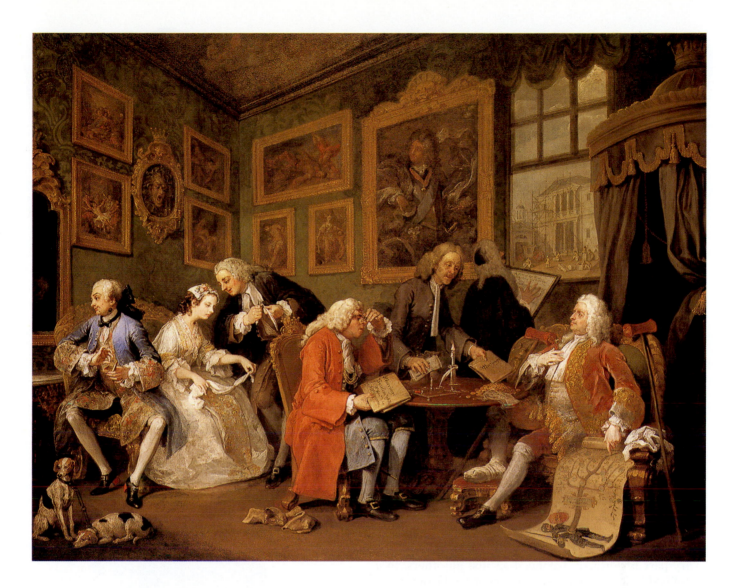

11.28 William Hogarth, *The Marriage Contract* from *Marriage à la Mode* (Scene I), 1744. Oil on canvas, 27 × 35 ins (69 × 90 cm). National Gallery, London.
Hogarth filled his painting with telling narrative detail: the botched neoclassical building, evidence of the aristocrat's faulty taste; the dogs chained together, symbolic of the couple's ill-fated union; and the syphilitic pox marks on the bridegroom's face, proof of his dissolute living.

married off their children for their own advantage. In the first painting, *The Marriage Contract* (Fig. **11.28**), the dissolute Earl of Squander points to his family tree to prove the noble pedigree of his son, the prospective bridegroom. The merchant, father of the bride, has laid the dowry on the table and scrutinizes the contract like a good businessman. Meanwhile, the bridal couple ignore both the negotiations and each other. The groom admires himself in the mirror and the bride is distracted by the flattery of the lawyer, Counselor Silvertongue. Later scenes in *Marriage à la Mode* recount the lawyer's seduction of the young countess, with disastrous results. Such

moralizing, along with his command of narrative detail and satiric touch, made Hogarth's works highly successful among a new middle-class art public.

Voltaire

The Enlightenment's most famous satirical voice – indeed, the figure who came to symbolize enlightenment itself – was François Marie Arouet, known as Voltaire (1694–1778; Fig. **11.29**). Voltaire [vol-TAIR] had a fertile literary intelligence and from his pen poured a stream of pamphlets, plays, tales, and poetry. His *Philosophical Letters* (1734), for example, helped to popularize English philosophy and

CRITICAL QUESTION

Analyze Swift's ironic tone in the passage from *A Modest Proposal*. How does he manage to sound reasonable while making such a cruel and inhuman proposal?

science among French thinkers, while bitterly attacking France's political and religious establishment.

A masterful conversationalist, Voltaire was a prized guest at Paris's court and salons. In later life, he moved to an estate in Ferney, Switzerland, just across the French border, where a stream of visitors paid homage to him. From the safety of Ferney, Voltaire attacked France's religious zealots with the battle-cry "Écrasez l'infame" ("Crush infamy") – by which he meant oppose the evils of religious bigotry. He openly mocked his religious opponents, saying, "I have never made but one prayer to God, a very short one: 'O Lord, make my enemies ridiculous.' And God granted it."

Voltaire's *Candide* The activism of Voltaire's later years dates from 1759, when he published his most famous and enduring work, the philosophical tale *Candide* [kan(h)-DEED]. This simple story of a naive young man's "enlightenment" lacks the fiery indignation of Voltaire's pamphlets, but truthfully exposes human vice and folly. With *Candide*, Voltaire addressed himself to the age's most perplexing philosophical problems: human suffering and evil, belief and doubt, and the possibility of reasoned action in an irrational world.

Voltaire's Candide (his name suggests his "candor" or innocence) subscribes to the philosophical "optimism" of Pangloss, his tutor. Pangloss's rationalist optimism is a parody of conventional Enlightenment belief. It resembles the ideas of the German philosopher Gottfried Wilhelm von Leibniz (1646–1716), who saw an absolute harmony between divine order and the material world. The rationalist Leibniz [LIPE-nits] was describing a world organized in an absolute hierarchical order, so that every part is perfectly balanced against all others. In a simplified version, Leibniz's ideas supported the optimism expressed in Alexander Pope's philosophical poem *An Essay on Man* (1734), which claimed that if humans could glimpse God's entire plan for the world, they would see that "Whatever is, is right."

This philosophical complacency infuriated Voltaire, who once wrote that "doubt is not a pleasant condition, but certainty is a ridiculous one." *Candide* is a relentless parody of rationalist optimism, since each new twist in the unlikely plot brings a new calamity. The tale is all the more horrifying because it portrays disasters and atrocities that could be documented in Voltaire's time. Candide and Pangloss witness the great Lisbon earthquake, an actual

11.29 Jean-Antoine Houdon, *Voltaire*, 1781. Marble, height 20 ins (51 cm). Victoria & Albert Museum, London.
Houdon's famous bust managed to capture the ironic tilt of the philosopher's head and the witty gleam in his eye.

> Pangloss: "All events are linked up in this best of all possible worlds."
> Candide: "Tis well said, but we must cultivate our garden."
>
> Adapted from Voltaire, *Candide*

disaster in 1755, and suffer persecution by the Spanish Inquisition. When all the characters are reunited, they are still perplexed by the meaning of their suffering. They finally meet a Turkish merchant who rejects philosophical speculation altogether and works to make a comfortable life for his family: work, says the merchant, wards off the "three great evils: boredom, vice, and need." At the tale's conclusion Pangloss sums up the adventures and misfortunes from the entire tale, and Candide resolves to "work without theorizing."

The whole small fraternity entered into this praiseworthy plan and each started to make use of his talents. The little farm yielded well. … Pangloss sometimes said to Candide: "All events are linked up in this best of all possible worlds; for, if you had not been expelled from the noble castle, by hard kicks in your backside for love of Mademoiselle Cunegonde, if you had not been clapped into the Inquisition, if you had not wandered about America on foot, if you had not stuck your sword in the Baron, if you had not lost all your sheep from the land of Eldorado, you would not be eating candied lemons and pistachios here."

"'Tis well said," replied Candide, "but we must cultivate our garden."[13]

VOLTAIRE
From Candide (1759)

Voltaire's solution to evil and bigotry is, as *Candide*'s ending suggests, a modest one. Candide finally does achieve a measure of enlightenment: to "cultivate our garden" means to reject speculative and merely philosophical solutions to the world's problems. It means to cultivate oneself, to work hard, and see that one's own life is comfortable and reasonable. Voltaire believed that humans had the resources, in their intelligence and industry, to make the world better – but not perfect. The revolutionary years that followed Voltaire's death would become a historical laboratory for testing his convictions.

CHAPTER SUMMARY

The Rococo Style In France art patrons preferred a tamer and more light-hearted version of the baroque style, called the rococo. Rococo wit and grace were displayed in the salons of Paris and other European capitals. The rococo style in painting was marked by nostalgia, frivolity, and an indulgence of the senses. Eighteenth-century dance gave new attention to the skills of female dancers and to plot, through the rise of the *ballet d'action*. In Germany, rococo palaces and churches reveled in ornate decoration and riotous color, while in Britain painters like Gainsborough flattered their patrons in rococo fashion.

The Enlightenment The eighteenth century spawned an intellectual movement called the Enlightenment, centered in Paris and led by philosophes who aimed to reform society by applying reason and science. The philosophes dedicated themselves to educational projects such as the *Encyclopedia* and defended freedom of thought, while criticizing orthodox religion. Throughout Western society, thinkers sought to apply Enlightenment principles to the practical problems of human existence – Rousseau in education, Adam Smith in political economy, and Kant in moral philosophy. The goal of Enlightenment activists was the education of free and autonomous individuals.

The Bourgeois Response The middle classes preferred a less frivolous art that was nevertheless suffused with sentimental feeling. In painting, Chardin and Greuze painted simple genre scenes and moralizing dramas. In literature, the novel offered bourgeois readers a variety of uplifting moral tales and resourceful heroes and heroines. The

German bourgeois theater, with heroes such as Goethe's Götz, helped to establish a German national culture.

Music in the Age of Enlightenment The age of enlightenment enjoyed a burst of musical genius called the Classical period. One Classical innovator, Joseph Haydn, composed at the court of a Hungarian noble, while the other, Wolfgang Mozart, worked in Vienna, Europe's musical capital. Mozart excelled in many musical forms, especially the operas that appealed to both noble and middle-class audiences. The Classical symphony, as developed by Haydn and Mozart, was a model of formal clarity and rigor.

The Neoclassical Style The most versatile eighteenth-century style was neoclassicism, fueled by archaeological discoveries and moralism. Neoclassical residences were built throughout Europe and America as symbols of good taste, universal truth, and elegance. In England, the painter Reynolds perfected the "grand style" of neoclassical portraiture. In France, painter David devised a stringent neoclassical style that criticized the indulgence and corruption of eighteenth-century society.

The Age of Satire The Enlightenment's critical spirit exerted itself in brilliant works of satire. The age's bitterest satirical works came from the pen of Swift, who exaggerated human vice and folly as a way of advocating social justice. Hogarth ridiculed the excesses and hypocrisy of the moneyed classes. The Enlightenment sage and activist Voltaire engaged in the period's central philosophical debates. His tale *Candide* recounts a young man's struggle to make sense of a world of violence and prejudice.

12 Revolution and Romanticism

12.1 Jacques-Louis David, *The Death of Marat*, 1793. Oil on canvas, 5 ft 3¾ ins x 4 ft 2⅜ ins (1.62 x 1.28 m). Musées Royaux des Beaux-Arts, Brussels.

The revolutionary journalist Jean-Paul Marat was assassinated by a young noblewoman as he sat in his bath. The painter David emphasized the pathos of this revolutionary tableau, contrasting the simplified design of rectangular shapes with the drooping posture of Marat's head and shoulder.

It is a vivid and dramatic scene, symbolic of its time: as the French revolutionary champion Jean-Paul Marat sits in his bathtub writing a pamphlet, a young noblewoman enters his quarters and stabs him fatally in the breast (Fig. 12.1). Marat becomes a martyr of the revolution, the woman an image of her nation's agony.

As memorialized by the neoclassical painter Jacques-Louis David, the pale body of Marat is a symbol of the **spirit of revolution**: a dedication to the principles of equality, reason, and representative government. However, the overthrow of kings in America and France did not end injustice or establish a utopia of reason. As middle-class society took shape, a new sensibility arose, called romanticism, which glorified the individual and prized feeling over reason and intellect. This period of revolutionary change and romantic reaction (1775–1850) laid down the principles, and discovered the demons, of the first modern society.

Revolutions and Rights

Identify the leading philosophical and political ideas of the American and French revolutions.

The political revolutions in America in 1776 and France in 1789 are turning points in the history of Western civilization. Today's leading political ideas, such as democracy, republicanism, and equality before the law, were first tested in those revolutionary upheavals. Many of today's political institutions – congresses, presidencies, constitutions – resulted from those revolutionary conflicts. Yet scholars and politicians still debate whether the revolutions were righteous and the outcomes beneficial, and whether other nations can apply the lessons in other times. Since 1789, each generation has had to answer these questions for itself.

The Revolutionary Wave – 1776 and 1789

The revolutionary wave began on the colonial fringes of Western civilization. Through the early eighteenth century, Britain's American colonies had grown prosperous from trade in fish, tobacco, and other New World commodities. By the mid-eighteenth century, the American colonists had begun to resent the burden of Britain's economic and political control. In summer 1776, a handful of American colonists gathered to discuss boldly their grievances against the British king George III (ruled 1760–1820). In their minds, he had violated their basic rights as British citizens and threatened their prosperity with heavy taxation. Believing that the king's oppression left them no choice, they declared their independence of the British government and embarked on the dangerous course of revolution.

The American revolutionaries readily cited classical precedents and enlightened principles in justifying their rebellion. They compared their uprising to the Romans' revolt against the Etruscan kings that had established the Roman republic. Their leader George Washington (Fig. 12.2) was later honored by a statue portraying him as the ancient Roman Cincinnatus, who left his plow to defend the Roman republic. Like the Italian civic humanists of Renaissance Florence (see page 190), they called for a republic of morally virtuous and publicly minded citizens. By casting off the tyranny of Britain's monarchy, the American revolutionaries intended to establish an American community of independent farmers and merchants, dedicated to the common good. The American Declaration of Independence applied the liberal doctrines of the social contract, popular sovereignty, and individual freedom (see Key Concept, page 328). Claiming that the

12.2 Jean-Antoine Houdon, *George Washington*, 1786–96. Marble, life-size. State Capitol, Richmond, Virginia.
The famous French sculptor shows Washington as a dutiful republican, laying down his military authority to resume the guise of a gentleman farmer.

British monarchy had worked to destroy the people's liberty and sovereignty, the Declaration proclaimed:

> … that whenever any Form of Government becomes destructive of these ends, it is the Right of the People to alter or to abolish it, and to institute new Government, laying its foundation on such principles and organizing its powers in such form, as to them shall seem most likely to effect their Safety and Happiness.[1]

The Americans' successful revolution was followed by an intense struggle over the proper organization of their republican government. Should it be a loosely federated group of independent states, like the cantons of Switzerland? Or should the states be subordinate to a strong central government with a powerful executive? The Americans' solution came in the United States Constitution of 1787, which established, for the first time among Western nations, a republican government with an elected executive and a guarantee of individual rights.

The new constitution was defended in a remarkable series of political essays known as the Federalist papers, published anonymously in newspapers during 1787–8. The Federalist writers defended the proposed constitution's balance between state authority and the rights of the individual, applying the theories of republicanism and liberalism in the laboratory of history. The constitution's complex system of checks and balances among the branches of government reflected the Enlightenment belief in a self-correcting mechanism. But one essay, written by future U.S. president James Madison (1751–1836), acknowledged that no system could entirely overcome the defects of human nature:

> It may be a reflection on human nature that such [checks and balances] should be necessary to control the abuses of government. But what is government itself but the greatest of all reflections on human nature? If men were angels, no government would be necessary.[2]

For all their brilliance, the Federalist papers did not address one central question of the American republic: slavery. Despite declarations on the equality of all men, the new constitution allowed the continuation of slavery as an economic necessity. Since early colonial days, slaves had been imported from Africa to work on plantations in the southern American colonies and the Caribbean

> But what is government itself but the greatest of all reflections on human nature? If men were angels, no government would be necessary.
>
> James Madison, Federalist #51

islands. The new United States, founded on liberal principles, continued to sanction slavery until the practice was ended by the American Civil War (1861–1865).

The American revolutionary doctrine was not easily contained. Frenchmen who fought with the American colonists returned to their homeland fired with radical ideas. Their fervor helped to ignite a revolutionary inferno that consumed France in Europe's widest and most divisive upheaval since the Reformation. The revolutionary drama began in earnest in 1789, as King Louis XVI (ruled 1774–1793) and France's ruling factions jockeyed for power. Representatives of the educated and wealthy middle classes pressed their political demands for a constitutional monarchy. On July 14, 1789, a Parisian crowd assaulted the Bastille, a royal prison that had long been a symbol of royal authority and the medieval past. When the warden surrendered, the crowd executed him and triumphantly paraded his head on the end of a pike to the city hall. In August 1789, revolutionary delegates issued the Declaration of the Rights of Man and the Citizen, endorsing the principles of liberal constitutional government.

The French Declaration was clearly derived from Enlightenment political doctrines, especially Rousseau's belief in equality and popular sovereignty. It promised a society of merit, where success depended on talents and not on inherited rank. It proclaimed the legal equality of all citizens and their right to basic freedoms. Like the United States Constitution, the Declaration also

THE WRITE IDEA

If you were writing a contemporary "Declaration of Human Rights" for today, how would you revise or expand the revolutionary documents of 1776 and 1789? Explain how your "Declaration" reflects the leading ideas of today.

REVOLUTIONARY MILESTONES

1776	American colonists declare their independence from the British crown
1788	Constitution ratified in the United States
1789	Paris mob storms royal prison at Bastille; French parliament declares "Rights of Man and the Citizen"
1799	Napoleon seizes control of French revolutionary government
1793–1802	Toussaint-l'Ouverture leads rebellion against slavery and colonial rule in Haiti
1817–25	Simón Bolívar leads independence struggles in South America

enshrined property as an inviolable right. The delegates, many of them wealthy bourgeois and nobles, did not care to sacrifice their fortunes to equality. Nevertheless, more than any other single document, the Declaration of the Rights of Man embodied the ideas of Enlightenment political philosophy. Every contending faction in France's revolutionary struggle would quote its principles of liberty, equality, and brotherhood.

Between 1789 and 1795, France was seized by political intrigue and revolutionary turmoil. In 1793, King Louis XVI and his widely hated queen, Marie Antoinette, were beheaded by the new "scientific" instrument of execution, the guillotine. Leaders declared a "Republic of Virtue," built churches to Reason, and instituted a new calendar attuned to the cycles of nature. Economic crisis and the threat of invasion led to the so-called "Reign of Terror" (May 1793–July 1794), during which a small group of revolutionary leaders sent thousands of French citizens to the guillotine. To some observers the horrors of the Terror confirmed the folly of exchanging the traditional rule of law for a republic of abstractions. The British conservative Edmund Burke (1729–1797) remarked that by "changing the state as often, and as much, and in as many ways, as there are floating fancies or fashions, the whole chain and continuity of the commonwealth would be broken." If one generation were to break so readily its ties to the last, wrote Burke in his *Reflections on the Revolution in France,* "men would become little better than the flies of a summer."[3]

The Napoleonic Era

By 1799, ten years after revolution erupted, the French found their republic of virtue inhabited by citizens full of greed and prejudice. Having beheaded a king, the French now entrusted their hard-won liberties to the military hero Napoleon Bonaparte (1769–1821). To many French people, Napoleon personified the principles of their revolution, even as he imposed dictatorial control over the nation (Fig. **12.3**). In France, Napoleon satisfied his middle-class supporters by revising France's legal system and modernizing its government, thus erasing the vestiges of absolute monarchy and aristocratic privilege. He satisfied his own dreams of a French empire by crowning himself emperor in 1804 and embarking on a military campaign that devoured virtually all of Western Europe. With each conquest, Napoleon proclaimed the revolutionary values of liberty and republicanism, infecting Europe with liberal ideas.

At home in France, Napoleon proved a skillful propagandist for his own reign, disguising his power and cleverly manipulating the symbolism of the Revolution. Where the revolutionaries had posed as heroes of the Roman republic, Napoleon now presented himself as a Roman emperor and set out to make Paris an imperial capital on the scale of ancient Rome.

Like the Roman emperors, Napoleon advertised his power by patronizing the arts and starting an ambitious building program. The royal palace of the Louvre became a museum to hold the artistic plunder brought from Italy and Egypt. He erected arches of triumph on public squares (Fig. **12.4**) and a triumphal column (modeled after the Column of Trajan in Rome) cast from the metal cannons of defeated armies. To face the Place de la Concorde (where the guillotine had stood), he commissioned a great neoclassical temple dedicated to the soldiers of his army. Known as La Madeleine (Fig. **12.5**), the temple stood atop a 23-foot (7 m) high podium and was surrounded by a gigantic Corinthian colonnade.

The painter J.-L. David's devotion to the emperor earned him the title of "First Painter," and the control of the government's artistic patronage. David's stirring and idealized equestrian portrait of Bonaparte (see below) commemorated the general's Italian campaign. David's pupils did not always so readily obey the dictates of imperial propaganda. Marie Guillemine Benoist (1768–1826) presented her riveting portrait of a turbaned black woman

12.3 Jacques-Louis David, *Napoleon Crossing the Alps*, 1800. Oil on canvas, 8 ft × 7 ft 7 ins (2.44 × 2.31 m). Musée de Versailles. David's stirring portrait of Napoleon depicts him following the path of ancient generals such as Hannibal and Charlemagne (whose names are carved in the rocks). Like many revolutionaries, David approved of Napoleon's rule, believing that he could restore order to a weary France.

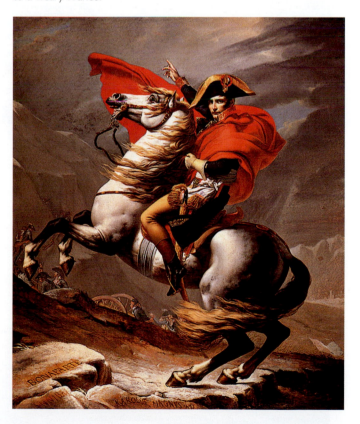

(Fig. **12.6**) at the official Salon in 1800. Six years earlier, France's revolutionary government had abolished slavery in the nation's colonies, but had so far declined to grant French women equal rights. On the contrary, remarked the exiled painter Elisabeth Vigée-Lebrun, before 1789, "women reigned; the Revolution dethroned them." Benoist's portrait has been interpreted as a subtle reproach to the French Revolution's failures on women's rights.

12.4 *(right)* Jean-François Chalgrin, Arc de Triomphe de l'Étoile, Paris, 1806–37.
Napoleon's great arch surpassed in scale any comparable triumphal work of ancient Rome (compare the Arch of Trajan, Fig 4.5). The monument's sculptures, including François Rude's stirring rendition of *Departure of the Volunteers, 1792* (*La Marseillaise*), were not finished until the 1830s, years after Napoleon's fall.

12.5 *(below)* Pierre-Alexandre Vignon, La Madeleine, Paris, 1762–1829. Length 350 ft (106.7 m), width 147 ft (44.8 m), height of base 23 ft (7 m).
Napoleon adapted the fashion for Roman antiquity to legitimize his dictatorial rule. Compare this Napoleonic monument to the ancient Roman Temple of Portunus (Fig. 4.13) in its method of construction, scale, and decoration.

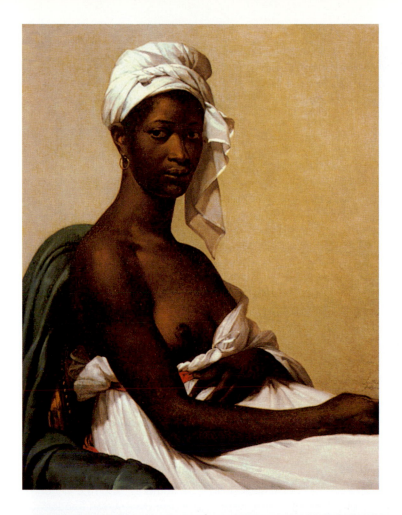

Benoist's impassive subject provides an interesting counterpoint to the sculptural portrait of Napoleon's sister by the Italian Antonio Canova (1757–1822). Canova was commissioned to portray members of the Bonaparte family, whom Napoleon had placed on the thrones of conquered Europe. His frigidly neoclassical sculpture of Pauline Bonaparte shows her as Venus (Fig. **12.7**), reclining on a divan that might almost have been excavated from the ruins of Pompeii.

12.6 *(left)* Marie Guillemine Benoist, *Portrait of a Black Woman*, 1800. Oil on canvas, 32 x 25$^{1}/_{2}$ ins (81 x 65 cm). Louvre, Paris.

Though painted in the restrained neoclassical style of her teacher, J.-L. David, Marie Benoist's portrait of an African woman is remarkably empathetic. The bare-breasted pose presents the sitter as a classical goddess, most likely Liberty. Compare Delacroix's *Liberty Leading the People* (Fig. 12.12).

12.7 *(below)* Antonio Canova, *Pauline Bonaparte as Venus*, 1808. Marble, life-size. Galleria Borghese, Rome.

Canova portrays Napoleon's sister Pauline as holding the apple of Venus, the prize of beauty granted to the goddess by Paris's famous judgment. Compare the figure's awkward posture, which presents her head in profile but turns her nude torso entirely to the front, to Marie Benoist's *Portrait of a Black Woman* (left).

Freedom

"Man is born free, and yet everywhere he is in chains," proclaimed Jean-Jacques Rousseau. The liberal revolutions of 1776 and 1789 declared their aim to restore humanity to its natural condition – liberty from tyranny and oppression. The doctrines of individual freedom – the call for sovereignty over one's self and one's property – were perhaps the most important and lasting achievement of the liberal revolutions and the political philosophy that inspired them.

The liberal concept of individual freedom had arisen out of centuries of social experience in Europe. The ancient Greeks' aim of personal autonomy had been subjected to Augustine's Christian philosophy, which regarded freedom as the root of human sin and error. Further, Augustine maintained, to oppose legitimate political authority was to oppose God's ordained hierarchy. By the Renaissance, however, European city-dwellers were successfully gaining their autonomy from both feudal lords and Christian popes. The conditions of legal and moral self-responsibility started to feel natural, in contrast to the practices of serfdom and slavery still widely practiced in the world.

The liberal revolutions were most concerned with the freedom from arbitrary government authority. Perhaps the most ardent and radical voice against government tyranny was that of Thomas Paine, the British-born author of *Common Sense* (1776). "Society in every state is a blessing, but government even in its best state is but a necessary evil; in its worst state an intolerable one,"[4] wrote Paine. The U.S. Constitution's Bill of Rights specified the individual freedoms – among them, freedom of speech, association, and the press – that the new government might not infringe. With persistent struggle, the revolutions and reforms of the nineteenth century enshrined these principles in most Western constitutions and law.

As Western governments increasingly reflected the will of social majorities, however, the liberal concept of freedom showed itself to be fraught with paradox. In his classic statement *On Liberty* (1859), philosopher John Stuart Mill reconsidered the principles of liberalism. As a core principle, he declared that the "only purpose for which power can be rightfully exercised over any member of a civilized community, against his will, is to prevent harm to others." But what human actions are purely "self-regarding?" asked Mill. And why should society not prevent individuals from harming themselves?, he added. In answer to his own objections, Mill argued that a social majority might justly coerce individuals to respect their "distinct and assignable obligations to others."[5] For each individual, there are two zones of action – one where society may properly regulate individual freedom and one where individual freedom is inviolate.

The movable boundary between J. S. Mill's zones of freedom – one subject to just authority and the other absolute – marks the history of debate over human freedom in the modern world.

> The only purpose for which power can be rightfully exercised over any member of a civilized community, against his will, is to prevent harm to others. His own good, either physical or moral, is not a sufficient warrant.
>
> John Stuart Mill, *On Liberty*

CRITICAL QUESTION

Identify two significant actions in which you regularly engage, one which society may justly regulate and one which is justly private and free from government coercion. How would you justify this distinction philosophically?

Colonial Revolutionaries The revolutionary turmoil in Europe had repercussions in the American colonies of France and Spain. In 1793, on the Caribbean island of Hispaniola (present-day Haiti and the Dominican Republic), the freed slave François Dominique Toussaint-l'Ouverture [TOO-san(h) LOO-vuh-tyoor] (c.1743–1803) assumed command of a slave revolt. By 1801, Toussaint's skilled and ruthless leadership secured the abolition of slavery in the island's French and Spanish colonies. Though professing republican ideals, Toussaint imposed a constitution on the island that gave him nearly absolute power. In 1802, he surrendered to a French military force dispatched by Napoleon, demanding only a French promise not to reimpose slavery.

In South America, the Creoles – native-born colonials of European descent – instigated the struggle for independence from Spain. Their charismatic leader was Simón Bolívar (1783–1830), nicknamed *El Libertador* (The Liberator) for his role in liberating much of South America from Spanish rule. Inspired by Napoleon's example, Bolívar envisioned a united Spanish America, governed by constitutional republics and a president elected for life. From 1817 to 1822, he undertook a long campaign that eventually freed the Spanish colony of

Gran Colombia (present-day Colombia, Venezuela, and Ecuador). By 1825 Bolívar had also defeated Spanish forces in Peru, and had been named president of a Latin American federation. But Bolívar's grand vision succumbed to his own authoritarian tendencies and the forces of regional independence. Civil war flared and the federation disintegrated, leaving South American nations independent but insecurely republican, and still governed by the Creole elite.

1776–83	American war of independence
1789–99	French Revolution; Reign of Terror 1793–4
1793	David, *Death of Marat* (12.1)
1799–1815	Napoleon rules France
1808	Canova, *Pauline Bonaparte as Venus* (12.7)
1830	"July Revolution" in Paris
1820–70	Industrialization of Europe and the United States

The Industrial Revolution

By 1820 Great Britain was being transformed by the rise of industrial production, a revolution every bit as profound as the liberal political revolutions (Fig. **12.8**). The use of water- and steam-driven machinery in textile factories dramatically increased the pace and lowered the costs of cloth manufacture. The factories drew laborers to new industrial towns and cities, and factory owners soon were investing their enormous profits in other innovations – especially railroads. By the 1840s, industrial production had spread to continental Europe and the U.S., and the construction of railways effected a revolution in the experience of time and space, bringing Europe's capitals within just a day's travel of each other and effectively shrinking the North American continent.

The new industrial cities – for example, Manchester and Leeds in England, or Lowell and New York City in the U.S. – produced two distinctly new classes: a commercial bourgeoisie and a "proletariat" of factory laborers. The energetic class of factory owners did not aspire to noble rank and an aristocratic lifestyle, as had previous generations of the newly rich. Instead, they developed their own

cultural institutions, subscribing to music and theater series, establishing societies for the advancement of learning, and reading the magazines in which novels and stories were often first published. Middle-class clients provided a new medium for support of the arts, in addition to traditional state-sponsored patronage. Politically, the commercial middle class sought freedom from traditional restraints on commerce and wages, invoking the principles of liberalism. By abolishing longstanding protections for small farms and wage laborers, they effectively depressed wages and assured a supply of low-paid workers for their mines and factories.

For the workers who operated the machines and stoked the furnaces, the new industrial cities were miserable places. The romantic critic Thomas Carlyle bemoaned the atmosphere of Manchester with "its cotton-fuzz, its smoke and dust, its tumult and contentious squalor."[6] After working a twelve-hour day, urban laborers retired to tenements built row upon monotonous row, where cramped quarters bred tuberculosis and other disease. The new industrial society achieved its material progress

12.8 Contemporary view of Mancehester, Britain. The new industrial cities bred a class of "new men," middle-class entrepreneurs made fabulously wealthy by profits from their textile mills, and also an impoverished class of urban laborers living in unimaginable soot and squalor.

at great spiritual cost. "Civilization works its miracles," said a foreign journalist on a visit to Manchester, "and civilized man is turned back almost into a savage."[7]

Revolution and Philosophy

Nineteenth-century philosophy grappled to understand the dynamic forces of revolution and social change that animated Western societies. G. W. F. Hegel (1770–1831) was a German thinker whose comprehensive idealism dominated European philosophy in the mid-nineteenth century. Hegel [HAY-gull] was a philosophical idealist – idealism here meaning the philosophical belief that reality is grounded in the workings of the mind. For Hegel's idealist predecessor Immanuel Kant (see Key Concept, page 339), reality was grounded in the passive mental categories of space and time. For Hegel, the essential powers of Mind were always active in the world and engaged with actuality, giving shape to concrete reality as lived by humans. Historical reality reflected the needs of Mind, or, as Hegel put it, "The real is rational, the rational is real." Abstract reason could be realized only through the concrete particulars of historical time and place. The rise of the Roman Empire, for example, reflected the action of Mind in the world. So did its decline and the subsequent rise of medieval Christianity. Mind engaged in a creative struggle with history's materials and circumstances that Hegel called the dialectic. The dialectic begins with thesis and antithesis – Mind and the opposing particulars of a historical moment. In their struggle, they create a new set of circumstances (the synthesis), with which Mind will engage once again as a new antithesis.

As applied to history, Hegel's dialectic described an organic, stage-like progress from lower to higher forms. At each historical moment, an immanent World-Spirit expressed itself in concrete forms of government and in particular world-historical individuals. In his own time, Hegel recognized Napoleon as the bearer of the World-Spirit. He wrote, "The Emperor – this World-Spirit – I saw riding through the city to review his troops. It is indeed a wonderful sensation to see such an individual who, here concentrated into a single point, reaches out over the world and dominates it."

Inspired by the political ferment of the 1840s, political philosopher and economist Karl Marx (1818–1883) recast the terms of Hegel's idealist dialectic of history. Rather than great men or a World-Spirit, Marx argued, history was propelled by material forces and the struggle of classes. The industrial revolution had created the final stage of a historical dialectic – a world-historical struggle between the rulers of industry and their laborers. The victory of labor would inaugurate a socialist or communist society, in which the tools of production are collectively owned and their products equitably distributed. Marx's *Communist Manifesto* (1848) summoned factory laborers to overthrow their industrial masters. "Workers of the world, unite! You have nothing to lose but your chains," Marx cried. In addition to apocalyptic pronouncements, Marx and other socialists worked to combat the abuses of industrial society. They advocated the right to vote for all citizens, including women; an eight-hour workday with a minimum wage; free medical care; and the right to organize workers' unions.

The Romantic Hero

Identify the essential characteristics of the romantic hero, both historical and fictional.

Even as industrialism was creating a world of humdrum labor and utilitarian values, the post-revolutionary age produced a new sensibility, called **romanticism**, that arose gradually between 1775 and 1850. Romanticism appeared first in England and Germany, then in post-revolutionary France and North America, during the same era as the industrial revolution. The romantic attitude preferred feeling and imagination to the sober dictates of reason and also prized the powers of creative genius. Romanticism was embodied in the romantic hero, whose genius was like a force of nature – "the fire of a volcano which must absolutely burst into the open, because its nature absolutely compels it to shine, to illuminate, to astonish the world," as the nineteenth-century romantic painter Delacroix wrote.[8]

For example, German composer Ludwig van Beethoven (1770–1827) seemed cast by fate to be the ultimate suffering, romantic genius; Delacroix once said that Beethoven [BAY-toh-ven] had endured the pains that were the "nourishment" of romantic genius. Beethoven was abused by an alcoholic father and appointed his brothers' guardian before the age of eighteen. By twenty-five, the composer's hearing began to fail. In 1802, Beethoven wrote a desperate "testament" to his brothers, confessing his ailment and its emotional effects. It reveals a man tortured by his social isolation and convinced that others misunderstood him – the epitome of the romantic hero. Thinking of suicide, Beethoven confessed that "art alone restrained my hand." He wrote:

> Ah, how could I possibly admit an infirmity in the *one sense* which ought to be more perfect in me than in others, a sense which I once possessed in the highest perfection, a perfection such as few in my profession enjoy or ever have enjoyed.[9]

The profound crisis caused by deafness did not hamper Beethoven's work as a composer: he recovered from his depression to compose works of unprecedented scope and feeling.

Faust and the Romantics

In Germany, the towering figure of the romantic age was Johann Wolfgang von Goethe (1749–1832), whom Byron called "the undisputed sovereign of European literature." During the early 1770s, Goethe had been a leader of the pre-romantic *Sturm und Drang* movement (see page 309), but then rejected his youthful emotionalism in favor of a more restrained classicism. Goethe even once said, "Romanticism is sickness, classicism is health." Only later in his career did he regain a sympathy for his youthful works and return to romantic themes, completing his masterpiece, the two-part drama *Faust* (1808, 1832).

Goethe's Faust [fowsst] symbolized the romantic desire to burst all constraint and indulge in an unquenchable desire for all human experience. In Goethe's version of the medieval legend, the university professor Faust bargains with the devil – in the person of the wily Mephistopheles [meh-fiss-TOFF-e-lees] – for the power to feel all "that is allotted to humankind," to "embrace all human selves." If his striving spirit is ever once satisfied, Faust vows, then Mephistopheles may have his soul. Having signed this pact in his own blood, Faust voices the romantic desire for an experience without limit.

> In the depths of sensuality
> Let us now quench our glowing passions!
> And at once make ready every wonder
> Of unpenetrated sorcery!
> Let us cast ourselves into the torrent of time,
> Into the whirl of eventfulness,
> Where disappointment and success,
> Pleasure and pain may chop and change
> As chop and change they will and can,
> It is restless action makes the man.[10]

J. W. VON GOETHE
From Faust, Part 1 (1808)

> I have only galloped through the world
> And clutched each lust and longing by the hair;
> What did not please me, I let go,
> What flowed away, I let it flow.
> I have only felt, only fulfilled desire,
> And once again desired and thus with power
> Have stormed my way through life; first great and strong,
> Now moving sagely, prudently along.[11]

J. W. VON GOETHE
From Faust, Part 2 (1832)

As Mephistopheles promises "No limit is fixed for you," Faust embarks on a romantic quest for all that love, power, and science can bring him. In Part 1, he explores the world of personal feelings through his love for the innocent girl Gretchen. He succeeds only in destroying Gretchen, who is imprisoned and condemned for drowning their child. Faust is left unsatisfied.

In the drama's second part, written some twenty-five years later, Faust's quest for the whole range of human experience extends to science, politics, and history. The action ranges across great stretches of space and time in a fantastic plot that no stage could actually accommodate. Though he cannot balance his visionary designs with a sympathy for human limitations, Faust does not regret his endless quest for satisfaction and achievement.

The scope of Faust's ambitions reflects those of Goethe himself. The poet had supervised building projects, engaged in diplomatic missions, and directed cultural affairs for his patron, the Duke of Weimar [VYE-mar]. But, like Faust, Goethe felt that his achievements never quite matched his designs, leaving him with a residue of longing and desire.

Goethe's drama exercised a great stimulus on the romantic imagination. The painter Eugène Delacroix illustrated a French translation of the first part of *Faust* with appropriately demonic lithographs (Fig. 12.9). Among the most famous of Franz Schubert's *Lieder* (composed at

12.9 Eugène Delacroix, *Faust Visits Marguerite in Prison*, illustration from the French edition of Goethe's *Faust*, 1828. Here the hero of Goethe's romantic tragedy visits Gretchen ("Marguerite" in French), who has murdered the child of their union, while Mephistopheles calls him away. Gretchen refuses Faust's offer of rescue, recognizing that he no longer loves her.

age seventeen) was *Gretchen at the Spinning Wheel*,
depicting a scene from the earliest version of Faust. The
song's accompaniment creates the musical image of the
spinning wheel, while in the song's text Gretchen alter-
nates between passion and despair. The song begins and
ends with the same words: "My heart is heavy, my peace
is gone." In 1859, the French composer Charles Gounod
(1818–1893) based a successful opera on *Faust*. Gounod's
[goo-NOH] stirring finale is set in Gretchen's prison cell,
where Mephistopheles insistently calls Faust to leave,
Faust implores his lover to escape, and Gretchen prays
for forgiveness for murdering her child.

Delacroix and the Byronic Hero

French romantic artists of the 1820s were not much
interested in the scientific ambition and German con-
science of Goethe's Faust. The French were more attracted
to the defiant sensuality of the life and works of Lord
Byron, the English poet. Byron (1788–1824) lived a life of
sexual freedom, political idealism, and exotic travel (Fig.
12.10). His unfinished poetic masterpiece was *Don Juan*
(begun 1819), in which he portrays himself as the leg-
endary lover. Byron's works and life defined what came
to be known as the Byronic hero, the rebellious genius
whose intellectual and moral freedom isolated him from
an unsympathetic world. The Byronic hero appealed to
young French artists repelled by the conventional moral-
ity and avid commercialism of middle-class society.

The French artist most inspired by the Byronic hero
was the painter Eugène Delacroix (1798–1863). Delacroix
[dell-ah-KWAH] cut a dashing and aristocratic figure in
the Parisian salons. He was one of a generation of young
romantics that included the composer Hector Berlioz,
the novelist Alexandre Dumas, and the spokesman for
French romanticism, dramatist Victor Hugo (author of
Les Misérables). As a painter, Delacroix mounted his own
rebellion against the official academic style of French
painting, which emphasized line and skillful drawing.
Delacroix instead preferred riotous color, turbulent com-
positions, and exotic themes. He painted an enormous
range of subjects – many drawn from literary works
(including Byron's) – which reflect an artistic rebellion
against the society in which he lived.

The Death of Sardanapalus (Fig. **12.11**), for example,
expresses an orgy of egoism, violence, and sexuality that
scandalized Parisian art circles. The theme is taken from a
play by Byron. According to legend, the Assyrian monarch

Sardanapalus [sar-da-NAP-a-luss] destroyed himself and
all his possessions when threatened by a rebellion. In
Delacroix's version, slaves deliver the fatal blow to a con-
cubine (on the right) and to the king's struggling horse
(on the left). Meanwhile, Sardanapalus lies propped on
his pillow in sadistic detachment, his own cup of poison
at hand. Delacroix unifies the tumultuous scene by means
of bold colors – the reds, greens, and golds are visible in
every detail.

Delacroix was among the many French romantics
inspired by the July 1830 revolution in France. Recalling
the revolutionary spirit of 1789, the citizens of Paris bar-
ricaded their streets in July 1830, and again overthrew
their king – the Bourbon monarchy that had ruled France
for fifteen years. The Bourbon king abdicated and was
replaced by the "Citizen-King," Louis-Philippe, whose
monarchy endured until insurrection again convulsed
France in 1848.

During the July insurrection, some romantic novelists
and artists took their places on the barricades, while

12.10 Thomas Phillips, *Lord Byron in Albanian Costume*, 1814.
Oil on canvas, 29¹/₂ x 24¹/₂ ins (75 x 62 cm). Courtesy of the
National Portrait Gallery, London.
The romantic hero as noble savage: the scandalous poet Byron,
dressed in native Albanian costume, on his first trip to aid the Greek
rebellion against the Turks. Byron's unconventional morality and
enthusiasm for political causes inspired a generation of romantic
artists and poets.

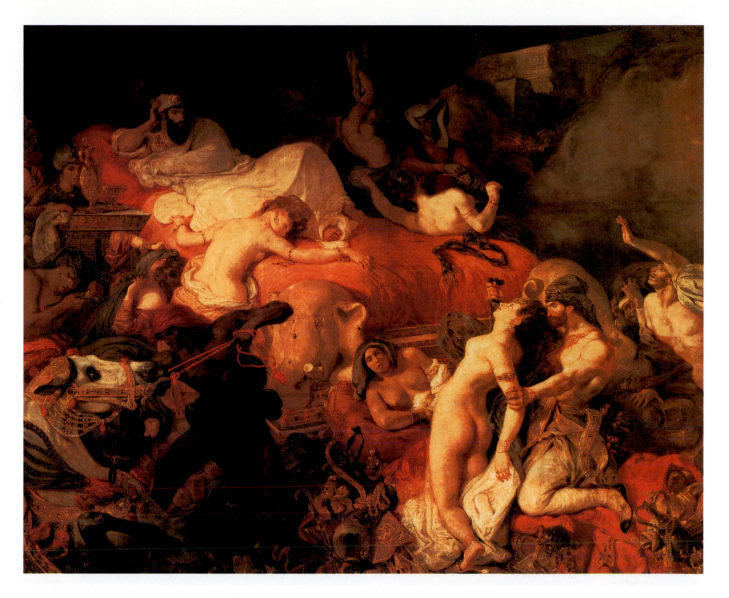

12.11 Eugène Delacroix, *The Death of Sardanapalus*, 1826. Oil on canvas, 12 ft 11½ ins × 16 ft 3 ins (3.95 × 4.95 m). Louvre, Paris. Both subject and technique of Delacroix's lurid masterpiece were condemned by academic critics, who rightly saw the picture as an assault on academic painting and moral principle. In the scene taken from ancient history, an Oriental monarch presides over the destruction of his wives and possessions before his own suicide. Assess the emotional effect of placing Sardanapalus in the background, and Delacroix's use of color and line to define an atmosphere of erotic violence.

Delacroix observed the events from a balcony. He said months later, "If I did not fight for our country, at least I will paint for her." His depiction of the July revolution, *Liberty Leading the People* (Fig. **12.12**), embodies the event's romantic spirit, with a combination of the grotesque and the ideal. Delacroix's picture centers on the allegorical figure of Liberty, desexualized enough to be heroic. Liberty strides triumphantly across a barricade littered with the naked bodies of fallen rebels. On the left, a grimy worker fights beside a dandified student in a top hat, symbolizing the unity of working and middle classes. Caught in France's moment of political romanticism, Delacroix momentarily forgot his Byronic irony and detachment, and joined in the revolutionary enthusiasm of his fellow French citizens.

Music and Dance in the Romantic Age

Identify the changes in music from the Classical to romantic periods.

The romantic period saw dramatic changes in the standing of Western musicians and composers. Aristocratic patronage declined and a new urban middle class became music's primary audience, attending concerts in large music halls and auditoriums. Composers increasingly

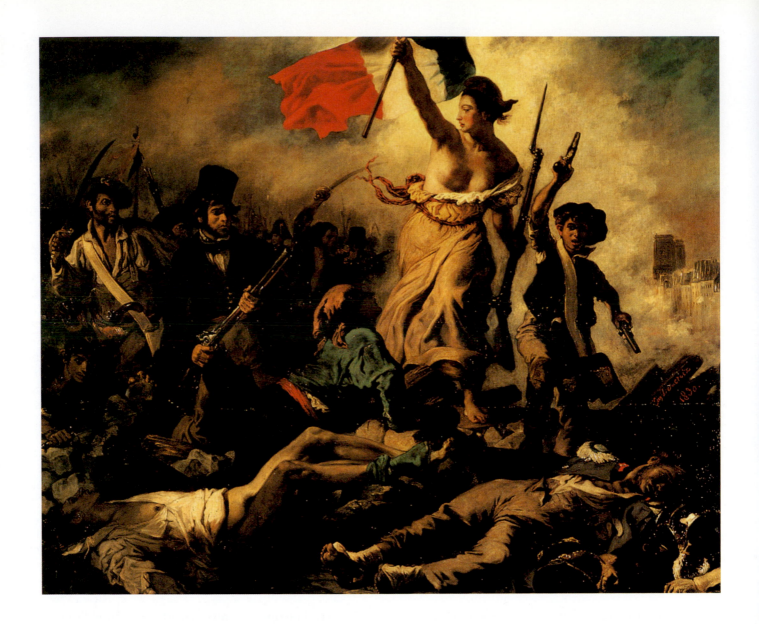

12.12 Eugène Delacroix, *Liberty Leading the People*, 1830.
Oil on canvas, 8 ft 6 ins x 10 ft 8 ins (2.59 x 3.25 m). Louvre, Paris.
Delacroix's visual hymn to patriotic revolution is unified by his use
of the French tricolor flag. The red, white, and blue are echoed in the
uniform of the kneeling guardsman who gazes up at Liberty and in
smoke rising above the cathedral of Notre Dame at right.

worked as free artists, the middle-class peers of their
audience, and many were virtuoso stars of the concert
stage. Romantic musical works grew longer and reflected
the romantic concern for feeling and empathy.

Beethoven: From Classical to Romantic

Ludwig van Beethoven began as musical heir to the
Classical style of Haydn and Mozart and ended as a titanic
figure of musical romanticism. The young Beethoven
made his name as a pianist, performing in the courts
and concert halls of Vienna. Passionately committed to
the republican ideals of the French Revolution, he was
often disdainful of his aristocratic audiences – a position
he could afford to take, since, unlike Mozart, Beethoven
supported himself largely through the publication of
his compositions. The profound crisis caused by deaf-
ness did not hamper Beethoven's work as a composer:
he recovered from his depression to compose works of
unprecedented scope and feeling. Beethoven enlarged
the symphonic orchestra, adding the piccolo and trom-
bone, and he exchanged the elegant dance movement
of Haydn's and Mozart's symphonies for a rougher,
more vigorous *scherzo* [SKAIR-tso] (Italian, "joke").
Beethoven's Symphony No. 3, called the *Eroica*, was
a watershed between the Classical style in music (see
page 331) and the more ambitious and adventurous
romantic style.

12.13 Ludwig van Beethoven, score of opening bars of Symphony No. 5 in C Minor, 1808, first movement.
The relentless rhythm of the opening four-note motif is audible throughout the symphony's four movements.

Beethoven's expansion of the Classical sonata form is audible in his Symphony No. 5 in C Minor, with its compelling theme and volcano of sound. This symphony has been interpreted as the composer's confrontation with fate, a struggle depicted in the shifting modulations between minor keys. The composer himself supposedly described the symphony's opening four tones as "Fate knocking at the door." Their menacing rhythm – three short beats and one long – dominates the symphony's long first movement (Fig. **12.13**). Beethoven enlarges the Classical mold through the recurring four-note **motif** (a term for a short musical idea). The motif moves through repeated moments of harmonic tension and ends the movement with a dynamic *coda*, or closing. Even here Beethoven has still not exhausted his motif, which recurs throughout the symphony, unifying its complex structure and further expanding the Classical symphonic form. At the end of the third movement, Beethoven added yet another innovation. Instead of the customary pause, the music continues directly into the last movement. Symphony No. 5 achieves a heroic grandeur that matches the legend of its composer.

Age of the Virtuoso

The romantic era in music was marked by the unprecedented fame acquired by musical virtuosos – performers of spectacular ability whose flair appealed to the wider audiences of the nineteenth century. In his day, perhaps the most famous of these virtuosos was the Italian violinist Niccolò Paganini (1782–1840), who toured Europe displaying his dazzling technical ability. Paganini [pah-gah-NEE-nee] employed a showman's tricks, but also inspired several composers to more daring compositions for violin.

Virtuosos of the voice displayed their expressive talent through the German art song (called in German the *Lied*, pl. *Lieder* [leet, LEE-der]). *Lieder* were often romantic

poetry set to music, such as *The Erlking* (1815) by Viennese composer Franz Schubert (1797–1828). In a ballad by Goethe (see page 331), a father bears his delirious son in his arms on a frantic ride through the night forest. Over an insistent and ominous piano accompaniment, the boy describes how the king of the elves, symbol of death, beckons to him. Schubert's *Lied* creates in the three voices – boy, father, and elf – a compelling drama of romantic death.

On the piano, the era's greatest virtuoso was the Polish musician Frédéric Chopin (1809–1849). The delicate appearance and rhapsodic compositions of Chopin [SHOH-pan(h)] defined a romantic musical type very different from the burly Beethoven. Chopin's compositions used smaller musical forms, including Polish dances such as the mazurka and polonaise, and explored the piano as an instrument of delicate nuance. The *Étude* in C Minor, called the "Revolutionary," (1831), likely written in response to Russia's invasion of Poland, begins with tumultuous downward passages in the left hand. The melody begins dramatically, quiets, and then finishes in crashing chords. Chopin was famous also for his love affair with the flamboyant George Sand (the male pseudonym of the female novelist Aurore Dudevant). Sand nursed Chopin as he slowly died of tuberculosis, and later described their relationship in a novel.

Romantic genius was often associated with ecstatic states that bordered on madness. Composer Robert Schumann (1810–1856) eventually succumbed to mental illness (probably manic depression), but managed to compose the most lyrical of romantic songs and symphonies. After his mental collapse and death, Schumann's wife, Clara (1819–1896), continued to perform his music and support their family with her own professional career. When her friend, the composer Johannes Brahms, chastised her for leaving her children to continue concert tours, she replied: "You regard them merely as a means of earning money. I do not! I feel I have a mission to produce beautiful works." Clara Schumann's achievement as a pianist and composer – she excelled in writing *Lieder* – came by fierce dedication to her art, which, she said to Brahms, "is the very air I breathe."[12]

The romantic age also witnessed virtuosos of the dance, especially the professional ballerinas who perfected dancing "on point" (in French, *en pointe*) – that is,

1804	Beethoven, Symphony No. 3 (*Eroica*)
1808, 1832	Goethe, *Faust*, Parts I and II
1814–15	Schubert, *Lieder* (songs) settings of Goethe's poetry
1830	Berlioz, *Symphonie fantastique*
1838	Schumann, *Kinderszenen*

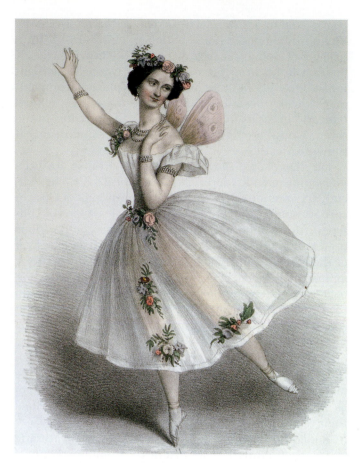

12.14 Marie Taglioni in *La Sylphide, Souvenir d'Adieu*, c. 1832. Colour lithograph. Bibliothèque des Arts Décoratifs, Paris.
Ballerinas like Taglioni used the dance *en pointe* to emphasize their technical ability and give even greater prominence to women in nineteenth-century dance.

on tiptoe in slippers with a hardened toe cap. The ballerina Marie Taglioni (1804–1884) dazzled audiences in the premier of *La Sylphide* (1832), in which the star plays a fairy-like forest creature (Fig. **12.14**). Ballerinas shortened their skirts to display their technique and were lifted by male partners or on wires to emphasize their ethereal qualities. Romantic ballet stories such as *Giselle* (1841) gave greater prominence to women characters and star ballerinas, who earned fortunes for their stage performances.

Berlioz's Fantastic Symphony

Romantic composers, so often inspired by literature and art, frequently told musical stories or described musical scenes, a practice called **program music** (because descriptions were printed in the concert program). Perhaps the most bizarre and ambitious example was the *Symphonie fantastique* (*Fantastic Symphony*) of Hector Berlioz [BAIR-lee-ohz] (1803–1869). Composed in 1830, the

Fantastic Symphony described a lurid fantasy, based on Berlioz's own own obsessive love for an Irish actress who had rejected him:

> A young musician of morbid sensibility and ardent imagination in a paroxysm of lovesick despair has poisoned himself with opium. The drug, too weak to kill, plunges him into a heavy sleep accompanied by strange visions. His sensations, feelings, and memories are translated in his sick brain into musical images and ideas. The beloved one herself becomes for him a melody, a recurrent theme that haunts him everywhere.[13]

Throughout the symphony, the artist's beloved appears musically through the recurring *idée fixe* [ee-DAY FEEKS], which changes in musical character as love flowers and then sours (Fig. **12.15**). The *Fantastic Symphony*'s last movement is a phantasmagoria of the demonic and macabre. The artist sees himself "at a witches' sabbath surrounded by a host of fearsome specters who have gathered for his funeral." The *idée fixe*, initially charming and playful, turns "trivial and grotesque" as played by a mocking clarinet. The lover's tune is interwoven with other melodies – a ponderous melody from a Mass for the dead and a swirling "witches' dance." Berlioz's symphony not only captured the romantic spirit of the macabre, it also exudes a romantic sense of excess and vitality.

12.15 Hector Berlioz, *idée fixe* from the first and fifth movements of *Symphonie fantastique*.
In its first version (introduced by solo flute and violins), the *idée fixe* represents the musician's lover in a noble and idealized guise. The second version, from "Dream of the Witches' Sabbath," is vulgar and grotesque, played by a high-pitched clarinet.

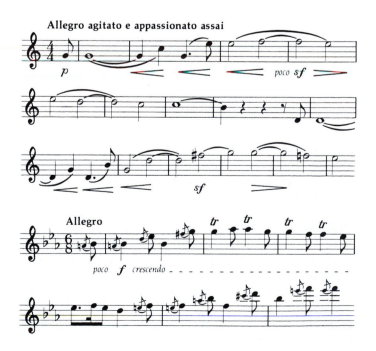

Elements of Romanticism

Link the different elements of romanticism to the historical and social circumstances of the romantic age.

The heroic individualism evident in *Faust* and in the life and works of Lord Byron is just one element of the romantic movement. Other common elements recur in the arts and movements of the romantic period (c. 1800–1850). Romantics in several nations raised a protest against political and social injustice. Some romantics were attracted to nature or indulged in a nostalgia for a medieval past, while others exhibited a fascination with the evil and exotic. Thus, romanticism was a mosaic of artistic and philosophical concerns, not a unified movement or style. What the romantics shared was a sensibility that responded to their social and historical circumstances.

Romantic Social Protest

The early romantics thrilled at the revolutionary declarations of equality and freedom issued in 1776 and 1789. On the other hand, the romantics were witness to the misery and bondage of large-scale industrial society, especially in the towns of England. In factory towns, workers starved in the midst of industrial plenty; women turned to prostitution to feed their families; children labored frantically in factories and mines. Fierce images of urban oppression appeared in the early poetry of the Englishman William Blake (1757–1827). Blake was a visionary mystic who created his own elaborate personal mythology, saying he "must create a system or be enslaved by another man's." He was a sympathetic observer of those enslaved by the industrial city and passionately condemned the evils of urban existence with dense, powerful images.

In Blake's poem *London*, the miserable faces of London's poor are portrayed. The poem rails against the "mind-forg'd manacles" of law, religion, and marriage – social institutions that Blake believed had the effect of creating their opposites: poverty, violence, and prostitution. One of Blake's "Proverbs of Hell" reads: "Prisons are built with stones of Law, Brothels with bricks of Religion." Industrialism had degraded human labor, symbolized by the chimney-sweep (hazardous labor reserved for young

1794	Blake, *London*
1814–15	Goya, *Executions of the Third of May, 1808* (**12.16**)
1815–21	Nash, Royal Pavilion, Brighton, England (**12.22**)
1818	Mary Shelley, *Frankenstein*
1840–65	Barry and Pugin, Houses of Parliament, London (**12.21**)

boys) and the prostitute (the only sure employment for poor urban women). Blake's protest was romantic in the emotional idealism of its last image, the wedding carriage seen as hearse. What ought to bear a couple full of love and optimism, instead carries the harlot's child, blighted by venereal disease.

> I wander thro' each charter'd[a] street,
> Near where the charter'd Thames does flow,
> And mark in every face I meet
> Marks of weakness, marks of woe.
> In every cry of every Man,
> In every Infants cry of fear,
> In every voice: in every ban,[b]
> The mind-forg'd manacles I hear.
> How the Chimney-sweepers cry
> Every blackning Church appalls,
> And the hapless Soldiers sigh,
> Runs in blood down Palace walls.
> But most thro midnight streets I hear
> How the youthful Harlots curse
> Blasts the new-born Infants tear,
> And blights with plagues the Marriage hearse.[14]

WILLIAM BLAKE
London (1794)

a. charter'd, Blake suggests that the streets and the river have been licensed to private commerce.
b. ban, a curse or public denunciation.

Romantic Feminism A more genteel romantic protest was heard in the writings of Mary Wollstonecraft (1759–1797), author of the first feminist manifesto. Wollstonecraft lived a life of intellectual and personal freedom. She became the lover of the radical social theorist William Godwin (1756–1836), and died soon after the birth of their daughter Mary (author of *Frankenstein*). In applying the French Revolution's principles to women, Wollstonecraft answered conservatives such as Edmund Burke, the British politician and theorist, and the revolution's philosophical godfather, Jean-Jacques Rousseau. Rousseau had patronized women in his writings on education, calling for the protection of wives and mothers from society's harsh demands. Wollstonecraft countered this idea, claiming that sheltering women from society stifled their creative energies and deprived society of their contribution.

In her manifesto *A Vindication of the Rights of Women* (1792), Wollstonecraft boldly compared middle-class women to soldiers. Both received a narrow training and suffered from their assigned roles. Her startling comparison – soldiering was supposedly the most masculine of occupations – supported her advocacy of women's education. It also responded to Rousseau's claim that women were inferior because they could not perform military

duty. Wollstonecraft's appeal for recognition by men was to be echoed by later generations of feminists:

> Would men but generously snap our chains, and be content with rational fellowship instead of slavish obedience, they would find us more observant daughters, more affectionate sisters, more faithful wives, more reasonable mothers – in a word, better citizens. We should then love them with true affection, because we should learn to respect ourselves …[15]

However, the revolutions that sought the liberty and education of men merely added to legal and social restrictions on women. In France, Napoleon's revision of the legal code denied women the right to hold property within marriage, and most Western nations denied women the right to vote. Mary Wollstonecraft's protest for the rights of women was largely forgotten until the revival of the woman's suffrage movement in the 1840s.

Goya and Spain The greatest artist of romantic protest was the Spanish painter Francisco Goya (1746–1828),

12.16 Francisco Goya, *Executions of the Third of May, 1808*, 1814–15. Oil on canvas, 8 ft 8³/₄ ins x 13 ft 3³/₄ ins (2.66 x 3.45 m). Prado, Madrid.
Goya's romantic protest against the cruelty of war offers none of the idealism in Delacroix's *Liberty Leading the People* (see Fig. 12.12). Spanish resisters against Napoleon's invasion are lined up for gruesome slaughter by faceless French soldiers, who embody the revolutionary ideals of freedom and equality gone mad.

whose paintings and drawings depicted the senseless brutality of war and oppression. Goya was court painter in Madrid when Napoleon's army invaded Spain in 1808 to overthrow the weakened Spanish monarchy. Spanish citizens rose in sporadic but violent resistance to the French army, fighting the first *guerrilla*, or "little war." The uprising generated mutual reprisals of extreme brutality, which Goya sketched in a horrifying series called *The Disasters of War*. In *Executions of the Third of May, 1808* (Fig. **12.16**), Goya depicts the execution of Spanish insurgents with such a raw truthfulness that the picture has been called "the explosion of modern painting." Goya shows us a sacrifice without ideals, a martyrdom without

redemption. In his white shirt, the Christ-like central figure draws the viewer's eye to his dead compatriots. The scene is lighted by a stable lantern, normally a symbol of enlightenment and grace that here merely serves to illuminate the soldiers' grisly work. The moral realism in Goya's painting is a testimony to the demonic forces of war, loosed on a world without reason or optimism.

The Romantics and Nature

As Western societies became more urbanized, nature assumed a new significance for the romantic sensibility. Since ancient Greece, nature had symbolized the divine cosmos, of which human society was a part. For the romantics, however, nature became the negation of society, a world of beauty unspoiled by human endeavor. Among the English romantics, nature also represented a childlike existence that was lost to adults, except through moments of poetic transcendence. In their imagination (see Key Concept, opposite), English romantic poets momentarily felt communion with the natural world and, through nature, with themselves.

The poetry of English romanticism often portrayed the poet's imaginative union with nature, such as John Keats (1795–1821) contemplating a nightingale's song, or Percy Bysshe Shelley (1792–1822) listening to the west wind. The English poet William Wordsworth (1770–1850) was the leading nature poet of the romantic age. Wordsworth's poetry recorded moments of transcendental insight gained during his contemplation of nature.

Where Goethe's Faust had sought "infinitude" in human ambition, Wordsworth found infinity in the sublime experience of nature. Nature served as the catalyst to the poet's own spiritual development or renewal, reflecting and confirming his own powers of imagination (Fig. **12.17**). This correspondence between nature and the artist's inner soul was a commonplace of romanticism. In this passage from *The Prelude, or Growth of a Poet's Mind* (1799–1805), Wordsworth's poetic powers are stimulated by his night-time excursion to Mt. Snowdon in Wales:

> There I beheld the emblem of a mind
> That feeds upon infinity, that broods
> Over the dark abyss, intent to hear
> Its voices issuing forth to silent light
> In one continuous stream; a mind sustained
> By recognitions of transcendent power …[16]

Often, the romantic's contemplation of nature caused a profound sense of melancholy. The purity of nature reminded the romantics of their lost innocence and alienation from the natural world. In the poem *The World is Too Much With Us*, Wordsworth bemoans the distractions of a "too busy world" and envies the ancient Greeks' naive vision of nature. The knowledge that his wish is impossible makes his melancholy all the more acute.

Imagination

Enlightenment empiricists had embraced the philosopher John Locke's bold metaphor for the workings of the human mind — the "blank slate" that mechanically records sense experience. With their emphasis on genius and human feeling, the romantics naturally rejected this mechanical and passive notion of the human mind. To the romantics, the human mind was more like the hand of God at the moment of creation. The English poet William Blake even said, "One Power alone makes a Poet: Imagination, Divine Vision." In the view of romantic poets, at least, **imagination** was that faculty of mind that creatively shaped experience and rendered it as the poet's unique vision of the world. The romantic poet Samuel Taylor Coleridge (1772–1834) explained that imagination "dissolves, diffuses, dissipates, in order to re-create." In other words, the creative imagination acts on, adds to, and reshapes the facts of sense experience, to create a perception entirely individual and new. In this way, a painter such as Turner might imaginatively recreate a maritime disaster in a fictional work — a fiction that is more truthful than mere observational data.

The romantic poets' idea of imagination rested on a more profound disagreement within European philosophy. The German philosopher Immanuel Kant (1724–1804) had already challenged the Enlightenment idea of the mind as a blank slate. Kant [kawnt] — a near-contemporary of Rousseau and so a philosophical child of the Enlightenment — asserted that the human mind gave order to sense experience. The mind employed transcendental categories of knowing that existed *a priori* — that is, "from the beginning." The most fundamental of these *a priori* categories were time and space, but Kant deduced others (causality, necessity, quantity). Any human experience — the contemplation of a flower, for example — consisted of perceptual knowledge (provided by the senses) and conceptual knowledge (provided by the mind). In Kant's view, imagination was the mind's power to synthesize these two elements into a unified experience.

Kant's philosophical idea of a "transcendental" self, which shapes and orders experience, found popular expression in the poetic idea of imagination. It acknowledged in Western thinking the power of the human mind to create its own reality — whether it was a scientist's hypothesis, a painter's vision, or a madman's delusion — from the raw materials of experience.

The world is too much with us; late and soon,
Getting and spending, we lay waste our powers:
Little we see in Nature that is ours;
We have given our hearts away, a sordid boon!
The Sea that bares her bosom to the moon;
The winds that will be howling at all hours,
And are up-gathered now like sleeping flowers;
For this, for everything, we are out of tune;
It moves us not. – Great God! I'd rather be
A Pagan suckled in a creed outworn;
So might I, standing on this pleasant lea,
Have glimpses that would make me less forlorn;
Have sight of Proteus[a] rising from the sea;
Or hear old Triton[a] blow his wreathèd horn.[17]

WILLIAM WORDSWORTH
The World is Too Much With Us (1807)

a. Proteus and Triton, Greek gods of the sea.

12.17 Caspar David Friedrich, *The Wanderer Above the Mists*,
c. 1817–18. Oil on canvas, 29¹/₂ × 37¹/₄ ins (75 × 95 cm).
Kunsthalle, Hamburg.
The German romantic painter Caspar David Friedrich depicts a
wanderer struck by the sublime power of nature. In Friedrich's view,
much like Wordsworth's, all of nature contained the presence of God.
"The Divine is everywhere," he said, "even in a grain of sand."

THE WRITE IDEA
Write a commentary on Wordsworth's assertion that "getting
and spending we lay waste our powers," from the poem *The
World is Too Much With Us*. Which human abilities are "wasted" in
the acquisition of material wealth? Which are developed?

The romantic return to nature reached a final expression in the writings of the Americans Ralph Waldo Emerson (1803–1882) and Henry David Thoreau (1817–1862). Emerson's musings on nature had a kinship with the mysticism of Hindu philosophy. He claimed that all humanity was part of the divine "Over-soul," and that individuals possessed within themselves the capacity to know all things. Thoreau's love of nature was more matter-of-fact, as expressed in the famous book *Walden, or Life in the Woods* (1854). By living for a year close to nature, Thoreau hoped he could learn the essentials of human existence and escape the "lives of quiet desperation" led by most inhabitants of the modern world.

If Wordsworth was romanticism's greatest nature poet, his compatriot John Constable (1776–1837) was its greatest nature painter. Constable's favorite subjects were rustic landscapes in which, in Wordsworth's words, "the passions of man are incorporated with the beautiful and permanent forms of nature." Constable's nature scenes may have been commonplace, but his technique as a painter was not. He applied color aggressively to the canvas, laying down daubs and dashes of pure color that created a shimmering vitality in his pictures. The picturesque calm in *The Hay Wain* (Fig. **12.18**), for example, renders the changing light and brilliant hues of the English countryside, visible in the red of the oxen's yoke and the dappled sunlight on the distant pasture. His intense use of color influenced Delacroix to adopt his bold method of coloring, and was later imitated by French impressionist painters (see page 370).

The paintings of Joseph Mallord William Turner (1775–1851) show nature as a violent and mysterious force, overwhelming the puny inventions of humanity. Even more obsessively than Constable, Turner experimented with color – especially blues and yellows – frequently transforming and fusing his colors to convey the effects of fog, steam, or smoke. Sometimes, it seems, color was the mystic veil through which Turner revealed humanity and nature. In *The Slave Ship (Slavers Throwing Overboard the Dead and Dying – Typhoon Coming On)* (Fig. **12.19**) a turbulent sea swallows up the bodies of diseased slaves. Because Britain's slave trade had been abolished for twenty years, Turner probably chose the subject not as a political protest but rather out of interest in its apocalyptic atmosphere.

Romantic landscape painting gained a special place in North American culture, where the proximity of the

12.18 John Constable, *The Hay Wain*, 1821. Oil on canvas, 4 ft 2¹/₂ ins × 6 ft 1 ins (1.28 × 1.85 m). National Gallery, London. A master colorist, Constable created his brilliant foliage from overlaid dabs of green. The green is balanced by its complementary color (red) in the horses' harness and the scarf of a fisherman barely visible above the rowboat at right.

wilderness gave the genre religious overtones. The painter who established this American genre was Thomas Cole (1801–1848), founder of the so-called Hudson River school. Cole's carefully rendered scenes of the Hudson River Valley in New York almost always bore some heroic or moralizing detail, and purported to reveal the presence of God through unspoiled nature. Cole's contemporary, Asher B. Durand, said of their landscape subjects: "To the spectator, a landscape becomes companionable, holding silent converse … touching a chord that vibrates to the innermost recesses of the heart."[18] A second generation of American landscape painters specialized in grand views of the American West. Albert Bierstadt (1830–1902) painted his majestic panoramic views of the Rocky Mountains and Yosemite Valley (Fig. **12.20**) for urban collectors back east, who valued the anthropological

details of Native American cultures that were being destroyed by war, disease, and encroaching settlement.

Romantic Escapes

Each age finds in the past a reflection of its own values, and the romantics were no exception. Because the cataclysmic French Revolution made the past feel more distant, the romantics were better able to recognize that each past age had its own unique sensibility. Romantic works sought to recreate the past in historical detail, sometimes preferring to reconstruct the past instead of observing the present.

In romantic Germany especially, a revived interest in Gothic styles included the imitation of Gothic architecture and the use of Gothic settings in literary works. The

> To the spectator, a landscape becomes companionable, holding silent converse … touching a chord that vibrates to the innermost recesses of the heart.
>
> Asher B. Durand, "Letters on Landscape Painting," Letter IV

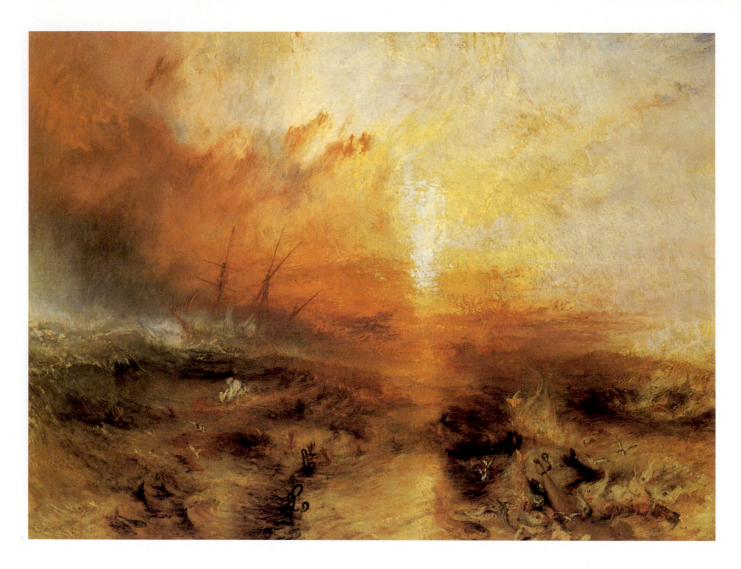

12.19 Joseph Mallord William Turner, *The Slave Ship (Slavers Throwing Overboard the Dead and Dying – Typhoon Coming On)*, 1842. Oil on canvas, 35³/₈ x 48¹/₄ ins (91 x 123 cm). Courtesy, Museum of Fine Arts, Boston, Henry Lillie Pierce Fund.
In this romantic phantasmagoria of natural and human violence, Turner depicts an incident from the British slave trade. Fishes devour the body of a cast-off slave (lower right), while the doomed ship sails into a blood-red storm. Compare this painting's perspective on humans' relation to nature with John Constable's *Hay Wain* (Fig. 12.18).

German poet Heinrich Heine [HIGH-nuh] (1797–1856) defined romanticism as "the re-awakening of the life and thought of the Middle Ages." The medieval Gothic cathedral became a feast of romantic symbolism: the ancient, the mystic, the picturesque, and the organic. In Germany, romantics engineered the completion of Cologne's Gothic cathedral in 1834, a project that fused romantic medieval nostalgia with German cultural nationalism.

One striking example of the Gothic revival in England was William Beckford's estate at Fonthill Abbey (begun 1796), which grew into an elaborate Gothic fantasy. Gothic ruins were thought especially picturesque, so Beckford employed the architect John Wyatt to replicate a ruined convent at his summer home. A Gothic tower and other additions eventually created a jumbled stone concoction that bore no resemblance to any genuinely Gothic building. When the tower collapsed in 1825, it left a "Gothic" ruin that symbolized both organic growth and organic decay.

There were more enduring examples of medieval revivalism. The gigantic Houses of Parliament in London (Fig. **12.21**) – rebuilt after a disastrous fire in 1834 – were more Gothic in decoration than in construction. The imposing façade facing the Thames is as regular and geometric as any neoclassical building's. Augustus Welby Pugin (1812–1852), the designer of the Gothic decoration, called his work "Tudor details on a classic body." Still, the famous irregular towers and the building's intricate exterior carving made it an impressive presence in London architecture. In North America, the medieval revivalist James Renwick (1818–1895) designed two of the continent's most familiar buildings. He copied the towering St. Patrick's Cathedral in New York City from medieval French examples of the Gothic style. His design for the Smithsonian Institution in Washington, D.C., reverted to

the stone masses of the medieval Romanesque style (see page 145).

With the end of the Napoleonic wars in 1815, the societies of Europe and North America settled into a comfortable routine of middle-class life. The appropriate symbol of this complacency was France's bourgeois king, Louis-Philippe (ruled 1830–1848), who dressed in a businessman's frock coat and gambled his fortune on the stock market. Ironically, as European societies succumbed to conservatism, they were drawn to art of the exotic and grotesque. Middle-class readers and patrons wished to be transported outside the narrow limits of middle-class experience. Artists reacting against Enlightenment rationalism were also eager to explore the domains of evil and exoticism.

The European colonization of Africa and Asia brought the romantic sensibility into contact with exotic Oriental cultures. In England, when the Prince of Wales redesigned his residence at Brighton, the architect John Nash

12.20 Albert Bierstadt, *Among the Sierra Nevada Mountains in California*, 1868. Oil on canvas, 5 ft 11 ins × 10 ft (1.83 × 3.05 m). National Museum of American Art, Smithsonian Institution, Washington, D.C.
Bierstadt first visited the American West in 1859, sketching and making photographs of its grand mountain vistas. In this gigantic landscape, the tiny foreground wildlife set off the spectacular scale and brilliant light of the cliffs and peaks.

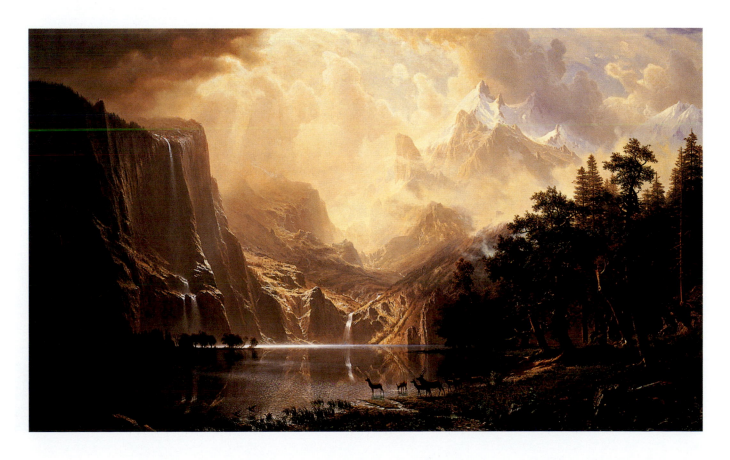

12.21 (above) Sir Charles Barry and A. W. Pugin, Houses of Parliament, London, 1840–65. Length 940 ft (286.5 m).

The massive Houses of Parliament in England were the romantic era's greatest public building in the Gothic style. Note the tension between the building's symmetrical core and the irregular towers.

12.22 (right) John Nash, Royal Pavilion, Brighton, England, 1815–21.

Nash's Royal Pavilion was typical of romantic exoticism. It arbitrarily borrowed elements from Islamic and Asian design, and combined them into an artificial but delightful architectural fancy. Compare this building to the fantasy architecture of contemporary theme parks and tourist attractions.

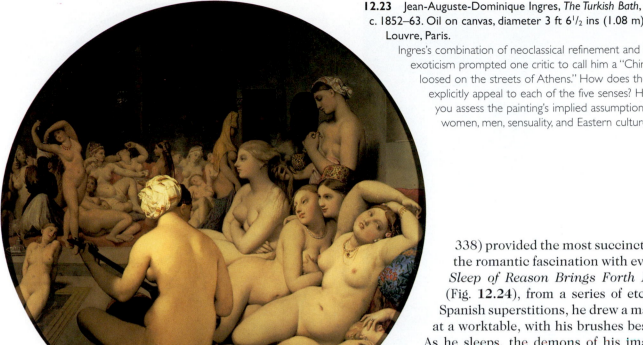

12.23 Jean-Auguste-Dominique Ingres, *The Turkish Bath*, c. 1852–63. Oil on canvas, diameter 3 ft 6½ ins (1.08 m). Louvre, Paris.

Ingres's combination of neoclassical refinement and romantic exoticism prompted one critic to call him a "Chinese loosed on the streets of Athens." How does the painter explicitly appeal to each of the five senses? How would you assess the painting's implied assumptions about women, men, sensuality, and Eastern cultures?

(1752–1835) created a fantastic confection of Arabic, Chinese, and Indian styles. Nash's Brighton Pavilion (Fig. **12.22**) used Oriental and Moorish elements in a willful disregard for authenticity and carried the exotic themes over into the building's interior decoration.

Not to be outdone by English exoticism, French romantics followed in the wake of French colonial expeditions to northern Africa. In 1832, the painter Delacroix embarked on an unlikely (and dangerous) mission to Morocco. Fascinated by the rich colors of Arab dress, he sketched a Moorish harem and succeeded in getting an invitation to a Muslim wedding. Even Delacroix's rival, the academic painter Jean-Auguste-Dominique Ingres (1780–1867), was not immune to the seductions of exoticism. His *Turkish Bath* (Fig. **12.23**) offers a key-hole view of a Turkish harem as he imagined it, an erotic feast of the senses. While appealing to the voyeuristic pleasure of his male public, Ingres [ang(r)] maintained the cool restraint of his academic style. The form of the lute-player in the left foreground might be a classical statue.

Evil and the Gothic Novel

Where Enlightenment rationalists expected evil to be defeated by moral diligence, the romantics found it to be as mysterious and irrepressible as the human imagination itself. The Spanish artist Francisco Goya (see page 338) provided the most succinct image of the romantic fascination with evil. In *The Sleep of Reason Brings Forth Monsters* (Fig. **12.24**), from a series of etchings on Spanish superstitions, he drew a man asleep at a worktable, with his brushes beside him. As he sleeps, the demons of his imagination liberate themselves and rise with triumphant energy above him. The enigmatic inscription reads, "The sleep of reason produces monsters." It suggests that behind wakeful reason, the destructive fiends of the human imagination are lurking. With such insights, the romantics anticipated the discoveries of modern psychology.

The literary fascination with evil and the demonic was evident in the **Gothic novel**, a genre characterized by horror, supernatural occurrences, and often a medieval setting. The most spectacular Gothic atmospheres were created in the stories of American author Edgar Allan Poe (1809–1849). Such tales as *The Pit and the Pendulum* and *The Fall of the House of Usher* demonstrate Poe's mastery of Gothic horror and his insight into human fear and remorse. In Europe, the sisters Charlotte and Emily Brontë both used the wild landscapes of their remote English homeland to frame stories of tortured and willful souls. In Charlotte's *Jane Eyre* and Emily's *Wuthering Heights* (both published 1847), the central figures are impelled by their passion and loneliness to confront social obligation and moral choice. The stories of these and other romantic authors became prototypes of the Gothic-style narratives of horror and romance still popular today.

The best-known Gothic novel today is Mary Shelley's *Frankenstein, or the Modern Prometheus* (1818), which synthesized Gothic atmosphere with the romantic themes of genius and the noble savage. The life of Mary Wollstonecraft Shelley (1797–1851; Fig. **12.25**) might well have been a romantic drama, with its acts of passionate abandon and lonely struggle. The daughter of freethinking radicals, the precocious Mary eloped with the young romantic poet Percy Bysshe Shelley, who was estranged

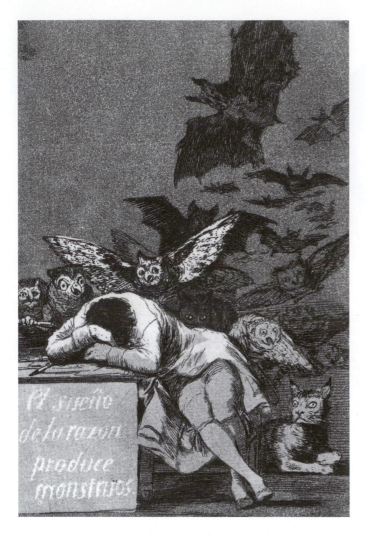

12.24 Francisco Goya, *The Sleep of Reason Brings Forth Monsters*, from *Los Caprichos*, 1796–8. Etching, 8¹/₂ × 6 ins (21.6 × 15.2 cm). British Museum, London.
This etching – the frontispiece to a book of prints titled "Caprices" – recorded Goya's insight into the darkness of the human soul. Goya's original caption read, "Imagination abandoned by reason produces impossible monsters; united with her, she is the mother of the arts and the source of their wonders."

12.25 Mary Wollstonecraft Shelley, shown in a miniature by Reginald Easton. Bodleian Library, University of Oxford.
More than any other Gothic novel, Mary Shelley's *Frankenstein* engaged the romantic themes of genius, heroic alienation, and the protest against society's evils.

from his wife and child. The Shelleys became companions of Lord Byron in his dissolute European exile. Their idyll ended when Percy Shelley drowned in Italy. Mary Shelley returned to England with the couple's son and became a professional writer, earning a living and educating her son, while also editing and publishing her husband's poetic works.

Mary Shelley traced the genesis of her *Frankenstein* to a night in Switzerland, when she and her literary companions had challenged each other to a ghost-story competition. She had dreamed that night about a "hideous phantasm of a man stretched out" who, "on the working of some powerful engine, shows signs of life, and stirs with an uneasy, half vital motion." In Shelley's novel, this

"phantasm" – the grotesque creature – owes its existence to Victor Frankenstein, a romantic version of the Greek hero Prometheus, who stole fire from the gods. Believing that he has discovered the secret to life, Victor chortles that "a new species would bless me as its creator and source; many happy and excellent natures would owe their being to me." But when his hideous creation springs to life, Victor is horrified and abandons the monster, who embarks on his own odyssey of loneliness and despair. The creature finally appeals to Frankenstein to fashion a mate for him, an "Eve" to share his miserable state:

> "What I ask of you is reasonable and moderate; I demand a creature of another sex, but as hideous as myself: the

THE WRITE IDEA

Compose a letter to a romantic figure explaining modern civilization's continued fascination with evil, the demonic, and the grotesque, as demonstrated by contemporary popular literature and film.

gratification is small, but it is all that I can receive, and it shall content me. It is true, we shall be monsters, cut off from all the world; but on that account we shall be more attached to one another. Our lives will not be happy, but they will be harmless, and free from the misery I now feel. Oh! my creator, make me happy; let me feel gratitude towards you for one benefit! Let me see that I excite the sympathy of some existing thing; do not deny me my request!"[20]

MARY SHELLEY
From Frankenstein (1818)

Victor refuses the appeal, and the two figures – creator and creature – are finally locked in a tortuous pursuit, determined to destroy each other.

In Frankenstein, Shelley created a hero who suffers a conflict between his God-like ambitions and his moral blindness. In the creature, she imagined the noble savage, who learns hatred and cruelty from humans whose civilization has failed to make them kind. With all its interwoven themes, Shelley's Gothic tale is one of the richest documents of romanticism.

CHAPTER SUMMARY

Revolutions and Rights The revolutionaries of 1776 in America and 1789 in France justified themselves with the principles of Enlightenment philosophy. In America, the Declaration of Independence put into bold action the principle of popular sovereignty, while the Federalist writers defended the new American constitution with enlightened rationalism. In France, the revolutionary drama included the Declaration of Rights of Man and the Citizen (1789) as well as European war and the Reign of Terror. Despite the Terror, Western societies adopted the liberal goal of individual freedom – sovereignty over oneself and one's property.

During the Napoleonic era (1799–1815), the military hero Napoleon presented himself as the champion of revolutionary principles while seizing absolute power. Taking ancient Rome as a model for his capital, Paris, Napoleon employed the arts to project his imperial ambitions, served by such artists as David and Canova. In the Americas, revolutionaries overthrew colonial rule and established constitutional governments. In England the Industrial Revolution in manufacture and transportation promised to transform Western culture and society. The German philosophers Hegel and Marx strove to grasp the dynamics of history. Hegel believed that history advanced through the dialectical development of a "World-Spirit." Marx argued that history progressed through the struggle of social classes.

The Romantic Hero Following Napoleon's defeat in 1815, a new romantic sensibility suffused European society, preferring feeling to reason and individual genius over mechanical laws. In the romantic era (1800–1850), heroic geniuses were prized for their extraordinary powers and achievements. In literature, the German poet Goethe recast the Faust legend as a romantic striving to taste all human experience – his *Faust* inspired artists and composers. The life of poet Lord Byron, advocate of

moral and intellectual freedom, defined another kind of romantic hero, which powerfully influenced the French painter Delacroix.

Music and Dance in the Romantic Age Music in the romantic age was performed in new venues suitable to increasingly middle-class audiences. The tortured genius Ludwig van Beethoven composed expansive symphonies that bridged the Classical and romantic styles. Virtuosos in music and dance won international acclaim, and women dancers especially earned fame and fortune. Berlioz's expansive *Fantastic Symphony*, an example of romantic program music, told the musical story of an artist's obsessive love, ending in a lurid dream of a witches' Sabbath.

Elements of Romanticism The elements of romantic art and literature arose in response to different social and historical circumstances. Romantic-era poets protested the social injustices of early industrial society: While Mary Wollstonecraft demanded equal rights for women, the Spanish painter Goya bitterly depicted the cruelties of war. In England and North America, romantic authors such as Wordsworth and Emerson saw nature as a mirror of the human imagination. Painters used new effects of color and light to render the natural landscape's sublime beauty. Still other romantics sought escape in the past, fostering a taste for picturesque medieval architecture. As industrial life became more dull and mechanical, the lure of exotic lands spurred the imaginations of architects such as Nash and painters such as Delacroix and Ingres. The romantics' fascination with evil, the demonic, and the grotesque was reflected in the novel, with its medieval setting and tortured characters. The most famous Gothic novel was Mary Shelley's *Frankenstein*, a summation of romantic motifs – the genius, the noble savage, the protest against injustice, and the fascination with evil.

13 The Industrial Age: The Spirit of Materialism

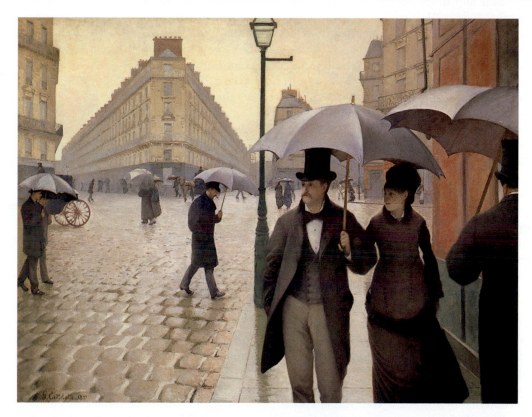

13.1 Gustave Caillebotte, *Paris Street: Rainy Weather*, 1877. Oil on canvas, 6 ft 11½ ins x 9 ft ¾ ins (2.12 x 2.76 m). Art Institute of Chicago (Charles H. and Mary F. S. Worcester Collection, 1964.336).

This scene of Paris's modern boulevards shows the painter's fascination with oblique angles and uneven proportions. Compared to the romantics' view of humans in nature, what does this picture say about humans in the urban landscape? What elements of the picture make it feel "modern"?

Finely dressed shoppers stroll down a rainy boulevard in 1870s Paris (Fig. **13.1**), the "capital of the nineteenth century." Fashionable apartments rise like modern pyramids behind them. Within a decade, the great Eiffel Tower, a masterpiece of engineering and design, will be erected nearby. Like other capitals of modernity – Berlin, New York, Chicago – this glistening Paris is a triumph of **materialism**: the belief that science, technology, and industry can know all truth, solve all problems, and create human happiness.

But we must ask about these urbane citizens of the industrial age, striding purposefully into a modern future: Do they feel a bit of nostalgia for the old Paris? Are they alienated from the others – the workers, the poor, the powerless – who share their sidewalk? What, ultimately, are the spiritual costs of their materialism and prosperity? These are the questions that came to perplex the great **age of industry** (1850–1910), when modernity prevailed in Western civilization and brought astounding material progress.

Materialism and Progress

Identify the technical and scientific advances that contributed to the age's social and artistic progress.

In the mid-nineteenth century, Western societies were entering a new age of material production, a triumph of machines and commodities. Europe and North America were in the midst of a great economic boom, fueled by discoveries in applied science and industrial technology.

The Victorian era, as this time is called in Britain, hailed the age's material prosperity and prized the values of utilitarianism – the philosophic belief that moral good lies in the greatest happiness for the greatest number. But new ideas like Darwin's theory of evolution shook traditional beliefs, and philosophy sought the laws and logic of future historical change.

The Victorians

In Great Britain, the most prosperous and powerful of all the industrial nations, this age took its name from the long reign of Queen Victoria (1837–1901). The so-called **Victorians** – a term best applied to the burgeoning middle classes of the new industrial cities – witnessed rising standards of living and stunning technological advances. In 1876, the first transatlantic telegraph cable connected Europe with North America, enabling swift telecommunication. Programs of sanitation and vaccination began to eradicate epidemic diseases such as smallpox and typhus. By the end of the century, water-powered electrical plants were providing electricity for Thomas Edison's newly invented light bulbs. The British Victorians and their bourgeois counterparts in Vienna, Paris, and New York, were justifiably optimistic about scientific and technological progress, and suffered only occasional qualms about the injustice of their urban slums and colonial empires (Fig. **13.2**).

The triumph of the Victorian era was the 1851 Great Exhibition in London, housed in Joseph Paxton's magnificent Crystal Palace (Fig. **13.3**). Paxton (1801–1865), a former gardener, employed new methods of iron-and-glass construction in his design, which resembled a

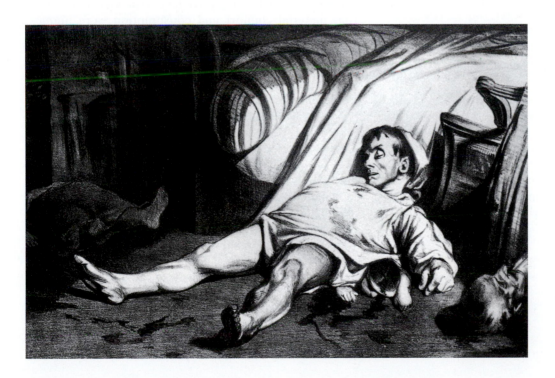

13.2 Honoré Daumier, *Rue Transnonain, April 15, 1834*, 1834. Lithograph, 11½ x 17½ ins (29 x 44.5 cm). The realist painter and illustrator Honoré Daumier was deeply engaged in the political struggles of the mid-nineteenth century. This scene shows the aftermath of an atrocity by government soldiers against a poor Parisian family. Daumier's lithographic prints were published frequently in newspapers and pamphlets, achieving an immediacy and evocative power that today characterizes journalistic photography and videography.

13.3 Joseph Paxton, Crystal Palace, London, 1851. Cast iron and glass, length 1,851 ft (564.2 m).
Paxton's glass-and-iron palace housed the 1851 Great Exhibition, a celebration of Victorian England's progress and ingenuity. Its prefabricated parts of cast- and wrought-iron were so precisely manufactured that the entire building was assembled in a few months.

monumental greenhouse. The building's iron framework and glass panels were manufactured off-site, prefabricated to be easily assembled and disassembled. The entire building, nearly 2,000 feet (c. 610 m) long and covering 26 acres (10.5 ha), was constructed in less than ten months. Full-size elm trees were planted inside the Palace's arched central "nave," as Paxton called it – implying that his grand hall was like a cathedral of materialism.

> Actions are right in proportion as they tend to promote happiness; wrong as they tend to produce the reverse of happiness.
>
> John Stuart Mill

The 1851 Exhibition's pavilions, piled high with the produce of British industry, reflected the Victorians' belief that material comfort and consumption were unquestioned goods. The philosophical version of this belief was expressed in **utilitarianism**, a moral philosophy that evaluated all actions against a single standard of judgment – the greatest pleasure for the greatest number. Like the ancient Epicureans (see page 65), utilitarians argued that the good consisted in the pleasure and well-being of humans and other sentient beings. Utilitarianism's founder, Jeremy Bentham (1748–1832), argued that the happiness promised by social reforms could be positively and empirically measured. He claimed to have reduced moral judgment to a calculus of "felicity." Bentham removed all religious consideration from ethical action – God had nothing to do with happiness – and offered a straightforward secular hedonism that appealed to Victorian practicality. The philosopher John Stuart Mill (1806–1873) developed a more subtle position, advocating women's right to vote and other social reforms based on their utility to society. In his concise essays *On Liberty* (1859) and *The Subjection of Women* (1869), J. S. Mill defended social justice by a rigorous but flexible utilitarian standard. "Actions are right in proportion as they tend to

Realism in the Arts

Many artists reacted to Western industrial society with sober detachment and practicality, an attitude called **realism**. Realism in the arts aimed to give a truthful and objective representation of the social world, without illusion or imaginative alteration. In the words of the American journalist and novelist William Dean Howells (1837–1920), realism was "nothing more or less than the truthful treatment of material."

The most militant realist painter was the French artist Gustave Courbet (1819–1877), whose scenes of ordinary provincial life outraged the Parisian art public. Courbet [koor-BAY] declared boldly that painting "can only consist of the presentation of real and existing things." In his own work, he found artistic truth in the ordinary lives and routine events of industrial society, presenting his subjects without nobility or sophistication.

When Courbet's *Burial at Ornans* [or-NAHN(h)] (Fig. **13.4**) was shown in 1851 at the official Salon – the annual exhibition of work by professional artists – the Paris connoisseurs were scandalized. They attacked the picture of funeral-goers from Courbet's native town as the incarnation of socialism. They considered the picture to be carelessly composed, and complained that the subject lacked any hint of heroism or exalted truth. Courbet had, in fact,

promote happiness; wrong as they tend to produce the reverse of happiness," he wrote in a succinct maxim.[1]

Though the Victorians were great believers in human progress, one Victorian idea aroused a firestorm of religious objection. When the biologist Charles Darwin (1809–1882) published his *Origin of Species* (1859), he challenged the Judaic and Christian teachings on humanity's origins. Rather than originating in a primeval act of God, Darwin argued, humans had evolved naturally from lower animals, according to inexorable laws of mutation and adaptation. By these laws of **natural selection**, species survived in nature depending on how well they adapted to scarcity or threat. All species were engaged in a competition for scarce resources – the "struggle for life," as Darwin called it. Humanity was no different – humans, too, had evolved from ape-like species through the gradual process of natural selection. Humans appeared to be far advanced beyond the highest apes, but "the difference in mind between man and the higher animals, great as it is, is one of degree and not of kind," as Darwin wrote in *The Descent of Man* (1871). Darwin's ideas had impact far beyond biological science. Victorian thinkers developed a "social Darwinism," using Darwin's naturalist principle of natural selection to justify the class divisions in industrial nations and Europe's colonial exploitation of Africa and Asia.

13.4 Gustave Courbet, *Burial at Ornans*, 1849. Oil on canvas, 10 ft 3⅝ ins × 21 ft 9¾ ins (3.14 × 6.65 m). Louvre, Paris.
Courbet's realism outraged the official art world, which expected painters to depict mythic allegories and historical subjects. With this monumental scene of an ordinary incident in village life – Ornans was his provincial hometown – what might Courbet be saying about the heroic and idealized subjects of academic painting?

THE WRITE IDEA

Write a "realistic" and "objective" description of the event depicted in Courbet's *Burial at Ornans*. To what degree must you rely on the artist's perceptions? How might your description be different if you were looking at a photograph of the funeral, or if you had witnessed the event firsthand?

portrayed the mourners crowded around the open grave with no regard for social hierarchy – the priest, pall-bearers, and attendants are depicted with utter honesty, including a beadle (in red) flushed with drink. Realism, Courbet would say, was "democracy in art."

In 1860s Paris, a controversial painter stepped from Courbet's shadow and boldly recast the Western tradition of painting in modern terms. Edouard Manet (1832–1883) had been trained in the prevailing academic style and his most famous pictures were styled after masterworks of the old masters. But Manet updated traditional paintings with modern subjects in ways that scandalized the French art world. His *Le Déjeuner sur l'herbe* (*Luncheon on the Grass*; Fig. **13.5**) roused greater official outrage in 1863 than Courbet's *Burial at Ornans* had done fifteen years earlier. The Paris public was shocked by its vivid juxtaposition of a nude female and clothed men in a contemporary setting. Even more, they protested Manet's style of painting, which rendered the woman's nude form in a flat, chalky white. While the public accepted nudity in traditional painting, they rejected Manet's modernized version because it violated painterly tradition. Though he

13.5 Edouard Manet, *Le Déjeuner sur l'herbe* (*Luncheon on the Grass*), 1863. Oil on canvas, 7 ft ³/₄ ins × 8 ft 10³/₄ ins (2.15 × 2.71 m). Musée d'Orsay, Paris.
Manet's painting scandalized the public with its bold juxtaposition of the nude female and her clothed companions in a contemporary setting. Analyze the effect of the painting's harsh frontal lighting and the nude woman's bold gaze at the viewer.

13.6 Edouard Manet, *The Bar at the Folies-Bergère*, 1881–2. Oil on canvas, 37½ x 51 ins (95 x 130 cm). Courtauld Institute Galleries, London.
Edouard Manet and his successors, the impressionists, embraced the colorful life of the modern city. Here a barmaid coolly engages a customer, while the mirror behind reflects a balcony full of gaily dressed theater-goers enjoying a circus performance. Compare the background image (influenced by impressionist technique) to the solid shapes of the barmaid, bottles, and fruit.

did eventually win official recognition, Manet also became a sympathetic sponsor of the innovative young painters known as the impressionists (see page 370). His last paintings, such as *Bar at the Folies-Bergère* (Fig. **13.6**), reflects the impressionist treatment of light and color.

Critics found a more palatable brand of realism in the works of Rosa Bonheur (1822–1899), the most famous female painter of her day. Bonheur's [BOHN-err] father belonged to a socialist group that believed firmly in women's equality, and Rosa lived by his teachings. She wore men's clothes (which required a police permit), smoked cigarettes, and never married, living instead with female companions. Her painting was as bold as her life. *The Horse Fair* (Fig. **13.7**), painted between 1853 and 1855, depicts a sweeping parade of horses animated by

a fierce energy that nearly overwhelms their handlers. Bonheur's approach was less threatening and political than Courbet's crude scenes of provincial life, and earned her great popularity in Victorian England.

The realist attitude achieved its greatest immediacy through printmaking and the new medium of photography. In France, the prints of Honoré Daumier [dome-YAY] reported the sufferings of the poor and caricatured the folly of the powerful. Daumier worked under relentless deadlines to produce up-to-the-hour images of current events (see Fig. 13.2). Invented in various forms by 1850, photography was first widely employed as a cheap means of portraiture. In 1854, a photographic entrepreneur patented the photographic *cartes de visite,* or "calling cards," mass-produced images of studio portraits. But photography quickly found more serious applications. The Parisian photographer Gaspard-Félix Tournachon, known as Nadar (1820–1910), not only photographed the most famous personages of his age (Fig **13.8**) but also documented the streets and sewers of the modern city and built his own helium balloon to make the first aerial photographs. In the United States, powerful images of the American Civil War were preserved by the cameras of Matthew Brady (1823–1896) and his team of photographers, who captured the faces and bodies of fallen

13.7 *(above)* Rosa Bonheur, *The Horse Fair*, 1853–5. Oil on canvas, 8 ft ¼ in x 16 ft 7½ ins (2.44 x 5.06 m). The Metropolitan Museum of Art, New York, Gift of Cornelius Vanderbilt, 1887 (87.25). Photograph ©1997 The Metropolitan Museum of Art .
Rosa Bonheur studied her animal subjects with scientific detachment, frequently visiting slaughterhouses and animal markets. The artist herself compared this parade of animals to the Parthenon frieze of the acropolis at Athens (see Fig. 3.25).

13.8 *(left)* Nadar, portrait of Sarah Bernhardt (1844–1923). Photograph taken in the late 1870s.
Nadar's photographic studio was celebrated for its portraits of notable Parisians. He made his first portrait of French actress Sarah Bernhardt when she was twenty. Here she is costumed as one of the characters that she made famous on the international stage.

soldiers "with a terrible distinctness," as one contemporary critic put it.

In the post-war United States, realists competed with American imitators of European academic styles. In the works of Winslow Homer (1836–1910) and Thomas Eakins (1844–1916), realist technique was combined with American matter-of-factness. After working as a wartime magazine illustrator, Homer visited Paris, where he saw the works of Courbet and Edouard Manet (see page 352). Homer's favorite subjects were scenes of children at play or of high drama at sea. Eakins [AY-kunz] studied in Paris with an academic history painter and composed his outdoor subjects – rowers, sailors, and swimmers – with precise attention to perspective and balance. In *The Gross Clinic* (Fig. **13.9**), he portrayed a famous Philadelphia doctor demonstrating a daring surgical procedure. The

13.9 Thomas Eakins, *The Gross Clinic*, 1875. Oil on canvas, 96 × 78 ins (2.44 × 1.98 m). The Jefferson Medical College, Philadelphia, Courtesy Thomas Jefferson University.

Thomas Eakins' uncompromising realism was based on careful observation of human anatomy but often repelled art patrons. Note how the light falls across the doctor's forehead to the patient's exposed thigh, where attendants with bloody hands hold open an incision. Compare the emotional responses of Dr. Gross, the note-taking scribe, and the female relative of the patient (left, middle ground).

physician's attendants hold open the bloody incision in the patient's thigh, while he impassively lectures his medical student audience. Eakins's choice of subject and theatrical use of light were influenced by Rembrandt's famous *Anatomy Lesson of Dr. Tulp* (see Fig. 10.35).

The Realist Novel

While the romantic sensibility was most intensely expressed through lyric poetry, the description of industrial society was best accomplished in the social novel, which became the dominant literary form of the later nineteenth century.

Of the many novelists who flourished in this age, the English novelist Charles Dickens (1812–1870) was perhaps the most outspoken in his protests against the injustices of industrialism. His novels portrayed the social evils of nineteenth-century England, particularly its cruelty to children. Dickens knew this cruelty from experience – his father was often in debtors' prison and he himself was working in a factory by the age of twelve. Young Dickens educated himself, becoming a lawyer's assistant and later a parliamentary reporter. By the age of twenty-four, he was a literary success and was soon serializing his novels in his own weekly publications. He later fictionalized his rise from poverty to literary

CRITICAL QUESTION

What radical ideas appeal to the poor and oppressed peoples of today's world? From what political, religious, or ethnic traditions are these radical ideas drawn?

prominence in the novel *David Copperfield* (1849–50). His other novels also drew from his experience as a child and young adult – for example, *Bleak House* (1852), a bitter portrait of the English legal system.

Dickens's ability to draw memorable characters and to fill his novels with unlikely coincidences and sentimentality made his books immensely popular. They too were a product of industrialism, appearing in installments beside advertisements for new products. The novels often appealed directly for industrial and social reform. Dickens's anger from his early life of poverty never cooled. His works pointedly compared the miseries of industrial society with the complacent life of the wealthy.

The French novelist Gustave Flaubert (1821–1880) was in many ways the opposite of Dickens. Where Dickens suffered an impoverished London childhood, Flaubert [floh-BAIR] grew up in a comfortably middle-class French provincial family. Where Dickens wrote quickly, sometimes only days ahead of publication, Flaubert spent hours searching for *le mot juste*, the most appropriate word. Flaubert's best-known work was *Madame Bovary* (1865), the story of a naive provincial woman overwhelmed by the sophistication of the modern world. Emma Bovary's idealized view of life and sentimentality lead her to adultery, debt, and finally suicide. The novel's plot scandalized the French public and Flaubert stood trial for obscenity after its publication. Flaubert's most complex novel, *L'Education sentimentale* (*The Sentimental Education*, 1869), was his cynical reflection on French political events in the revolutionary period of the 1840s. The novel deals with themes of illusion and disillusionment, romantic hope and cynical realism, lofty principle and mean-spirited hypocrisy. The novel's hero, the young provincial Frédéric Moreau, is so absorbed in his own sentimental conceits that he fritters away opportunities for success, while history swirls around him. In the novel's account of the 1848 Paris uprising, Flaubert bitterly portrays the cruelty of the French National Guard, which in February had supported a liberal revolt, but in June turned against the republic's supporters. To Flaubert, the

1848	Revolutionary uprisings throughout Europe
1848	Marx, *Communist Manifesto*
1853–5	Bonheur, *The Horse Fair* (**13.7**)
1869	Flaubert, *The Sentimental Education*

different factions had achieved an ironic equality – "an equality of brutish beasts, a common level of bloodstained savagery." The disillusioned narrator of *The Sentimental Education* concludes, "For the fanaticism of the rich was as great as the frenzy of the poor, the aristocracy was as prey to the same madness as the rabble, and the cotton nightcap proved as hideous as the revolutionary bonnet. The mind of the nation was unbalanced, as it is after great natural upheavals."[2] Utopian dreams had dissolved into a counter-revolutionary nightmare.

The Modern City

The modern city was the scene of the triumphs and traumas of the industrial age. It was in the modern city, for example, that the romantic American poet Walt Whitman (1819–1892) experienced the unity of being in all its vibrant and vulgar diversity. Where earlier romantics had contemplated nature in solitude, Whitman roamed the raucous streets of New York City, celebrating his own sense of being alive amidst Manhattan's teeming life. In his poem *Leaves of Grass* (1855), an enthusiastic

13.10 Henri Labrouste, Reading room of the Bibliothèque Nationale, Paris, 1854–75.

The use of slender iron arches and glass skylights lends Labrouste's interiors a graceful airiness that compares favorably to ancient Roman baths or Gothic-style churches. Note the recurring geometric pattern of circles, arcs, and rectangles.

hymn to modernity and American-style democracy, Whitman wrote:

I celebrate myself,
And what I assume you shall assume,
For every atom belonging to me as good as belongs to you...
Walt Whitman, a kosmos, of Manhattan the son,
Turbulent, fleshy, sensual, eating, drinking and breeding,
No sentimentalist, no stander above men and women or
 apart from them,
No more modest than immodest. ... [3]

In architectural terms, the mid-nineteenth century Western city was a mishmash of architectural styles. Neoclassicism contended with Gothic and Renaissance revivals as the proper style for new urban buildings. The only genuinely new style in architecture was based on a

1851	Paxton, Crystal Palace, London (13.3)
1854–75	Labrouste, National Library, Paris (13.10)
1859	Darwin publishes *Origin of Species*
1887–9	Eiffel Tower, Paris (13.11)

13.11 Gustave Eiffel, Eiffel Tower, Paris, 1887–9. Cast and wrought iron, height **984 ft (299.9 m)**.
Except for the decorative arches connecting the legs, the tower is the pure expression of engineering in metal. It echoes the technical virtuosity of such engineering achievements as the Brooklyn Bridge, New York, begun in 1868.

new material, the combination of iron and glass in building. Not since the ancient Romans introduced concrete had a building material so revolutionized construction. During the nineteenth century, iron-and-glass construction was mostly used to enclose large, open spaces – railway stations, shopping arcades, or exhibition halls like Paxton's Crystal Palace.

The aesthetic possibilities of iron construction were mastered by Henri Labrouste (1801–1875) in his Bibliothèque Nationale (National Library) in Paris (1854–1875). Labrouste showed iron's flexibility in handling different spaces. The library stacks rise to five levels on iron girders, while the reading room has the flavor of a Romanesque monastery (Fig. **13.10**). Its terracotta vaulting and glass-covered oculi are outlined by iron and supported on graceful iron columns. The most ambitious iron structure of the industrial age was the Eiffel Tower (Fig. **13.11**), the controversial landmark of the 1889 World

Exhibition in Paris. Like Paxton's Crystal Palace, the cast-iron tower designed by Gustave Eiffel (1832–1923) was more a feat of engineering than architecture. It soared to a height of 984 feet (c. 300 m), an obelisk in pure metal that far surpassed Napoleon's imperial monuments.

The industrial age actually saw greater advancements in urban planning than architecture. Early modern architects and city planners had been called upon to build entire cities from scratch, such as the United States capital, Washington, D.C., and St. Petersburg in Russia, each built on a vacant site. To build a fine modern city in a vacant swamp was one thing; it was quite another to transform an ancient city, with its cramped streets and dingy quarters, into a plan of grand boulevards and spacious parks. This greater challenge – to modernize

the city of Paris – was taken up by Baron Georges-Eugène Haussmann [(h)OHSS-mahn] (1809–1891), inventor of the modern city. Haussmann was appointed by Emperor Napoleon III (Bonaparte's nephew), who wanted an opulent imperial capital and an efficient center of modern commerce and industry. The emperor also wanted a seat of government secure from the French capital's habitual political uprisings.

13.12 (opposite) Claude Monet, *Boulevard des Capucines, Paris*, 1873. Oil on canvas, 31³/₄ × 23¹/₂ ins (81 × 58 cm). The Nelson-Atkins Museum of Art, Kansas City, Missouri, purchase: the Kenneth A. and Helen F. Spencer Foundation Acquisition Fund F72–35.
This impressionist view of a modern Parisian boulevard captures the bustle and excitement of nineteenth-century urban life. The painting's lack of explicit composition or a unified center of interest shows the influence of photography. In fact, Monet painted this scene from the balcony of the pioneering photographer Nadar.

13.13 (right) Louis H. Sullivan, Wainwright Building, St. Louis, Missouri, 1890–1. Missouri Historical Society
Sullivan's skyscraper style – clean, modern, without historicist decoration – originated in Chicago and spread quickly to other American cities.

To build the straight new boulevards, Haussmann plowed through traditional neighborhoods, demolishing some 12,000 buildings, including many homes of the poor and working classes. He lined his boulevards with uniform, fashionable apartment buildings and punctuated his streets with broad plazas, where Parisians could stroll and play (Fig. **13.12**). In all, Paris gained some 95 miles (150 km) of new streets and a feeling of spaciousness and regularity. Not surprisingly, Haussmann's Paris was best suited to the city's affluent middle class, who enjoyed fashionable housing, parks for their leisure, and a chance to profit in Haussmann's complicated financial schemes.

One important architectural style rose out of the North American heartland in the 1880s. When Chicago's urban center of iron-frame buildings was destroyed by fire in 1871, Chicago architect Louis Sullivan (1856–1924) responded by designing the modern skyscraper – a building of several stories constructed of a fire-resistant interior steel frame. The invention of the mechanical elevator made possible the height of Sullivan's Chicago-style skyscraper, such as the Wainwright Building in St. Louis (Fig. **13.13**). The skyscraper's steel-cage frame was usually clad in a windowed stone or ceramic façade that expressed the underlying rectilinear structure. In the aesthetics of the tall building, Sullivan said famously, "Form ever follows function." But he also softened the sometimes harsh rigidity of his designs with floral decoration in cast iron, borrowing from the highly decorative style called Art Nouveau (see page 365). Sullivan's buildings were "commercial palaces," grand settings for the consumption of goods and pursuit of wealth. By 1910, Chicago-style skyscrapers lined entire blocks of New York's commercial avenues.

Music and Modernity

Explain Wagner's concept of the "total work of art" as it was realized in his operas.

The centerpiece of Baron Haussmann's modern Paris was the opulent Opéra (completed in 1875). In this luxurious building, fashionable Parisians could enjoy the age's most spectacular musical art. Given opera's popularity at the time, it is not surprising that the industrial age should spawn two geniuses of the art. Giuseppe Verdi [VAIR-dee] was the idol of Italy's opera-loving public, hailed like today's popular-music and sports stars. Richard Wagner [VAHG-ner] envisioned himself as musical high priest of the German nation and his operas as a mythic ritual.

Verdi's Operas

Giuseppe Verdi (1813–1901) rose from humble beginnings to become the national hero of Italian opera. Born to a family of small landowners, he learned music helping play the town organ. His career reached a climax in 1851–1853, with the success of three operatic masterpieces: *Rigoletto*, *Il Trovatore*, and *La Traviata*. All three had stories touched by tragedy, and featured dramatic songs of luscious beauty. In *Rigoletto,* a philandering duke takes advantage of Gilda, the sheltered daughter of his court jester. In Act III, he sings the famous aria *La donna è mobile* ("Women are fickle") to rationalize his sexual license. Ironically, although the duke sings, "Women are changing forever, constant (ah!) never," it is Gilda's true love and sacrifice at the opera's climax that saves his life. At the height of his fame, Verdi retired to the life of a gentleman farmer, but the world still sought him out. Egypt's ruler commissioned an opera to mark the opening of the Suez Canal, one of the age's great engineering feats. The result, *Aïda* [eye-EE-duh] (1871), was staged in Egypt with a cast of 300, a production so bombastic that even Verdi was disgusted.

Though his operas excelled in lyric beauty and dramatic effect, Verdi had not been a great technical innovator. Late in his career, however, he was spurred by two challenges: the musical ideas of his contemporary Richard Wagner, and the chance to set Shakespeare to music. In his last operas, Verdi proved able to match Shakespeare's breadth of action and depth of character. In *Otello* (1887), he dramatized the tragedy of the Moorish general Othello, who is incited to murder his bride by the evil Iago. In *Falstaff* (1893), Verdi captured the comic vigor of Shakespeare's lusty braggart from *Henry IV*.

Musically, Verdi's Shakespearean operas followed Wagner's lead, advancing beyond the standard opera form of aria alternating with recitative. Verdi experimented with "accompanied recitative," which instead of stopping for a song kept the plot moving forward. The orchestral accompaniment mirrored the characters' moods and emphasized the action, much as today's film soundtracks. Verdi's scenes of intense emotion were such a rousing success that when *Otello* premiered at the famous opera house La Scala in Milan, the aging composer had to answer twenty curtain calls. Afterwards, admirers pulled his carriage through the streets in triumph.

Musical scholars still debate whether Verdi was influenced by Wagner's more systematic innovations. Verdi himself refused to be cast as Wagner's rival. He attributed their differences to the differing musical sensibilities of Germany and Italy. He once said to a German conductor: "Everyone ought to keep the characteristics inherent in

their nation. Well for you, who are still sons of Bach! And we? We too, sons of Palestrina."

Wagner's Musical Revolution

Compared with the humble Verdi, Richard Wagner (1813–1883) was a flamboyant artistic egoist whose life had enough passion and betrayal, triumph and failure, to be an opera itself. He blamed his initial musical failures on opera's commercialism and finally convinced a mad Bavarian king to finance his operas at the lavish Festspielhaus (Festival House) at Bayreuth (Fig. **13.14**). Throughout his career, he engaged in titanic love affairs with the wives of patrons and musical colleagues. Late in life, the composer used to receive his fanatical disciples at Bayreuth [BEYE-roit] while dressed in velvet cap and satin gown.

Wagner's musical ideas exceeded even the extravagance of his life. Wagner envisioned opera as the synthesis of all the arts – myth, music, poetry, drama, and pictorial design. He called this concept the *Gesamtkunstwerk* [ghe-SAHMT-koonst-vairk] (the "total work of art") and compared it to the classical tragedy in ancient Greece. To achieve this all-embracing experience, Wagner believed that he had to control everything about his operas: the text, music, design, and production. For his stories, Wagner rejected the trivial plots of conventional opera and turned instead to Germanic myth and legend, vowing that myth "is true for all time; and its content, no matter how terse or compact, is inexhaustible for every age."[4]

Wagner's Musical Innovations All his mature operas demonstrate the basic elements of Wagner's musical revolution:

- the primary importance of the orchestra over singing;
- the *Leitmotif* as unifying element;
- chromatic, or "colored," harmonies.

13.14 Bayreuth Festspielhaus, Bavaria, Germany, 1876.
Wagner's entire *Der Ring des Nibelungen* (*The Ring of the Nibelung*) was first performed in 1876 at this special festival playhouse in southern Germany. Designed to Wagner's specifications, the playhouse allowed audiences to stroll through the grounds and refresh themselves between acts of sometimes five-hour performances. Not everyone was enchanted; the French composer Debussy once exclaimed, "My God! How unbearable these people in skins and helmets become by the fourth night."

Modernity

Baron Haussmann's urban renewal was guided by the spirit of **modernity**, the process by which the new, the up-to-date, and the contemporary replace the outmoded and traditional. In the nineteenth century, modernity swept away the antiquated remnants of traditional existence, what Marx called "the dead weight of the years," and in its place installed the standardized products and routines of modern life. The cities of Paris, Berlin, New York, and Chicago were dynamic metaphors of modernity, with their vibrant industry and busy avenues. Economic modernity usually involved replacing human or animal labor with machines, or inefficient machines with more efficient ones. For example, horse-drawn street cars were replaced by electric cars, and antiquated iron foundries by new open-hearth furnaces. The advance of modernity in the late nineteenth century accomplished a "second industrial revolution," in which first-generation machinery was replaced with more efficient

In Wagner's theory, the orchestra should be the master of the dramatic action, not a mere accompaniment to the singing. The orchestra was able to reflect every feeling and action through his use of the *Leitmotif* ("leading motive"). A *Leitmotif* [LITE-moh-teef] was a distinct melody or melodic fragment associated with a character, object, or idea; when any element appeared in the drama, its *Leitmotif* appeared in the orchestral music. Wagner intertwined his motives in complex developments, so that the motives evolve with the opera's action. The climactic *Liebestod* [LEE-buss-toht], or Love-Death, of Wagner's opera *Tristan and Isolde* (1865) is built from two

improvements. Even today, "modernizing" an industrial plant or office usually means installing new machinery and uprooting workers from old places or habits.

The critics of modernity ranged from the sentimental to the visionary. To some, modernity was an assault on the human spirit. The French poet Charles Baudelaire (see page 365) reflected on Haussmann's changes to Paris, saying that "old neighborhoods turn to allegory, and memories weigh more than stone." The Russian novelist Fyodor Dostoyevsky (see page 379) was perhaps the most impassioned critic of modernity. He symbolized all of modernity's promises in the "tower of Babel," an emblem of human vanity and self-destruction. In Dostoyevsky's view, modernity would lead ultimately to a cannibalistic mass society (Fig. **13.15**).

The conflict between modernity and tradition is not yet resolved. Today, voices still defend traditional family life or education from modernity's negative effects. Nations hold fiercely to their religious or cultural traditions, while accommodating themselves to a constantly modernizing world. Faced with modernity's ceaseless changes, people still wonder about the human heart.

13.15 (opposite) Henri de Toulouse-Lautrec, *At the Moulin Rouge*, 1892–5. Oil on canvas, 4 ft $^1/_2$ in x 4 ft $7^3/_8$ ins (1.23 x 1.41 m). The Art Institute of Chicago, Helen Birch Bartlett Memorial Collection, 1928.610.
The garish faces and heated atmosphere in this cabaret scene imply a spiritual alienation peculiar to modern city life. How does the framing of the singer at right and the table at lower left contribute to the claustrophobia of the scene and its central group?

motives, "yearning" and "love-death." These are unified in a third motive ("transcendental bliss") whose last chords represent the lovers' blissful union in death.

Wagner's third musical innovation is more technical. He increasingly used all twelve of the tones in a scale (in a C major scale, the black keys as well as the white keys on the piano). This is called the **chromatic** scale (from *chroma*, meaning "coloring"). Wagner's use of chromaticism, or tonal color, tended to dissolve traditional tonality and lend his music its restless emotionalism.

Wagner's musical innovations culminated in his gigantic four-opera masterpiece titled *Der Ring des Nibelungen* (*The Ring of the Nibelung*, 1876). The *Ring* tells how the Nordic gods' own desires ultimately corrupt and destroy them. Wagner's story takes some sixteen hours in performance to tell, and it contains some of opera's most famous moments. At the opening of *Das Rheingold* (*The Rhine Gold*), the dwarf Alberich chases the teasing river maidens and then snatches the gold that will doom the gods (Fig. **13.16**). In *Siegfried*, the hero tastes the blood of the slain dragon and hears the song of nature. The loping music of the "Ride of the Valkyries" from *Die Walküre* (*The Valkyrie*) has become associated with

13.16 Arthur Rackham, illustration to *Das Rheingold* (*The Rhine Gold*), 1910.
Wagner enjoyed a great vogue among symbolist poets and artists at the turn of the century. Here the illustrator Arthur Rackham imagines the heated grasping of Alberich (the Nibelung of the cycle's title) at the elusive Rhine maidens; the dwarf's frustration leads him to renounce love altogether and seize the Rhine Gold.

doom. In the finale of *Götterdämmerung* [guh(r)-ter-DEMM-er-oonk] (*Twilight of the Gods*), the heroine Brünnhilde rides onto her own funeral pyre, while the palace Valhalla collapses in flames. But no list of high-lights can do justice to the musical complexity of Wagner's masterpiece or its impact on his own and future generations.

Late Romantic Music and Dance

Where Wagner's music was relentlessly innovative, his principal German rival, the late romantic composer Johannes Brahms (1833–1897), looked back to the Classical era. Of the titanic Beethoven, Brahms once wrote, "You will never know how the likes of us feel when we hear the tramp of a giant like him behind us." Despite his reservations, Brahms's four symphonies come closer than any others to matching the scope and sophisticated design of Beethoven. Brahms rejected romantic-style program music and all his symphonies (composed between 1876 and 1885) possess the weighty structure and inspired variations that he admired in his Classical predecessors. Brahms represents the last great composer of "absolute" music in the tradition of Mozart and Beethoven.

Another development of late romantic music was the rise of musical nationalism, especially among composers from Eastern Europe. The *1812 Overture* by the Russian Peter Tchaikovsky [tcheye-KOFF-skee] (1840–1893) and *The Moldau* by the Czech Bedrich Smetana [SMET-tun-uh] (1824–1884) celebrated the valor of the two composers' peoples and the beauty of their homelands. The musical nationalists typically incorporated native folk music and programmatic musical descriptions into their compositions.

Tchaikovsky composed some of his greatest music for the style of ballet that blossomed in czarist Russia under the creative genius Marius Petipa (1818–1910). As director of the Russian Imperial Ballet in St. Petersburg,

LATER NINETEENTH-CENTURY MUSIC

Giuseppe Verdi	Italian	*Rigoletto* (1851) *La Traviata* (1853); *Aïda* (1871); *Otello* (1887); *Falstaff* (1893)
Richard Wagner	German	*Tristan and Isolde* (1865); *Ring of the Nibelung* (1876); *Parsifal* (1882)
Johannes Brahms	German	*Symphony #4* (1885)
Claude Debussy	French	*Prélude à "L'après-midi d'un faune"* (1894)

Petipa invented a grand style that became so widely popular that it is now referred to as the **classical ballet** – the repertoire of works and style of dancing still performed and taught in the contemporary world. In *Swan Lake* (1877) and *The Sleeping Beauty* (1890), both composed by Tchaikovsky, Petipa perfected the full-length ballet as spectacle. He used the *corps de ballet* (the large company of dancers) in majestic formation and choreographed showpiece duets for his company's leading ballerinas and danseurs. Petipa's influence helped make nineteenth-century Russia an international center of ballet performance and training.

Late Romantics and Early Moderns

Explain why the symbolists and like-minded artists rejected the artistic tastes of middle-class society.

Richard Wagner's explorations of inner experience found a deep sympathy among artists in the late nineteenth century. On first glance, these artists appear to be latter-day romantics because of their praise for artistic genius and fascination with evil and the exotic. They also rejected crass materialism and the superficial entertainments preferred by the middle classes. Yet, in withdrawing from modern industrial society, these last romantics anticipated the artistic techniques that defined the artistic modernism of the twentieth century. These included:

- in poetry, the dense and enigmatic works of the symbolists;
- in the visual arts, the decorative plant motifs of Art Nouveau;
- in music, the dreamy compositions of Debussy;
- in sculpture, the rugged figures of Rodin.

In their reaction against Western industrial society, the late romantics foreshadowed the coming modern revolution.

Symbolism and Art Nouveau

The French symbolist poets were a literary group known for their dream-like and deeply symbolic poetic works. The symbolists created a poetic language of rich ambiguities that expressed their intuitive insights and fascination with language. At the same time, they emphatically rejected the moral hypocrisy and greedy materialism of modern civilization. The later symbolists withdrew into a world of mysticism and decadence, mocking the banality of middle-class existence.

The symbolists' acknowledged inspiration was the poet Charles Baudelaire [boh-de-LAIR] (1821–1867), whose poetry explored the sensational connections between the sordid and the sublime. Baudelaire's collection *Les Fleurs du Mal* (*The Flowers of Evil*, 1857) was so frankly erotic that Baudelaire was prosecuted on morals charges after its publication. Many Baudelaire poems were morbid in their self-analysis and grotesque imagery. In the prologue to *Les Fleurs du Mal*, entitled "To the Reader," Baudelaire draws the reader into the poet's satanic world of violence and oblivion.

> Like a poor profligate who sucks and bites
> the withered breast of some well-seasoned trull,
> we snatch in passing at clandestine joys
> and squeeze the oldest orange harder yet.

> Wriggling in our brains like a million worms,
> a demon demos holds its revels there,
> and when we breathe, the Lethe[a] in our lungs
> trickles sighing on its secret course.

> If rape and arson, poison and the knife
> have not yet stitched their ludicrous designs
> on to the banal buckram[b] of our fates,
> it is because our souls lack enterprise!

> But here among the scorpions and the hounds,
> the jackals, apes and vultures, snakes and wolves,
> monsters that howl and growl and squeal and crawl,
> in all the squalid zoo of vices, one

> is even uglier and fouler than the rest,
> although the least flamboyant of the lot;
> this beast would gladly undermine the earth
> and swallow all creation in a yawn;

> I speak of Boredom which with ready tears
> dreams of hangings as it puffs its pipe.
> Reader, you know this squeamish monster well,
> – hypocrite reader, – my alias, – my twin![6]

CHARLES BAUDELAIRE
From Les Fleurs du Mal (1857)

a. Lethe, the mythic river of forgetfulness; Baudelaire may refer to opium smoking.
b. buckram, a stiff cloth used to line clothing.

Baudelaire became an icon for the symbolist group but where he had praised the busy boulevards and fashions of modern Paris, the symbolists flatly rejected the values of industrial mass society. They saw themselves as an artistic elite, aloof from the petty lives of the middle class. The leading poet of the symbolists, Stéphane Mallarmé [MALL-ar-may] (1842–1898), said, "Let the masses read works on morality, but for heaven's sake do not give them our poetry to spoil." The symbolists' philosophy also included the principle of *l'art pour l'art* or "art for art's sake," – a slogan coined by the English writer Walter Pater in 1868 – which placed art in a parallel universe to the real world, governed by its own special rules and methods. The symbolist poets polished their works like jewels of language, full of secret symbols and cryptic phrases. Though the doctrine of *l'art pour l'art* was rooted in romantic ideas of artistic genius, it was later sustained by twentieth-century artists who escaped from mass society into a separate universe of art.

Symbolism's reaction against industrialism was shared by **Art Nouveau** [arr noo-VOH], a style of decorative art and architecture that used floral motifs and stressed the organic unity of artistic materials and form. Art Nouveau's love for sinuous, vegetal forms can be seen in

the illustrations of Aubrey Beardsley, which often achieved a sinister combination of eroticism and evil. A favorite Art Nouveau medium was colored glass: the workshops of American Louis Tiffany, for example, produced popular glassware, lamps, and furniture in floral design (Fig. **13.17**).

In architecture, Art Nouveau was largely a decorative style applied to the surface of otherwise conventional buildings. The style's originator, Belgian Victor Horta (1861–1947), typically employed Art Nouveau motifs in wrought iron details, wall decoration, and floor tiles. The one architect who integrated Art Nouveau principles into a building's form was the Catalan Antonio Gaudí y Cornet (1852–1926). The walls of Gaudí's [gow-DEE] Casa Milá apartment building in Barcelona (Fig. **13.18**) undulate like the gently rocking ocean waves. The wrought-iron balcony railings writhe like seaweed or sea creatures. Gaudí's buildings were the most ambitious example of Art Nouveau's attempt to unify the work of art in one organic piece. Whatever it was called – in Spain *Modernismo*, in Germany *Jugendstil*, in Vienna the *Sezession* – Art Nouveau reached back to romantic organicism while pushing forward to modernity.

In Vienna, capital of the Austro-Hungarian empire, Art Nouveau became the vehicle of protest against a stuffy cultural establishment. In 1898, a group of artists declared that they would "secede" from Vienna's official institutions and sponsor their own independent exhibitions. The most important painter of this Vienna "Secession" was Gustav Klimt, who presented erotic subjects in an intensely decorative style. In Klimt's *The Kiss* (1907–1908), for example, the vivid garments and jewelry seem to envelop the lovers in a cloak of erotic energy, while also shielding their passion from the viewer (Fig. **13.19**). At the high point of the Vienna Secession in 1900, the emperor himself dedicated a new pavilion topped by a gilded floral globe – nicknamed "the golden cabbage." Klimt contributed a scandalous allegorical mural titled the *Beethoven Frieze*, in which the "hostile powers" of the cosmos are represented by a giant ape and a pregnant nude. Though their works were not as technically daring as those of the later modernists, the Secessionists helped to break the power of official institutions and acclimate the public to the spare and abstract style of modernism.

Debussy and Rodin – The Break with Tradition

In music and sculpture, two Frenchmen – Claude Debussy and Auguste Rodin – typified this period's break with longstanding European traditions. Though he disdained the musical pretensions of Richard Wagner, the French composer Claude Debussy (1862–1918) followed Wagner in exploring new harmonic relationships and exotic tone colors. Debussy [deh-BYOO-see] was affected by two musical influences: Wagner's operas, heard on a visit to Wagner's Bayreuth playhouse, and the gamelan [GAMM-uh-lan] orchestras of Java (part of today's Indonesia), which toured Paris in the 1880s. The Javanese **gamelan orchestra** consisted of various gongs, chime-bars, and a solo string instrument called the *rebab*, producing a rich blend of tone colors and playing in harmonic modes rather than Western keys. Drawing on these musical influences, Debussy's compositions evoke dream-like moods and suggestive impressions, much like the symbolists' poetic images. Even Debussy's titles – *Clouds, Waves at Play, Reflections on the Water* – suggested poetic reverie.

13.17 Louis Comfort Tiffany, "Jack-in-the-Pulpit" vase, 1915. "Favrile" glass, height 19¹/₂ ins (49.5 cm). The Detroit Institute of Arts.
Louis Comfort Tiffany's workshop artists incorporated "organic" Art Nouveau motifs into their designs for interior furnishings.

13.18 Antonio Gaudí, Casa Milá, Barcelona, 1905–7.
Though Art Nouveau was typically a decorative style employed in building interiors and furnishings, Antonio Gaudí applied its principles across the entire façade of the Casa Milá. The undulating walls cover a conventional steel frame.

Debussy's most famous work was inspired by a Mallarmé poem about a satyr and wood nymphs. The *Prélude à "L'après-midi d'un faune"* (*Prelude to "The Afternoon of a Satyr,"* 1894) was the musical equivalent of an idle erotic daydream. The opening flute sounds a musical theme that dreamily dissolves into another musical idea (Fig. **13.20**). The vagueness derives in part from Debussy's use of a whole-tone scale, the six whole tones of a normal scale without the half-steps. The whole-tone scale sounds unstable to anyone more accustomed to conventional Western major and minor scales, and creates a musical fuzziness akin to the impressionist style of painting.

While discarding conventional harmony, Debussy also rejected the formal structures of the baroque and Classical traditions. In contrast to the forward-moving structures of Brahms, Debussy's compositions were comparatively static, full of languid moods and harmonic nuances. This was music wafting into the twentieth century like a nymph's song.

Where Debussy rejected the rational structure of German music, the French sculptor Auguste Rodin (1840–1917) broke with the heroic style of commemorative public sculpture represented by Auguste Bartholdi's

CRITICAL QUESTION
Do you agree with the symbolists that great art is, by its nature, *unpopular?* Using examples from your experience, discuss the fate of literature, art, and music in a mass society.

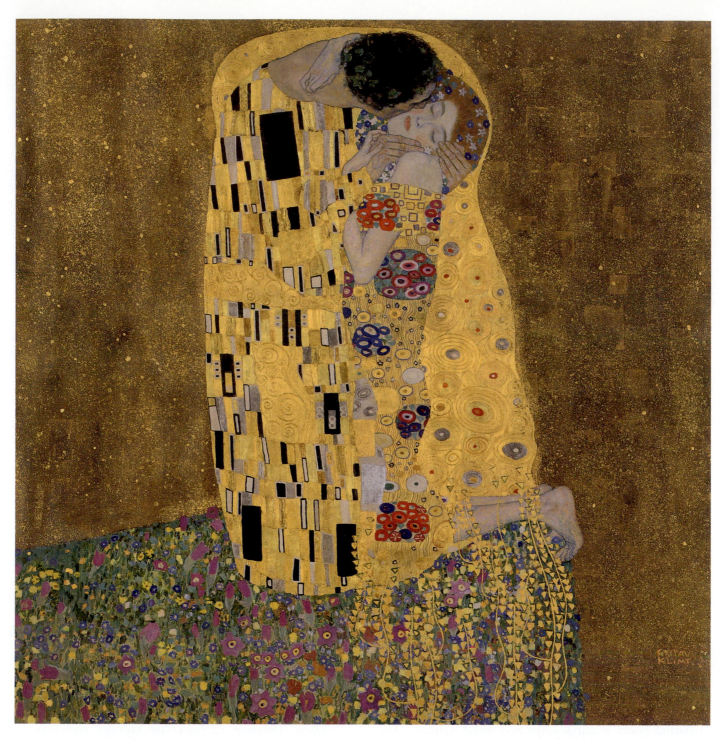

13.19 Gustav Klimt, *The Kiss*, 1907–8. Oil and gold on canvas, 5 ft 10⅞ x 5ft 10⅞ ins (1.8 x 1.8 m). Österreichische Galerie Belvedere, Vienna.

Klimt achieved success as an easel painter after the break-up of the Vienna Secession in 1905. In this painting, note how the contrasting decorative motifs in the two lovers' garments distinguish the identity and form of each while the gilded background merges them in erotic union.

First Theme

p douce et expressif

13.20 Claude Debussy, opening theme of *Prélude à "L'après-midi d'un faune"* (Prelude to "The Afternoon of a Satyr"), 1894.

Statue of Liberty, a gift of the French government to the United States in honor of the American centennial. By exploring a new mode of figural sculpture, Rodin [roh-DAN(h)] established himself as the precursor of modern sculpture but also exposed himself to ridicule and scorn.

13.21 Auguste Rodin, *The Gates of Hell*, begun 1880. Bronze (cast from plaster model), 20 ft 8 ins x 13 ft 1 in (6.3 m x 3.99 m). The Rodin Museum, Philadelphia, Bequest of Jules E. Mastbaum, 1929. Inspired by Dante's *Inferno*, Rodin's masterpiece is a sculptural essay on the tortures of guilt and the vanity of hope. It contained some 186 figures, including the famous *Thinker*, who broods over the tortured products of his imagination. Compare the roiling figures of Rodin's *Gates* to the Renaissance clarity of Ghiberti's *Gates of Paradise* in Florence (Fig 8.11).

In 1877, Rodin was engaged to sculpt a decorative portal for a Paris museum. He conceived his portal as *The Gates of Hell* (Fig. **13.21**), intending to depict the tortured souls of Dante's *Inferno* (see page 179). *The Gates of Hell* soon took on a life of its own, as Rodin worked intensely for eight years, furiously adding and subtracting figures, and generating sculptural ideas that he later turned into separate life-size figures. When *The Gates of Hell* (in plaster model) was exhibited in 1900, the two massive panels seethed with dozens of tortured figures. Above the door lurks the now-familiar form of *The Thinker*, originally conceived as the poet Dante brooding over his creation. Below him are figures seared by the hot pangs of unfulfilled desires.

Rodin's most controversial work was a statue of the French novelist Honoré de Balzac [ball-ZAHK], who had died thirty years before the commission (Fig. **13.22**). To grasp his subject, Rodin had a suit made by Balzac's old

13.22 Auguste Rodin, *Honoré de Balzac*, 1892–7. Plaster, height 9 ft 10 ins (3 m). Musée Rodin, Paris, S163. Even to Rodin's sophisticated patrons, this portrait ventured too far from academic conventions of heroic sculpture. Rodin himself could see the statue's link to the bronze warriors of ancient Greece, but his public could not.

tailor, found some lost photographs, and finally made seven life-size studies in his studio. Atop the striding figure, a massive lion-like head suggested the immense appetites and prolific energy of the great novelist. But Rodin's *Balzac* was rejected by the literary society that had commissioned it and critics condemned the statue as an insult to France. They compared it (with some accuracy) to a heathen god – an effect that Rodin was striving for. The artist insisted that the statue was a "pivot" of his aesthetic. He wrote, "I had forged a link between the great, lost traditions of the past and my own time which

each day will strengthen." With Rodin, as with other late romantics, art was becoming an increasingly private and subjective affair, not to be shared with society at large.

Impressionism

In 1874 a group of younger artists led by the painter Claude Monet (1840–1926) mounted their own exhibition in Paris, certain that their work would never be accepted by the official art world. A derisive critic labeled them "impressionists," after Monet's painting titled *Impression: Sunrise* (Fig. **13.23**). For a decade, this group formed a loose circle and exhibited their work together, shocking the traditional art world with their spontaneity of technique, scientific detachment, and innovations in pictorial design. The group included Monet, Pierre-Auguste Renoir,

13.23 Claude Monet, *Impression: Sunrise*, 1872. Oil on canvas, 19½ x 24½ ins (49.5 x 62 cm). Musée Marmottan, Paris.
In the painting that gave impressionism its name, Monet used broad swatches of grays and orange to suggest the sun's reflection and the ghostly ships at rear. He borrowed the arrangement of rowboats along a receding diagonal perspective from Japanese woodblock prints.

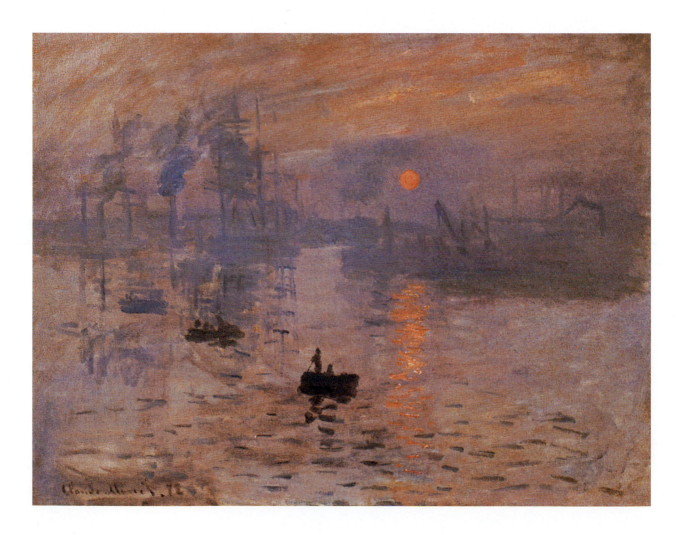

13.24 Berthe Morisot, *View of Paris from the Trocadéro*, 1872. Oil on canvas, 18 x 32 ins (46 x 81 cm). Collection of the Santa Barbara Museum of Art (Gift of Mrs. Hugh N. Kirkland).
In this urban landscape, shown in the 1874 impressionist exhibition, Morisot treats the figures, the carriages, and the Parisian skyline with the same spontaneous and vibrant brushwork. Her painting was condemned as amateurish and unfinished.

Berthe Morisot, Edgar Degas, and the American expatriate Mary Cassatt. They were encouraged by Edouard Manet, the controversial realist who had challenged conventional academic painting (see page 352). Following in Manet's footsteps, the impressionists became the first painters of modernity.

The "pure" impressionist style of Monet, Renoir, and Morisot sought to capture the fleeting effects of light and color with rapid, sketchy brushstrokes (see Fig. 13.23). Pictures like Berthe Morisot's *View of Paris from the Trocadéro* (Fig. **13.24**) discarded the conventional subjects of academic painting and, instead, painted the shifting light of the suburban landscape and the ceaseless motion of the Parisian boulevard. Like other impressionists, Morisot [MOR-ee-soh] painted outside in the "open air," applying colors directly to the canvas without mixing them on the palette. The results were pictures of vibrant, shimmering color that carried no evident moral or intellectual values.

Monet [moh-NAY] in particular painted many versions of the same subject – a cathedral, grain stacks in a field, or his lily pond – hoping to capture each subject as it was altered by changing light. In 1877 Monet applied his method to the St.-Lazare railroad station in Paris (Fig. **13.25**), an urban subject seemingly without picturesque qualities. As rendered in ten different paintings, the scene beneath St.-Lazare's glass roof became for Monet like a Wagnerian musical motif, transforming itself in the different light at different times of day. In his late career,

13.25 Claude Monet, *St.-Lazare Station*, 1877. Oil on canvas, 29 1/2 x 41 ins (75.5 x 104 cm). Musée d'Orsay, Paris.
Here Monet applies his impressionist method to a gritty urban subject. The locomotive nearly obscured by steam, the anonymous figures on the platform, and the apartment building in the background, are all rendered in loose, sketchy brushstrokes.

The Japanese Color Print

The Paris of the impressionists was awash in a great wave of Japanese art, especially the inexpensive color prints called *ukiyo-e* [OO-kee-yoh-AY] – "scenes of the floating world." The "floating world" referred to the pleasure districts of Japan's commercial cities in the Edo period (1616–1868; see page 309). The principal visual art of this milieu was the multi-color (or **polychrome**) woodblock print, usually depicting scenes of everyday life. The early *ukiyo-e* printmakers excelled in portraits of gracious courtesans and actors from the kabuki theater. The master Kitagawa Utamaro (c. 1753–1806) portrayed geisha entertainers with a wistful delicacy that has been compared to the French rococo painter Antoine Watteau. *Ukiyo-e* prints were immensely popular in Japan and also inexpensive, selling usually in series or bound in books.

The polychrome print enjoyed a late flowering in the nineteenth-century works of Katsushika Hokusai [HOHKS-eye] and Ando Hiroshige [hee-ruh-SHEE-gay]. In 1822, Hokusai produced his famous *Thirty-six Views of Mount Fuji*, portraying Japan's famous mountain in various aspects – transformed by rain, set against blossoming trees or a tossing sea (Fig. **13.26**). Hokusai's younger rival, Hiroshige, created a competing series entitled *Fifty-three Stations of the Tokaido*, which depicted life on the busy road from Edo to Kyoto.

The Japanese aesthetic expressed in these prints exercised an immense influence on the impressionist and post-impressionist Europeans. In the prints of Hokusai and Hiroshige, especially, we find the techniques that helped revolutionize European painting: dramatic settings, the tension between foreground and background, high and low points of view, and decorative fields of solid color.

13.26 Katsushika Hokusai, *The Great Wave off Kanazawa*, from the *Thirty-six Views of Mount Fuji*, 1823–9. Polychrome woodblock print, 10 x 14 ins (25.5 x 37.5 cm). Victoria & Albert Museum, London.
In this famous print, Hokusai contrasts the heaving waves against the quiet stability of Mt. Fuji in the background. What statement does this image make about the place of humans in the natural world?

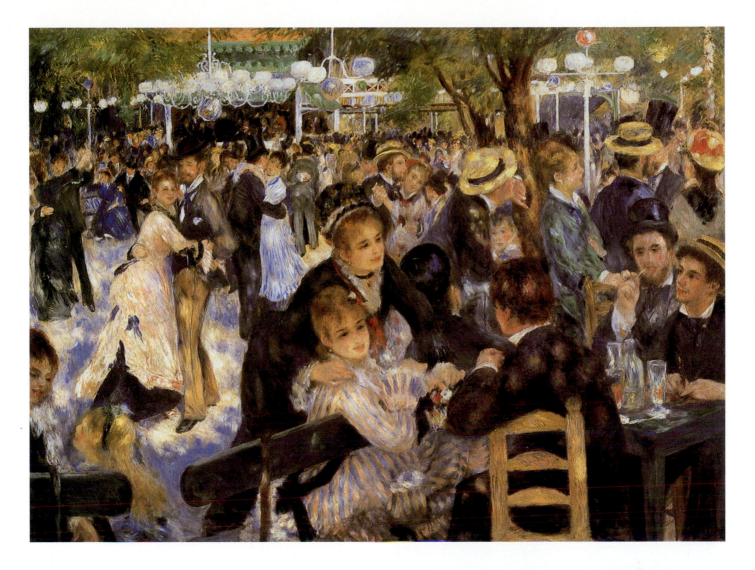

13.27 Pierre-Auguste Renoir, *Le Moulin de la Galette*, 1876. Oil on canvas, 4 ft 3¹/₂ ins × 5 ft 9 ins (1.31 × 1.75 m). Musée d'Orsay, Paris.

In this painting of ordinary city-dwellers at their leisure, Renoir used the full range of impressionist colors, dominated by the yellow of the straw hats and the chairback on the right.

long after the impressionist group had dissolved, Monet painted his most famous series, abstracted views of the lily pond at his provincial home in Giverny.

The impressionist paintings of Pierre-Auguste Renoir (1841–1919) were more lyrical than Monet's, less bound to the empirical facts of perception. Renoir [ren-WAH(r)] captured the informal mood of city life in his café scene *Le Moulin de la Galette* (Fig. **13.27**). In the open-air dance hall, young working women enjoy their day off, dancing rather gracelessly with male companions. Typical of impressionist composition, Renoir has created an accidental pattern of yellow straw hats and a variation in the prints of the women's cheap dresses. The whole scene can be taken as a modern and unpretentious version of the rococo *fête galante* (see Fig. 11.1).

The works of Edgar Degas (1834–1917), socially the most conservative of the impressionists, have an undertone of alienation and spiritual exhaustion. In style and subject, Degas [duh-GAH] was close to the realists. But the arbitrary framing of his subjects made his paintings as disconcerting as Monet's sketchiness. Typically he created off-center compositions, such as *The Dancer in*

Green (Fig. **13.28**), whose figures seem to be anonymous robots of the ballet. The perspective nearly tilts the dancer into our laps, and two other figures appear only as torsos and legs. This painting uses devices that were characteristic of Japanese prints – an off-center composition, with objects placed along a receding diagonal or cut off by the picture's edge. Such techniques gave Degas's colorful scenes a disorientating tension.

Degas was close friends with the American expatriate painter Mary Cassatt (1844–1926), who joined the impressionists and exhibited in their 1879 group exhibition. Like most of the group, Cassatt was influenced by the popularity in Paris of Japanese art. She was especially attracted to the large areas of unbroken color and the flattened perspective of Japanese prints. In *The Boating*

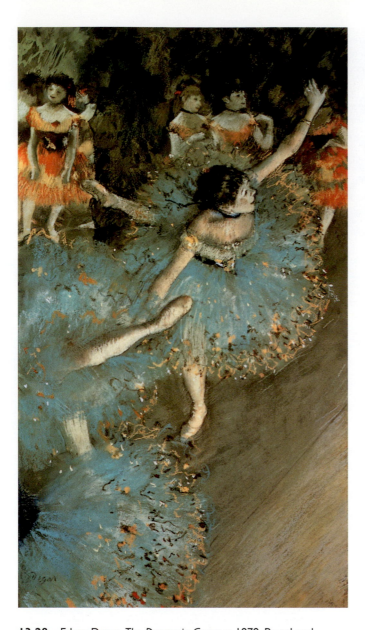

13.28 Edgar Degas, *The Dancer in Green*, c. 1879. Pastel and gouache on paper, 25 × 14 ins (64 × 36 cm). Museo Thyssen-Bornemisza, Madrid. Thyssen-Bornemisza Collection, Lugano.
The composition in Degas's paintings of commonplace subjects is often off-center in a vaguely disturbing way. Here he plots the figures along a sharp diagonal outlined by the central dancer's arms.

Party (Fig. **13.29**), the mother and child in the bow of the boat are framed against a brilliant field of blue water. The boat and sail, together with the rower's dark form, provide contrasts that are interesting in themselves. By the time of this painting (1893–1894), Cassatt was pursuing a path toward greater abstraction. Color and form were gaining an intrinsic value, quite apart from the subject depicted.

Beyond Impressionism

In the 1880s and 90s, several important artists intensified the impressionists' break with tradition. These artists are now termed **post-impressionists** because their works extended impressionist techniques in different directions. The most important post-impressionists are Georges Seurat, Paul Cézanne, Paul Gauguin, and Vincent van Gogh. Each represented a step, in form or style, away from impressionism toward modernist painting.

Of the post-impressionists, Georges Seurat [surr-AHH] (1859–1891) was the closest in technique to Monet's pure impressionism, depicting scenes of urban life and applying unmixed colors directly to the canvas. However, Seurat reacted against the improvisation and informality of the impressionist style. Where Monet had dashed his brush across the canvas, Seurat applied paint in tiny, meticulous dots, a method he called **pointillism**. With his pointillist technique, Seurat claimed he could scientifically control the mood of a painting.

Seurat's most famous picture, *Sunday Afternoon on the Island of La Grande Jatte* (Fig. **13.30**), illustrates the complex formality of the pointillist style. The subject, a typical scene of Parisian modernity, shows Sunday afternoon strollers on an island park. Had an impressionist painted this scene, we might have expected the casual manner of Renoir's *Le Moulin de la Galette* (see Fig. 13.27). Instead, Seurat creates a subtle pattern of parallel lines and interlocking shapes. The pattern is created in the repeated shapes of the umbrellas, the ladies' bustles and bodices, and the gentlemen's hats and canes. Each figure is treated with scientific dispassion and precision, flattened and contained by Seurat's formulas.

Under the same influences, many have said Paul Cézanne (1839–1906) made a great new beginning – the beginning of modernist art. Cézanne [say-ZAHN] wanted to "make of impressionism something solid and durable like the art of the museums." That is, he wanted to find in impressionist subjects the enduring forms of nature that were the basis of traditional art. Like his impressionist contemporaries, Cézanne painted directly from nature in brilliant colors, especially greens, blues, and yellows. But more than transient effects of light and color, Cézanne studied the permanent structure of natural forms. He once advised a young painter to "treat nature through the cylinder, the sphere, the cone."

Cézanne's style as a painter matured when he abandoned Paris in the 1880s and returned to his native southern France. There he frequently painted outdoors in the warm Mediterranean light, striving to capture nature's immediacy while also exploring its essence. Dozens of times he painted Mont Sainte-Victoire, a low peak near his home town (Fig. **13.31**). In Cézanne's paintings, the mountain is an enduringly solid arrangement of masses and planes, a monumental puzzle of nature's forms. While Monet could not paint fast enough to be true to his

13.29 (right) Mary Cassatt,
The Boating Party, 1893–4. Oil on
canvas, 35$\frac{1}{2}$ × 46$\frac{1}{4}$ ins (90 × 117 cm).
National Gallery of Art, Washington,
D.C., Chester Dale Collection.
This is one of many Cassatt paintings
focused on the intimacy between a
mother and child. Note how the rower's
arm and oar form a flattened pyramid
with its apex at the child.

13.30 (below) Georges Seurat, *Sunday
Afternoon on the Island of La Grande Jatte*,
1884–6. Oil on canvas, 6 ft 9$\frac{1}{2}$ ins ×
10 ft $\frac{3}{4}$ ins (2.07 × 3.05 m). Art
Institute of Chicago, Helen Birch
Bartlett Memorial Collection, 1926.224.
Seurat's carefully calculated pointillist
technique resulted in paintings that were
cousins to impressionism, but more
formal and distant. In this famous picture,
does the rhythm of shapes create a
mood of unity and tranquillity among
these city-dwellers enjoying their leisure?
Or is the mood better described as the
anonymity and self-absorption of life in
the modern city?

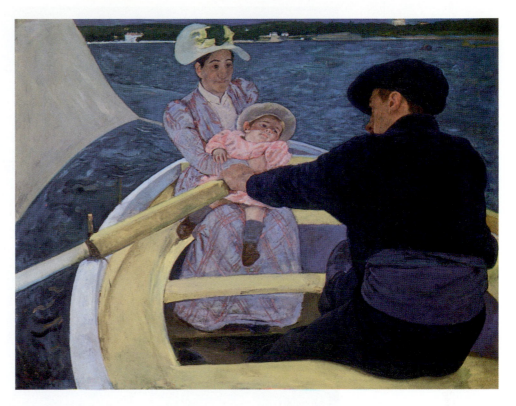

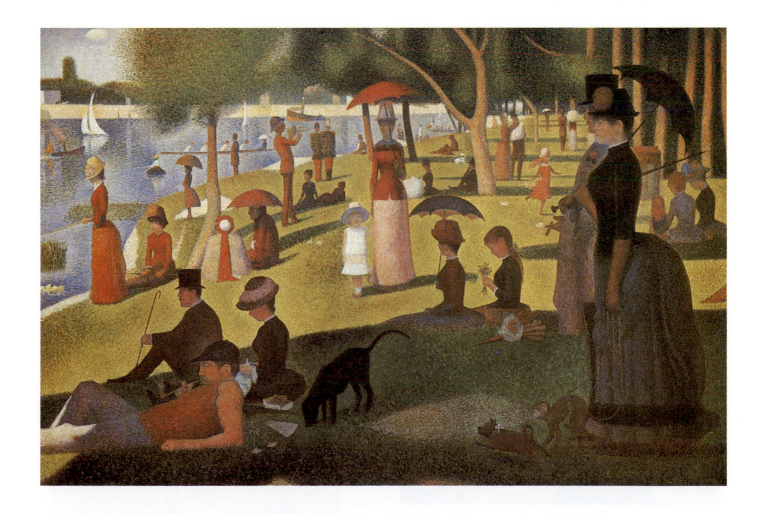

13.31 Paul Cézanne, *Mont Sainte-Victoire from Les Lauves*, 1902–4. Oil on canvas, 27½ × 35¼ ins (70 × 89.5 cm). Philadelphia Museum of Art, George W. Elkins Collection.

Cézanne's paintings of nature are as fresh and immediate as those of the impressionists; yet he also sought the solid, enduring structures beneath the surface of nature. The painter said of the neoclassical painter Nicolas Poussin: "I want to do Poussin over again, after nature."

13.32 (below) Paul Cézanne, *Apples and Oranges*, 1895–1900. Oil on canvas, 29 × 36¾ ins (74 × 93 cm). Musée d'Orsay, Paris. Compare Cézanne's carefully defined shapes and complex composition to the orderliness of Chardin's commonplace scenes (Fig. 11.13).

13.33 (right) Paul Gauguin, *Self-Portrait with Halo*, 1889. Oil on wood, 31³⁄₈ × 20³⁄₈ ins (79.6 × 51.7 cm). National Gallery of Art, Washington, D.C., Chester Dale Collection, 1963.10.150.

The post-impressionist Gauguin shared the symbolists' disaffection with conventional society (see page 365), regarding himself as a misunderstood genius. In a letter to a fellow artist, Gauguin wrote: "What does it matter to me if I'm setting myself apart from the rest, for the masses I'll be an enigma, for a few I'll be a poet, and sooner or later quality finds its true place."

subject, Cézanne let the fruit rot on the plate while he studied his still-life models (Fig. **13.32**).

The impact of Cézanne's vision on other European painters has been compared to Giotto's reinvention of painting in the fourteenth century (see page 183). Giotto's innovations in visual realism set the stage for the Renaissance masters and the 500-year phase of art that followed. In the view of some critics, Cézanne brought that long phase of painting to an end. His works prepared for a new painting of abstraction and formal purity.

Two post-impressionist painters – Paul Gauguin (1848–1903) and Vincent van Gogh (1853–1890) – achieved a more intense visual expressiveness through bold design and intense color. Gauguin (Fig. **13.33**) sought to express the elemental forces of human feeling, to enter through his painting "the mysterious center of thought." Gauguin [go-GAN(h)] was drawn to the primitive beliefs and customs of the French provincial countryside of Brittany, in northwest France. There he found a "wildness and primitiveness" among the peasants and in the landscape. In 1891, he withdrew even further from conventional society, going to live in the South Pacific islands and taking a Polynesian wife. In Polynesia, Gauguin satisfied his love of exoticism and his desire to find the primitive core of human imagination.

Gauguin resembled the romantics in his search for the exotic and picturesque, but his style as a painter was something the romantics could hardly have imagined. He used unnatural colors, heavily drawn boundaries, and flattened shapes to achieve a consciously symbolic visual style. In *The Vision after the Sermon (Jacob Wrestling with the Angel)* (Fig. **13.34**), superstitious Breton peasant women imagine Jacob's struggle with the angel of God

13.34 Paul Gauguin, *The Vision after the Sermon (Jacob Wrestling with the Angel)*, 1888. Oil on canvas, $28^3/_4 \times 36^3/_4$ ins (73 x 92 cm). National Galleries of Scotland, Edinburgh.
Gauguin created an aura of mysticism with his highly decorative visual style. Here he communicates the vision of pious Breton women: the white caps of their folk dress are set off against the field of mystical red color. Note the distortions of scale and perspective and the bold diagonal line of the tree trunk.

(Genesis 32). The picture's sense of unreality derives from the bright field of red and the cow wandering across the boundary – formed by the trunk of a tree – between the women and their vision. As with his later pictures of Tahitian subjects, Gauguin here simplified and stylized shapes and chose colors according to the dictates of his artistic imagination.

The Dutchman Vincent van Gogh (1853–1890) was also drawn to the countryside and peasant life. Instead of Gauguin's rather self-conscious primitivism, however, van Gogh [van GOH] was motivated by a religious sympathy for the peasants' harsh existence. In his realist early pictures, he painted dark and crudely powerful images of the rural poor. When he came to Paris in 1886, Van Gogh was struck by the intoxicating energy of the modern city and the bright hues of impressionist paintings. Color became such an extension of feeling that, as he said of one painting, he could "express the terrible passions of humanity by means of red and green." In Van Gogh's *Starry Night* (Fig. **13.35**), the swirling lines generate a palpable, almost violent energy. The pulsating life of the skies, released in vivid yellows, overwhelms the quiet

innocence of the village and countryside below. Although the work may seem a spontaneous expression of emotion, van Gogh's sketches show the painter's careful plan for the picture's formal elements. He applied the paint thickly, often with a palette knife, creating a bold design that was influenced by his love of Japanese art.

Inevitably, we associate van Gogh's paintings with his unhappy life. Yet, some of his most brilliant, joyous canvases were painted in his last year, before depression finally led him to suicide. In a letter to his art-dealer brother, the dying van Gogh despaired whether the modern world could recognize what he and the post-impressionists had defined as modern art.

13.35 Vincent van Gogh, *Starry Night*, 1889. Oil on canvas, 29 x 36¼ ins (74 x 92 cm). Collection, The Museum of Modern Art, New York, acquired through the Lillie P. Bliss Bequest.
Van Gogh expresses the awesome forces of the cosmos by means of blue and yellow. Trace the swirling lines of the sky across the scene, then down to the tranquil village below, and over to the cypress tree at left. What might this composition say symbolically about the relation of humans to the cosmos?

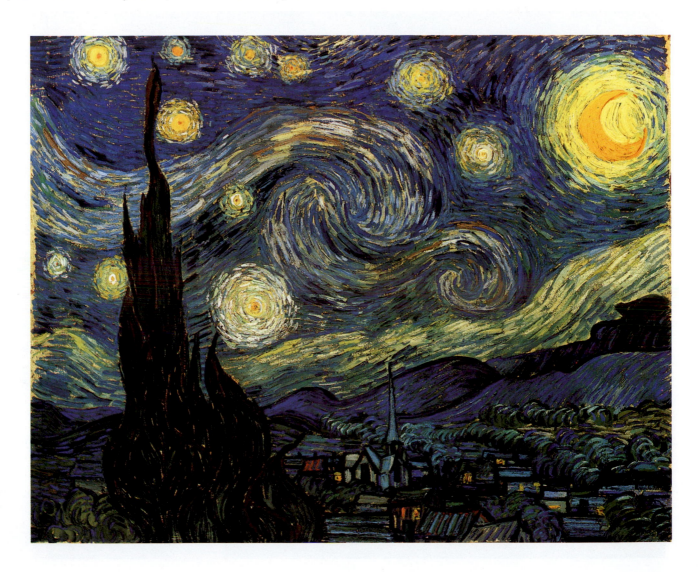

The Dark Side of Progress

Summarize the criticisms made by Ibsen and Dostoyevsky of Western industrial society.

The astounding material progress of the industrial age exacted an awful toll of suffering in mines and factories. While Western nations prospered through global trade and technological inventions, these same forces brought colonial oppression to Asia and Africa. Western civilization's dedication to wealth, science, and progress had unleashed immense powers of change. But some feared that progress had been purchased with spiritual impoverishment.

In the last decades of the nineteenth century, a handful of thinkers explored the darker side of the materialist spirit. The dramatists Chekhov and Ibsen explored beyond the formal limits of realism, into the realms of psychology and symbolism. The novelist Dostoyevsky [doss-stoy-EFF-skee] unraveled the conflicts between belief and doubt, while the philosopher Nietzsche [NEETS-shuh] embraced the egoism of the industrial age, preaching that an elite race of supermen would rule mass society.

The Realist Theater

By 1870, theaters throughout Europe were recovering from a decline suffered during the romantic era. This recovery was based in part on the success of plays in the realist mode. Usually written in prose, Realist plays had plots contrived according to strict rules of plausibility. Such "well-made plays," as they were called, absorbed the audience in a compellingly logical plot. Stage directions and sets were carefully defined, and the use of curtains and electric lighting further enhanced the stage's realism.

In the late nineteenth century, playwrights began to employ realist techniques to delve into human psychology. In Russia, Anton Chekhov (1860–1904) emphasized the complexity of human character in realistic settings. His greatest plays, *The Three Sisters* (1901) and *The Cherry Orchard* (1904), deal with the Russian landowning class in crisis. Chekhov's characters are caught between Russia's slow modernization and their bonds with their aristocratic heritage. Typically, in confronting the changes in Russian society, they prove unable to face the reality that impinges on their idealistic dreams.

Ibsen's *A Doll's House* The Norwegian Henrik Ibsen (1826–1906) also examined the inner conflicts of middle-class society. The topics of his plays were often controversial – venereal disease, marriage, the role of women – but Ibsen was also widely praised for exploring subjects of social and philosophical interest. Among his masterpieces were *The Wild Duck* (1884) and *Hedda Gabler* (1890). Ibsen's psychological insight into character shifted theater away from merely ingenious plots. His use of powerful and ambiguous symbols such as the wild duck explored a symbolic depth in theater that reached beyond realist conventions. His psychological realism probed beneath the appearances of middle-class society. There, he found spiritual emptiness and hypocrisy.

Ibsen's most shocking play was *A Doll's House* (1879), in which the heroine, Nora, has committed forgery to pay for her husband's medical treatment. Nora's husband, Helmer, condemns her deceit, even though the money has saved his life. Nora realizes that she is expected to act like a doll, adorning her husband's household and bearing his children, but taking no decisive actions on her own. In the play's final scene, Nora declares to her patronizing husband her intention to leave him and seek her freedom:

> When you'd recovered from your fright – and you never thought of me, only of yourself – when you had nothing more to fear – you behaved as though none of this had happened. I was your little lark again, your little doll – whom you would have to guard more carefully than ever, because she was so weak and frail. At that moment it suddenly dawned on me that I had been living here for eight years with a stranger and that I'd borne him three children. I can't bear to think about it! I could tear myself to pieces![7]

HENRIK IBSEN
From A Doll's House (1894)

The final scene ends as Nora closes the door of her past life with a decisive reverberation. It was said that the sound of that door echoed across the theaters of Europe.

The Novel and Modern Philosophy

Like the realist theater, the late nineteenth-century novel was increasingly concerned with the inner life of psychologically complex characters. Two examples are the works of the American novelists Henry James (1843–1916) and Edith Wharton (1862–1937), who shifted their stories' focus from external action toward their characters' perceptions and feelings. These writers aimed to reveal subtle shifts in consciousness and ironically complex social situations. James's exquisitely crafted novels were associated with the *l'art pour l'art* movement of the late nineteenth century.

The psychological novels of the Russian Fyodor Dostoyevsky (1821–1881) voiced a profoundly philosophical criticism of modern progress. In his early career, Dostoyevsky championed humanitarian values and utopian socialist schemes, steeped himself in Western philosophy and literature, and voiced his disgust at Russia's backwardness and its repressive czarist regime. He was nearly executed for political activity and then sent to Siberian exile for eight years. In Siberian prisons, he experienced

the moral anarchy and class hatred that would be such a force in his later novels.

Dostoyevsky's prison experience convinced him that only Christian love and the simple faith of the Russian peasantry could redeem Western society, which had been seized by materialism and spiritual alienation. Dostoyevsky's mature works reflect a profound ambivalence between his religious conviction and the rationalist skepticism of modern civilization. He believed that God was necessary, yet could not answer the skeptics' doubts that God even existed. In a letter he wrote, "If someone proved to me that Christ is outside the truth and that *in reality* the truth were outside of Christ, then I should prefer to remain with Christ rather than with the truth."[8] Dostoyevsky's ambivalence infects his literary works; each character's beliefs are "tried in the crucible of doubt," as Dostoyevsky called it.

Dostoyevsky and Nietzsche Dostoyevsky's great novels – including *Crime and Punishment* (1866) and *The Idiot* (1869) – deal with a spiritual crisis in which the characters' moral kindness and generosity inexplicably turn into cruelty and murder. The most complex of his works is *The Brothers Karamazov* (1880), which concerns three brothers, one of whom is accused of murdering their father. Dostoyevsky weaves his characters into

> What is good? – All that heightens the feeling of power, the will to power.
>
> Friedrich Nietzsche

a vast, richly detailed narrative. Despite its realistic tone, *The Brothers Karamazov* achieves an atmosphere of mystery and evil, and explores the moral and psychological alienation of humans in an age of material progress. The characters' faith in redemption is balanced against their moral freedom to commit the most hideous crimes.

At the heart of *The Brothers Karamazov* is the story of the Grand Inquisitor, a "poem" that Ivan recounts to Alyosha. It tells of a fictional second coming, when Christ appears in Spain during the Great Inquisition. Christ is challenged by the Grand Inquisitor, who explains how a priestly elite has "corrected" Christ's message of moral freedom. The elite offer the masses material wealth and mystic rituals, he says, rather than the anguished doubt of freedom. The Inquisitor ominously predicts that society will be misled by the promises of materialism and modernity, and in the end it will submit to an elite, powerful and charismatic, offering security and certainty.

KEY CONCEPT

Human Will

The scientist Charles Darwin was a dedicated naturalist not given to metaphysical speculation. But his evolutionary theories touched on a haunting premise of human civilization that also intrigued philosophers. What if humans were much like animals, motivated by a deep biological urge that intellect and reason could never subdue?

The German philosopher Arthur Schopenhauer (1788–1860) identified this urge – a blind and relentless striving that is rooted in our animal nature – as the **will**. Schopenhauer [SHOH-pen-HOW-er] willingly granted to Kant and the idealists the powers of reason to perceive the world. But, he wrote, "consciousness is the mere surface of our mind, of which, as of the earth, we do not know the inside but only the crust." Beneath the crust of intellect was the blind force of will, which caused humans to love and want in spite of reason, and therefore assured human suffering. In his chief work, *The World As Will and Representation* (1819), Schopenhauer explained that two worlds exist within the human entity: an intellect that seeks to understand everything; and a will that motivates everything, but can never be understood. The will "is the primary and substantial thing; the intellect, on the other hand, is something secondary and

additional, in fact a mere tool in the service of the will."[9]

Schopenhauer's understanding of the will – and indeed, his own brooding nature – led to his famous pessimism. "Life is given us, not to be enjoyed, but to be overcome – to be got over," he wrote in later life. But, more importantly, he challenged the split between mind and body that was an essential premise of both Plato and Descartes. The will and the body were one, and in our will, humans were linked to the vital life of nature.

It took the iconoclastic writings of Friedrich Nietzsche (see opposite) to affirm the will as a creative cultural force. Nietzsche saw morality and tradition as encrusted human weakness and mediocrity. Happiness came in humans' assertion of the "will to power," the will to live without guilt or regret. Nietzsche acknowledged readily (and without regret) that the will to power might be exercised in war and domination. But the same will to power and life also accounted for humanity's greatest acts of creativity. To Schopenhauer's pessimism, Nietzsche's answer was straightforward. "What is good? – All that heightens the feeling of power, the will to power," he wrote in 1888. "What is happiness? – The feeling that power *increases* …"[10]

Oh, ages are yet to come of the confusion of free thought, of their science and cannibalism. For having begun to build their tower of Babel[a] without us, they will end, of course, with cannibalism. But then the beast will crawl to us and lick our feet and spatter them with tears of blood. And we shall sit upon the beast and raise the cup, and on it will be written, "Mystery." But then, and only then, the reign of peace and happiness will come for men. …Oh, we shall persuade them that they will only become free when they renounce their freedom to us and submit to us. And shall we be right or shall we be lying? They will be convinced that we are right, for they will remember the horrors of slavery and confusion to which Thy freedom[b] brought them.[11]

FYODOR DOSTOYEVSKY
From The Brothers Karamazov (1880)

a. For Dostoyevsky, a symbol of materialism and human vanity; see Genesis 11.

b. The "free verdict of the human heart" that Christ offered to his followers.

In defending his Christian belief, Dostoyevsky anticipated the most modern of conditions: mass society governed by an elite who offer them material comforts and the illusion of freedom.

The specter of submissive masses and authoritarian elite took a different shape in the works of the German philosopher Friedrich Nietzsche (1844–1900). Nietzsche rejected both Christianity and democracy, which were based on what he called a "slave morality" of self-denial. He believed that every conception of God, especially Christianity's obsessive concern with guilt and sin, prevented humans from affirming their true power and creativity. "God is dead," a Nietzschean character declared, and so modern society had to recreate its values by discarding Judeo-Christian definitions of "good" and "evil." While rejecting Christian self-denial, Nietzsche also attacked the complacent optimism and materialism of modern society, which would lead humanity to become the blinking dullard that he called "the last man." The hope of humanity lay in reaching "beyond good and evil," as Nietzsche titled one of his writings, and casting off the stultifying bonds of morality and materialism.

Nietzsche expected that only a few humans would be able to free themselves from the deadening constraints of conventional morality. He called these audacious types *Übermenschen* [YOO-ber-mentsh-en] ("over-men" or supermen). The superman was an artist of the self, able to create a personal life and a personal system of values in total freedom. Of such figures, Nietzsche wrote, "They have awoken again and again the sense of comparison, of contradiction, of joy in the new, daring, untried, they have compelled men to set opinion against opinion, model against model."[12] The Nietzschean superman was able to live with the inevitable contradictions of human experience – that the impulses to love and create lie close to the psychic well-springs of hatred and destructiveness, for example. From these contradictions, however, arose the superman's creative powers. Nietzsche imagined the German poet Goethe as such a superman and also himself, portrayed as his philosophical alter-ego in *Thus Spoke Zarathustra* (1892). Critics have also seen the dynamics of Nietzsche's superman in Dostoyevsky's tortured main characters, including Ivan Karamazov and the diabolical hero Stavrogin in *The Possessed* (1871–1872).

Dostoyevsky and Nietzsche both anticipated the psychological theories of Sigmund Freud and the postmodern idea that no absolute truth or morality exists. Both presented ideas and values in contest with each other, with no one position or character providing a perspective of secure and absolute truth. Nietzsche's attacks on conventional religion and morality were a prelude to the broader assault on tradition in science and the arts that set off the twentieth century's modernist revolutions.

THE WRITE IDEA

In your opinion, is human progress best achieved through greater human freedom or less? What would be the likely consequences, both constructive and destructive, of expanding or restricting humans' freedom to make moral decisions?

CHAPTER SUMMARY

Materialism and Progress In the industrial age, Western societies were entering a new age of material production and commodities. In Great Britain, the so-called Victorians – the new urban middle class – witnessed remarkable advances in technology and living standards. The Victorians' belief in material comfort was reflected in the moral philosophy of utilitarianism, which judged every action against the standard of "the greatest good to the greatest number."

The Victorian creed of social progress found confirmation in the evolutionary theories of Charles Darwin, which held that all nature was bound by laws of natural selection. In art, the realist style sought to depict the world without illusion or fantasy. Realist painters portrayed ordinary life with sober detachment; Manet's bold style used realism to challenge the rules of academic painting. Photography further altered the traditional relations of art and reality. In the hands of Dickens and Flaubert, the realist novel mercilessly exposed the injustice and hypocrisy of middle-class society and the sometimes desperate lives of ordinary citizens. Applying advances in urban planning and building construction, modern cities were built from scratch or rebuilt in a grand manner, like Baron Haussmann's Paris. The architect Sullivan built the first steel-cage skyscrapers in American cities. A sense of incessant change and loss of traditions defined the spirit of modernity.

Music and Modernity The industrial age's taste for musical spectacle fostered a golden age in opera. In Italy, Verdi enjoyed a long career that culminated in operas based on Shakespearean plays. In Germany, Wagner's revolutionary operas presented Nordic myths as morality tales of modern life. Musically, Wagner revised and modernized operatic techniques, unifying opera with the *Leitmotif* and expanding the harmonic possibilities of Western music. A late romantic musical nationalism fostered the blossoming of the Russians Tchaikovsky and Petipa, who collaborated to create a definitive or "classical" form of ballet.

Late Romantics and Early Moderns A generation of late romantic poets and artists concentrated on symbol, mood, and the artist's inner sensibility. Inspired by Baudelaire, the symbolist poets pursued the principle of *l'art pour l'art* ("art for art's sake") in their poetry of dense meaning. The same idea could be found in the decorative style of Art Nouveau, embodied in the Vienna Secession painter Klimt and the fluid buildings of the Spaniard Gaudí. The composer Debussy devised a "musical impressionism" of dream-like moods and musical colors. The sculptor Rodin mystified the artistic public with his impassioned renderings of the human figure.

In painting, impressionists sought to depict the modern city and capture the transient effects of light and color. The pure impressionism of Monet sketched open-air scenes in vibrant color, while other impressionists showed interest in the human figure and pictorial design. Following impressionism, Seurat and Cézanne sought greater formal order through abstraction, while Gauguin and van Gogh aimed for a more intense expressiveness and decorative effect.

The Dark Side of Progress Using the devices of realism, the dramatists Chekhov and Ibsen explored the complexity of human character and the alienation of middle-class society. Ibsen explicitly addressed such issues as women's rights and modern marriage. Dostoyevsky's panoramic novels explored the dark side of social progress, depicting the conflicts among materialism, modernity, and moral freedom. The philosopher Nietzsche rejected traditional morality and boldly declared the freedom of self-defining "supermen."

14 The Spirit of Modernism

14.1 Marcel Duchamp, *Nude Descending a Staircase* No. 2, 1912. 58 x 35 ins (147.3 x 89 cm). Philadelphia Museum of Art, Louise and Walter Arensberg Collection.

Duchamp's abstract painting was the most notorious work in the 1913 Armory Show, which stunned the American public with art by Picasso, Matisse, and other early modernist masters.

In 1913, a new mode of thought and expression exploded across the Western world. In Paris, an innovative ballet called *The Rite of Spring* – pulsing with primitive rhythms and unconventional dancing – incited an audience riot at its premiere. In New York, an exhibition of strange new art scandalized the American public. Visitors to the Armory Show were especially outraged by *Nude Descending a Staircase* (Fig. **14.1**), which one critic called "an explosion in a shingle factory."

The next year, 1914, witnessed a global explosion – a world war that would kill nine million people and end with Russia convulsed by communist revolution. The poet W. B. Yeats succinctly grasped the crisis of Western civilization. "Things fall apart; the center cannot hold," he wrote. Out of this failing center, born between freedom and anarchy, came the **spirit of modernism**, the aggressive style of 1900–1950 that demolished tired cultural traditions and defined a bewildering future for the twentieth century.

A Turbulent Century

Identify the historical events and forces that shaped the rise of modern mass society.

In the first decades of the twentieth century, new discoveries and catastrophic events seemed to overturn the very foundations of Western civilization. Scientists revised Newton's universal laws of physics to describe the physical universe in terms of relativity and probability. Western civilization's smug assumptions about its cultural progress were dissolved in a bloody world war from 1914 to 1918. Out of that war arose disturbing social and political forces – communism in Soviet Russia and fascism in Germany – that employed new forms of mass culture and murderous methods of social control. The Irish poet William Butler Yeats [yates] (1865–1939) registered the new century's bloodied disorientation in the vivid images of a falcon escaping his master's call:

Turning and turning in the widening gyre[a]
The falcon cannot hear the falconer;
Things fall apart; the center cannot hold;
Mere anarchy is loosed upon the world,
The blood-dimmed tide is loosed, and everywhere
The ceremony of innocence is drowned;
The best lack all conviction, while the worst
Are full of passionate intensity.[1]

WILLIAM BUTLER YEATS
From The Second Coming (1920)

a. gyre, gyration; here, circling flight.

I shall never believe that God plays dice with the world.

Albert Einstein

Yeats's foreboding poem intimates that more cataclysms will come but voices the faint hope that something new – if not better – would be born from civilization's trauma. The world that Yeats anticipated – shaped by war, revolution, and the rise of mass culture – was created in the period 1900–1950. In many ways, it is still the world we live in today.

A New Science

Building on discoveries in electromagnetism and the study of light, the young physicist Albert Einstein proposed in 1905 a **special theory of relativity** that held that time and mass were relative to the observer's frame of reference. Because the speed of light was constant, reasoned Einstein, everything else must be changeable in relation to the speed of light. In one famous thought experiment, Einstein imagined passengers in a spaceship leaving the planet at nearly the speed of light. By a clock in their spaceship, the travelers send a signal back to earth every quarter hour. But to observers on earth, the signals would arrive more slowly, until eventually they were decades apart. Time as observed in the speeding space ship actually slowed down relative to observers on earth. Physicists quickly confirmed Einstein's theory with empirical observation.

In 1918, Einstein expanded his theory of relativity to describe gravity in a revolutionary way. What to Newton had appeared to be the mutual attraction of objects – gravity – was actually the movement of objects through the four-dimensional continuum of "space-time." For most objects, the theory of gravity provided adequate explanation. But large objects like the sun created enormous distortions in the geometry of space-time that affected the behavior of even distant objects like the planets. Newton's simplistic laws of mechanics could not explain the complex geometry of space-time in a way that applied to all frames of reference. Einstein's **general theory of relativity** did.

Einstein made fundamental contributions to another vein of modern physics called quantum mechanics, though he objected to some of its conclusions. Atomic scientists determined that sub-atomic particles behave at times like particles of matter and at other times like light energy moving in waves. This meant that an atom's electrons could not be measured or plotted precisely. According to German physicist Werner Heisenberg's "uncertainty principle," we could know precisely an electron's position or its velocity, but not both. The quantum physicists concluded that, at the sub-atomic level, the

universe is "probabilistic" – that is, calculable according to statistical likelihood. Einstein's response was, "I shall never believe that God plays dice with the world."[2]

The Great War

The path-breaking discoveries of modern physics had little effect on daily life in Western civilizations. By contrast, the "Great War" – World War I – changed the lives and consciousness of an entire civilization. In 1914, with the nations of Europe locked in conflicting alliances, a political assassination in central Europe set off a war of unprecedented carnage and futility. World War I was the first industrialized world conflict, a triumph of industrial invention and productivity. It demonstrated how effectively Western societies could mobilize vast armies, supply them with efficient weapons, and annihilate human lives in pointless conflict. Barbed wire and rapid-fire machine guns made troop entrenchments virtually impregnable. Poison gas was used to early effect by German and British troops, and the tank and the airplane made their first appearance.

The Great War's technologies of destruction produced a three-year stalemate on the battlefield. Dug into their defensive trenches, troops suffered constant and fearsome artillery bombardment. Under this deadly fire, the novelist Erich Remarque wrote, "the world as they had taught it to us broke into pieces." Offensive assaults on trench lines were as lethal as they were ineffective. At the Battle of the Somme in 1916, both sides lost together more than a million dead or wounded, though barely 100 square miles (259 ha) changed hands.

The Russian Revolution The deprivations of war produced an event in Russia as momentous as the Great War itself. In October 1917, the radical Bolsheviks – the Russian Social Democratic Party – overthrew a temporary government and established the first socialist state in Europe. The Bolshevik Revolution was led by V. I. Lenin (1870–1924), who determinedly applied Marxian socialism to backward Russia. Lenin theorized that a highly trained party elite could compensate for Russia's lack of a class-conscious proletariat.

In fact, Lenin centralized power in the hands of party leaders, who used the czarist secret police to suppress dissent. Lenin's successor, Joseph Stalin (1879–1953), undertook a massive industrialization, increasing the Soviet Union's steel production five-fold in a single decade.

Along with this progress came widespread suffering, including mass starvation, caused by Stalin's forced collectivization of farming. As many as twenty million Soviet citizens died, many in a brutal system of prison camps.

The first years of Soviet communism stimulated a lively artistic avant-garde. Soviet artists put themselves at the service of the workers' state, and produced works of abstract design that won praise from modernist groups in Western Europe (Fig. **14.2**). Soviet actors and dramatists organized **agit-prop** (for "agitation-propaganda") troupes who carried the revolutionary message to Russian villages. Agit-prop theater rejected the subtleties of realism, aiming for a bold impact on its largely uneducated audiences. Soviet artistic experiments were gradually suppressed by Stalin, whose henchmen finally declared "socialist realism" as the only true revolutionary style. Modernist art was suppressed and artists either fled to the West or disappeared into prison camps.

14.2 Vladimir Tatlin, model for *Monument to the Third International*, 1919–20. Wood, iron, and glass. Contemporary photograph.
Tatlin's projected structure was 1,300 feet (396.2 m) tall, and was to be built of iron and glass. It would have had three levels, each rotating slowly at different speeds – truly a revolutionary design for a revolutionary age.

CRITICAL QUESTION
What kinds of political ideas are best communicated through the images and messages of television, radio, and mass advertising? Why were such ideas so important during the 1920s and 30s?

Fascism and the Rise of Mass Society

Western political leaders feared that Lenin's revolution would be an incentive to the workers in Western Europe and the United States. Instead, anti-communist reactions in Italy and Germany spawned the new ideology of **fascism**, which proved just as devastating and fatal. Fascism (from *fasces*, an ancient Roman symbol of authority) prized nation and race above all individual rights, and typically used government power to regiment social life and suppress opposition. Fascist movements arose in Italy and in Germany, where the National Socialist (Nazi) party was led by the charismatic Adolf Hitler (1889–1945).

In Germany, the fascists proved to be masters in appealing to the masses of unemployed. The skillful orator Hitler pounded away at Nazi themes of German pride, anti-communism, and anti-Semitism (the hatred of Jews). When the Nazis took power in 1933, they forced Jews out of official positions and stripped them of German citizenship. The Nazis were masters of both simplified slogans and potent symbolism, using the mass media of radio and film for political purposes. Nazi party rallies, depicted on film in Leni Riefenstahl's *Triumph of the Will* (see page 408), massed thousands of supporters in festivals adorned with flags, banners, and uniforms. In German town squares, Nazis burned the literary works of well-known

14.3 Dorothea Lange, *Migrant Mother, Nipomo, California*, 1936. Gelatin silver print. Library of Congress, Washington, D.C.
Lange and other documentary photographers of the New Deal era strove to arouse the viewer's sympathy, while also truthfully recording the visual facts. Lange took this photograph in a California migrant workers' camp filled with refugees from drought and famine. Note the details of pose and gesture that communicate the subjects' anguish.

intellectuals, and many prominent artists quickly left Germany after 1933.

While fascism never flourished in the United States, Americans responded enthusiastically to the new mass media. The new art of commercial filmmaking established itself in Hollywood, California, churning out movies with standardized storylines and star actors (see page 408). President Franklin Roosevelt (1882–1945) gave "fireside chats" on radio to reassure an American people beleaguered by the Great Depression. To justify his economic programs, dubbed the "New Deal," Roosevelt's administration sent legions of writers and artists into rural areas. Their mission was to document poverty and suffering by using **documentary arts** (reportage, photography, and film), that recorded social conditions directly and objectively. Documentary photographs by Margaret Bourke-White, Walker Evans, and Dorothea Lange (Fig. **14.3**) graphically illustrated the hardships of the rural and urban poor. Concerned for artists' survival during the Depression, Roosevelt's New Deal agencies also provided direct support to theater and other traditional arts.

Communism, fascism, and the New Deal all employed new media – posters, photography, radio, and film – that had broader appeal than the traditional arts. With the introduction of television by 1940, these media would constitute a new mass culture that soon overshadowed traditional forms of artistic expression.

Modernism in Art

Discuss the ways in which modernists discarded or transformed longstanding traditions in the visual arts.

In the emerging mass society, the traditional arts redefined themselves by exploding tradition. The diverse artistic innovations of the period 1900–1950 are grouped loosely under the label of **modernism**. Like romanticism, modernism was more an attitude than a coherent philosophy or style. Nearly all modernists negated some part of the realist tradition in painting and sculpture, and nearly all were interested in new artistic forms and materials. Modernist art sought to free itself from the depiction of external reality, and concentrated instead on pure color, form, feeling, or idea. One radical and revealing example was the Russian artist Kasimir Malevich's *Black Square*

WINDOWS ON DAILY LIFE

War, Fashion, and Feminism

Shortly after the Great War ended, women in Britain and in the United States gained the right to vote. Their cause was aided by the dislocations of war, which forced changes in women's fashion. Here Ray Strachey, a British feminist, associates the new freedom in dress with women's growing social independence and opportunity.

For a long time fashion fought valiantly against any further development of physical freedom for women. … The war, however, brought deliverance. Under the necessities of the time fashion gave way, and short-skirted uniforms, and even breeches, became familiar sights. Women, when they had once really tasted the joys of this deliverance, refused to be put back into the old costumes. The trade tried, indeed, when the war was over, to reinstate the old ideas; but they did not "take." Skirts grew shorter and shorter, clothes grew more and more simple and convenient, and hair, that "crowning glory of a woman," was cut short. With one bound the young women of 1919 burst out from the hampering conventions, and with their cigarettes, their motor-cars, their latch-keys, and their athletics they astonished and scandalized their elders.[3]

RAY STRACHEY
From "The Cause": A Short History of the Women's Movement in Great Britain, 1928

(1915). Malevich [mal-YAY-vitsch] explained that his simple black square was "a desperate attempt to free art from the burden of the object"[4] (see Fig. 14.12).

The modernists often banded together to repel their detractors and educate the public about their artistic aims. Modernism's various movements, or "-isms," ran in different veins: one toward formal abstraction, another toward the expression of feeling and states of mind, and yet another toward the wholesale redefinition of art. For all their differences, the modernists were responding to an era of turbulent change, to exhausted artistic tradition, and to each other's radical new vision of artistic truth and beauty.

Picasso and the Revolution in Art

The Spaniard Pablo Picasso (1881–1973) was to become the twentieth century's most versatile and influential artist. The young Picasso had mastered traditional techniques of drawing and form, as was evident in his first original works, the paintings of his "blue period" and "rose period." By 1907, already a success in the Paris art world,

Picasso was determined to discard the Renaissance artistic tradition and formulate a new set of artistic rules.

The first great manifesto of modernist painting was Picasso's *Les Demoiselles d'Avignon* [lay demm-WAW-zell dah-veen-YOHN(h)] (Fig. **14.4**), which depicts a group of nude prostitutes parading themselves before their customers. Instead of the traditional alluring female nude, these women are grotesque mannikins, who project an aggressive threat to the viewer. The central pair gazes frankly out at the viewer from faces that resemble archaic Spanish sculpture. Most disturbing of all, the masked figures at right project an unmasked hostility toward their male customers.

Scholars identify two creative influences on Picasso in the years 1906 and 1907. At a retrospective Cézanne exhibition, Picasso saw a Cézanne sketch entitled *The Bathers* that clearly influenced his treatment of the nude form. In the same period, Picasso visited a museum of non-Western art in Paris. There he saw African and Polynesian masks that stylized the human face in ways reflected in Picasso's grotesque prostitutes. Despite the painter's later denials, *Les Demoiselles* unmistakably shows the influence of **primitivism** (see page 390). A third factor in shaping *Les Demoiselles* was Picasso's own experimentation with the elements of visual expression. By deconstructing the human form and flattening the pictorial space, Picasso was violating the centuries-old pictorial tradition more aggressively than any painter before him.

By painting *Les Demoiselles d'Avignon*, Picasso began to define **cubism**, a style that analyzed natural forms into planes, angles, and geometric shapes. The co-inventor of cubism with Picasso was Frenchman Georges Braque [brawk] (1882–1963), a less brilliant artist but a determined innovator. Between 1907 and 1914, the two worked so closely – "roped together like two mountain climbers," said Braque – that some of their paintings are virtually indistinguishable.

During these years, Picasso and Braque methodically decomposed the pictorial tradition, defining a technique of formal abstraction that established an entire branch of modernism. In Braque's *The Portuguese* (Fig. **14.5**), the sitter's features dissolve into flattened shapes, distinguishable as a fez-like hat, shoulder epaulets, and guitar. Neither the tantalizing lettering nor the image itself can

14.4 Pablo Picasso, *Les Demoiselles d'Avignon*, 1907. Oil on canvas, 8 ft x 7 ft 8 ins (2.43 x 2.33 m). Collection, The Museum of Modern Art, New York, acquired through the Lillie P. Bliss Bequest.
Picasso's acid deconstruction of the female nude was a manifesto of pictorial modernism. Note the abstracted treatment of the nude female form and flattening effect of the background curtain. Compare to a traditional female nude such as Boucher's (Fig. 11.6).

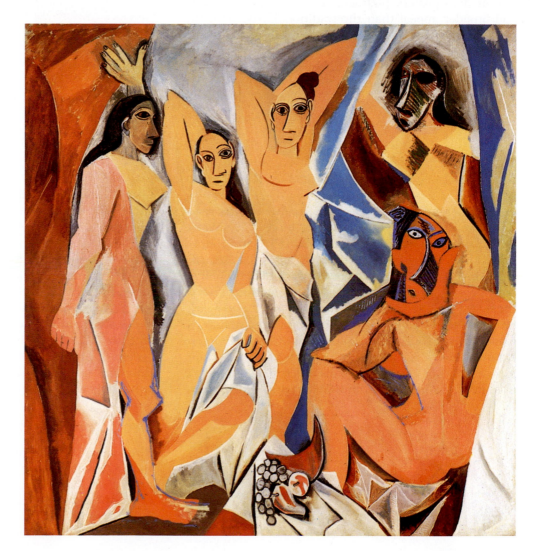

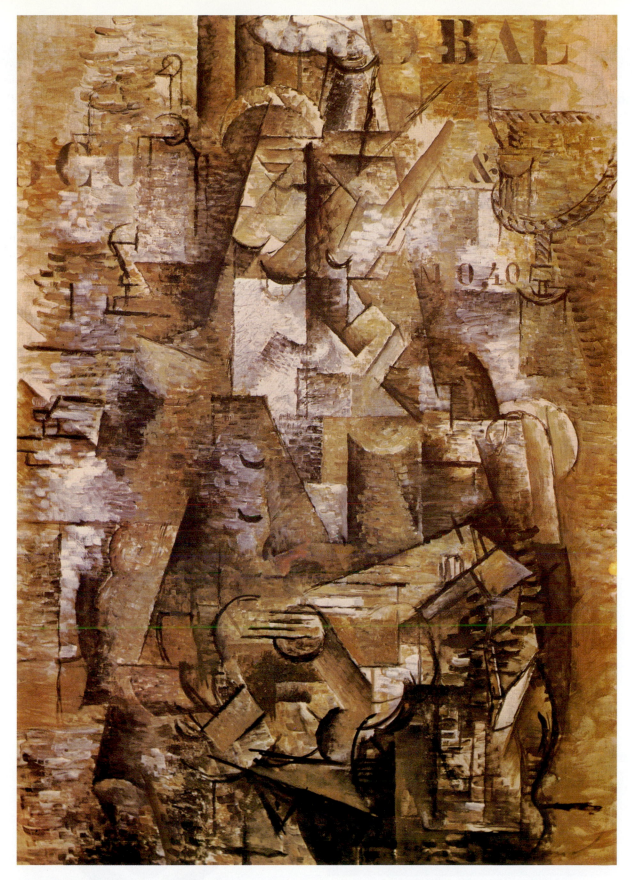

14.5 Georges Braque, *The Portuguese*, 1911.
Oil on canvas, 46¼ x 32¼ ins (117.5 x 82 cm).
Kunstmuseum, Basel.
The cubist Braque presents the figure as if in multiple exposure, captured not by the eye but by the intellect. His portrait of a bar-room singer with guitar is punctuated by the cryptic lettering "Bal" ("dance") and "10.40" (evidently a drink tab). Note the underlying pyramidal form.

Primitivism

No study of Picasso's paintings fails to mention the evidence in his work of **primitivism**, the influence of arts from supposedly "primitive" tribal cultures in Africa, Oceania, and the Americas. Picasso and other modernists collected tribal art the way the impressionists collected Japanese prints. The modernists had little interest in the anthropological study of primitive art or its place in tribal culture. They were more concerned with the formal inventiveness of tribal artists who were unschooled in realist techniques. Some modernists also hoped to tap the savage vigor (real or imagined) they felt in tribal art, thus shocking their own exhausted civilization into new life.

The works of tribal artisans exhibited formal qualities that paralleled the innovations of modernist artists. Tribal artists did not show things as they were seen by the eye, a rule that had governed Western art since the Renaissance. Tribal masks and sculpture were governed by abstract or symbolic representation: Picasso owned an African mask that depicted the eyes as protruding cylinders and the mouth as a block. In tribal styles, some modernists found confirmation of their search for an art of concept rather than empirical perception.

Others sought in primitivism an art of intense feeling, as in the German expressionist Emil Nolde's *Still Life of Masks I* (Fig. **14.6**). Nolde combines popular carnival masks with versions of Oceanic and South American tribal masks (Fig. **14.7**) that he had seen in European collections.

In one sense, modernists were responding to tribal artists' use of a universal visual language. Removed from its cultural and religious context, tribal art struck the modernists as remarkably free and inventive in its use of shape, line, and proportion. In another sense, the modernists were refurbishing the romantic myth of the noble savage. Some presumed that tribal art delved closer to the core of human experience, beneath the falsifying veneer of Western civilization. But where the romantics saw in the noble savage a model of reason and nobility, the modernists saw in the primitive a violent expressiveness that violated the polite boundaries of Western art. Inevitably, the modernists judged primitive art purely in terms of their own culture and artistic interests, welcoming its affirmation of their own artistic inventions. Their borrowings cannot be taken as a measure of tribal art's meaning or value.

14.6 Emil Nolde, *Masks,* 1911. Oil on canvas, 28³/₄ x 30¹/₂ ins (73 x 77.5 cm). The Nelson-Atkins Museum of Art, Kansas City, Missouri, gift of the Friends of Art, 54-90.
Nolde combined popular carnival masks (center) with versions of Oceanic and South American tribal masks that he had seen.

14.7 Ram mask, Kwele peoples, Congo, 19th–20th century. Wood and paint, height 20³/₄ ins (52.7 cm).
Modernist artists looked to tribal cultures as an ideal of unbridled erotic freedom and savage energy.

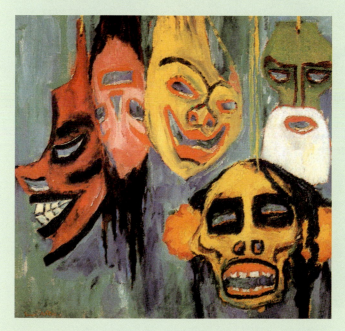

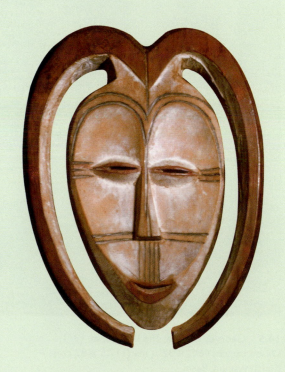

be fully reconstructed. In this so-called "analytical" phase of cubism, Picasso and Braque largely restricted their colors to browns and grays. They wanted no color to distract from the abstracted lines and intersecting planes of their portraits, still lifes, and landscapes. By abandoning perspective – the Renaissance trick of showing three dimensions in two – analytical cubism had achieved a fourth dimension, the object as seen in time or motion.

By 1912 the cubists entered a second phase, called synthetic cubism, in which they glued objects – newspaper, string, even sawdust – directly to the painting surface. This technique was called **collage** (from the French *coller*, "to glue"), and it restored (literally) a third dimension to cubist pictures. Instead of dissolving objects into planes and angles, as in analytic cubism, the cubists now constructed their paintings from scraps of paper and other "real" objects. In *Le Courrier* (Fig. **14.8**) Braque overlaid his drawing of a café table with pasted scraps representing a newspaper, playing card, and cigarette pack. The collage technique extended cubism's original purpose, which was to supersede the pictorial tradition.

Picasso's collaboration with Braque ended abruptly with the outbreak of war in 1914, although cubist techniques enjoyed a vigorous afterlife in his later works. In 1920 he painted two versions of *The Three Musicians*. In the version here (Fig. **14.9**), the raucous shapes and colors are more vivacious than in the cubist paintings. The painting appears to be a collage of disparate pieces that nevertheless merge into an amusing whole.

Toward Formal Abstraction

Some cubist painters stepped back from the brink of pure abstraction and returned to representational painting. Other artists followed the cubist path to its logical end, and created works of pure line, shape, and color. The result was called **non-objective** (also **non-figurative**) art, which depicts no object at all. The trend toward a non-objective sculpture was visible already in the works of the Italian **futurists**. The futurists were an aggressively modernist group who toured the capitals of Europe in the pre-war years. Their scandalous performances and outrageous calls for a "machine art" gained them notoriety. World War I brought an early end to their ambitions, including their uncritical view of new technology as the salvation of the world. One memorable futurist work is the fluid sculpture entitled *Unique Forms of Continuity in Space* (1913; Fig. **14.10**) by Umberto Boccioni [boh-chee-OH-nee] (1882–1916). Although clearly a striding human form, the figure's surface also resembles that of a windswept sea.

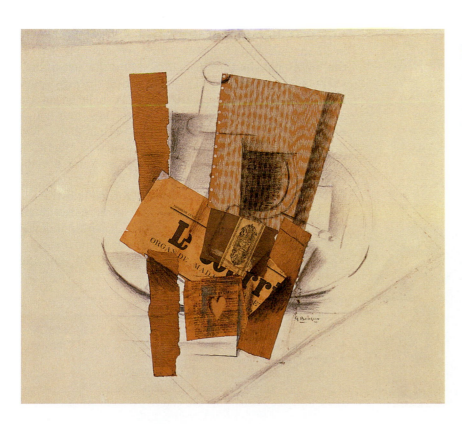

14.8 Georges Braque, *Le Courrier*, 1913. Pasted paper and charcoal, 20 x 22¹⁄₂ ins (51 x 57 cm). Philadelphia Museum of Art, A. E. Gallatin Collection, 1952.

By gluing paper, string, and other objects to the canvas – the technique of collage – Braque hoped to make "the reality in the painting" compete with "the reality in nature." The pasted paper shapes define the work of art as an object in its own right, not an illusionist window through which the viewer looks.

14.9 Pablo Picasso, *The Three Musicians*, 1921. Oil on canvas, 6 ft 7 ins × 7 ft 3³/₄ ins (2.01 × 2.23 m). Collection, The Museum of Modern Art, New York, Mrs. Simon Guggenheim Fund.

Picasso continued to use cubist technique long after his collaboration with Braque ended. Here, two figures from the *commedia dell'arte*, a pierrot and harlequin, join a somber monk in a carnival concert. Note the comically irregular shapes, such as the harlequin's gaping jaw and the dislocated dog.

As sculpture became less figurative, sculptors emphasized the textures and expressive potentials of the material itself. In Constantin Brancusi's *Bird in Space* (Fig. **14.11**), the highly polished bronze surface and the streamlined shape suggest the ease of a bird soaring through space. Brancusi [bran-KOO-zee] (1876–1957) usually began with an organic shape, such as the bird or egg, and sought to define the formal or abstract idea in that shape. With *Bird in Space*, Brancusi sought "the essence of flight," as he called it, aiming at pure concept and not a visual representation.

The modernist trend toward formal abstraction reached a brief zenith in the Soviet avant-garde in the years 1915–1925. Inspired by cubism, Kasimir Malevich (1878–1935; see page 387) painted monochromatic squares on a white ground and installed his paintings

14.10 Umberto Boccioni, *Unique Forms of Continuity in Space*, 1913. Bronze (cast 1931), 43⁷/₈ × 34⁷/₈ × 15³/₄ ins (112.2 × 88.5 × 40 cm). The Museum of Modern Art, New York, acquired through the Lillie P. Bliss Bequest.

The Italian futurist Boccioni's sculpture captures the dynamism of analytical cubism, but in more fluid and organic shapes. The undulations define the figure's volume but also engage the enclosing space.

as if they were religious icons. His *Black Square* was first exhibited in 1915 just before the revolution (Fig. **14.12**), and set the tone for post-revolutionary Soviet constructivists who applied this pure abstraction to more practical arts. One versatile constructivist, Lyubov Popova (1889–1924), applied geometric abstraction to stage design, posters, dishware, and textiles – abstract art that served the people.

Abstraction expressed a different kind of ideal for the Dutch artist Piet Mondrian [pee-ETT MOHN-dree-ahn] (1872–1944). Mondrian's flat, rectangular grids of red, yellow, and blue lines were as rigorously non-objective as Malevich's squares. The Dutchman believed that line and color were the "pure" materials of painting, rectangles were "pure" forms, and both should be liberated from "the particulars of appearance." Mondrian had an almost Platonic faith in the power of such formal abstraction to bring harmony and order to the modern world. His vigorous defense of abstract art would powerfully influence future art trends.

Anti-art and Expressionism

The redefinition of art was undertaken by a modernist group called dada, which devoted itself to an attack on art, philosophy, and Western values. The nonsensical name "dada" symbolized the group's playful attitude toward conventional meaning. Founded in 1916 in Zurich, dadaism established outposts in Paris, New York, and later Berlin. The dadaists frequently engaged in scandalous so-called "manifestations," raucously improvised performances of poetry and art that sometimes turned into riots. With their rejection of reason and order as sources of meaning in art, the dadaists represented the opposite of Mondrian's philosophical abstraction.

The most inventive anti-artist was Marcel Duchamp (1887–1968), who playfully redefined art by stressing idea over fabrication. With his **ready-mades**, Duchamp [doo-SHAN(h)] presented ordinary "found" objects as unique works of art. One ready-made, a bicycle wheel attached to a kitchen stool, was also the first mobile sculpture. Another was a porcelain urinal, entitled *Fountain*, that Duchamp submitted to a New York art exhibition. In the "rectified" version (Fig. **14.13**) of Leonardo's famous *Mona Lisa*, Duchamp penciled in a graffito beard and a caption that, when pronounced in French, makes an obscene suggestion about Mona Lisa. Most likely Duchamp was also alluding to Leonardo's homosexuality, then a taboo subject.

Duchamp and dadaism successfully broadened the definition of art, and prepared the way for such later innovations as happenings, performance art, and pop art – all stimulating elements of the contemporary scene.

Alongside the trend toward formal abstraction, other modernists moved toward an art of more intense expression. The expressionist branch of modernism also began

14.11 (right) Constantin Brancusi, *Bird in Space*, c. 1928. Bronze (unique cast), height 4 ft 6 ins (1.37 m). The Museum of Modern Art, New York, given anonymously.
Denying that his works were abstract, Brancusi said, "I pursue the inner, hidden reality, the very essence of objects in their own intrinsic fundamental nature." To increase the viewer's sense of motion and freedom, Brancusi sometimes placed his works on a rotating base.

14.12 (below)
Kasimir Malevich, *Black Square*, first exhibited 1915, this version 1923. Oil on canvas, 41¼ x 41¼ ins (104.7 x 104.7 cm). Russian State Museum, St. Petersburg.
Black Square embodied many of Malevich's spiritual beliefs. The black square itself is meant to be the essence of pure cosmic feeling, while the white border represents the void which is the absence of that feeling.

14.13 Marcel Duchamp, *La Boîte en Valise (L. H. O. O. Q.)*, 1919. Rectified ready-made, pencil on reproduction, 7³/₄ x 4⁷/₈ ins (19.7 x 12.2 cm). Collection of Mrs. Mary Sisler.
Duchamp's "rectified" version of Leonardo's *Mona Lisa* mocked the painting's status as an icon of traditional art. Duchamp's ready-mades wittily questioned the boundary between works of art and the objects of daily life.

14.14 Henri Matisse, *The Blue Window*, Issy-les-Moulineaux, 1913. Oil on canvas, 51¹/₂ x 35⁵/₈ ins (130.8 x 90.5 cm). The Museum of Modern Art, New York, Abby Aldrich Rockefeller Fund.
Matisse flattened the picture's space so that the table, vases and lamp, and bulbous blue trees outside all seem to occupy the same plane. This childlike indifference to perspective enhances the picture's quiet, reassuring mood.

in Paris, in the works of French painter Henri Matisse (1869–1954). Matisse was a pioneer who rivalled Picasso in his influence on the course of modernist art. Matisse was associated with a group labeled the **fauvists** [FOH-vists] (from the French *fauve*, or "wild beast"), named by a critic who said a statue at their 1905 exhibition was like "Donatello among the wild beasts." Actually, the pictorial subjects of fauvist works were quite gentle; the critic was responding to their bold use of color.

Matisse expressed himself in the decorative arrangement of a picture's elements, including boldly unnatural colors that created their own pictorial structure. "Expression to my way of thinking," he wrote in 1908, "does not consist of the passion mirrored upon a human face or betrayed by a violent gesture. The whole arrange-

ment of my picture is expressive. The place occupied by figures or objects, the empty space around them, the proportions, everything plays a part."[5] Compared to the other modernists, Matisse harbored no revolutionary ambitions. In his *Notes of a Painter*, he said his dream was "an art of balance, of purity and serenity, devoid of troubling or depressing subject-matter."[6] *The Blue Window* (Fig. **14.14**) illustrates precisely Matisse's desire to make of art "something like a good armchair in which to rest from physical fatigue."[7]

German Expressionism The German expressionists achieved an art of morbid, volcanic energy, more dynamic and psychologically intense than Matisse's gentle shapes and liquid colors. Two groups of German expressionism

What I dream of is an art of balance, of purity and serenity, devoid of troubling or depressing subject-matter, an art that could be a soothing, calming influence on the mind, something like a good armchair that provides relaxation from fatigue.

Henri Matisse, *Notes of a Painter*

formed in the wake of the fauvists: *Die Brücke* ("The Bridge"), formed in Dresden in 1905, and *Der Blaue Reiter* ("The Blue Rider"), organized in Munich in 1911. *Die Brücke*'s [BRYOOK-uh] leading painter was Emil Nolde (1867–1956), whose pictures showed a preoccupation with religion. In *Dance Around the Golden Calf* (Fig. 14.15), Nolde [NOLL-duh] depicted the pagan abandon of the Israelites worshiping an idol. Painted in torrid colors, the forms and features of the dancers dissolve in Dionysian intoxication.

Der Blaue Reiter [BLOW-uh RYE-ter] (named for its almanac published in 1919) included among its members the Russian artist Wassily Kandinsky (1866–1944). Like Mondrian's abstraction of line and form, Kandinsky's work pushed artistic expression to the very limits of non-objectivity. His most innovative pictures consisted of swirling colors and freely drawn lines and shapes, with no discernible subject. Kandinsky's style clearly had an improvisational spirit since the line and color flowed directly from Kandinsky's feelings (Fig. 14.16). Kandinsky wanted to achieve an immediate effect on the viewer, and believed the effect of color was most powerful if not mediated through a pictorial subject.

Another member of *Der Blaue Reiter* was Paul Klee (1879–1940), a painter whose career intersected with every major style in the modernist idiom: cubism, expressionism, and the Bauhaus style of modern design. Klee [klay] tapped the primitivism of the child, recapturing by intellectual effort the freshness and simplicity of a child's consciousness. For example, in *All Around the Fish* (Fig. 14.17), the central image is surrounded by vases containing fancifully symbolic flowers. The pictorial techniques of modernism – abstraction, the autonomy of shape and color, the preeminence of feeling and intellect over pictorial subject – are all subordinated to Klee's own private and mystical vision.

14.15 Emil Nolde, *Dance Around the Golden Calf*, 1910. Oil on canvas, 34³/₄ × 39¹/₂ ins (88 × 100 cm). Staatsgalerie Moderner Kunst, Munich.
From the Judeo-Christian tradition, so concerned with sin and divine law, the German expressionist Nolde chose a scene of orgiastic pleasure. Consider how this painting might be considered "primitivist" (see page 390).

14.16 (left) Wassily Kandinsky, *Improvisation 28 (Second Version)*, 1912. Oil on canvas, 3 ft 7$^7/_8$ ins x 5 ft 3$^7/_8$ ins (1.11 x 1.62 m). Collection, The Solomon R. Guggenheim Museum, New York, Gift, Solomon R. Guggenheim, 1937, 37.239. To stress the non-objectivity of his paintings, Kandinsky titled dozens of them *Improvisation*. He wrote that color was like the keys of the piano that the artist touched "to cause vibrations in the soul."

The Modern Mind

Summarize Freud's view of the role of sexuality in human thought.

If modernism in the visual arts revolutionized the ways humans saw the world, Sigmund Freud [froyd] and modernist literature redefined how they saw themselves. Freud (1856–1939) outlined a theory of the human mind in which human consciousness was in a constant struggle with repressed desires. Modernist storytellers and poets exposed the rambling and allusive process of human thought, discarding the familiar landmarks of narrative and poetic form.

Freud and Surrealism

In 1900, seven years before Picasso painted *Les Demoiselles d'Avignon,* Sigmund Freud published his study *The Interpretation of Dreams,* a work that revolutionized psychology much as Picasso transformed art. According to Freud, the mind was not the center of reason and self-mastery, but a battleground between unconscious desires and the oppressive demands of society. The family was not a sanctuary of innocent love, but a cauldron of incestuous attachments and murderous wishes. Freud analyzed subjects that were normally taboo – masturbation, incest, perversion. His writings gave us a new vocabulary for understanding human thought, including now-familiar terms such as "unconscious," "ego," and

14.17 (opposite) Paul Klee, *All Around the Fish,* 1926. Oil on canvas, 18³/₄ x 25³/₈ ins (46.67 x 63.82 cm). The Museum of Modern Art, New York, Abby Aldrich Rockefeller Fund, 1939.
Speculate on the symbolism of the flowers, fish, cross, and other elements of this mystical scene.

"Oedipus complex." Every domain of the humanities, from surrealist art to philosophy and religion, has been affected by Freud's theories.

Freud was the inventor of **psychoanalysis**, a method of treating mental illness by analyzing unconscious desires. One psychoanalytic method required the patient to talk freely about his or her thoughts and feelings. This "free association" of ideas revealed the unconscious thoughts behind the mental symptom and exposed the patient's thoughts to interpretation. Through analysis, the patient eventually could acknowledge the sexual wish or fear that caused the symptom. All human activity was motivated by a powerful psychic energy that Freud called **libido** (Latin for "wish" or "desire"). Most people had successfully repressed their libido along the paths of marriage, work, parenthood, and other ordinary human activities. The person who suffered from mental illness or sexual perversion, however, had unsuccessfully repressed the libido. Freud drew no clear line between the normal and abnormal psyche. The actor who stepped before an audience every night was gratifying the same libido as the sexual exhibitionist.

The most controversial aspect of Freud's theory was his view of child sexuality. Western civilization had long thought children were free of sexual motives. However, Freud asserted that children were driven by libido from the beginning of their psychic lives. The child was reluctant to give up the erotic attachment to his or her parents and, according to Freud, mentally reenacted the Greek legend of Oedipus (see page 59). In the "Oedipus complex," the child unconsciously wished to murder his or her parental rival and preserve a sexual attachment to the parent of the opposite sex. According to Freud, the experience of the Oedipus complex influences our future relations with our parents, our choice of a mate, even our choice of an occupation.

In later years, Freud generalized his psychological theories to the domains of mythology, religion, and politics. In *Civilization and Its Discontents* (1925), for example, he argued that civilization was built on an inevitable conflict between humans' true desires and the requirements of work and achievement. In other works on religion and mass psychology, Freud daringly tested his theories on the major social and psychic phenomena of his day, usually with controversial results.

14.18 Giorgio de Chirico, *The Mystery and Melancholy of a Street*, 1914. Oil on canvas, 33¹/₂ x 27¹/₄ ins (85 x 69 cm). Resor Collection, New Canaan, Connecticut.
De Chirico was an Italian who arrived in Paris at the height of cubism. Note the ominous relation between the silhouetted girl and the looming shadow, framed by arcaded walls in oblique and disorienting perspective.

14.19 Joan Miró, *The Birth of the World: Montroig, summer 1925*, 1925. Oil on canvas, 8 ft 2³/₄ ins x 6 ft 6³/₄ ins (2.51 x 2 m). Museum of Modern Art, New York.
Miró said that this painting describes "a kind of genesis." Miro's biomorphic images here depict a recumbent mother birthing a child that floats away like a balloon on a string, but may also represent the artist and his work, or a creator deity and the newly created world.

Freud's interest in dreams corresponded to a trend already established in the visual arts, especially in the dream-like images of Giorgio de Chirico (1888–1978). Working without any knowledge of Freud, de Chirico [day KEE-ree-koh] captured something of the eerie, compelling logic of the unconscious mind. Painted in 1914, *The Mystery and Melancholy of a Street* (Fig. **14.18**) shows a girl playing on a street that narrows between two arcaded walls. Like a dream, the images possess a startling clarity – the brightly illuminated arcade, for example – but are combined in obscure and ominous associations.

The first artists consciously to adopt Freud's theory of the unconscious mind were the **surrealists**, a group of writers and painters initially based in Paris who sought to release unconscious images and words in their art. The result was an art "beyond" reality (in French, *surréalisme*), or, as the surrealists claimed, a transmutation of dream and reality. The surrealists' leader, French writer André Breton [breh-TOHN(h)] (1896–1966), issued a manifesto in 1924 in which he defined surrealism as

"pure psychic automatism" – that is the straightforward "dictation" of unconscious thoughts into writing or art, without any rational control. Automatism in writing produced a poetry of dream-like associations and arbitrary word play. The surrealists compared automatism with the free association of thoughts and feelings in Freudian psychoanalysis. Inspired by Freud, they called aggressively for liberation from sexual taboos.

The most accomplished painter of the Paris surrealists was Joan Miró (1893–1983), a Spaniard whose method foreshadowed the abstractions of post-World War II art. Of his painting, Miró [mee-ROH] said, "I begin painting and as I paint, the picture begins to assert itself, or suggest itself under my brush. The form becomes a sign for a woman or a bird as I work."[8] Miró used "biomorphic" shapes that suggested organic creatures without defining them. In *The Birth of the World* (Fig **14.19**), the reclining mother is tied by a faint umbilical cord to a rising globe. Miró has washed the paint unevenly on the unprimed canvas, creating an atmosphere of the primeval void.

The Unconscious

A century before the modernists, the romantics had praised the mysterious source of creativity in the unconscious mind. The philosopher Friedrich Nietzsche (see page 381) had mocked the puny efforts of reason to control the irrational powers of dream and imagination. Not until Sigmund Freud, however, did the concept of an unconscious mind enter the philosophical calculation of Western civilization. In Freud's theory, the unconscious was composed of powerful memories suppressed from consciousness, but still affecting thinking and behavior. The unconscious was like an underground river, hidden but powerful, that might erupt in an eerie dream or a caustic slip of the tongue.

Freud saw the unconscious as a psychic repository, a mental attic stuffed full of old memories. Stored there were the psyche's most powerful and frightening thoughts — thoughts of death, violence, and sexual desire. To protect against its own dangerous ideas, the conscious mind censored these thoughts, repressing them into the unconscious. However, Freud found that this repression was never entirely successful. Unconscious thoughts reappeared as dreams or neurotic symptoms, disturbing normal thought with their insistent desires and fears. In Freud's mental system, the conscious mind had to work constantly to control unconscious thoughts and transform their energy into socially acceptable activity.

Freud found evidence of the unconscious mind in virtually every aspect of human thinking. The apparently accidental forgetting of a friend's name revealed an unconscious desire that she die. The artistic works of Sophocles and Leonardo, men long dead, left a record of their unconscious fantasies. Above all, the dream — that ordinary but puzzling mental work performed by every human every night — revealed the workings of the unconscious. The dream was, as Freud said, the "royal road" to the unconscious (Fig. **14.20**).

The existence of an unconscious mind put a question mark beside the entire history of Western thought. Since the time of Plato and Aristotle, Western philosophy had enshrined reason as the core of human thinking. In his theory of the human psyche, however, Freud claimed that unconscious thoughts were more powerful and in a sense truer than conscious thinking. Logic and rationality were a necessary but inadequate defense mechanism against repressed desires and fears. After Freud, reason would never be the same again.

14.20 René Magritte, *The Key of Dreams*, 1932. Oil on canvas, 16³/₈ x 11 ins (41.5 x 28 cm). Collection Jasper Johns, New York.
The illogical "logic" of the unconscious was captured by the surrealist Magritte, who arbitrarily associated pictures with unrelated captions.

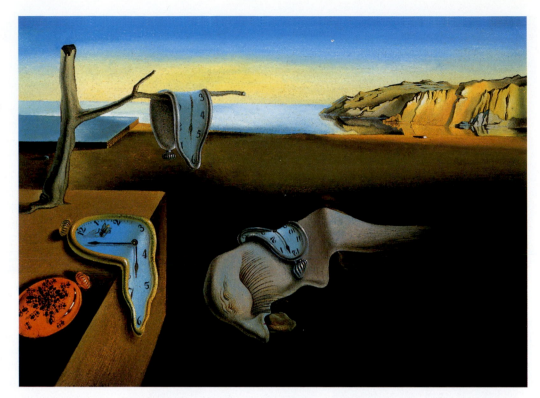

14.21 Salvador Dalí, *The Persistence of Memory*, 1931. Oil on canvas, 9½ x 13 ins (24 x 33 cm). The Museum of Modern Art, New York, given anonymously.
What elements of this Dalí scene most directly evoke the logic and imagery of dreams? How might the symbols here be interpreted?

CRITICAL QUESTION

Record a particularly vivid or puzzling dream in as much detail as you can. Then, explain as best you can the meaning or mental associations of the dream's images.

The method of another surrealist, Salvador Dalí (1904–1989), was more mannered and self-conscious. Dalí [dah-LEE] called his paintings "hand-painted dream photographs," and works such as *The Persistence of Memory* (Fig. **14.21**) combined minute detail with bizarre images and vividly painted landscapes. Of the limp watches in *The Persistence of Memory*, Dalí said they "are nothing more than the soft, extravagant, solitary, paranoiac-critical Camembert cheese of space and time."[9] Dalí also contributed, with director Luis Buñuel [boon-(y)-WELL] (1900–1983), to the surrealist film *Un Chien Andalou* (*An Andalusian Dog*, 1928), which contained a famous scene of a razor slicing open an eyeball.

Modernism in Literature

Twentieth-century literature explored new forms with the same intensity as the other arts and with the same disorienting effects on the public. Storytellers could not make their works entirely non-objective, as Mondrian and Kandinsky did in painting. They could, however, experiment with poetic language and narrative form.

Modernist poets often discarded poetic meter and rhyme, writing in *vers libre* [VAIR leeb(r)] ("free" or non-metrical verse). Novelists concentrated more on the inner lives of their characters, registering subtle gradations of consciousness. As a result, the action in many modernist novels was less coherent than in conventional works, with fewer causal connections. The modernist style was distinguished by its writers' desire to alter or expand traditional literary forms and discover new topics for the literary imagination.

Modernist prose fiction concentrated on characters' inner thoughts, recording unconscious associations. Such inwardness characterized the novels of Virginia Woolf (1882–1941). Woolf developed the technique of **interior monologue** (also called "stream of consciousness"), which reproduces the flow of a character's inner thoughts. Interior monologue gave to fiction the same kind of subjective complexity and relativism that we find in cubist painting. In Woolf's *Mrs. Dalloway* (1925), for example, the events of a single day are described through the

That visit to Oxbridge had started a swarm of questions. Why did men drink wine and women water? Why was one sex so prosperous and the other so poor? What effect had poverty on fiction?

Virginia Woolf, *A Room of One's Own*

interior thoughts of several characters. Woolf's *A Room of One's Own* (1929) was the first modern work of feminist criticism, addressing the question of why there had been no female Shakespeare and "what effect had poverty on fiction." She answered that a woman who wanted to write required an independent income and "a room of one's own."

The most influential modernist novelist was the Irishman James Joyce (1882–1941). His novel *Ulysses* (1922) is the story of a day in the life of Dubliner Leopold Bloom. This long novel recounts Bloom's adventures selling newspaper advertisements and arguing with friends, comparing them (often ironically) to the exploits of the epic hero Ulysses. Packed with the dense allusions and symbolic associations of the symbolist poets (see page 365), Joyce's style makes *Ulysses* difficult to read, but gives the novel a rich texture of meaning that more conventional novels lack.

In poetry, the path to modernism had been blazed by the symbolists. Modernist poets extended the symbolists' use of intensely imagistic and allusive language, and wrote in *vers libre*. In 1922 Anglo-American poet T. S. Eliot (1888–1965) published *The Waste Land*, probably the most influential modernist poem in English. Eliot's poem evoked disturbing images of spiritual desolation, contrasting modern despair with ancient symbols of fertility and regeneration. To achieve unity, *The Waste Land* relied on literary allusion and recurring mythic symbols, drawn from anthropology, religion, and the musical works of Richard Wagner. By his use of symbolism, Eliot contradicted the romantic idea that a poem expresses the author's inner state of mind or emotion. Instead, Eliot's poem adopts a pose of ironic detachment, speaking through images that are chosen – sometimes quite arbitrarily – from diverse sources.

The new forms in literature were coupled with a new type of hero. While the traditional realist novel was still primarily focused on the exploits or moral development of a central character, modernist literature was more likely to present an ironic hero, a character who frustrates or disappoints the reader's expectations for decisive action and moral growth. The modernist hero is over-self-conscious, unable to bring himself or herself to action, immobilized by anxieties. One Eliot character asks with neurotic insecurity, "Shall I part my hair behind? Do I dare to eat a peach?"

The stories and novels of Czech author Franz Kafka (1883–1924) had a more sinister cast than Eliot's ironic wit. Kafka imagined his central characters caught in absurd and terrifying circumstances, yet recounted their experiences with detached matter-of-factness. His novels created an insane, nightmarish world that we now describe with the adjective "Kafka-esque." In Kafka's story *Die Verwandlung* (*The Metamorphosis*), for example, the character Gregor Samsa awakes one morning to find himself transformed into a giant insect:

THE WRITE IDEA

Describe a literary or film hero who represents, to your mind, the antithesis of the modernist ironic hero. What do these opposing kinds of heroes tell you about the world you live in? Which is truer, in your experience?

As Gregor Samsa awoke one morning from uneasy dreams he found himself transformed in his bed into a gigantic insect. He was lying on his hard, as it were armor-plated, back and when he lifted his head a little he could see his dome-like brown belly divided into stiff arched segments on top of which the bed quilt could hardly keep in position and was about to slide off completely. His numerous legs, which were pitifully thin compared to the rest of his bulk, waved helplessly before his eyes.[10]

FRANZ KAFKA
From The Metamorphosis (1924)

Gregor's family gradually abandons him to his degraded condition and he dies in loneliness and desperation. Such modern themes of impotence, alienation, and despair recur in some of Kafka's more traditional modernist contemporaries, including Ernest Hemingway (1899–1961) and Thomas Mann (1875–1955).

Modernist Music and Architecture

Explain why modernist music often outraged or alienated popular audiences.

Modernist currents in music led in two different directions. In one of these, exemplified by Stravinsky's ballets, music achieved its own version of modernist primitivism, while the other path led toward esoteric innovation. Modernist architects strived for a rationalism and functionality that would make architecture the most accessible of the modernist arts.

Stravinsky and Schoenberg – The New Music

The scandalous Paris debut of *Le Sacre du Printemps* (*The Rite of Spring*) in 1913 announced a new agenda for the performing arts. Where traditional works had intended to entertain and delight their audiences, modernist performances seemed determined to provoke and perplex, even when rejected by an artistic public that was comfortable with traditional arts.

The *Rite of Spring* involved the collaboration of several geniuses of modernism. Sergei Diaghilev (1872–1929) was artistic director of the Ballets Russes, a Russian dance troupe that typified the modernist attitude. Diaghilev's [DYAW-ghe-lev] daring productions made him the single most important figure in the rise of modernist ballet. His principal dancer was Vaslav Nijinsky (1888–1950), a brilliantly inventive dancer and choreographer who had outraged Parisian audiences with his erotic ballet for Debussy's *Prélude à "L'après-midi d'un faune."* Leon Bakst's costume designs (Fig. **14.22**) were themselves masterpieces of modernist style and had a formative effect on the art deco style (see opposite).

Stravinsky's music attacked the truisms of traditional music, the use of a consistent meter and key. Instead of using a single meter, Stravinsky employed numerous meters within a section, often changing the number of beats from one measure to the next (Fig. **14.23**). The use of different time signatures simultaneously or in rapid succession is called **polyrhythm**, and it gave Stravinsky's music a jagged, "primitive" pulse. The *Rite of Spring* also exploited **polytonality**, the use of two or more musical keys at the same time. Polytonality expanded the harmonic

14.22 Vaslav Nijinsky, portrayed by costume designer Leon Bakst. The set and costume designs of the Ballets Russes's Leon Bakst defined a style of lushly colored exoticism that broadly influenced modern design.

14.23 Igor Stravinsky, section of first movement from *Le Sacre du Printemps* (*The Rite of Spring*), 1913.

possibilities of music and allowed for broader dissonances – the tension created by unexpected chords. The dissonances in *Rite of Spring* are pronounced and prolonged, accounting for the ballet's disturbing effect on the audience at its premiere.

Stravinsky later moved from the primitivism of his compositions for the Ballets Russes to music structured somewhat in the Classical style of Haydn or Mozart. The composer was partly motivated by his opposition to the cult of Wagner, with its subordination of music to feeling, story, and myth. Stravinsky's later compositions, though Classical in form, continued to rely on modernist techniques of dissonance and innovative rhythms. Much of Stravinsky's influence in modern music can be attributed to this eclectic attitude – a borrowing from many sources, both modern and traditional.

While Stravinsky's music was rooted in Russian folk traditions, the musical ideas of Arnold Schoenberg (1874–1951) were formed by the intense aestheticism and expressionist fervor of early-twentieth-century Vienna. Schoenberg [SHUH(r)N-bairk] rejected the Classical tradition of orchestral music as completely as Kandinsky broke with objective painting.

A Viennese contemporary of Freud and associate of expressionist painters, Schoenberg packed his early music with chromatic scales (scales using the half-tones of a musical key). By his use of chromaticism and dissonance, Schoenberg dissolved the boundaries of the major–minor key system and created the first **atonal** music – that is, music not composed in a musical key. His atonal compositions were called musical "expressionism" because of their intense emotionality.

Schoenberg applied his new atonality in both instrumental and vocal forms. The *Six Little Piano Pieces* (1911) are short fragments of atonal ideas. His song cycle *Pierrot Lunaire* [PEE-(uh)-roh loo-NAIR] (*Pierrot of the Moon*, 1912), is still more expressionist. The series of twenty-one songs is written for a female vocalist and five musicians. The texts relate the neurotic jokes and bizarre stories of someone on the verge of mental breakdown. According to Schoenberg's direction, the poems were to be half-sung, half-spoken, in a haunting method

of delivery called *Sprechstimme* [SPREKH-stimm-uh] (German for "speaking voice"). In the music for *Pierrot*, there is no tonal center, no "home" tone where the music begins and ends. Instead, the melodic line is broken into small fragments that are not bound together by a major or minor scale.

The most popular work of atonal music was the opera *Wozzeck* (1925), composed by Schoenberg's student Alban Berg (1885–1935) and considered a masterpiece of musical expressionism. Based on a fatalistic nineteenth-century play, *Wozzeck* [VOH-tsek] depicts opera's most compelling modernist hero. The opera's atmosphere of paranoia and despair relies upon Berg's intricate musical score and frequent use of *Sprechstimme*. Its atonal harmonies are contained within tightly defined traditional forms, such as the sonata and fugue. In the opera's final scene, Berg uses children's songs to give the tragic story a final, aching twist.

Musically, Berg's *Wozzeck* already contains elements of Schoenberg's most radical innovation: the elimination of all tonality, in favor of his own compositional system. In the 1920s, Schoenberg achieved this with the **tone-row**, in which he arranged the twelve tones of the chromatic scale in a fixed sequence, or "series" – hence the names **serial composition**, **serialism**, or the **twelve-tone method**. Schoenberg's method dictated that every tone in the tone-row had to be played before any tone could be repeated; there was no tonic note toward which the music gravitated (Fig. **14.24**). Although the tone-row gave the composition unity and abstract coherence, it did not provide melodic themes or motifs to orient the audience. Serialism placed high demands on its audience and never enjoyed great popular success.

14.24 Tone-row for a Schoenberg piano concerto. The original tone-row is also shown retrograde (backwards), inverted, and retrograde-inverted.

Original

Retrograde

Inversion

Retrograde Inversion

Modernist Building and Design

Modernists in architecture discarded the historical revivalist styles of the late nineteenth century and conceived a building style based on simple geometric forms, functionality, and modern industrial materials. Working with glass, steel, and steel-reinforced concrete (called ferro-concrete), modernist architects sought forms that were suited to the industrial and social needs of the early twentieth century. Some called their new buildings "machines for living in."

In Germany and the Netherlands especially, architects developed design principles that would define the essence of the modern. At the progressive German art school called the Bauhaus [BOW-howss], directed by the architect Walter Gropius (1883–1969), designers subordinated artistic form to function, creating steel-tube chairs and unadorned lamps that could be cheaply produced to serve the masses. The same principles of clean, functional, modern design were applied to architecture when Gropius constructed the school's new Weimar campus in 1926. The Bauhaus studio is a conglomeration of rectangular forms, constructed of steel, ferro-concrete, and glass (Fig. **14.25**). Gropius's signature invention was the so-called "curtain wall," an exterior wall of glass that also displays the interior design of the building. Through the curtain wall, a building could present itself with total honesty of form and material, free of any decorative façade to obscure or falsify.

The greatest visionary of modernist architecture was the Frenchman Charles Edouard Jeanneret, known as Le Corbusier (1887–1965). Trained by the same teacher as Gropius, Le Corbusier [luh kor-BOO-zee-AY] shared the German's aim of a socially useful architecture. He envisioned "radiant cities" based on his designs of glass skyscraper apartments and super-highways. Le Corbusier's actual buildings in the 1920s and 1930s were more modest than his visionary designs. The Villa Savoye (Fig. **14.26**) in Poissy, France, embodied his principles of geometric regularity and utility. The cubical box, 60 feet square (18.3 m²), is supported on pylons, to emphasize its independence from its site. Le Corbusier's post-World-War-II buildings were built on the same principles and would define the "International Style" of modernist architecture.

The commercial buildings of the later 1920s and 1930s typically employed a less severe, more popular style of modern design now generally called **art deco**. At the time the style was called "Moderne," "zig-zag," or "jazz-modern."

> A house is a machine for living in.
>
> Le Corbusier, *Toward a New Architecture*

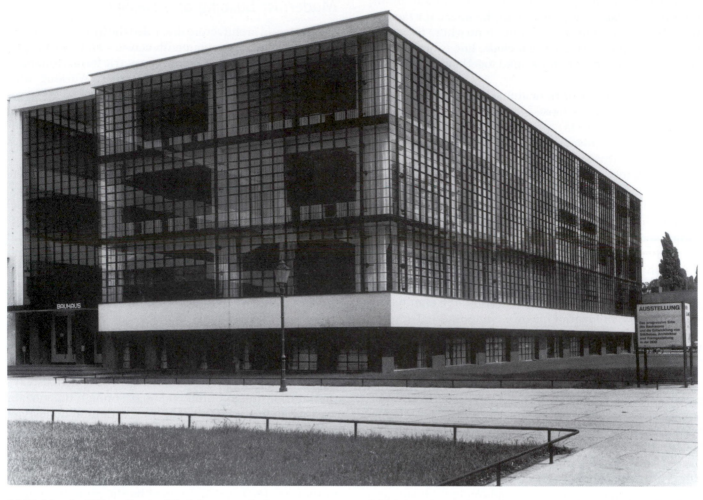

14.25 *(above)* Walter Gropius, Workshop wing, Bauhaus, Dessau, Germany, 1925–6.

The sheer simplicity of Gropius's glass and steel design recalls the purified abstraction of Mondrian. Gropius became an influential teacher in America and a founder of the so-called International Style in architecture.

14.26 *(below)* Le Corbusier, Villa Savoye, Poissy, France, 1929–30. The exterior is rigorously simple with a ribbon window stretching along the whole wall, a design that became a common feature in modernist building. The building's design is more forgiving on the interior, with its pastel colors and roof garden.

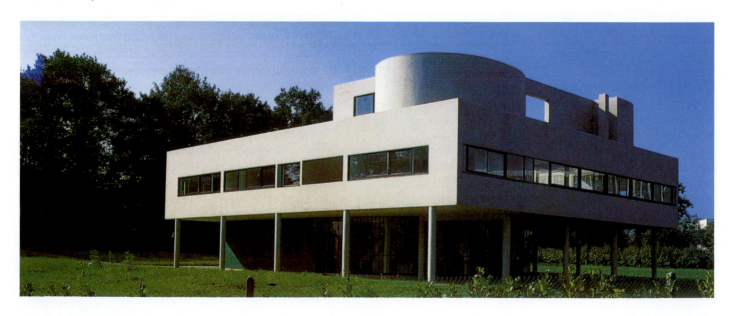

Art deco combined sleek, simple shapes with distinctive decorative motifs – the chevron, the zigzag, Egyptian and Central American symbols, and vegetal forms. As with Bauhaus-style productions, art deco objects typically employed modern materials like chromium, stainless steel, and plastic. But, where the Bauhaus advocated a purist functionalism that served the masses, art deco's eclectic sense of luxury and elegance appealed more to a middle- and upper-class public. Art deco's most exuberant statement came in the skyscrapers, department stores, cinemas, and hotels of North American cities. The spire of the art deco Chrysler Building in New York (Fig. 14.27), designed by William Van Alen, was clad in radiating stainless steel chevrons, soaring above gigantic "gargoyles" in the shape of hood ornaments.

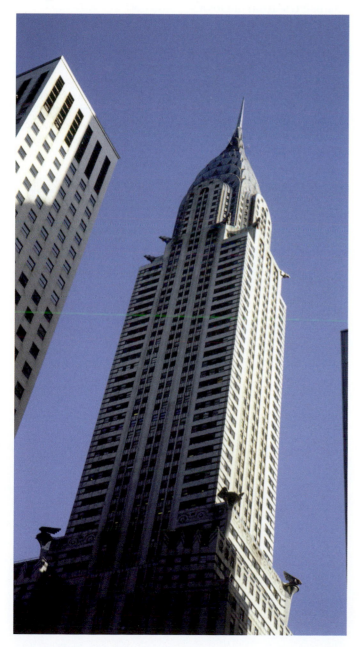

14.27 William Van Alen, Chrysler Building, New York, 1928–30. Especially in North America, the art deco style celebrated the inventiveness of industrial production and glamorized consumption. The Chrysler Building's stainless steel chevrons were typical of art deco motifs; the building was under construction at the same time as New York's other great art deco skyscrapers, the Empire State Building and Rockefeller Center.

Art and Politics

Compare the different political beliefs that were communicated in the works of modernist artists.

Just as in the Reformation and the French Revolution, so too in the 1920s and 30s artists and writers were drawn into the political conflicts of their time. Sharp lines were drawn over such issues as communism, fascism, labor unions, and the poor. Modernists spoke with eloquence from many points on the political spectrum, commenting on events and agitating for change through the media of drama, painting, film, and photography.

Brecht's Epic Theater

Devastated by inflation and unemployment, Germany in the late 1920s was splintered into political factions, with increasing polarization between left-wing parties and the Nazis. An atmosphere of decadence and political cynicism pervaded German cities, where party shock troops battled in the streets and cabaret singers mocked the corruption of wealth.

German artists responded with an ironic soberness exemplified in the works of the poet and dramatist Bertolt Brecht (1898–1956). Rejecting the extravagant staging of German expressionist theater, Brecht devised a theory of acting and dramatic presentation that he called **epic theater**, which the playwright combined with Marxist political ideas. In Brecht's method, the dramatic action was interrupted by song, narrative commentary, and other techniques intended to break the "illusionist" spell of the conventional stage. In the epic theater, audiences would act as experts able to judge the action, like spectators at a boxing match. In 1928, despite his growing radicalism, Brecht and the composer Kurt Weill (1900–1950) scored

1912	Schoenberg, *Pierrot Lunaire*
1913	Stravinsky and Ballets Russes, *Rite of Spring*
1925	Gropius, Bauhaus studio, Dessau, Germany (14.25); Louis Armstrong, jazz soloist, records with "Hot Five"
1936–7	Wright, "Fallingwater," Pennsylvania (14.35)

a gigantic theatrical hit with *Die Dreigroschenoper* (*The Threepenny Opera*). Brecht and Weill's sardonic "ballad opera" compared the decadent ruling class to the criminal underworld of gangsters, beggars, and prostitutes. Weill's [vile] music was full of bitter melancholy and modernist dissonance and contrasted sharply with the mythic Wagnerian opera that dominated German stages.

In 1933, Brecht went into exile, not long before Nazi censors ordered his works to be burned. His later plays expressed his Marxist ideas, and were more didactic, usually centering on a character torn between virtue and expedience. Brecht intended these plays to have an "alienation effect" on the audience, challenging them to consider social and political contradictions.

Painting and Politics

The political passions of the 1920s and 30s deeply touched the art of painting. In Mexico a bold style of mural painting arose out of the country's popular revolution against a colonial-era dictatorship (1910–1920). In the revolution's wake, the painters José Clemente Orozco, Diego Rivera, and David Siqueiros were commissioned to paint the walls of Mexican public buildings, reviving the mural traditions of Renaissance Europe and pre-Columbian Mexico. Like the artists of the Soviet avant-garde, the Mexicans wanted their art to serve the popular struggle. "We repudiate so-called easel painting," proclaimed one muralist manifesto, "and we praise monumental art in all its forms, because it is public property."[11]

In the early 1930s, murals by Orozco and Rivera affirmed Mexican national identity, celebrating the Aztec and Maya past and criticizing colonial oppression of Mexico's indigenous people. Rivera's *Enslavement of the Indians* (Fig. **14.28**) decorates the walls of the palace built by the Spanish conqueror Cortés. Orozco painted the entire history of American civilization on the library walls of a New England college. His history led from the vitality of pre-Columbian myth and ritual to the spiritual degradation of modern materialism.

Another Mexican painter of this circle, Frida Kahlo (1907–1954), has become an icon of Mexican modernism, though not for her left-wing politics. At age eighteen Kahlo was injured in a bus accident and took up painting in her hospital bed. Ten years later she married Diego Rivera and the artistic couple began a tumultuous, lifelong love affair. Essentially self-taught as a painter, Kahlo used self-portrait as a vivid diary of her suffering and conviction. *The Broken Column* (1944; Fig. **14.29**) depicts her body pierced by nails and braced by a steel corset. The torso is cleft to expose a broken Ionic column in place of her spine.

The single most famous political painting of this era must be Pablo Picasso's *Guernica* (Fig. **14.30**), an allegory of suffering and inhumanity. Picasso was responding

to an incident from the Spanish Civil War (1936–1939), in which Spain's progressive republican government battled an insurgent army of conservatives and fascists. In 1937, in support of the Spanish fascists, German bombers attacked the Basque city of Guernica [GAIR-nee-ka]. It was the first massive aerial bombardment of a civilian target, and the city, which had no military value, was obliterated.

Treating this outrage in modernist terms, Picasso depicted the city's people allegorically as a picador's horse, pierced by a spear and fragmented into jagged planes. Its anguished cry is shared by the human figures engulfed in the flaming city. An eerie eye and a lantern held by a ghostly witness illuminate the atrocity. While drawing on the vocabulary of artistic modernism, Picasso created a monumental work of passionate protest in the great Spanish tradition of Goya.

14.28 Diego Rivera, *Enslavement of the Indians*, 1930–1. Fresco. Palace of Cortés, Cuernavaca, Mexico.
In the tradition of the great Renaissance fresco painters, the muralist Diego Rivera used an emphatic visual style to depict native Mexicans' suffering under Spanish colonialism. Note the sagging lines of the bundled sugar cane, repeated in the curving backs of the Indians, the overseer's riding crop, and (inverted!) the lounging hacienda owner's hammock.

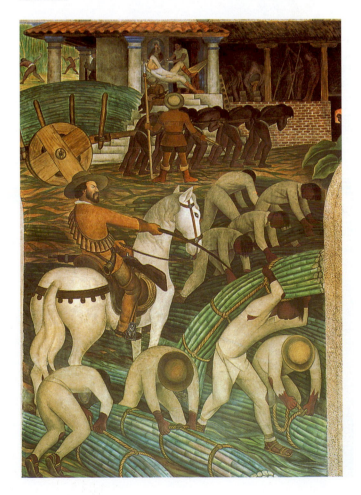

Politics and the Cinema

The art of cinema rose from gritty working-class beginnings to the preeminent popular art form of the twentieth century. The silent film era's greatest pioneer was D.W. Griffith (1880–1948), whose three-hour epic *The Birth of a Nation* (1915) established the fundamental techniques of moviemaking. By the 1920s, the silent cinema was a thriving international industry that defined distinctive movie genres – from the comic genius of Charlie Chaplin (1889–1977) to the brooding German expressionism of *Nosferatu* (1922), the first vampire movie.

In the Soviet Union, a generation of pioneering filmmakers quickly adapted film to political purposes. In 1925, Sergei Eisenstein (1898–1948) made the classic film *Battleship Potemkin*, an international success and one of the most influential films in the history of cinema. The film recounts a 1905 mutiny on a czarist warship, an uprising that foreshadowed the Bolshevik Revolution. To tell the story, Eisenstein [EYE-zen-STINE] used an editing technique called **montage**, the rapid juxtaposition of different images to create an idea or emotion in the viewer. *Potemkin*'s most famous montage sequence is the "Odessa Steps," when czarist soldiers slaughter the townspeople who are cheering the mutineers. The sequence cuts rapidly back and forth between soldiers and victims, while a baby

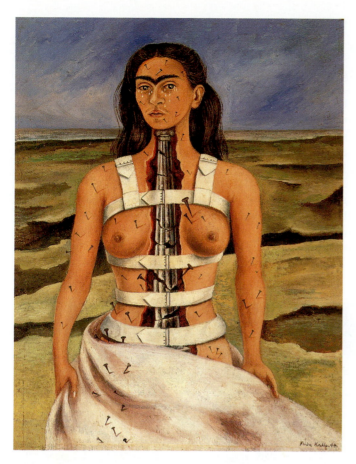

14.29 *(above)* Frida Kahlo, *The Broken Column*, 1944. Oil on canvas, 15³/₄ x 12¹/₄ ins. Fundacion Dolores Olmedo, Mexico City, Mexico.
Kahlo's paintings were largely autobiographical, exploring a persona of fortitude and creative conviction in the face of physical suffering. Compare Grünewald's depiction of the crucifixion in the Isenheim altarpiece, Fig. 9.14.

14.30 *(below)* Pablo Picasso, *Guernica*, 1937. Oil on canvas, 11 ft 5¹/₂ ins x 25 ft 5³/₄ ins (3.49 x 7.77 m). Museo Nacional Centro de Arte Reina Sofía, Madrid.
Picasso's masterpiece protested an atrocity of the Spanish war by translating the event into an allegory of the bullfight. Hulking over a mother and her dead child is the bull, which represented "not fascism, but brutality and darkness," according to Picasso.

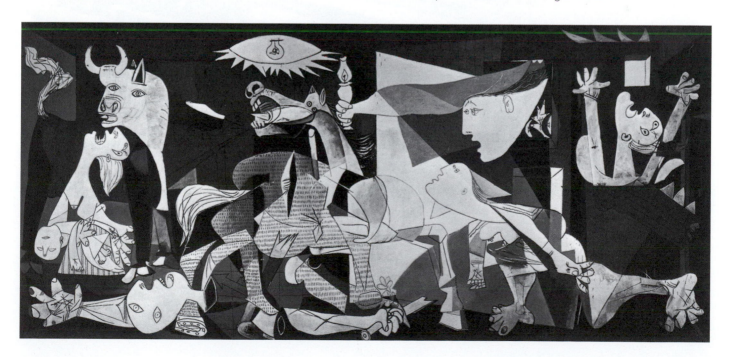

THE WRITE IDEA
Choose a contemporary work of film, video, or photography that you would classify as propaganda. Analyze the political message of the work, paying special attention to its use of the visual medium.

carriage careens down the steps (Fig. **14.31**) – an image symbolizing the vulnerability and innocence of the people.

The introduction of talking movies in 1927 revolutionized the art of cinema, and by the early 1930s international film was dominated by the Hollywood studio system. The commercial film studios produced thousands of movies in a standardized narrative and visual style, carefully fitting star actors into appropriate genres – musical, comedy, Western.

In this era of the classic Hollywood cinema (about 1930–1950), artistic genius flourished, and defined film as a popular and richly varied narrative medium – comparable to the novel in its heyday of Dickens and Balzac.

The classic Hollywood cinema offered welcome relief from economic depression and war. In Germany, however, the Nazis recognized cinema's potential as a medium of political propaganda. Hitler found his own cinematic genius in Leni Riefenstahl (1902–2003). Riefenstahl [REEF-en-stahl] was invited to make a documentary of a Nazi party rally at Nuremberg, with finance from the Nazi government. The resultant film *The Triumph of the Will* (1934) contained visually stunning shots of massed troops and Nazi flags, as well as endearingly human scenes of Nazi youths. While presenting itself as documentary, *Triumph of the Will* effectively communicated both

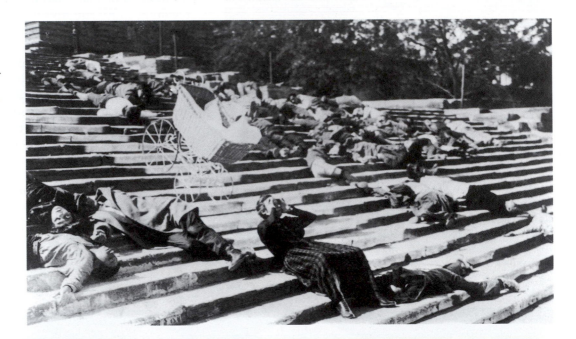

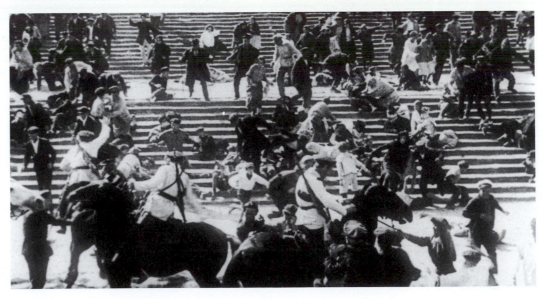

14.31 Sergei Eisenstein, shots from the "Odessa Steps" sequence from the film *Battleship Potemkin*, 1925. Eisenstein's *Battleship Potemkin* symbolized to many Westerners the cultural progress of revolutionary Russia. This famous montage sequence illustrated Eisenstein's effective alternation of brief shots.

Hitler's hypnotic power as an orator and his ordinariness and vulnerability. Though the film was no great popular success, Riefenstahl recorded the spectacular pageantry and mass solidarity of Nazi politics in a way that explains its popular appeal.

In the American Grain

Identify the most significant American innovators of the modernist era.

The modernist period – about 1900–1950 – saw an artistic flowering in a North America stimulated by its contact with Europe but no longer culturally dominated by Europe. New York City was the center of New World modernism, although post-revolutionary Mexico (see page 406), Chicago, and California all fostered modernist genius, too. It was in New York that Marcel Duchamp created his ready-mades (see page 393), and the 1913 Armory Show drew tens of thousands to gawk at cubist paintings and abstract art.

Regionalism and Renaissance

In New York City, a group of gifted Americans gathered around Alfred Stieglitz (1864–1946), often called the father of modern photography. Stieglitz pioneered the art of "straight" photography – photographs that artfully captured visual truth without manipulation or influence from other arts. Stieglitz was joined in New York by the painter Georgia O'Keeffe (1887–1986), whose works transmuted organic shapes – flowers, skeletons, landscapes – into abstract forms. O'Keeffe's attraction to the pure forms of nature was shared by a group of West Coast photographers who called themselves the **f/64 Group**. Rather than Stieglitz's city scenes, the f/64 photographers trained their cameras on Western landscapes and the curves and volumes of flowers or fruit (Fig. **14.32**), finding there a purity of form and eternal beauty that linked them to the American landscape tradition.

In Harlem, uptown from Stieglitz's New York avant-garde gallery, a dynamic group of poets and artists created the **Harlem Renaissance**, a flowering of African-American letters in the 1920s. The movement's intellectual father was W. E. B. DuBois [doo-BOYZ], who declared prophetically in *The Souls of Black Folk* (1903), "The problem of the twentieth century is the problem of the color-line – the relation of the darker to the lighter races of men in Asia and Africa, in America and the islands of the sea."[12] Among its most important figures were poets Countee Cullen (1903–1946) and Langston Hughes (1902–1967). Hughes powerfully expressed the frustrated desires of black Americans in such poems as *Harlem*, with its potent questions: "What happens to a dream deferred? Does it dry up like a raisin in the sun? ... *Or does it explode*?" The Harlem Renaissance also included the young folklorist

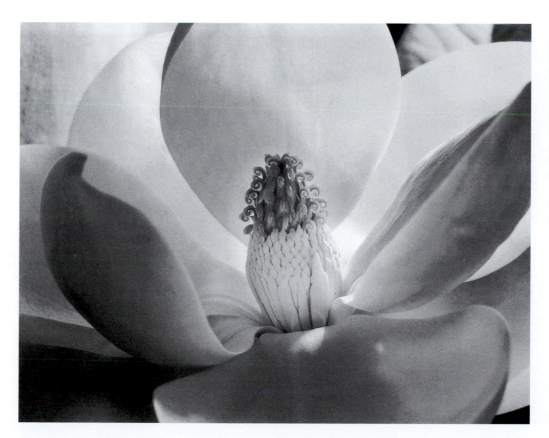

14.32 Imogen Cunningham, *Open Magnolia*, 1925. Photograph. © The Imogen Cunningham Trust, Berkeley, California.

By photographing her floral subjects in extreme close-up, Cunningham revealed the abstract purity of line and shape in nature. Compare the approach of romantic nature painting (see page 340), which sought in nature the revelation of moral and philosophical truth.

14.33 (above) Edward Hopper, *Nighthawks*, 1942. Oil on canvas, 33 x 60 ins (84 x 152 cm). Art Institute of Chicago, Friends of American Art Collection 1942.51.

Hopper painted lonely pastorals of American urban life, stylistically more naturalistic than European modernism.

14.34 (below) Martha Graham's *Appalachian Spring*, 1944, with music by the American composer Aaron Copland and sets by the Japanese-American sculptor Isamu Noguchi.

Copland's music for the last scene of *Appalachian Spring* builds on variations of the familiar tune "Simple Gifts," a melody from the Shaker faith.

Zora Neale Hurston, author of *Their Eyes Were Watching God* (1937), a novelistic rendering of a young black woman's search for love.

Outside New York, American artists drew their literary or artistic innovations from the speech and landscape of American locales – the kind of distinctively American scenes captured by painter Edward Hopper (Fig. **14.33**). Among these American "regionalists," known by their association with various American regions, were the novelist Willa Cather (1876–1947), whose novels were set in Nebraska, and William Faulkner (1867–1962), who created an imaginary Mississippi county filled with intriguing characters. Faulkner's most important novels, such as *Absalom, Absalom!* (1936), achieved a richness of language and complexity of form that ranked him with other masters of the modernist style in fiction.

The American Scene

The invention of **modern dance** – the expressive and often spontaneous dance form based on a rejection of ballet's classical rules – is often credited to the free-spirited American Isadora Duncan (1878–1927). Duncan earned her first dancing job after she exclaimed, "I have discovered the art which has been lost for two thousand years." Thinking she was recreating the ancient art of Greek dance, Duncan was actually challenging the regimented world of classical ballet with her freely interpretive movements. She was famous for her "free dances," in a flowing white costume, moving lyrically on her scandalously bare feet to the strains of Beethoven or Wagner.

Less flamboyant but no less legendary experimenters followed Duncan's example. Trained in the Ballets Russes and the Russian ballet tradition, George Balanchine (1904–1983) found the artistic freedom in New York to create what was called **modern ballet**. Balanchine maintained a rigorously classical training, but his modern ballet sought a more abstract version of classical dance and a freer relationship to music. Martha Graham (1894–1991) fashioned a system of teaching modern dance that made it as rigorous as ballet. Graham taught dance as a means of directly expressing inner states of mind. Her dancers learned to feel opposing forces in their bodies – forces that would draw their bodies down to the floor and then back upright again. Graham's methods were proved in dance works that usually centered on her own performance. She first worked only with female dancers, and she often worked with women's themes. Her works included *Primitive Mysteries* (1931) and *Appalachian Spring* (1944; Fig. **14.34**), a portrayal of a heroic pioneer woman. The music to *Appalachian Spring* was composed by Aaron Copland (1900–1990), whose works frequently quoted from American ballads and folk songs.

The American scene also fostered a budding genius in symphonic music. Composer Charles Ives (1874–1954) captured the aural flavor of American popular life – the Fourth of July, marching bands, and camp meetings – in his *Three Pieces in New England* (1903–1911). One of the work's movements, called "Putnam's Camp," records the sounds of an Independence Day festival, punctuated by a dream sequence full of musical energy. Ives's musical techniques had none of the abstract rigor of Schoenberg's methods, but did explore broad dissonances.

The same special affinity for the American place and people was apparent in the architecture of Frank Lloyd Wright (1869–1959). Influenced by his boyhood summers on a Wisconsin farm, Wright believed that a building should reflect its natural surroundings and mediate between its occupants and their natural environment. Though he designed many types of buildings, Wright's organic sense of form is best expressed in his houses.

Wright's organic theory of architecture is demonstrated in "Fallingwater" (Fig. **14.35**), a vacation house on Bear Run in Pennsylvania. The house is built literally around a waterfall: from its central core, concrete terraces were cantilevered out over the stream, creating a daring, airy effect. Inside, the treatment was just as fluid. Space flowed around a central fireplace, with glass walls looking out over the wooded site. Although technically daring, "Fallingwater" had a serenity that derived from its harmony with the natural setting.

The Age of Jazz

The most distinctly American art form was jazz, a music of popular melodies played with improvisational invention and a characteristic "swing" rhythm. By 1920, jazz music could be heard in the clubs and dance halls of every city with a large African-American population, and by the 1930s it had become popular throughout America and Europe. Mainstream composers adapted jazz melodies and rhythms to concert music, particularly George Gershwin (1893–1937) in his *Rhapsody in Blue* (1924) and his opera *Porgy and Bess* (1935).

Jazz originated as an ensemble music, usually played in collective improvisation, that blended diverse African and European musical elements. **Improvisation** is the technique of composing the musical work while it is being performed. Typically, a jazz soloist improvises variations on a familiar melody, inventing new rhythmic or melodic ideas at the moment of performance.

The first great genius of the jazz solo was trumpeter Louis Armstrong (1900–1971; Fig. **14.36**), probably the best-known figure in the history of jazz. Armstrong migrated from New Orleans to Chicago, where he eventually led his own jazz groups, the "Hot Five" and the "Hot Seven." With his cornet or trumpet, Armstrong was able to mimic jazz singers by bending notes up or down, creating a mournful effect. In songs such as *Hotter than That* (1927), composed by his wife, the pianist Lil Hardin, Armstrong altered the tempo for dramatic effect and "played around the tune," exploring melodic variations

14.35 Frank Lloyd Wright, "Fallingwater" (Kaufmann House), Bear Run, Pennsylvania, 1936–7.

Wright's organic use of setting and materials contrasts sharply with the self-contained designs of Le Corbusier (see Fig. 14.26). Wright used native stone as a material inside and out, and repeated a visual motif (seen in the cantilevered sections visible here) that mimicked the stream's course.

in improvisational style. Armstrong also invented **scat singing**, vocals of nonsense syllables that imitate a jazz instrumental solo. Later in his career Armstrong became an icon of American culture, best known for popular tunes like *Mack the Knife* and *Hello, Dolly.*

The jazz ensemble was revived with the large dance bands of the 1930s and 40s. These so-called "swing" bands expanded jazz's appeal as dance music, especially to white audiences. To meet the enormous demand for jazz compositions, several important jazz composers became prominent, among them Duke Ellington (1899–1974). As one of his players said, "Duke played the piano but his real instrument was the band." Although he composed

longer works, Ellington's most famous pieces, such as *It Don't Mean a Thing (If It Ain't Got That Swing)* and *Satin Doll*, were short enough to be recorded on 78-rpm records. Ellington's music spanned moods from ebullience to melancholy, and it skillfully took advantage of the skills of his gifted band members.

World War and Holocaust

The buoyant sound of jazz swing bands consoled America and the world through the hardship of the Great Depression. But when Adolf Hitler's German armies invaded the rest of Europe and ignited World War II (1939–1945), the Depression dissolved into global war. The confrontation of Axis powers (Germany, Italy, and Japan) and Allies (France, Great Britain, the Soviet Union, and the U.S.A.) demonstrated that Western civilization had made considerable progress, if only in its powers of military destruction. The war witnessed the first use of large-scale aerial bombardment, tank warfare, and (most ominously) atomic weapons. Ultimately in Europe, the

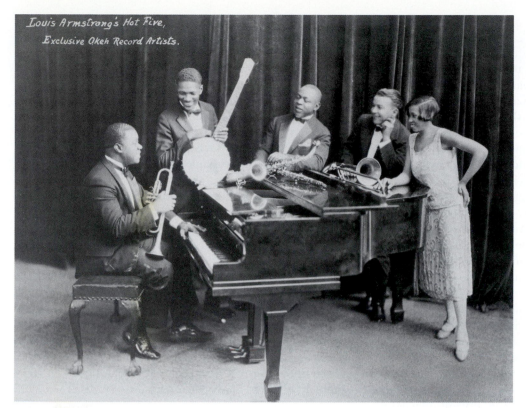

Louis Armstrong's Hot Five,
Exclusive Okeh Record Artists.

14.36 *(left)* Louis Armstrong and the Hot Five, 1925.
Louis Armstrong's recordings with the "Hot Five" and "Hot Seven" in the 1920s defined jazz music as a soloist's art. Armstrong's brilliant gift for musical improvisation influenced every generation of jazz musicians in the twentieth century.

14.37 *(below)* Cloud from the atomic bomb dropped on Nagasaki, Japan, December 9, 1945.
The atomic bombs dropped on Hiroshima and Nagasaki ended World War II with a display of awesome and deadly military power. In Nagasaki, some 74,000 people died from the explosion and its aftermath – more than a third of the city's population.

determination of the Soviet Red Army and U.S. industrial power defeated Germany. In the Pacific, savage fighting had brought Japan to the brink of defeat when the United States employed its awesome new atomic bomb against Japanese cities.

The end of World War II brought more horror to light. As they liberated Europe, Allied forces discovered death camps where the Nazis systematically slaughtered millions of Jews, Slavs, and others, a calamity now called the Holocaust. Christian Europe's ancient anti-Jewish prejudice had culminated in the Nazis' "final solution," a program to eradicate the Jews and other supposed inferior races. Revelations of the death camps shook Western values to their core. In the view of one German philosopher, there was no room left in society for such romanticizing arts as poetry after the horrors of Auschwitz.

A holocaust of another sort was unleashed by the U.S. invention and use of atomic weaponry. The incineration of Hiroshima and Nagasaki in Japan in 1945 by atomic bombs ushered in a new era of human destructiveness (Fig. **14.37**). The apocalyptic scale of its destructiveness meant that a single weapon could alter the course of human history. A mushroom cloud hung over the world at mid-twentieth century.

> After Auschwitz, to write poetry is barbarism.
>
> T. W. Adorno, German philosopher.

CHAPTER SUMMARY

A Turbulent Century In the twentieth century's first decades, new discoveries and catastrophic events shook the foundations of Western civilization. Modern physicists revised their understanding of the Newtonian universe, theorizing that space and time were relative to one's individual standpoint and that sub-atomic particles existed according to probabilistic laws. The Great War of 1914–1918 slaughtered millions and set off the Bolshevik Revolution in Russia, where Lenin established the first self-proclaimed socialist state. In Germany, fascism employed authoritarian rule and anti-Semitic doctrines to gain control of government. Hitler's Nazis and Roosevelt's New Deal used mass media and new documentary art forms to appeal to disaffected masses.

Modernism in Art Artistic modernism discarded artistic tradition and embraced the "primitive" style of African and Pacific art. Picasso's pictorial innovations ignited the cubist style, blazing a path toward greater abstraction in art. Some artists developed modernism toward pure abstraction or non-objective art, while Duchamp and dada attacked the very idea of art, mocking conventional definitions of art. German expressionists, inspired by the example of Matisse, pursued an art of unbridled expressiveness.

The Modern Mind Like artistic traditions, Western intellectual traditions were shaken in the twentieth century. Freud's theory of the mind located the origins of human thought in the unconscious, while psychoanalysis sought the key to psychological development in childhood sexuality. The surrealists applied Freud's theory in their works of "psychic automatism" and bizarre symbolism. Modernist writers revealed their characters' inner psychic life through stream-of-consciousness narrative, while poets employed dense allusion and fragmented form. Ironic modern heroes suffered deep alienation from a perplexing and nightmarish social world.

Modernist Music and Architecture Working with Diaghilev's daring dance company, the Ballets Russes, the composer Stravinsky developed new complexities of rhythm and harmony that disturbed tradition-minded audiences. Schoenberg's atonal music and Berg's atonal operas created an atmosphere of neurotic despair; eventually Schoenberg discarded the major-minor key system in favor of his twelve-tone or serial method. By contrast, modernist architects devised a logical, functional building style typified by Bauhaus architect Gropius's undecorated glass and steel cubes. The art deco style employed in commercial buildings offered a luxurious alternative to modernist austerity.

Art and Politics Art in the modernist era served as a vehicle for political protest and propaganda. Brecht's epic theater sought to stimulate a critical attitude in audiences through his "alienation effect." Mexican muralists revived a Renaissance tradition to criticize colonialism, while Picasso's modernist masterpiece *Guernica* protested against the brutality of modern war. Pioneering filmmakers Eisenstein in the Soviet Union and Riefenstahl in Nazi Germany employed new cinematic techniques in their innovative works of propaganda.

In the American Grain The modernist period brought a new confidence to American artists and authors. In New York, Stieglitz led a movement to make photography a pure art in its own right. The Harlem Renaissance nurtured a brief but intense flowering of African-American literature and art. Outside New York, American regionalists captured the distinctive character of American locales. In dance, Isadora Duncan and Martha Graham helped invent the expressive and spontaneous form of modern dance, while the composer Ives typified a budding American genius in music. Architect F. L. Wright organically linked his eclectic buildings to people and place. North America produced a genuinely new art form in jazz, pioneered by the improvisational genius of jazz musicians such as Armstrong and Ellington. At mid-century, fascism's aggression unleashed the horrors of World War II; the Nazi slaughter of Jews in concentration camps and the United States' use of atomic weapons cast an apocalyptic shadow across humanity's future.

15 The Contemporary Spirit

15.1 Christo and Jeanne-Claude, *Wrapped Reichstag*, Berlin, 1971–95.

Crowds gather around the artists' work of art entitled *Wrapped Reichstag*. The past and future parliament building is located near the site of the Berlin Wall and the Brandenburg Gate. All are symbols of Germany's troubled political past.

One might say the spirit of contemporary civilization was "wrapped up" by an event in the mid-1990s. For two weeks, the artists Christo and Jeanne-Claude cloaked Germany's past and future parliament building with silver fabric and blue ropes (Fig. **15.1**). The building in Berlin was a potent historical symbol, recalling the horrors of war and Germany's long division between democracy and communism. The crowds that gathered to view the wrapped Reichstag were animated by the **contemporary spirit**: exhilarated by global unity, alive with the possibility of new technologies, but a little perplexed by what it all meant and how quickly it changed.

The Age of Anxiety

Explain the artistic and philosophical response to the age of anxiety.

Across the world, in the age that followed World War II, hope for peace was troubled by anxiety about humanity's future. The technology of nuclear weapons assumed a life of its own, sustained by scientists' pursuit of pioneering research and politicians' hope for the ultimate weapon. The rivalry between the United States and the Soviet Union, known as the Cold War, threatened a global nuclear war. Meanwhile, Europe's former imperial colonies won their independence, sometimes peacefully but more often with bloody struggle (see Global Perspective, opposite).

In the United States, ebullient consumerism did not quench some artists' thirst for spiritual meaning. Meanwhile, Europeans explored a new aspect of the human condition – the possibility that human existence has no ultimate or transcendent meaning, that it was absurd.

Post-war America

By 1950 the United States had emerged as the world's dominant economic power, its consumer products and brands giving the world an American stamp. North American artists responded to the widening consumer culture with a search for inner truth and artistic purity. Jazz, for example, saw a revival of improvisational purism in jazz in the style called "be-bop." Be-bop's more jagged, adventurous style was perfected by saxophonist Charlie "Bird" Parker (1920–1955). On such be-bop classics as *Little Benny* (1947) and *Bloomdido* (1950), Parker's searching improvisations maintained only the chords of the original tune. As a relentlessly innovative improviser, Parker's influence in jazz is rivaled only by Louis Armstrong's.

Parker's exploratory solos of be-bop jazz marked the direction that jazz took in the post-war era. The insistent experimentation of musicians such as Parker, John Coltrane, Miles Davis, and their successors later restricted jazz to small and musically knowledgeable audiences.

But it also spawned the immensely popular forms of rock-and-roll and rhythm-and-blues, the basis of most contemporary pop music.

As in the nineteenth century, materialism was associated with spiritual alienation and emptiness. The poet Allen Ginsberg (1926–1997) belonged to a 1950s group of writers called the Beats, American writers who explored themes of rootlessness and the endless quest for meaning. In one poem, Ginsberg describes an encounter with the ghost of Walt Whitman, the nineteenth-century American poet, in a California supermarket. Ginsberg's consumer images seem to ask whether well-stocked supermarket aisles mask a spiritual desolation in the midst of material prosperity.

I saw you, Walt Whitman, childless, lonely old grubber, poking among the meats in the refrigerator and eyeing the grocery boys.
I heard you asking questions of each: Who killed the pork chops? What price bananas? Are you my Angel?
I wandered in and out of the brilliant stacks of cans following you, and followed in my imagination by the store detective.
We strode down the open corridors together in our solitary fancy tasting artichokes, possessing every frozen delicacy, and never passing the cashier.
Where are we going, Walt Whitman? The doors close in an hour. Which way does your beard point tonight?
(I touch your book and dream of our odyssey in the supermarket and feel absurd.)[1]

ALLEN GINSBERG
From Howl and Other Poems (1955)

While the Beats' quest took them "on the road" (the title of a Beat novel), a group of American women authors turned inward. Called the "confessional poets," these writers recorded intensely intimate accounts of their personal lives. Their spiritual self-searching was compounded with their protest against the subordinate roles often forced on them as women. The confessional poet Anne Sexton (1928–1974) employed graphic images of female sexuality and menstruation, topics seldom explored by male poets. Another confessional, Sylvia Plath (1932–1963), was author of the autobiographical novel *The Bell Jar* (1963), which described her fascination with suicide. Both Plath and Sexton eventually took their own lives.

Exploring the Absurd

Amid the horror and spiritual desolation left by World War II, a new philosophy explored the possibilities for human freedom and meaningful action in the nuclear age. The philosophy of **existentialism** [eks-iss-STEN-shull-ism] (see Key Concept, page 418) sought engagement in a world that was essentially "absurd," empty of

Gandhi and Colonial Liberation

In the post-1945 period, the nations of Africa and Asia shed the yoke of Western imperialism and won national independence. The first triumph in this historical process was India's struggle against British rule, led by the activist sage Mohandas K. Gandhi (1869–1948), known as Mahatma ("Great-souled"). Gandhi's philosophy of principled, non-violent resistance would influence many of the century's struggles against injustice.

As an Indian lawyer in South Africa, Gandhi suffered the humiliation of the nation's race laws. In organizing South Africa's Indian community, Gandhi first articulated the principle of *satyagraha* (literally "devotion to truth"), the peaceful non-cooperation with unjust laws. Gandhi's philosophy of non-violence was derived from his eclectic interpretation of Christian, Muslim, and Hindu writings, especially the *Bhagavad-Gita*, the ancient dialogue between the god Krishna and an anguished warrior.

Gandhi's principles characterized the pursuit of truth as a kind of combat but without violence. *Satyagraha*, he wrote in his autobiography, "did not admit of violence being inflicted on one's opponent," instead, the opponent "must be weaned from error by patience and sympathy."[2] Gandhi also preached Indian self-sufficiency, urging Indians to weave their own cloth and to boycott British schools.

Gandhi's campaign against Britain's imperial rule of India reached a dramatic climax in 1930 with his famous Salt March. Gandhi's example mobilized thousands of Indians to suffer British violence in disobeying imperial salt laws. When India finally won its independence in 1948, however, Gandhi could not prevent his country's violent partition into Hindu and Muslim nations, modern India and Pakistan (today Pakistan and Bangladesh).

In the next two decades, nations across Africa and Asia gained their independence, often through peaceful negotiation but sometimes in bloody conflict, for example in Algeria and Vietnam. Mahatma Gandhi's principle of *satyagraha* was more often adopted in Western democracies, where advocates used non-violent resistance to protest against racial discrimination, nuclear weapons, and war.

15.2 Mahatma Gandhi.

Gandhi made the spinning wheel a symbol of Indian independence from the manufactured products of British imperialism. When his followers accepted arrest in non-violent resistance to imperial laws, they overwhelmed the justice system and eventually British rulers agreed to Indian national rule.

Existentialism

In the post-war world, the fresh memories of holocaust were overlaid by Cold War confrontations and a mass society of avid consumption. Some philosophers responded to this situation by rebelling against all systems, asserting the need for authentic, individual action in an indifferent world. This attitude was called **existentialism**, a philosophy determined to live without the illusions of a universal order or an essential human nature. Jean-Paul Sartre (see below), a prominent French existential philosopher, said human "existence precedes essence." That is, humans must live their lives without absolute values or divine laws. For the existentialist, there were no assurances of human happiness or worth. There was an absolute freedom – for better or worse – to define what humanity was.

The existentialist hero typically was caught in a Kafkaesque world, faced with a choice between conformity and an anguished but genuine freedom. The French writer Albert Camus (1913–1960) described this predicament in his reinterpretation of the ancient myth of Sisyphus. Sisyphus was condemned by the gods to push a stone perpetually up a hillside. To Camus [kam-YOO], Sisyphus's labor was a metaphor for the absurdity of all human action. The hero recognizes that his efforts will never lead anywhere, never attain fruition or transcendence. Yet, in Camus's version, Sisyphus resumes his perpetual labor with a smile, thus affirming his absurd condition.

Although easily exaggerated and caricatured, existentialism was rooted in a longstanding philosophical issue. Christian philosophers had long assumed that God controlled the universe and gave purpose to human life. Enlightenment philosophers had assumed that reason guided human history; existential philosophers stripped away such presumptions. Sartre believed humans were "condemned to freedom." No divine order had prevented the Nazis' horrible crimes against humanity. On the other hand, no innate human nature prevented humans from acting kindly and responsibly toward each other.

In the works of Sartre and Camus, existentialism was ultimately an affirmative philosophy. In their view, humans could live decently and "in good faith," but only if they understood how precarious and uncertain their values were. To live life fully and responsibly required a recognition of the universe's final absurdity.

THE WRITE IDEA

Recall an experience in your life that taught you about the essential nature of human existence. How does your insight compare with the assertions of existentialist philosophy?

fundamental or ultimate meaning. The existential hero typically faced a circumstance that negated all human effort, like the doctor who combats the bubonic epidemic in Camus's novel *The Plague* (1947). In the face of a meaningless universe, Camus's existential hero can only savor brief moments of joy or achievement.

Jean-Paul Sartre (1905–1980) was an existentialist man of action. With Camus, Sartre [SART(r)] was a leader of the French Resistance during World War II, writing and producing his first play in Nazi-occupied Paris. After the war, he associated himself with the French communists and the movement to free France's colonies, declining the Nobel Prize for Literature in 1964 for political reasons. When Parisian students and workers revolted in May 1968, they acclaimed Sartre as an intellectual father of the student movement. Sartre followed his own prescription for *l'homme engagé*, the human individual engaged in the struggles of his own time.

Sartre expressed his complex and often contradictory philosophical positions in literary works. His best-known play was *Huis clos* (*No Exit*, 1944), in which three characters serve as each other's tormentors in hell. In a revealing scene, a woman guilty of over-riding vanity finds that there are no mirrors in her part of hell. She must rely on a companion to apply her lipstick, and finally despairs that her perceptions of herself must be transmitted through others. The characters' pessimistic conclusion is the play's famous motto: "*L'enfer, c'est les autres*" – "Hell is other people."

Sartre's literary works reinforced his teaching that every human must ultimately take responsibility for his or her own actions. For this reason, Sartre found the existence of God to be incompatible with human freedom. Like Dostoyevsky and Nietzsche before him, Sartre argued that, even if God existed, then humans were still left utterly free. He wrote:

Everything is permissible if God does not exist, and as a result man is forlorn, because neither within him nor without does he find anything to cling to. He can't start making excuses for himself.

Jean-Paul Sartre

Dostoyevsky said, "If God didn't exist, everything would be possible." That is the very starting point of existentialism. Indeed, everything is permissible if God does not exist, and as a result man is forlorn, because neither within him nor without does he find anything to cling to. He can't start making excuses for himself.[3]

Sartre was closely associated with the existentialist woman of action Simone de Beauvoir (1908–1986). De Beauvoir [BOH-vwah(r)] was author of *The Second Sex* (1947), a founding text of modern feminism that criticized "the feminine" as a philosophical category. When women were treated as essentially different from men, she argued, they were robbed of their existential freedom. Their value as persons was defined by and against men's. De Beauvoir wrote frequently about the obstacles to free and equal male–female relationships, including her lifelong relationship with Sartre. As an activist, she closely linked the personal and the political. Her study of existentialism and action, *The Ethics of Ambiguity* (1949), examined the difficulty of making ethical choices in a world without universal rules or values.

The Theater of the Absurd

The "theater of the absurd" rejected realistic devices or explicit political messages. Instead, absurdists used dream, burlesque comedy, and nonsensical language as dramatic metaphors for the emptiness of the human condition. The dramatist who most vividly dramatized a world without God was the Irishman Samuel Beckett (1906–1989), whose comically pathetic characters inhabit a wasteland of empty hopes and futile action. His plays stripped drama to its bare essentials – pairs of characters yoked to each other by dependency, speaking words that barely communicate, acting in the grotesquely exaggerated gestures of farce.

In Beckett's theater, loneliness and alienation are afflictions that dwarf all other human suffering. In his "tragicomedy" *Waiting for Godot* (1952), the tramps Vladimir and Estragon spend their days waiting for a command from "Godot" [go-DOH] that will give their lives purpose. These characters dwell in pointless triviality – no work, no love, no sense of time. They encounter only the sado-masochistic pair of Lucky and the blind Pozzo, who renders the play's bitterest commentary on human life: "They give birth astride of a grave, the light gleams an instant, then it's night once more."[4] In the play's poignant final scene, Vladimir and Estragon decide not to hang themselves from the nearby tree because neither wants the other to be left alone. Better to confront the futility of their wait for Godot together, than for one to be condemned to loneliness.

The theater of the absurd of the 1950s anticipated a more politicized theater of the next decade. One example is *The Persecution and Assassination of Jean-Paul Marat as Performed by the Inmates of the Asylum of Charenton under the Direction of the Marquis de Sade* (1964), written by the German Peter Weiss [vice] (1915–1982) and usually known under the shortened title *Marat/Sade*. The play within a play mixes political commentary, history, and ritualized violence, and centers on a debate between the revolutionary orator Marat and the sexual eccentric Sade.

The Existential Hero

In the fiction of the 1950s, a kind of existential hero emerged who was searching for individual identity in the face of an oppressive or insanely bureaucratic system. The archetype of this existential hero appears in Ralph Ellison's stunning novel *Invisible Man* (1952). Ellison (1914–1994) relates a young black man's encounters with a white-dominated world, including racist civic leaders in his home town, a hypocritical college president, and a political party that wants only to exploit his talents.

Invisible Man is an existentialist *Bildungsroman* (novel of education), a form established in the eighteenth century. The main character (whose name we never learn) struggles to find his own identity, while the absurd world perceives him through stereotyped masks. His invisibility, the narrator says, is not simply a consequence of the color of his skin. It is a condition of the eyes through which others see him. As the narrator says in the novel's prologue, when others "approach me they see only my surroundings, themselves, or figments of their imagination – indeed, everything and anything except me."[5]

In Joseph Heller's novel *Catch-22* (1961), World War II is a symbol of the absurdity of human existence. Heller (1923–1999) portrays the futile efforts of the bomber captain Yossarian to escape from his maniacal commander. The commander keeps raising the quota of bombing missions necessary to be sent on leave. Yossarian hopes to save himself by claiming insanity, but is trapped by the impossible situation of a "Catch-22," which gives the book its title: a pilot "would be crazy if he wanted to fly more missions and sane if he didn't, but if he was sane, he had to fly them. If he flew them he was crazy and didn't have to; but if he didn't, he was sane and had to."[6]

Like Beckett and Ellison, Heller exploited irony and wit to expose the insanities of Yossarian's world. Underneath the comedy, however, is an unrelenting horror at the senselessness of human suffering.

1939–45	World War II; Holocaust of Nazi death camps; first atomic weapons
1940–50	Rise of New York avant-garde
1944	Sartre, *No Exit*
1952	Ellison, *Invisible Man*
1965	Calder, *Spring Blossoms* (15.11)

Art in the Post-war Era

Identify the modernist trends and techniques that were extended or developed by the post-war avant-garde.

For a long while, Western artists had migrated to Paris to join the newest movements or study the latest style. After 1945, the French capital lost its preeminence in the visual arts to the American upstart New York City. New York in the post-war era was to be the heart of the artistic avant-garde (see Key Concept, page 423) – the newest wave of artistic experiment.

One reason for New York's prominence was the war itself. Major European artists such as Piet Mondrian and Walter Gropius had fled Nazi Europe to the United States, where they were an enormous stimulus to American artists.

Meanwhile, the European art world was temporarily suppressed by the war's aftermath and dominated by aging masters of modernism like Matisse, Picasso, and Braque (see pages 394, 387, 388). The innovative spirit erupted in New York. Radical new styles were often encouraged as a symbol of the West's artistic freedom, and compared to the repression of Soviet-style communism.

The New York School

Out of the heady atmosphere of post-war America arose a confident group of artists now called the New York school, whose artistic styles pushed aggressively toward abstraction. Taking their cue from European modernists, the New York school developed a style called **abstract expressionism**. While each painter had an individual style, most abstract expressionists also shared a non-objective style that also had the emotional directness of the expressionists. Hence the combination of "abstract," in the manner of Mondrian and Kandinsky, and "expressionist," in the manner of Matisse and Nolde.

The best-known abstract expressionist was Jackson Pollock (1912–1956), an intense artist whose radical methods symbolized the New York avant-garde. Pollock had been trained as a realist, but in the 1940s his work

15.3 Jackson Pollock, *Number 1*, 1948. Oil and enamel on unprimed canvas, 5 ft 8 ins x 8 ft 8 ins (1.73 x 2.65 m). The Museum of Modern Art, New York. Purchase.
Labeled "Jack the Dripper," Pollock was the best known of the avant-garde New York painters called "abstract expressionists." Some critics saw existential despair in Pollock's "drip" method. Others saw his cryptic canvases as the transcript of a pure and "existential" encounter between artist and materials.

grew increasingly abstract. Finally, he discarded the brush altogether and took to dripping and splattering paint on the canvas, often mixing paint with sand or crushed glass (Fig. **15.3**). Pollock described his painting method in these words:

> My painting does not come from the easel. I hardly ever stretch my canvas before painting. I prefer to tack the unstretched canvas to the hard wall or the floor. I need the resistance of a hard surface. On the floor I am more at ease. I feel nearer, more a part of the painting, since this way I can walk around it, work from the four sides and literally be in the painting. This is akin to the method of the Indian sand painters of the West.
>
> I continue to get further away from the usual painter's tools such as easel, palette, brushes, etc. I prefer sticks, trowels, knives, and dripping fluid paint or a heavy impasto with sand, broken glass, and other foreign matter added.[7]

His method was self-consciously unconscious, akin to the psychic automatism of the surrealists. Such a spontaneous method was also called "action painting." He said, "I have no fears about making changes, destroying the image, etc., because the painting has a life of its own. I try to let it come through. It is only when I lose contact with the painting that the result is a mess."[8]

A host of other New York painters practiced similar principles of abstraction, but with substantially different results. The works of Mark Rothko (1903–1970) are interesting in part because of the religious overtones in his luminous rectangles of color. Rothko left the edges of his rectangular shapes vaguely defined, so that the fields of color gently merged. Hence critics gave the name "color-field painting" to his work. His majestic canvases often evoked in viewers a mood of spiritual contemplation (Fig. **15.4**). A so-called second generation of abstract expressionists emerged in the 1950s to extend the range of New York school abstraction. These included Helen Frankenthaler (b. 1928), who "washed" thinned paints onto raw canvas. Frankenthaler's stained canvases were evanescent, free-form abstractions that had none of the existential anxiety of Pollock and her other predecessors.

Pop, Minimalism, and the Avant-garde

The New York avant-garde that followed abstract expressionism was **pop** (for "popular") **art**, a style far removed from the drip paintings of Jackson Pollock. Pop art borrowed from the mass-produced commercial art of magazines, television, and movies. Pop artists incorporated iconic images and objects – for example, flags or beer cans – into works that posed as "high" art. By crossing between elite and mass culture, pop art brought a refreshing irreverence and accessibility to the avant-garde.

The most flamboyant pop artist was Andy Warhol (1928–1987), whose works of mass-culture images show

15.4 Mark Rothko, *Green and Maroon*, 1953. Oil on canvas, 7 ft 7¹/₈ ins × 4 ft 6⁷/₈ ins (2.3 × 1.3 m). Acquired 1957, The Philips Collection, Washington, D.C.
Rothko wanted his "color-field" paintings to destroy the "finite associations" of ordinary life and refer to a "transcendent realm" of human experience.

little visible attempt at artistic creativity. Warhol worked with the most banal and familiar images he could find, like a Coca-Cola bottle or a Campbell's soup can (Fig. **15.5**). His silk-screened images of Elvis Presley and stacks of Brillo boxes directly challenged the aesthetics of abstraction. By repeating these consumer icons, however, Warhol invested them with an aesthetic value that the same objects lacked when sitting on a supermarket shelf. In other words, any image could be art, just as any person (including himself) could be a celebrity. Warhol became famous for his pronouncement, "everyone will be famous for fifteen minutes."

The pop artist Robert Rauschenberg [ROW-shun-berg] (b. 1925) studied at Black Mountain College in North Carolina, where he came into contact with other avant-garde innovators. Rauschenberg's pop works followed in the tradition of dada artists, who often created art from discarded objects. In the late 1950s, Rauschenberg devised his "combine paintings," mixed-media compositions of photographs, silk-screens, and "found" objects. His *Monogram* (Fig. **15.6**) rehabilitated the refuse of mass society and charged it with new meaning.

15.5 (right) Andy Warhol, *200 Campbell's Soup Cans*, 1962. Oil on canvas, 6 ft x 8 ft 4 ins (1.83 x 2.54 m). Private Collection. Courtesy Leo Castelli Gallery, New York.

Warhol was the best known of the "pop" artists, who drew their imagery from the mass culture of post-war consumer society.

15.6 (below) Robert Rauschenberg, *Monogram*, 1955–9. Construction, 5 ft 4½ ins x 3 ft 6 ins x 5 ft 3¼ ins (1.64 x 1.07 x 1.61 m). Moderna Museet, Stockholm.

Rauschenberg's "combine" paintings merged painting and printmaking into three-dimensional sculptures of "found" objects like the stuffed goat and tire here.

The Avant-garde

In the 1950s, the New York school represented the latest incarnation of the **avant-garde**, the label applied to artists and writers who define the newest wave of artistic experiment. Although the modernists did not consciously use the term, their rejection of traditional forms in art, music, and literature was an important phase of the avant-garde. Inevitably, however, modernism itself became the artistic tradition which the New York school claimed to be "in advance of."

As often happens in cultural history, the New York school of painters relied on critics to explain their significance as the new avant-garde. The New York art critic Clement Greenberg argued that Jackson Pollock (Fig. **15.7**) and the abstract expressionists represented the next logical development of modernism because their work was *new*. Innovation, along with artistic technique and vision, became an essential criterion for judging the arts. The novelty of abstract expressionism was so radical, however, that Greenberg feared it would estrange wealthy collectors and patrons. He pleaded for New York's elite to buy avant-garde works, so that genuine art would not lose its "umbilical cord of gold."

Greenberg's writings revealed the continuing paradox of the idea of the avant-garde. To forge ahead, avant-garde artists could not be too bound to social or artistic conventions. Yet if their work was to be understood (and purchased), it had to communicate intelligibly to a significant audience. Greenberg's essays on abstract expressionism were intended to educate potential patrons about the value of avant-garde innovations.

Today, much publicly funded art seen in university and public galleries suffers from the same paradox. How do avant-garde artists achieve innovation and freedom of artistic expression, and still find understanding among the public that supports their work? On the other hand, what fresh insights are lost to a public that does not support an artistic avant-garde, the very artists who challenge conventional assumptions about art's definition or meaning?

15.7 Jackson Pollock at work in his Long Island studio in 1950. Pollock's radical painting methods and cryptic abstract canvases were an emblem of the post-1945 avant-garde.

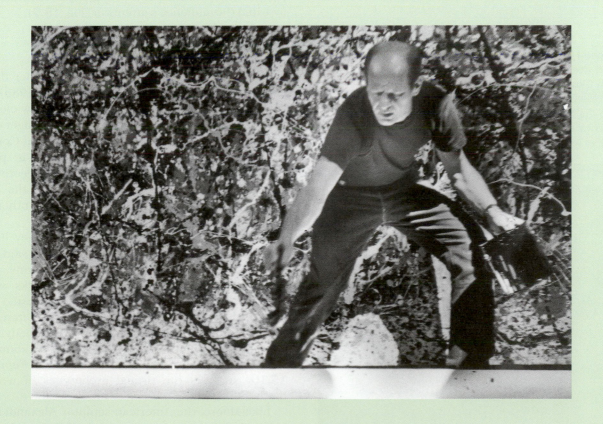

By 1960, an abstractionist trend in the arts was leading toward extreme objectivity that was intentionally anti-expressionist. The "hard-edge" painters of this trend worked in large geometric forms of uniform color. The fields of color were flat and delineated by a precise "hard" edge. The sculptural version of this trend, called **minimalism**, also worked in large-scale geometric forms, stripping sculpture of all content or decoration. Minimalist sculptors limited themselves to simple and unadulterated materials, such as plain lacquered planks or precisely machined aluminum boxes. The sculptor Donald Judd (1928–1994), for example, purged his work of any reference to other objects or ideas (Fig. **15.8**). He chose sculpture to do away with "illusionism," which he called one of "the most objectionable relics of European art."[9] Judd purchased a town-sized fort in Marfa, Texas, as a shrine to contemporary art, filling one warehouse with a hundred identical milled-aluminum boxes. As the scale of minimalists' sculptures grew, they were often sited outdoors, where they became part of an urban or natural landscape.

While minimalist sculptors questioned the work of art as a finished object, other avant-garde artists stressed art as idea and process. By 1960 the avant-garde scene was witness to "happenings," intentionally provocative and improvisational events executed by artists. Out of the happenings grew a new genre called **performance art** – theatrical presentations by a single artist that often mixed visual arts and media. The most radical of the

performance artists was the German Joseph Beuys (1921–1986), one of the post-war avant-garde's most influential figures. Trained as a sculptor, Beuys [boyz] proclaimed sculpture "as an evolutionary process; everyone an artist." His signature performance "actions" often cryptically juxtaposed art and nature. In "How To Explain Paintings to a Dead Hare" (1965), he toured an art gallery in conversation with an animal carcass.

In dance, the avant-garde spirit of improvisation and collaboration was best realized in Merce Cunningham (b. 1919), a graduate of Martha Graham's modern dance school. Although Cunningham's dance choreography was classically abstract and technically demanding, he built spontaneity into his performances – sometimes choosing the sequence of movements in a dance by flipping a coin. Several of his works were performed with sets designed by Rauschenberg and other artists of his time, and he believed that music, dance, and setting should be independent of one another, creating visual dissonances that arrested the audience's attention (Fig. **15.9**).

Sculpture in the Post-war Era

At mid-century the sculptural arts fell under the influence of Englishman Henry Moore (1898–1986), whose smoothly carved organic forms added a new element to the vocabulary of modernism. Moore, a younger contemporary of the modernists, acknowledged that Constantin Brancusi (see page 392) had succeeded in purifying sculpture. After experimenting with non-objective sculpture, however, Moore began to work in the massive human forms that he saw in Aztec and other native American sculpture.

Moore crafted his works to look as if they had been shaped by the timeless forces of nature. He said, "I have always paid great attention to natural forms, such as bones, shells, and pebbles."[10] Moore's works were less severe than earlier modernism and contrasted sharply with the hard-edged works of minimalism. Often suggesting the solidity of the earth and the human body, Moore's carvings took on a "human, or occasionally animal character and personality." The *Recumbent Figure* (Fig. **15.10**) suggests the primal archetypes of woman or mother and child.

Like Moore, the American sculptor Alexander Calder (1898–1976) was a contemporary of Miró and Mondrian.

15.8 Donald Judd, *Untitled* (*Perforated Steel Ramp*), 1965. Perforated steel, 119$\frac{1}{4}$ × 8$\frac{1}{4}$ × 65$\frac{3}{4}$ ins (303 × 21 × 167 cm). Collection Giuseppe Panza di Biumo-Varese.

The minimalist Donald Judd created radically understated sculptural works, like this metal ramp. The artist eventually removed himself entirely from the work's manufacture, having an industrial shop fabricate the "sculpture" according to his exact specifications.

15.9 (above) Merce Cunningham in *Travelogue,* 1977.
Set designed by Robert Rauschenberg.
Cunningham often choreographed his dance works by flipping a coin
or by other chance methods.

15.10 (below) Henry Moore, *Recumbent Figure,* 1938.
Green Horton stone, length 4 ft 7 ins (1.40 m). Tate, London.
Moore, a transitional figure between early modernism and post-
war sculpture, explored the interaction of sculptural void and
mass. His smoothly carved figures suggest primal archetypes of
woman or mother and child, akin to the pre-Columbian sculpture
that he admired.

Calder's characteristic works were assemblages of cut-out shapes suspended in air, dubbed by Duchamp as **mobiles**. The different shapes of Calder's mobiles seemed to be borrowed from Miró's surrealist paintings (see Fig. 14.19). By suspending them on wire, however, Calder introduced an element of chance into the parts' movement and interaction (Fig. **15.11**). Other Calder mobiles were motorized so that the motion was constant and predictable. From the 1940s, Calder became interested in monumental works that interacted with the surrounding environmental space. He called these "stabiles," large stationary works made from cut-out metal plate, which often stood on plazas.

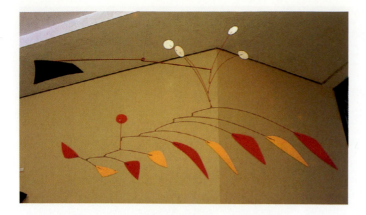

15.11 Alexander Calder, *Spring Blossoms*, 1965. Painted metal and heavy wire, height 4 ft 4 ins (1.32 m). Palmer Museum of Art of The Pennsylvania State University, Gift of the Class of 1965.
Calder often suspended his mobiles from the ceiling, where a breath of air might set them in motion. The lyrical whimsy of his mobiles provided an important connection between the modernists and post-war sculpture.

THE WRITE IDEA
Compare the sculptural works featured here and choose the one that you would most like to see firsthand. What appeals to you about this particular work's material and shape?

Constructed metal sculpture was the preferred medium of David Smith (1906–1965), the most important North American sculptor in the post-war era. Smith had no academic training as a sculptor or first-hand contact with the modernists. Having learned to weld in an automobile plant, he created large metal constructions whose abstract shapes were inspired by the Soviet constructivists and their effort to unite art with industrial design and technology. He produced works that clearly represented the machine age; metal, he said, "possesses little art history." His machinist skills enabled Smith to explore the aesthetic qualities of steel: sometimes the surface was polished to a high sheen (Fig. **15.12**) and other times it was scraped away to create texture.

Louise Nevelson (1900–1988) used the refuse of industrial society to compose her sculptures of discarded

15.12 David Smith, *Cubi XVIII, Cubi XVII, Cubi XIX*, 1964, 1963, 1964. Heights 9 ft–9 ft 8 ins (2.74–2.95 m). Tate, London.
Smith's *Cubi* series combined large geometric shapes in dynamic composition. Consider Smith's play with balance and mass in these monumental standing constructions. How does the natural setting shown here enhance their visual impact?

The Trials of Modern Architecture

Summarize the artistic goals of post-war architecture, as evident in the works of the International Style.

The Great Depression and World War II suspended most large-scale building projects in the United States and Europe through the 1940s. As architecture was revived in the post-war period, the monolithic glass towers of the International Style developed into the dominant language of urban building. The centers of North American cities became forests of glass skyscrapers in the austere, geometric style of modernist architecture. At the same time, architects experimented with more sculptural designs, especially in smaller-scale building. While these post-war styles realized the architects' artistic aims, they also often suffered from a tension between architectural form and intended function. In the post-war era, modern architecture's artistic vision was put to the test of social usefulness and durability.

Triumph of the International Style

The German architect Ludwig Mies van der Rohe [MEES van-der-ROH-uh] (1886–1969) was already a leading architect of the pre-war International Style when he emigrated to the United States. Once Mies settled in Chicago in 1938, he boldly redefined the city's skyscraper tradition, proclaiming that, in architectural design, "Less is more!" Mies's monolithic glass-and-steel towers served as high-rise apartment buildings and as government offices. Outside Chicago, Mies designed a private residence with outer walls of nothing but $9\frac{1}{2}$ foot-high (3 m) panes of glass. The disgruntled owner complained, "Less is not more. It is simply less!"

Mies's restrained style became the preferred idiom of office buildings. His Seagram Building (Fig. **15.14**) in New York, co-designed with Philip Johnson, was a simple thirty-eight-story box on metal stilts, with an exterior of bronze I-beams and a gray-tinted glass skin. Mies was recruited for the project by the daughter of the president of the Seagram distilling company, who liked Mies's use of metal beams as both a decorative and a structural element, which she compared to the Greek architectural orders. The Seagram Building offered North American corporations a style of unadorned purity on a grand scale.

The International Style became truly internationalized in the post-war building boom, though not always with happy results. Miesian skyscrapers created inhospitable urban centers in booming cities such as Houston, Texas, and Brasilia, the new capital of Brazil. India's newly independent government commissioned Le Corbusier to build an entire new capital at Chandigarh in Punjab. When used in mass housing, International Style buildings

15.13 Louise Nelson, *Black Wall*, 1959. Wood, 112 x 85¼ x 25½ ins (264.2 x 216.5 x 44.8 cm). Tate, London.
Nelson composed her wall assemblages from "found" wood objects – chair slats, spindles, and benches. Compare her use of found materials to Rauschenberg's in *Monogram* (Fig. 15.6).

boxes, furniture, and other off-casts. Sculpture built up from such disparate, often "found" materials, is called **assemblage**, a method pioneered by cubism and Duchamp. Nevelson composed her assemblages from found wood objects – chair slats, spindles, and benches. These odd components, enclosed within crate-like boxes and built into an imposing wall of shapes and textures, were often unified by the single color of the paint. The paint reminded the viewer to see these as artistic shapes, as well as the rehabilitated refuse of modern urban society (Fig. **15.13**). In a sense, Nevelson's wood assemblages were the opposite of Warhol's pop art, an art of authentic objects instead of an art of image.

> Less is more!
>
> Ludwig Mies van der Rohe

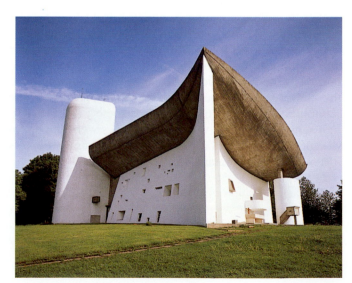

15.14 *(left)* Ludwig Mies van der Rohe and Philip Johnson, Seagram Building, New York, 1954–8. Height 512 ft (156.2 m). Mies's glass-and-steel box was the logical outcome of the International Style, invented by modernist pioneers Walter Gropius and Le Corbusier. Similar skyscrapers dominated the skylines of North American cities in the 1960s and 70s.

frequently became unlivable Babels of crime, violence, and human alienation. Le Corbusier's confident vision of a "radiant city" of glass towers turned into bitter failure.

Building as Sculpture

The triumph of Mies's angular purity did not prevent other architects from seeking new directions. Even the pioneer of International Style, Le Corbusier, increasingly abandoned his box-like "machines for living" to explore the potential of building as sculpture.

A dramatic example of building as sculpture was Le Corbusier's Ronchamp [rohn(h)-SHAHN(h)] Chapel (Fig. **15.15**), a small pilgrimage church in a village in eastern France. The church's trademark is the swooping roof, whose curves rise to form what resembles the prow of a ship. The shape was also compared to a nun's hat or a crab shell (Le Corbusier's own organic metaphor). The building's sculptural plasticity carries over to the interior, where the massive sloping walls are pierced by irregular funnel-like windows. Gone was Le Corbusier's interest in a smooth, mechanical "skin" for his buildings. Instead, the roof showed his use of rough (in French, *brut* or "raw") concrete, an unfinished surface that showed the marks of the wooden forms.

15.15 *(below)* Le Corbusier, Notre-Dame-du-Haut ("Our Lady of the Heights"), pilgrimage church of Ronchamp, France, 1950–4. Compare the swooping lines of this church exterior to the rectilinear logic of the architect's Villa Savoye (Fig. 14.26).

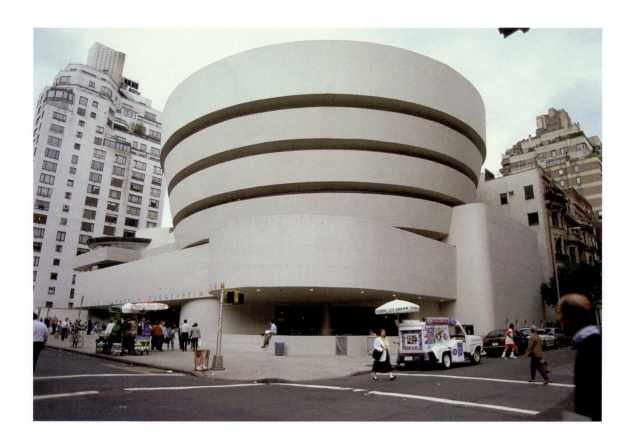

15.16 Frank Lloyd Wright, Solomon R. Guggenheim Museum, New York, 1957–9. Largest diameter 128 ft (39 m), height 92 ft (28 m). Guggenheim Museum, New York.
Completed after Wright's death, the Guggenheim realized his ambition to create a purely sculptural building.

In his Solomon R. Guggenheim Museum (Fig. **15.16**), his last great building commission, Frank Lloyd Wright achieved a plasticity that few modern buildings surpassed. As Wright said, "Here for the first time architecture appears plastic, one floor flowing into another (more like sculpture) instead of … stratified layers cutting and butting into each other."[11] The building's interior was a helix of spiral ramps, widening as they rose, enclosing a central, glass-domed atrium. The same spiral was expressed on the exterior in a shape resembling an inverted beehive.

The Guggenheim Museum was, indeed, a beautiful work of sculptural architecture. However, built to house a famous collection of modern art, the Guggenheim's curving walls and narrow exhibition space were ill-suited to its primary function. Some hinted that the Guggenheim was Wright's last joke on artistic modernism, which he always disliked. The joke was on New York, too. One can hardly imagine a building less married to its surroundings than the Guggenheim Museum, which perches on New York's Fifth Avenue like a giant concrete snail.

The height of sculptural vision in post-war architecture was attained by Jörn Utzon (b. 1918), who designed the Sydney Opera House in Australia (Fig. **15.17**). Utzon's [OOT-tsohn] prize-winning design for the cultural center envisioned gleaming, sail-like shells lifting from a rectangular base. The shells would serve as both ceiling and wall, with the open faces encased in a curtain of glass. Built on a spit of land jutting into Sydney harbor, the arching shells would present a splendid view to all four sides. However, the problems in constructing Utzon's design proved to be enormous. The construction delays and cost overruns were so frustrating that Utzon resigned from the project in 1966, to be replaced by a team of architects. This group had to redesign the building's interior and the original estimated cost of seven million dollars rose eventually to one hundred million dollars. This most difficult trial of modern architecture illustrates the uneasy relation between the modern architectural imagination and practicality.

1950–4	Le Corbusier, Notre-Dame-du-Haut, Ronchamp, France (**15.15**)
1956	Stockhausen, *Gesang der Jünglinge*
1959	J. Utzon begins Sydney Opera House; completed 1972 (**15.17**)
1967	García Marquéz, *One Hundred Days of Solitude*
1976	Glass, *Einstein on the Beach*
1980–3	Graves, Public Services Building, Portland, Oregon (**15.21**)

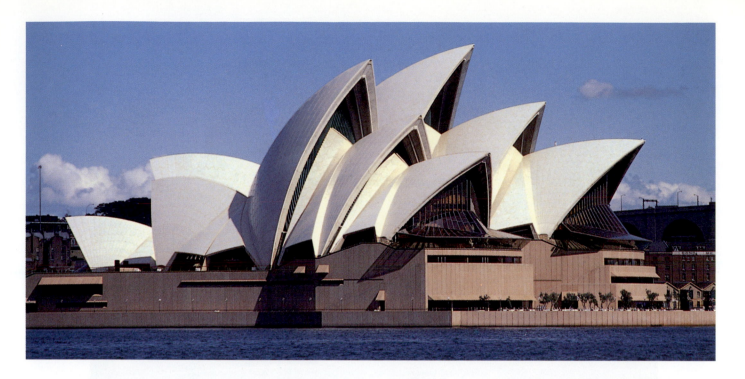

15.17 Jörn Utzon, Opera House, Sydney, Australia, 1959–72. Height of tallest shell 200 ft (61 m).

"Instead of making a square form," Utzon wrote of the opera house, "I have made a sculpture." The architect had to invent the technology to build the ferro-concrete shells (ten in all), which were all curved to the same radius. The finished building may be compared to a Gothic-style church, in both its soaring lines and the difficulties and expense of construction.

Post-1945 Music

Describe the two major trends in avant-garde music after 1945.

Music in the 1950s and 60s saw an avant-garde scene move farther from popular audiences, while popular music itself was revitalized by a rebellious new form called rock-and-roll. The use of electronic instruments and computers satisfied the desire of some composers for total musical control. Spontaneity, chance, and a rocking good time were still the goals of others.

The Avant-garde in Music

One trend in post-war music extended the experiments of serial composer Arnold Schoenberg toward a music of ever more precise calculation. The French composer Pierre Boulez [boo-LEZZ] (b. 1925) devised a method called **total serialism**, in which he calculated every aspect of a composition – pitch, duration of notes, dynamics – according to numerical formulas. In his two-piano composition *Structures I* (1952), the prescribed patterns interact to create a shifting, sometimes elusive texture of sound. Boulez was probably the single most influential composer in post-war concert-hall music.

The trend toward total control intensified still further with the advent of electronic music. Electronic devices – synthesizers, electronic instruments, and computers – allowed composers to manipulate rhythm, tone, harmony, and dynamics with complete precision. The composer no longer had to rely on the interpretation or execution of a performer. Milton Babbitt (b. 1916) was among the first to use a music synthesizer, carefully controlling tone color and tempo. Babbitt acknowledged the difficulty of his works for audiences in an essay entitled, only half-jokingly, "Who Cares if You Listen?".

The best-known composer of electronic music was the German Karlheinz Stockhausen [SHTOK-how-zen] (b. 1928), whose *Gesang der Jünglinge* (*Song of Youths*, 1956) consisted of a biblical text sung and chanted against an electronic accompaniment. The singer's voice was altered electronically so that it ranged between the extremes of pure noise (unorganized sound) and pure musical tones. The composer explained, "Whenever speech momentarily emerges from the sound-symbols in the music, it is to praise God."[12] In 2002, Stockhausen completed work on a mammoth cycle of seven operas entitled *Licht* (*Light*) that require twenty-nine hours for an entire performance.

John Cage and the Music of Chance A quite different avant-garde trend was defined by John Cage (1912–1992), a witty creator of highly unconventional music. Cage joined the New York avant-garde scene in the 1940s, after studying in Europe with Schoenberg. In New York, he became interested in Oriental philosophy, especially the

Zen Buddhist principle of non-intention, or "mindlessness." Under the influence of Zen, Cage composed works that reduced the role of choice or decision in composition. In 1951, he wrote a piece for piano by flipping a coin to decide the sequence of tones – hence the term **aleatory music** [AY-lee-uh-tor-ee] (from the Latin *alea*, or dice).

The signature composition of aleatory music was Cage's *Imaginary Landscape No. 4* (1951), which called for twelve radios, each tuned to a different frequency. Another famous Cage work reached to the very boundary of music itself – silence. His *4'33"* (1952) instructed the performer to sit with his or her instrument for the specified time, playing nothing. The "music" consisted of the audience's reaction and other chance sounds in the auditorium. Cage collaborated closely with dance choreographer Merce Cunningham (see page 424), who also employed chance operations in his dance.

The Pop Rebellion

Despite the avant-garde's esoteric experiments, the concert hall did not lose all its popular appeal. Conductor and composer Leonard Bernstein (1918–1990) introduced classical music to wide audiences through children's concerts and television programs. Bernstein's works for musical theater, including *Candide* (1956) and *West Side Story* (1957), updated literary classics with contemporary musical ideas. The number "Mambo," from *West Side Story*, adapted the finger-snapping rhythms of Afro-Cuban jazz, which combined Latin rhythms with the inventive improvisations of be-bop.

No theater tune was a match, however, for the hip-rolling rebellion of **rock-and-roll** music – a pop style featuring electric guitars and a strong rhythmic drive. The charismatic Elvis Presley and other early rock stars skillfully reinterpreted traditional African-American blues styles for their white audiences and infused this tradition with youthful energy.

Elvis and other North American rock-and-rollers transmitted their music via tours and recordings to Britain, where it was taken up by bands in working-class cities. The resultant "British wave" of rock-and-roll was led by the Beatles, a clean-cut group from Liverpool whose love songs charmed the Anglo-American public. The Beatles' revolutionary album *Sergeant Pepper's Lonely Hearts Club Band* (1967) was a landmark in popular music. It was the first rock-and-roll record to present itself as a coherent musical whole, rather than a collection of popular tunes.

Meanwhile in the United States, the civil rights movement and racial integration provided new avenues for African-American musicians. The signature style of this new era was rhythm-and-blues (also called "soul"), a music with a strong rhythmic ground and blues inflections. Talented rhythm-and-blues singers such as Wilson Pickett, James Brown, and Diana Ross became pop stars on a great scale, known all round the world.

Post-modern Styles

Illustrate the stylistic tendencies of post-modern art with examples from several media or forms.

One social critic called the later twentieth century a "post-industrial society," dominated by the exchange of information rather than material production. This new age was characterized by rapid social change, shifting boundaries, and a loss of certainty. In response, a new sensibility emerged called **post-modernism**, which could be summarized as:

- skepticism toward any representation of reality that claimed to be universal or objective;
- a focus on the "construction of reality" through language and symbol;
- an emphasis on the local and particular rather than the universal;
- in the arts, a tendency toward parody, pastiche, and an eclectic mixture of styles.

Post-modernism had learned to stop seeking redemption or expecting life to make sense. As one commentator said, post-modern humanity had "stopped waiting for Godot":

> To the existentialists, the discovery of a world without meaning was the point of departure; today a loss of unitary meaning is merely accepted; that is just the way the world is.[13]

Post-modern artists had to find their place between two overwhelming cultural forces. On the one side were modernism and its heroic inventors – Picasso, Joyce, and Schoenberg. On the other side was the mass culture of television, film, and advertising, with its capacity to absorb avant-garde techniques. Toward their modernist predecessors, contemporary artists adopted an attitude of ironic or playful quotation. In an installation at the Guggenheim Museum, for example, Jenny Holzer (b. 1950) used the museum's spiraling white interior as a billboard for her provocative slogans (Fig. **15.18**). By choosing her artistic medium from the realm of advertising, however, Holzer sought to compete with the blaring commercial messages of mass culture.

For this reason, noted one critic, the challenge for post-modern artists is "to choose and combine traditions selectively, to *eclect* (as the verb of eclecticism would have it) those aspects from the past and present which appear most relevant for the job at hand."[14] Post-modern works were often stylistic hybrids. A post-modern novel such as Umberto Eco's *The Name of the Rose* (1980) could be detective fiction, Gothic novel, and learned treatise, all in one. Post-modern buildings quoted decorative motifs from Renaissance and neoclassical architecture.

15.18 Jenny Holzer, *Untitled (Selections from Truisms, Inflammatory Essays, The Living Series, The Survival Series, Under a Rock, Laments and Child Text)*, 1989. Extended helical tricolor L.E.D, electronic-display signboard, site-specific dimensions 16½ ins x 162 ft x 6 ins (41.9 cm x 49.3 m x 15.2 cm). Solomon R. Guggenheim Museum, New York, Partial Gift of the artist, 1989 89.3626

Holzer's banal "mock clichés" flash along the spiraling ramps of F. L. Wright's Guggenheim Museum. Post-modern art often consciously quoted from classical modernism and other historical styles, while also drawing from the slogans and images of mass culture.

Meanwhile, post-modern philosophy questioned whether the author or artist really existed. It claimed that, in the post-modern era, the human "subject" – the autonomous, individual, rational self – was disappearing. Its place was being taken by the "protean" self, a constantly changing and evolving self, made of the interwoven voices and images of post-industrial culture. Under such circumstances, buildings still managed to get built, novels written, plays produced, and music performed. Post-modernism's announcement of the "end" of culture may have been premature.

Post-modern Architecture

Post-modern architecture arose from a reaction against modernism's negation of the architectural past. Modernists such as Mies van der Rohe insisted on buildings in which nothing distracted from the clarity of form. Contemporary architects responded with an open-minded eclecticism, a willingness to borrow and compromise. Robert Venturi (b. 1925), a pioneer of this new eclecticism, wrote in 1966: "Architects can no longer afford to be intimidated by the puritanically moral language of orthodox Modern architecture. ... I am for messy vitality over obvious unity."[15]

One flamboyant response to modernist purism was the high-tech architecture of the Georges Pompidou National Center for Arts and Culture (1977) in Paris (Fig. **15.19**). Like so much French public architecture, this museum was a political monument (dedicated to a former French

president) and a statement of French nationalism. With this brash museum dedicated to contemporary art, music, and culture, Paris hoped to regain some of the prominence lost to New York in the 1950s.

Designed by Renzo Piano (b. 1937) and Richard Rogers (b. 1933), the Pompidou Center was a high-tech fantasy. The building's mechanical guts – heating and cooling ducts, plumbing, service elevators – are its skin, brightly colored for visual emphasis. Although Parisians initially opposed this brazenly non-traditional building, the museum's plaza soon became a lively stage for Parisian street life. As a tourist attraction, the Pompidou Center surpassed both the highbrow Louvre Museum and the Eiffel Tower.

One danger in post-modernism was that its eclectic spirit would end in mere pastiche, a hodgepodge of earlier styles. This warning might be raised about the buoyant post-modern historicism of Charles Moore (1925–1993). Charles Moore's Piazza d'Italia (Fig. **15.20**) in New Orleans is a fountain complex that pays homage to the heritage of New Orleans's Italian-Americans, and was intended as a site for Italian-American ethnic festivals and community activities. The piazza is a feast of historical styles, illuminated by neon lights and bright paint. The pseudo-façades incorporate witty post-modern substitutions, such as "columns" of sheets of water and columns and capitals made of stainless steel.

In the 1980s, post-modern architecture proved itself in constructing the large, urban office towers that had been the staple of modernism. The first significant public

building in post-modern style is Michael Graves's Public Services Building (Fig. **15.21**) in Portland, Oregon, known as "the Portland." The building's decorative façade distinguishes it immediately from the uniformity of modernism. Two piers rise on either side of a seven-story barred window, ending in "eyebrow" ledges. Graves (b. 1934) mounted the squat tower on a base of darker granite, a technique adapted from the art deco of the 1920s. The whole façade has an Egyptian flavor, and its symbolism is punctuated by the statue of "Portlandia" in front.

15.19 Renzo Piano and Richard Rogers, Georges Pompidou National Center for Arts and Culture, Paris, 1977.
The museum's high-tech exterior of exposed struts and pipes explicitly violates the modernist ideal of a smooth exterior shell. By placing these elements on the outside of the building, the architects also expanded the interior space available for exhibitions.

Minimalism in Music

Compared with the bare abstractions of minimalist painting and sculpture, minimalism achieved considerable popular success in music. Music critics applied the term "minimalist" to a small group of avant-garde composers, chiefly Terry Riley, La Monte Young, Steve Reich, and Philip Glass. In the 1960s, the minimalists broke away from their training in the twentieth-century tradition of atonality. They stripped music down to a few bare musical fragments that were repeated with slow and subtle variations. For example, Terry Riley's (b. 1935) *In C* (1964) consists of fifty-nine musical fragments in the key of C, to be played by the ensemble in any order they choose.

The best-known minimalist composer is Philip Glass (b. 1937), who developed minimalist technique in more ambitious works involving dance and theater. His early music consists of interwoven melodic patterns, described

15.20 Charles Moore, Piazza d'Italia, New Orleans, 1978–9.

Moore's post-modernist pastiche abandons the doctrinaire purity of modernist architecture. Note the concoction of neoclassical elements (Corinthian columns, arches) employed in mocking ways (doorways that lead nowhere, capitals of steel, columns of water).

by one unappreciative critic as "sonic torture." However, Glass achieved a remarkable popular success with his opera entitled *Einstein on the Beach* (1976), which sold out performances in the traditionalist Metropolitan Opera in New York. As staged by Robert Wilson, Glass's opera consisted of oversized dramatic tableaux suggesting physicist Albert Einstein's scientific theories. In this and other Glass operas (Fig. **15.22**), the mesmerizing music was reinforced by the languid movement and precise lighting of Wilson's theatrical staging.

Part of Glass's enthusiastic audience consisted of fans crossing over from rock music, drawn by Glass's use of amplified instruments. The success of *Einstein on the Beach* paved the way for others, most significantly John Adams's *Nixon in China* (1987) and *The Death of Klinghoffer* (1991), both topical and well-received operas staged by theatrical designer Peter Sellars. This revival of opera as a popular form ranked as one of the most surprising developments of the post-modern era.

The Contemporary Visual Arts

Painting and sculpture in the post-modern era explored several directions, with no one style or influence predominating. The variety of trends includes the wholesale revival of earlier styles, including neo-expressionism and

15.21 Michael Graves, Public Services Building ("the Portland"), Portland, Oregon, 1980–3.
Note the decorative elements ("eyebrow" ledges, the wreaths on the side) that Graves employs to emphasize the building as an image.

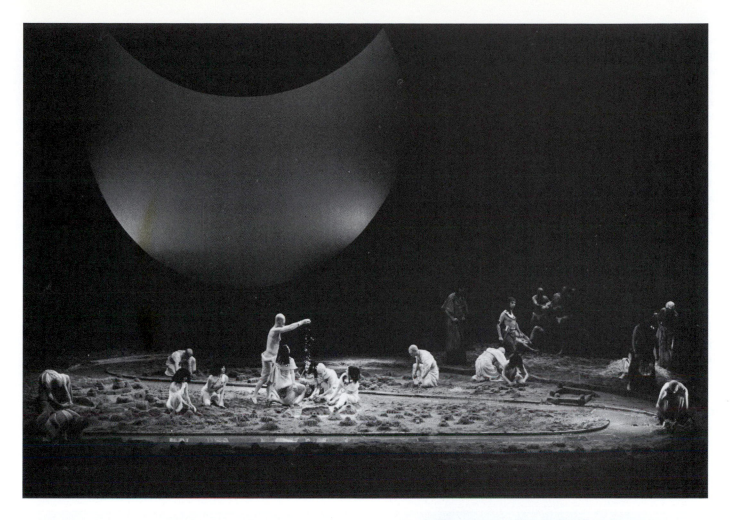

15.22 (above) A scene from the English National Opera production of Philip Glass's *Akhenaten*, London, 1985.
Glass followed the monumental success of his *Einstein on the Beach* with *Akhenaten* (1984), which told the story of Egypt's heretic pharaoh in mesmerizing chant.

neo-romanticism, and the frequent "quoting" of historical styles in an artistic pastiche.

One contemporary revival grew directly out of pop art. **Superrealism** in painting faithfully reproduced in paint the qualities of the photographic image. Chuck Close (b. 1930) was quite explicit in his aim to transfer photographic information to paint, often painting oversize portraits directly from photographs (Fig. **15.23**). Sculptor Duane Hanson (1925–1996) sculpted mannequin-like

15.23 (right) Chuck Close, *Phil*, 1969. Synthetic polymer on canvas, 9 x 7 ft (2.74 x 2.13 m). Whitney Museum of American Art, New York, Purchase with funds from Mrs. Robert M. Benjamin, 69.62.
Close meticulously reproduced photographic images in paint, resulting in giant portraits far beyond the scale of the photographs he copied. Here the subject is minimalist composer Philip Glass.

figures faultlessly crafted of polymers to resemble breathing humans. Placed in airports or banks, Hanson's figures were often mistaken for real people.

Another trend in art was to move outside the studio and find a new relation to nature and the social world. An outgrowth of minimalist sculpture, called **earth art** (or **land art**), merged sculpture with the environment. Earth art was constructed of materials virtually identical to the surrounding natural site, often primeval landscapes in the desert or prairie. The best-known work of earth art was Robert Smithson's *Spiral Jetty* (1970; Fig. **15.24**), a spiral form built from black basalt, limestone rocks, and earth in the Great Salt Lake of Utah. For Smithson (1938–1973), the work evoked a geological time that superseded the brief history of artistic fashion. In 1977, James Turrell (b. 1943) undertook the reshaping of Roden Crater in the wilderness of Arizona. Turrell constructed tunnels beneath the crater that aligned with the cardinal directions in the manner of ancient temples. Said Turrell, "the separation that occurs in a gallery between spectator and artwork is impossible when the 'work' surrounds you and extends for a hundred miles in all directions."[16] As his project neared completion, Turrell bought land around his private mountain for a public park, in the hope of forestalling commercial tourist development.

Like the earth artists, the artists Christo and Jeanne-Claude (both b. 1935) conceived works that burst the bounds of the studio and gallery. The Christos' projects transform their rural or urban settings and usually require a lengthy process of gaining permits and erecting the work with a legion of workers. Their *Running Fence* was a white nylon curtain hung on steel cable suspended on poles across 24$\frac{1}{2}$ miles (39 km) of California landscape. The Christos' other projects include *The Umbrellas, Japan–USA* (1984–1991) and the *Wrapped Reichstag* in Berlin (see Fig. 15.1).

In Germany the meditative painter Anselm Kiefer [KEE-fer] (b. 1945) was part of a wave often labeled "neo-romanticism." Kiefer describes himself as "bringing to light things that are over, that are forgotten," and *Die Meistersinger* (Fig. **15.25**) illustrates the rather ominous overtones of his work. The canvas suggests a ringed pyramid encrusted with straw and paint. The title, borrowed from a Wagnerian opera, evokes Germany's long-repressed Nazi past.

One feature of the contemporary arts was the temporary or ephemeral quality of the work of art itself. Artists such as Judy Pfaff (b. 1946) worked in **installation art**,

15.24 Robert Smithson, *Spiral Jetty*, 1970. Black basalt, limestone rocks, and earth, length 1,500 ft (457.2 m). Great Salt Lake, Utah. Smithson's earth art tended to minimalize not only the artist but also the spectator. Because the site was virtually inaccessible, the work could be viewed only through photographs.

15.25 *(above)* Anselm Kiefer, *Die Meistersinger*, 1982. Oil and straw on canvas, 9 ft 3 ins x 12 ft 6 ins (2.8 x 3.8 m). The Saatchi Collection, London.
Kiefer's brooding, neo-romantic canvases show his fascination with evil and grotesque themes, and his preoccupation with Germany's heroic past. Mixing paint with straw and other media, his monumental works establish an apocalyptic mood.

artistic works created for a particular site (usually a museum or gallery) and then dismantled. Pfaff's installation of *Dragon* (Fig. **15.26**) was like a three-dimensional abstract painting, composed from diverse materials and partly improvised on the spot. Pfaff's most ambitious project has been a huge, circus-like permanent installation in the ceiling space of a convention center.

15.26 *(right)* Judy Pfaff, *Dragon*, 1981. Mixed media. Installation view at the Whitney Museum of American Art, New York.
Viewers are often able to walk into Pfaff's brilliantly colored and free-form installations, experiencing them in three dimensions.

The New Fiction

When the novelist John Barth (b. 1930) suggested in the 1960s that literature was "exhausted," he meant that literary modernists had used up the novel and the short story. Using these exhausted fictional forms, works such as Barth's *The Sot-Weed Factor* (1967) and Thomas Pynchon's *Gravity's Rainbow* (1973) exhibited a dizzying self-consciousness of language and form, with convoluted plots and shifts among different fictional forms.

These post-modern works were often called **meta-fiction** because they seemed to be stories about stories and fictions about fictions. The acknowledged master of contemporary meta-fiction was the Argentinian writer Jorge Luis Borges (1899–1986), whose metaphysical style influenced a generation of post-modern writers. Borges's [BOR-hayss] short fiction and essays (he never wrote a novel) are largely concerned with the sphere of intellectual games and fantasy. Borges admitted quite readily that his stories did not describe social reality, as narrative fiction had done for three centuries. Instead, he created intricate but artificial literary worlds that were more interesting and more intelligible than the real.

Borges's dominant metaphor for this artificial world is the labyrinth, a self-contained maze that defines its own rules and signposts. In one well-known story, *Tlön, Uqbar, Orbis Tertius*, Borges tells of a forty-volume encyclopedia describing life on the imaginary planet of Tlön. The encyclopedia of Tlön resembles a labyrinth (and life, for that matter) in its apparently infinite complexity.

> One of the schools in Tlön has reached the point of denying time. It reasons that the present is undefined, that the future has no other reality than as present hope, that the past is no more than present memory.[a] Another school declares that the whole of time has already happened and that our life is a vague memory or dim reflection, doubtless false and fragmented, of an irrevocable process. Another school has it that the history of the universe, which contains the history of our lives and the most tenuous details of them, is the handwriting produced by a minor god in order to communicate with a demon. Another maintains that the universe is comparable to those code systems in which not all the symbols have meaning, and in which only that which happens every 300th night is true. Another believes that, while we are asleep here, we are awake somewhere else, and that thus every man is two men.[17]
>
> JORGE LUIS BORGES
> *From Tlön, Uqbar, Orbis Tertius (1956)*

a. Bertrand Russell (*The Analysis of Mind*, 1921, page 159) conjectures that our planet was created a few moments ago, and provided with a humanity which "remembers" an illusory past. [Borges's note]

CRITICAL QUESTION
What makes fictional worlds – films, stories, fantasies – more attractive than real experience? What are the psychological and moral consequences of absorbing ourselves in fictional (but reasonable) worlds like Borges's Tlön?

Borges's narrator compares the benevolent fantasy of Tlön's inventors to the ideological fictions of modern politics. "Why not fall under the spell of Tlön and submit to the minute and vast evidence of an ordered planet?" the narrator asks. "Tlön may be a labyrinth, but it is a labyrinth plotted by men, a labyrinth destined to be deciphered by men."[18]

Magic Realism In Latin America, Borges was precursor to an adventurous new style called **magic realism**, for its blend of realistic narrative and elements of fantasy and myth. The Colombian novelist Gabriel García Márquez (b. 1928) received international acclaim for his *One Hundred Years of Solitude* (1967). The novel recounts the lives of seven generations of a family in the fictional village of Macondo. García Márquez [gar-SEE-a MAR-kez] merged surreal circumstances with realistic observations of social class and politics. At one point, for example, the villagers all lose their memory and need to erect signs to remind them of the names of things. One sign reads simply, "God exists." In a typical post-modern gesture, the narrative's last pages incorporate characters from other Latin American novels, acknowledging their influence by giving their characters a new fictional life. García Márquez's splendid mix of fantasy and realism inaugurated a new wave of Latin American fiction. In its wake came novels from Carlos Fuentes, Julio Cortázar, and the Peruvian Mario Vargas Llosa.

The Global Culture

Summarize the changes in Western civilization at the end of the twentieth century.

The twentieth century's last decades saw a rising consciousness among groups long denied a strong voice in Western politics and culture. By 1970, a determined movement in the United States had abolished racial segregation and gained basic civil rights for American blacks. An international women's movement likewise demanded equal rights for women. In Africa, Latin America, and other former European colonies, writers and artists reasserted national traditions.

The 1980s and 90s saw an increasingly integrated and interdependent global culture, no longer defined by

national or regional boundaries. With the break-up of the former Soviet Union in 1989, demonstrators joyously demolished the symbol of Europe's Cold War divisions, the Berlin Wall. In Africa, the last bastion of white supremacy, South Africa, achieved a peaceful transition to black majority rule. At the same time, revived ethnic conflicts and the global epidemic of AIDS provided grim reminders that a "new world order" of peace and well-being was not yet secure.

These epochal events had profound effects on the arts and ideas of what had been Western civilization. New voices demanded a revision of the **canon**, the body of artistic and philosophical works recognized as the best and most important. These efforts brought recognition to a new generation of artists and introduced fresh controversy to debates over artistic and historical value.

Liberated Voices

As African nations gained their independence from colonial powers, Africans stepped onto the world's literary stage. In 1959 Nigerian Chinua Achebe [ah-CHAY-bay] (b. 1930) published his landmark novel *Things Fall Apart*, an anguished tale of the clash between traditional Africans and missionary intruders. Another Nigerian, Wole Soyinka [shah-YENG-kah] (b. 1934), often criticized Africa's political authoritarianism in his poems, plays, and essays, applying the existentialist ideal of the "engaged" writer.

In the United States, the African-American artist Romare Bearden [ROH-muh-ree BEER-dun] (1912–1988) rose to prominence in the 1960s, when he turned from an abstract style to techniques of collage and **photomontage**. A contemporary of the New York school, Bearden was never entirely comfortable with subjective abstraction or hard-edged minimalism. Partly through his activism in the civil rights movement, Bearden's works increasingly celebrated African-American ritual, myth, and community. Rejecting the extreme individualism of avantgarde art, he drew explicitly from African-American community life.

Bearden composed his works from fragments of photographs, cloth, and other ordinary objects. He compared the process of composition to mosaic, in which the artist carefully chooses and arranges small pieces of glass. His works are more clearly representational than those of many contemporary artists, with recurring visual motifs such as trains, baptism (Fig. **15.27**), and African-American "conjure women" with magical powers.

Often through bitter struggle, opportunities grew for American blacks in other media. In 1958, Alvin Ailey (1931–1991) formed the American Dance Theatre, creating dance works based on the rhythms of blues and jazz. He created for dancer Judith Jamison the demanding solo piece *Cry* (1971), which was set to jazz and soul music and dedicated to "all black women everywhere –

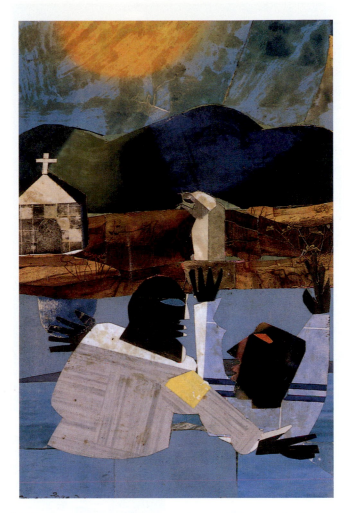

15.27 Romare Bearden, *Baptism*, 1964. Collage, 22 × 18 ins (56 × 46 cm). Estate of Romare Bearden, Courtesy of ACA Galleries, New York.
Bearden himself noted the "prevalence of ritual" in his collage works – rituals of work, play, and religious faith. Here, with cutout figures against a painted landscape, he invokes the ecstatic immersion of baptism.

especially our mothers." Jamison, dressed in a flowing white dress, gave a landmark performance of modern dance (Fig. **15.28**).

African-American authors gained broad readership and critical esteem as the literary canon widened to include them. The poet Gwendolyn Brooks (1917– 2000) recorded racial wounds in soft-spoken poems with an uncommon candor and sensitivity. Playwright August Wilson (1945–2005) created a series of ten dramas that presented "the unique particulars of black American culture" in each decade of the twentieth century. In *Fences* (1987), for example, the main character, Troy Maxson, bitterly recalls the baseball career that was denied him by racial segregation. The spiritual costs of a life of responsibility lead Troy to alienate his son and wife, building "fences" between him and his loved ones.

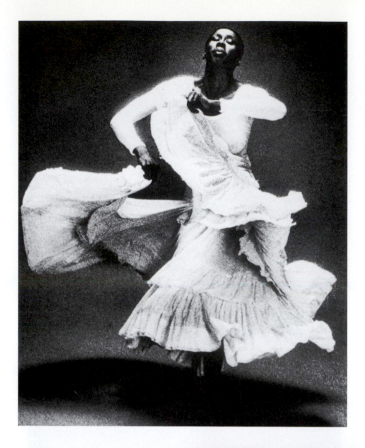

Contemporary feminists undertook a determined recovery of a lost tradition of women's history and art. One example was *The Dinner Party* (1979), a work of installation art by the feminist avant-garde artist Judy Chicago (b. 1939). In *The Dinner Party* (Fig. **15.29**), she set up a three-sided dinner table with place settings for thirty-nine women figures, both historical and mythological. Chicago wanted to acknowledge the domestic decorative arts of china-painting and embroidery, long practiced by American women. However, the suggestive design aroused such controversy that the show was closed soon after its opening. Women's groups responded

15.28 (*above*) Judith Jamison in *Cry*, 1971. Alvin Ailey, choreographer. Courtesy American Dance Theater, New York.

Jamison's acclaimed performance represented what choreographer Ailey called the vitality of "all black women everywhere — especially our mothers."

15.29 (*right*) Judy Chicago, *The Dinner Party*, 1979. Multimedia installation, china painting on porcelain with needlework, 48 x 48 x 48 ft (14.6 x 14.6 x 14.6 m). Copyright © Judy Chicago 1979.

Chicago's thirty-nine painted plates commemorated goddesses, queens, poets, and other women figures of historical note. Each setting contains a hand-painted plate decorated with an abstract design of butterflies or vulva-like flowers.

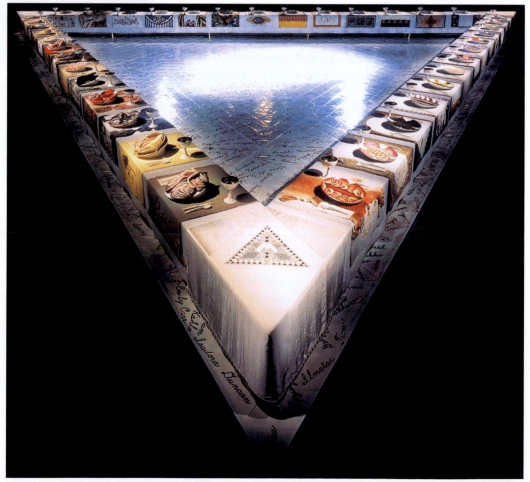

by raising enough funds to send the exhibition on a successful North American tour.

Faith Ringgold (b. 1930) was an activist in efforts to gain museum access for women and artists of color. Ringgold's own work drew on the quilt-making traditions of her African-American ancestors. Her fanciful "story quilts" combined textiles, text, and painting. In *Tar Beach* (1988), based on memories from Ringgold's Harlem childhood, a young girl flies far above the family scene, delighting in her freedom to go wherever she wants (Fig. **15.30**). For Ringgold, the affirmation of her life story was more important than artistic style or technique.

The 1970s and 80s saw an unprecedented flowering of women writers. Novelist Toni Morrison (b. 1931) gained wide acknowledgment for her novel *Beloved* (1988), in which a ghost child revisits the mother who murdered the girl to save her from slavery. Morrison's novel involved a complex narrative technique, based on flashback and fragmented narrative voices, that harked back to early modernism. Morrison and other women writers found considerable life in the "exhausted" literary forms of the novel, short story, and lyric poem.

The poet Denise Levertov [LEFF-er-toff] (1923–1997) maintained an outspoken commitment to poetry as a literary enterprise rather than a vehicle for ideas. Yet she was also actively involved in protests against the Vietnam War and nuclear proliferation. Her poem *In Mind* aptly expresses an ambivalence that many women of her era felt.

> There's in my mind a woman
> of innocence, unadorned but
> fair-featured, and smelling of
> apples or grass. She wears
> a utopian smock or shift, her hair
> is light brown and smooth, and she
> is kind and very clean without
> ostentation —
> but she has
> no imagination.
> And there's a
> turbulent moon-ridden girl
> or old woman, or both,
> dressed in opals and rags, feathers
> and torn taffeta,
> who knows strange songs —
> but she is not kind.[19]

DENISE LEVERTOV
In Mind (1964)

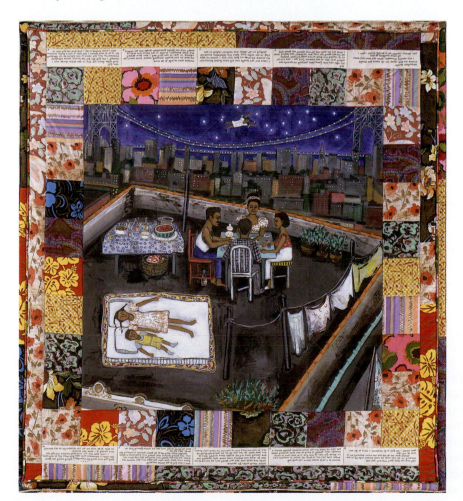

15.30 Faith Ringgold, *Tar Beach*, 1988. Acrylic on canvas bordered with printed, painted, quilted and pieced cloth. 6 ft 2⁵/₈ ins × 5 ft 8¹/₂ ins (1.8 × 1.7 m). The Solomon R. Guggenheim Museum, New York. Gift, Mr. and Mrs. Gus and Judith Lieber, 1988 88.3620.
In this "story quilt," the artist remembers her family escaping the summer heat by gathering on a "tar beach" — the roof of their tenement. A hand-written text surrounding the image describes the eight-year-old heroine's fantasies.

THE WRITE IDEA

In Levertov's poem *In Mind*, compare the clothing of the two kinds of women she describes. How does their garb symbolize the two types of women? Then consider how you might be drawn to be two such contrasting types of people.

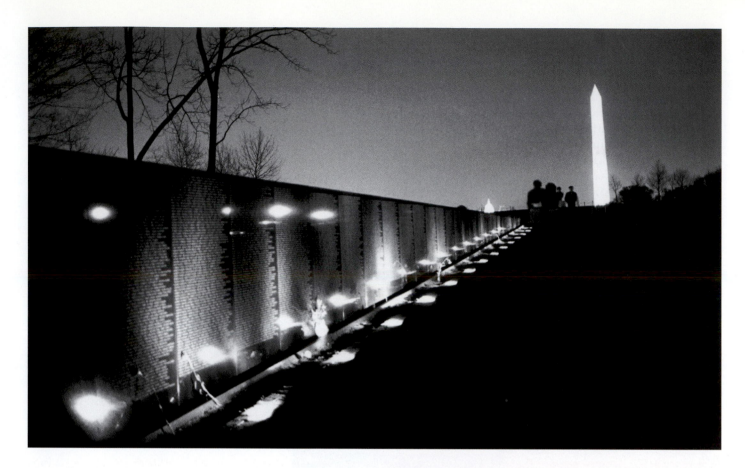

15.31 Maya Lin, Vietnam War Memorial, 1981–4. The Mall, Washington, D.C. Black polished granite, two wings, each 246 ft (75 m) long.

Consisting of little more than a V-shaped granite wall engraved with names of the dead, Lin's minimalist memorial became a shrine at which mourners leave flowers, war medals, and other mementoes.

The Vietnam War was commemorated in a powerful but controversial war memorial designed by Maya Lin (Fig. **15.31**). Lin's simple design of two monolithic black walls inscribed with the names of American soldiers killed in the war inspired protests from veterans' groups. Opponents successfully demanded that a more realistic and heroic sculpture of three soldiers be placed nearby. But Lin's simple wall proved itself as the more powerful remembrance, becoming a shrine that helped to heal the divisions of a troubled era.

AIDS and the Arts

By the 1990s, the spread of AIDS, a usually fatal virus infection, had killed millions worldwide and had struck arts communities especially hard. As with the medieval Black Death, the condition stimulated creative responses, including the NAMES project: a gigantic quilt of panels, each created by family and loved ones to memorialize an AIDS victim. Each NAMES panel was the size of a grave and decorated with materials ranging from chintz to

black leather, all symbolizing the remnants of lost life. By the mid-1990s, the project comprised more than 25,000 panels, and could only be exhibited in sections.

A more traditional memorial was the so-called "AIDS Symphony," the Symphony No. 1 by John Corigliano [kor(g)-lee-AHH-noh] (b. 1938). In this haunting work, composed in memory of colleagues lost to AIDS, one friend "appears" in the sound of a single piano, playing a favorite melody offstage. The symphony's second movement is a *tarantella*, a frantic Italian dance that recalls the madness often associated with the final stages of AIDS. Corigliano acknowledged that he was inspired by the AIDS quilt, and compared the symphony to "a quilt-like interweaving" of melodic motifs.

The AIDS epidemic was also a central theme in the exhilarating theater piece *Angels in America* by Tony Kushner (b. 1956). Subtitled *A Gay Fantasia on National Themes*, Kushner's 1993 drama mixed historical with fictional characters, incorporating the themes of homosexuality, AIDS, and politics in the conservative era of the 1980s. In keeping with the play's somber subject, the author asserted, "If we are to be visited by angels we will have to drag them out of the skies, and the efforts we expend to draw the heavens to an earthly place may well leave us too exhausted to appreciate the fruits of our labors."[21]

A New Century – Hope and Terror

The turn of the twenty-first century – at least as measured by the traditional Western calendar – brought hopeful and horrific reminders of a world drawn closer together. In the year 2000, images of worldwide celebrations of the new millennium flashed across televisions, computer networks, and cellular phones. On September 11, 2001, the same networks transmitted horrifying images of New York's World Trade Center towers collapsing from a terrorist attack. The events of "9/11" – history's shorthand for that day's terrorist assaults – demonstrated the unity of the post-modern world and its terrible vulnerability at the same time. Like the telegraph and the railroad 150 years earlier, electronic communication and jet travel had suddenly compressed the world's economies and societies. The global computer network, appropriately named the "World Wide Web," had speeded up communication and commerce and provided access to a vast fund of information. But these same networks helped terrorists coordinate their attacks and gave them a worldwide audience for their opposition to modern Western values. The world's attention was fickle, some critics pointed out. While cameras recorded the catastrophe of 9/11, the world hardly noticed as ethnic violence killed millions in Africa and the AIDS epidemic infected one-fourth of the population in some African nations.

Yet the arts and culture still served as media of unity and reconciliation. Architecture, especially, reflected an international language that could be spoken across national and cultural boundaries. The most discussed building at the century's turn was Frank Gehry's titanium-clad building for the new Guggenheim Museum in Bilbao, Spain (1997). The architect compared the gleaming jumble of curvaceous forms to a flower. The building's exterior skin was textured to resemble fish scales, and the museum complex sat next to an industrialized harbor like some post-modern ship, moored to the past but looking confidently to the future (Fig. **15.32**). Critics gave the name "deconstructivism" to such buildings that appear to be assembled from disharmonious abstract shapes, without a clear visual logic. Gehry and other deconstructivists were sometimes criticized for designing "art architecture," buildings that were more an artistic statement than a functional construction.

Music also reflected an increasingly global exchange of tastes and styles. Out of the urban black culture in U.S. cities arose "hip-hop" and the music of rap – chanted lyrics accompanied by vocalized or synthesized percussion. The lyrics were often explicitly violent and sexist, but rap's improvisational wit and rhythmic energy earned it an audience first among white teenagers in the U.S. and then worldwide. In India, for example, youths adapted traditional Indian popular songs to the funky rhythms of hip-hop. Hip-hop's global success was a reminder that jazz had originated in a parochial American culture and translated itself into a universal musical idiom. In fact, jazz's vitality continued unabated, as evident in the example of Wynton Marsalis (b. 1961), a classically trained trumpet player who undertook a vigorous reclamation of the jazz heritage. Marsalis was also remarkable in his ease at crossing the division between elite classical music and the popular scene.

Globalization's evolving technologies and cultural unification set new conditions for artistic creativity. The Korean-born Nam June Paik (b. 1932), who had begun as a performance artist in the style of Joseph Beuys (see page 424), turned exclusively to video art at the century's end. Paik [pike] explored television's effect on perceptions of time, geography, and reality – one work was a "robot" figure of Shakespeare's Hamlet composed of video monitors and other electronics equipment. In 1989, a landmark exhibition of Chinese contemporary art titled "China/Avant-garde" was abruptly closed by the Chinese authorities; then in June, the government ruthlessly suppressed a democracy movement at Tiananmen Square. In the wake of these upheavals, many Chinese artists emigrated and were absorbed into the international avant-garde, while younger artists tested the limits of artistic freedom in China itself. The artist Xu Bing (b. 1955), for example, has used traditional Chinese arts such as printmaking, calligraphy, and landscape painting to question traditional values. His *Book from the Sky* (1987–1991) is an installation of gigantic scrolls and books that contain false text – meaningless marks that resemble actual

15.32 (*above*) Frank Gehry, Guggenheim Museum,
Bilbao, Spain, 1997.
Gehry designed the varied and irregular curving forms of the
museum with the aid of sophisticated computer programs. The
interior includes a gigantic central gallery for the exhibition of
large-scale contemporary sculpture and installation art.

15.33 (*below*) Xu Bing, *A Book from the Sky*, 1987–91.
Mixed media installation, including hand-printed books and ceiling
and wall scrolls. The Elvehjem Museum of Art
When first exhibited in China in 1988, Xu Bing's mammoth
installation puzzled viewers with its nonsense characters. Xu had
used traditional Chinese arts of bookmaking and calligraphy to
question the viability of language in the contemporary world.

Chinese characters (Fig 15.33). Xu's work provides an ironic commentary on the fleeting and often false character of communication in the contemporary world.

At "Ground Zero," the site of the 9/11 attacks in New York City, art was commissioned to memorialize the loss. Deconstructivist architect Daniel Libeskind (b. 1946), whose most important building to date had been the acclaimed Jewish Museum in Berlin, proposed a new building for the site that would reach 1,776 feet (540 m) – an obviously symbolic height. Artists, such as Julian La Verdiere and Paul Myoda, were also commissioned to create temporary memorials (Fig. 15.34). Remembering and defending against terror attacks became a part of the urban landscape across the world.

In the new century, it seemed, humanity's struggle with itself – the battle between its creative and its destructive urges – would continue as vigorously as ever before. The inexorable forces of modernization and globalization would still wrench against traditional beliefs and ancient customs. The modern found itself often in bitter conflict with the traditional. Yet, as always, the human spirit found a way to begin and to build again.

15.34 Julian LaVerdiere and Paul Myoda, *Tribute in Light*, site of World Trade Center, New York, 2002.

To memorialize the victims of the September 11 terror attacks in New York City, eighty-eight searchlights were pointed skyward overnight to create ghostly images of the World Trade Center's collapsed towers. Since the initial installation in 2002, the memorial has been repeated annually on the night of September 11.

CHAPTER SUMMARY

The Age of Anxiety The advent of the Cold War created an atmosphere of alienation and anxiety among Western artists and thinkers. In post-war America, an ebullient consumerism could not console the soul-searching of be-bop jazz musicians, the beat writers, and the confessional poets. In Europe, the existentialists stressed the absurdity and utter moral freedom of human life, but also engaged in political activism against injustice. Beckett's absurdist theater portrayed characters condemned to loneliness, living in a world without redemption. Novels of the 1950s dramatized the plight of the existential hero in an indifferent universe.

Art in the Post-War Era The artistic avant-garde was revived in the aggressively abstract works of the New York school, ranging from Pollock's "drip paintings" to Rothko's majestic fields of color. "Pop" art borrowed icons from mass culture – Warhol's soup cans and music stars – while minimalist sculpture and happenings continued to challenge conventional definitions of art. In post-war sculpture, modernist abstractionists gave way to the constructions and assemblages of a generation seeking authenticity.

The Trials of Modern Architecture The International Style of urban architecture reached a triumphant height in the monolithic glass-and-steel skyscrapers of Mies van der Rohe. Using new methods and materials, other architects treated buildings as sculptures, achieving striking organic forms that were beautiful, if not always practical and durable.

Post-1945 Music In the musical avant-garde, composers turned to synthesizers and electronic instruments to achieve total control over the musical performance.

Cage employed Zen Buddhist ideas to create a music of chance that stretched the definitions of music to the limit. While traditional classical music and musical theater demonstrated continuing popular appeal, the charismatic stars of rock-and-roll led a youthful pop rebellion that crossed racial and national boundaries.

Post-modern Styles Rapid changes in the late twentieth century produced a sensibility called the "post-modern," skeptical of universal truths and eclectic in its approach to art and ideas. Post-modern architecture abandoned modernist purity in favor of a colorful flamboyance and historicism. Minimalist composers won a broader audience for the musical avant-garde. In the visual arts, super-realists reduced art to direct copies of photographs, while earth art and conceptual art escaped the studio to create on a super-human scale. The self-conscious meta-fictions of post-modern writers culminated in the "magic realism" of Latin American novelists.

The Global Culture The civil-rights and feminist movements brought a call to broaden the canon of artistic and philosophical masterworks, while post-colonial nations produced important new literary voices. With unprecedented opportunities, African-American artists excelled in painting, dance, and drama, and women novelists and poets flourished without post-modern conceits. The turn of the twenty-first century brought new promise and new horror. Architects and musicians especially created an international vocabulary of creative inspiration. But advances in global communications and trade also prompted global epidemics and political tensions. Faced with terrorist violence, the arts and culture were called on once again to enlighten humanity's struggle with its own nature.

Notes

Chapter 2

1 *The Great Hymn to Aten*, quoted in N. Grimal, *A History of Ancient Egypt*, trans. Ian Shaw. Oxford: Blackwell, 1992, pp. 228–9.

2 Herodotus, *History of the Persian Wars*, Book II.78, trans. George Rawlinson. See Charles A. Robinson, Jr., ed., *Selections from Greek and Roman Historians*. New York: Holt, Rinehart & Winston, 1957, pp. 12–13.

3 "so large a marketplace and so full of people, and so well regulated and arranged" [quoted, Alvin M. Josephy, Jr., *500 Nations: An Illustrated History of North American Indians*. New York: Gramercy, 2002. p. 100].

Chapter 3

1 The *Iliad of Homer*, trans. Richard Lattimore. Chicago: U. of Chicago Pr., 1951, 1976, pp. 488–9. Copyright © 1951 The University of Chicago Press. Used by permission.

2 Willis Barnstone, *Sappho and the Greek Lyric Poets* (rev. ed. of *Greek Lyric Poetry*). New York: Schocken, 1988. Copyright © 1962, 1967, 1988 by Willis Barnstone. Reprinted by permission of Schocken Books, published by Pantheon Books, a division of Random House, Inc.

3 Hesiod, *Theogony*, in *Hesiod, the Homeric Hymns, and Homerica*, trans. Hugh G. Evelyn-White. Loeb Classical Library. New York: Macmillan, 1914.

4 Thucydides, *History of the Peloponnesian War*, trans. Benjamin Jowett. In Charles A. Robinson, Jr., ed., *Selections from Greek and Roman Historians*. New York: Holt, Rinehart & Winston, 1957, p.80.

5 Thucydides, *History of the Peloponnesian War*, Book II.52, trans. Richard Crawley. See Thucydides, *The Peloponnesian War*, ed. John H. Finley. New York: Modern Library, 1951, p. 113.

6 Sophocles, *Antigone*, trans. Robert Fagles. In *The Three Theban Plays*. Harmondsworth: Penguin, 1982, pp. 76–7. Translation copyright © 1982 by Robert Fagles. Used by permission of Viking Penguin, a division of Penguin Books USA Inc.

7 Aristotle, comment on *Oedipus* in *Poetics* [1453 8]

8 *The Great Learning*, in W. T. de Bary and others, *Sources of Chinese Tradition*, Vol. 1. New York: Columbia U. Pr., 1960, p. 115.

9 Plato, from *The Republic* [443d, Bollingen p. 686]

10 Aristotle, from *Politics* [1253a]

Chapter 4

1 Virgil, *Aeneid*, trans. W. F. Jackson Knight. Harmondsworth: Penguin Classics, 1956, p. 173. Reproduced by permission of Penguin Books Ltd. Copyright © G. R. Wilson Knight, 1956.

2 *The Creed of Epictetus as contained in the Discourses, Manual and Fragments*. Trans. Ulysses G. B. Pierce. Boston: Beacon, 1916.

3 Renate Bridenthal and Claudia Koonz, eds., *Becoming Visible: Women in European History*, 1st ed. Boston: Houghton Mifflin, 1977, p. 75. Copyright © 1977 by Houghton Mifflin Company. Used with permission.

4 From *The Poems of Catullus* by Catullus, trans. James Michie. Copyright © 1969 James Michie. Reprinted by permission of Random House, Inc.

5 Virgil, *Aeneid*, p. 27.

6 Virgil, *Aeneid*, p. 116.

7 *The Satires of Juvenal*, trans. Rolfe Humphries. Indianapolis: Indiana U. Pr., 1958. © 1958 Indiana U. Pr. Used by permission.

8 Lucretius, *On the Nature of the Universe*, trans. R. E. Latham. Harmondsworth: Penguin Classics, 1951, p. 124. Reproduced by permission of Penguin Books Ltd. Copyright © R. E. Latham 1951.

9 Lucretius, *On the Nature of the Universe*, pp. 24–5.

10 Marcus Aurelius, *The Meditations*, trans. G. M. A. Grube. Indianapolis: Liberal Arts Pr., 1963, Book VII.9, pp. 62–3.

11 Marcus Aurelius, *The Meditations*, Book II.5, p. 13.

Chapter 5

1 Genesis 1:26–28. Scripture quotations are from the Revised Standard Version of the Bible, copyright 1946, 1952, 1971 by the Division of Christian Education of the National Council of the Churches of Christ in the USA.

2 Genesis 3:1–5.

3 Job 38:1–11.

4 Matthew 5:27–29, 38–42.

5 Josephus, *The Jewish Wars*, trans. William Whiston. See *The Works of Flavius Josephus*. Philadelphia: International Pr. [1904], p. 818.

6 St. Augustine, *The Confessions*, trans. E. B. Pusey. In *Great Books of the Western World*, Vol. 18. Chicago: Encyclopedia Britannica, 1952, pp. 10–11.

7 John Julius Norwich, *Byzantium: The Early Centuries*. New York: Knopf, 1989, p. 203.

8 The Koran (Qur'an), trans. N. J. Dawood. Harmondsworth: Penguin Classics, 1956, 6th rev. ed. 1990. Copyright © N. J. Dawood 1956, 1959, 1966, 1968, 1974, 1990.

Chapter 6

1 Charlemagne, quoted in Pierre Riché, *Daily Life in the World of Charlemagne*, trans. Jo Ann McNamara. Philadelphia: U. of Pennsylvania Pr., 1983, pp. 133–4.

2 From *The Song of Roland*, trans. Frederick Goldin. Copyright © 1978 W. W. Norton & Company, Inc. Reprinted by permission of W. W. Norton & Company, Inc.

3 Hrotsvit, quoted in Katharina Wilson, *Medieval Women Writers*. Athens, Georgia: U. of Georgia Pr., 1984, p. 38.

4 Hrotsvit, quoted in Wilson, *Medieval Women Writers*, p. 38.

5 Bernard of Clairvaux, "Apologia" to William, Abbot of St.-Thierry. In Elizabeth G. Holt, ed., *A Documentary History of Art*, Vol. 1. *The Middle Ages and Renaissance*. New York: Doubleday, 1957, p. 20.

6 Hildegard of Bingen, *De Sancta Maria*, from *Hildegard of Bingen's Book of Divine Works*, ed. Matthew Fox. Santa Fe, New Mexico: Bear & Co., 1987. Reprinted with permission. © 1987 Bear & Co.

7 The Pseudo-Dionysus, *Mystical Theology*, quoted in Denise L. Carmody and John. T. Carmody, *Mysticism: Holiness East and West*. New York: Oxford University Press, 1996, p. 205.

8 Nicholas of Cusa. *Selected Spiritual Writings*, trans. by H. Lawrence Bond. New York: Paulist Press, 1997, pp. 251–52.

9 Hildegard, quoted in Sabina Flanagan, *Hildegard of Bingen, 1098–1179: A Visionary Life*. 2nd ed. London: Routledge, 1998, p. 4.

10 Master Eckhart, quoted in Denise L. Carmody and John. T. Carmody, *Mysticism: Holiness East and West*. New York: Oxford University Press, 1996, p. 207.

11 Peter Abelard, trans. Mary Martin McLaughlin, quoted in *The Portable Medieval Reader*. Ed. James Bruce Ross and Mary Martin McLaughlin. New York, Viking Press, 1949, p. 333.

12 Fulcher of Chartres, quoted in Branu Leone, ed., *The Middle Ages: History Firsthand*. San Diego, CA: Greenhaven Press, 2002, p.154.

Chapter 7

1 François Villon, "For His Mother to Our Lady," in *French Lyrics in English Verse*, trans. William Frederic Giese. Madison, Wisconsin: U. of Wisconsin Pr., 1946.

2 Abbot Suger, quoted in Gerda Panofsky-Soergel, ed., *Abbot Suger on the Abbey Church of St.-Denis and its Art Treasures*, 2nd ed. Princeton: Princeton U. Pr., 1979, p. 49.

3 Abbot Suger, quoted in Panofsky-Soergel, *Abbot Suger*, p. 51.

4 Andreas Cappellanus, *The Art of Courtly Love*. New York: Columbia U. Pr., 1990.

5 Bernart de Ventadorn, from "Quan vei la lauzeta mover," trans. Craig E. Bertolet, ed., Frederick Goldin.

6 Ramon Llull, *Book of the Order of Chivalry*, quoted in Maurice Keen, Chivalry. New Haven: Yale U. Pr., 1984.

7 Beatriz de Dia, "A chantar m'er de so qu'ieu non volria" (Of things I'd rather keep in silence), from Magda Bogin, *The Women Troubadours*, p. 87. New York: Norton, 1980. Reprinted by permission.

8 Dante Alighieri, *The Divine Comedy*. Vol. 1: Inferno, Canto V, trans. Mark Musa. Indianapolis: Indiana U. Pr., 1971. © 1971 Indiana U. Pr.

9 Henry Knighton, from *Chaucer's World* by Edith Rickert. © 1948 Columbia University Press. Reprinted by permission of the publisher. New York: Columbia U. Pr., 1948, pp. 353–4.

10 Boccaccio, trans. D. G. Rossetti, in *The Portable Medieval Reader*. Ed. James Bruce Ross and Mary Martin McLaughlin. New York, Viking Press, 1949, p. 386.

11 Geoffrey Chaucer, *The Canterbury Tales*, trans. Neville Coghill. London: Penguin, 1977, p.279.

12 Petrarch, Sonnet CCXCII, "Gli occhi di ch'io parlai sí caldamente," *Sonnets*, trans. Edwin Morgan.

Chapter 8

1 Pico della Mirandola, *Oration on the Dignity of Man*, trans. Elizabeth Forbes. In Robert Warnock and George K. Anderson, eds., *The World in Literature*. Chicago: Scott, Foresman, 1959, p. 546.

2 Lorenzo de' Medici, "A Carnival Song," trans. J. A. Symonds. In James Bruce Ross and Mary Martin McLaughlin, eds., *The Portable Renaissance Reader*. New York: Viking, 1953, pp. 432–4.

3 Benvenuto Cellini, *The Autobiography of Benvenuto Cellini*, Book VIII, trans. J. A. Symonds. Immortal Classics edn, p. 62.

4 Quoted in Leeman Perkins, *Music in the Age of the Renaissance*. New York: Norton, 1999, p. 688.

5 Quoted in *Women and Music: A History*, Karen Pendle, ed. Bloomington: Indiana U. Pr., 1991, p.48.

6 Niccolò Machiavelli, *The Prince*, trans. and ed. Thomas G. Bergin. Wheeling, Illinois: Crofts Classics Series, © 1947 Harlan Davidson Inc., pp. 50–51, Used by permission.

7 Niccolò Machiavelli, *The Prince*, trans. and ed. Thomas G. Bergin. Wheeling, Illinois: Crofts Classics Series, © 1947 Harlan Davidson Inc., pp. 25–26, Used by permission.

8 Quoted in *Leonardo on Painting*, Martin Kemp, ed. and trans. New Haven, Connecticut: Yale U. Pr., 1989, p. 48.

9 Baldassare Castiglione, *The Book of the Courtier*, trans. George Bull. Harmondsworth: Penguin, 1967, p. 221.

Chapter 9

1 "The Defense of Liberty Against Tyrants" (1579), translated into English in 1688. See J. H. Hexter, ed. *The Traditions of the Western World*, Vol. 2. Chicago: Rand McNally, 1967, p. 380.

2 George Buchanan, *The Law of Government Among the Scots* (1579). Quoted in Arthur Herman, *How the Scots Invented the Modern World*. New York: Three Rivers, 2001, pp. 18–19.

3 Diane de Poitiers, in Katherine M. Wilson, ed., *Women Writers of the Renaissance and Reformation*. Athens: U. of Georgia Pr., 1987, p. 166.

4 Albrecht Dürer, from a letter. In Wolfgang Stechow, *Northern Renaissance Art 1400–1600: Sources and Documents*. Englewood Cliffs, New Jersey: Prentice-Hall, 1966, p. 91.

5 Albrecht Dürer, from a draft of his study of proportion. In Elizabeth G. Holt, ed., *A Documentary History of Art*, Vol. 1. *The Middle Ages and Renaissance*. New York: Doubleday, 1957, p. 311.

6 Erasmus, *Handbook of the Militant Christian*. In John P. Dolan, *The Essential Erasmus*. New York: New American Library, 1964, p. 39. Copyright © 1964 by John P. Dolan. Used by permission of New American Library, a division of Penguin Books USA Inc.

7 Erasmus, *In Praise of Folly*, trans. Betty Radice. Harmondsworth: Penguin Classics, 1971, pp. 150, 179, 161–2. Reproduced by permission of Penguin Books Ltd. Translation copyright © Betty Radice, 1971.

8 *The Complete Essays of Montaigne*, trans. Donald Frame. Stanford, CA: Stanford U. Pr., 1958, p. 421.

9 *The Complete Essays of Montaigne*, p. 329.

10 Shakespeare, *Hamlet*, Act II, sc. ii, 160–71.

11 Quoted in Gustave Reese, *Music in the Renaissance*, rev. ed. New York: Norton, 1959, p. 449.

Chapter 10

1 Quoted in *Life of St. Teresa*, trans. J. M. Cohen. Harmondsworth: Penguin, 1957, p. 210.

2 Claudio Monteverdi, *L'Orfeo*. London: J. & W. Chester, 1923, pp. 51–2.

3 Miguel Cervantes, *Don Quixote*. In *The Portable Cervantes*, trans. Samuel Putnam. New York: Viking, 1951, pp. 110–11. Translation copyright © 1949, 1950, 1951 by Viking Penguin, Inc. Used by permission of Viking Penguin, a division of Penguin Books USA Inc.

4 David Hume, "An Enquiry Concerning Human Understanding," IV, ii. In Edwin A. Burtt, ed., *The English Philosophers from Bacon to Mill*. New York: Modern Library, 1939, p. 603.

5 Galileo, quoted in Giorgio de Santillana, *The Crime of Galileo*. Chicago: University of Chicago Press, 1955, p. 312.

6 René Descartes, *Discourse on Method and the Meditations*. Harmondsworth: Penguin, 1968, pp. 53–4.

7 *Samuel Pepys's Diary*, ed. Richard Le Gallienne. New York: Modern Library, n.d., pp. 199–200.

8 John Locke, *Essay on Civil Government*. In Edwin A. Burtt, ed., *The English Philosophers from Bacon to Locke*. New York: Modern Library, 1939, p. 438.

9 Locke, *Essay on Civil Government*, p. 438.

Chapter 11

1 Edmond and Jules de Goncourt, *The Woman of the Eighteenth Century*, trans. Jacques de Clercq and Ralph Roeder. New York: Minton, Balch, 1927, p. 44.

2 Jean-Jacques Rousseau, *The Social Contract*, trans. Charles Frankel. New York: Hafner, 1947, p. 19.

3 Immanuel Kant, *Foundations of the Metaphysics of Morals* and *What is Enlightenment?*. Trans. Lewis White Beck. New York: Liberal Arts, 1959, p. 39.

4 Marie Jean Antoine de Condorcet, *Sketch for a Historical Picture of the Progress of the Human Mind*. Trans. June Barraclough. London: Weidenfeld & Nicolson, 1955, pp. 4–5.

5 Kant, *Foundations of the Metaphysics of Morals* and *What is Enlightenment?*

6 Adam Smith, quoted in Arthur Herman, *How the Scots Invented the Modern World*. New York: Three Rivers, 2001, p. 218.

7 Adam Smith, *The Wealth of Nations*. New York: Knopf, 1991, pp. 10, 13.

8 Kant, *Foundations of the Metaphysics of Morals* and *What is Enlightenment?*, p. 39.

9 Samuel Johnson, quoted in Roy Porter, *The Creation of the Modern World : The Untold Story of the British Enlightenment*. New York: Norton, 2000, p. 75.

10 Samuel Richardson, *Pamela*. London: Dent, 1962, p. 57.

11 Jonathan Swift, *A Modest Proposal*. In Swift, *Satires and Personal Writings*, ed. W. A. Eddy. London: Oxford U. Pr., 1973, pp. 23–4.

12 César de Saussure, "A Foreign View of England." In *Eyewitness to History*, ed. John Carey. Cambridge, MA: Harvard U. Pr., 1987, p. 215.

13 Voltaire, *Candide, or Optimism*. Wheeling, Illinois: Harlan Davidson, 1946, pp. 114–15.

Chapter 12

1 *The Declaration of Independence*. New York: Oxford U. Pr., 1947, pp. 3–7.

2 The *Federalist*, #51 (1788); *The Federalist Papers*. New York: New American Library, 1961, p. 322.

3 Edmund Burke, *Reflections on the Revolution in France* (1790). See J. H. Hexter, ed. *The Traditions of the Western World,* Vol. 2. Chicago: Rand McNally, 1967, p. 538.

4 Thomas Paine, *Common Sense* (1776). In *Collected Writings.* New York: Library of America, 1995, p. 6.

5 J. S. Mill, *On Liberty* (1859). Indianapolis: Hackett, 1978, pp. 9, 79.

6 Thomas Carlyle, quoted in Eric Hobsbawm, *Industry and Empire: From 1750 to the Present Day.* New York: New Press, 1999, p. 65.

7 *Industry and Empire*, p. 65.

8 Eugène Delacroix, quoted in Lorenz Eitner, *Neoclassicism and Romanticism 1750–1850*, Englewood Cliffs, New Jersey: Prentice-Hall, 1970, p. 101.

9 Ludwig van Beethoven, "Heiligenstadt Testament," in *Thayer's Life of Beethoven*, rev. ed., Vol. 1, Elliot Forbes, ed. Princeton: Princeton U. Pr., 1967, pp. 304–6.

10 *Goethe's Faust*, Parts I and II, trans. Louis MacNeice, p. 61. Copyright © 1951, 1954 by Frederick Louis MacNeice; renewed 1979 by Hedli MacNeice. Reprinted by permission.

11 *Goethe's Faust*, p. 282.

12 Clara Schumann, quoted in *Women Making Music,* ed. J. Bowers and J. Tick. Urbana: U. of Illinois Pr., 1986, p. 265.

13 Berlioz's program for *Symphonie fantastique*, quoted in Joseph Machlis, *The Enjoyment of Music*, 4th ed. New York: Norton, 1977, p. 106.

14 William Blake, "London," from *Songs of Experience*. In Northrop Frye, ed., *Selected Poetry and Prose of William Blake*. New York: Modern Library, 1953, p. 46.

15 Mary Wollstonecraft, *A Vindication of the Rights of Women*. New York: Norton, 1988, pp. 149, 150.

16 William Wordsworth, *The Prelude*, Book XIV, 70–75. In Mark van Doren, ed., *Selected Poetry*. New York: Random House, 1950, p. 384.

17 William Wordsworth, "The World is Too Much With Us." In *Selected Poetry*, p. 536.

18 "Letters on Landscape Painting," Letter IV, *Crayon*, no. 7 (February 14, 1855), p. 98.

19 Grenville Goodwin, *Western Apache Raiding and Warfare*, ed. K. Basso. Tucson: U. of Arizona Pr., 1971, p. 29.

20 Mary Shelley, *Frankenstein*. Harmondsworth: Penguin, 1985, pp. 190–1.

Chapter 13

1 J. S. Mill, *Utilitarianism, Liberty, and Representative Government.* New York: Dutton, 1951, p. 8

2 Gustave Flaubert, *The Sentimental Education*, trans. Perdita Burlingame. New York: Signet, 1972, p. 330. Translation copyright © 1972 Perdita Burlingame. Used by permission of New American Library, a division of Penguin Books USA Inc.

3 Walt Whitman, *Leaves of Grass*. In *Complete Poetry and Collected Prose*. New York: Library of America, pp. 188, 210.

4 Richard Wagner, quoted in Bryan Magee, *Aspects of Wagner*, rev. ed. Oxford: Oxford U. Pr., 1988, p. 5.

5 Lillian Nordica, *Lillian Nordica's Hints to Singers*. New York: Dutton, 1923, pp. 13–14.

6 Charles Baudelaire, "To the Reader," *Les Fleurs du Mal*, trans. Richard Howard. Boston: Godine, 1982, pp. 5–6. Translation © 1983 Richard Howard. Reprinted by permission of David R. Godine Publishers.

7 Henrik Ibsen, *A Doll's House*, trans. Eva LaGallienne. In *Six Plays by Henrik Ibsen*. New York: Random House, 1957.

8 Dostoyevsky, quoted in Peter Conradi, *Fyodor Dostoyevsky*. New York: St. Martin's Pr., 1988, p. 17.

9 Arthur Schopenhauer, *The World as Will and Representation*, trans. E. Payne, New York, Dover, vol. 2, p. 205.

10 Friedrich Nietzsche, *The Anti-Christ*, quoted in *A Nietzsche Reader*, trans. R. J. Hollingdale. Harmondsworth: Penguin, 1977, p. 231.

11 Fyodor Dostoevski (Dostoyevsky), from *The Brothers Karamazov*, trans. Constance Garnett, edited with a foreword by Manuel

Komroff. Indianapolis: Bobbs-Merrill, 1948, pp. 37–8. © 1960 by Manuel Komroff. Reprinted by permission.

12 Nietzsche, *The Gay Science*, quoted in *The Portable Nietzsche*, ed. Walter Kaufmann. New York: Viking, 1968, p. 93.

Chapter 14

1 W. B. Yeats, "The Second Coming," in *The Poems of W. B. Yeats: A New Edition*, ed. Richard J. Finneran. New York: © 1924 Macmillan Publishing Co, renewed 1952 by Bertha Georgie Yeats. Reprinted with permission of Simon & Schuster, Inc.

2 Albert Einstein, quoted in Ronald W. Clark, *Einstein: The Life and Times*. New York: World, 1971, p. 340.

3 Ray Strachey, *"The Cause": A Short History of the Women's Movement in Great Britain*. Port Washington, New York: Kennikat Pr., 1969, p. 389.

4 Kasemir Malevich, quoted in H. H. Arnason, *A History of Modern Art*, 4th edn, 1998, p. 224.

5 Henri Matisse, quoted in Nikos Stangos, *Concepts of Modern Art*. London: Thames and Hudson, 1981, pp. 23–4.

6 Matisse, quoted in John Canaday, *Mainstreams of Modern Art*. New York: Simon & Schuster, 1959, p. 407.

7 Matisse, quoted in Robert Goldwater, ed., *Artists on Art*, 3rd ed. New York: Pantheon, 1958, p. 98.

8 Joan Miró, quoted in Herschel Chipp, *Theories of Modern Art*. Berkeley, California: U. of California Pr., 1968, p. 435.

9 Salvador Dalí, quoted in Robert Descharnes, *Salvador Dalí*. New York: Abrams, 1976, p.30.

10 Franz Kafka, *The Metamorphosis*, from *Short Stories of Franz Kafka*. New York: Random House. Copyright © 1952 Random House Inc, pp. 19, 20.

11 David Alfaro Siqueiros, quoted in Desmond Rochfort, *Mexican Muralists: Orozco, Rivera, Siqueiros*. San Francisco: Chronicle, 1993, p. 39.

12 W. E. B. DuBois, *The Souls of Black Folk*, Dover, 1994, p. 9.

Chapter 15

1 Allen Ginsberg, "A Supermarket in California," from *Collected Poems 1947–1980*. Copyright © 1955 Allan Ginsberg, copyright renewed. San Francisco: City Lights, 1959, pp. 29–30. Reprinted by permission of HarperCollins Publishers Inc.

2 *All Men are Brothers: Life and Thoughts of Mahatma Gandhi as Told in his Own Words*, UNESCO, 1958, p. 88.

3 Jean-Paul Sartre, "Existentialism," trans. Bernard Frechtman. In *Existentialism and Human Emotions*. New York: Philosophical Library, 1957, p. 22.

4 Samuel Beckett, *Waiting for Godot*. New York: Grove, 1966, p. 57.

5 Ralph Ellison, *Invisible Man*. New York: Modern Library, 1952, p. 3.

6 Joseph Heller, *Catch-22*. New York: Dell, 1961, p. 47.

7 Jackson Pollock, quoted in Herschel Chipp, *Theories of Modern Art*. Berkeley, California: U. of California Pr., 1968, pp. 547–8.

8 Pollock, quoted in Chipp, *Theories of Modern Art*, pp. 547–8.

9 Donald Judd, quoted in *Theories and Documents of Contemporary Art. A Sourcebook of Artists' Writing*, Kristine Stiles and Peter Selz, eds. Berkeley: U. of California Pr., 1996, p. 116.

10 Henry Moore, quoted in Chipp, *Theories of Modern Art*, p. 595.

11 Frank Lloyd Wright, quoted in Spiro Kostof, *A History of Architecture*. New York: Oxford U. Pr., 1985, p. 742.

12 Karlheinz Stockhausen, quoted in H. H. Stuckenschmidt, *Twentieth Century Music*. New York: McGraw-Hill, 1969, p. 187.

13 Steiner Kvale, "Themes of Postmodernity," in *The Truth about the Truth*, Walter Truett Anderson, ed. New York: Tarcher/ Puttnam, 1995, p.25.

14 Kvale, "Themes of Postmodernity," p.27.

15 Robert Venturi, *Complexity and Contradiction in Architecture*, 2nd ed. New York: The Museum of Modern Art, 1977, p. 16.

16 James Turrell, quoted in Suzi Gablik, *Has Modernism Failed?* New

York: Thames and Hudson, 1984, p.83.

17 Jorge Luis Borges, "Tlön, Uqbar, Orbis Tertius," from *Ficciones*, trans. Alastair Reid, © 1962 by Grove Pr., renewed copyright © 1990 Grove Weidenfeld. Used with permission of Grove/Atlantic Monthly Pr. In Emir Rodríguez Monegal and Alastair Reid, eds., *Borges: A Reader*. New York: E. P. Dutton, 1981, pp. 116–17.

18 Borges, "Tlön, Uqbar, Orbis Tertius," pp. 121–22.

19 Denise Levertov, "In Mind," from *Poems 1960–1967*. Copyright © 1966 by Denise Levertov. Reprinted by permission of New

Directions Publishing Corp.

20 Paul Monette, *Borrowed Time: An AIDS Memoir*. New York: Harcourt Brace. Copyright © 1988 Paul Monette, reprinted by permission of Harcourt, Inc.

21 Tony Kushner, "Angels in America, A Gay Fantasia on National Themes," quoted in Rob Baker, *The Art of AIDS*. New York: Continuum, 1994, p. 221.

Sources for boxed quotations

Page 45, Homer: See Chapter 3 note 1.

Page 50, Pericles: In Thucydides, *History of the Peloponnesian War*, trans. Benjamin Jowett. See Chapter 3 note 4.

Page 61, Protagoras: Diogenes Laertius, *Lives of the Philosophers*; see J. B. Wilbur and H. J. Allen, *The Worlds of the Early Greek Philosophers*. Buffalo, NY: Prometheus, 1979, p. 245.

Page 73, Virgil: See Chapter 4, note 1.

Page 93, Lucretius: See Chapter 4, note 8.

Page 95, Marcus Aurelius: See Chapter 4, note 10.

Page 98, Exodus: See Chapter 5, note 1.

Page 102, Job: See Chapter 5, note 3.

Page 103, Matthew: See Chapter 5, note 4.

Page 124, The Qu'ran: See Chapter 5, note 8.

Page 143, The Rule of St. Benedict: Quoted in David Knowles, *Christian Monasticism*. New York: McGraw-Hill, 1969, pp. 34–5.

Page 144, French chronicler: Quoted in Robert Lacey, *The Year 1000*. New York: Little, Brown & Co., 1999, p. 182.

Page 150, Bernard of Clairvaux: See Chapter 6, note 5.

Page 155, Peter Abelard: See Chapter 6, note 11.

Page 156, Fulcher of Chartres: See Chapter 6, note 12.

Page 174, Thomas Aquinas: *St. Thomas Aquinas: Philosophical Texts*. Trans. Thomas Gilby. Oxford: Oxford University Press, 1951, p. 284.

Page 181, Boccaccio: See Chapter 7, note 10.

Page 190, Leonardo Bruni: *The Humanism of Leonardo Bruni: Selected Texts*. Trans. Gordon Griffiths, James Hankins, and David Thompson. Binghamton, NY: Medieval & Renaissance Texts & Studies, 1987, p. 125.

Page 206, Niccolò Machiavelli: See Chapter 8, note 6.

Page 209, Leonardo da Vinci: *The Literary Works of Leonardo da Vinci*, Vol. 1. Ed. Jean Paul Richter. Berkeley: Univ. of California Press, 1977, p. 37.

Page 224, Calvinist treatise: See Chapter 9, note 1.

Page 238, Thomas More: *Utopia*, 1516.

Page 238, Montaigne: *Montaigne: Selections from the Essays*. Trans. Donald Frame. Arlington Heights, IL: Harlan Davidson, 1973, p. 53.

Page 275, Jean-Baptiste Colbert: Quoted in T. C. W. Blanning, *The Culture of Power and the Power of Culture: Old Regime Europe 1660–1789*. London: Oxford University Press, 2002, p. 35.

Page 285, John Locke: *Essay Concerning Human Understanding* (1690).

Page 286, René Descartes: See Chapter 10, note 6.

Page 291, John Locke: *Two Treatises of Government*, (1690).

Page 304, Voltaire: *Philosophical Dictionary* (1764).

Page 305, Jean-Jacques Rousseau: *Émile, or Education* (1762).

Page 305, Immanuel Kant: See Chapter 11, note 3.

Page 305, Immanuel Kant: See Chapter 11, note 3.

Page 307, Samuel Johnson: See Chapter 11, note 9.

Page 312, Johann Winckelmann: *On the Imitation of the Paintings and Sculpture of the Greeks* (1755). In David Irwin, ed., *Writings on Art*. London: Phaidon, 1972, p. 61.

Page 320, Voltaire: See Chapter 11, note 13.

Page 324, James Madison: See Chapter 12, note 2.

Page 328, John Stuart Mill: See Chapter 12, note 5.

Page 341, Asher B. Durand: See Chapter 12, note 18.

Page 350, John Stuart Mill: See Chapter 13, note 1.

Page 351, Charles Darwin: *The Descent of Man* (1871).

Page 359, Charles Baudelaire: "The Swan," *Flowers of Evil* (1857).

Page 360, Louis Sullivan: "The Tall Office Building Artistically Considered" (1896).

Page 380, Friedrich Nietzsche: See Chapter 13, note 12.

Page 384, Albert Einstein: See Chapter 14, note 2.

Page 395, Henri Matisse: See Chapter 14, note 6.

Page 400, Virginia Woolf: *A Room of One's Own* (1929). New York: Harcourt, Brace, Jovanovich, 1957, p. 25.

Page 403, Le Corbusier: *Toward a New Architecture* (1923), trans. 1946. Chapter 1, "Eyes Which Do Not See: Airplanes."

Page 413, T. W. Adorno: "Cultural Criticism and Society" (1959). Trans. Samuel and Shierry Weber. In *Prisms*. Cambridge, MA: MIT, 1981, p. 34.

Page 418, Jean-Paul Sartre: See Chapter 15, note 3.

Page 445, Daniel Libeskind: See Chapter 15, note 21.

Glossary

absolutism The political philosophy that a monarch should exercise absolute political power and control all aspects of national life.

abstract expressionism The term commonly applied to a group of painters active in New York City in the 1940s and 1950s; their works are characterized by the highly abstract use of color, line, and shape.

academy The Academy was originally the school established by Plato in Athens; generally, the term refers to an officially established school or group that dictates (usually conservative) rules and standards of taste.

additive sculpture *Sculpture* that is fashioned by building up a shape (as with plaster or clay), constructing a shape from raw materials (such as metal), or assembling a shape from various materials.

aleatory music Music in which significant choices in the composition or performance are left to chance or whim (from Latin *alea*, "dice").

allegory A literary or artistic device in which characters, objects, or actions represent abstract ideas or meanings; in Dante's *Divine Comedy*, for example, the poet's journey stands allegorically for every human's journey through life.

ambulatory The walkway around the *choir* of a Christian church, giving access to the *apse* and *chapels*.

analytical cubism See *cubism*.

antiphonal Music in which two or more groups sing or play in alternation (hence "antiphonal singing").

apse Originally the semicircular niche at the ends of a Roman *basilica*; in Christian architecture, the niche-like eastern end of a church, usually housing the altar.

arabesque An intricate surface decoration, often consisting of repeating linear designs and, in Islamic art, containing no figures.

arch The architectural form in which a curved construction spans the distance between two columns or walls (Fig. 4.15).

Archaic A period of ancient Greek art (c. 700–480 B.C.), typified in sculpture by the stylized *kouros* and *koré* figures.

architrave In classical architecture, the horizontal beam that forms the lowest part of the *entablature*.

archivolt The molding that frames an arched doorway.

aria A song usually found in operas, oratorios, and cantatas, commonly sung as a solo and often the occasion for virtuoso singing (Italian, "air").

Ars Nova In music, a style of *polyphony* (current c. 1320–1400) characterized by greater refinement and expressiveness (Latin, "new art").

Art Nouveau In art, a style of decoration and architecture (current c. 1890–1910) characterized by floral and plant motifs (French, "new art").

assemblage A process in which a work of art is built up, or "assembled," from miscellaneous three-dimensional materials.

atmospheric perspective (also **aerial perspective**) The *perspective* technique that creates the illusion of depth by blurring the outlines and altering the color tones of distant objects.

atonal Music that is not composed in a *key*.

atrium The inner courtyard of a Roman house; also, the forecourt of an Early Christian church.

aulos A pipe instrument used in ancient Greece, usually played in pairs, one held in each hand.

avant-garde The group of artists or writers who are considered at the time to be the most "advanced" in their methods or subject matter.

ballet A dramatic art combining dance, pantomime, and music, usually to tell a story or evoke a mood; also, a musical composition to accompany ballet.

baptistery The part of a church where baptism is performed; in Early Christian and medieval churches, often a separate building constructed on a circular plan.

baroque A style of European art and music in the period c. 1600–1750, characterized by theatricality, elaborately decorative design, and monumental scale.

barrel vault (also **tunnel vault**) A *vault* composed of an extended, continuous arch (Fig. 4.15).

basilica In ancient Roman architecture, a colonnaded hall used for law courts or other public functions; form later adapted to Christian churches (Fig. 5.13).

bass The lowest range of the male voice; also, any bass instrument.

blank verse Poetic meter consisting of iambic pentameter, or five iambs (˘ ˉ) in a line.

Bronze Age Period of human culture in Europe and Asia characterized by use of bronze tools and weapons (from c. 4000–3000 B.C. to c. 1000 B.C.).

buttress In architecture, a supporting arm or post, usually to brace a wall, arch, or *vault* (Fig. 7.6).

cadence In music, a conclusion or resting place.

caliph Ruler of the Muslim community.

canon In architecture or sculpture, a set of rules for proportion; generally, any officially prescribed set of books.

cantata A form of musical composition for voice and orchestra, consisting of several movements or sections, often including opera-like *arias* and *recitative*; as developed by Bach in the baroque period, the most important musical component of Lutheran worship.

capital The upper part of a column; see *order*.

casting A sculptural process in which a liquid material (wax, plaster, clay, or metal) is poured into a mold; when the liquid has hardened, the mold is removed, leaving a replica of the original shape.

catharsis According to Aristotle, the cleansing of the emotions experienced by the audience of an ancient Greek *tragedy* (Greek, "purgation").

cella The inner room of a Greek temple, usually containing a cult image of a deity.

chant See *plainchant*.

chapel A small space in a church or other building usually containing an altar.

chiaroscuro In painting, the use of shades of light and dark to suggest volume; also, strong contrasts of light and dark for dramatic effect (Italian, "light–dark").

chivalry The rules and customs governing knightly conduct in the Middle Ages, requiring loyalty to the lord, fairness in combat, and courtesy toward women (from French *chevalier*, "horseman," "knight").

choir The part of a church where the service is sung, usually east of the *nave* (Fig. 6.29).

chord Any combination of two or more notes sounded together.

choreographer The artist who devises and directs the movements of dancers.

chorus In ancient Greek theater, a group of singers and dancers who commented on the action; in music, a group of singers who perform together, usually singing in parts; also, the section of a musical work designated for choral singing.

classical Pertaining to the civilization of ancient Greece and Rome; also (usually *Classical*), the period in European music, c. 1750–1820, as defined by the works of Haydn, Mozart, and Beethoven.

clef In musical *notation*, the sign placed at the beginning of a *staff* to indicate the pitch of one line, and hence establishing the range of notes for all the lines and spaces (French, "key").

clerestory The row of windows along the top of the *nave* walls of a basilica or church.

cloister The enclosed courtyard of a Christian monastery, often surrounded by covered, arcaded walkways.

collage The technique of pasting materials – paper, string, cloth, etc. – to a canvas or board, often combined with painting (from French *coller*, "to paste").

colonnade A row of columns.

column An upright post, usually a support but sometimes built independently as a monument (Fig. 4.11); in the classical *orders* (Fig. 3.17), consists of shaft, *capital*, and base.

comedy A literary or dramatic form involving wit, humor, and ridicule, usually intended to provoke laughter.

composition The formal arrangement of parts within a work of art; also, a work of music.

concerto A musical composition for an ensemble of voices and instruments; in the baroque *concerto grosso*, a small group of instruments plays in contrast with a larger orchestra; in the Classical concertos of Mozart and Beethoven, a solo instrument plays with an orchestra.

contrapposto A pose of the human figure in which the upper torso is twisted slightly, so that the shoulders and hips form an oblique angle (Italian, "opposite"; Fig. 8.24).

Corinthian order A classical *order* of architecture, with finely carved leaf *capitals*, popular in Hellenistic Greece and imperial Rome.

cornice In classical architecture, the horizontal ledge overhanging the *entablature*; hence, any horizontal projection along the top of a wall.

counterpoint As a synonym for *polyphony*, the musical technique of combining two different melodic lines played simultaneously; also applies to systematized methods in Renaissance and baroque music for combining contrapuntal voices (from Latin *contrapunctum*, "against note").

cross vault (also **groin vault**) *Vault* formed by the intersection of two tunnel vaults (Fig. 4.15).

cubism The abstract style of art developed by Picasso and Braque in the period 1907–1914; its early phase, *analytic cubism*, decomposed objects into abstract planes and shapes; its later phase, *synthetic cubism*, combined *collage* with abstract painting.

dada The movement of European artists characterized by provocation and mockery of traditional art; active c. 1916–1922 in Zürich, Paris, and Berlin.

deism Religious belief in the existence of a God who has created the universe and left it to operate according to rational laws; prominent among *Enlightenment* intellectuals.

dissonance A combination of notes that violates the prevailing harmonic system, producing discord and a feeling of tension in the listener.

dome A hemispherical *vault*, composed of an arch rotated 180 degrees.

Doric A classical *order* of architecture characterized by austere simplicity (Fig. 3.17).

dynamics The aspect of music that determines the variations of loudness or softness of the sound.

empiricism Philosophical belief that all knowledge is derived from experience and the senses; denies the existence of innate ideas independent of experience; compare *rationalism*.

engraving Process of printmaking by incising a metal plate, which is then inked and used to print an image; also, the print itself.

Enlightenment The term given to the eighteenth-century intellectual movement that sought to apply reason and science to human affairs; also the period (c. 1715–1800) of the movement's greatest prominence.

entablature In classical architecture, the horizontal section above the *columns*, consisting of *architrave*, *frieze*, and *cornice* (Fig. 3.17).

entasis The slight outward swelling in the shaft of a classical *column*.

epic A long narrative poem recounting the adventures of a heroic central figure, who is usually aided by supernatural forces.

Epicureanism The philosophical belief that the universe is composed of atoms and void, and that the highest good lies in moderate pleasure.

epistles Letters, especially the letters of Paul and the apostles in the Christian New Testament.

epistolary novel A novel that recounts its story through letters written by one or several of the characters.

essay In literature, a brief work of analytic, interpretive, or critical prose, often dealing with its subject from a personal point of view.

etching The process of *engraving* in which the metal plate is incised, or eaten away, by acid.

ethics The branch of philosophy concerned with human conduct.

ethos In ancient Greece, the belief that music could shape human character (Greek, "character").

Eucharist In Christian belief, the ritual celebration of the Last Supper or Lord's Supper, consisting of bread and wine that symbolize the body and blood of Christ (Greek, "thanksgiving").

Evangelist One of the four authors of the Christian Gospels (Matthew, Mark, Luke, and John).

existentialism Philosophical belief that asserted the absurdity of human existence and stressed the necessity for human struggle and individual responsibility; popularized by Sartre and Camus during the period 1940–1960.

exposition See *sonata form*.

expressionism An artistic or literary style that seeks to express the author's emotions or inner vision; as a movement, applies to writers and artists active, especially in German-speaking Europe, in the period c. 1910–1930.

façade The front of a building.

farce A *comedy* of exaggerated expressions and ludicrous situations.

fauvism A style of painting emphasizing free use of color, practiced by a group of French artists, led by Matisse, in the years 1905–1907.

feudalism the system of landholding and political alliance prevalent in medieval Europe, in which oaths of allegiance and military service are exchanged for possession of land.

fluting In architecture, vertical grooves carved into the shaft of a *column*.

flying buttress The external support of a Gothic church, formed by an arched arm that braces the *nave* wall and transfers its *thrust* to a vertical *buttress* (Fig. 7.6).

form The overall design or structure of a literary, musical, or artistic work.

fresco A technique of wall or ceiling painting in which paint is applied to wet plaster (Italian, "fresh").

frieze Any horizontal band of sculptural decoration; in classical architecture, the sculpted band above the *architrave* and beneath the *cornice*.

fugue A form of musical composition in which a *theme* is developed usually by *counterpoint*.

futurism The movement of artists and intellectuals who rejected tradition and exalted the speed and machines of modern life; active in Italy and Russia c. 1909–1928.

gallery In architecture, the passageway above the church *aisles*.

genre In painting, the depiction of scenes from ordinary life; generally, a type or category of art or literature (portraiture as a *genre* of painting, the novel as a *genre* of literature).

Gesamtkunstwerk (German, "total work of art") The term coined by Wagner to describe his vision of opera as the perfect union of music, theater, dance, and the visual arts.

Golden Age A period of exceptional cultural achievement; in ancient Greece, refers to Athens in 480–404 B.C.

Gospels The first four books of the Christian New Testament (Matthew, Mark, Luke, and John), devoted to accounts of, and commentaries on, the life of Jesus (Greek, "good news").

Gothic In art history, a style associated with the later European Middle Ages (c. 1200–1450); in literature, a *genre* employing horror, supernatural effects, and medieval settings.

Greek cross A cross with arms of equal length.

Gregorian chant A form of *plainchant* attributed to Pope Gregory I (590–604) but probably unified as a body of sacred vocal music during the reign of Charlemagne, c. 800.

Guidonian hand A method of musical notation, attributed to Guido of Arezzo (active early eleventh century), in which different parts of the hand represented different tones.

hamartia Aristotle's term for the tragic error that brings a hero's downfall.

Harlem Renaissance Movement of African-American authors and artists in Harlem (New York City) during the 1920s.

harmony The combination of notes to produce *chords* and the successive use of chords in a progression that pleases the ear.

high-relief See *relief*.

hippodrome In ancient Greece and Rome, an oval stadium for horse races.

homophonic The term for the type of *polyphony* in which a principal melodic line is accompanied by subordinate lines in chordal *harmony*, as distinct from *counterpoint*, in which the melodic lines move independently (Greek, "like-voiced").

hubris Greek for arrogant or excessive pride.

humanism The philosophical belief in the nobility of human character and achievement; in the Renaissance, a humanist was a scholar who studied ancient Greek and Latin authors.

hydraulis An ancient type of organ that used water to control the wind pressure in the organ's pipes.

hymn A religious song of praise and adoration.

icon In the Byzantine Church, paintings on panel representing holy persons (Greek, "image").

iconoclasm A movement in the Byzantine Christian Church (730–843) to destroy *icons* and other visual images (Greek, "image smashing").

iconography Any system of symbols and their meanings.

idealism The philosophical belief that a permanent and unchanging world exists apart from the world known through sense experience.

idée fixe The term coined by Berlioz for a melody that recurs, with variations, in different movements of a work.

imitation In music, the immediate or overlapping repetition of a melodic phrase by different voices, often at a different pitch.

impasto In painting, thick applications of oil paint.

imperialism The domination by a single nation or city-state over the life of other areas.

impressionism The movement and style of painting developed by Monet and others, chiefly in the period 1870–1890, characterized by the effort to capture the transient effects of light and color in outdoor scenes.

improvisation Spontaneously creating or adding to a musical work as it is being performed; especially prominent in baroque music and *jazz*.

installation art A work of art erected or arranged (usually temporarily) in a particular site or exhibition space.

interval The distance between two musical *pitches*; designated by counting up or down on the seven-tone *scale* from the starting point (C up to G is an interval of a "fifth").

Ionic A classical *order* of architecture with slender *columns* and elegant scrolled *capitals* (Fig. 3.17).

jamb The vertical member that frames a doorway.

jazz A type of popular music characterized by *improvisation* on popular melodies and a swinging rhythm; originated by African-American musicians in the early 1900s.

jongleur A medieval wandering minstrel.

key The tendency of a musical work to gravitate toward a tonal center (the "key" note, or *tonic*); also, in keyboard instruments, the lever that causes sound to be made.

keystone The central stone in an arch or *vault*.

Koran See *Qur'an*.

kouros A nude male statue of the *archaic* period in ancient Greece, characterized by a frontal stance and stylized anatomical features; the female version (*koré*) was always clothed.

Latin cross A cross with a longer vertical arm that bisects the shorter crossing arm.

Leitmotif In opera, a well-defined theme that symbolizes a character, object, or idea, often recurring with variations to reflect developments in the dramatic action (German, "leading motif").

libretto The written text of an opera (Italian, "small book").

linear perspective The *perspective* technique that creates the illusion of depth by making parallel lines converge in the far distance.

lintel The horizontal beam spanning opening between posts or columns.

liturgy The formalized and official rites used in public worship.

lyric A *genre* of poetry, originally designating poetry recited with musical accompaniment; generally, any brief poem, often expressing direct emotion and suggestive of song (Greek *lura*, "lyre," a stringed instrument).

madrigal A type of song popular in Renaissance Italy and England; the Italian madrigal (popular 1350–1560) was a two- or three-voice song of several verses with repeating music; the English madrigal (popular in Elizabethan England) was a secular song in five or six voices often set to love poetry.

major In music, a seven-tone scale or *key* that contains half-step *intervals* between the third and fourth and seventh and eighth steps in the scale (Fig. 10.28).

mannerism In painting and sculpture, a style prominent in Italy between the Renaissance and baroque periods, characterized by elongated figures and deliberate distortions of color, *perspective*, and scale.

masonry In architecture, stone or brick-work.

Mass In religion, the *liturgy* of the *Eucharist* in the Catholic Church, composed of the Ordinary (text always the same) and the Proper (texts vary according to liturgical season); in music, a musical composition to accompany the Mass.

materialism In ancient philosophy, the belief that all things are composed of physical matter; in modern thought, the belief that all existence is the manifestation of physical reality and that the good lies in physical comfort or well-being.

medium (pl. **media**) In general, the physical or technical means by which a work of art is realized (in painting, for example, oil paint vs. *fresco*).

megalith A large stone block, often arranged or aligned in Stone-age structures.

melisma In *Gregorian chant*, a chain of several notes sung on a single syllable.

melody A series of musical tones arranged in succession, in a *rhythmic* pattern, to form a recognizable unit.

meter In poetry, any regular scheme of stressed and unstressed syllables; in music, a regular pulse of beats, grouped in larger units called measures (or bars), usually containing two (duple meter) or three (triple meter) beats per measure.

metopes Square slabs, often decorated with sculpture, that alternate with triglyphs in the *frieze* of a Doric temple.

minimalism In the arts, a highly conceptual style of the 1960s that sought to eliminate art's expressive or symbolic qualities; in music, a style of composition using repetition and static harmony, prominent in the U.S. in the 1970s.

minor In music, a seven-tone *scale* or *key* which, in its natural version, contains half-step *intervals* between the second and third and fifth and sixth steps in the scale (Fig. 10.28).

miracle play A medieval drama depicting the life and martyrdom of a saint (see *mystery play*).

mobile A type of sculpture in which different parts move freely or are moved by a motor.

mode Any group of notes that form a musical *scale* and serve as the basis for a musical composition.

modernism The styles and movements in the arts, literature, and music associated with the rise of the modern world, especially in the period 1910–1945.

modulation In music, the change from one *key* to another.

monophonic The term for music consisting of a single melodic line, such as *plainchant* (Latin, "one-voiced"); compare *polyphony*.

monotheism Religious belief in a single, usually all-powerful deity.

montage In film, the rapid editing of brief film segments so as to create a powerful effect on the viewer; see also *photomontage*.

morality play A medieval drama that illustrates a Christian moral teaching, usually through *allegory*.

mosaic A pictorial *medium* consisting of colored pieces of glass, stone, and tile cemented to a wall, floor, or ceiling.

mosque A Muslim religious building for communal prayer.

motet A *polyphonic* musical form used widely in the period c. 1250–1750; in medieval and Renaissance versions, the upper voices often sang different texts (French *mot*, "word").

motif (also **motive**) A brief, often fragmentary musical idea, usually elaborated or developed in a larger composition.

movement In music, a section of a larger composition, such as a symphony.

mural A painting on a wall.

mystery play A medieval religious drama that depicts biblical stories.

mysticism The experience of a direct, subjective union or communion with God or an ultimate reality; also, the belief that such direct experience of God or spiritual truth can be attained subjectively or intuitively, often in a trance or vision.

myth Ancient story or belief usually explaining, in metaphoric or symbolic terms, cosmic origins or sacred truths.

narthex The porch or vestibule of a church.

naturalism In the visual arts, any style that seeks fidelity to nature.

nave The rectangular space of a church where worshipers congregate (Latin, "ship").

Near East Region of the ancient world from present-day Turkey to Iran and Arabia.

neoclassicism The revival of the styles and tastes of ancient Greece and Rome, especially as pursued in France and England in the seventeenth and eighteenth centuries.

Neoplatonism A late classical philosophy derived from Plato that asserts three levels of reality leading to the One or the Good; widely adapted by Christian philosophers in the medieval and Renaissance eras.

nominalism The medieval philosophical doctrine that denied the existence of "universals," the ideas referred to by such general terms as "red" or "beauty."

notation Any system for writing music.

octave The *interval* between one note and the next note of the same *pitch*, for example, from middle C to the next C higher or lower; on the seven-tone *scale*, the interval of an "eighth."

oculus A circular opening in a wall or a domed ceiling.

opera A musical drama in which all or some of the dramatic text is sung to orchestral accompaniment.

oratorio An extended musical composition for voice and orchestra, usually with a sacred text; contains the musical elements of opera but without costume or theatrical staging.

orchestra In ancient Greek theater, the circular space where the chorus danced and sang its part; in music, an instrumental group that includes stringed instruments, organized to perform musical works (Greek, "dancing place").

order In architecture, a style of decorating a classical temple, distinguished by the treatment of *column* and *entablature* (Fig. 3.17).

organum Generally, the forms of medieval *polyphony* based on *plainchant*; usually with a slow-moving lower voice and one or more higher, more rapid voices.

overture An orchestral composition that introduces an *opera*, *oratorio*, or *ballet*.

pantomime (also **mime**) A dramatic form in which actors use gestures without words.

parable A simple story that teaches a lesson or illustrates a moral principle.

Passion The events of Jesus' last hours, from the Last Supper to his death; also, an *oratorio* recounting these events.

pediment The triangular area formed by the gabled roof and *cornice* of a classical temple.

pendentives Concave, triangular devices that support a dome (Fig. 5.17).

performance art Type of art consisting of performances by visual or musical artists, rather than actors or dancers, often provocative in nature.

perspective In the visual arts, techniques for creating the illusion of three-dimensional depth on a flat surface.

philosophes Eighteenth-century French intellectuals who professed *Enlightenment* beliefs.

photomontage A *collage* of photographic images.

pier A masonry support, usually square or rectangular, for a roof or *vault*.

pietà A painting or sculpture depicting the Virgin Mary grieving over the dead Christ.

pilgrimage A journey to a shrine or holy place.

pitch The quality of a sound that fixes it, high or low, on a scale.

plainchant (also **plainsong**) The *monophonic*, unaccompanied vocal music arising in early Christianity and performed with the Christian *liturgies* (see *Gregorian chant*).

polyphonic The term for music in which two or more independent melodic lines sound simultaneously (Greek, "many-voiced"); compare *monophonic* and *homophonic*.

polytheism Religious belief in many gods.

pop art A style of art based on "popular" or mass cultural forms such as advertising, commodity packaging, popular music, and film; prominent in the U.S. during the 1960s.

post-and-lintel An architectural form based on *columns* supporting horizontal beams, as in a Greek temple.

post-impressionism A style in painting (about 1880–1900) that developed from *impressionism*.

prelude In music, a *movement* that introduced a larger instrumental work; often performed unattached as an independent work.

proscenium In ancient Greek theater, the area in front of the *skenē* building where the principal actors performed their parts (Greek, "before the *skenē*").

psalter Book containing the Psalms of the Bible.

quadrivium In medieval learning, the higher division of the seven liberal arts, consisting of arithmetic, geometry, astronomy, and music.

Qur'an The Muslim sacred scriptures, as recorded by the prophet Muhammad.

rationalism The philosophical belief that emphasizes the power of human reason over emotion or divine revelation; also, in contrast to *empiricism*, the belief that some ideas are innate to the human mind.

realism An artistic and literary style of the mid-nineteenth century that sought truthfulness to life, instead of traditional idealized representations; used generally, a synonym for *naturalism*.

recitative In opera and similar forms, a style of singing that follows the natural rhythms of the voice, as distinguished from song-like *arias* and ensembles.

Reconquest (also **Reconquista**) Campaign by medieval Spanish Christians to regain Muslim-held territories in Spain.

relativity The scientific principle of modern physics that time and distance are relative to the observer's frame of reference.

relics Objects (often bones or possessions) venerated because of their association with a holy person.

relief Sculpture attached to, and projecting from, a backing wall or panel; low-relief sculpture projects slightly, while *high-relief* sculpture projects farther.

reliquary A container for sacred remains, such as a saint's bones.

Renaissance The literary and artistic period, c. 1400–1600, characterized by artistic innovation, new confidence in human abilities, and interest in classical civilization.

responsorial singing A form of *plainchant* in which a soloist sings and a chorus responds.

rhythm In music, a regular pulse or beat; in the visual arts, the repetition of some element (line, shape, etc.).

ribbed vault A *vault* supported by thin ribs of stone (Fig. 7.5).

rococo An eighteenth-century artistic style, especially in France, characterized by soft colors, decorative designs, and frivolous mood (French *rocaille*, "shell-work").

Romanesque The medieval artistic style of c. 900–1200, in architecture characterized by the use of rounded arches, *tunnel vaults*, and other features of Roman architecture (hence the name "Romanesque").

romanticism An artistic movement or sensibility prominent c. 1775–1850, characterized by heroic individualism, a nostalgia for nature or the past, and the prevalence of feeling over reason.

satire Any work that criticizes wickedness and folly through wit and humor, usually with the intent to correct and improve.

scale In music, a sequence of *tones* in ascending or descending order of *pitch*; in general, the relative size or proportion of an object of art.

scholasticism The method in medieval theology and philosophy characterized by a synthesis of Christian doctrine and the works of Aristotle.

Scientific Revolution The intellectual movement of seventeenth-century Europe that developed the principles and methods of modern science, especially the empirical observation of nature and the verification of truth by experiment and mathematical calculation.

sculpture Any type of art in which a three-dimensional object is fashioned either by removing material (*subtractive sculpture*) or by building up a shape from one or several materials (*additive sculpture*).

serial composition (also **twelve-tone method**) The method of musical composition, devised by Schoenberg c. 1920, based on the varied combination of a series, or "row," of twelve *tones*.

skenē In ancient Greek theater, the building that housed costumes and props and served as a backdrop for the performance.

socialism The philosophical and political belief that society should be based on collective ownership and control of the production of goods.

sonata form A three-part musical form, employed in the Classical *symphony*, consisting of musical *themes* elaborated through an exposition, development, and recapitulation (Fig. 11.20).

sonnet A form of *lyric* poem composed of fourteen lines in one of several traditional rhyme schemes.

sophists A group of teachers in fifth-century Athens who taught persuasion in argument and questioned the independence of knowledge from the knower (Greek *sophos*, "wisdom").

squinches A system of columns or beams placed diagonally so as to support a dome.

staff In music, the set of horizontal lines and intervening spaces on which music is written.

stoicism The philosophical belief, prominent in classical Rome, that reason governs the universe and that individuals should accept events beyond their immediate control.

subtractive sculpture *Sculpture* fashioned by carving or chipping away material (such as wood or marble) from an unshaped block.

superrealism In the visual arts, a style of extreme realism, prominent in the U.S. in the 1970s.

Symbolism A literary and artistic movement, c. 1885–1910, characterized by a reaction against *realism* and the use of evocative but often private symbols.

symphony An extended form of musical composition for *orchestra*, usually with three or four *movements*.

synthetic cubism See *cubism*.

tempera A paint made of pigment, water, and egg yolk.

tempo The "time" of a musical composition, determining the speed of its performance; traditionally designated by Italian terms (for example, *allegro*, "quick").

tenor In medieval *organum*, the lower voice consisting of long, sustained notes (Latin, *tenere*, "to hold"); also, the highest range of the male voice in regular use.

theme The self-contained melody on which all or part of a composition may be based.

thrust The force that causes a roof to push supporting walls outward.

tonality In music, the series of relationships among *pitches* as based on one central note (the *tonic*); in particular, the system of *keys* governing Western music from the seventeenth to the twentieth centuries.

tone (also **note**) A musical sound of particular *pitch*.

tone row In *serial composition*, the series of twelve tones that forms the basis of the composition.

tonic The main note in a musical *key*.

tracery Decoratively-shaped openings in a *Gothic* church window.

tragedy In ancient Greece, a form of poetic drama involving song and dance, usually relating the fall of a hero through some tragic error; in general, a serious drama involving a character's courageous struggle against destiny or defeat (Greek *tragoidia*, "goat song").

transept The crossing arm of a cross-shaped church.

triforium Arcaded wall passage facing onto the *nave* of a church.

triptych A painting on three panels.

trivium In medieval learning, the lower division of the seven liberal arts, consisting of grammar, rhetoric, and dialectic.

troubadours Poet-musicians of southern France, prominent c. 1100–1350.

tympanum In medieval architecture, the area enclosed by the *lintel* and framing arch of a doorway.

utilitarianism The attitude or philosophical belief that utility, or usefulness, should be the standard for judging an object or action.

utopia An ideal society (Greek for "no-place").

vanishing point In *linear perspective*, the point at which parallel lines seem to converge.

vault A masonry ceiling or roof constructed on the principle of the *arch*.

vernacular The spoken language of a region or country, as opposed to a literary or cultured language; for example, Luther translated the Bible into vernacular German from medieval Latin.

virtuoso In music, a performer of exceptional brilliance or skill.

voice In musical composition, one of the several melodic strands or parts of a *polyphonic* work; for example, the *tenor* voice or a *fugue* in three voices.

whole tone scale Musical *scale* consisting only of whole-tone *intervals*, without the half-tone steps in a traditional musical *key*.

woodcut The process of printmaking by incising a plank of wood, which is then inked and used to print an image; also, the print itself.

word painting The musical depiction of the meaning of a word or phrase in the text; for example, a quickened rhythm on the word "joyous."

ziggurat Mesopotamian stepped pyramid.

Further Reading

General
Brown, J. R. *The Oxford Illustrated History of Theatre*. 1996.
Cass, Joan. *Dancing Through History*. 1993.
Cumming, Robert. *Annotated Art: The World's Greatest Paintings Explored and Explained*. 1995.
Janson, H. W. *History of Art*, 5th ed. rev. 1997.
Sadie, S., ed. *The Norton/Grove Concise Dictionary of Music*. 1988.
Solomon, Robert, and Kathleen Higgins. *A Short History of Philosophy*. 1996.

Ancient World
Armstrong, Karen. *A Short History of Myth*. 2005.
Arus, Joan, ed. *Art of the First Cities: The Third Millennium B.C. from the Mediterranean to the Indus*. 2003.
Diamond, Jared. *Guns, Germs, and Steel: The Fates of Human Societies*. 1997.
Grimal, Nicolas. *A History of Ancient Egypt*. 1992.
Saggs, H. W. F. *Civilization before Greece and Rome*. 1989.
Stevenson Smith, W. *The Art and Architecture of Ancient Egypt*. Rev. ed. Pelican History of Art. 1998.

Classical Greece
Beard, Mary. *The Parthenon*. 2002.
Boardman, John. *The Oxford History of Classical Art*. 1993.
Cantarella, Eva. *Pandora's Daughters: The Role and Status of Women in Greek and Roman Antiquity*. 1987.
Comotti, Giovanni. *Music in Greek and Roman Culture*. 1989.
Ford, Andrew. *Homer: The Poetry of the Past*. 1992.
Green, Peter. *Alexander to Actium: The Historical Evolution of the Hellenistic Age*. 1990.
Howatson, M. C., ed. *Oxford Companion to Classical Literature*, 2nd ed. 1989.
Pollitt, J. J. *Art and Experience in Classical Greece*. 1972.
Vlastos, Gregory. *Socrates: Ironist and Moral Philosopher*. 1991.

Ancient Rome
Boardman, John, and others, eds. *The Oxford History of the Classical World*. 1986.
Connolly, Peter. *The Ancient City: Life in Classical Athens and Rome*. 1998.
Freeman, Charles. *The World of the Romans*. 1993.
Galinsky, K. *Augustan Culture: An Interpretive Introduction*. 1996.
Grant, Michael. *The Art and Life of Pompeii and Herculaneum*. 1979.
Hadot, Pierre. *What Is Ancient Philosophy?* 2002.
Hopkins, Keith, and Mary Beard. *The Colosseum*. 2005.
Kleiner, Diane. *Roman Sculpture*. 1992.
Ward-Perkins, J. B. *Roman Imperial Architecture*. Pelican History of Art. 1981.

Judaism, Christianity, Islam
Alter, Richard. *The World of Biblical Literature*. 1992.
Armstrong, Karen. *A History of God. The 4000-Year Quest of Judaism, Christianity and Islam*. 1993.
Brend, Barbara. *Islamic Art*. 1991.
Brown, Raymond. *An Introduction to the New Testament*. 1997.
Fredriksen, Paula. *Jesus of Nazareth, King of the Jews: A Jewish Life and the Emergence of Christianity*. 2000.
Freeman, Charles. *The Closing of the Western Mind: The Rise of Faith and the Fall of Reason*. 2004.
Friedman, Richard. *Who Wrote the Bible?* 1987.
Frymer-Kensky, Tikva. *In the Wake of the Goddesses: Women, Culture, and the Biblical Transformation of Pagan Myth*. 1992.

Hourani, Albert. *A History of the Arab People*. 1989.
Krautheimer, Richard. *Early Christian and Byzantine Architecture*. Pelican History of Art. 1975.
McManners, J, ed. *The Oxford Illustrated History of Christianity*. 1990.
Shanks, Hershel, ed. *Ancient Israel: A Short History From Abraham to the Roman Destruction of the Temple*. 1988.

Early Middle Ages
Barbero, Alessandro. *Charlemagne: Father of a Continent*. 2004.
Conant, Kenneth. *Carolingian and Romanesque Architecture 800–1200*. 1979.
Flanagan, Sabina. *Hildegard of Bingen: A Visionary Life*. 1998.
Hoppin, Richard. *Medieval Music*. 1978.
Lacey, Robert. *The Year 1000: What Life Was Like at the Turn of the First Millennium—An Englishman's World*. 1999.
Lawrence, C. H. *Medieval Monasticism*, 2nd ed. 1989.
Marenbon, John. *Early Medieval Philosophy (480–1150)*. 1983.

The Gothic Age
Armstrong, Karen. *Holy War: The Crusades and Their Impact on Today's World*. 1991.
Favier, Jean. *The World of Chartres*. 1990.
Gallagher, Joseph. *To Hell & Back with Dante: A Modern Reader's Guide to The Divine Comedy*. 1996.
Hyman, A., and J. Walsh, eds. *Philosophy in the Middle Ages: The Christian, Islamic, and Jewish Traditions*, 2nd ed. 1983.
Knowles, David. *The Evolution of Medieval Thought*. 1962.
Labarge, Margaret Wade. *A Small Sound of the Trumpet: Women in Medieval Life*. 1986.
Sekules, Veronica. *Medieval Art*. Oxford History of Art. 2001.

Italian Renaissance
Bramly, S. *Leonardo: Discovering the Life of Leonardo da Vinci*. 1991.
De Grazia, Sebastian. *Machiavelli in Hell*. 1989.
Fenlon, Iain, ed. *The Renaissance*. Man & Music. 1989.
Hartt, Frederick. *History of Italian Renaissance Art*, 4th ed. 1994.
Kelley, Donald. *Renaissance Humanism*. 1991.
King, Ross. *Brunelleschi's Dome: How a Renaissance Genius Reinvented Architecture*. 2000.
Olson, Roberta J. M. *Italian Renaissance Sculpture*. World of Art. 1992.
Perkins, Leeman. *Music in the Age of the Renaissance*. 1999.

Reformation and Late Renaissance
Arnold, Dennis. *Giovanni Gabrieli and the Music of the Venetian High Renaissance*. 1979.
Hale, John. *The Civilization of Europe in the Renaissance*. 1993.
Harbison, Craig. *The Mirror of the Artist: Northern Renaissance Art in its Historical Context*. 1995
McGrath, Alister. *Reformation Thought: An Introduction*. 1988.
Nauert, Charles. *The Age of Renaissance and Reformation*. 1981.
Ozment, Stephen. *Protestants: The Birth of a Revolution*. 1992.
Rosand, David. *Painting in Sixteenth-Century Venice: Titian, Veronese, Tintoretto*. 1997.
Rowse, A. L. *Elizabethan Renaissance: The Cultural Achievement*. 1972.

The Baroque
Brown, Jonathan. *The Golden Age of Painting in Spain*. 1991.
Downes, Kerry. *The Architecture of Wren*. 1982.
Garrard, Mary D. *Artemisia Gentileschi: The Image of the Female Hero in Italian Baroque Art*. 1991.
Mainstone, Madeleine. *The Seventeenth Century*. 1981.
Montclos, Jean-Marie. *Versailles*. 1991.

Morrissey, Jake. *The Genius in the Design: Bernini, Borromini, and the Rivalry That Transformed Rome*. 2005.
Palisca, Claude. *Baroque Music*, 3rd ed. 1991.
Pendle, Katherine, ed. *Women and Music: A History*. 1991.
Schwartz, Gary. *Rembrandt: His Life, His Paintings*, 2nd ed. 1991.

The Enlightenment
Craske, M. *Art in Europe 1700–1830*. Oxford History of Art. 1997.
Downs, Philip. *Classical Music: The Era of Haydn, Mozart, and Beethoven*. 1992.
Gay, Peter. *The Enlightenment: An Interpretation*, 2 vols. 1969.
Heartz, Daniel. *Mozart's Operas*. 1990.
Honour, Hugh. *Neo-classicism*. 1977.
Jones, Stephen. *The Eighteenth Century*. 1985.
Norberg-Schulz, C. *Late Baroque and Rococo Architecture*. 1974.
Porter, Roy. *The Creation of the Modern World: The Untold Story of the British Enlightenment*. 2000.
Yolton, John, and others. *The Blackwell Companion to the Enlightenment*. 1992.

Revolution and Romanticism
Bennett, B., and C. Robinson, eds. *The Mary Shelley Reader*. 1990.
Boime, Albert. *Art in an Age of Revolution 1750–1800*. 1987.
Dabundo, Laura, ed. *Encyclopedia of Romanticism: Culture in Britain, 1780s–1830s*. 1992.
Hobsbawm, E. J. *The Age of Revolution. Europe 1789–1848*. 1962.
Rosen, Charles. *The Romantic Generation*.1995.
Rosenblum, Robert, and H. W. Janson. *19th Century Art*. 1984.
Schama, Simon. *Citizens: A Chronicle of the French Revolution*. 1989.
Wood, Gordon. *The Radicalism of the American Revolution*. 1992.

The Industrial Age
Berman, Marshall. *All That Is Solid Melts Into Air: The Experience of Modernity*. 1982.
Butler, Ruth. *Rodin: The Shape of Genius*. 1993.
Conradi, Peter. *Fyodor Dostoyevsky*. 1988.
Dennett, Daniel. *Darwin's Dangerous Idea: Evolution and the Meanings of Life*. 1995.
Donington, Robert. *Opera and its Symbols: The Unity of Words, Music, and Staging*. 1990.
Garb, Tamar. *Women Impressionists*. 1986.
Herbert, R. *Impressionism: Art, Leisure, and Parisian Society*. 1988.
Hobsbawm, E. J. *The Age of Empire, 1875–1914*. 1987.
Hitchcock, Henry-Russell. *Architecture: Nineteenth and Twentieth Centuries*. 1971.
Whittall, Arnold. *Romantic Music: A Concise History from Schubert to Sibelius*. 1987.

Modernism
Arnason, H. H. *A History of Modern Art*, 4th ed. 1998.
Breger, Louis. *Freud: Darkness in the Midst of Vision*. 2000.
Cantor, Norman. *The American Century: Varieties of Culture in Modern Times*. 1997.
Fussell, Paul. *The Great War and Modern Memory*. 1975.
Griffiths, Paul. *Modern Music: A Concise History*. 1985.
Ogren, Kathy J. *The Jazz Revolution: Twenties America and the Meaning of Jazz*. 1989.
Varnedoe, Kirk. *A Fine Disregard: What Makes Modern Art Modern*. 1990.

Contemporary Age
Brindle, Reginald S. *The New Music: The Avant-garde since 1945*, 2nd ed. 1987.
Chadwick, Whitney. *Women, Art, and Society*, 2nd ed. 1997.
Docherty, Thomas, ed. *Postmodernism: A Reader*. 1993.
Hopkins, David. *After Modern Art: 1945–2000*. Oxford History of Art. 2000.
Jencks, Charles. *The New Paradigm in Architecture: The Language of Postmodernism*. 2002.
Kaufmann, Walter, ed. *Existentialism from Dostoevsky to Sartre*, rev. ed. 1975.
Madoff, Steven, ed. *Pop Art: A Critical History*. 1997.
Stiles, Kristine, and Peter Selz, eds. *Theories and Documents of Contemporary Art: A Sourcebook of Artists' Writings*. 1996.

Index

Selections from "Music for the Humanities"

"Music for the Humanities" includes selections that represent the breadth of the Western musical tradition and a hint of traditions beyond the West. Many are short excerpts from longer works. Please visit www.prenhall.com/bishop for links to the full compositions and listening guides for every selection.

1 Traditional Chinese, "Han Ya Xi Shui"

2 Traditional Islamic, Call to Prayer (Adhan). Courtesy of Smithsonian Folkways Recordings.

3 Ewe Atsiagbekor (Ghanaian Drumming). Courtesy of Smithsonian Folkways Recordings.

4 Hildegard of Bingen, "O Viridissima Virga," Oxford Camerata, Jeremy Summerly conducting.

5 Bernart de Ventadorn, "Quan vei la lauzeta mover." Unicorn Ensemble, Michel Posch conducting.

6 Weelkes, "As Vesta Was," from *The Triumphes of Oriana,* collected by Thomas Morley. Oxford Camerata, Jeremy Summerly conducting.

7 Palestrina, "Kyrie," from *Pope Marcellus Mass.* Oxford Camerata, Jeremy Summerly conducting.

8 Bach, Brandenburg Concerto No. 2 in F Major: Allegro Assai. Cologne Chamber Orchestra, Helmut Muller-Bruhl conducting.

9 Handel, "Hallelujah!" from *Messiah.* Scholars Baroque Ensemble.

10 Purcell, "Dido's Lament," from *Dido and Aeneas,* Act 1. Scholars Baroque Ensemble.

11 Haydn, Symphony No. 94 in G Major, "Surprise," Andante. Capella Istropolitana.

12 Mozart, "Cinque…dieci," from *The Marriage of Figaro,* Act 1, Scene 1. Hungarian State Opera Orchestra, Pier Giorgio Morandi conducting.

13 Mozart, Symphony No. 40 in G Minor, K 550: Molto Allegro. Capella Istropolitana, Barry Wordsworth conducting.

14 Beethoven, Symphony No. 5 in C Minor, Op. 67: Allegro con Brio. Nicolaus Esterhazy Sinfonia, Belah Drahos conducting.

15 Berlioz, *Symphonie Fantastique,* Op. 14: *Dies irae, Ronde du sabbat.* San Diego Symphony Orchestra, Yoav Talmi conducting.

16 Chopin, "Revolutionary" Etude In C Minor, Op.10. Idil Biret, piano.

17 Schubert, "Der Erlkonig," tr. Franz Liszt. Antii Siirala, piano.

18 Wagner, "Bridal Chorus," from *Lohengrin.* Slovak Philharmonic Chorus, Slovak Radio Orchestra, Johannes Wildner conducting.

19 Debussy, "Clair de Lune." Slovak Radio Orchestra, Keith Clark conducting.

20 Schoenberg, "Etwas Rasch," from *Six Little Piano Pieces,* Op.19. Peter Hill, Piano.

21 Stravinsky, "Dance of Youths and Maidens," from *The Rite of Spring.* Belgian Radio and Television Philharmonic Orchestra, Alexander Rabhari conducting.

22 Bernstein, "Mambo," from *West Side Story.* Nashville Symphony Orchestra, Kenneth Schermerhorn conducting.

23 Glass, *Akhnaten: Dance* (Act II, Scene 3). Ulster Orchestra, Takuo Yuasa conducting.